The English Prize

YALE CENTER FOR BRITISH ART, NEW HAVEN

PAUL MELLON CENTRE FOR STUDIES IN BRITISH ART, LONDON

REAL ACADEMIA DE BELLAS ARTES DE SAN FERNANDO, MADRID

ASHMOLEAN MUSEUM OF ART AND ARCHAEOLOGY, UNIVERSITY OF OXFORD

YALE UNIVERSITY PRESS, NEW HAVEN AND LONDON

The English Prize

The Capture of the Westmorland, An Episode of the Grand Tour

Edited by María Dolores Sánchez-Jáuregui and Scott Wilcox

WITH CONTRIBUTIONS BY

MARÍA DEL CARMEN ALONSO RODRÍGUEZ, SARAH ARMITAGE, JOHN BREWER, KELLY CANNON,

ELISABETH FAIRMAN, CLARE HORNSBY, ELEANOR HUGHES, JOSÉ M. LUZÓN NOGUÉ,

AURELIO NIETO CODINA, STEFFI ROETTGEN, FRANK SALMON, MARÍA DOLORES SÁNCHEZ-JÁUREGUI,

KIM SLOAN, CHRISTINA SMYLITOPOULOS, CATHERINE WHISTLER,

SCOTT WILCOX, JOHN WILTON-ELY, JONATHAN YARKER,

AND ALISON YARRINGTON

This publication accompanies the exhibition *The English Prize: The Capture of the Westmorland, an Episode of the Grand Tour*, co-organized by the Yale Center for British Art, New Haven; the Ashmolean Museum of Art and Archaeology, University of Oxford; and the Paul Mellon Centre for Studies in British Art, London; in association with the Real Academia de Bellas Artes de San Fernando, Madrid, on view at the Ashmolean Museum of Art and Archaeology from May 17 to August 27, 2012, and at the Yale Center for British Art from October 4, 2012, to January 13, 2013.

This publication has been supported generously by the David T. Langrock Foundation.

Library of Congress Cataloging-in-Publication Data

The English prize : the capture of the Westmorland, an episode of the grand tour / edited by María Dolores Sánchez-Jáuregui and Scott Wilcox.
 pages cm
 ISBN 978-0-300-17605-6 (hardback)
1. Art treasures in war—Europe—History—18th century.
2. War of American Independence, 1775–1783
3. Westmorland (Ship) 4. Art—Collectors and collecting—Great Britain—History—18th century. 5. Grand tours (Education) 6. Travelers—Italy—History—18th century. I. Sánchez-Jáuregui, María Dolores. II. Wilcox, Scott, 1952–
N9135.E54 2012
707.4'42574--dc23

 2011049266

A catalogue record for this book is available from the British Library.

10 9 8 7 6 5 4 3 2 1

FRONT JACKET: *Francis Basset* (cat. 21, detail)
BACK JACKET: *Head of the Medici Venus* (cat. 99, detail)
ENDPAPERS: *The Raphael Loggia* (cat. 123, details)
FRONTISPIECE: *Campi Phlegraei* (cat. 60, pl. XXXVII, *View of the Island of Stromboli*, detail)
PAGE VI: *Ariccia* (cat. 26, detail)
PAGE VIII: *The Persian Sibyl* (cat. 129, detail)
PAGE X: *Temples of Vesta and the Sybil at Tivoli* (cat. 73, detail)
PAGES 162–63: *Arch of Titus* (cat. 71, detail)
PAGE 164: *José Moñino y Redondo, Conde de Floridablanca* (cat. 6, detail)

Designed by Susan Marsh
Set in ITC Bodoni by Tina Henderson
Map and crate marks drawn by Mary Reilly
Copyedited by Richard Slovak
Printed on 135 gsm Gardapat Kiara
Printed and bound in Italy by Conti Tipocolor SpA, Florence

To Brian Allen,
friend, colleague, and wise counselor,
this book is gratefully
and affectionately dedicated.

Contents

Directors' Foreword

THE AMERICAN WAR OF INDEPENDENCE and the Grand Tour tend to occupy different compartments in our historical imagination, yet the war had repercussions far beyond the thirteen American colonies. One encounter of that war was the capture of the *Westmorland*, not an event of any significance in determining the outcome of the larger ongoing global conflict but one that provides us with rich insights into the phenomenon of the Grand Tour. This exhibition and catalogue present the episode and take the opportunity it provides to propel Grand Tour studies in exciting new directions.

The contents of the ship, purchased by Carlos III of Spain and deposited in large part in the Real Academia de Bellas Artes de San Fernando in Madrid, belonged to a range of British travelers, collectors, and dealers. These objects speak not just of an admiration for great works of Continental art and the acquisition of masterpieces for the great collections of Britain, but of the practicalities and hazards of acquiring works and sending them home—not just masterpieces, but copies of masterpieces; not just lavish folio volumes of prints, but the guidebooks and dictionaries and grammars, even the pleasure reading, used day to day by the tourists on their travels.

As several of the contributors have commented in the essays in this volume, the *Westmorland* offers a unique time capsule that provides extraordinary insights into a short period at the height of the Grand Tour. In prizing open this capsule three people have played a special role. José M. Luzón Nogué, Director of the Museum at the Real Academia, initiated the research that uncovered the story of the *Westmorland* and promoted and directed the research that led first to an exhibition in Spain in 2002 and now to the exhibition at the Ashmolean Museum of Art and Archaeology and the Yale Center for British Art. José María's enthusiasm for the project was matched by that of Brian Allen, retiring Director of Studies of the Paul Mellon Centre for Studies in British Art, in London, whose active involvement and generous support have been crucial in sustaining the project and to whom we gratefully dedicate this publication. María Dolores Sánchez-Jáuregui (known to us as Lola), Senior Research Fellow at the Paul Mellon Centre for Studies in British Art and affiliate of the Real Academia, has been a researcher on the project since its early days. Her years of hard work and devotion to the subject have made her the foremost expert on this extraordinary episode of cultural history.

Lola has worked closely with Scott Wilcox, Chief Curator of Art Collections and Senior Curator of Prints and Drawings at the Center, and Elisabeth Fairman, the Center's Senior Curator of Rare Books and Manuscripts, to shape the exhibition that will be seen at the Ashmolean and Yale. The Ashmolean is an ideal venue given its historic collections of art and antiquities that testify to the long tradition of collecting the antique in Britain and the enduring interest of artists and collectors in Italy's art and architecture. As great university museums both the Ashmolean and the Yale Center for British Art take pride in presenting new scholarly research in engaging ways to a

wide audience. The presentation at the Ashmolean has been overseen with elegance and discernment by Catherine Whistler, Senior Assistant Keeper. The staff at each of our two institutions has worked with customary professionalism and grace. While fuller thanks are expressed in the acknowledgments, here we would briefly mention, at the Yale Center: Timothy Goodhue, Registrar; Eleanor Hughes, Associate Curator and Head of Exhibitions and Publications; and Beth Miller, Associate Director for Advancement and External Affairs; and, at the Ashmolean: Agnes Valenčak, Head of Exhibitions, and Aisha Burtenshaw, Acting Senior Registrar.

In the publication Lola and Scott have been joined by an outstanding group of scholars to illuminate various aspects of the story of the *Westmorland* and its contents. To all these contributors we owe a tremendous debt of gratitude, as we do to Sally Salvesen of

Yale University Press for her editorial supervision and to Susan Marsh for her exceedingly handsome design.

But, of course, our greatest thanks are owed to our lenders in Spain, Britain, and the United States, particularly the Real Academia de Bellas Artes de San Fernando. As the repository for the vast majority of the *Westmorland*'s cultural contents, the Real Academia was as much a partner in the project as a lender to the exhibition. To Antonio Bonet Correa, the Director; to all the Academicians; and to all the staff of the Real Academia's Museum, Library, and Archive, our sincerest thanks and warmest wishes.

AMY MEYERS
Director, Yale Center for British Art

CHRISTOPHER BROWN
Director, Ashmolean Museum of Art and Archaeology, University of Oxford

Acknowledgments and Notes to the Reader

As the essay "The Rediscovery of the 'English Prize'" relates, the present volume builds on the research of a number of people over more than a dozen years. It relies heavily on the catalogue of an earlier exhibition, *El Westmorland: Recuerdos del Grand Tour*, which was seen in three venues in Spain in 2002, while expanding, amplifying, and at times correcting the information to be found in the earlier publication.

It was a pleasure and a privilege to work with the contributors to the present volume: María del Carmen Alonso Rodríguez, Sarah Armitage, John Brewer, Kelly Cannon, Elisabeth Fairman, Clare Hornsby, Eleanor Hughes, José M. Luzón Nogué, Aurelio Nieto Codina, Steffi Roettgen, Frank Salmon, Kim Sloan, Christina Smylitopoulos, Catherine Whistler, John Wilton-Ely, Jonathan Yarker, and Alison Yarrington. The essays "The Rediscovery of the 'English Prize,'" "Educating the Traveler: The Tutors," "Books on the *Westmorland*," and "A Crate of Saints' Relics," as well as the inventories in the appendixes, were translated from the Spanish by Laura Suffield. "Anton Raphael Mengs's *The Liberation of Andromeda by Perseus*: A European Odyssey from Rome to St. Petersburg" was translated from the German by Liz Robinson. Dave Langlois provided a working translation of the catalogue of the earlier exhibition in Spain. All other translations, unless otherwise noted in the text, are by the authors and editors.

The production of the book has been overseen by Sally Salvesen, the Center's publisher with Yale University Press, London, and her colleague Sophie Sheldrake. It has been exquisitely designed by Susan Marsh, copyedited by Richard Slovak, and typeset by Tina Henderson. Eleanor Hughes, Associate Curator and Head of Exhibitions and Publications at the Center, has worked with tireless enthusiasm to see both book and exhibition to fruition, assisted by her colleagues Diane Bowman, Craig Canfield, Imogen Hart, Christina Smylitopoulos, and Ava Suntoke, who have played crucial roles in the process of creating the book and in the presentation of the exhibition at Yale. There the installation has been beautifully designed by Stephen Saitas and realized by Richard Johnson, Head of Installation, and the Center's installation team, working with Lyn Bell Rose and Elena Grossman, Graphic Designers. The Center's Registrar, Timothy Goodhue, and his colleagues, notably Corey Myers, have, as usual, superbly handled all the logistics of the loans. We are also grateful to Beth Miller, Associate Director for Advancement and External Affairs, and her colleagues Kaci Bayless, Amy McDonald, Julienne Richardson, and Amelia Toensmeier; and to Martina Droth, Head of Research, and her colleagues Jessica Dilworth, Lisa Ford, Linda Friedlaender, Cyra Levenson, and Jane Nowosadko, for the events and programming that accompany the exhibition at Yale. Conservators Mark Aronson, Theresa Fairbanks Harris, Dong-Eun Kim, and Mary Regan-Yttre have provided assistance with conservation issues. Bekah Dickstein, formerly Senior Curatorial Assistant in the Department of Rare Books and Manuscripts, helped

with research, as did Yale students Sarah Armitage and Kelly Cannon, who both provided entries in the catalogue.

At the Ashmolean, we would like to thank Catherine Whistler, Senior Assistant Keeper and the organizing curator for the exhibition, who has been a wonderfully collegial and attentive partner. She has been joined by Agnes Valenčak, Head of Exhibitions, and Aisha Burtenshaw, Acting Senior Registrar, in exhibition organization; Graeme Campbell, Head of Design, Greg Jones, Senior Graphic Designer, and Byung Kim in the Design Office; Susie Gault, Head of Press & Publicity, and Claire Parris in the press office; Tess McCormick, Head of Development, and Theresa Nicholson, Corporate Partnerships Manager, in Development; and Mercedes Cerón, Sackler Fellow, and the Ashmolean Conservation Department, led by Mark Norman—to all of whom we are deeply grateful.

Without the Real Academia de Bellas Artes de San Fernando in Madrid, there would, of course, have been no exhibition. For so generously sharing their collections and their knowledge, we would like to thank Ismael Fernández de la Cuesta, Vice-Director, and Fernando Terán, Secretary General; in the Museum, José M. Luzón Nogué, the Academician for the Museum, and his colleagues Mercedes González de Amezúa, Curator, with Ascensión Ciruelos, Laura Fernández Bastos, and Rosa Recio; and in the Library, Alfonso Gutiérrez Ceballos, the Academician for the Library, and his colleagues Irene Pintado, Esperanza Navarrete, Maite Galiana, Marisa Moro, Ana Casas, Luis Val, and Mari Carmen Salinero. We express gratitude to the conservators who so expertly prepared the Real Academia's collections for display: Adolfo Rodríguez at the Real Academia, Judith Gasca and Ángeles Solís y Silvia Viana at Albayalde Restauro, Mónica Moreno and Arantza Platero at Alet Restauración, and the staff of Marcalagua and of Barbáchano & Beny. We also are grateful to the photographers who provided the images of the collections for the catalogue: Enrique Sáenz de San Pedro, Mauricio Skrycky, and Pablo Linés.

For their assistance with research and with the loan of materials to the exhibition, we would like to thank María Jesús Herrero, José Luis Sancho, and José Luis Valverde at the Patrimonio Nacional; Sofía Rodrí-guez Bernís, Director, and Maruja Merino de Torres of the Museo Nacional de Artes Decorativas; Aurelio Nieto Codina and Begoña Sánchez of the Museo Nacional de Ciencias Naturales; Andrés Úbeda de los Cobos and Miguel Falomir from the Museo Nacional del Prado; Mar Fernández Sabugo from the Museo Nacional de Reproducciones Artísticas; Father Holt from the Archives of the British Province of the Society of Jesus, London; and Iain Jenkins at the National Library of Scotland.

Among the many other people who have contributed information, advice, and research suggestions over the years and to whom we are greatly indebted, we particularly would like to recognize Julia Marciari Alexander, Patricia Andrew, Timothy Barringer, John Baskett, Hugh Belsey, Antonio Miguel Bernal, David Bindman, Jeremy Black, Andrea Bouchard, Juliette Carrasco, Mercedes Cerón, Constance Clement, Viccy Coltman, Lisa Cooke, Ana Luisa Delclaux, Jorge García Sánchez, Carla Giugale, Carlos Gracia, Benjamin Gusberg, John Ingamells, Ian Jenkins, Carlo Knight, María Luisa López Vidriero, John Marciari, Carlos Martínez Shaw, María Rosa Menocal, Pedro Moleón Gavilanes, Alexandra Nasser, Anna Ottani Cavina, Nicholas Penny, Martin Postle, Monica Price, Jules Prown, Marion Reder, Robert Ritchie, Isabel Rodríguez López, Rafael Sánchez Mantero, José Sierra Pérez, Samuel Sullivan, Haley Thurston, Reinhard Wegner, Barry Williamson, and Andrew Wilton. Ilaria Bignamini expressed great interest in the project; but for her illness and untimely death, she certainly would have been a major resource and an important participant.

From the earliest days of research on the *Westmorland*, the information on Grand Tourists in the archive assembled by Sir Brinsley Ford and given to the Paul Mellon Centre for Studies in British Art, London, and made widely available through the splendid *Dictionary of British and Irish Travellers in Italy, 1701–1800*, compiled from the archive by John Ingamells, has played a key role in the processes of identifying and understanding the contents of the ship. The combined scholarship of Ford and Ingamells as embodied in this invaluable dictionary is evident throughout the present volume. Information about the contents

of the *Westmorland* that is otherwise unattributed in the volume can be assumed to come from the research of María Dolores Sánchez-Jáuregui and the database of the ship's contents that she created.

Finally, a few notes on spelling and terminology. In contemporary references, the ship's name is sometimes spelled *Westmoreland* and sometimes *Westmorland*. The spelling *Westmorland* was used in the catalogue of the Spanish exhibition in 2002, reflecting the more common practice in the Spanish documents. Further research has made clear that in more official records and in those documents most closely connected with the owners of the ship, the name is given as *Westmoreland*; however, because it has become known in the growing literature on the subject as the *Westmorland*, we have decided to retain that spelling in this volume.

In the inventories of the *Westmorland*'s contents and in Spanish letters about the cargo, the word *caxon* or *cajón* is used to describe the containers in which the contents were shipped. This could be translated as either "crate" or "case." In the letters in English

referring to the *Westmorland*, such as those from Father John Thorpe to Lord Arundell, the containers are frequently described as "cases." We have decided, however, to use "crate" as providing a clearer sense of these packing boxes.

In some of the catalogue entries and throughout the inventories that appear as appendixes, references are made to units of measurement employed in Spain in the eighteenth century. These are listed here with rough modern equivalents (the measurements varied slightly from one Spanish province to another, so that a *quarta* in Málaga might differ from a *quarta* in Madrid). In measurements of length one *dedo* is approximately $^{11}/_{16}$ inch or 1.75 centimeters. Twelve *dedos* equal a *quarta* (or *cuarta*), which is also equal to a *palmo* (8¼ in. or 21 cm), and four *quartas* equal one *vara* (33 in. or 83.8 cm). One *pie* equals approximately 11 inches, or 28 centimeters. In measurements of weight, one *libra* is slightly over a pound, or 0.46 kg, and 25 *libras* equal one *arroba* (25 lbs., or 11.5 kg).

MARÍA DOLORES SÁNCHEZ-JÁUREGUI
SCOTT WILCOX

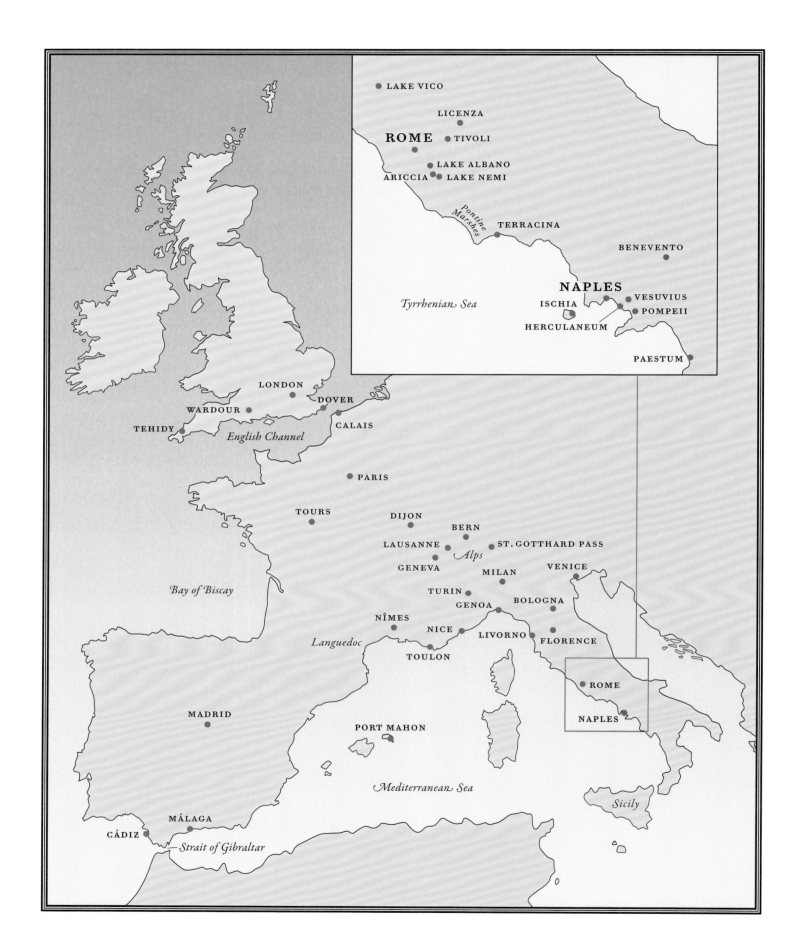

Places Associated with the Westmorland Episode

The English Prize

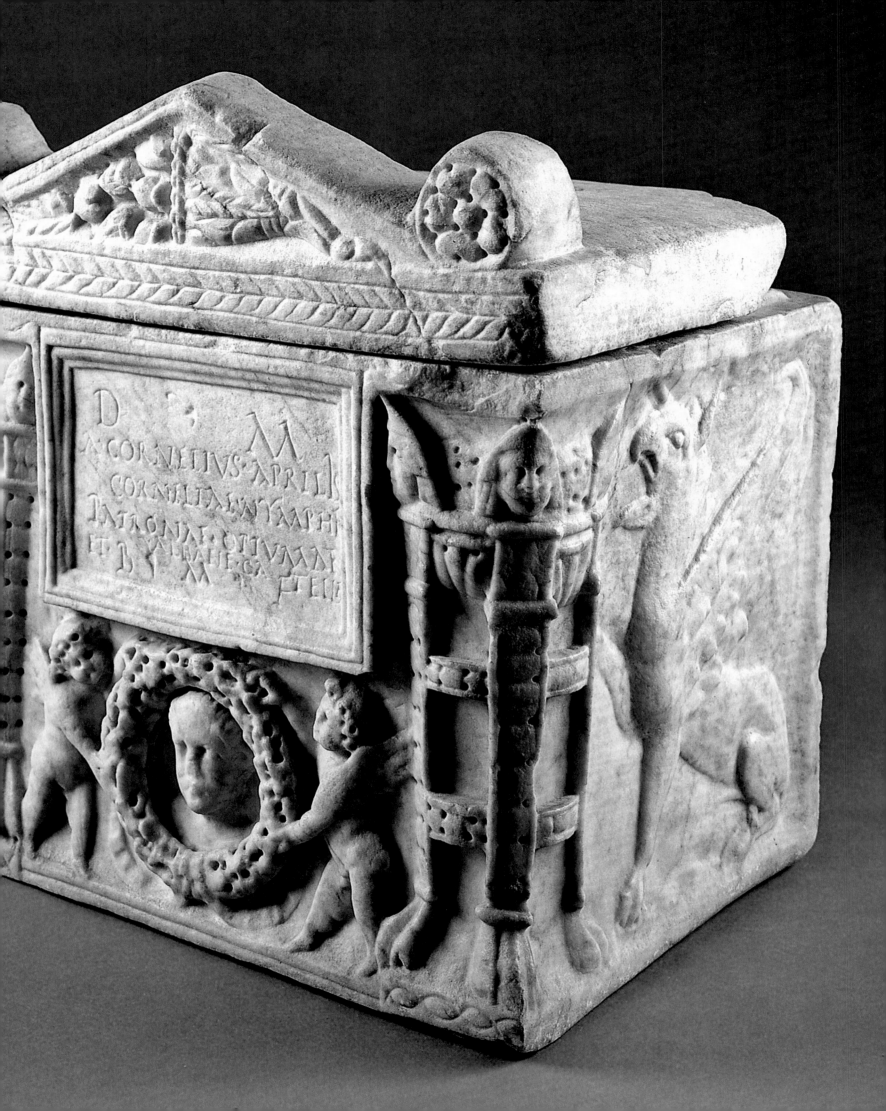

The Rediscovery of the "English Prize"

JOSÉ M. LUZÓN NOGUÉ

AND MARÍA DOLORES SÁNCHEZ-JÁUREGUI

AN ATTEMPT TO LOCATE information on five supposedly ancient Roman urns (see cats. 134 and 139–40) in the Museo Arqueológico Nacional in Madrid proved to be the first step in the recovery of the story of the *Westmorland* and its contents, leading from the Real Academia de Bellas Artes de San Fernando to other archives both in Spain and abroad. The urns arrived at the Real Academia in the eighteenth century but were moved to the archaeological museum when it was founded in 1867.[1] In 1872 Manuel Catalina, one of the curators of the museum, published a lengthy article on them in the museum's journal, in which he provided information on their provenance and referred to the ship captured a century before.[2] Nonetheless, that complex episode and the relationship between the urns and the other art objects and books that came from the ship remained obscure.

Over subsequent years catalogues published by the Real Academia were the source of sporadic references to the captured English ship and to the works of art brought from Málaga on that occasion, but they provided few details, nor was any attempt made to undertake a separate study of the collection. By the late 1990s the *Westmorland* provenance had been so completely forgotten that both the identities of the

sitters in two portraits by Pompeo Batoni in the Museo del Prado (cats. 21 and 110) and how the paintings had arrived in Spain were wholly unknown. Nor was it known how a mantelpiece installed in the Casita del Príncipe at El Pardo (fig. 1) had come to be there.

In 1999, under the direction of the present author, Professor José M. Luzón Nogué, a group of students and scholars was assembled to explore aspects of the history of museums in Spain. As part of this research project the group undertook an examination of the documents housed in the archives of the Real Academia relating to the cinerary urns in the Museo Arqueológico Nacional.[3] This initial study uncovered various inventories of the contents of the captured

Figure 1. Chimneypiece from the *Westmorland* crate marked "J. S." Real Sitio de El Escoria, Casita del Príncipe. Patrimonio Nacional, Madrid

Cinerarium (cat. 140, detail)

3

ship. These inventories, though they presented some puzzling discrepancies, provided crucial information on crates from the *Westmorland*'s cargo that had arrived at the Real Academia. A number of the crates were labeled "H. R. H. D. G.," and the realization that these initials stood for "His Royal Highness the Duke of Gloucester" marked a milestone in the process. The discovery of a *pro memoria* note (cat. 11)—given by Father John Thorpe to the Spanish *procurador general* (king's attorney) in Rome, José Nicolás de Azara y Perera, marqués de Nibbiano, who passed it on to the Spanish prime minister, José Moñino y Redondo, conde de Floridablanca—provided another crucial key, the name of the ship: the *Westmorland*.

The outlines of future research began to take shape. With further funding from the government and from the private sponsors Fundación Cajamurcia and Fundación El Monte, grants were given to two graduate students, Ana María Suárez Huerta and the coauthor of this essay, María Dolores Sánchez-Jáuregui. Led by the director of the project, she and Suárez, together with other members of the original project team, expanded the research beyond the Real Academia to other Spanish archives. In the Archivo Provincial in Málaga, the port where the French frigates had arrived in 1779 with the captured British vessel, there was information relating to the transport of the crates and their contents, including a contract taken out with a transport company from Aragon, which brought all the items in question from Málaga to Madrid in two trips in 1783.[4] The Archivo Histórico Nacional has all the reports that were sent to the secretary of state from military ports in Spain, including Málaga, where the sale of the *Westmorland*'s cargo took place, and Cádiz, where its crew and passengers were released.[5] When the Spanish king was informed that there was a cargo of works of art, books, and prints in Málaga that might be acquired for the Real Academia, negotiations began with the current owner of the items in question, a trading company known as the Compañía de Lonjistas de Madrid. The company's archives have not been located, but the fact that the purchase was carried out via the Banco de San Carlos means that there is a complete record of the negotiations and the price in the archives of what is now the Banco de España.[6] We know that Floridablanca's intention was to select the most valuable and interesting objects for the king and then to make a larger selection of art and books for teaching purposes at the Real Academia (fig. 2). Subsequently the Lonjistas (trading agents) agreed to add the rest as a donation.

Ongoing research into the inventories in the archives of the Real Academia matched initials in the inventories with prominent individuals and members of the British aristocracy who had traveled around France, Switzerland, and Italy in the years immediately preceding the *Westmorland*'s capture. Fortunately, the Paul Mellon Centre for Studies in British Art, London, had recently published *A Dictionary of British and Irish Travellers in Italy, 1701–1800*, and this excellent compilation, based on Sir Brinsley Ford's archive, offered a valuable tool for the confirmation of some of these identifications.[7]

The *Westmorland* inventories gave the researchers a guide to books and prints from the ship that they could expect to find in the library of the Real Academia. This process of identification was made easier by the fact that in the late eighteenth century the librarian Pascual Colomer had written the initials "P. Y.," standing for "Presa Ynglesa" (English Prize), in ink on the books and prints from the *Westmorland*. In some cases the names of the Grand Tourists, or of persons associated with them, such as their tutors, were inscribed on these objects, confirming identifications that had been made by comparing initials from the crates with information in John Ingamells's dictionary. Moving between the inventories, Colomer's "P. Y." annotations, annotations by the Grand Tourists themselves, and other documentation that was increasingly coming to light, the present authors and the rest of the research team were able to reconstruct the contents of many of the crates from the *Westmorland* and identify many of the books, prints, and works of art that had belonged to each of the travelers whose identities were revealed in the process.

By 2000 the project had moved beyond Spain. The importance of the *Westmorland*'s cargo, the individuals involved, and the international nature of the episode necessitated research in archives abroad. With further backing from the two private foundations,

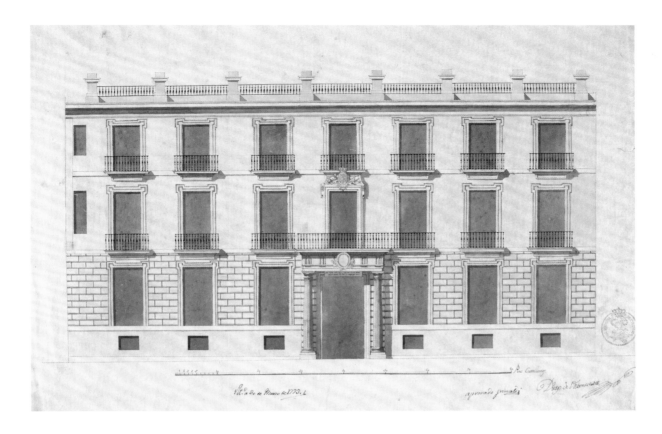

Figure 2. Diego de Villanueva, *Project for the Main Facade of the Real Academia des Bellas Artes de San Fernando*, 1773, watercolor and pen and ink over graphite on paper, 15⅝ x 23¼ in. (39.6 x 59 cm). Real Academia de Bellas Artes de San Fernando, Museo (cat. 8)

as well as the art newspaper *El Punto de las Artes*, Suárez Huerta traveled to Livorno, Pisa, and London and Sánchez-Jáuregui spent much of the year in Britain. In the following year Suárez Huerta returned to Livorno and Pisa, and Sánchez-Jáuregui conducted research in Paris, also holding fellowships at the Real Academia de España in Rome and at the Yale Center for British Art.

As anticipated, various London archives contained documents that shed crucial light on the *Westmorland* story. The National Archives, Kew, holds the reports that the British ambassador, Thomas Robinson, second Baron Grantham, sent from Madrid following the ship's capture.[8] Among the Egerton Papers in the British Library, London, is one of the most complete inventories of the *Westmorland*, presumably sent from Málaga (fig. 3). The archives of Lloyd's insurance company also proved to contain references to

the *Westmorland*.[9] Finally, private archives provided information on specific objects that had been lost and the negotiations that had been undertaken for their recovery. For example, the Basset archives include documents referring to objects on board the *Westmorland* and to the prices paid for them, as does the correspondence between George Legge, then Viscount Lewisham, and his father, William Legge, second Earl of Dartmouth.[10] Smaller archives now accessible through online resources, such as the "Access to Archives" of the National Archives (UK), proved extremely valuable for the present project, enabling us to locate correspondence and other documents pertaining to the *Westmorland*. One such example is the correspondence between Frederick Robinson and his brother, the British ambassador. Shortly after the ship's capture the latter noted that he had dined with Commodore George Johnstone (previously the first British governor of West Florida, in the 1760s), and

Reconocimiento de los siguientes efectos del Navio de Presa Inglesa nombrado el Westmoreland, que existen, y se hallan depositados en las Casas de Comercio maritimo de esta Ciudad de Malaga, titulada D.n Pedro Quintin, Galvey, y Obrien, hecho de orden de la Compañia de Longistas de Madrid, con intervencion del Cabo del Resguardo, nombrado por el Cavallero Administrador de esta Real Aduana, á saver

H.R.H. **D.G.** N.º 5 * con peso de 23@ y 7 ℔	Una Caja, que contiene: Una Estatua de Alabastro, de Cuerpo entero, q.e representa dos Figuras abrazadas, y tiene de largo una vara incluso el pedestal = Otra Estatua de Alabastro de Cuerpo entero, que representa como la anterior dos Figuras abrazadas, y tiene la misma medida, que la antecedente.
H.R.H. **D.G.** N.º 4.º * con 26@ y 18 ℔	Una Caja, que contiene: Dos Columnas de Alabastro Estriadas, y tiene de largo cada una 63 dedos, y 14 dhos de ancho la basa de cada una = Dos Pilastras tambien de Alabastro, Estriadas, y tiene cada una 63 dedos de largo, y 12 dhos de ancho. Y se nota, que una de ellas tiene quebrada una Estria, y se conoce que la pieza estubo pegada con dos alambritos, y lo quebrado puesto, y metido en un Papelito como bá.
🏺 * **L. B.** N.º 45. con 23@ y 23 ℔	Una Caja, que contiene: Quatro Estatuas de Alabastro de Cuerpo entero, que representan Diosas; Y se nota, que una de ellas son dos unidas, y tiene cada una de otras Estatuas 40 dedos de alto; y tiene dicha Caja en lugar de Clabos, tornillos.
◇ * 14@ y 5 ℔	Una Caja, que contiene: Una Estatua de Alabastro, de medio cuerpo, q.e representa una Matrona Romana con Peinado á la Romana antigua, y tiene de alto 38 dedos.
H.R.H. **D.G.** N.º 2. 35 @	Una Caja, que contiene: Dos Basas de Alabastro para Columnas, y tiene cada una 33 dedos de largo, 18 de ancho, y 8 de grueso = Dos Basas de Alabastro quadrilongas de baxo relieve, y tiene cada una 28 dedos de largo, 13 de alto, y 10 de grueso = Dos Piezas de Alabastro que representan los Diagonales de una Cornisa, y tiene cada una 34 dedos de largo, 16 de alto, y 6 de grueso = Y Quatro Paquetes, que incluyen 12 libros en 8.º de pasta, que tratan de Historia Romana en Idioma Italiano.
I.S. N.º 1. sa plomo 🏺 * 5 arrobas	Una Caja, que contiene: Una Pieza de Alabastro, que representa un Ramo de varias frutas, como Ubas, manzanas, peras &.ª puesto sobre un Canasto, curiosamente labrado, y tiene de largo 32 dedos, y diez y siete de alto.

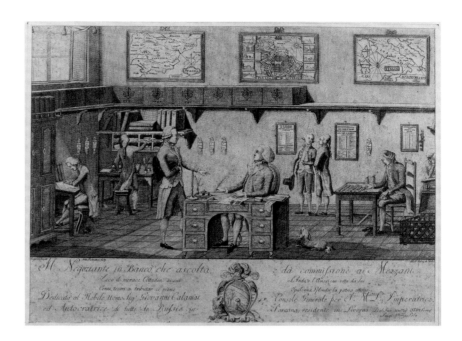

Figure 3. Compañía de Lonjistas de Madrid, Inventory of the Contents of the *Westmorland*, Malaga, July 13, 1783. British Library, London, Egerton Papers, 545 (cat. 12)

Figure 4. Antonio Piemontesi, *Visit of a Mezzano to the Bank*, 1793, etching, 10⅞ x 14⅜ in. (27.7 x 36.5 cm). Camera di Commercio di Livorno. Delays in departure created problems for the insurers of ships' cargoes; these were dealt with by *mezzani* (middlemen).

it is likely that their meeting was connected with the arrival in Málaga of the *Westmorland*, on which Johnstone's two sons and their tutor had been traveling.[11]

The port of Livorno was another likely source of documentation, and the Archivio di Stato there proved to contain documents relating to the insurance of the cargo and its insurers. For example, it houses all the documentation from before the departure of the *Westmorland*, which remained at anchor for several months while waiting for an opportune moment to set sail (fig. 4). William MacCarty, who consigned part of the cargo, was in Livorno at this date, as was the British consul, John Udny, who undertook small-scale trading activities with his brother Robert in London, to whom he sent various prints, possibly for the purpose of sale, hence the presence of the initials "R. Uy." on one of the crates.[12]

The sale of such a valuable ship was extremely gratifying news for the French consul in Málaga, named Humbourg, who hoped that part of the proceeds of this sale would fall to him. This did not prove to be the case, however, and in the Centre d'Accueil et de Recherche des Archives Nationales de Paris there are documents in which he describes his part in the affair and the unsuccessful demands that he made with regard to it.[13] In contrast, the naval archive in Toulon has a detailed list of the division of the proceeds from

the *Westmorland* sale distributed to the crews of the French ships that took part in the capture.[14]

The lives of some of the objects from the *Westmorland* took them beyond the confines of the Real Academia. Two paintings depicting children at play had been sent to the Palacio Real in Madrid. No trace of them survives today, but the description in the *Westmorland* inventories reveals them as the source for the decoration of items produced by the Buen Retiro porcelain manufactory in Madrid.[15] There is also evidence that the prints by Giovanni Battista Piranesi now in the Academia de San Carlos in Valencia, the Academia de San Carlos in Mexico, and the Universidad Complutense in Madrid were from the *Westmorland* and were given or lent by the Real Academia to support these institutions at the time they were created. Plaster casts were also made of some of the busts and decorative marble figures that arrived at the Real Academia, and these, too, were distributed to different institutions. In all, this preliminary phase of the project took the researchers to at least twelve museums and other institutions that house objects from the *Westmorland*.

In November 2000 Luzón Nogué, who had now been elected a member of the Real Academia, organized a seminar on the *Westmorland* at the Universidad Complutense de Madrid with Brian Allen,

director of studies at the Paul Mellon Centre for Studies in British Art, London, and Professor David Bindman as participants. It was Bindman who first recognized that the suite of watercolors from the crate marked "F. Bt." were by John Robert Cozens (cats. 23–28). This seminar was the first of a series of programs in which the investigations of the *Westmorland* were presented to an interested scholarly community. Summer courses held in conjunction with the Universidad Complutense de Madrid and supported by the Mellon Centre took place in the summers of 2002 and 2007. Toward the end of 2002, the results of the initial period of research provided the subject matter for an exhibition in Spain, *El Westmorland: Recuerdos del Grand Tour*, which, together with its corresponding catalogue, enabled the research team to present its new discoveries to a broader audience. The exhibition was seen in three Spanish venues: Centro Cultural las Claras in Murcia (October–December 2002), Centro Cultural El Monte in Seville (January–March 2003), and the Real Academia in Madrid (April–June 2003). In addition, the *Westmorland* episode and its consequences for art history and collecting gave rise to doctoral dissertations by Suárez Huerta and Sánchez-Jáuregui.[16]

Given the richness and complexity of the *Westmorland*'s story, various aspects required further study and a more systematic program of research. With this aim in mind, a new phase of study was embarked on, directed by Brian Allen and generously supported by the Mellon Centre.[17] During this second phase, research has focused on studying the works of art that had been on board the ship; identifying exactly what this cargo originally consisted of; locating its present whereabouts; identifying its provenance, owners, and makers; and, finally, analyzing its significance within the broader context of the cultural phenomenon of the Grand Tour.

In order to go beyond the level of identification of the works on the *Westmorland* that had been accomplished in the first phase, it was necessary to create a database that would combine in an ordered and systematic manner all the information derived from the nine inventories in the archives. With the aim of providing access to the information in those inventories in a precise and accurate manner, such a database was designed by Sánchez-Jáuregui.

According to the database, 778 cultural items on board the *Westmorland* arrived in Madrid in 1784.[18] Through a painstaking process of combing through the collections of the Real Academia and those of other repositories in which objects from the *Westmorland* came to reside—such as the Museo Arqueológico Nacional, with which we started this essay—a more complete accounting and understanding of the ship's contents has been achieved. So far, 165 titles have been identified in the Real Academia's library, from an original total of 294. All 49 maps have been identified, as well as 98 of the 107 prints, but only 2 pieces of sheet music from the 136 that were on board. Among the holdings of the institution's drawings collection, 26 architectural drawings have been identified, along with 62 watercolors and gouaches from an initial total of 67. The process of identification of paintings and sculptures was the most problematic, as many had been attributed to other artists in later inventories and were frequently described (particularly in the case of copies) as works sent by *pensionados* (grant students) of the Real Academia studying in Rome. In addition, during the nineteenth century, various paintings were sent on long-term loan to other institutions in Spanish provinces, where they have now been located. In some cases new, unrecorded objects have been discovered in the rooms of the Real Academia. As a result the project has been able to identify 28 sculptures of the 40 that arrived in Madrid and 33 paintings from a total of 59.

On completion of this project a catalogue entry was drawn up for each object in the database, including all the information relating to the crate in which it was found; any previous location in other crates on the *Westmorland*; the name of the owner, artist, or author; signatures and annotations; present location; state of preservation; related archival documentation; bibliography; and all other relevant information. Material deriving from this research has been made available to the contributors to the present volume, to allow them to combine it with their own knowledge of the artists and historical period in question in order to offer the best possible interpretation of each object discussed.

The publication of the present volume does not in any way imply that research on the *Westmorland* has come to an end. Many aspects of this story invite further inquiry. The owners of a number of crates remain unidentified, and much remains to be learned about many of the owners who have been identified, such as John Henderson of Fordell, Penn Assheton Curzon, Lyde Browne, and John Barber. Given that the sale of the contents of the *Westmorland* was carried out in Málaga on board the ship *Caton* and therefore on French soil, French archives may yet yield more substantial documentation on the sale. It is our hope that this volume will encourage the academic community to pursue new lines of study that will further advance our knowledge of this remarkable episode within the history of the Grand Tour.

1. Luzón Nogué 2000.

2. Catalina 1872.

3. The research undertaken at the Universidad Complutense de Madrid, as part of the Systematic Compilation of Documentary Holdings of Museums project, fell within the Spanish Ministry of Education and Culture's Call for Grant Applications for Scientific Research and Technological Development (1999–2001). The research was able to continue within the project entitled Collections and Antiquities from 18th-Century Italy, which also fell within that ministry's grant applications procedure (2003–6).

4. With regard to the transportation of the works from Málaga to Madrid, Dr. Marion Reder of the Universidad de Málaga has recently located detailed documents, which will be published.

5. Dossier 546, section: Estado, Archivo Histórico Nacional, Madrid.

6. Luzón Nogué and Sánchez-Jáuregui 2003, 67–100.

7. Ingamells 1997.

8. Thomas Robinson, second Baron Grantham, to Thomas Thynne, third Viscount Weymouth, secretary for the southern and northern departments, March 1, 1779, SP 94/207, fol. 10, National Archives, Kew.

9. The documentation in the archive covering this period was lost in a fire. In *Lloyd's Register* for 1778, however, we were able to locate the name of the ship, the captain, tonnage, and where it was built.

10. Documents relating to Lord Lewisham's Grand Tour are located in the Staffordshire and Stoke-on-Trent Archive Service, Staffordshire Record Office, Stafford, while those relating to Francis Basset are at the Cornwall Record Office, Truro.

11. This dinner took place on Feb. 9, 1779. In addition, various letters that Frederick Robinson sent to his brother in 1779 refer to the capture of Johnstone's sons on board the *Westmorland*. L30/14/333/176-177-190 and L 30/14/201, Bedfordshire and Luton Archives and Record Service, Bedford.

12. Suárez Huerta 2002, 49–67.

13. Correspondance Consulaire, A.E.B. I-287 and A.E.B. I-812, Archives Nationales de France.

14. Dossiers 1 A1 87, 2Q 23, 2Q 33, Archives du Service Historique de la Marine, Toulon.

15. Inventoried in a crate belonging to Francis Basset: "A Painting that depicts a Boy with a Goldfinch in his hand = Another Painting that depicts another Boy with some Rusks and cherries in his hands, both of these paintings measures 36 *dedos* square." See the transcription of the inventories in the appendix to the present volume, p. 311.

16. Ana María Suárez Huerta, "Arte y Artistas del Westmorland: Un caso singular del Grand Tour," supervised by José M. Luzón Nogué and presented for approval at the Universidad Complutense de Madrid in 2004; and María Dolores Sánchez-Jáuregui, "Viajeros, tutores y recuerdos del Grand Tour," also supervised by José M. Luzón Nogué, will be presented for approval at the Universidad Complutense de Madrid in 2012.

17. Throughout this research the Real Academia de Bellas Artes de San Fernando has also been involved, offering full collaboration and access to its collections.

18. The figures cited here may be subject to slight variations depending on the organizing criteria, new identifications, and consequent adjustments. This database was created by Sánchez-Jáuregui as the principal source of material for her doctoral dissertation.

The *Westmorland*: Crates, Contents, and Owners

MARÍA DOLORES SÁNCHEZ-JÁUREGUI

AND SCOTT WILCOX

In MARCH 1778 an armed British merchant ship named *Westmorland* lay at anchor in the harbor of Livorno (known as Leghorn to the British) on the Tuscan coast (fig. 5), waiting to depart for England. A ship of three hundred tons with a crew of sixty men and equipped with twenty-two cannons, the *Westmorland* was commanded by an Englishman named Willis Machell. France had just entered the American War of Independence on the side of the colonists, and Machell was clearly aware of the danger of capture; he was also prepared to capture enemy merchant ships himself. The *Westmorland*'s varied cargo included olive oil, barrels of anchovies, silk, medicinal drugs, Genoa paper, and Parmesan cheeses. Also on board were crates containing works of art and books intended for collectors back in Britain or acquired by travelers on their Grand Tour and being sent home.[1] The *Westmorland* had previously transported art objects; in a letter from the dealer Thomas Jenkins to the collector Charles Townley in November 1777, Jenkins mentioned a consignment of "four cases of Marbles on board the Westmorland" delivered in an earlier crossing.[2]

Although the *Westmorland* was supposed to set sail by the end of March, it remained in port. Departure was repeatedly postponed through the following months, provoking complaints from the insurers of its perishable cargo; Machell did not set sail until December of that year. At noon on January 7, 1779,

the *Westmorland* was captured off the eastern coast of Spain by two French warships, the *Caton* and the *Destin*, commanded by Jean-Louis Charles Régis de Coriolis d'Espinouse, chevalier de Malte, and Henri-Auguste de Collomp de Seillans. The *Westmorland* itself, the reasons for its delay in leaving Livorno, the circumstances of its capture, and its place in the larger context of commerce and conflict in the period are detailed in the essay by Eleanor Hughes in this volume. The present essay looks at the fate of the works of art, books, and other materials taken from the ship and at their owners and consignors.

THE WESTMORLAND IN MÁLAGA

On the morning of January 8 the *Westmorland*, together with the *Hector* and the *Ranger*—two other English ships, laden with cod, that the *Caton* and *Destin* had already seized—were brought to Málaga (fig. 6), a safe port where the French could sell their cargoes. On that day the Spanish *gobernador de la costa*, Bernardo O'Connor y Ophaly, conde de Ofalia, reported, albeit somewhat confusedly, the arrival of the ships to the prime minister, José Moñino y Redondo, conde de Floridablanca (fig. 7). The French consul in Málaga, M. Humbourg, wrote the following day to the French navy minister, Antoine Gabriel de Sartine, comte d'Alby, informing him that although rough seas had prevented him from boarding the ships and talking to the captain, he believed that one of the

Figure 5. Alexander Cozens, *View of Leghorn Seen from the Lighthouse*, ca. 1746, pen and black ink with watercolor on paper, 7 x 9⅜ in. (17.8 x 23.9 cm). British Museum, Department of Prints and Drawings

Figure 6. Mariano Ramón Sánchez, *Vista del Puerto de Málaga* (View of the Port of Málaga) 1785, oil on canvas, 30¾ x 47⅝ in. (78 x 121 cm). Patrimonio Nacional, Madrid (cat. 5)

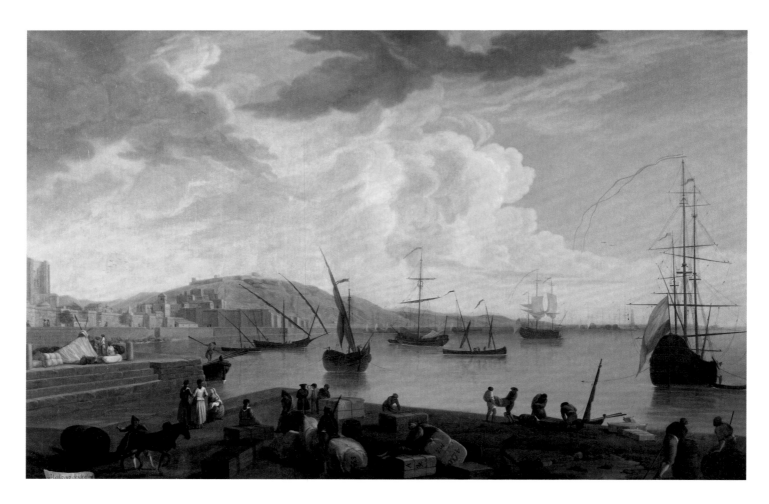

three prizes "doit être considerable" (should be considerable).[3] Mr. Marsh, the British consul in Málaga, likewise mentioned the incident to the British ambassador in Madrid, Thomas Robinson, second Baron Grantham.[4]

The Spanish authorities in Málaga prepared what they called a "Nota del manifiesto del cargamento de Navio Ingles el Vestmorland, su Capita Wiliu Machell, viniendo de Lorna, con destino para Londres" (Note of the cargo manifest of the English Ship *Westmorland*, its Captain Willis Machell, sailing from Livorno to London), which the French consul there, Jean Baptiste Poirel, passed along to the governor of Cádiz, Nicolás Manuel Bucareli y Ursúa, conde de Xerena Bucareli, who in turn included the manifest with a dispatch to Floridablanca on January 15 (cat. 10). Included with the commercial goods in the *Westmorland*'s cargo, according to this document, were "23 caxas de marmol en estatuas; 35 piezas de marmol en pedazos; 22 caxas de estampas, retratos y libros" (23 crates of marble in statues; 35 pieces of marble fragments; 22 crates of prints, portraits and books). The listing concludes with this comment:

> La carga importara como 100mil. libs. esterlinas. El Capitan asegura hay muchos retratos, y estatuas de bastante precio, y entre ellos algunos, que estaban destinados para S.A.R. el Sor. Duque de Gosesther, Hermano del Rey de Inglaterra. Hay tambien una pintura del valor de 80 escudos romanos, ó 40 libras tornesas, que componen diez mil pesos de nuestra moneda. (The cargo is worth about 100,000 English pounds. The captain affirms that there are numerous portraits and statues of considerable value, and among them some that were destined for His Royal Highness the Duke of Gloucester, brother of the king of England. There is also a painting worth 80 Roman scudi, or 40 Tours pounds, equivalent to 10,000 pesos of our currency.)[5]

On January 9 a naval trial at the port of Málaga established the legality of the prize. The *Westmorland* was declared a "Bonne Prise" (good prize), and the French authorities were confirmed in their assertion

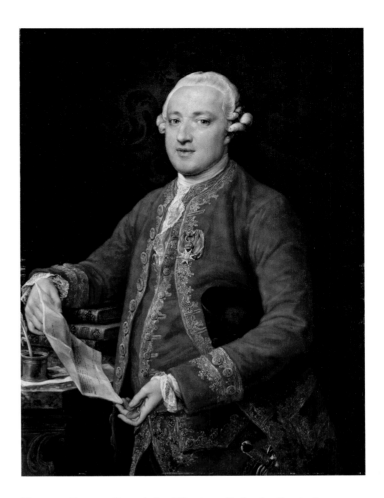

Figure 7. Pompeo Batoni, *José Moñino y Redondo, Conde de Floridablanca*, 1775–76, oil on canvas, 39¼ x 29⅝ in. (99.7 x 75 cm). The Art Institute of Chicago, Charles H. and Mary F. S. Worcester Collection, 1974.386 (cat. 6)

of rights over the ship and the prisoners.[6] Once the *Westmorland*'s cargo had been unloaded and stored in Málaga, the French changed the flag of the ship and set out with eighty-six prisoners who could be exchanged only in Cádiz, where they arrived on February 13.[7] Among the prisoners were the two sons of Commodore George Johnstone along with their tutor, who were on the way back from their European Grand Tour. The prisoners were eventually exchanged, and Johnstone's sons were freed.[8]

The first object removed from the cargo was the valuable painting mentioned in the manifest sent to Floridablanca. Coriolis d'Espinouse asked the French consul in Málaga to send it overland to the French embassy in Madrid and from there to the navy minister, Sartine, as a personal gift from the naval officer.[9] This

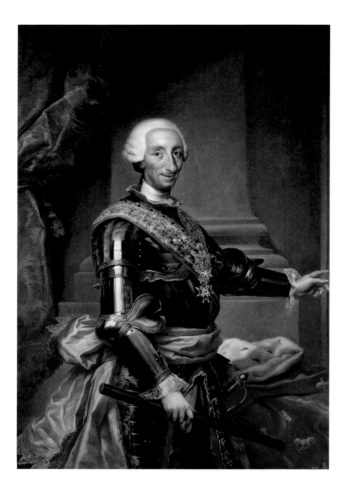

Figure 8. Studio of Anton Raphael Mengs, *Carlos III*, 1761, oil on canvas, 60⅝ x 43¼ in. (154 x 110 cm). Museo Nacional del Prado, Madrid (cat. 7)

work was *The Liberation of Andromeda by Perseus*, by Anton Raphael Mengs, which had been commissioned in Rome in 1768 by Sir Watkin Williams Wynn, and finally dispatched to him (cat. 17). The history of this celebrated painting from its commissioning to its ultimate arrival in St. Petersburg is related in the essay by Steffi Roettgen in this volume.

As more details were revealed, newspapers spread word of the prize among the nations involved. The Spanish paper *La gazeta de Madrid* broke the news on January 19, 1779. The incident was of the utmost interest for the insurers of the cargo at Livorno, eager to assess their losses. The local paper there, *Notizie del mondo*, published the news on February 10, 1779: "Si sente che il Vascello Francese il Destino abbia predati, e condotti a Málaga tre Bastimenti Inglesi,

uno dei quali assai ricco, che era di qui partito per Londra." (We learn that the French vessel the *Destin* has captured, and brought into Málaga, three English ships, one of them quite rich, that sailed from here to London.) Shortly afterward the *Gazzeta toscana* stated the name of the vessel for the first time.[10]

With news of the capture in the press, some owners of the goods on board inquired about the fate of their belongings, and the Italian merchants who had shipped and insured their goods hastened to make their compensation claims.[11] According to documents preserved at Toulon, the *Westmorland* was among the more valuable prizes taken during the war, and many merchant companies competed for the purchase of its cargo. Bureaucratic wrangling engaged the chancellor of the French consulate in Málaga, named Esquirol, for an entire year. The cargo was finally sold in 1780 to a grocers company called the Compañía de Lonjistas de Madrid (Company of Commercial Agents of Madrid).[12]

THE CONTENTS OF THE WESTMORLAND GO TO MADRID

The foodstuffs and other commercial merchandise aboard the *Westmorland* were sold by the Compañía de Lonjistas, but the crates containing art objects and books remained in its warehouse in Málaga. More than four years had passed since the ship's capture before these crates came to the attention of the Spanish prime minister, Floridablanca, who in turn probably informed Carlos III (fig. 8). On July 9, 1783, the king ordered Pedro Pimentel de Prado, marqués de la Florida Pimentel, the vice protector of the Real Academia de Bellas Artes de San Fernando in Madrid, to select "a man of taste" to examine and determine the value of the cargo.[13] Persuaded that there was no one in the region capable of doing it, and following the vice protector's suggestion, the king then instructed the merchants to make a list of the contents at Málaga (cat. 12). From there the crates would be taken with the utmost care to the Real Academia, where someone trained in the arts could examine them.

Documents at the Real Academia reveal that in October 1783, Floridablanca learned that a first dispatch of seventeen crates was on its way to Madrid. He

gave specific instructions for their arrival: the carters should not be delayed at the customs post but should be sent straight to the Real Academia. There the crates were to be unloaded, examined, and taken to the rooms where they would remain until Floridablanca decided on their final destinations. Once the process was completed the carters would return to Málaga for the rest of the cargo, thirty-three more crates. The invoice for transport, together with a list stating the contents of the crates, would be sent to Floridablanca.[14]

At the Real Academia the concierge, Juan Moreno, assisted by two carpenters, opened all of the first crates but one and recorded their contents.[15] The history of the unopened crate and its contents is related in an essay by José M. Luzón Nogué in this volume. Working without precise instructions the concierge made his initial list somewhat hastily and inaccurately.[16] Only a week after those crates arrived, Floridablanca visited the Real Academia to check personally on the state of the objects. On November 28 of the same year, the second consignment of thirty-three crates arrived from Málaga. During transit heavy rains had soaked some crates. Two boxes with artificial flowers and books were damaged, but the rest were in good condition and were registered in another list, a copy of which was addressed to Floridablanca.

When the secretary of the Real Academia, Antonio Ponz (fig. 9), returned from a journey through Britain in 1784, he was entrusted with the care and cataloguing of the objects.[17] During the spring of 1784 Floridablanca and Ponz exchanged lists and inventories that the latter had made, with the prime minister marking the items he thought would be to the king's taste. Once Carlos III, through Floridablanca, had taken the objects of his choosing, the Real Academia could keep those items deemed most useful for the teaching of the arts. Where there were multiple copies of books, prints, or maps, the Real Academia would, in principle, keep only one: in Ponz's words, if "repeated, one is put aside." The king would pay for all the objects, and those turned down could be returned to the Compañía de Lonjistas, which could then reach some agreement with the British ambassador, who was interested in recovering what he could for the original owners.[18]

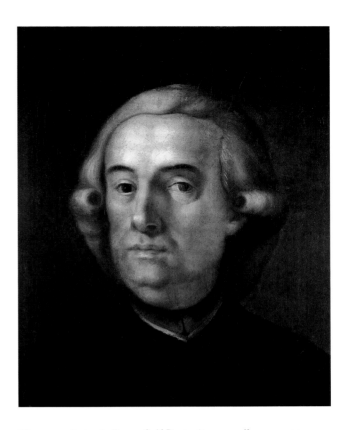

Figure 9. Antonio Ponz, *Self-Portrait*, 1774, oil on canvas, 16⅞ x 14⅛ in. (43 x 36 cm). Real Academia de Bellas Artes de San Fernando, Museo

Negotiations with the Compañía de Lonjistas for the purchase might have begun as early as the end of 1783; the first known written evidence dates from 1784. In these documents the merchants asked for reimbursement of 600,000 pesos for the art objects.[19] It took the Lonjistas almost two years to complete a deal, with the latest known documents dating from February 1785, when the king paid an agreed-upon 500,000 pesos through the Banco de San Carlos (later the Banco de España).[20]

With the listing process completed, a selection of objects for the king was sent to the Palacio Real in Madrid and to the small palace (Casita del Príncipe) built for the prince of Asturias (Carlos Antonio de Borbón, the future Carlos IV) in the Real Sitio de El Pardo, near Madrid. These included two mantelpieces, two inlaid-marble tabletops and drawings depicting them, some small marble sculptures, and feather flowers and flower trimming for dressing gowns delivered to the princess of Asturias (María

Luisa de Borbón-Parma). Ponz set aside a collection of books, engravings, sculptures, and paintings for the use of the students and teachers at the Real Academia. The rest of the crates remained in the Real Academia rooms waiting for the Lonjistas to collect them. In the end, however, the merchants declined to recover them, claiming that they were of no interest to the company. Some paintings, including two portraits by Pompeo Batoni (cats. 21 and 110), and marble tabletops were sent to the prime minister's official residence; the rest remained at the Real Academia.[21]

THE REDISCOVERY OF THE CONTENTS OF THE WESTMORLAND

As José M. Luzón Nogué and María Dolores Sánchez-Jáuregui have noted in their introduction to this volume, the long sequence of lists and inventories of the crates from the *Westmorland*, beginning with the one made by the Compañía de Lonjistas in Málaga in July 1783 (cat. 12), provided the basis for the recovery of the identities of the travelers, collectors, and dealers whose possessions were lost when the ship was captured. The initial task was to decipher the meaning of the initials that marked the crates. Did they refer to the owners, the port consignees, or other persons involved in the dispatch of the cargo? The initials "H. R. H. D. G." on five crates supplied a clue: they correspond to His Royal Highness Duke of Gloucester (William Henry), who, as stated in the "Note of the cargo manifest of the English Ship *Westmorland*," had crates on board. The books in the *Westmorland* crates further helped to identify the names behind the initials. On their arrival at the Real Academia, the librarian had marked their provenance with "P. Y." for "Presa Ynglesa" (English Prize), making it easy to distinguish them. Fortunately for us, many of the books were annotated with prices, commentaries, and the signatures of their owners. These notations provided additional pieces of the puzzle, allowing us to link initials to names and then to add to the existing biographies of the travelers some details of their taste for the arts and their time abroad.

As works listed in the inventories were matched with objects in the Real Academia, the contents of the crates, now associated with particular owners,

began to flesh out the profiles of those owners, frequently young men on the Grand Tour with their tutors. Crates marked "F. Bt.," "F. B.," and "Fs. B." (or "F. S. B.") belonged to Francis Basset; those marked "E. D." and "E. L. D." belonged to George Legge, Viscount Lewisham, directed to his father, William Legge, second Earl of Dartmouth; and those marked "E. B." belonged to Frederick Ponsonby, Viscount Duncannon, also directed to his father, William Ponsonby, second Earl of Bessborough. Other travelers with crates on board included John Henderson of Fordell ("J. H.") and Penn Assheton Curzon ("P. C." or "P. Cn."). In addition to these young men, there were dealers, collectors, and artists who lost works in the cargo of the *Westmorland*: Charles Townley, whose two crates marked "C. T." were being sent to him by the dealer Thomas Jenkins; the banker Lyde Browne ("L. B."), whose crate held marble sculptures; the painter Allan Ramsay ("A. Ry."), who lost two landscape paintings and possibly barrels with pigments; and dealers' consignments, including a range of fine prints for Robert Udny ("R. Uy.") from his brother John, the British consul in Livorno; as well as paintings, books, and engravings dispatched to the Reverend George Moir ("G. M."), brother-in-law of the dealer James Byres. Some initials, such as "J. G.," "J. P.," and "W. A. F.," still elude identification.

If one branch of research into the *Westmorland* has consisted of identifying and fleshing out the histories of the owners of the crates, another branch has involved tracking down the objects contained in the crates and tracing their histories. Once again the inventories made at the capture, sale, and arrival in Madrid of the contents have provided the primary evidence. But as the inventories were made for different purposes, in different circumstances, on different dates, there are, not surprisingly, inaccuracies and discrepancies among them. The creation of a database by Sánchez-Jáuregui incorporating all nine inventories enabled the production of a comprehensive master list of engravings, gouaches, watercolors, copies after old masters in various media, architectural drawings, fans, paintings, sculptures (both ancient and modern), tabletops, chimneypieces, candelabras, books, maps, musical scores, mineral-

ogical samples, and ancient lamps, all adding up to a total of some 778 objects shipped in fifty crates. The vast majority of these objects were incorporated into the collections of the Real Academia de Bellas Artes de San Fernando. Over the centuries the Real Academia gave away parts of its collections, dispersing some of the *Westmorland* items; nonetheless, it preserved most of the materials among the collections of its library, museum, and archive, although they were catalogued with no mention of their origin. The paintings, sculptures, and chimneypieces that had originally been sent to the royal palaces and the secretary of state's residence are now in the collections of the Patrimonio Nacional and the Museo del Prado, Madrid. Other objects enrich the galleries of the Museo Nacional de Ciencias Naturales and the Museo Arqueológico Nacional.

The vague descriptions, misspellings, and misreading of subject matter in the inventories presented obstacles to the identification of those objects in the Real Academia's collections or in other collections in Spain that had come from the *Westmorland*, which was the first step in the larger process of cataloguing the items from the ship.[22] As objects in present-day collections were linked to the entries in the inventories, numerous discoveries were made, including the revelation of early works by John Robert Cozens, the identification of the sitters in two Batoni portraits at the Prado as Francis Basset and George Legge, and the addition of a group of sculptural busts to the known oeuvre of the Irish sculptor Christopher Hewetson.

THE TRAVELERS

Of the travelers sending acquisitions home on the *Westmorland*, Francis Basset bought the greatest number of art objects and spent the most money.[23] He was born into a wealthy family with long-standing links to Tehidy Park, in Cornwall.[24] Orphaned at an early age, he inherited nearby land to the south of Carn Brea, where his family owned three mines known collectively as the Basset Mines, which reported great profits at a time when Devon and Cornwall were among the world's most important copper and tin producers. Basset was educated at Harrow, Eton, and King's College, Cambridge, which he left in 1775.[25]

At age nineteen he set off on his Grand Tour in the spring of 1777. Accompanying him as his tutor was the Reverend William Sandys, vicar of the family parish church of St. Illogan, who had already spent three years in Italy from 1771 to 1774.[26] Books and maps in the crates marked "F. Bt." and "Fs. B." testify to Basset's and Sandys's travel through France and a stay in Paris.[27] After leaving Paris they probably headed for Switzerland, passing through Geneva, where they acquired several more books and maps.[28] To guide them in crossing the Alps, Basset brought with him *A Relation of a Journey to the Glaciers in the Dutchy of Savoy*. According to its author, Marc Théodore Bourrit, "the most favourable time for this journey is the end of July, or the beginning of August; for at this season the latest snows being generally melted, leave the dangerous passages discoverable. If the traveller thinks proper, the journey may be made on horseback, or even in carriage."[29] Basset and Sandys seem to have crossed the Alps into Italy in late July.

Other prints and maps indicate visits to Genoa and then Florence.[30] In Florence Basset could have met the young architect Christopher Ebdon, who was based there and had recently been awarded a gold medal from the Accademia delle Arti del Disegno for architectural design.[31] It was probably from him that Basset commissioned a set of four drawings depicting the plans for a chapel (cats. 29–32).

There is no further evidence of their itinerary in Italy until they reached Rome. Their presence in the city is first recorded in a letter from the English sculptor Thomas Banks to the Royal Academy of Arts, London, dated December 13, 1777: "We expect a great many English gentlemen here this season some are already come . . . here is a Mr. Molesworth & Mr. Penn & Mr. Curzon, Mr. Tands [*sic*] and Mr. Bosset [*sic*]."[32] Among the most outstanding of the many acquisitions of art that Basset made in Rome are the full-length portrait (fig. 10) he commissioned from Batoni (along with a half-length portrait) and a suite of six watercolors by the young Cozens depicting views of the Alban Hills (cats. 23–28), which Basset and Sandys probably visited themselves. Basset also acquired a view of the monastery of San Cosimato, near Licenza, by Solomon Delane (cat. 22), painted

three years before for Charles Warwick Bampfylde, as Banks—still referring to Sandys and Basset as "Mr. Tands and Mr. Bosset"—recorded. Basset also commissioned his bust *alla romana* from Hewetson (cat. 128), who provided two portrait busts, one in terracotta covered with a bronze-like patina, and a plaster cast taken from the former before it was fired.[33] In addition, Basset acquired many engravings, such as the colored series of the *Loggie di Rafaele nel Vaticano* and the *Galleria Farnese* by Giovanni Volpato (cat. 40) and fourteen volumes of engravings by Giovanni Battista Piranesi, who, as a sign of gratitude, dedicated to him one of the plates of his volume *Vasi, candelabri, cippi, sarcofagi, tripodi, lucerne et ornamenti antichi* (Vases, Candelabras, Gravestones, Sarcophagi, Tripods, Lamps, and Antique Ornaments) (fig. 11).

By the beginning of 1778, in time to enjoy the carnival in Naples, Basset and Sandys were in the south of Italy. They visited the excavations of Pompeii and Herculaneum, with the *Lettre de M. l'Abbé Winckelmann . . . a Monsieur le Comte de Brühl* (cat. 51) in hand, and probably went to Paestum as well, as they procured a series of prints by Filippo Morghen of the antiquities of Paestum and Pozzuoli (cat. 46).[34] But the primary attraction seems to have been Mount Vesuvius, one of the main subjects in Basset's traveling library.[35] The books in his crates show a penchant for history, geography, and antiquities, although this may reflect Sandys's tastes more than Basset's, for it is Sandys's signature that appears in many of the volumes. The inclusion of several books on Sicily raises the possibility that the two men were at least considering extending their tour across the Strait of Messina. By May 16, 1778, they were again in Florence, where the *Gazzeta toscana* published the news of the christening of the second son of George Nassau Clavering Cowper, third Earl Cowper, at which Basset acted on behalf of Francis Godolphin Osborne, Marquess of Carmarthen.[36]

Basset and Sandys were recorded as being in Venice on May 26. Basset may have ended his Grand Tour with the Prussian army.[37] Thirty-two years later, while dining in the company of Joseph Farington, Basset, by then first Baron de Dunstanville and first Baron Basset, mentioned the episode: "This evening Lord Dunstanville told me that when he was a very young man, 19 or 20 years old, he was in Germany and passed some time with the Prussian Army which was then in the field contending respecting the Bavarian Succession. It was commanded by Prince Heinrich of Prussia. At this time His Lordship was much acquainted with Prince Leopold of Brunswick."[38]

Basset's collecting and commissioning of art was part of a lifelong pattern; Gustav Friedrich Waagen, writing shortly after Basset's death, included him in a list of the most distinguished collectors in England.[39] A discerning patron of the arts, he was especially inclined to support his own countrymen, acquiring during his time in Italy watercolors by Cozens and Jacob More, in addition to the busts by Hewetson and the plans for a chapel possibly by Ebdon. The two portraits he commissioned from Batoni and the bust by Hewetson take their place in a sequence that also includes two earlier portraits by Joshua Reynolds and a later portrait by Thomas Gainsborough. Like the chapel plans, much of the art he acquired while in Italy would have been intended to enrich and ennoble the family country house at Tehidy Park and to contribute to his image as a modern Maecenas.

Apart from his stint with the Prussian army, Basset seems to have spent about a year on his Grand Tour, most of which was in Italy. George Legge, Viscount Lewisham, spent about three years touring Europe, and his itinerary included stays in France, the Netherlands, Germany, Hungary, Switzerland, and Italy. Indeed, the Grand Tours of Basset and Lewisham were as different as their backgrounds. Lord Lewisham belonged to an old aristocratic family. He was the eldest son of William Legge, second Earl of Dartmouth, who was the stepbrother of the prime minister, Lord North (Frederick North). Dartmouth, who had made his own Grand Tour between 1752 and 1754, played an important role during the American War of Independence while George Legge was traveling on the Continent. But as correspondence between Dartmouth and his son, as well as his son's tutor, David

Figure 10. Pompeo Batoni, *Francis Basset*, 1778, oil on canvas, 87 x 61⅞ in. (221 x 157 cm). Museo Nacional del Prado, Madrid (cat. 21)

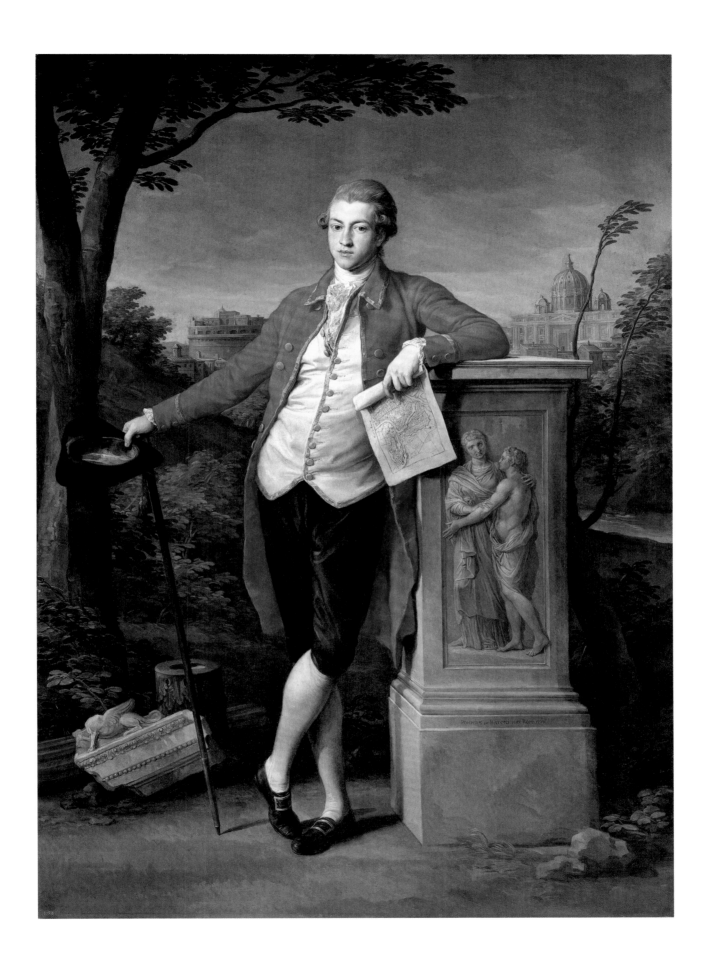

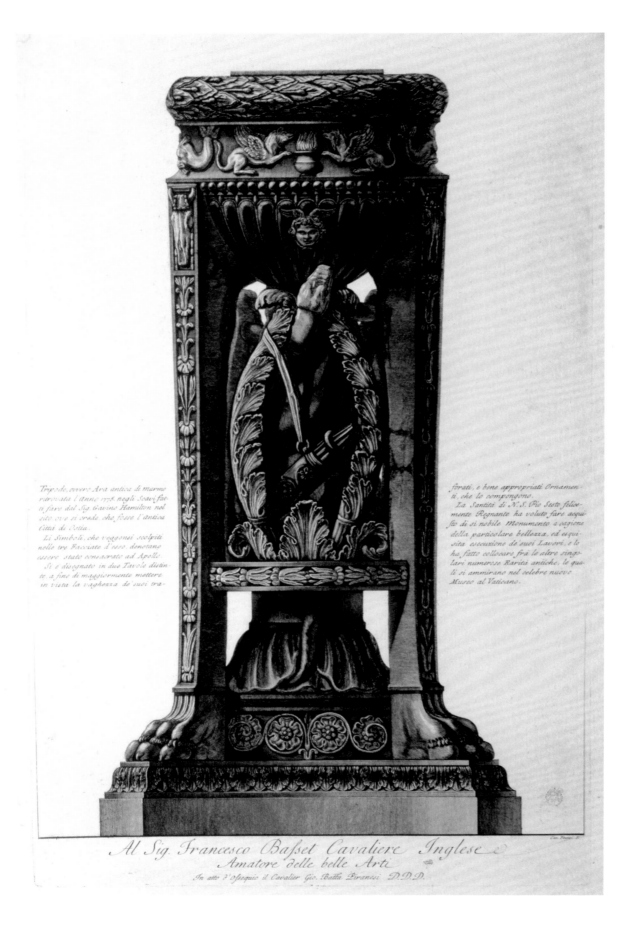

Tripode, ovvero Ara antica di marmo
ritrovata l'anno 1776. negli Scavi fat-
ti fare dal Sig. Gavino Hamilton nel
sito ove si crede, che fosse l'antica
Città di Ostia.

Li Simboli, che veggonsi scolpiti
nelle tre Facciate d'esso, denotano
essere stato consacrato ad Apollo.

Si e disegnato in due Tavole distin-
te, a fine di maggiormente mettere
in vista la vaghezza de' suoi tra-

forati, e bene appropriati Ornamen-
ti, che lo compongono.

La Santità di N. S. Pio Sesto felice-
mente Regnante ha voluto fare acqui-
sto di sì nobile Monumento a cagione
della particolare bellezza, ed esqui-
sita esecuzione de' suoi Lavori, e lo
ha, fatto collocare fra le altre singo-
lari numerose Rarità antiche, le qua-
li si ammirano nel celebre nuovo
Museo al Vaticano.

Al Sig. Francesco Basset Cavaliere Inglese
Amatore delle belle Arti
In atto d'Ossequio il Cavalier Gio. Batta Piranesi D.D.D.

Stevenson, makes clear, he took a keen interest in his son's tour. The first record of young George's Grand Tour is of his departure from Dover for Calais on July 25, 1775.[40] He was in Paris by July 30, accompanied by his younger brother William and Stevenson.[41] After a few days they left for Fontainebleau, Dijon, and the Loire valley, arriving before the end of August at Tours, where they remained for two and a half months.[42] Hosted at an abbey, the two brothers joined an academy for instruction in dancing, fencing, and French language and literature.

By November 19 of that year, the party was back in Paris, at the Hôtel d'Angleterre.[43] Lord Lewisham joined another academy to continue his education. Stevenson wrote, "I shall be impatient till the academy is again open. Fencing commences on Tuesday, the dancing master is expected on Wednesday, the French master cannot begin before next week, as this will be entirely taken up in visiting palaces, cabinets et other curiosities."[44]

In December Lewisham's brother William returned to England.[45] Lewisham and Stevenson remained in Paris for a few more months, committed to entering Parisian society, as the Earl of Dartmouth wanted. Lewisham also met John Henderson, another of the travelers with cargo on the *Westmorland*.[46] How the tour should proceed after Paris became a subject of disagreement between the earl and his son, with Stevenson attempting to play the role of mediator.[47] The young Lewisham wanted to travel in the South of France, but the Earl of Dartmouth insisted that his son spend the summer in Germany and afterward either return to England or cross into Italy.

Early in March 1776 Lewisham and Stevenson left Paris for the western coast of France,[48] visiting Rennes, Saint-Malo, and Calais, where Lewisham sent back home some acquisitions he had already made. In June they were in Brussels, where they gained a new companion, referred to only as Charles. From there they proceeded to the Netherlands, where their

stay in The Hague was "shorter than was intended, owing to the absence of the Prince of Orange and his court."[49] They also visited Amsterdam and Utrecht before heading to Germany. By the end of July Lewisham, Stevenson, and Charles were in Hanover, where, as the tutor wrote to the Earl of Dartmouth, "Our reception has been the most friendly imaginable, we meet everywhere your old friends, your old laquais, your old tradesman."[50] After a week they left for Brunswick, Berlin, Mecklenburg-Strelitz, Leipzig, Dresden, and Prague, reaching Vienna on September 17.[51] For six months Stevenson employed masters of fencing, dancing, and German for Lewisham, who was introduced to Viennese society and traveled to Hungary to see the gold mines. At this point their plan, approved by the earl, was to return to England. In a letter to Lewisham in February 1777, Dartmouth stated, "As you say no more upon your idea of going on into Italy, I conclude you have laid it aside, and adopted the scheme mentioned by Mr. Stevenson in his last letter of leaving Vienna the end of this month, and advancing homewards with more deliberation than was originally intended. I like this plan very well."[52]

By mid-May 1777, however, Lewisham and Stevenson were back in Paris making arrangements to cross the Alps. From June to September they toured the Swiss cantons on horseback; based in Geneva they made excursions to Bern, Lausanne, and St. Gotthard before proceeding to Italy. By October 24, 1777, they were in Genoa, dining with the British consul. They had passed through Milan and Florence by the end of the year, and by January 12, 1778, they were probably in Rome,[53] dispatching a crate with engravings to Livorno by February.[54] A letter from Sir William Hamilton, the British envoy extraordinary and minister plenipotentiary to the court of Naples, reported them in that city in February, and by April they were back in Rome.[55] There Lewisham sat for Batoni (fig. 12), and by May they were in Venice.[56] The date of their return to England must have been sometime between June 1778 and January 1779.[57]

The contents of Lewisham's crates on the *Westmorland* marked "E. D." consisted mainly of books written in Italian and dealing with Italian literature,

Figure 11. Giovanni Battista Piranesi, *Tripode*, ca. 1778, etching, 31½ x 22½ in. (80 x 57 cm). Real Academia de Bellas Artes de San Fernando, Archivo-Biblioteca (cat. 38)

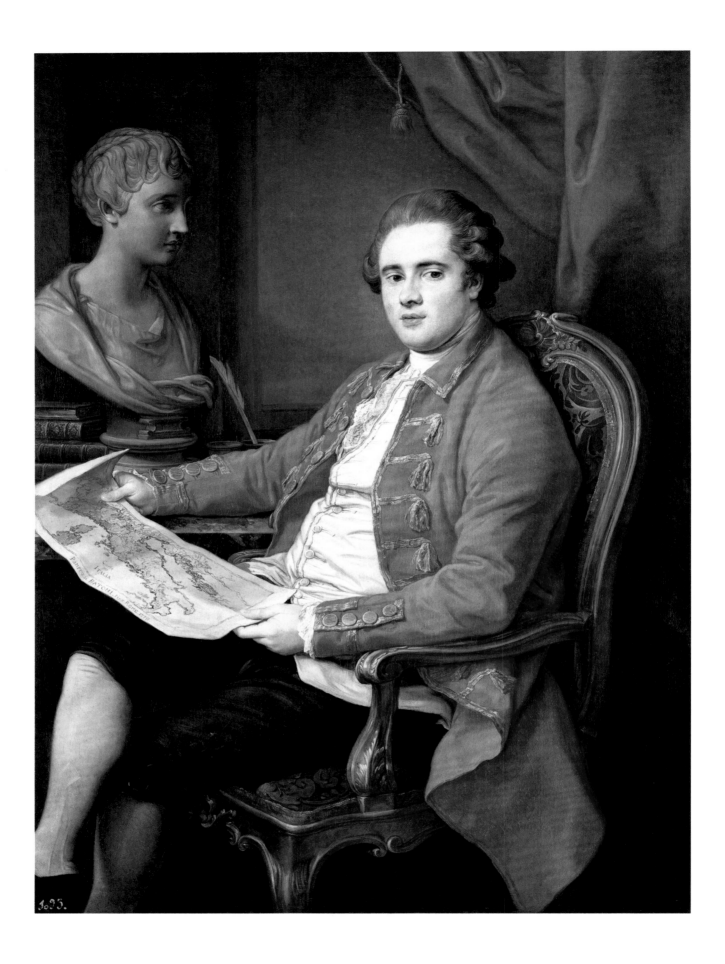

art, theater, and history, as well as guidebooks, conforming to the usual baggage for a tour through Italy.[58] They also included engravings by Volpato and Salvator Rosa (cat. 115),[59] together with flower bulbs, intaglios, and lava samples from Vesuvius. Lord Lewisham's other artistic acquisitions were copies of Raphael's *Madonna della Seggiola* (cat. 111) and of Domenichino's *Cumean Sibyl* (cat. 112), a pair of miniature portraits, and a small view of Vesuvius on paper. Although he might have sent home some major acquisitions in earlier shipments from Calais and Livorno, the number and significance of art objects in Lewisham's crates on the *Westmorland* are not outstanding, either because his focus was on establishing social contacts rather than serious collecting or because, given the existing family collection, such collecting was unnecessary.

Like Lewisham, Frederick Ponsonby, Viscount Duncannon (fig. 13), came from a distinguished family. Also like Lewisham, his father, William Ponsonby, second Earl of Bessborough, had previously been on the Grand Tour (1736–38) and had amassed a significant art collection. After attending Oxford from 1774 to 1777, Duncannon embarked on his Grand Tour with his tutor, Samuel Wells Thomson. Although there are no written references to their travels prior to his arrival in Italy, the *Westmorland* material suggests the earlier stages of their tour. A period in France is indicated by the presence of French grammars and dictionaries, two plans of Paris, and guidebooks.[60] Maps, prints, geographic books, and guidebooks for Switzerland leave no doubt of their passing through the Alps, probably during the summer, as Basset and Lewisham did.[61] They were in Milan in November. The following year they spent carnival in Naples from February to March 9, 1778, and enjoyed the company of Sir William Hamilton, who wrote to the Earl of Bessborough about his son: "He has infinite curiosity, spirit and resolution; this I saw in his having persevered in going to Benevento, to see the famous arch,

Figure 13. Joshua Reynolds, *Frederick Ponsonby, Viscount Duncannon*, 1785, oil on canvas, 29 x 24 in. (73.7 x 61 cm). From the Collection at Althorp, Northampton, UK

when the rest of his party, except Thomson, gave it up in account of difficulties and bad roads."[62]

Duncannon and his tutor were in Rome in April, when the artist Thomas Jones met them: "There was at Rome about this time a great concourse of the English nobility and gentry . . . all of whom, I believe, did me the honour of coming to see my pictures—and some became purchasers . . . Lords Lewisham and Duncannon."[63] On May 17 they arrived in Venice, whence they proceeded north. The death of Thomson, probably from consumption, at Gratz (now Graz), Austria, on July 27 may have marked the end of Duncannon's Grand Tour. Back in England, he was elected member of Parliament for Knaresborough and married Lady Henrietta Frances Spencer, both in 1780.

During his Grand Tour, the acquisition of major works of art seems, as with others, not to have been a priority, although Duncannon was clearly a serious devotee of the arts. His crates were packed with architectural drawings and views of Switzerland and of Roman sites, as well as delicate fans decorated with

Figure 12. Pompeo Batoni, *George Legge, Viscount Lewisham*, 1778, oil on canvas, 50 x 39⅜ in. (127 x 100 cm). Museo Nacional del Prado, Madrid (cat. 110)

copies of famous masterpieces and Italian *vedute* (views), maybe intended for his future wife. There were also many books largely devoted to art, specific to the cities he had visited or hoped to visit, such as *Les antiquités d'Arles*; *L'antiquario fiorentino*; *Pitture, . . . della città di Bologna*; *Descrizione . . . di Campidoglio*; and *Observations . . . de la Galerie Electorale de Dusseldorff*. He was also something of an artist himself, as Hamilton observed in his letter to the Earl of Bessborough: "He has Your Lordship['s] good eye and good taste. . . . The Drawings Lord Duncannon has taken of many delightful spots in this country are, I protest, more just than any I have ever been able to procure from the best artists here."[64] A number of amateur watercolors in Duncannon's crates are probably his own works. A sketchbook (now in the Dundee Central Library) from a later visit to Italy with his wife in 1792–94 testifies to his continuing practice of drawing.

Other travelers with cargo on the *Westmorland* came from less distinguished families and had less elevated social status. John Henderson's family were wealthy Scottish landowners. He was a lawyer and later a member of Parliament for Fife (fig. 14). There had been no known evidence of his trip to Italy before the discovery of the Fordell coat of arms and the signature of Sir John Henderson in some of the books in the crates labeled "J. H." revealed that the contents of the crates belonged to him. His father, Sir Robert Henderson, fourth Baronet of Fordell, had gone on his own Grand Tour between 1739 and 1742.[65] John Henderson, who does not seem to have been accompanied by a tutor, was in Paris in December 1775, and he befriended Lord Lewisham there.[66] The first evidence of his presence in Italy places him in Florence on September 17, 1777.[67] Thanks to the annotations with which Henderson filled his books, we know the exact date he entered Rome. In a copy of Giuseppe Vasi's guide to Rome *Itineraire instructif . . .* , underneath an engraving of the Porta del Popolo, which was the customs post and the normal point of entry for foreigners, Henderson wrote in pencil, "19 December 1777." (cat. 109). On April 12, 1778, he was in Naples, where he witnessed the signing of a statement by a certain Nicolas Henderson that the latter was not the son

Figure 14. John Brown, *Sir John Henderson of Fordell, 5th Bt.*, 1782, graphite on paper, 20 x 13¾ in. (50.8 x 35 cm). Scottish National Portrait Gallery

of Sir Robert Henderson of Fordell (and thus John's brother). The document was presumably meant to put an end to paternity claims dating back to Sir Robert's Grand Tour.[68]

The books in Henderson's crates reveal much about his personality. Selected works by authors such as Carlo Goldoni, Pietro Metastasio, Petrarch, Torquato Tasso, and Molière, as well as essays on literature such as *Les trois siècles de la littérature française*, bear witness to a cultivated taste for French and Italian literature, theater, and poetry. He was equally interested in music, politics, and philosophy; two works by Voltaire and the satire *Le nouveau Parlement d'Angleterre* were also part of his shipment.[69] Henderson's numerous annotations are all written in French, even correcting typographical errors in the texts. He made some art purchases as well, including three cop-

ies after old masters: Titian's *Venus and Adonis* (cat. 102) and *Danaë*, and Correggio's *La Zingarella*. Also in his crates was a portrait of a young man whose identity has not yet been recovered, but who was clearly significant to Henderson (cat. 101).

Penn Assheton Curzon is the most elusive of the travelers with materials on the *Westmorland*. Details of his Grand Tour are sketchy at best. His signature in a book in the crate labeled "P. C." (or "P. Cn." as recorded in another inventory) established his identity, and the books and maps in that crate suggest travels through France, Switzerland, Italy, and Germany, though no dates are registered in any of them. A "Mr. Curzon" is recorded as being in Rome for Christmas in 1777, at the same time as Basset, and again in December the following year; however, it is unclear if both these references are to Penn Assheton Curzon.[70] The books, maps, and prints that he consigned to the *Westmorland* reflect a fairly standard Grand Tour taste. He did acquire a complete set of Piranesi volumes, and, as with Basset (and his tutor, Sandys), Piranesi dedicated a plate of his *Vasi, candelabri...* to Curzon.[71]

OWNERS' ATTEMPTS AT RECOVERY

Shortly after the capture of the *Westmorland*, the original owners began attempts to recover the objects. As early as February 1779 Thomas Jenkins reported the capture to Charles Townley and explained his efforts to contact the British consul in Málaga and prevent the sale of his crate containing "two deities"; these works have not yet been identified. Jenkins expressed doubt that the banker Lyde Browne had anything on board—though, in fact, he did.[72] Documents at the Real Academia record that ownership of part of the cargo was left to the Compañía de Lonjistas in the event that they could reach an agreement with the British ambassador in Madrid. When the American War of Independence ended in early November 1783, several claims were addressed to Robert Liston, British minister plenipotentiary to Spain, including one from Alexander Munro writing on behalf of the Earl of Dartmouth in an effort to recover Lord Lewisham's property.[73] On November 23 Liston addressed inquiries to the company of Mr. Joyes & Sons on behalf of John Henderson:

I am induced to trouble you at present in consequence of a request I have received from a particular friend of mine, Sir John Henderson. That Gentleman had a Box, containing some Prints & pictures coming from Italy on board the Westmoreland, which was taken & carried into Malaga about the beginning of the war. He sent orders to that place to endeavour to purchase the articles that belonged to Him, when the Ship's cargo should be exposed to Sale. But I am informed by Mr. Morphy [*sic*], who acts as our vice consul at Málaga, that the Box in question, with as many other goods as loaded fifteen carts, was sent from thence about three weeks ago by orders of his Catholic Majesty. The persons chiefly concerned in the purchase of the Westmoreland's Cargo were a Body of Merchants in Madrid, known by the name of the Gremios, the favour I would beg of you Gentlemen, who are of course acquainted with the principal of those merchants, is that you would procure me information when the Court is likely to make choice of what may suit them, & when the remaining part is to be exposed to sale. In this last predicament, I suppose, most of the articles intended for Sir John Henderson will be, as the pictures are all copies, and none of them of any considerable value; & I should wish to have an opportunity of offering what I may think them worth.[74]

Among other efforts, Father John Thorpe, a former Jesuit who was acting as agent for Henry Arundell, eighth Baron Arundell of Wardour, exchanged letters with Lord Arundell about the marble plinth transported in the crate marked "T. H. D. nº. 7," containing relics intended for Arundell's private chapel. Once the war ended, Thorpe struggled to retrieve the relics through channels in Livorno, London, and Málaga, his efforts being the subject of discussion in many of their letters; see the essay "A Crate of Saints' Relics" by José M. Luzón Nogué in this volume.[75]

Five years later Liston and Floridablanca were still exchanging official diplomatic dispatches concerning *Westmorland* items. On November 17, 1788, Liston wrote to the prime minister again:

En vous priant de vouloir bien donner ordre que les deux portraits et les desseins nous soient remis, ainsi â que les livres et les habits. J'espererois la même grace pour les morceaux de sculpture, excepte toutefois ceux dont le mérite serait assez grand pour leur faire occuper une place essentielle dans la collection du Roi. Et si quelquesuns des articles étaient tombés entre les mains de particuliers, je proposerois d'en payer un prix raisonnable. (Praying that you would be so kind as to order the return to us of the two portraits and the drawings, also the books and clothes. I would hope for the same favor for the pieces of sculpture, except for those valuable enough that they would occupy an essential place in the king's collection. And if some articles have fallen into particular hands, I would propose to pay a reasonable price.)[76]

Floridablanca answered:

Muy Señor Mio: enterado del papel de VS [Vuestra Señoría]. de 17 del corriente en punto ál contenido del *Navio Ingles el Westmoreland* apresado por dos vageles de Guerra franceses en 1779 y traidos a Malaga; dispondré en yendo a Madrid se entregasen á VS algunos de los efectos pertenecientes á los Cavalleros ingleses de que VS. trata; respecto de no poder ser todos especialmemte las chimeneas los retratos y parte de los dibujos que no quiere el Rey quitarlos a quien los dio haviendo pagado S.M. por ellos mas de 300(mil)r.ˢ a los Armadores. (My dear Sir: knowing of Your Excellency's note of the 17 of this month concerning the contents of the English vessel *Westmorland* captured by two French warships in 1779 and brought into Málaga, I will arrange that when you come to Madrid, some of the objects belonging to the English gentlemen that Your Excellency mentioned will be handed over to you. It cannot be all of them, particularly the chimneypieces, the portraits, and some of the drawings, as the king does not wish to take them away from those to whom he gave them, having paid more than 300 (thousand) reales to the owners.)[77]

Despite the owners' best efforts, nothing—with the exception of Arundell's crate of relics—seems to have been returned to them.

WESTMORLAND OBJECTS AT THE REAL ACADEMIA

What was the subsequent history of the objects from the *Westmorland* at the Real Academia? The institution had been created some forty years before the *Westmorland*'s cargo arrived and already possessed a small collection intended for teaching (fig. 15).[78] The collection mainly comprised the works of the Real Academia's teachers, such as Louis-Michel van Loo and Corrado Giaquinto; the works of students who had been awarded prizes in annual competitions; pictures from the convents of the Jesuits whose order had been abolished in 1773; and a number of paintings from the royal collections. The majority of these works were of historical or religious subjects, mostly by Spanish painters.

The copies of old master paintings with which the crates of the *Westmorland* abounded could have been a useful teaching tool, but Spanish students in Rome (*pensionados*) were already copying the same paintings in situ.[79] Indeed, it has sometimes been difficult to distinguish the copies on the *Westmorland* from the *pensionados*' copies. There are few indications that the *Westmorland*'s paintings inspired student work at the Real Academia, an exception being the two copies of David Allan's *Origin of Painting* (cat. 120). While they ignored the name of the artist, two students, perhaps attracted by its Neoclassical subject, produced an engraving based on the work in 1790.[80] There is no evidence that such works as the Cozens watercolors, the many architectural drawings, the views of Rome, the classical sculptures, the landscape paintings, and portraits were used by the teachers or their students.

At the time of the arrival of the *Westmorland* consignments, the Real Academia's library had only about forty books. Mostly handbooks and treatises dealing with the arts and intended for teaching, they had been acquired in Spanish bookshops or given by the king and academicians.[81] The *Westmorland*'s consignments added 378 objects, including books, engravings, maps, and musical scores, creating the need for a new position of librarian, filled by Pascual Colomer.

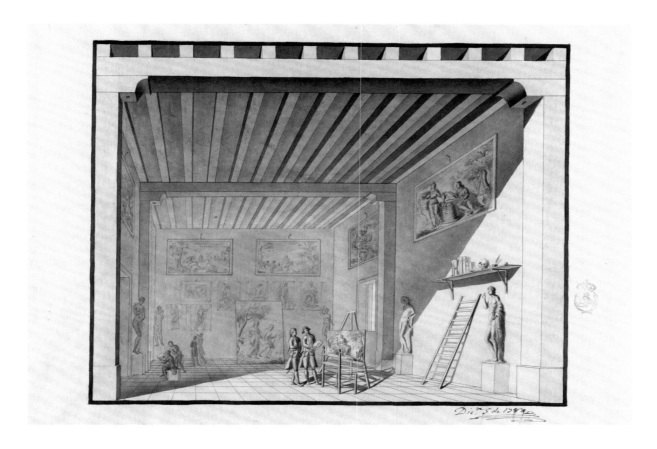

Figure 15. José López Enguídanos, *Re-creation of the Interior of the Academy (Painting Lecture)*, December 5, 1785, ink and gray watercolor, 14⅝ x 21¼ in. (37 x 54 cm). Real Academia de Bellas Artes de San Fernando, Museo

Although the academicians were familiar with works by Piranesi (four volumes by him already existed in the library prior to the arrival of the forty volumes transported on the *Westmorland*), books such as *Campi Phlegraei*, or Giovanni Pietro Bellori's or Rosa's engravings, must have been fascinating novelties. Yet many of the theoretical and philosophical works by Johann Joachim Winckelmann, Voltaire, and others, not to mention literature by authors such as Goldoni and Laurence Sterne, written in German, French, Italian, or English, probably saw limited use.[82]

The *Westmorland*'s contents brought to the Real Academia some of the latest productions in the arts and culture of Europe; however, the academicians and students seem to have shown surprisingly little interest. Perhaps the institution was too embroiled in controversy over the strictly classical teaching regimen that Anton Raphael Mengs had instituted in the 1760s to take much notice, although one might assume that this sudden influx of art and literature would have benefited the Mengs faction.[83] But if the contents of the *Westmorland* quietly disappeared into the collections of the Real Academia, two hundred years later they have reemerged as a uniquely valuable resource for scholars. Their limited use has kept them together and largely free from alteration.

The *Westmorland* presents us with a time capsule from 1779, a window into the art market and the collecting culture of the Grand Tour at a very precise moment. The frequent recurrence in the crates of copies of certain works of art in various painted and printed forms suggests that acquisitions were made according to a tacit canon of masterworks, promoted by the many guidebooks in circulation, popular art treatises, and dealers. The tutors also played an active role in influencing the acquisitions made by their charges. The absence of great original old

master paintings or outstanding pieces of ancient sculpture in the cargo suggests a decline in what was available for the traveler/collector by the late 1770s. Comparing the purchases made by the second Earl of Dartmouth or the second Earl of Bessborough on their Grand Tours with the acquisitions made by their sons, it is hard not to perceive a dramatic shrinking of possibilities in just one generation. The examples of British work on the *Westmorland* testify to the important community of British artists in Italy who contributed enormously to the advancement of arts in Britain, encouraged by the patronage of their wealthy countrymen. The range and variety of *Westmorland* objects, especially the richly informative array of books, provide a density and particularity of detail that have already reshaped previous thinking about the subject and offer the prospect, as we continue to study the *Westmorland*'s cargo and ponder its meanings, of a more complex and deeply nuanced understanding of the Grand Tour.

Except as noted, information in this essay is based on material in Westmorland 2002 and subsequent research by María Dolores Sánchez- Jáuregui.

1. Luzón Nogué 2000.

2. Thomas Jenkins to Charles Townley, Nov. 26, 1777, quoted in Bignamini and Hornsby 2010, 2:105.

3. "À Malaga le 8 Janvier 1779. J'ay l'honneur de vous announcer l'heureuse arrivée dans ce port des deux vaisseaux du Roy, Le *Caton* et le *Destin*, conduisant trois prises Angloises dont l'une doit être considerable. . . . La grosse mer m'a empeché, Monseigneur, de me rendre à bord." (Málaga, January 8, 1779. I have the honor of announcing the happy arrival in this port of two naval vessels, the *Caton* and the *Destin*, bringing three English prizes, of which one should be considerable. . . . The heavy sea prevented me, Sir, from going on board.) Correspondance Consulaire, A.E.B. I-812, Archives Nationales de France, quoted in Luzón Nogué 2002b, 70 n. 6.

4. "Mr. Marsh, His Majesty's Consul at Malaga has acquainted me that on the 8th. Instant two French Ships of the Line put into that Port with three Prizes, one an Act Ship from Leghorn, of very considerable Value; & two laden with Fish From Gibraltar." Baron Grantham to Thomas Thynne, third Viscount Weymouth, secretary for the southern and northern departments, Jan. 20, 1779, SP 94/207, fol. 83, National Archives, Kew, quoted in Luzón Nogué 2002b, 75.

5. Dossier 540, section: Estado, Archivo Histórico Nacional, Madrid, complete transcription in Luzón Nogué 2002b, 73–74 (translation by Dave Langlois).

6. "La Declaration du neuf du dite mois, fait par devant le dit consul par le Sieur de Seilllans contenant memes faits que dessus, tout vu et consideré . Nous en vertu du pouvoir a nous attribué a cause de notre dite charge d'Amiral, avons declare et Déclarons de bonne prise le dite navire Anglais le Westmorland, ses armes, agrès, et apparaux, ensemble, les marchandises de son chargement, et les adjugeons aux preneurs. Ordonnons en conséquence que le tout sera vendu." (The statement of the ninth of the said month made in the presence of the said consul by M. de Seillans, containing the same facts as above. The whole seen and considered, we, by virtue of the power attributed to us due to our said office of admiral, have declared and declare to be a good prize the said English vessel, the Westmorland, its arms, tackles, and rigs, together with the goods of its cargo, and allot them to the captors. We order thus that the whole shall be sold.) Dossier 2Q 33, [Rémises pour parts de prises (1779–1782). Prises conduites á Marseille, Almería, Malaga, Majorque, Cadix, Livourne et en Corse (1778–1781)], Archives du Service Historique de la Marine, Toulon.

7. By the end of Jan. 1779, two more frigates—*Magicienne* and *Atalante*—had rejoined the French fleet at Málaga under the command of Jean-Louis Charles Régis de Coriolis d'Espinouse. SP 94/266, National Archives, Kew; see also Luzón Nogué 2002b, 79.

8. Johnstone was the first governor of West Florida during Britain's brief administration, from 1763 to 1767. Luzón Nogué 2002b, 78–80.

9. Luzón Nogué 2002b, 76 n. 25.

10. Luzón Nogué 2002b, 74–75.

11. Suárez Huerta 2002, 54–62.

12. For Esquirol and the bureaucracy surrounding the sale, see Luzón Nogué 2002b, 77–79. On Dec. 19, 1780, Humbourg, the French consul, declared that the net profit from the sale of the *Westmorland*'s cargo, after deducting all the expenses, consular taxes, gratifications, and other disbursements, together with the particular clearances addressed to the navy minister, amounted to a total of 2,466,395 reales de vellón, compared to 248,273 reales de vellón and 6 maravedíes de reales de vellón each for the sale of the *Hector* and *Ranger* cargoes. Dossier 2Q 33, Archives du Service Historique de la Marine, Toulon.

13. 4-87-1-2, Archivo-Biblioteca, RABASF (cat. 13). The protector and vice protector held the most important positions in the Real Academia. Their responsibilities and powers would be equivalent to those of its current director.

14. Carta Orden from Floridablanca to the vice protector, marqués de la Florida Pimentel, Oct. 7, 1783, 4-87-1-2, Archivo-Biblioteca, RABASF.

15. Only the crate containing the relics of a saint remained unopened.

16. In a list dated March 27, 1784, Antonio Ponz, secretary of the Real Academia, complained that the concierge had removed the sacking and opened the crates without first meticulously registering contents and initials. 4-87-1-24, Archivo-Biblioteca, RABASF.

17. The secretary had one of the most important positions in the Real Academia. He was responsible for its relations with the king, he controlled the committees that governed the Real Academia as well as the accounts, and he was also the head of staff.

18. Conde de Floridablanca to Antonio Ponz, Aranjuez, April 19, 1784, 4-87-1-25, Archivo-Biblioteca, RABASF, quoted in Luzón Nogué 2002a, 95. For Ponz's words, see 4-87-1-26, Archivo-Biblioteca, RABASF (cat. 14).

19. 1-4 132, fols. 287r–v, 289v, Banco de España, Libro de Actas del Banco de San Carlos, Archivo del Banco de España; published in Luzón Nogué 2002b, 82–83.

20. Board of Governors, Feb. 15, 1785, 1-4 134, fol. 107r–v, Banco de España, Libro de Actas del Banco de San Carlos, Archivo del Banco de España.

21. Pedro Arnal to José Moreno, Sept. 24, 1790, 4-87-1-50, Archivo-Biblioteca, RABASF.

22. For example, an engraving described as "St. Peter and St. Paul preaching to the gentiles" was actually *The School of Athens*.

23. From July 22, 1777, to June 22, 1778, his time abroad, total expenses of £3,101 are registered in the state accounts of the Basset family. AD894/7/66, Cornwall Record Office, Truro. Our thanks to Jonathan Yarker, who found this information and passed it on to us.

24. Much of the following information related to Basset derives from Sánchez-Jáuregui 2002, 119–43.

25. Thorne 2006.

26. According to Joseph Farington, "Mr. Sandys told me he went to Rome in 1771. . . . Mr. Sandys remained in Italy three years . . . returned in 1774 being 30 years old and in 1777 again went to Italy with Lord Dunstanville (then Sir Francis Bassett) & was absent with him ab[ou]t a year and a Half, Lord Dunstanville being of age in 1778." Farington 1978–98, 10:3758–59, entry for Sept. 20, 1810. As Basset was sitting for his portrait by John Opie in March 1777, their departure must have been after that, which would have allowed them to cross the Alps in the summer.

For Sandys, see the essay "Educating the Traveler: The Tutors" by María Dolores Sánchez-Jáuregui in this volume.

27. Among them are a *Plan of Paris* and *Nouveau plan d'Orléans augmenté de ses Fauxbourgs*, Mp-52, Archivo-Biblioteca, RABASF. The *Westmorland* lists also mention a book on travels through France, unidentified, 4-87-1-10, Archivo-Biblioteca, RABASF.

28. Some of these are Nicolas Chalmandrier, *Nouveau plan de Genève . . .*; Robertus Gardelle, *Vue de la ville de Genève du côté du Midy*; and *Dictionnaire géographique, historique et politique de la Suisse*.

29. Bourrit 1776.

30. These include Benedetto Varchi, *Istoria delle guerre di Fiorenza* (signed by Sandys); Giovanni Lami, *Lezioni di antichità toscane* (cat. 45); and maps such as *Pianta della città di Firenze . . . 1755*.

31. Ebdon received the gold medal on Feb. 15 of that year. See Ingamells 1997, 328.

32. Banks 1938, 22. In addition to getting the names of Sandys and Basset wrong, Banks also mistook Penn Assheton Curzon for two people: "Mr. Penn & Mr. Curzon."

33. For the portraits of Basset by Batoni and Hewetson, see Sánchez-Jáuregui 2001b, 420–25.

34. J. J. Winckelmann, *Lettre de M. l'Abbé Winckelmann, antiquaire de sa sainteté, a Monsieur le Comte de Brühl* (Dresden, 1764). On page 19, where Winckelmann states that there were only eight people excavating at Pompeii, Sandys added in French, "1778 de même" (the same in 1778; cat. 51).

35. The Vesuvius books contained in crate "F. B." are Giovanni Maria della Torre, *Incendio del Vesuvio accaduto il 19. d'Ottobre del 1767* (Naples, 1767); and della Torre, *Storia e fenomeni del Vesuvio* (Naples: Presso Guiseppe Raimondi, 1755). Also on board was the French edition of the latter (Naples: Donato Campo, 1771).

36. "S. Eccellenza Mylady Gohor Consorte di S.E. Mylord Cowper dette felicemente alla luce nel di 6 un secondogenito al quale [. . .] i Padrini del neonato Figlio sono [. . .] questo Ministro Britannico Cav. Orazio Mann, e Madame Pitt; e per Mylord Carmarthen ha supplito il Sig. Basset." (Her Excellency My Lady Gore, consort of H.E. Mylord Cowper, on the sixth, happily gave birth to a second child to whom . . . godfathers of the newly born boy are . . . this British Minister Horace Mann and Mrs. Pitt; and Mr. Basset acted on behalf of Mylord Carmarthen.) Sánchez-Jáuregui 2002, 136.

37. This might have been facilitated by Lord Cowper. See Sánchez-Jáuregui 2002, 139.

38. Farington 1978–98, 10:3753, entry for Sept. 14, 1810.

39. Sánchez-Jáuregui 2002, 141 n. 21.

40. Historical Manuscripts Commission 1899, 217–18.

41. While Lord Lewisham was at Oxford his tutor was a Mr. Jackson, but a letter from the Earl of Dartmouth, dated

June 7, 1774, stated that Jackson would not travel with Lewisham. D(W)1778/V/853, Papers of the Legge Family, Earls of Dartmouth, Staffordshire and Stoke-on-Trent Archive Service, Staffordshire Record Office, Stafford (hereafter SRO).

42. According to a letter from Stevenson to the Earl of Dartmouth dated Aug. 8, 1775, they left Paris that day and were planning to return along the Loire. In another letter to the earl, on Aug. 28, 1775, Stevenson reported their arrival at Tours. D(W)1778/V/885, SRO.

43. Stevenson reported their arrival in Paris in a letter to the Earl of Dartmouth dated Nov. 26, 1775. D(W)1778/V/885, SRO.

44. Stevenson to the Earl of Dartmouth, Nov. 26, 1775, D(W)1778/V/885, SRO.

45. The Earl of Dartmouth to Lord Lewisham, Dec. 18, 1775, D(W)1778/V/853, SRO.

46. The Earl of Dartmouth to George Legge, Jan. 3, 1776, D(W)1778/V/853, SRO.

47. Stevenson to the Earl of Dartmouth, Paris, Jan. 29, 1776, D(W)1778/V/886, SRO.

48. In a letter to the Earl of Dartmouth from Paris dated March 7, 1776, Stevenson mentions, "Our departure being now fixed for tomorrow morning." D(W)1778/V/886, SRO.

49. Stevenson to the Earl of Dartmouth, Brussels, June 15, 1776, D(W)1778/V/886, SRO.

50. Stevenson to the Earl of Dartmouth, Hanover, Aug. 2, 1776, D(W)1778/V/886, SRO.

51. Queen Charlotte was princess of the Duchy of Mecklenburg-Strelitz when she married George III.

52. The Earl of Dartmouth to Lord Lewisham, Feb. 3, 1777, D(W)1778/V/853, SRO.

53. This is suggested by Stevenson's signature and date on the G. B. Nolli map of Rome, "Jan. 12 1778" (cat. 113).

54. John Udny reported to the Earl of Dartmouth from Livorno, Feb. 16, 1778, that he had the bill of Lading of the said crates marked "E. D." D(W)1778/V/904, SRO.

55. Ingamells 1997, 600. In Naples they probably acquired the volumes of the *Campi Phlegraei* sent home in Lord Lewisham's crates. The date for their second appearance in Rome comes from a mention in T. Jones 1946–48, 70.

56. Suárez Huerta 2006, 252–56.

57. Lewisham was elected member of Parliament for Plymouth in June 1778, probably in his absence. Ingamells 1997, 600. A letter dated Jan. 11, 1779, from Stevenson to Lord Lewisham, already in England, indicates the approximate latest date for their return. D(W)1778/V/886, SRO.

58. The scarcity of French books could be explained by previous dispatches from Calais and Livorno, already mentioned.

59. His father, the second Earl of Dartmouth, collected works by Rosa during his own Grand Tour. See Ingamells 1997, 277.

60. These include Lewis Chambaud, *A Grammar of the French Tongue*...; Joseph Jérôme Lefrançais de La Lande, *Voyage d'un françois en Italie* (cat. 92); Joseph Seguin, *Les antiquités d'Arles*; and a copy of John Millard's *The Gentleman's Guide in His Tour through France*.

61. Among other books is the *Dictionnaire géographique, historique et politique de la Suisse*, B-2336-37, Archivo-Biblioteca, RABASF.

62. Sir William Hamilton to the Earl of Bessborough, March 24, 1778, Hamilton 1999, 150.

63. T. Jones 1946–48, 70.

64. Sir William Hamilton to the Earl of Bessborough, March 24, 1778, Hamilton 1999, 150.

65. Copies of letters written by Major Charles Anstruther to Sir Robert Henderson, fourth Baronet of Fordell, GD172/979ᵃ, National Archives of Scotland.

66. A letter from the Earl of Dartmouth to his son in Paris, Jan. 3, 1776, mentions, "I have received your letter inclosing Mr. Henderson's ---- & wish I could be of any service to yr. friend." D(W)1778/V/853, SRO. Henderson then asked Lord Lewisham, nephew of Lord North, for support for his parliamentary candidature for Fifeshire. Historical Manuscripts Commission 1899, 223.

67. GD172/475, National Archives of Scotland: a certificate of baptism for an Italian baby issued by the Cancelliere del Primo Dipartimento delle Arti riunite alla Camera di Commercio, Arti, e Manifatture della Città di Firenze.

68. GD172/478, National Archives of Scotland. Attached to this declaration is the baptism certificate cited in note 67, suggesting that it was obtained by John Henderson as part of his attempt to prove that Nicolas Henderson was not his brother.

69. Voltaire, *Nouvelles probabilités en fait de justice* (Lausanne, 1773); *Lettre del M. de Voltaire à la Academie Françoise*, untraced but mentioned in a *Westmorland* list, dossier 4-87-1-10, Archivo-Biblioteca, RABASF; and *Le nouveau Parlement d'Angleterre: Érigé en communes a la tauerne de la liberté par une Société de Citoyens; traduit de l'anglois* (Amsterdam, 1775), C-289, Archivo-Biblioteca, RABASF (name of author not known).

70. For the 1777 visit, see note 32 above. Ellis Cornelia Knight includes Curzon as well as Lewisham and Duncannon in a long list of British visitors to Rome in her early days there, but the dates when she would have met them is unclear. E. C. Knight 1861, 1:50.

71. The plate represents a marble vase from Villa Albani. The engraving is included in the copy of *Vasi, candelabri...* preserved at the Real Academia. A-1070, Archivo-Biblioteca, RABASF. See also Focillon 1963, no. 669.

72. Jenkins to Townley, Feb. (?) 1779, in Bignamini and Hornsby 2010, 2:114.

73. Robert Liston was appointed secretary of the embassy to

the king of Spain on March 12, 1783, and minister pleni-potentiary in 1784. Alexander Munro wrote: "Dear Sir . . . I have to thank you, which I do very sincerely for the pains you have taken to oblige me, and particularly in the affairs which concerns Lord Dartmouth and his things, taken in the Westmoreland; . . . and if any of his things are ever recovered his thanks are only due to you, by means of the promise you obtained from the Spanish Minister some time ago." Alexander Munro to Robert Liston, Aug. 11, 1784, MS/5541, National Library of Scotland, Edinburgh.

74. Robert Liston to the company of Mr. Joyes & sons, El Esco-rial, Nov. 23, 1786, 72, MS/5554, National Library of Scot-land, Edinburgh.

75. The dispatch and claims of this case have been extensively studied by Luzón Nogué. See Luzón Nogué 2002c, 165–71.

76. Liston to Floridablanca, Nov. 17, 1788, dossier 4237, sec-tion: Estado, Archivo Histórico Nacional, Madrid.

77. Draft of letter by Floridablanca at El Escorial, dated Nov. 22, 1788, dossier 4237, section: Estado, Archivo Histórico Nacional, Madrid.

78. There were several proposals and attempts to create an academy in 1726, 1741–44, and 1751. Official approval came by a royal order in April 1752.

79. That Spanish students were copying the same works indi-cates an existing canon for training students and amateurs across Europe.

80. This was also published in Westmorland 2002, no. 90 (entry by María Dolores Sánchez-Jáuregui).

81. The first inventory of the Real Academia, "Inventario de las Alhajas de la Real Academia de Sⁿ Fernando," dated 1758, included the books existing in the library. The titles in the inventory run from a first edition of the *Ruins of Pal-myra* to sixteenth-century editions of Ovid and Vitruvius. 2-57-1-1, Archivo-Biblioteca, RABASF. See also Navarrete Martínez 1989, 291–314.

82. On the four volumes of Piranesi engravings prior to the arrival of the *Westmorland* objects, see 2-57-1-1, Archivo-Biblioteca, RABASF. Navarrete Martínez 1999, 127–65.

83. The classical ideas about art and the teaching of art that Mengs advocated were strongly criticized by Francisco de Goya and Juan de Villanueva, among others, who proposed an overhaul of the existing curriculum for training artists. They privileged the freedom of the artist and his capacity for creation above ideal beauty and Mengs's theories, as well as advocating national artistic tradition. See Úbeda de los Cobos 2001, 415–39.

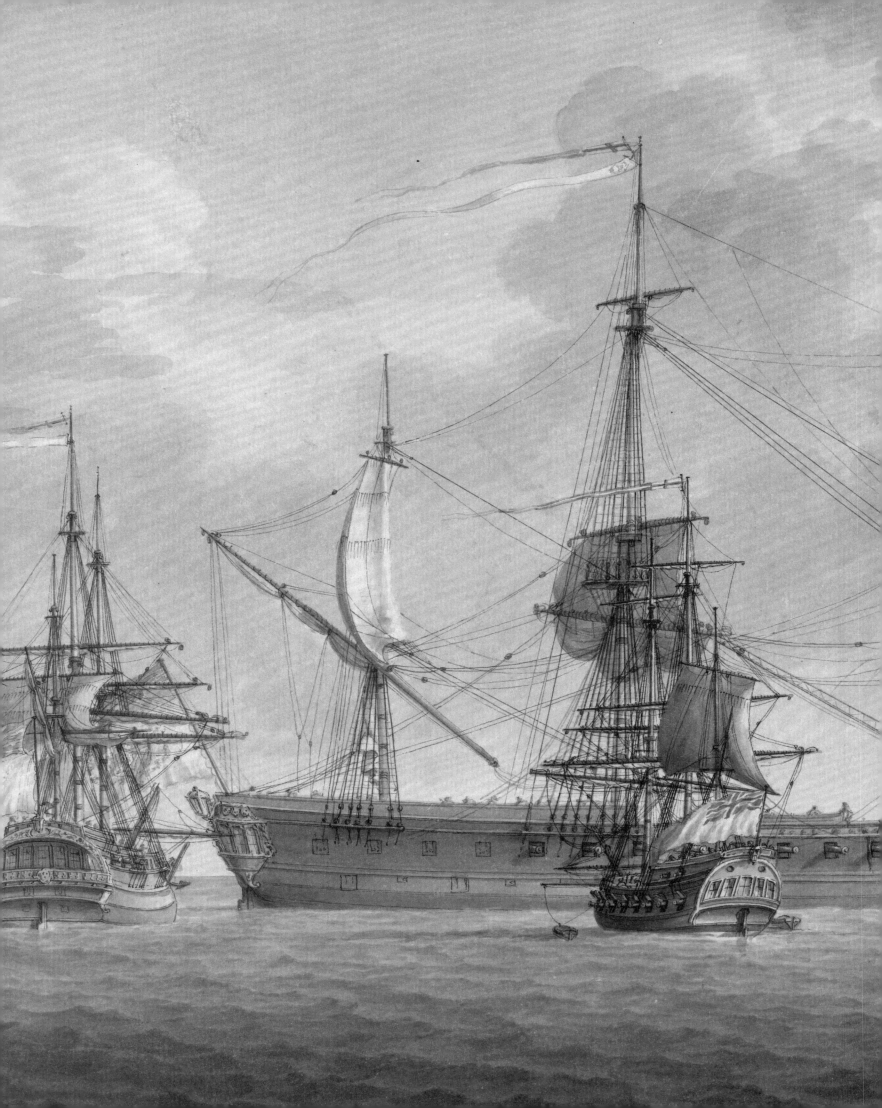

Trade and Transport: The *Westmorland* in Context

ELEANOR HUGHES

O N JANUARY 7, 1779, the British ship *Westmorland* was captured off the eastern coast of Spain by two French frigates and taken into Málaga. While the singularity of the *Westmorland*'s story derives from the preservation of the contents of its crates of Grand Tour materials, the ship—along with its captain, crew, and cargo—was in other respects a constituent in multiple and repeating patterns of commerce and warfare that played out in the eighteenth-century Mediterranean. This essay will situate the longer history of the *Westmorland*, from before its capture in 1779 to its subsequent recapture, within the narratives of the Mediterranean trade and the transportation of artworks, privateering, and the American War of Independence.

WILLIS MACHELL AND THE WESTMORLAND

The story of the *Westmorland* itself is intimately bound up with that of its captain, Willis Machell, who was descended from a "family of high antiquity" that owned land in Westmorland, in northwestern England, and had long-term interests in shipping and trade.[1] Machell was a seasoned commander of armed merchant vessels; he appears to have specialized in the "Leghorn trade" between London and Livorno, a distance of twenty-seven hundred miles that could take three months' sailing each way. From at least 1759 until 1761 he commanded the ship *Europa*, owned by his relative Richard Willis, a London merchant, and comparable in burden, crew, and armament to the *Westmorland* at three hundred tons, eighty men, and

twenty carriage guns.[2] From 1761 he commanded the *Saint George*, a smaller ship owned by Robert Willis.[3] While their exact relation to each other and to the Machells has yet to be established, the Willises are known to have been involved in the lead business—in his obituaries Robert Willis was described as "an eminent Lead Merchant and Plumber"—which helps to explain their interest in the Leghorn trade; along with wool and fish, tin and lead were the main exports from Britain to the Mediterranean.[4]

Machell applied to the Admiralty for letters of marque—licenses to engage in privateering—for each of these vessels. Privateering constituted a regulated form of private maritime warfare during periods of declared conflict, whereby armed merchantmen were granted letters of marque, or commissions, which gave them sole rights to the proceeds from enemy vessels and goods taken as prizes. The letters of marque provided the owner of a merchant ship (which was then itself referred to as a letter of marque) with the opportunity to supplement the profit from the ship's primary function—transporting freight for consignees—by taking prizes; perhaps more importantly, the chance of taking prizes in a defensive action provided a financial incentive to ships' crews "to defend and fight the ship as though she was actually one of His Majesty's Ships of War."[5] To obtain a letter of marque the commander of the vessel, or his representative, had to make a declaration before the High Court of Admiralty comprising "a particular true and exact account of the ship or vessel," including its name,

Figure 16. "A New River-built Ship . . . The WESTMORELAND," *Morning Chronicle and London Advertiser*, February 21, 1776. British Library, London

tonnage, crew size, armaments, and the names of its commander, officers, and owners.[6] Letters of marque for armed trading vessels such as the *Westmorland* (as opposed to private men-of-war, which were commissioned predators carrying large crews and no cargo) were valid only for one voyage and, during the American War of Independence, were issued separately against each specified adversary.[7] During the War of Independence general reprisals were granted by His Majesty's Orders-in-Council against the American colonies in April 1777, the French in August 1778, the Spanish in June 1779, and the Dutch in December 1780. In all, 7,352 privateer commissions and letters of marque were granted to 2,676 vessels between April 1777 and January 1783.[8]

The pattern of Machell's career in the Leghorn trade is revealed through the classified advertisements that appeared in the press. Merchant captains and their agents regularly advertised the arrivals and impending departures of their vessels. In 1760, for example, the "Proprietors of the Goods remaining on board . . . the Europa, Captain Willis Machell, from Leghorn," were asked to claim their goods from the ship "immediately that the Ships may be cleared, as they are obliged to proceed on other Voyages directly."[9] As departures approached, the sailing date was advertised so that exports could be received on board. Between 1760 and 1785 Machell made no more than one trip each year to Livorno and back, in some years leaving London in early spring and returning in the autumn, and in others leaving in late summer or autumn and returning in late spring of the following year. He seems to have thus avoided sailing in high summer, when the likelihood of Mediterranean calms would have hampered travel.

On February 21, 1776, the *Morning Chronicle and London Advertiser* carried an announcement for a "New River-built Ship, the first Voyage, in Rotation, and warranted to depart the First Ship, for Villa Franca, Genoa, and Leghorn (without touching at any other Port whatever) The WESTMORELAND. Willis Machell, Commander" (fig. 16). *Lloyd's Register*, which published information on ships for the benefit of the underwriters and merchants who insured and chartered them, listed the *Westmorland* as a ship of 250 tons—the estimated weight of cargo that the ship was capable of carrying—built in 1775 in one of the Thames dockyards ("River"), owned by "Captain and Company" and bound for "Str'ts"—the Strait of

Figure 17. West India Trader, in F. H. Chapman, *Architectura Navalis Mercatoria* (Stockholm, 1768–1806).

Gibraltar and the Mediterranean.[10] Later documents would list the *Westmorland* as capable of carrying 300 tons of cargo; estimating burden was not an exact science, and as a new ship its capacity was still being tested. Like the *Europa* and *Saint George*, the *Westmorland* was a substantial trading ship, comparable to the West India trader illustrated by F. H. Chapman in his *Architectura Navalis Mercatoria*, which has a draft of 15¼ feet (the *Westmorland*'s was 14) and a similar carrying capacity of 300 tons (fig. 17). A vessel of this size evidently allowed for sufficient cargo to make an annual trading voyage financially feasible. Even in times of peace among the European powers, the route between England and Livorno held myriad potential hazards, not only storms and calms but also pirates operating from the Barbary coast.[11] A well-armed merchant ship like the *Westmorland*, which when it left Livorno carried twenty-two carriage guns and either twelve or sixteen swivel guns, could hope to forgo the necessity of sailing in convoy under naval protection, which could be slow, and could also offer some degree of protection to other merchant vessels.

In the absence of a visual record of the *Westmorland*, a useful comparison is offered through the practice of Nicholas Pocock, who began his career as a merchant captain and left the sea to become a marine painter, exhibiting at the Royal Academy of Arts, London, and becoming a founding member of the Society of Painters in Water Colours. Just as Machell was employed by the Willises in London, Pocock worked for Richard Champion, a Bristol merchant.[12] During the 1760s and 1770s Pocock commanded several different vessels owned by Champion; on one occasion, in 1770, he sailed to Livorno in the *Betsey*, taking tinware, haberdashery, twine, cheese, tobacco pipes, and vinegar. Both the outbound and return voyages were beset by mishaps, and the route was not repeated. Pocock famously illustrated his logbooks with drawings of the ship in different weather conditions, coastal profiles, and views of ports; serving as the frontispiece to the log of his return voyage is a portrait of the *Betsey*—a ship comparable in shape and size to the *Westmorland*—in the harbor of Livorno, with the city beyond (fig. 18).

Delays in sailing were extremely common,

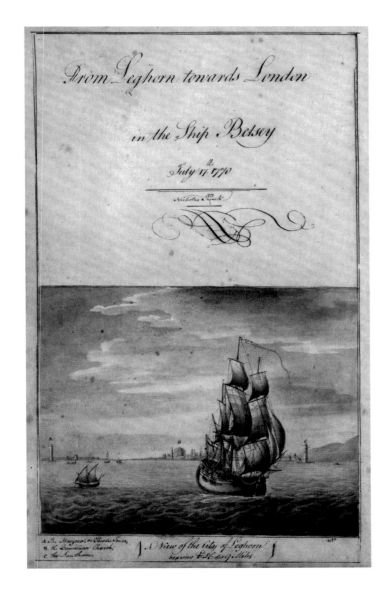

Figure 18. Nicholas Pocock, *From Leghorn towards London in the Ship Betsey, A View of the City of Leghorn*, 1770, pen and ink and gray wash, from the logbook of the *Betsey*. National Maritime Museum, London (LOG/M/3)

announcements of imminent departures appearing for as long as four months at a time before ships actually left port. While the departure date for the *Westmorland*'s maiden voyage was initially advertised as March 1776, the ship was still in dock in May of the same year, "the major part of her cargo on board, and will absolutely clear and sail on Saturday next."[13] It was on the return leg of this voyage that Machell conveyed four crates of "Marbles" sent to the antiquarian Charles Townley by his dealer in Rome, Thomas Jenkins.[14]

The *Westmorland* was only one of dozens of ships used by agents in Italy to send artworks to their owners in England, and an abundance of evidence survives concerning the precautions that dealers and agents took to safeguard the objects being conveyed to their clients. Some, such as drawings that could be rolled up, were sent overland; intaglios, jewelry, and other small items might be sent in personal baggage or with a trusted third party.[15] For paintings and sculpture the sea route was probably cheaper. From Rome they were transported to Ostia or to Civitavecchia by river, then to Livorno by sea.[16] Horace Mann, the British resident in Florence, writing to his friend and correspondent Horace Walpole on the latter's purchase of the Greek sculpture known as the "Boccapaduli" eagle, promised to "order him [the eagle] directly to Leghorne by sea, and from thence will contrive some way to send him home, in a man of war if possible, for as he has not Jupiter's thunder with him, he can only be safe under the protection of that of Neptune."[17] On news of the eagle's arrival in London without its pedestal, however, Mann unblushingly reversed his position: "I am glad to hear your eagle has got home safe, but can't conceive what is become of his pedestal. I always told you that a man of war was the worst conveyance in the world."[18] In fact, both pedestal and eagle had been conveyed in a naval storeship; for the most part merchantmen were relied on to transport artworks, and some acquired a reputation for their speed and reliability, as one dealer indicated: "I have inclosed a bill of loading for the pictures mentioned in my last which are shipd on board one of the best ships in the Leghorn trade & hope will sail soon."[19] Letters from agents to their clients routinely included mention of the names of ship and captain by which their purchases were being conveyed.

In addition to fees for overland freight, customs duty, and licenses, agents' accounts detail payments such as those made to carpenters for building crates, as well as for the fabrication of screws to be used instead of nails "to avoid any occasion of beating with a hammer."[20] The transportation of sculptures was of particular concern and necessitated a certain amount of experimentation with packing materials. On the occasion of his sending sculptures of the Drunken Faun and Actaeon to Townley in 1775, Jenkins wrote to his client that "as a further Precaution, I have had the Case filled with Saw dust, and Baled with Such a Quantity of Straw, as will Save it from any Sudden Jolts."[21] Jenkins also provided detailed advice on the procedures to be observed at the customhouse, recommending that any parts of the crates that were removed in order to inspect the contents should be marked "before they are taken off in order that they may with facility be put in their proper places."[22] On occasion the advice was for more nefarious purposes, as when Jenkins notified Townley that a portfolio with a print of the eruption of Mount Vesuvius also contained "the Picture of Sasso Ferrato Conceald in the Cover of the Portfolio" and advised that "not any mention shoud be made at the Custom House of the Picture in the Portfolio its absolutely Invisible."[23] Such deceptions were apparently common.

Of additional concern was the transportation by land once the objects arrived in England. In 1766 the Scottish painter, archaeologist, and dealer Gavin Hamilton wrote:

> I should be glad to know in what manner the last marbles have suffered for my future regulation they seemd to be so well packd up that they could not possibly be moved in the case so as to rub, & with regard to either rain or sea water I don't think they could suffer from it I am afraid they have been taken out at the custome house in that case it is very probable they may have suffered a little in the carriage home especially if carried into the country.[24]

In other instances blame was placed firmly on the sailors who had handled the works. In 1775 Hamilton complained to Townley of

> the disagreable news of the Victory and candelabrum, which I can proceed from nothing but the negligence of those barbarions who throw things promiscuously into the hold, I myself was an eye witness to its being safe screwd up, if the

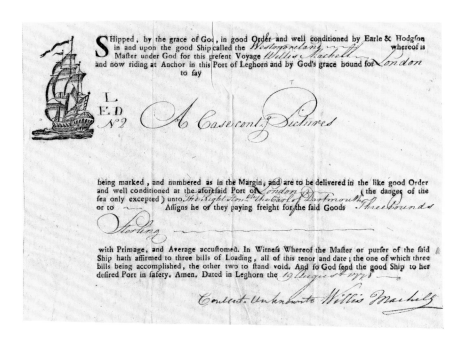

Figure 19. Consignment note for the crate on board the *Westmorland* belonging to William Legge, 2nd Earl of Dartmouth, August 19, 1778, enclosed in a letter from Thomas Jenkins to Dartmouth. Staffordshire Record Office, Dartmouth correspondence (cat. 9)

break was owing to any sudden jolt from the cart in unloading at Ripa or at Leghorn, the large statues woud from their weight, run a greater risque than the small ones, the proof is that I never yet had any that suffered in the least, the reason is plain because the sailors can not sling them into the hold as they doe the small cases, when I think of the vase my hair stands on end, to the best of my remimbrance I used this additional precaution of filling the case & vase with sawdust, then the boards screwed down & lastly embailed . . . depend on it that the things now packing shall be done in such a manner that they will bid defience to all the cursed crew of mariners etc.[25]

In addition to crates of artworks and other Grand Tour acquisitions being shipped back to England by agents in Rome (fig. 19), the *Westmorland* conveyed cargoes that place it firmly within the patterns of Mediterranean trade. From the late sixteenth century, Britain's principal exports to the Mediterranean were woolen cloth, fish, tin, and lead.[26] The fact that Willis Machell's relations Robert Willis and Richard Machell were lead merchants goes some way toward explaining the involvement of the family in the Mediterranean trade; presumably their primary business was the direct export of lead, with the carriage of other goods bringing additional income, including reexported

goods from the transatlantic trade, such as indigo.[27] The London advertisements for the *Westmorland*'s last voyage before its capture announce the shipping rates at which "Woollen Goods" would be received on board the ship. The inventories made of the *Westmorland*'s contents at the time of the capture list the typical nature of goods shipped from Livorno, some from Italy ("5 crates of black silk from Bologna"; "84 rolls of Genoa paper"; "32 Parmesan cheeses"; and manna, from Calabria), others from points farther east that would have come to Livorno via the Levant trade and reexported, taking advantage of that city's status as a free port. For example, the twelve sacks of oak galls, the sole source of tannic acid in the eighteenth century and used in the production of iron-gall ink as well as the dyeing of cloth, would have come from Aleppo, in the eastern Mediterranean; the 129 pounds of silk might also have come from the Levant.[28] Among the ship's human cargo—its crew and passengers—mention should be made of a passenger whose presence on the ship was revealed after its capture, again in a classified advertisement: "A BLACK BOY from Bengal, who was passenger on board the Westmoreland, Captain Willis Machell, from Leghorn, is now in London, and ready to be restored to his master, whose name is understood to be Home, or Hume. Information may be had by applying at the bar of Will's Coffee-House, Cornhill."[29]

In April 1777 one of His Majesty's Orders-in-Council was issued against the American colonies, granting general reprisals against shipping. The next month the *Westmorland* was advertised as a letter of marque (fig. 20); however, it was not until October that Machell appeared before the High Court of Admiralty to secure his letter against American vessels. In his signed declaration to the Admiralty, Machell, who is listed with John Atkinson of Great Ormond Street as "the owners and setters out of the said ship," described the *Westmorland* as a square-sterned, three-masted vessel with a figurehead, its outbound cargo consisting of "Woollens, Linnens, Iron, Lead, Hardware, Leather, Indigo & other Merchandize" (fig. 21).[30] In March 1778 Machell was in Livorno and published a notice to local merchants through his insurance broker (*mezzano*) in Livorno, Franco d'Onorato Berte:

La Nave nuova, atta di forza e con Patente in guerra nominata Westmorland, Cap[ita]no Willis Machel Inglese di portata tonnellate trecento, cannoni 22 di Libbre sei di calibro con petriere e ogni altro atrazzo necessario di guerra e con 60 uomini d'Equipaggio avendo impegnato buona parte del suo carico sarebbe stata la prima che sarebbe partita per Londra, dopo la Nave Duca di Savoia. (The new ship, well-equipped and with a license to war, called *Westmorland*, Captain Willis Machel from England, carrying 300 tons, with 22 cannons of 6 pound caliber stone balls, and every other necessary instrument of war and with 60 crewmen, having filled the good part of its load to capacity, will be the first to leave for London, after the Ship *Duke of Savoy*.)[31]

The very long delay before the *Westmorland* actually sailed in December 1778 has been well documented through the complaints issued by insurers of its perishable cargo.[32] As we have seen, postponements of sailing dates by several months were very common; while possible reasons for this more prolonged delay have been proposed, the pattern of Machell's career suggests that its main cause may

Figure 20. "A Letter of Marque . . . The Westmoreland," *Morning Chronicle and London Advertiser*, May 20, 1777. British Library, London

have been anticipation of war with France, a far more powerful and dangerous enemy in the Mediterranean than the American colonies. In July of that year Jenkins was writing to Townley: "By Yesterday Papers from England, I find Hostilities have Commenced between Keppel & the French, and I now look upon War as Ine[vitable] between France & America I think we have our hands fully employed."[33] Indeed, the following month war was declared, and on August 17 the Admiralty began issuing letters of marque against the French. Three days later one Samuel Enderby appeared before the High Court of Admiralty "on behalf of Capt.n Willis Machell now at Leghorn" to apply for a letter of marque for the *Westmorland* (fig. 22).[34] Clearly Enderby must have had prior instruction from Machell that if war were to be declared, he should secure a commission; given his previously demonstrated caution, Machell may have waited at Livorno for notification of his letter of marque before sailing.

The precaution initially paid off: when the *Westmorland* finally sailed in December, it captured a ship. The *Morning Chronicle and London Advertiser* for

Figure 21. Declaration for a Letter of Marque for the *Westmoreland*, October 9, 1777. The National Archives, Kew (cat. 1)

Figure 22. Declaration for a Letter of Marque for the *Westmoreland*, August 20, 1778. The National Archives, Kew (cat. 2)

January 26, 1779, published an extract of a letter from Paris, dated January 8, noting that the "Westmorland, Captain Matchell, from Leghorn to London, has put into Port Mahon, with a Swedish [*sic*] ship, bound to Marseilles, which he took on his passage." The *New Lloyd's List* also reported that the "Westmoreland, Matchell, from Leghorn for London, is put into Mahon, and carried in with her a Ship loaded with Corn from Turkey, bound for Marseilles."[35] A relevant notice appeared much later in the *London Gazette*:

> The several Persons who were actually on Board the Private Armed Ship Westmoreland, whereof Willis Machell was Commander, at the Time of her taking the Danish Dogger called the *Frau Frederica*, Cornelius Bundez Master, in the Month of December, 1778, the Cargo whereof was condemned at Mahon as French Property, may personally, or by their lawful Attornies, receive their respective Shares of Prize Money arising out of the Proceeds of said Cargo, by applying to T. Atkinson, Notary Public.[36]

On the same day that it described the arrival of the *Westmorland* and its prize in the English-occupied Port Mahon (now Mahón, on Minorca), the *New Lloyd's List* also reported that the British ship *Triton*, sailing from Alicante, Spain, and the *Southampton*, sailing from Livorno, had been captured by two French frigates and taken to Málaga, adding, "The Southampton sailed with the Westmoreland."[37] Several days later the news of the *Westmorland*'s capture, relayed from Málaga via Paris, reached London. Confusion over the details reflects the unreliability of information transmitted:

> This Day arrived a Mail from France.
> Malaga, Jan. 8.
> The following French men of war, which sailed from Toulon Dec. 25, are arrived here, viz. the Cato, of 64 guns and 600 men, and the Destin, of 74 guns and 700 men. They have taken three English prizes, two loaded with cod, and the Westmoreland, from Lisbon [*sic*], whose value the English Captain estimates at 100,000 livres.[38]

A report made for the French admiralty provides the most detailed account of the capture:

> On the seventh of January in the present year toward noon . . . the ship *Caton* made signal to the *Destin* to chase to the southeast where three vessels had been sighted: one Danish, another Dutch, and the third English. When this last had been taken, the officer in charge being taken on board the prize along with the first lieutenant, Sr. Chevalier de Lort[?], they learned that the said vessel was named *Westmorland*, that it carried twenty-two cannons, sixteen swivel guns, and other small arms, and seventy men; that it sailed from Livorno carrying various merchandise for London, and that its capacity was three hundred tons.[39]

The Danish and Dutch ships mentioned in the report were released. The next morning the *Caton* and *Destin* brought the *Westmorland*, together with two other English prizes—the *Hector* and *Ranger*—filled with cod, to the safe port of Málaga, where the French would be able to sell their cargoes. There they joined the French frigates *Magicienne* and *Atalante* and their prizes, including the *Southampton*.

WAR AND AFTERMATH

As suggested by the number of prizes brought into Málaga in such a short space of time, the capture of the *Westmorland* was by no means an unusual occurrence. The day before the *Westmorland* was taken, Jenkins wrote to Townley of the dangers of shipping at this moment: "The Ship with the Pictures on Board is still detained at Nice for want of Convoy, this is a Misfortune, therefore I do not add it to a list of Complaints, already too numerous, had all the Pictures been coming on my Account or Rich, I certainly should have ordered them to have been Sent on a Neutral Bottom."[40] By the following month, in the same letter in which he noted the capture of the *Westmorland* and the consequent loss of Townley's two crates of "marble deities," Jenkins was writing, "Our commerce in the Mediterranean . . . fully neglected, there not being a single ship . . . in that sea."[41] Such concerns were more than justified; later in the same year

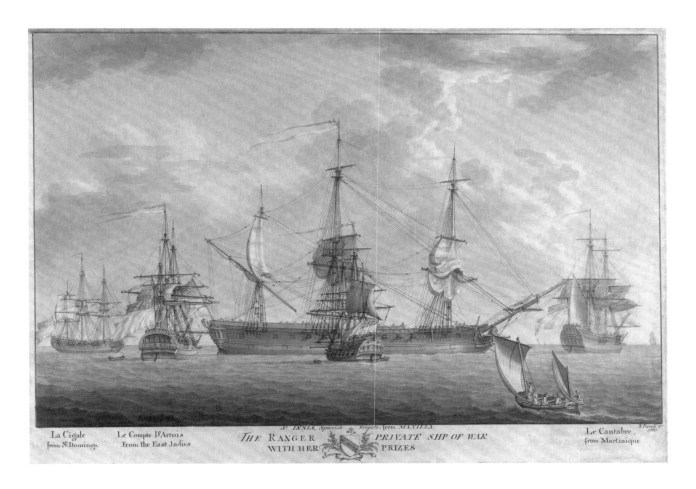

La Cigale
from S. Domingo.

Le Compte D'Artois
From the East Indies

St INNIS, Spanish Frigate, from MANILLA.

THE RANGER
WITH HER

PRIVATE SHIP OF WAR
PRIZES

Le Cantabre,
from Martinique

Figure 23. Nicholas Pocock, *The Ranger, Private Ship of War, with Her Prizes*, 1780,
pen and ink and gray wash on paper, 15 x 21 in. (38.1 x 53.3 cm). Yale Center for British Art, Paul Mellon Collection (cat. 4)

Townley lost further crates of artworks when the privateer *Favorite*, along with three other ships valued together at £200,000, was captured by the French and taken to Toulon, where its contents were sold.[42] A happier outcome was the case of Thomas Moore Slade, who with John Udny purchased the Bartolomeo Vitturi collection in Venice:

> The American war breaking out, I was called to England by my friends. My pictures, and other objects of virtu, of which I had formed a most valuable assemblage, were sent by sea; and as war with France was expected, I had them all cased up under the name of Illustrissimo Signor Cavalli, who happened to be then going on his embassy to England; I took the precaution likewise of writing all the lists and memoranda in Italian, and well I

did so, for the vessel was captured in the Mediterranean by a French privateer, and carried into a Spanish port. Cavalli, however, claimed them as his property, and after much difficulty they were delivered up, shortly afterwards to my great joy arrived safe in England.[43]

At the same time, British privateers continued to take prizes comparable in value to the *Westmorland*, such as the French East Indiaman *Ferme*, taken by two smaller privateers in November 1778 and said to be worth £100,000.[44] The majority of the 872 French and 128 Spanish ships captured by privateers and condemned at the Prize Court in London between 1777 and 1783 were certainly not as lucrative. Among the most spectacular British captures of the war, however, was that made by the privateers *Ranger* and

Amazon, from Bristol and Liverpool, respectively; their prize was the *Santa Inés*, an eight-hundred-ton vessel initially reported to contain gold, silver, coffee, china, cochineal, and indigo, but which in fact carried sugar, black pepper, dyewood, and beeswax, along with "a beautiful zebra, remarkably tame and quite young," that was later sold to Philip Astley's circus; altogether, the prize was valued at "upwards of 200,000."[45] The *Ranger*'s role in the capture was celebrated in a watercolor by the marine painter Nicholas Pocock that shows the privateer dwarfed by the Spanish prize (fig. 23).

Following the capture of the *Westmorland*, Machell and his crew were exchanged for French prisoners, and he made his way back to England, perhaps even as soon as the "black boy from Bengal," who was in London by May 1779. Machell continued to sail in the Leghorn trade, captaining the ship *Lively*, until his death from an "apoplectick fit" in London in 1785.[46] As with all his vessels Machell secured a letter of marque for the *Lively*, and he made several captures, including those of the *Gustavus*, the *Rebecca and Harriett*, and the *Four Friends*, American vessels en route from Amsterdam and Göteborg to Boston and Philadelphia. Their cargoes, including spices, canvas, and munitions, "part of Admiral [Richard] Kem-

penfelt's prizes," were offered up for public auction in 1782.[47] The *Westmorland* was recaptured by the British in late 1783 or early 1784 off Antigua and sold to pay the salvage; those insurers of goods who had taken a loss from its capture in 1779 were told to apply for their proportion of the net proceeds; "otherwise they will be excluded from all Benefit arising from the Re-capturing of said Ship."[48]

This close examination of the history of the *Westmorland* and the career of Willis Machell reveals the engagement of both captain and ship with patterns that were endlessly replicated within the context of eighteenth-century maritime trade and warfare. Such patterns, often expressed statistically—the transportation of goods, including imports, exports, and reexports; the complex web of captures, counter-captures, and recaptures by multiple parties during periods of international conflict; and the economics of privateering—are brought into a singular focus by the capture of this ship and the preservation of the extraordinary assemblage that made up part of its cargo. The patterns revealed by this assemblage—including those of the production and circulation of artworks; of the careers of makers, dealers, and owners; and of the cultural phenomenon of the Grand Tour—form the focus of the essays that follow.

I am grateful to Yinshi Lerman-Tan for her research assistance and to Laura E. Ruberto for her help with translations.

1. Anonymous note dated Feb. 22, 1772, DDMC 33/4, Lancashire Record Office, Preston. There were several ships named *Westmorland* (or *Westmoreland*) sailing during the same period as this one; an earlier *Westmoreland* was commanded in 1749 by an Edwin Machell (exact relation to Willis Machell unknown) and originally owned by Robert Bateman, an English merchant from the village of Ings, in Westmorland (formerly spelled "Westmoreland"), who lived in Livorno (e-mail from Leonard Smith to José M. Luzón Nogué, March 16, 2009).

2. Register of Declaration for Letter of Marque, *Europa*, March 19, 1759, HCA 26/11, fol. 21, National Archives, Kew.

3. Register of Declaration for Letter of Marque, *Saint George*, Sept. 1761, HCA 26/12, fol. 121, National Archives, Kew.

4. Announcements of the death of Robert Willis in 1765 mentioned that the business would be carried on by his "relation and partner, Mr. Richard Machell." *Lloyd's Evening Post*, Jan. 28–30, 1765; *St. James's Chronicle or the British Evening Post*, Jan. 29–31, 1765; *Gazetteer and New Daily Advertiser*, Jan. 31, 1765; and *Public Advertiser*, Jan. 31, 1765.

5. Articles of Agreement, *Royal George*, Nov. 19, 1747, HCA 30/663, National Archives, Kew, cited in Starkey 1990, 52.

6. Starkey 1990, 23.

7. Starkey 1990, 196.

8. Starkey 1990, 200–201.

9. *Public Advertiser*, April 28, 1760.

10. *Lloyd's Register*, 1778.

11. See Colley 2003, 43–72.

12. Cordingly 1986, 16.

13. *Morning Chronicle and London Advertiser*, May 9, 1776.

14. Thomas Jenkins to Charles Townley, Nov. 26, 1777, in Bignamini and Hornsby 2010, 2:105.

15. See, for example, Gavin Hamilton to Lord Shelburne, Feb. 18, 1772, Bignamini and Hornsby 2010, 2:22–23.

16. Bignamini and Hornsby 2010, 1:27.

17. Horace Mann to Horace Walpole, Oct. 12, 1745, in Walpole 1954, 19:122.

18. Mann to Walpole, Aug. 1, 1747, in Walpole 1954, 19:427. The pedastal was found "at the bottom of the store ship." Walpole to Mann, July 28, 1747, in Walpole 1954, 19:430.

19. Gavin Hamilton to John FitzPatrick, second Earl of Upper Ossory, April 27, 1770, in Bignamini and Hornsby 2010, 2:15.

20. Hamilton to Lord Upper Ossory, July 8, 1769, in Bignamini and Hornsby 2010, 2:11.

21. Jenkins to Townley, Jan. 7, 1775, in Bignamini and Hornsby 2010, 2:55.

22. Jenkins to Townley, ca. 1768, in Bignamini and Hornsby 2010, 2:7.

23. Jenkins to Townley, Aug. 22, 1770, in Bignamini and Hornsby 2010, 2:17–18.

24. Hamilton to Henry Temple, second Viscount Palmerston, April 12, 1766, in Bignamini and Hornsby 2010, 2:5.

25. Hamilton to Townley, Jan. 24, 1775, in Bignamini and Hornsby 2010, 2:57-8.

26. See Pagano de Divitiis 1997, 153–81; and Davis 1967, 26–42, 96–115.

27. Indigo is mentioned in Machell's declaration before the High Court of Admiralty. Declaration for Letter of Marque, *Westmoreland*, Oct. 9, 1777, HCA 26/61, fol. 79, National Archives, Kew. The lead export business was "a rather specialized one." Davis 1967, 180 n. 2.

28. Cox and Dannehl 2007, accessed Aug. 20, 2010, http://www.british-history.ac.uk/source.aspx?pubid=739.

29. *Morning Chronicle and London Advertiser*, May 18, 1779.

30. Declaration for Letter of Marque, *Westmoreland*, Oct. 9, 1777, HCA 26/61, fol. 79, National Archives, Kew.

31. Suárez Huerta 2002, 59 (translation by Laura E. Ruberto).

32. Suárez Huerta 2002, 54–56, 59–60.

33. Jenkins to Townley, July 15, 1778, in Bignamini and Hornsby 2010, 2:109.

34. Declaration for Letter of Marque, *Westmoreland*, Aug. 20, 1778, HCA 26/33, fol. 131, National Archives, Kew.

35. *New Lloyd's List*, Jan. 26, 1779.

36. *London Gazette*, Aug. 4–7, 1781.

37. *New Lloyd's List*, Jan. 26, 1779.

38. *London Chronicle*, Feb. 6–9, 1779.

39. "Le sept janvier de la presente année portant que le dit jour vers midy . . . le vaisseau le Caton fit signal a celui le Destin de chasser de l'Est au Sud ou il apperçut trois bâtiments d'ont l'un Danois l'autre hollandois et le troisième Anglais: qu'on se serait emparé de ce dernier et que l'officier chargé du detail avec le Sr. Chevalier de Lort[?] premier Enseigne, s'etant transporté a bord de la dite prise; ils auroient reconnu que le dite bâtimente le nommoit Westmorland, qu'il est armé de vingt deux cannons, seize perriers, et autres menues armes, équipe de soixante dix personnes, qu'il servit parti de Livourne chargé de differentes marchandises pour Londres, et qu'il on du poids du trois cent tonneaux." Dossier 2Q 33, Archives du Service Historique de la Marine, Toulon. I am grateful to María Dolores Sánchez-Jáuregui for sharing this document with me.

40. Jenkins to Townley, Jan. 6, 1779, in Bignamini and Hornsby 2010, 2:113.

41. Jenkins to Townley, Feb. (?), 1779, in Bignamini and Hornsby 2010, 2:114.

42. *St. James's Chronicle or the British Evening Post*, Sept. 2–4, 1779; and *London Chronicle*, Sept. 11, 1779.

43. Buchanan 1824, 1:325–26. My thanks to Jonathan Yarker for providing me with this reference.

44. Starkey 1990, 229.

45. *London Chronicle*, Sept. 19–21, 1779; *St. James's Chronicle or the British Evening Post*, Sept. 19–21, 1779; *Lloyd's Evening Post*, Sept. 20–22, 1779; and Starkey 1990, 229.

46. *Morning Chronicle and London Advertiser*, Sept. 16, 1785; and *Whitehall Evening Post*, Sept. 15–17, 1785.

47. *Morning Chronicle and London Advertiser*, Aug. 30, 1782.

48. *London Gazette*, May 12–16, 1789. One other insurance claim resulting from the capture of the *Westmorland* has come to light thus far: on July 31, 1779, the London Assurance Company paid £134 6s. 6d. to a James Matthias, Esq., "for a total loss in the Westmoreland." The London Assurance Company Marine Department Ship Charter Journal 1756–1795, CLC/B/192/MS08741/002, London Metropolitan Archives, Clerkenwell. I am grateful to Pamela Marsh and Catherine Whistler for bringing this document to my attention.

Whose Grand Tour?

JOHN BREWER

AT FIRST SIGHT the evidence derived from the cargo of the *Westmorland* seems to fit easily into what has become the familiar story of the British experience on the Italian leg of the Grand Tour, one dominated by the travels of rich young men, as well as by the plunder of the cultural riches of Italy in order to acquire a cosmopolitan taste and civic-mindedness embodied in objects of *virtu*—classical antiquities and fine art—purchased in Italy and ostentatiously displayed at home. Although this is certainly a part—an important part—of the tale of the *Westmorland* and its treasures, such a narrative, as much recent scholarship has come to suggest, replicates a partial story that does not do justice to the disparate individuals (dealers, bankers, sea captains, soldiers and sailors, painters and restorers, porters, ciceroni and other guides, innkeepers, tailors, servants, chaplains and priests, shopkeepers, and tradesmen) and complex processes (involving networks of diplomacy and patronage, and markets for money, trade, goods, and sex) that both made such tourism possible and thrived on it; nor does it reveal the disparate, varied, and eclectic taste of much of the collecting that accompanied such travels. To examine (grand) tourism from the (grand) tourists' point of view—to stand in their shoes, a position taken by so many students of the Grand Tour—entails a range of assumptions, particularly about the formation of taste and the creation of collections, that need to be questioned.

The Welsh artist Thomas Jones, who was a pupil of Richard Wilson and lived in Italy between 1776 and 1783, once remarked that there were three groups of Englishmen in Rome: the painters, the "mezzi cavalieri ... who lived genteely, independent of any profession," and the "Milordi Inglesi."[1] In seeking to move beyond the perspective of this last group, however, we should not occlude it. It is worth beginning with the conventional story of the aristocratic Grand Tour, so that we can refashion or retell it in another way. Its protagonist was a young man (anywhere between sixteen and twenty-three years old), a wealthy aristocrat or gentleman, often educated at Eton, Westminster, or Harrow, and with some experience of residence in an Oxbridge college, especially Christ Church. Of the travelers with goods on the *Westmorland*, Francis Basset attended both Harrow and Eton, which was also the old school of George Legge, Viscount Lewisham; Sir Watkin Williams Wynn was a pupil at Westminster; both Lewisham and Frederick Ponsonby, Viscount Duncannon, attended Christ Church, Oxford. This was typical of the English milords. As the rather boorish young William FitzGerald, Marquess of Kildare, wrote to his mother from Turin in the summer of 1768, "we are about ten English at present, and eight of us were at Eton together. It is amazing how one picks up our old Eton acquaintances abroad. I dare say I have met above forty since I have been in Italy."[2]

Grand Tourists normally traveled first through France, stopping in Paris, often for some time, to see the art, the court, and fashions before journeying south. Some visited the Loire valley to perfect their

Figure 24. Christian Gottlieb Geissler after Jean Jalabert,
Vue du Prioure et de la Vallée de Chamouni de coté du Glacier des bois, 1777, hand-colored etching,
11⅜ x 17½ in. (29 x 44.5 cm). Real Academia de Bellas Artes de San Fernando, Archivo-Biblioteca (cat. 81)

French language (as that region was believed to speak the purest French). They then traveled to Italy either by sea—from a French port to Genoa, Lerici, Civitavecchia, or, most often, the free port of Livorno (which the British called Leghorn)—or, with increasing frequency later in the eighteenth century, by mountain, crossing over the Alps. The overland route was safer than the journey by sea, and it offered the prospect of a visit to Voltaire at Ferney, France (in 1763 he was the host to Willoughby Bertie, fourth Earl of Abingdon; John Byng; George Macartney; John Stuart, called Lord Mount Stuart; Robert Darcy, fourth Earl of Holderness; and Robert Piggott), and the chance to enjoy the spectacular and sublime scenery of the glaciers of Savoy as well as the Alps, sites that attracted the special attention of Basset in 1777 (fig. 24). Many then visited the city of Turin, the seat of the king of Sardinia's court (where attendance at what was called

the Academy, a sort of finishing school for young men said to employ "the best dancing master in Europe," was the norm), and then moved at a leisurely pace down Italy—taking in (inter alia) the cities of the Po valley, Florence (fig. 25), perhaps Siena, then a real sojourn at Rome (which was always crowded with tourists during Holy Week) (fig. 26), a winter escape to Naples—which from mid-century almost certainly took in the ruins of Pompeii and Herculaneum—and finally a return to northern Europe, often via Venice. Of course, as Jeremy Black has reminded us, there were many alternative itineraries—for example, the journey to Sicily and on to Asia Minor became more important with the Greek revival at the end of the century—and military conflicts often affected the tourists' routes; nevertheless, the core of the Grand Tour was through France and Italy.[3]

Such trips might be protracted. Thomas Coke

Figure 25. Johann Zoffany, *The Tribuna of the Uffizi*, 1772–78, oil on canvas, 48⅝ x 61 in. (123.5 x 155 cm). The Royal Collection, Her Majesty Queen Elizabeth II

Figure 26. David Allan, *The Arrival of a Young Traveler and His Suite during the Carnival in Piazza di Spagna, Rome*, ca. 1775, pen and brown ink wash over graphite, 15¾ x 21¼ in. (40 x 54 cm). The Royal Collection, Her Majesty Queen Elizabeth II

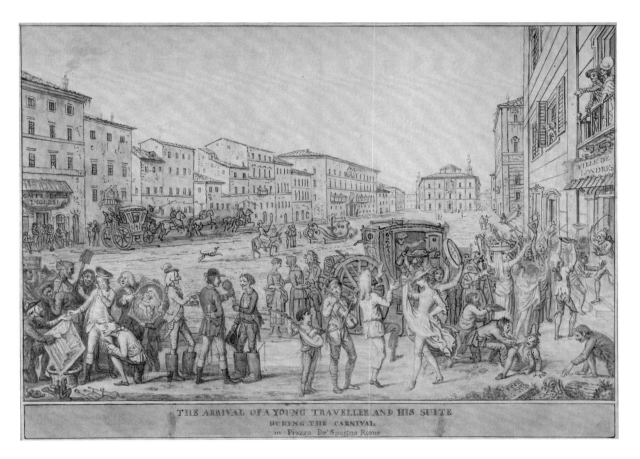

THE ARRIVAL OF A YOUNG TRAVELLER AND HIS SUITE
DURING THE CARNIVAL
in Piazza De' Spagna Rome

Figure 27. Johann Zoffany, *Charles Townley's Library, No. 7 Park Street, Westminster*, 1781–83, 1792, 1798, oil on canvas, 48⅝ x 39⅛ in. (123.5 x 99.5 cm). Burnley Borough Council, Towneley Hall Art Gallery & Museums

began his tour in 1713 when he was fifteen; he was accompanied by Dr. Thomas Hobart (his bear leader), a fellow of Christ's College, Cambridge, and spent nearly six years traveling, four of them in Italy.[4] But by the 1770s tours tended to be shorter, and tourists often paid more than one visit to the peninsula. The new pattern is clearly discernible in the milords who had materials on the *Westmorland*. Williams Wynn completed his tour between August 1768 and January 1769. Lewisham, Duncannon, and Basset all arrived in Italy in the autumn of 1777 and left by the following May. Lyde Browne was in Italy from May 1776 until early 1777. The most recent visit to Italy by William Henry, Duke of Gloucester, brother to the king, lasted somewhat longer, from September 1775 to August 1777; Charles Townley's final visit to Italy was much briefer, including only the first four months of 1777. Many of these men made more than one tour. Townley, a Roman Catholic who devoted his life to collecting antiquities and who had been educated on the

Continent, made three trips between 1767 and 1777 (fig. 27). Browne, Duncannon, Basset, and the Duke of Gloucester all made more than one tour, including at least one in the company of their wives and children. In this they reflected a general trend that made the tour less of a masculine experience and more of a familial one. The lists of the *bon ton* residing in Italy, published in the English newspapers of the 1790s, contain numerous family parties.[5]

Milords, as we can see, did not often travel alone. Many Grand Tourists had an entourage of followers and friends; quite a few journeyed with school chums. In 1782 the über-rich William Beckford's traveling band, replete with artist (John Robert Cozens), tutor, personal physician, harpsichordist, and a bevy of servants, was so great that when he was traveling south through Augsburg he was mistaken for the emperor of Austria.[6] At the very least a Grand Tourist was accompanied by a tutor whose task was to keep his charge out of trouble and ensure that the educational goals of the trip were in part fulfilled. Many were clerics, some were fellows of the ancient universities—and a few were remarkably erudite.

En route the Grand Tourist used several of a growing number of guidebooks, employed local ciceroni, and took courses (especially in Rome) to understand the antiquities and architecture of the ancient world. He also had his portrait painted. The most desirable portraitist in the early part of the century was the pastelist Rosalba Carriera; by the time of the *Westmorland*'s capture, Anton Raphael Mengs and Pompeo Batoni were by far the most fashionable. The ship's cargo contained Batoni portraits of both Basset and Lewisham (cats. 21 and 110), as well as examples of the popular portrait busts executed by the Irish sculptor Christopher Hewetson (fig. 28; cats. 128, 135, 136). In addition, the Grand Tourist bought what works of *virtu* he could find and afford, as well as memorabilia, casts of sculpture, and copies of paintings, shipping his loot back home. The more enthusiastic tourists continued to buy from Italy on their return and

Figure 28. Christopher Hewetson, *Francis Basset*, plaster cast, ca. 1778, 22 x 13¾ x 5⅞ in. (56 x 35 x 15 cm). Real Academia de Bellas Artes de San Fernando, Museo

maintained the contacts they had made on the peninsula (again, this was true of Basset), and many were elected to the Society of Dilettanti or the Society of Antiquaries of London a few years later.

The young men undertook the Grand Tour as an educational rite of passage and often just before they took up their public duties—as magistrates, landlords, and politicians—and fulfilled their dynastic obligations through marriage (fig. 29). Their journey looked back to their school days, when most had been brutally tutored in the classics, and forward to their life in polite society; it was intended to shape a certain sort of individual, knowledgeable about classical antiquity, modern taste, and other nations, but resolutely British. The experience was built around a shared culture: the knowledge—prior to Italy—of classical texts. These tourists were instructed in how to think and see things "classically." This meant more than the acquisition of a certain sort of knowledge; it entailed the cultivation of a certain way of seeing the world, what Henry Temple, second Viscount Palmerston, who made three tours to Italy between 1763 and 1792, called "a disposition of mind," and James Boswell, fretting about his own ability to achieve it, described as "a mind . . . well furnished with classical ideas."[7] The object of the direct observation of classical antiquity was to understand classical civilization and its values, especially its supposed commitment to public spirit. As Philip Dormer Stanhope, fourth Earl of Chesterfield, put it in his famous letters to his son: "View the most curious remains of antiquity with a classical spirit, and they will clear up to you many passages of the classical authors."[8] In fact, the process was more commonly the reverse, and, in a highly scripted experience, the landscape and antiquities of Italy were seen through the writings of Virgil, Cicero, Horace, and the Roman historians. What the young milord observed was thus both tantalizingly novel and comfortingly familiar. For example, Frederick North (known as Lord North) wrote to his tutor:

You know that the road from Rome to Naples abounds with classical amusement: I can assure you that the road from Naples to Paestum is no less amusing in the same way. There is scarce a town, a rivulet, a hill, or a valley, that is not mentioned & even distinctly pointed out in some of the antient writers. Those travelers, who are well read in them, & who have already made the same journey several times in their imaginations, are highly pleased to find themselves in a well-known country. Almost every spot they see, and every step they take, recalls or refreshes, confirms or clears up some old Idea.[9]

More than one Grand Tourist remarked on how boring their journey would have been without this prior education. Richard Wellesley, second Earl of Mornington, wrote of his tour in 1790–91 that "all the old ideas of Eton and [Christ Church] Oxford employed my mind," without which "I think the journey through Italy would lose the greatest part of its amusement."[10]

For the classically educated, and this included tutors and many genteel visitors, Italy was saturated with classical allusion—Italy was a land of texts. The Irish clergyman Martin Sherlock, on his tour of 1778–79, wrote that his greatest pleasure was to have "his Horace in one pocket, and his Virgil in the other, and to look at a thousand objects which have been painted by these masters." The philosopher David Hume, on his arrival in Italy, "kist the Earth that produc'd Virgil." The physician Lucas Pepys (Christ Church) remarked in a similar vein in 1767 that to tread the same floor as Cicero was "a kind of delightful dream . . . which cannot be expressed." Like Pepys, many travelers were reading or rereading the classics as they journeyed. Some of the coaches they used had special book shelves or "a wooden case which serv'd for a traveling library" filled with guidebooks and classical texts, such as that carried by Thomas Chinnal Porter (Christ Church).[11]

This view that the relics of Italy provided privileged insight into the past was more often than not based on an exemplary notion of history, which was itself derived from Cicero. The Grand Tourist was, as Viccy Coltman has pointed out, a sort of time traveler, eager to get beyond the present to inhabit a Roman world and imbibe its values.[12] Thus John Northall, the author of *Travels through Italy* (1766), explained that busts of classical figures, "standing, as it were

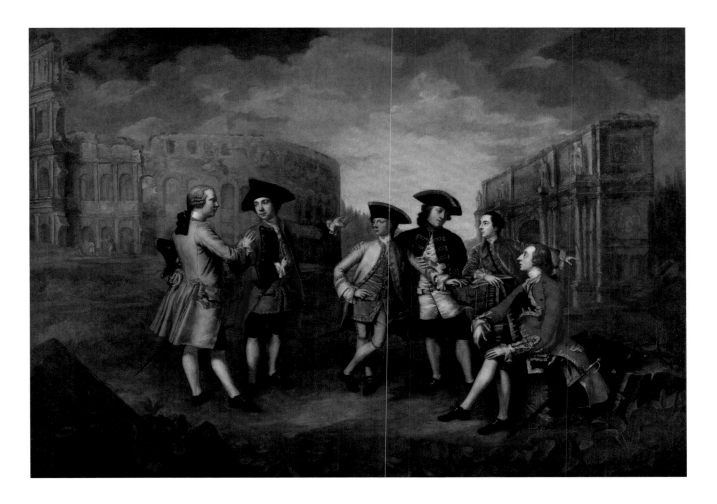

Figure 29. Katharine Read, *British Gentlemen in Rome*, ca. 1750,
oil on canvas, 37¼ x 53 in. (94.6 x 134.6 cm). Yale Center for British Art, Paul Mellon Collection

in their own person before us, gives a man a cast of almost 2000 years backwards, and mixes the past ages with the present."[13] This was the spirit in which many Grand Tourists had their portrait busts sculpted in the Roman manner by Hewetson, Joseph Wilton, and John Deare.[14]

Such, of course, were the educational ideals of the Grand Tour, but to what extent were they realized? The British periodical press and the graphic satires of Pier Leone Ghezzi, with their images of dim-witted, ignorant young men led by their tutors, deluded by foreign manners, and outwitted by foreign sharpers, provide a sharp contrast with the educational ideals of *virtu* and classical civilization. And many tutors, who struggled to contain their charges' wilder behavior and focus their attention on their education, took, it must be said, a jaundiced view of the young

men and their experiences in Italy. The cleric Joseph Atwell accompanied William Clavering-Cowper, second Earl Cowper, who by all accounts was well behaved and attentive to his studies of antiquity; nevertheless, Atwell complained of "Boys just escaped from the lash of a severe Master, & the tedious confinement to Books and Studies [who visit a] Foreign Country where they first give a full swing to their Passions, & lead such Lives as they are sensible would be attended with shame at home."[15] A generation later the refrain was little different. John Hinchliffe, later the master of Trinity College, Cambridge, who led John Crewe (Westminster and Christ Church) on his tour in 1761–62, grumpily concluded, "I cannot see what has induced the generality of travellers to extol this country [Italy]. . . . For my part I am satisfied that the dangers of travelling far exceed the boasted

advantages . . . & a young man must have an extraordinary share of prudence to return home with as few vices & follies as he set out."[16]

Tutors complained about the drunken high jinks of their charges, such as the kicking of tradesmen, ejecting of coachmen, and riding on horseback around the ramparts of Turin, as observed by the British diplomat there, Louis Dutens.[17] But the real fear was sexual: the Grand Tourist's contraction of an undesirable disease or, even worse, an undesirable alliance. Parents, guardians, and tutors warned against not just "drink, gaming" but "all improper connections" with Italian women, who, as George Hay, ninth Earl of Kinnoull, told his ward, were "bewitching sirens who fascinated young men if they were not upon their guard."[18] Referring to such amorous attentions, Lady Charlotte Burgoyne complained, "The turn of all women in that country [Italy] is gallantry. . . . I have no idea how anyone can live in Italy, that does not give themselves wholly to passion."[19] Anxiety (and prurience) focused on the practice of Italian married women taking a *cicisbeo*, a male admirer and publicly paraded companion, who, as Boswell found out in Siena, sometimes became a bedfellow.[20]

Grand Tourists, who were rich, young, often exploitative, and sometimes gullible, took full advantage of their freedom from home. Augustus John Hervey cut a swath across Italy, taking numerous lovers in Florence, Genoa, and Naples during the 1750s, while Henry Seymour Conway wrote from Florence, "There are but two things at all thought of here—love and antiquities, of which the former predominates so greatly that I think it seems to make the whole history and the whole business of this place."[21] Some milords got themselves into serious scrapes. On his tour in 1769–72, for instance, the young Henry Fiennes Pelham-Clinton, Earl of Lincoln, was swindled out of 12,000 guineas by his lover—a Venetian dancer—and her accomplices.[22]

Private sexual intrigue, however, was not incompatible with the pursuit of *virtu*. To the contrary, being seduced by Italy's treasures—its marbles and its women—was part of the Grand Tour's allure. Hervey found time between his conquests to examine the galleries of Florence, sketch ruins, and visit Pompeii

and Herculaneum. The culture of the connoisseur, as the circles around such figures as Townley and Richard Payne Knight, and clubs like the Dilettanti, make clear, easily conflated the private pursuit of sexual pleasure with the joys of collecting and displaying objects of antiquity and *virtu*.[23]

But it would be a mistake to assume that, for all their classical education, the young milords all embraced antiquity with unalloyed enthusiasm. Many did not. There are numerous examples of young men who viewed their studies as at best boring and at worst downright unpleasant. The courses in antiquity in Rome, which could last up to six weeks, attracted particular hostility. Thomas Pakenham, third Baron Longford and second Earl of Longford, spoke for many when he repeatedly complained of having "to stand an hour hungry & cold under an ugly old pillar of marble while a prosing antiquarian harangues on the merits thereof—all this because 'it is the custom,'" and tartly concluded that this is "not the place for me."[24]

More modern painting was perhaps a little easier to appreciate and certainly easier to acquire, but it still proved baffling for some. Sir Gregory Turner, third Baronet (Eton and Oxford), the twenty-year-old charge of William Patoun, who led five separate parties on the Grand Tour during the 1760s and 1770s, self-effacingly wrote home that "he had passed through Parma, Regio, Modena & Bologna, in all which towns I saw several very fine original pictures, as Mr Patoun tells me, for I do not pretend to be a judge myself."[25]

Of course, there were also Grand Tourists who took their task seriously, and whose experiences informed their tastes and interests for the rest of their lives. Edward Gibbon managed no fewer than fourteen visits to the Galleria degli Uffizi in his four months in Florence. Thomas Egerton, Baron Grey de Wilton (Christ Church), filled seventy-four pages of his journal with notes from his course on antiquities with James Byres in 1785, visited artists' studios, and commissioned a number of drawings.[26] Some years earlier another Christ Church man, Francis Hastings, tenth Earl of Huntington, praised by Lord Chesterfield as a "bright exemplar of the union of scholar with man of the world," was reported in Florence as having

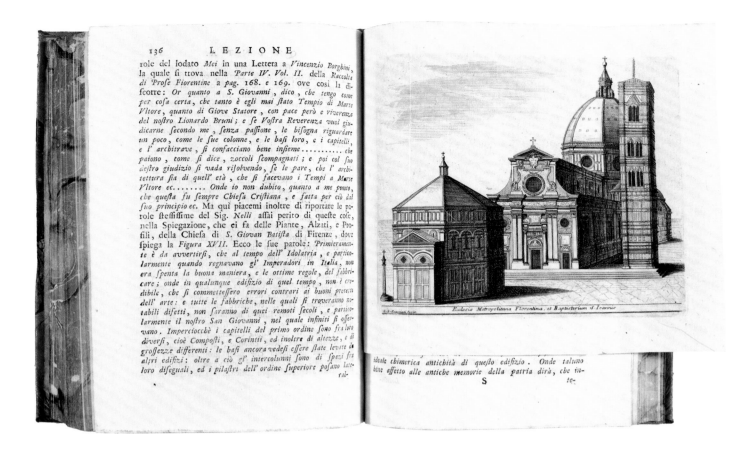

Figure 30. Giovanni Lami, *Lezioni di antichità toscane e spezialmente della città di Firenze* (Florence, 1766).
Real Academia de Bellas Artes de San Fernando, Archivo-Biblioteca (cat. 45)

"learned Italian to a surprising degree of perfection in a month, and which he studies for three hours every morning, and then passes as many more with Dr. Antonio Cocchi and his medals, after which he stays till past four in the Gallery to examine the statues and busts with [the sculptor Joseph] Wilton."[27] A few tourists made important contributions to antiquarian knowledge. The drawings and notes of Sir Roger Newdigate, fifth Baronet, who made two tours, as a callow twenty-year-old in 1739–40 and again in 1774–75, described antiquities in northern Italy that had never been subject to scholarly examination, detailed the holdings of the Uffizi, and commented in detail on the different ways in which sculpture was displayed in the museums of Florence and Rome.[28] As their surviving books and collections from the *Westmorland* make clear, Basset, Lewisham, Duncannon, and John Henderson of Fordell were just such assiduous Grand Tourists, using works in Italian and French, as well as English, to guide their studies (fig. 30).

It is striking that, with a few notable exceptions, a great many of the more attentive participants in the Grand Tour were not striplings fresh out of school and university but men of more mature years. Repeatedly—and to the chagrin of their young charges—tutors, almost all older than their milords, expressed greater enthusiasm and displayed greater knowledge of the arts and antiquities they studied. When we turn to the question of collecting—a tangible and costly commitment to the pursuit of *virtu*—then the most important collections were just as likely to be assembled by middle-aged or married men as by younger, unmarried ones. Admittedly, early in the eighteenth century, when in certain respects it was easier to acquire antiquities and pictures, especially if you were a Catholic or a Jacobite sympathizer, a number

Figure 31. The Sculpture Gallery at Newby Hall, North Yorkshire

of young men assembled important collections. Religious connections to the Holy See and political contacts with the exiled Stuart court in Rome sometimes helped secure access to art and antiquities that Hanoverian Protestants found hard to obtain until the 1760s. The Jacobite Henry Somerset, third Duke of Beaufort, was only twenty-one when he shipped ninety-six crates of paintings and antiquities out of Italy in 1728; John Bouverie, another Jacobite, began his collections during the first of his three tours, in 1741, at the age of nineteen. Still, famously, Thomas Coke (a true Whig and Protestant) was not yet twenty when he acquired his first treasures for Holkham Hall.[29]

But this was much less true in the second half of the century. The Catholic collectors Townley and Henry Blundell began collecting in their thirties and fifties, respectively. Brownlow Cecil, ninth Earl of Exeter, who assembled a formidable collection

of old masters during two visits to Italy, in 1763–64 and 1768–69, was in his late thirties and early forties. Patrick Home of Wedderburn, who was born in 1728, began collecting during a trip with his wife to Italy in 1771. Frederick Hervey, fourth Earl of Bristol, started to collect in his forties. Even William Petty, second Earl of Shelburne, was already a widower at thirty-three when he began to assemble his great collection for Lansdowne House, and William Weddell was not much younger when he exported more than 112 crates of marbles from Italy back to Newby Hall in 1765 (fig. 31).[30] There were exceptions, but putting together a collection of any quality either was the work of many years—often begun on a second visit to Italy—or could be achieved only by using agents as intermediaries, at great expense.

Many of the collections accumulated in the first half of the century were the personal projects of men

of great erudition who were the friends and companions of Italian virtuosi and aristocrats. Such men as Sir Andrew Fountaine and the Jacobite Richard Rawlinson were able to assemble large collections of medals, drawings, prints, sculptures, and cameos through the good offices of Italian antiquaries who shared their enthusiasms. Erudition, not aesthetics, was their priority.[31] They tended to agree (though with occasional qualification) with the Cambridge divine Conyers Middleton, who explained to Horace Walpole that he collected curiosities not "out of any regard to their beauty or sculpture, but as containing what the Italians call erudition."[32]

This antiquarian view of art and antiquities linked collecting to the accumulation of expertise; display, though important, was secondary. Such collecting was therefore rather different from the sorts of shopping expeditions undertaken by some Grand Tourists that seem to have had much less to do with erudition and much more to do with home decoration. Charles Watson-Wentworth, Earl of Malton, was eighteen when he arrived in Italy in 1748, but his chief purpose was less his education than the assignment given him by his father to buy works of art to decorate the family's massive country house, Wentworth Woodhouse, and outstrip the decor of nearby Wentworth Castle, the home of his Yorkshire neighbor and rival, William Wentworth, second Earl of Strafford. Lord Malton's time was absorbed in buying pictures and commissioning customized copies of the finest antique statues for display in Wentworth Woodhouse's Great Hall.[33] Other shoppers of this sort included John Frederick Sackville, third Duke of Dorset, who paid for a series of paintings and then marbles for Knole House on his trip in 1770–71; John Spencer, first Viscount Spencer, who purchased works by Salvator Rosa, Gavin Hamilton, and Guercino to decorate the ballroom of his London residence, Spencer House; and Weddell, who bought almost his entire collection (which was to include the Barberini Venus) as a vast job lot from the dealer Thomas Jenkins.[34] Lord Shelburne's arrangement, made with Hamilton during a brief tour in the summer of 1771, required the artist, dealer, and antiquary to provide sixteen statues, twelve antique busts, twelve bas-reliefs, eleven large historical pictures,

and four landscapes of the Trojan War within a period of four years (and at a price of £6,050) to decorate his London town house in Berkeley Square.[35]

These elaborate schemes were the most prominent features of a growth in British Neoclassical taste that made its stamp not just on collections but also on interior decoration (most notably that of the Adam brothers), furnishings, domestic illustration (as in the very popular works of Angelica Kauffman), and the commercially produced ceramic wares of Josiah Wedgwood.

This sort of collecting, which was matched by the long-term accumulation of antiquities and pictures by such figures as the fourth Earl of Bristol, Charles Townley, and others, took place in a very different environment from what was true earlier in the eighteenth century. Although British diplomats and merchants, such as Consul Joseph Smith in Venice, Sir Horace Mann in Florence, and Anthony Lefroy in Livorno, had long been involved with Grand Tourists, providing banking facilities and introductions as well as acting as art agents or developing significant collections, their numbers and importance increased during the second half of the century. No figure achieved greater stature than Sir William Hamilton, the British envoy extraordinary and minister plenipotentiary, whose power in Naples as courtier to the Bourbons, British guide, collector, and volcanologist was unsurpassed; nevertheless, other figures such as John Strange in Venice and John Udny, also from the Veneto, successfully combined careers as diplomats, scholars, collectors, and dealers. Similarly, although there had always been dealers helping those in pursuit of antiquities and art—Ignazio Hugford, son of the English watchmaker to the Medici court in Florence, for example, and Mark Parker in Rome, who obtained eleven export licenses for statuary and reliefs between 1738 and 1745—none could match the power and importance of Thomas Jenkins, Gavin Hamilton, and James Byres in Rome, men at the pinnacle of what had become a growing and sometimes lucrative profession. Paradoxically, while there were more dealers than ever before, there was also an extraordinary concentration of power in the hands of a very few men.

These developments have to be seen against the background of changes in the size, scope, and nature of the British population in Italy. Perhaps the most important of these was the rapid growth of the community of British artists in Italy—chiefly Rome—from mid-century on. In the first half of the century, a few well-known figures, such as the architect William Kent, the connoisseur Jonathan Richardson the younger, and the painter Allan Ramsay, spent time in Italy, but it is only from the 1750s that painters, sculptors, architects, and engravers arrived in significant numbers. The roll call was illustrious and included painters like Joshua Reynolds, Richard Wilson, Gavin Hamilton, and George Romney; the landscape artists Jacob More, John Robert Cozens, and Solomon Delane; sculptors such as John Flaxman, Joseph Nollekens, and Christopher Hewetson; and architects including Christopher Ebdon and the Adam brothers. There were many other less bright lights who worked in the shadow of such luminaries, all of them driven by the aristocratic taste for Italy, classical antiquity, and the grand manner, along with the desire to use their Italian education as a means of artistic advancement.[36] As the architect William Chambers put it, "Traveling to an artist is what the University is to the Man of Letters, the last stage of a regular education."[37]

Artists of all sorts tended to stay much longer in Italy than the general tourist. A sample of seventy painters, architects, and sculptors who visited Italy after 1760 indicates that their average length of stay was nine years. Many were funded in the first instance by private patrons (Sir Watkin Williams Wynn supported the Welsh artist William Parry, for example)[38] or came in the baggage train of a wealthy Grand Tourist, as the watercolorist Cozens did in 1776 with Richard Payne Knight and again six years later with William Beckford.[39] But every bit as important were the new art institutions in Britain that offered stipends for study in Italy: the Royal Academy of Arts, London; the Dublin Society; the Society of Arts; the Society of Dilettanti; and the Foulis Academy of Glasgow. The effect of an Italian sojourn on the career of an artist varied. Some, such as Reynolds, Wilson, and Ramsay, used their Italian experience to enhance their reputation when they returned home; others, like the Scots Hamilton and More—who was "the best painter of air since Claude," according to Reynolds—remained in Italy to enjoy high regard there.[40] Some, like George Stubbs, were not impressed, and some, like the long-forgotten William Theed, were downright miserable. But all the artists in Italy, regardless of their reputation, had to make a living; very few were like Prince Hoare, "with an independent fortune of two of [or] three hundred a year," who relied on private means.[41] They did so in a variety of ways, and they were to become central to the tourist industry as it was to flourish in the second half of the eighteenth century.

Along with the artists there was an ever-growing number of travelers in the Italian peninsula whose purpose was neither art nor antiquity: lovers of music, especially opera, such as the historian Charles Burney, the singer Elizabeth Billington, and the composer Michael Kelly; classicists and philologists in pursuit of manuscripts in the peninsula's great libraries; book collectors and dealers intent on acquiring materials from impecunious Italian aristocrats; doctors eager to observe dissections and the medical models and collections at the universities; scientists and volcanologists who wished to observe experiments or witness volcanic eruptions.

A great many travelers were not so much drawn to Italy as they were fugitives from Britain. This was obvious for many Catholics and attainted Jacobites. Others, such as John Boyle, fifth Earl of Orrery, fled to Italy to escape creditors and establish "a scheme for economy."[42] (The cost of living a genteel life there was about half that in Britain, hence the growing number of retirees in Italy.) Even more ran away from familial or amatory misfortune; widows and widowers, disgruntled wives, jilted lovers, and errant husbands were to be found in abundance. And then there were the elopements and fugitives from polite society because of an inappropriate marriage. The most famous examples were, of course, the Hanoverian royals, including George III's sickly brother, the Duke of Gloucester, whose goods were on the *Westmorland* and who had traveled to Italy with his wife, the illegitimate Maria Waldegrave (née Walpole), once he was forced to tell the king of his marriage after his wife became pregnant.[43]

There was nothing to prevent those who fled from scandal at home, a scene of grief, or even a crime from taking an interest in classical ruins, modern art, or the values of ancient civilization. Sir Richard Worsley, a fugitive from one of the most embarrassing divorce cases of the eighteenth century, used his exile to patronize contemporary artists and sculptors and to accumulate a major collection of Greek sculpture, as well as cameos and precious stones.[44] Indeed, it was hard to resist such involvement, because so much of the social and economic life of the British and Italian communities, especially in major cities, was bound up with the business of culture. Its font was, of course, the very wealthy (hence Gavin Hamilton's repeated call "to pray for a lord"), because their presence injected huge amounts of money into the Italian economy. Lord Malton's shopping spree in 1748 cost £1,500 in its first year; Sir Henry Fetherstonhaugh laid out the same sum in just two months in 1776; Lord Palmerston claimed to have spent £9,000 during his tour of 1792–94.[45] Not all of this money was disbursed up front—the fourth Earl of Bristol, for example, was notorious for not honoring his commissions and debts—but it was the lifeblood of what, by the time the *Westmorland* was captured, had become a highly developed tourist industry.

The British writer Hester Lynch Piozzi, traveling in 1784 with her new Italian husband, Gabriel Mario Piozzi, was struck by the force of Voltaire's remark that "Italy was now no more than *la boutique*, and the Italians *les marchands fripiers de l'Europe*."[46] Voltaire's comment was characteristically tart, condemning Italians as sellers of what Mrs. Piozzi called "cast offs" (*marchands fripiers* sold secondhand clothing), but it exemplified a growing anxiety that what tourists could buy in Italy was not so much the genuine article as a simulacrum or pastiche. This was certainly the view of Edward Clarke, who was the companion of Thomas Noel Hill, second Baron Berwick, and of Henry Tufton on a tour in 1792–94, and was later a professor of mineralogy at Cambridge. He discouraged Lord Berwick from "meddling with antiquities," claiming that Rome "has been so long exhausted of every valuable relic, that it has become necessary to institute a manufactory for the fabrication of such

rubbish as half the English nation come in search for every year."[47]

This concern reflected the very real difficulty that tourists had in obtaining antiquities and artworks of real quality. (As early as 1748 Lord Malton had written home to his father that "I hear it will be impossible to have antique statues.")[48] This scarcity was in large part the result of the growing recognition of the papacy and secular monarchs such as the kings of Naples and Sicily that Italy's cultural heritage could be of great benefit—as a diplomatic tool, a means of political and ecclesiastical aggrandizement, and a way of stimulating the local economy—provided it was conserved and controlled by Italians.

This realization was most pronounced in the Papal States, which gradually forged a more rigorous system for regulating its cultural heritage. In Rome classical antiquities became subordinate to a papal agenda. The pope imposed strict and not easily evaded controls—a system of licenses—over the exportation of antiquities. A few choice pieces were sold off as political favors, and less accomplished or more damaged versions of sculptures already in the papal collections might be given an export license, as well as sculptures with erotic or suggestive content considered unfitting for a papal museum; officially, however, first refusal went to the pope and *commissario delle antichità di Roma e suo distretto*.[49]

The supply of antiquities was not fixed, of course, but also depended on new discoveries made through excavations. Again, the papacy controlled these through a system of licenses that required excavators to offer the best works to the Holy See. This did not diminish the number of digs. Indeed, in the first five years of Pius VI's papacy (1775–80)—the pope was himself an enthusiastic collector—about 130 licenses were issued for excavations within the Papal States. But it did mean that the best finds were at the disposal of the papacy.[50] Such rules and regulations could be subverted by smuggling, bribery, and the connivance and complicity of papal officials, but they were nevertheless an obstacle to British collectors that was not easily overcome.

The popes made available their new discoveries, along with the antiquities that had been accumulated

Figure 32. Charles Joseph Natoire, *Artists Drawing in the Interior Court of the Capitoline Museum Rome*, 1759, pen and wash heightened with white on colored paper, 11⅞ x 17¾ in. (30 x 45 cm). Musée du Louvre, Paris

since the sixteenth century, first through the Museo Capitolino and then the Museo Pio-Clementino in the Vatican. In 1733 Clement XII, perhaps mindful of the losses to British collectors such as Thomas Coke, and even more so of losses to the kings of Poland and Spain, who took large parts of the Chigi, Albani, and Odescalchi collections, bought up all of Cardinal Alessandro Albani's remaining antiquities and displayed them on the Capitoline Hill, in a museum that was first opened to the public in 1734 (fig. 32).[51] He thus initiated a policy and process that culminated in the construction of the magnificent Museo Pio-Clementino, a star attraction for tourists in Rome, which was eventually completed in the 1790s.

The decisive changes occurred during the papacies of Clement XIV (1769–74) and Pius VI (1775–99). Facing another wave of losses of antiquities (as much to other parts of Italy as to other countries), Clement acted decisively. As Jeffrey Collins has explained, "Clement's Mattei purchase, together with roughly contemporary acquisitions from the Barberini, Fusconi, and Verospi collections, helped turn the tide by reasserting papal rights and, more important by inducing the Pope to create his own antiquities museum [at the Vatican] rather than further enriching Rome's civic collection at the Capitoline."[52] Classical antiquity had entered the heart of the Holy See.

Similar developments occurred in Naples, where the excavations at Herculaneum and Pompeii, despite criticism by the German art historian and archaeologist Johann Joachim Winckelmann, came under the strict control of the government (visitors to the sites, who endlessly complained, were not allowed to take notes or make sketches), while the king of Naples and Sicily (later Carlos III of Spain), established a museum for the archaeological findings in a suite of rooms in Palazzo Reale di Portici, a royal palace he ordered built just south of Naples.[53] For a long period the Neapolitan monarchy also resisted the publication of engravings of the newly found antiquities; the nine folio volumes of *Le antichità di Ercolano esposte* were privately distributed as presentation copies, and only from the 1770s did the contents of the excavations gain wider currency. One needed to visit Naples to see its treasures (fig. 33).[54]

Both the kings of Naples and the popes were aware of the diplomatic value of their treasures, that they could be used to secure and cement valuable strategic friendships. Johann Wolfgang von Goethe may have been surprised to find items that probably came from Herculaneum and Pompeii in Sir William Hamilton's collections, but this sort of privilege was part of diplomatic currency. The Hanoverians and their subjects were also beneficiaries in the Papal

Figure 33. Pietro Fabris, pl. XXXXI, *View of the First Discovery of the Temple of Isis at Pompeii*,
hand-colored etching, 18⅞ x 27⅜ in. (48 x 69.5 cm), from William Hamilton, *Campi Phlegraei* (Naples, 1776).
Real Academia de Bellas Artes de San Fernando, Archivo-Biblioteca (cat. 60)

States. Britain's growth as a global power, a pro-English faction in the papal court, and the lukewarm Catholicism of Charles Edward Stuart, "the Young Pretender" (whose almost permanent and frequently public inebriation made him a risible tourist attraction and an embarrassment), led, as Ilaria Bignamini has pointed out, to a major shift in papal policy in the 1760s. The Young Pretender was not recognized as the British king when his father (son of the exiled James II of England) died in 1766, and from 1763 a succession of Hanoverian royals visited Rome, albeit in a private capacity. The papacy's pro-Hanoverian politics were signaled by the sale of Cassiano dal Pozzo's Paper Museum to George III, by a repeated preference for British excavators in the granting of licenses, and in the privileges accorded the Duke of Gloucester in the 1770s.[55] Gustav III of Sweden, among others, also enjoyed this sort of diplomatic privilege—in return for greater toleration of Catholics within his dominions, he was allowed to purchase and export a classical sculpture of Endymion with

which he was particularly infatuated—but the British gained most.[56]

There were several effects of these policies of state control (which in turn were part of an agenda referred to as "enlightened absolutism"), but perhaps the most important was to place an enormous amount of power in the hands of those intermediaries who had connections to the Vatican and who understood how to negotiate the complex politics of the Holy See. Three figures dominated such affairs at the time of the *Westmorland*'s capture: the Jacobite, Catholic, and Scots cicerone and dealer James Byres; the Scots artist, archaeologist, and dealer Gavin Hamilton, the man with "more true taste than any body at Rome"; and the Italian-born English artist turned dealer and banker Thomas Jenkins.[57] Byres was part of the Catholic, Jacobite, and Scottish circles that had dominated the trade in culture in Rome for more than a generation; he was a client of the Jesuit and antiquary Abbé Peter Grant. Jenkins, whose original connections were Whig—and quite radical—and

whom the old leaders of the trade tried to shut out in the 1750s, built up a formidable network of his own. The painter James Northcote, who complained bitterly of "those cursed antiquaries" who controlled art patronage, moaned that Jenkins's "gate and stairs used to be lined with petitioners as it was in his power to make the Pope do as he pleased."[58] Jenkins was the special favorite of Clement XIV. The artist Thomas Jones reported that "if that Pontiff had lived a little longer, it is said he might have been made a Cardinal if he chose it," while the Jesuit antiquary Father John Thorpe blamed Jenkins for a situation in which "no regard here [Rome] is for Catholicks, the protestants are the first in favour, & to whom nothing is to be refused."[59] Hamilton's power came less from hardnosed business acumen—Jenkins's forte—but from his acknowledged expertise as an antiquarian, as well as from his energy and skills as an archaeologist who was responsible for some of the most important discoveries of the 1760s and 1770s.[60] But like Jenkins, who survived Clement XIV's premature death and remained in the good graces of his successor, Hamilton knew the importance of papal support. When Pius VI was elected to the pontificate, Hamilton gave the pope one of his best antiquities, a magnificent bust of the Roman empress Sabina.[61]

The power of these middlemen had a number of effects. First, it was well-nigh impossible to acquire antiquities of any quality without their cooperation. For the richest and most ambitious collectors, such as Townley and Lord Shelburne, their work was essential. But this also meant that the middlemen had an opportunity to shape taste. They were, after all, buying and recommending works that they had discovered or bought, or for which they were acting as consignees. The collectors were sometimes buying sight unseen, though they were usually supplied with drawings of the pieces on sale. The surviving correspondence between Gavin Hamilton and Shelburne, in which the dealer promised to "make Shel-

burne House famous not only in England but all over Europe," shows clearly the extent of his ambition and his determination to shape not just Shelburne's collection but the manner and environment in which it would be displayed.[62] Art historians, finding Jenkins a little too close to trade, have been more reluctant to give him a role as tastemaker. But in a case like the Newby Hall collection, it is difficult not to accept Jenkins's assertion that he had William Weddell's confidence "in the Choise of his Collection of Paintings and Sculpture."[63] Weddell spent a mere twelve weeks in Rome, spoke little French and less Italian, and bought the bulk of his collection from Jenkins's stock. He could never have formed such a collection so swiftly without the help of such a broker.

Yet even these powerful middlemen were unable to satisfy the demand for antiquities and Italian art back in Britain. Inevitably copies of great works of art, casts of major antiquities, and souvenirs of Italy intended to remind viewers of their owners' travels and experience became a large part of the trade in cultural goods between the Mediterranean and Britain. Classical education—a classicism that, in the British case, emerged from the reading of the great authors of Roman antiquity—produced, by the late eighteenth century, Neoclassicism, a commodified and commercial version of classical culture that prized the original but also valued the copy and simulacrum. Ancient texts produced modern decor; erudition spawned an aesthetic vision. Major works of antiquity, the embodiment of classical virtue, were seen and admired by many in their captive state, safely shut up in Italian museums; they were pursued by some and successfully collected by a very few. In their place, as the crates from the hold of the *Westmorland* attest, Grand Tourists, with the aid of a formidable army of helpers, agents, artists, and accomplices, were able to assemble a version of their experiences in Italy that would, in happier circumstances, have been displayed as a memory of that country and a monument to their owners' taste.

Special thanks to John Ingamells and his collaborators for producing the invaluable book *A Dictionary of British and Irish Travellers in Italy, 1701–1800: Compiled from the Brinsley Ford Archive* (hereafter Ingamells 1997) and to Viccy Coltman for her comments and guidance on the essay.

1. T. Jones 1946–48, 70.

2. Ingamells 1997, 575.

3. Black 2003, 76.

4. Moore 1985, 33–39, 115–22.

5. For example, *World*, Dec. 12, 1792.

6. Ingamells 1997, 72.

7. Ingamells 1997, 733; Brady and Pottle 1955, 79.

8. Philip Dormer Stanhope, fourth Earl of Chesterfield, to Philip Stanhope, Dec. 16, 1749, in Chesterfield 1932, 4:1466.

9. Quoted in Coltman 2006, 30.

10. Ingamells 1997, 682.

11. Ingamells 1997, 534, 757, 783, 854; and Coltman 2006, 31–32.

12. Coltman 2006, 20.

13. Northall 1766, 362.

14. See also Ayres 1997, 63–75.

15. Ingamells 1997, 34.

16. Ingamells 1997, 500.

17. Ingamells 1997, 325.

18. Ingamells 1997, 417.

19. Ingamells 1997, 159.

20. Brady and Pottle 1955, 16–19; and Chard 1999, 92–93, 128–30, 237–38.

21. Ingamells 1997, 488.

22. Ingamells 1997, 603.

23. Coltman 2009 159–90; and Bermingham 1995, 489–514.

24. Ingamells 1997, 612.

25. Ingamells 1997, 957.

26. Ingamells 1997, 432.

27. Ingamells 1997, 537.

28. McCarthy 1981, 477–94.

29. Ingamells 1997, 67–69, 110–11, 225–26.

30. Ingamells 1997, 101–2, 126–30, 343–44, 515–17, 852, 946–48, 986–87.

31. Moore 1985, 26–31, 93–113; and Ingamells 1997, 376–77, 801–3.

32. Ingamells 1997, 658.

33. Coltman 2006, 134–37.

34. Ingamells 1997, 306, 882–84, 986–87.

35. Coltman 2009, 58–59.

36. For a full list of artists in Italy, see Ingamells 1996, app. 5, 1061–70.

37. Ingamells 1997, 194.

38. Ingamells 1997, 742.

39. Sloan 1986, 128, 138–42.

40. Quoted in Andrew 1989–90, 150.

41. Ingamells 1997, 503.

42. Ingamells 1997, 241.

43. Ingamells 1997, 402–4.

44. Ingamells 1997, 1018–19.

45. Ingamells 1997, 353–54, 631–33, 733–35.

46. Piozzi 1789, 1:124.

47. Ingamells 1997, 210; and Wilton and Bignamini 1996, 29.

48. Ingamells 1997, 632.

49. Haskell and Penny 1981, 66–67; and Bignamini and Hornsby 2010, 1:17–30.

50. Collins 2004, 166.

51. Haskell and Penny 1981, 62–64; and Collins 2004, 136.

52. Collins 2004, 118.

53. Coltman 2006, 99.

54. Haskell and Penny 1981, 74–75.

55. Wilton and Bignamini 1996, 33; and Bignamini 2010, 1:2–3.

56. Coltman 2009, 122.

57. See, among a large literature, Bignamini and Hornsby 2010, 1:195–221, 246–49; 2:passim.

58. Ingamells 1997, 555, 714.

59. T. Jones 1946–48, 93; and Ingamells 1997, 941.

60. Bignamini and Hornsby 2010, 1:195–207.

61. Collins 2004, 71.

62. Ingamells 1997, 450; and Bignamini and Hornsby 2010, 2:21–25, 29–32, 38, 43, 58, 65–66, 68, 71–72, 81–82, 84, 89, 91, 96, 103, 109, 120, 123, 167, 169–70, 174, 182, 186, 189, 202.

63. Ingamells 1997, 987.

Buying Art in Rome in the 1770s

JONATHAN YARKER AND CLARE HORNSBY

IN 1785 THE SCOTTISH DEALER James Byres (fig. 34) pulled off a remarkable coup: managing, by deception, to remove Nicolas Poussin's *Seven Sacraments* from Rome and sell them for £2,000 to Charles Manners, fourth Duke of Rutland, in London. The paintings, commissioned by Cassiano dal Pozzo and long an admired fixture of Palazzo Boccapaduli, were legally protected from sale by *fidecommisso*; therefore, to prevent detection, Byres replaced them with copies.[1] On the arrival of the paintings in Britain, Joshua Reynolds wrote to the duke that "one of the articles" agreed to by Byres and Giuseppe Boccapaduli to maintain the deception "was that he should bring the Strangers as usual to see the Copies and which he says he is obliged to do, and I suppose swear they are originals."[2] This episode has become a Grand Tour cliché, redolent of the duplicity of resident foreign dealers, the poverty of the Roman nobility, and the ability of the British to carry off untold treasures from Italy by means of their superior spending power.[3] In reality it was a rare success—so rare, in fact, that on their arrival in London the paintings were celebrated in the press and shown by royal command in the council room of the Royal Academy of Arts.[4]

By the 1770s there was a general feeling that a visit to Rome no longer offered the opportunities for collecting art that it had a generation earlier.[5] Extracting old master paintings and antiquities legally from Roman collections had become almost impossible; the papacy, fearing loss of patrimony, instituted a

Figure 34. Anton von Maron, *James Byres*, 1768, oil on canvas, 28⅞ x 23⅞ in. (73.4 x 60.6 cm). Courtesy of P. & D. Colnaghi & Co., Ltd., London and Bernheimer Fine Old Masters, Munich

series of restrictive export laws and established a bureaucracy to police them.[6] The majority of visitors were themselves less wealthy than the great collectors of the early eighteenth century; most were sons and heirs reliant on money from their families rather than financially autonomous. A paradox had emerged that

The Archangel Saint Michael (cat. 137, detail)

Figure 35. Angelica Kauffmann, *Anna Maria Jenkins and Thomas Jenkins*, 1790, oil on canvas, 51 x 37¼ in. (129.5 x 94.6 cm). National Portrait Gallery, London

while travel to Italy was still considered essential for instilling in young men a love of *virtu*, the thriving art market in London and Paris offered more opportunities for acquiring things of "taste" than the prohibitive atmosphere of Rome. This resulted in the creation of a lucrative market for reproductions and casts of sculpture, contemporary copies of famous paintings, and newly excavated antique sculpture that was generally heavily restored, a situation reflected in the cargo of the *Westmorland*.

Despite the difficulty in acquiring established masterpieces, Rome remained the commercial as well as cultural center of the Grand Tour. Ilaria Bignamini characterized the city as an "invisible academy," a model that stresses the educative role of travel to Italy but also suggests something of its structure.[7] By the 1770s British visitors tended to stay in a number of established lodgings close to Piazza di Spagna; a hand-

ful of ciceroni conducted visitors on tours of the city, usually following published schedules like those by Ridolfino Venuti or Giuseppe Vasi (cat. 109), showing an unvarying itinerary of buildings, paintings, and sculptures.[8] Most travelers employed one of several powerful resident British agents, usually dealers or antiquaries, who offered an increasingly comprehensive package of services. In no other city in Europe could a visitor rely on a single professional to organize finances, accommodation, and even entertainment as well as the coordination of any artistic commission. In turn each of these full-time brokers was able to recommend a small circle of loyal artists and craftsmen to his patrons. This institutionalization, as Francis Haskell observed, resulted in a narrowing of the aims and experiences of the average British traveler.[9] Something of this is discernible on the *Westmorland*, which contained multiple copies of Raphael's *Madonna della Seggiola* (see cat. 111) belonging to different owners; the same is true of Guido Reni's *Aurora* (see cat. 35).[10]

The paucity of exportable art had the inevitable effect of inflating the reputation of those objects that were removed from Rome. Dealers such as Byres and his rival Thomas Jenkins (fig. 35) spent much of their time attempting to insinuate their stock into the canon of accepted masterpieces. It is telling that several of the reproductions on board the *Westmorland* were of antiquities that had been excavated or assembled only a few years earlier. As tourists ceded power over their purchases to resident dealers, the scope of acquisitions became narrower still. This essay examines the commercial context of purchasing art in Rome in the decade before the *Westmorland*'s capture, using the cargo to illustrate the mechanics of art production and collecting at the height of the Grand Tour.

ACADEMY OR MARKETPLACE

It seems that commerce was as much a motivating factor as education for most artists' visits to Italy. In 1772 the Royal Academy instituted a "Rome prize" to send a student to Italy for three years; the remittance was a miserly £60 per annum, barely enough to cover living expenses.[11] Most subsisted by supplementing their academic work with more lucrative activities: making

Figure 36.
Giambattista Nolli,
Plan of Rome, 1773,
detail of the area
where British were
resident. Courtesy of
the Earth Sciences
and Map Library,
University of Cali-
fornia, Berkeley

Casa Moscatelli
lodging:
Jenkins, Wilson,
later Hamilton
(Goethe's House)

Jenkins's "museo"
near San Giacomo

Via del Corso

Hamilton's
sculpture store,
Barazzi's
lodging house

Via Vittoria:
Byres / Morison

Barazzi's Palazzo
at Via della Croce

Piazza di Spagna

Batoni's Palazzo

copies or drawing sculptures for travelers and buying
and selling works of art. An artist such as John Brown,
who spent a decade primarily in Rome from 1771, drew
famous sculptures and acted as a guide in the Galleria
degli Uffizi; eventually he purchased antiquities from
the Giustiniani collection in Venice in 1779 and sold
them through Carlo Albacini to the Vatican.[12] Deal-
ing appears to have been a tempting prospect for most
artists resident in Italy for any length of time. Jacob
More, Alexander Day, and Henry Tresham all arrived
as painters in Rome during the 1770s and, over the
next couple of decades, dealt in old master paintings
and antiquities. But serious dealing required capital,
which most British artists lacked.[13]

A directory of the principal sculpture dealers
in Rome survives from about 1770, in the form of a
handlist made at the inception of the Museo Pio-
Clementino by its first director, Giovanni Battista
Visconti, detailing sixteen potential suppliers to the

new museum.[14] Most of those mentioned in the list
had premises in the grid of streets around Piazza
di Spagna, the area frequented by British travelers
and artists (fig. 36). At this date dealers did not have
shops as such—unlike print and book sellers such
as Bouchard and Gravier, which occupied a build-
ing close to the church of San Marcello on Via del
Corso—their *musei*, where stock was displayed, were
usually visited by appointment only and typically
contiguous to their own houses.[15] The workshops
of the larger *restauratori* and *scalpellini* (restorers
and stonecutters), such as Bartolomeo Cavaceppi,
became tourist attractions in themselves, further
blurring the distinction between museum and market
(fig. 37). Johann Wolfgang von Goethe, at the end of
his stay in Rome in 1788, recorded visiting sites he had
neglected, "particularly Cavaceppi's house" on Via
del Babuino, where he mentioned being "especially
delighted with two casts of the heads of the colossal

Figure 37. Hubert Robert,
A Restorer's Studio, 1783, black chalk
on paper, 13¼ x 17⅜ in. (33.5 x 44 cm).
Le Claire Kunst, Hamburg

statues on Monte Cavallo," adding that "at Cavaceppi's they can be seen close up in their whole grandeur and beauty."[16]

But British travelers rarely bought directly from Italian dealers, or if they did, they were unlikely to be in Rome long enough to supervise the packing and dispatch of their purchases. An agent was required to handle all the practical aspects of acquisition. In the first half of the century, rich patrons had tended to sponsor their own agents; for example, Thomas Coke, by then the first Earl of Leicester, had helped to fund a trip to Rome by Matthew Brettingham the younger to undertake commissions for Holkham Hall in 1747.[17] By the 1770s a new type of resident agent had emerged; not reliant on a single client, he offered a versatile range of services from accommodations and finances to arranging the insurance and transportation of purchases to London.

BRITISH DEALERS IN ROME: PARTY POLITICS

This system was not appreciated by the artists it controlled. In 1767 the Irish painter James Barry lamented that English travelers who arrived in Rome with "the best of intentions" were made "instruments of dissension twixt the artists here. The antiquary and dealer are each provided with his own set of puffers; and, in return, whatever gentleman falls into his

hands, is taught to believe that, next to old pictures and statues which they deal in, these are the only people for modern work, either here or at home."[18] The monopoly that Barry deplored was characterized by the Welsh painter Thomas Jones as a party system, in which each visiting painter held allegiance to an individual dealer or antiquary. Jones identified the Scot James Byres as the principal antiquary in competition with the English dealer Thomas Jenkins, who "for years had the guidance of the Taste and Expenditure of our English Cavaliers, and from [their] hands all bounties were to flow."[19] The two men developed very different commercial models, a difference heightened by their personal rivalry and acute political animosity.

Byres was a Catholic and, educated on the Continent, had arrived in Rome in 1758 to practice as a painter; he was at the center of the large Scots community in Rome that included the artist, excavator, and dealer Gavin Hamilton (fig. 38) and other antiquaries such as Colin Morison and Abbé Peter Grant. Jenkins, on the other hand, was Protestant and English. Born in Devon in 1722, he traveled to Italy in 1751—like Byres, as a painter—but soon realized that selling the works of others was a more profitable enterprise.[20] The specter of Jacobitism lingered longer in Rome—where the exiled Stuarts maintained their court—than in London, and Jenkins was careful to capitalize

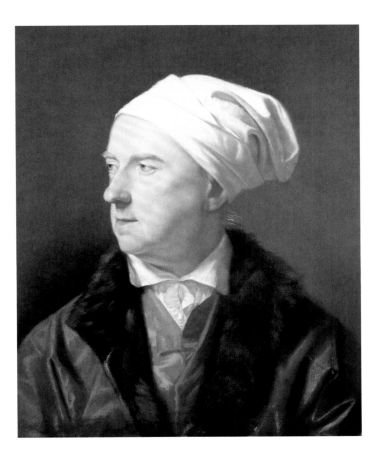

Figure 38. Archibald Skirving, *Gavin Hamilton*, ca. 1788, pastel on paper, 24 x 19⅛ in. (61 x 48.7 cm). Scottish National Portrait Gallery

on his opposition to the "scottish faction."[21] This animosity earned him, early in his career, the trust of the Anglophile Cardinal Alessandro Albani, a trust rewarded—after the Vatican decided to recognize the Hanoverian succession in 1766—with the status of unofficial British agent, taking charge of a stream of visiting British royals to the city.[22]

Byres followed a time-honored commercial model: he combined dealing with acting as an antiquary—in other words, a cicerone, or tour guide, to the sites of Rome.[23] It was a position that afforded ample opportunity to advertise his stock and steer his clients toward certain purchases and commissions. Countless travel diaries record visits to artists' studios as part of his tours.[24] In a letter from Rome dated July 1773, the sculptor Thomas Banks complained that "Little Wickstead has had most of the portraits to paint last season, owing to the endeavours of Messers Norton and Byres to carry every gentleman they

could get hold of to see him."[25] In return for this new business a painter like Philip Wickstead was expected to let Byres broker any commissions with prospective patrons as well as take a hefty cut.[26]

Thomas Jones was a keen recorder of the nuanced etiquette that governed the British artistic community in Rome, noting that, having dined and eventually banked with Jenkins, he "imperceptibly enlisted under his banner."[27] He described the tradition by which Byres and Jenkins held rival celebrations on Christmas Day for the artists under their protection and noted that a painter was expected to "present a Specimen of his abilities to his Protector, for which he received in return an antique ring or a few sechins— these specimens were hung up in their respective Rooms of audience for the inspection of the Cavaliers who came."[28] An inventory of Byres's house on Strada Paolina (now Via del Babuino) corroborates Jones's observation; the principal rooms were filled with the works of artists Byres sponsored.[29] These included paintings by the Irish landscape painter Solomon Delane, a "view of the Ponte Molli" by Jacob More, "a girl reading" by Wickstead, drawings by Louis Ducros and Henry Fuseli, and portraits by Hugh Douglas Hamilton, Nathaniel Dance, Pompeo Batoni, and the Polish painter Franciszek Smuglewicz.[30] Despite his protestations of being beyond such practice, Jones let Jenkins have a landscape, and Jenkins in turn seems to have handled the payments for a number of Jones's Roman works.[31]

But while Byres promoted artists in the capacity of a tour guide, Jenkins made a more decisive move: from 1773 he established himself as a financier, becoming the principal agent in Rome for most of the major British banking houses. This effectively gave Jenkins financial control of visitors to the city.[32] Up to this point travelers had used Italian bankers, most frequently Girolamo Belloni and his successors, based in a large house on Via del Governo Vecchio, or Francesco Barazzi, on Via Bocca di Leone. Jenkins employed his nephews John and James to run his operation, and the recent discovery of records of their London account with Drummonds Bank gives an idea of the amount of business they contracted with customers of just one English bank—more than £10,000 in 1779 alone.[33]

In contrast to other dealers who retained a desire to be seen as artists, being listed in the *stati dell'anime* (annual census) as *pittore* (painter), not *negoziante* (dealer), Jenkins consciously became a man of commerce; Giovanni Battista Visconti referred to him in 1782 as "Mercante di ragione che fa onore alla sua patria"(a skilled merchant who brings honor to his homeland).[34]

From 1773 Jenkins's bank was based in large premises in the Casa Celli, on Via del Corso, close to the church of San Giacomo degli Incurabili, and occupied the same premises as his extensive stock of antiquities and old master paintings.[35] It was therefore naturally linked to his dealing, and he frequently extended credit to accommodate purchases. In 1775 he wrote to his principal client, Charles Townley, regarding his young protégé James Hugh Smith Barry: "I freely supply Mr Barry with what cash he wants and am desirous of easing every indulgence that civility can admit of."[36] Barry had purchased sculptures and paintings from Jenkins on his arrival in Rome in 1772; a memorandum written by Townley records £5,430 spent on sculpture by 1776. He had also made a similarly sizable purchase of old master paintings; in all, Jenkins had lent Barry some £10,000 by 1777.[37] This eagerness to advance money and Barry's profligacy were an incendiary mix; Barry refused to pay and then impugned the quality of artworks supplied by Jenkins, resulting in a long-running legal battle.[38]

Acting as banker meant more than handling financial transactions. Barazzi provided accommodations for his clients, brokered commissions, and took responsibility for shipping purchases.[39] As financial guarantors Barazzi and Jenkins were frequently called on to offer more practical assistance; for example, Jones required Jenkins to intercede with the Roman authorities when he was robbed, and, when the tourist John Gifford died at Tivoli in 1779, it was Jenkins who organized his burial. Offering accommodations was a way for dealers to raise revenue and extend their influence over visitors. Gavin Hamilton wrote to Townley in August 1774 to inform him that Hamilton's common-law wife, Margherita Giulj, had taken "the 2nd Apartment of Barazzi's new house near Benedetto's which she has furnished out very neatly to

accommodate strangers. . . . I should be much obliged to you if you could recomment some body to her new apartments."[40] Hamilton rented the storeroom in the same house to store antiquities from his excavations, giving the travelers lodged there a tantalizing glimpse of sculpture fresh from the ground.

Jenkins went one step further, offering accommodations for potential clients in the Roman Campagna. By the 1770s Jenkins's position as unofficial British agent meant that he introduced countless English tourists to Clement XIV, even accompanying Sir William Hamilton on a visit to the pope.[41] Clement went so far as to call Jenkins "il mio caro Ruffiano" (my dear procurer), and it was even joked among British artists that "the Romans themselves would hardly be surprised if one of the vacant [cardinal's] hats was given to him."[42] Jenkins benefited from his closeness to the pope and from papal policy as well: in 1774, following the suppression of the Jesuit order the previous year, he took a lease on Villa Marzelli, formerly a country retreat of the order at Castel Gandolfo. Father John Thorpe wrote that "it will be made a trap for rich British dilettanti, who will be favoured with lodgings there for a few days and then can do no less than buy Virtu at any price from that noted dealer."[43] As Thorpe predicted, Jenkins frequently rented furnished rooms in the villa, overlooking Lake Albano, to potential clients, while reserving the apartment formerly used by the general of the Jesuits for himself.[44] In October Thorpe observed that James Hugh Smith Barry had been staying with Jenkins; the following June Jenkins reported his success in selling Barry a group of old master paintings, noting that he "has taken many things of Consequence of me, amongst others the large Tintoret, the large Bassan, & 4 of the Ghirardo della Notte's, which came from Venice."[45] No doubt a convivial time at Castel Gandolfo smoothed the way for Barry's purchases.

A country estate offered a place to entertain artists as well as prospective patrons, something both Barazzi and Jenkins did. The artist John Robert Cozens spent the summer of 1778 in Barazzi's villa at Pietralata, north of Rome, "for the benefit of the air," using it as a base to explore the Campagna on a "jack-Ass."[46] At Castel Gandolfo, Jenkins extended hospi-

Figure 39. Thomas Jones, *View of Castel Gandolfo and Lake Albano*, May 6, 1777, pencil on paper, 5⅛ x 7⅛ in. (12.9 x 18.2 cm). British Museum, Department of Prints and Drawings

tality to artists under his protection; for example, in May 1777, on one of his drawing trips, Jones stayed there with the sculptor Christopher Hewetson, the architect Thomas Hardwick, and the painter Prince Hoare (fig. 39).[47] His letters frequently record house parties attended by other artists, such Anton Raphael Mengs, Angelica Kauffman, and Albacini.

As a banker Jenkins would have known in advance when a traveler was expected.[48] A measure of the all-encompassing approach of his operation is demonstrated by the dedication to "all'illustris signore Tommaso Jenkins" in a guidebook, published in 1775, delineating the posting routes through Italy.[49] Jones described the "Cavalieri Inglesi" as moving "in a circle of superior splendour—surrounded by a group of satellites under the denomination of traveling tutors, antiquarians, dealers in Virtu, English Grooms, French Valets and Italian running footmen."[50] Robert Gray reported that on arriving in his lodgings in Piazza di Spagna, he found "our rooms were thronged with valets, tradesmen, and antiquarians, with recommendations from Mr. Jenkins or his servants."[51] Jenkins assembled a team that included the antiquary Orazio Orlandi, the picture restorer and draftsman Friedrich Anders, and the architect Giovanni Stern.[52] He promoted the services of the sculpture restorer Albacini, who was based close by at 67 Vicolo degli Incurabili

(between the Corso and the Mausoleum of Augustus); a portrait sculptor, the Irishman Hewetson, who was a lifelong friend and beneficiary in his will; and numerous sculptors and painters who worked either directly or indirectly under his protection.[53]

Byres and Jenkins were so successful at controlling their clients that by the 1770s it was possible to identify the dealer whom a traveler had used merely by his purchases. For example, James Hugh Smith Barry employed Orlandi as his cicerone, had his purchases of ancient sculpture from Jenkins restored by Albacini, and employed Stern to design a gallery to house them.[54] The small world, geographic as well as professional, in which dealers and artists lived and worked implied multiple connections between them; the number of wealthy visitors was also limited. Thus it is perhaps fair to see the party rivalry as being more keen in theory than in practice: in 1779 Jenkins reported to Townley that the diplomat and dealer John Udny had successfully sold Titian's *San Niccolò* altarpiece to Pius VI: "those that Envy him are Governed by Narrow Views, a Good Sale gives Credit to Merchandise, and is in Some degree of General Utility."[55] The principal losers seem to have been the artists. They felt ill served by a system that, by employing a middleman, distorted the traditional relationship between artist and patron.[56] In a letter to Edmund

Burke, James Barry accused Byres of conspiring to deny him access to the wealthy Sir Watkin Williams Wynn.[57] The sculptor John Deare, in a letter to John Cumberland about the preferment of Hewetson, complained of Jenkins's agency and added: "Yet this old wretch . . . says he's a friend of English artists."[58]

Writing to Sir William Hamilton in Naples about purchases he had made on behalf of the voracious collector Frederick Hervey, bishop of Derry, Jenkins observed that "those who seek for cheap things will never find abundance, and its happy for numbers that there are dilettanti of all denominations."[59] Dealers such as Gavin Hamilton and Jenkins hoped to foster a passion for *virtu* in their patrons that would endure after their return to Britain. But they were aware that such commitment was rare; most travelers were interested only in securing a few mementos of their visit and disinclined to engage in the costly pursuit of old master paintings or antique sculpture. This stratification was understood perfectly by Roman dealers, who were quick to assess the level of each visitor's taste and spending power.

Visitors such as Francis Basset and Williams Wynn were unusual in being independently rich, both having succeeded to their estates before departing for the Continent. Fragmentary estate records show that Basset drew the considerable sum of £3,101 in the period between July 1777 and June 1778 to fund his European tour.[60] Williams Wynn, who was in Rome in 1768–69, purchased more than £1,000 worth of paintings from Byres alone, leaving several spectacular commissions for contemporary art on his departure, including Mengs's *The Liberation of Andromeda by Perseus* (cat. 17). Both Basset and Williams Wynn traveled with older men who seem to have guided their purchases. Basset was accompanied by his tutor, the Reverend William Sandys, who had visited Italy earlier in the decade and made contact with many of the artists Basset was to employ, including Giovanni Battista Piranesi and Jacob More.[61] He also met Jenkins and Townley, with whom he corresponded during the 1770s.

More usually, young travelers such as Frederick Ponsonby, Viscount Duncannon, and George Legge, Viscount Lewisham, were restricted by having their finances, and therefore purchases, controlled at a distance by their fathers. In both cases, the father's taste and Grand Tour experiences shaped those of the son. Lewisham's father, William Legge, second Earl of Dartmouth, had been in Rome in 1752–53 and there had met, and been painted by, the young Jenkins.[62] Dartmouth was an important early patron for Jenkins, and they remained correspondents; the earl bought art from Jenkins by mail order during the 1750s and 1760s.[63] It was therefore natural for Dartmouth's son to rely on Jenkins when he arrived in Rome in 1777.[64] Duncannon's father, William Ponsonby, second Earl of Bessborough, was a noted collector of antiquities. Bessborough traveled to Rome only once, in the 1730s, but following a visit by Jenkins to him while in London in 1769, he began purchasing marbles from Rome. He never became a "first rate" dilettante, but he was able to buy significant quantities of sculpture.[65]

Selling by correspondence was central to the success of many Roman dealers. Both Townley and Lyde Browne formed their collections remotely, buying sculpture on the descriptions and accompanying drawings sent from Rome.[66] Townley had been in the city at the beginning of the decade and returned for a brief visit in 1777, but he relied principally on his agents in Italy to inform him by correspondence of all *virtu* news. Letters consisted of a heterogeneous mix of gossip, offers of recently excavated antiquities, and disparaging news of their rivals' stock. A major collector like Townley, corresponding with several dealers concurrently, was able to balance the hyperbole of one salesman against the cynicism of another.

Frequently during the 1770s Gavin Hamilton, as *cavatore* (excavator), discovered sculptures and sold them to Jenkins, who in turn passed them on to Townley at a profit. In early 1774 Hamilton found a statue, *Endymion Sleeping on Mount Latmos*, while excavating at Roma Vecchia; he mentioned it in passing to Townley but did not offer it for sale (fig. 40).[67] When Jenkins acquired the sculpture and offered it to Townley for £500, Hamilton was forced to justify why he had not done so, writing, "I concluded that the sculptour not being first rate, the subject unintelligible, my duty was to decline sending you this piece," and adding, "I should have charged you £180."[68] With this revelation, Jenkins was obliged to explain his offer to

Figure 40. Anonymous, *Endymion Sleeping on Mount Latmos*, second century, white marble, 51 in. (129.5 cm). British Museum, Department of Greek and Roman Antiquities

Figure 41. Friedrich Anders, *Endymion Sleeping on Mount Latmos*, 1775, black chalk on paper, 6⅛ x 7½ in. (15.4 x 18.9 cm). British Museum, Department of Greek and Roman Antiquities

his client: "I esteem this lovely figure equal to almost all the things that Ham[ilton] has found, his want of Precise Judgement, has done me Justice for his breach of Promise."[69] Townley was the winner, finally acquiring the statue for £300, £200 less than Jenkins's original offer.[70]

Townley's collecting was atypical in its focus on antiquities, as was the installation of his collection in his London residence rather than at his Lancashire estate. The creation of a "house museum" at 7 Park Street with himself as its resident curator exemplifies this (see fig. 27, p. 48). Like all collectors who purchased by correspondence, however, Townley was more reliant on the taste and judgment of his agents than was the Grand Tourist based in Rome. Jenkins was fond of chastising collectors who "saw with their ears," but this was the only option open to Townley, who had conducted the transaction for the *Endymion* before its arrival in Britain in August 1775, relying only on the conflicting assessments of the two dealers and a small drawing by Friedrich Anders that Jenkins sent (fig. 41). It is perhaps not unfair to ask precisely whose taste Townley's collection represented. In 1782 Jenkins observed that "tis no Small Satisfaction to me frequently to hear Your Collection mentioned as it ought, and that The Publick look up to You as a Model

of Taste, possibly I may be even flattered by this Idea, altho' no real merit on my part, but certainly esteem my Self fortunate to have been honoured with So considerable a share of Your Confidence in the forming Your Collection."[71] Both Hamilton and Jenkins frequently pressed their more lucrative clients about display, undoubtedly aware that, favorably arranged, the gallery of Lansdowne House or Townley's dining room operated like a London showroom.[72]

GRAND TOUR PURCHASES: ANTIQUITIES

When Thomas Coke of Holkham Hall (whose great-uncle Thomas had been Earl of Leicester) bought a cameo of the Roman emperor Claudius in 1774, Jenkins remarked that "by making such a noble beginning, it woud prevent his biting at trifles the too usual fate of Young Dilettanti."[73] If there was a hierarchy of consumers, there was an even more rigid hierarchy of purchases; antiquities in any form had the highest status. In an account of his excavations made during the 1770s, Hamilton implored Townley: "never forget that the most valuable acquisition a man of refined taste can make, is a piece of fine Greek sculptour."[74] A visit to Italy was, after all, in part motivated by the desire to be on "classic ground," and dealers tried to translate tourists' enthusiasm into consumption; their shops were

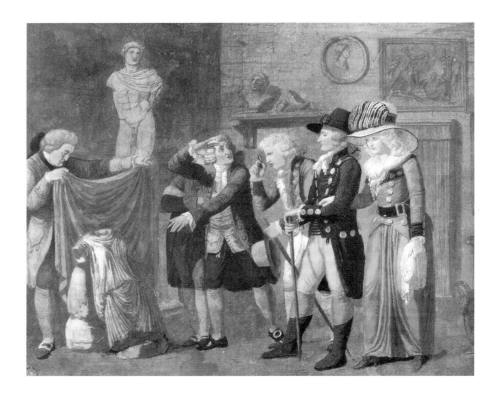

Figure 42. Jacques Sablet, *In the Antiquaries' Shop*, 1788, tempera, pen, graphite, and black ink on paper, 12 x 16 in. (30.5 x 40.5 cm). Private collection, Rome

filled with classical fragments, fully restored sculptures, and casts of their most celebrated sales (fig. 42).

The difficulty in buying sculptures from Roman collections meant that British dealers such as Hamilton, Jenkins, and Colin Morison turned increasingly to excavation to supply the market. Townley had at least one crate on board the *Westmorland* containing sculpture excavated by Jenkins at Genzano, near Lake Albano, in March 1774.[75] The excavation at Genzano was on land owned by the Lancelotti family; Jenkins found it expedient to undertake the enterprise in partnership with Cardinal Albani, who was still actively pursuing antiquities despite his old age and blindness. The cardinal often used intermediaries to handle administrative matters, and the practice of forming a *mezzaria*, or collaboration, with another entrepreneur, in this case Jenkins, was very common, given the high costs of any excavation.[76] It appears that Gaspare Sibilla, the papal assessor of sculpture, had visited the site—and the more significant one of Monte Cagnolo, located nearby—to inspect sculptures found there at the end of October 1773.[77] This demonstrates the extent to which the Vatican administration was monitoring the ongoing excavations near Rome. It seems that not until 1776 was anything

discovered at the site and we hear of the subsequent division of spoils that led eventually to Townley's acquisition, through Jenkins's agency, of two priapic fauns that were on the *Westmorland* according to Jenkins's account in his letters.

What emerges from the Townley correspondence is that the fragmentary finds which came to light during the digging season of 1776—broken heads, a vase, perhaps a Venus—and the fauns (usually small in scale and therefore more likely to be discovered whole) were the subject of rivalry and even open disagreement among the various parties involved. Jenkins was determined that Townley should have the priapic figures. Townley was an avid collector of such pieces, influenced at the time by the writings and opinions of his supernumerary librarian, the self-styled Baron Pierre d'Hancarville, and his theory of comparative religion. Regardless of the reason for Townley's preference, Jenkins never failed to make parenthetical remarks about the objects in his letters, suggesting that they were a "guilty pleasure" for his client.[78]

Hamilton wrote to Townley in February 1778 that the figures had been smuggled to Cardinal Albani, a circumstance to which Prince Lancelotti objected;[79] however, some weeks earlier, in December 1777, Jen-

kins was already confident enough to inform his client he had "found means to Get [them] out of the Cardinals claws."[80] The subsequent fate of the priapic figures in Spain remains a mystery. They were packed into a crate—one of four originally loaded on the *Westmorland* at Livorno for Townley.[81] A letter Jenkins wrote in 1779 discusses their loss, explaining that

> probably you will have heard before the receipt of this that the Westmoreland which had your case No. 22 on board containing the two deities has been taken by a 74 [gun] French ship and carried into Malaga, I write to our consul there by this post and mention your case and to beg he will use his utmost influence to prevent its being opened or sold, until he receives directions from you, what you wish to have done in this business, if the gentlemen were living probably the Spanish ladies would bid high for them as it is, probably they will be sold cheap, you will therefore be so good when you write to our consul there to mention how far you chuse to bid for the case, I have mentioned to him that the utmost precaution should be taken.[82]

Despite diplomatic representations having been made, Townley was never able to recover his property. The story of these small figurines for which Jenkins had competed with Cardinal Albani has a curious twist, which is revealed in the way they appear in the lists made in Spain of the cargoes. The first list, made in Málaga on July 13, 1783 (cat. 12), states that the two statues were dancing fauns but one was female (see appendix 1, p. 318)—something had happened to one of the "gentlemen." In a second list, made in Madrid, they are described as *faunitos* without being gender specific, and their Bacchanalian attributes—the thyrsus and the sistrum—are mentioned.[83] It appears that they were sent to one or another of the official residences, perhaps that of the prince of Asturias (Carlos Antonio de Borbón, the future Carlos IV), in the El Pardo area near Madrid, but there is no explanation as to how two "jolly gentlemen," complete with priapi, became a couple of dancing bacchantes.[84] One can only speculate as to the circumstances under which

they changed form and shape; perhaps they were "restored" by persons unknown, after the crate was unpacked in Málaga, to make them appear less phallic. Apart from the common practice of reworking or changing attributes of classical statues to suit the preference of clients, there is a famous example of a comparable "castration" performed on a statue of a hermaphrodite that Henry Blundell bought in 1801.[85] Townley's collecting continued to suffer en route back to Britain: in 1780 he lost more property on board the *Favorite*, and in 1783 another ship was held at Cádiz that carried his *Homer* bust, which was eventually restored to him.[86]

GRAND TOUR PURCHASES: AFTER THE ANTIQUE

While taste for the antique is well represented on the *Westmorland*, these modest priapic figures were the only significant antiquities on board. When Lyde Browne visited Rome briefly in 1776, he reported to Townley that "there is not a sculptors shop in Rome which I have not visited. . . . Cavaceppi has little & tho I shall lay out some money with Piranesi, yet you know they are but Pasticcios."[87] Browne was referring to the heavily—and often fancifully—restored antiquities that Giovanni Battista Piranesi supplied to tourists. Piranesi's creations, illustrated in engravings from his volume *Vasi, candelabri, cippi, sarcofagi, tripodi, lucerne et ornamenti antichi* (Vases, Candelabras, Gravestones, Sarcophagi, Tripods, Lamps, and Antique Ornaments) (cats. 38 and 39), represented a highly imaginative vision of antiquity reconstituted for modern use. But Piranesi was by no means the only sculptor-restorer who created "pasticcios"; most of the major workshops produced highly restored antiquities, modern vases, copies of ancient sculpture, and forged antiquities. The five cinerary urns on board the *Westmorland* (see cats. 134, 139–40) were modern fabrications. Piranesi illustrated a similar urn as having formerly belonged to Jenkins and also contained a bogus inscription.[88] Small antiquities such as these were considered fashionable classical dressing by British clients; for example, Lord Bessborough displayed funerary urns (including one that Jenkins sent in April 1763) at his villa at Roehampton, in a vaulted passage fitted with niches to imitate an ancient colum-

barium, and larger altars were sought after as plinths for bigger sculptures.[89]

The only property belonging to Browne on board the *Westmorland* was a set of four modern, reduced copies of ancient sculptures. One of the originals, *Cupid and Psyche* (see cat. 96), was well known, having been on public display in the Capitoline museum; another, the so-called Mattei *Amazon*, was a recent addition to the Vatican museum; the other two, the Newby Hall *Minerva* (fig. 43 shows Browne's copy) and the Marbury Hall *Bacchus and Ariadne* (see cat. 95), were less well known.[90] The choice of subject is suggestive, reminding us once again of the guiding hand of British dealers. Jenkins maintained that William Weddell's so-called Newby *Venus* and *Minerva* were two of the finest antiquities he had sold during the previous decade and used almost any opportunity to promote them.[91] In 1769 Jenkins donated a cast of the Newby *Venus* to the newly founded Royal Academy, for use in the drawing schools.[92] The *Minerva* was also frequently replicated, and in 1768 Jenkins reported to Townley that "the Moscovite [Ivan Shuvalov] has ordered a copy of Mr Weddells Minerva the size of the Original for the Empress [Catherine the Great]," which was presumably for use in the Russian Academy of Arts, St. Petersburg; the following year Townley received another cast.[93]

The *Bacchus and Ariadne* had similarly passed through Jenkins's hands. In 1772 William Henry, Duke of Gloucester, brother of George III, visited Italy. Carrying with him the prospect of royal patronage, Gloucester's arrival was of great interest to the Roman art world, and his itinerary and purchases were reported in detail in the *Diario ordinario di Roma*.[94] Albani recommended Jenkins to take charge of Gloucester, and he had some success, selling the duke antiquities and paintings, including the *Bacchus and Ariadne* and a *Marcellus*. But Gloucester had married secretly in 1766 and on his return to Britain in 1772 informed George III, resulting in a drastic reduction in his income. Jenkins was left with many of the duke's Roman purchases; unimpressed by George III's behavior, he noted, "H:M: its Plain has not a Sensation for Sculpture."[95] Jenkins was able to resell the *Bacchus and Ariadne* almost immediately to James

Hugh Smith Barry for £300. A terra-cotta model of the group survives in Palazzo Venezia and is listed in the 1802 inventory of Cavaceppi's studio compiled by Vincenzo Pacetti. As Alvar González-Palacios has shown, the model was used as the source for copies in several different media, including bronzes by Giuseppe Boschi and copies in marble by Pacetti himself.[96] A second set of reduced marble copies of *Bacchus and Ariadne* and *Cupid and Psyche* was on board the *Westmorland*, apparently from a crate belonging to the Duke of Gloucester; he had returned with his wife to Rome in 1775, when he purchased these figures, probably for a chimneypiece (cats. 95 and 96). This was perhaps a consolation for Gloucester's having lost the *Bacchus and Ariadne* on his previous stay.

The following year Gavin Hamilton wrote to Townley that "the Duke of Gloucester has taken up the spade & in a few days begins a cava at Quadraro di Barberine under the auspicies of our friend Jenkins, in short the frenzy of digging increases dayly."[97] Jenkins was trying again to interest Gloucester in antique sculpture, enlisting him to sponsor an excavation at Quadraro, then just southeast of Rome on the Via Latina-Tuscolana, from May 1776.[98] British dealers realized that excavations offered an attractive speculation for wealthy travelers staying in Rome, with a chance of acquiring antique sculpture straight from the ground, as well as providing a suitably "classical" diversion.[99] The finds from Quadraro were disappointing, even though Jenkins employed forty men: the only recorded antiquity was a small sculpture of *Minerva*, which Jenkins dismissed by writing to Townley that "the Preservation makes it an interesting figure for any Gentleman that wants an Elegant object for a Library or for Furniture."[100] Gloucester, despite his involvement, was not interested in forming a collection of sculpture; the excavation was a summer pastime while he stayed at Villa (or Palazzo) Drago, a residence in Castel Gandolfo belonging to Cardinal Albani.

Figure 43. Attributed to Carlo Albacini, *Minerva*, 1770s, marble, 30⅜ x 16½ x 12¼ in. (77 x 42 x 31 cm). Real Academia de Bellas Artes de San Fernando, Museo (cat. 54)

For British tourists determined, at least since the 1720s, to acquire some knowledge of pictures, Rome offered unequaled opportunities. In their account of the Académie de France in Rome, Denis Diderot and Jean-Baptiste d'Alembert observed that "in Italy, each church is, as it were, a gallery: monasteries, public and private palaces are adorned with paintings."[101] The Roman marketplace was inevitably structured to reflect this fact; while genuine old masters were scarce, copies and engravings after the most celebrated compositions were supplied in large numbers.

To a British audience Raphael represented the ideal, specifically the Roman Raphael of the *Madonna della Seggiola* and the Vatican Stanze. The Carracci and Guido Reni were viewed as his successors, co-opted into a "Roman" tradition that culminated with Carlo Maratti.[102] By the 1770s acquiring paintings by such celebrated masters had become difficult; major works of art in Rome, such as the Poussins at Palazzo Boccapaduli, were protected by law, accessible only through bargaining or deception. As with the market for antiquities, British dealers became increasingly resourceful in sourcing old master paintings, turning to less regulated parts of Italy for their stock. Venice, for example, offered a rich hunting ground. Hamilton corresponded with the Venetian dealer Giovanni Maria Sasso, alerting him to possible purchases, and both Hamilton and Jenkins visited the city on buying trips.[103] In 1774 Jenkins competed with the British consul in the city, John Udny, for the collection of Bartolomeo Vitturi, which Udny eventually secured with the help of the wealthy speculator Thomas Moore Slade.[104]

Hamilton in particular was successful at extracting important paintings from Italian collections, including Raphael's Ansidei altarpiece, purchased from a monastery in Perugia and sold in 1764 to Lord Robert Spencer, and Guercino's *David* and *Samian Sybil* from the Locatelli family collection in Cesena, which Hamilton sold in 1768 to John Spencer, first Earl Spencer.[105] But these successes represent only a handful out of the many attempts by British dealers to dislodge paintings from Italy.[106] If old masters were unavailable, patrons could rely on contemporary

painters who continued to practice in a late Baroque manner, or artists, such as Anton Raphael Mengs, whose works were calculated to appeal to the British taste for seventeenth-century painters.[107] Alternatively, collectors could purchase copies.

Copying was the staple activity of most artists studying in the city; not only was it a fundamental precept of training at most European academies, but for the majority of British painters resident in Rome it was also an important source of income.[108] The Royal Academy did periodically sponsor students to travel to Italy, but unlike the French *pensionnaires* or Spanish *pensionados*, there was no official British organization in Rome and scholarship money was minimal.[109] British artists therefore supplemented their income by selling any copies they made to tourists. Although students had been discouraged from copying by no less an authority than Joshua Reynolds, copying in a church or palace increasingly became an established way of making contact with potential patrons.[110] James Barry recorded copying Titian's *Venus Blindfolding Cupid* in Palazzo Borghese in January 1769 when Sir Watkin Williams Wynn entered accompanied by James Byres. As Barry noted to Edmund Burke, Byres bestowed "large praises upon what I was about, which Titian himself could hardly deserve." Barry hoped—in vain—that the encounter would result in a commission.[111]

Copies, like casts and reduced replicas of ancient sculpture, were comparatively inexpensive, fulfilling both an educational role and a decorative need. British critics were clear that copies were a suitable addition to a collection; Jonathan Richardson the elder had famously observed, "A copy of a very good picture is preferable to an indifferent original; for there the invention is seen almost intire, and a great deal of the expression, and disposition, and many times good hints of the colouring, drawing, and other qualities."[112] As with the antiquities reproduced, tourists demanded copies of a narrow group of masterpieces, and these copies can be roughly separated into three classes: full-size, accurate reproductions painted from the original; reduced copies generally painted from some form of intermediary; and small-scale copies, frequently colored engravings.

The first category was, inevitably, the most expen-

sive and desirable, requiring permission. This was not always straightforward; while institutions, such as the Uffizi, operated a simple application procedure, private collections and churches were notoriously tricky.[113] In 1754 one of the copies that Hugh Percy (né Smithson), then second Earl of Northumberland, ordered from Pompeo Batoni in Rome for the gallery of his London house was delayed while permission to erect scaffolding and trace directly from Raphael's frescoes in Villa Farnesina was sought from the Bourbon authorities in Naples. Even after Cardinal Albani had written directly to Giovanni Fogliani, secretary of state, permission was refused and Batoni was forced to complete the copies without a tracing.[114]

Full-scale copies by established painters were expensive, frequently costing more than an original composition by the same hand. James Durno was expecting £1,000 for his copy of Raphael's *Transfiguration* made in 1779, and a copy by the Welsh painter William Parry reportedly sold for 400 guineas in 1773, considerably more than either received for his own work.[115] It was a disparity noted by contemporaries; Father John Thorpe observed that "in general the purchasing of good old pictures is in many respects preferable to the making of new copies, for middling Copyies often demand more money than what some other good original may with industry be had for."[116] When Henry Arundell, eighth Baron Arundell of Wardour, through Thorpe, came to consider the decoration of his chapel at Wardour Castle (see fig. 119, p. 160), he dismissed a copy of the *Transfiguration* in favor of an original composition by Giuseppe Cades.[117]

Most tourists purchased more modest replicas as decorative additions to their collections. In 1771 Byres was commissioned to provide a series of copies for William Constable to furnish the new interiors of Burton Constable Hall in Yorkshire. Byres naturally turned to one of the artists under his protection, his fellow Scot James Nevay, who painted a version of Reni's *Fortuna with a Crown*, in the Accademia di San Luca, Rome (fig. 44). The copy, identical to one on board the *Westmorland*, cost only 30 sequins (about £15).[118] These inexpensive canvases, like the majority of those on board the *Westmorland*, were unlikely to

Figure 44. James Nevay, *Fortuna*, 1772, oil on canvas, 66 x 55⅞ in. (167.5 x 142 cm). Burton Constable Hall, East Yorkshire

have been painted from the original, but instead copied from prints and drawings. In 1775 Patrick Home wrote from Rome that he was then employing David Allan to copy Reni's *Aurora*, which was apparently "done from an old copy in [Giovanni Pietro] Bellori's hand but I believe principally from [Jakob] Frey's print" (fig. 45), as "no person whatever is allowed to copy it from ye original."[119] The inaccessibility of his fresco, on the ceiling of the Casino at Palazzo Rospigliosi, meant that copyists such as Allan had to rely on intermediaries.

Copies such as those by Nevay and Allan were considered, as Richardson observed, as preferable to doubtful old master paintings. Copies were also increasingly seen as a useful form of decoration, with certain compositions becoming staples of Neoclassical design. There were a number of versions of the *Aurora* on board the *Westmorland*, and the composition could be found incorporated into countless interiors in Britain.[120] During the 1770s Jenkins negotiated the completion of a modest decorative scheme using

Figure 45. Jakob Frey, *Aurora*, 1770s,
engraving, 14¾ x 34⅝ in. (37.5 x 88 cm). Real Academia de Bellas Artes de San Fernando, Archivo-Biblioteca

copies, after the diplomat Sir John Goodricke commissioned him to provide nine canvases for the Saloon at Ribston Hall in Yorkshire. The project, which consisted of a piecemeal selection of paintings by Reni, Guercino, and Daniele da Volterra, was executed by three painters then working in Rome: Ludovico Stern, Pietro Angeletti, and Franciszek Smuglewicz (fig. 46).[121] The centerpiece of the program consisted of large copies by Smuglewicz of Guercino's *Death of Dido* and Reni's *Rape of Helen*, a hang that consciously emulated the interior of Palazzo Spada in Rome.[122] The smaller overdoor panels required horizontal compositions to fit the space, and Jenkins used copies of the ancient *Aldobrandini Wedding* fresco paired with the *Aurora*.

The least expensive class of copy comprised small-scale reproductions, frequently drawings or colored prints, such as the gouache version of Reni's *Bacchus and Ariadne* (cat. 36) included in a crate with similar copies after the *Aurora* (fig. 47) and the *Aldobrandini*

Figure 46. The Harlequin Saloon at Ribston Hall, Yorkshire

Figure 47. After Guido Reni, *Aurora*, 1770s,
gouache on paper, 15¾ x 33⅛ in. (40 x 84 cm). Real Academia de Belles Artes de San Fernando, Museo (cat. 35)

Wedding (cat. 34) for Francis Basset. The *Bacchus and Ariadne* and perhaps *Aurora* are painted directly over engravings by Jakob Frey, whose son Filippo sold impressions from a shop next to the church of Santa Maria di Costantinopoli, near Piazza Barberini (on what is now the Via del Tritone).[123] Frey's prints were clearly purchased as a visual supplement to the Grand Tour library, used to illustrate the writings of Carlo Cesare Malvasia or any of the numerous guidebooks of Rome produced during the last half of the century. While Frey produced only single engravings his rival printsellers, particularly Piranesi and Giovanni Volpato, produced lavish bound volumes of their impressions. Volpato in particular created prints of whole decorative schemes, such as the Loggia of Raphael in the Vatican and Annibale Carracci's frescoes from the Galleria Farnese, calculated to appeal to English travelers. The diplomat and dealer John Udny had a crate on board the *Westmorland* with multiple copies of Volpato's Loggia engravings (cat. 40) addressed to his brother Robert, presumably for disposal in London.[124]

While Frey's and Volpato's engravings were of antiquarian interest, when professionally colored they become highly decorative works of art. Indeed, images from contemporary antiquarian publications frequently migrated from books to be used as ornament. The *Westmorland* was carrying two plates from the 1757 *Le antichità di Ercolano esposte* painted on silk (cat. 33), as well as multiple copies of Volpato's engravings of Raphael's decoration of the Vatican Loggia (cat. 123), both of which were heavily used by Neoclassical decorators.[125]

British dealers kept a weather eye on fashions in England, as well as news of the art market. Both Byres and Jenkins made periodic trips home and were keen to promote their services and stock in Britain. Throughout the 1770s Hamilton employed the Italian engraver Domenico Cunego to make impressions of his Homeric paintings, which he advertised in the British press.[126] It is revealing of the dealers' awareness of the home market that the *Westmorland* was carrying two versions of David Allan's *Origin of Painting* (cat. 120), dispatched by Byres to his

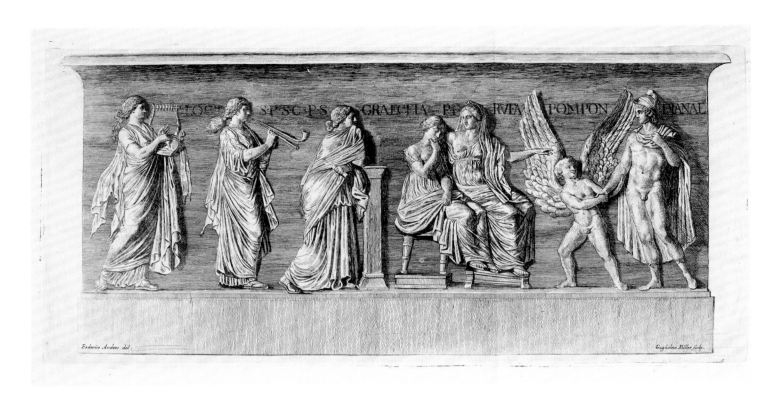

Figure 48. W. Miller after F. Anders, *The Jenkins Vase*, 1775, engraving, from Orazio Orlandi,
Le nozze di Paride ed Elena (Rome, 1775). Real Academia de Bellas Artes de San Fernando, Archivo-Biblioteca (cat. 91)

brother-in-law the Reverend George Moir for sale in Britain. Allan's paintings were also accompanied by an engraving by Cunego, suggesting the potential for further profit from reproduction of this highly desirable composition in another form.

As with newly excavated sculpture, British dealers promoted the paintings they successfully exported from Rome. Hamilton bought Lodovico Carracci's *Birth of John the Baptist* from the Bonfiglioli collection in Bologna, selling it in 1770 to John FitzPatrick, second Earl of Upper Ossory.[127] He included an engraving of the composition by Cunego in his collection of prints entitled *Schola Italica Picturae* of 1773 (cat. 59).[128] The Carracci is embedded within a sequence of engravings by Cunego and Volpato of established old masters in famous Roman collections.[129]

Although the *Schola Italica Picturae* contains relatively few plates celebrating Hamilton's commercial success, promotion was an essential part of most dealers' activities. The *Westmorland* carried copies of Piranesi's *Vasi, candelabri, cippi, sarcofagi, tripodi,*

lucerne ed ornamenti antichi, which showed plates of his stock, frequently dedicated to past or potential patrons; including plates dedicated to Basset and Sandys (cats. 38 and 39). Also on board was an edition of the *Raccolta di alcuni disegni del . . . Guercino*, which contained engravings by Piranesi, Nevay, and Giovanni Ottaviani, three of which were made after drawings in Jenkins's own collection. These publications blurred the boundaries between the scholarly and the commercial. Perhaps the most revealing of such enterprises was a lavish essay that Jenkins produced in 1775, publicizing a *puteal* (wellhead) from Palazzo Columbrano, Naples, that he had converted into a vase; three copies of this were on the *Westmorland* (see cat. 91).[130] Written by an associate, the scholar and cicerone Orazio Orlandi, and illustrated by the draftsman Friedrich Anders, it consisted of a dissertation on the vase's iconography and two engravings by William Miller after drawings by Anders. The engravings, one of which shows the relief from the vase, frieze-like (fig. 48), was calculated to appeal to

designers as much as to antiquarians; indeed, Jenkins managed to insert a painted version of it by Angeletti in the Saloon at Ribston Hall.

CONCLUSION

By the beginning of the 1780s the war with France over America meant that the number of travelers from Britain had declined, while shipping purchases back became increasingly difficult (the loss of the *Westmorland* being only the most notable example). Jenkins began to look northward—to Germany, Russia, and Poland—for patronage, entertaining a new wave of travelers.[131] His letters increasingly focus on small objects—gems and cameos particularly—indicating the paucity of larger purchases on the market. Hamilton was damaged by the financial failure of his excavation enterprises and ill health, and he went into semiretirement. Byres finally moved back to England in 1790.

There is no doubt that the altered political climate in Europe in the wake of the French Revolution had a fatal influence on Roman affairs; the eventual arrival of the French in 1798 brought the Grand Tour in its eighteenth-century form to an end, and the depredations of the Napoleonic Wars precipitated the dispersal of collections across Continental Europe, including that of the pope.[132] But in the 1770s Grand Tour Italy represented a highly structured marketplace, where receptive patrons undergoing education in the arts were in close proximity to a productive colony of artists. Even at its height, however, the commercial activity, directed by a small number of skilled individuals, was focused on a diminishing stock of antiquities and old master paintings. The rise in the number of British-led excavations at the time and the plethora of all types of copies of paintings, as well as the more obviously "touristy" purchases—fans, micro mosaics, pastes, and engravings, some of which can be seen in the cargo of the *Westmorland*—all indicate this trend, which it is perhaps tempting to characterize as a decline.[133]

With such assessments and with new work being done in this field, particularly concerning the role of Italians in the Roman market, it may be that this period, so often termed "the Golden Age of the Grand Tour," will be revealed to have been a frantic postlude to the collecting of the sixteenth and seventeenth centuries, with the earlier period being when the most significant discoveries of antiquities were made and the influential private collections of papal families in the city were formed.[134]

The *Westmorland*'s cargo provides us with a snapshot of the state of the market at the time, and as such it is far from being an artistic treasure trove. Nevertheless, its riches lie in the documentation it provides of a moment in the history of collecting of art in a Europe that, with the advent of Napoleon, was on the brink of destruction.

Much of the information on the contents of the *Westmorland* that appears in this essay is drawn from research by José M. Luzón Nogué and María Dolores Sánchez-Jáuregui. We would particularly like to thank Ms. Sánchez-Jáuregui for allowing us generous access to the database of the objects on board the *Westmorland*.

1. Stanring 1988, 610. The episode was first published in Whitley 1928, 2:75–76. Byres commissioned André de Muynck to complete the copies; he was apparently paid 7,000 livres. See Rosenberg 1994, nos. 63–69, 242.
2. Joshua Reynolds to Charles Manners, fourth Duke of Rutland, Oct. 4, 1786, in Reynolds 2000, 173. There is some evidence that the deception succeeded: a passage on Palazzo Boccapaduli published in about 1800 describes the "celebrated pictures representing the Seven Sacraments, by Poussin." J. Salmon 1798–1800, 2:59.
3. It is retold in most standard modern accounts of the Grand Tour. See Black 1992, 264; and Bowron and Rishel 2000, 39–40.
4. See, for example, *General Evening Post*, Sept. 19, 1786: "The Duke of Rutland has just purchased from a great collection of pictures, sold a short time since on the Continent, the Seven Sacraments, painted by the celebrated Poussin."
5. Writing at the end of the decade, the dealer Thomas Jenkins observed to the collector Charles Townley of the collection at Holkham Hall, formed in Rome between 1713 and 1717: "My Lord Leicester's Collection was made at a time when he was without a Rival, when Numbers of

things were to be Sold, therefore I always thought they must have been had on reasonable terms." Jenkins to Townley, July 15, 1779, TY 7/387, Townley Archive, British Museum, London.

6. For legislation in Rome, see Mariotti 1892, 220–25; Ridley 1992, 117–54, 140; and Emiliani 1996, 96–108.

7. Wilton and Bignamini 1996, 31.

8. William Patoun, in his advice on traveling, observed that "the best method I can recommend your Lordship to profit by the Antiquities, is to read over the Night before the Chapter in Venati's Book," referring to Ridolfino Venuti, *Accurata, e succinta descrizione topografica delle antichità di Roma* (Rome, 1763). See Ingamells 1997, xlv. A 1773 copy of Vasi's *Itineraire instructif divisé en huit journées* was on the *Westmorland* along with other guidebooks to the city, such as Joseph Jérôme Lefrançais de La Lande's *Voyage d'un François en Italie* (1769).

9. Wilton and Bignamini 1996, 10.

10. One painted copy of Raphael's *Madonna della Seggiola* arrived in one of the crates belonging to George Legge, Viscount Lewisham, and two others are described in crates marked "L. D." and "J. G.," belonging to unidentified owners. Several copies of Guido Reni's *Aurora* are described in the *Westmorland* inventories in different media: a gouache in a crate for Francis Basset (cat. 35); two oil paintings in crates marked "J. G." and "W. A. F.," respectively, for unidentified owners; two engravings by Jakob Frey, in a crate for George Moir and another marked "L. D."; and finally, a decorated fan (cat. 77) in one of the crates belonging to Frederick Ponsonby, Viscount Duncannon. This information is taken from the database created by Sánchez-Jáuregui.

11. The prize was determined in the Royal Academy Council on July 3, 1772, and the first student left for Rome in 1774. Frank Salmon pointed out that "even the prudent [John] Soane returned to Britain after only two years on the Continent with debts of £120." F. Salmon 2001, 29.

12. Lanciani 2000, 6:218–19. See also Bignamini and Hornsby 2010, 1:242–43.

13. Father John Thorpe described the practice of art dealing to Henry Arundell, eighth Baron Arundell of Wardour, in a letter from Rome dated Feb. 2, 1771: "For it is catch as catch can. The grand business is to have the first intelligence of where a good thing may be had, & there take it at first hand: for which purpose both an eye in the head and ready money in the pocket are necessary." Photocopies are in the Brinsley Ford Archive, Paul Mellon Centre, London.

14. Howard 1973, 40–61.

15. Giovanni Battista Piranesi had a shop in Strada Felice, while reproductive engravings by Jakob Frey of famous paintings could be purchased from Frey's son Filippo.

16. Goethe 1994, 425.

17. Kenworthy-Browne 1983, 37–132.

18. James Barry to Edmund Burke, undated (Rome, 1767), in Barry 1809, 1:70–71.

19. T. Jones 1946–48, 94.

20. Jenkins traveled to Rome with Richard Wilson; at the time both were portraitists. By 1753 Jenkins was handling Wilson's transactions with William Legge, second Earl of Dartmouth, and in 1758 he brokered Henry Hoare's commission of *Augustus and Cleopatra* from Anton Raphael Mengs. See Roettgen 1993, 149.

21. See Disney 1808, 4. Jenkins in turn was vilified in the circle around Palazzo Muti; see, for example, Dennistoun 1855, 1:287.

22. Thorpe observed to Lord Arundell, in a letter dated Feb. 6, 1774, that "no regard is here for Catholicks, the protestants are the first in favour, & to whom nothing is to be refused. This system is a mystery, & no one says by what merit Mr Jenkins & others have insinuated themselves into such distinction." Photocopies are in the Brinsley Ford Archive, Paul Mellon Centre, London. Jenkins is specifically designated as the British minister in the *Diario ordinario di Roma*. See Corp 2003.

23. For the most recent account of Byres's activity, see Coen 2002, 153–78.

24. For example, Elizabeth Somerset, Duchess of Beaufort, recorded visiting, in the company of Byres in 1775, "Minellis a sculptor and then to Hew[et]sons. They are both very good artists." "Minelli" was the *scalpellino* Antonio Vinelli, and Christopher Hewetson was the Irish sculptor. Ingamells 1997, 67.

25. C. F. Bell 1938, 16. Banks's opposition to Byres was probably "party political." When he was having difficulty securing payment from George Grenville (son of a former prime minister), for his relief entitled *Caractacus before Claudius* (Stowe House, Buckinghamshire), Jenkins (with whom Banks banked) wrote to Charles Townley to intercede on the sculptor's behalf: "if any thing can be done to Serve this Poor Man, it will be a kindness well Placd." Jenkins to Townley, April 4, 1778, TY 7/380, Townley Archive, British Museum, London.

26. Thomas Jones, on his departure from Rome in 1780, was accused by Byres, through his resident "puffer" (or promoter) Christopher Norton, of having "used him very ill" after he independently sold two landscapes to Byres's client Philip Yorke. As Byres had "not procured the commission," Jones felt he had "a right to be paid in the manner most convenient & profitable to myself." T. Jones 1946–48, 94. The two landscapes, *Lake Avernus* and the *Coast of Baja*, were included in Sumner and Smith 2003, nos. 104, probably 105.

27. T. Jones 1946–48, 56.

28. T. Jones 1946–48, 53, 94. Despite Jones's claim that the tradition was dying out, the English painter James North-cote recorded dining with Jenkins on Christmas Day 1778 "with a great many young painters." James Northcote to Samuel Northcote, Dec. 26, 1778, NOR/48, Royal Academy Archive, London.

29. For the contents of Byres's house, see "Inventory of the Furniture in the House of Mr James Byres at Rome," Byres/Moir Papers, National Library of Scotland, Edinburgh. The inventory was recently published in Coen 2010, 2:667–91, 709–12.

30. Recently Alastair Laing has added John Brown to this list. See Laing 2009, 12–17.

31. T. Jones 1946–48, 87–88. Jones's list of works executed contains the names of the dealers handling the transaction; they include a *View of Vietri* for Sir William Moles-worth, "to be delivered & pay'd for by Mr Jenkins," while Byres handled a commission from "Mr Powlet" and Gavin Hamilton handled one from Frederick Hervey, Earl-Bishop of Derry.

32. By 1777 Jenkins had superseded Francesco Barazzi as "chief Banker imploy'd by the English." See Hornsby 2009, 49–60.

33. Jenkins had several accounts with London banking houses, including Drummonds and Child's. His banking business was supposed to pass to Nicolas Castelli & Co. on Jenkins's departure from Rome, but in a letter to Townley in 1797 he noted: "I have Actually Given up My Bank & altho' at a Considerable loss." Jenkins to Townley, Sept. 23, 1797, TY 7/547, Townley Archive, British Museum, London.

34. Visconti and Visconti 1818, 1:248.

35. In the 1780s a string of European royalty was recorded visiting Jenkins's *museo*. See Vaughan 2000, 20–30.

36. Jenkins to Townley, April 1, 1775, TY 7/344, Townley Archive, British Museum, London. See Bignamini and Hornsby 2010, 2:235–36.

37. Vaughan 1987, 4–11.

38. At the conclusion of the protracted wrangling, during which Barry was arrested and denounced Townley at a meeting of the Society of Dilettanti for taking Jenkins's side, Jenkins lamented that for "a gentleman of Mr Barry's fortune and family to act as he does, is what I never could have expected," concluding that "the wanton tri-fling of Mr Barry and his agents have so totally deranged my affairs that it restrains me exceedingly." Jenkins to Townley, March 31 and Nov. 26, 1777, TY 7/368 and 7/377, Townley Archive, British Museum, London.

39. Letters from Robert Adam to his London agents, the firm of Innes and Clerk, specifically identify Barazzi as responsible for the export of Adam's property; for example: "Mr Barazzi is charged with all my cases and goods for England

which he is to send by first safe occasions, charging but little at a time aboard one vessel unless he is assured of a strong convoy to escort them in safety." Bolton 1922, vol. 2, pt. 7, app. A, 318–19.

40. Gavin Hamilton to Charles Townley, Aug. 5, 1774, TY 7/570, Townley Archive, British Museum, London. See Bignamini and Hornsby 2010, 1:195–96.

41. See Jenkins and Sloane 1996, 33.

42. Hutton 1885, 34–42. Ozias Humphry to Charles Rainsford, undated ca. 1773, HU/1/137, Royal Academy Archive, London.

43. Thorpe to Lord Arundell, Oct. 19, 1774. After James Hugh Smith Barry had been at Castle Gandolfo, Thorpe wrote, "Jenkins makes his new Country Seat to be a sort of Trap for such gentlemen." Thorpe to Lord Arundell, June 3, 1775. Photocopies of these letters are in the Brinsley Ford Archive, Paul Mellon Centre, London.

44. Ellis Cornelia Knight noted, "Vigna Margelli [Marzelli or Villa di Clodio], is a large house and vineyard, which formerly belonged to the Jesuits, it contains several good apartments, which are nearly filled up and let to different persons who wish to pass their 'Villeggiatura' here, the suite of rooms which formed the autumnal residence of the general of the order, was for many years inhabited by Mr Jenkins, whose acquisitions transmitted to England such numerous specimens of the classical ornaments of Italy." E. C. Knight 1805, 50.

45. Jenkins to Townley, June 6, 1775, TY 7/347, Townley Archive, British Museum, London. The paintings are recorded at Marbury Hall, Cheshire, in Waagen 1857, 406–13. They also appear in the drawings of Nikolaus Mosman in the British Museum. For the paintings attributed then to Gherardo della Notte (Gerrit van Honthorst) but now to Matthias Stom, see Verdi 1999, no. 7.

46. T. Jones 1946–48, 56.

47. T. Jones 1946–48, 59. It was on this occasion that Jenkins commissioned a painting from Jones (now lost) and designs for a villa from Hardwick (Sir John Soane's Museum, London). Hardwick's sketchbook in the Drawings Collection, Royal Institute of British Architects, London, contains a drawing from the terrace of the villa.

48. Jenkins's intelligence was not always infallible; in Sept. 1777 he informed Townley, "Mr Sandys is shortly expected in Rome as travelling governor to a young Scot whose name I do not know." Jenkins to Townley, Sept. 30, 1777, TY 7/375, Townley Archive, British Museum, London. The "young Scot" accompanying the Reverend William Sandys was Francis Basset of Cornwall. Jenkins recorded their arrival by the end of Oct. 1777.

49. Tiroli 1775.

50. T. Jones 1946–48, 70–71.

51. Gray 1794, 351–52.

52. Orlandi acted as cicerone for a number of Jenkins's clients, including Prince Henry, Duke of Cumberland and Stratheam, in 1773; on the arrival of Elizabeth Chudleigh, Duchess of Kingston, in 1774, Jenkins informed Townley that "I have just placed Orlandi with her for antiquary." Jenkins to Townley, Feb. 16, 1774, TY 7/326, Townley Archive, British Museum, London.

53. For Jenkins's will, see 11/1315, fols. 60v–67r, PROB, Public Record Office, National Archives, Kew, in which the relationship with Hewetson is described as "nostra costante amicizia." See also Ford 1974, 416–25; and most recently, Cesareo 2009, 221–50.

54. Jenkins to Townley, April 3, 1776, TY 7/354, Townley Archive, British Museum, London. In the letter Jenkins wrote that he was sending Townley "a Portfolio Containing Stern's design for Mr. Barry Proposd Room which I hope you will think very much to the purpose and in the true stile of the ancients."

55. Jenkins to Townley, July 15, 1779, TY 7/387, Townley Archive, British Museum, London.

56. See Coltman 2009, 58.

57. James Barry to Edmund Burke, Jan. 6, 1769, in Barry 1809, 1:108–17. Barry referred to a "quarrel with Byres the antiquary," explaining that Williams Wynn "was in the hands of Byres, Hewetson, Forrester, Delane &c who had every opportunity to put things in such light as would best answer their own schemes." In an earlier letter Barry wrote of having had an argument in the Caffè degli Inglesi with a man "who from the nature of his business & situation is courted exceedingly by such artists as desire to make either money or friends here as he & one or two more of the same interest & opinion are the only channels through which the acquaintance of English Gentlemen come." Barry to Burke, May 23, 1767, in Barry 1809, 1:67–75.

58. John Deare to John Cumberland, March 1, 1794, Add. MSS 36496, British Library, London. During the 1770s Jenkins acted for numerous British artists; in 1775 he sent Joseph Wright of Derby's paintings home for him. See Joseph Wright to Ozias Humphry, July 24, 1775, in Barker 2009, 86.

59. Thomas Jenkins to Sir William Hamilton, July 24, 1778, Osborn MSS, 8080, Beinecke Rare Manuscripts Library, Yale University.

60. AD894/7/6, 1777, Tehidy estate accounts, Cornwall Record Office, Truro. Basset banked in London with Sir Robert Herries & Co., whose Roman agent was Jenkins. The Herries accounts for this period have been destroyed.

61. In 1775 Jenkins wrote to Townley: "Mr. Sandys's his Commission was Immediately orderd, I have Got all Cav. Piranesi Works ready, and as Soon as ever a Perfect Set of the Coloured Prints are Compleat, the whole will be Sent away as directed." Sandys in turn corresponded with Townley about the commission. See TY 7/1203–4, Townley Archive, British Museum, London.

62. D(W)1778/V/853, Papers of the Legge Family, Earls of Dartmouth, Staffordshire and Stoke-on-Trent Archive Service, Staffordshire Record Office, Stafford (hereafter SRO).

63. SRO.

64. A letter from Jenkins to Dartmouth dated Sept. 2, 1778, records that "on my Lord Lewisham leaving Rome, he was pleased to honor me with his commands for such of his affairs as were not then completed, with orders to forward the things as soon as ready to your lordship." D(W)1778/III/378, SRO.

65. For a series of letters from Jenkins with drawings, dated between 1763 and 1769, see MSS fols. 46A, 77A, 240, Bessborough Papers, West Sussex Record Office, Chichester.

66. Coltman 2009, 49–83.

67. "I mentioned in my last a sleeping mercury which is good figure & very entire but decline sending it you, having it in my power to serve you." Hamilton to Townley, Oct. 13, 1774, TY 7/572, Townley Archive, British Museum, London.

68. Hamilton to Townley, March 21, 1775, TY 7/584, Townley Archive, British Museum, London.

69. Jenkins to Townley, April 1, 1775, TY 7/344, Townley Archive, British Museum, London.

70. For this whole affair, see Bignamini and Hornsby 2010, 134–40.

71. Jenkins to Townley, Jan. 29, 1782, TY 7/411, Townley Archive, British Museum, London.

72. For Hamilton's schemes for Lansdowne House, see Stillman 1970, 75–80. Despite Hamilton's best efforts the gallery was never built. Its rarity was appreciated by contemporaries; Jenkins observed that it represented "a Species of Magnificence very Rare in England." Jenkins to Townley, June 7, 1777, TY 7/369, Townley Archive, British Museum, London.

73. Jenkins to Townley, Jan. 5, 1774, TY 7/324, Townley Archive, British Museum, London.

74. Hamilton's reference to Greek sculpture reminds us that by the 1770s, visitors and dealers were aware of the system of classification derived from Johann Joachim Winckelmann's Geschichte der Kunst des Alterthums (1764), a French translation of which was on board the Westmorland, in a crate apparently destined for the Earl of Dartmouth. See Winckelmann 1766.

75. For a discussion of Genzano, see Bignamini and Hornsby 2010, 1:88–90.

76. For example, an earlier license taken out by a third party on the cardinal's behalf confirms this practice: "1771, 19 Luglio. "Per tenore . . . Concediamo licenza al Sig.r Ales-

sandro Cassini per commodo di S. Eminenza Sig.r Card.e Alessandro Albani cavare nella Vigna di detto Sig.r Casini posta fuori di Porta S. Sebastiano e precisamente incontro Vigna Videschi . . . Tavolozza." (1771, 19 July, on behalf of. . . . We grant a license to Signor Alessandro Cassini for the convenience of His Eminence Cardinal Alessandro Albani [to] excavate in the vineyard of the said Signor Cassini, located outside Porta San Sebastiano, precisely toward the Videschi vineyard.) Vol. 24 [=*Pres. Strade. Lettere Patenti*, b. 67], c. 83 [MS Lanc. 115, fol. 46], in Lanciani 2000, 6:184 (translation by Clare Hornsby).

77. "(1773). Al vetturino di Capranica Mattia Colmeglia p. carozza, 26 e 27 Xbre per la gita di Genzano con patto d'andare a Monte Cagnolo e altrove col Sig. Sibilla per la visita in Genzano de' marmi trovati e de' luoghi degli scavi Sc. 8.05." (To the carrier from Capranica Mattia Comeglia for [hire of] a carriage on October 26 and 27 for the trip to Genzano in order to go to Monte Cagnolo and other places with Signor Sibilla, for visiting at Genzano the marbles that had been found and the places where they were found.) MS Lanc. 115, fol. 62, in Lanciani 2000, 6:185 (translation by Clare Hornsby).

78. Some of the letters from Jenkins are of the following dates: March 26, 1774; June 15, 1774; Jan. 7, 1775; Jan. 17, 1776; July 23, 1777; Oct. 29, 1777; Dec. 24, 1777. Townley Archive, British Museum, London.

79. Vat. Lat. 10307, fol. 91r, Biblioteca Apostolica Vaticana, Rome.

80. Dec. 24, 1777, TY 7/378, Townley Archive, British Museum, London. This refers to the elderly Alessandro Albani, the noted collector, who was to die in 1779, and not to the cardinal-bishop of Ostia, Giovanni Francesco, who was his nephew, as appears in an editorial addition to a quotation from this letter in Bignamini and Hornsby 2010, 1:88.

81. It is clear, however, that only one case was on the *Westmorland* when it arrived in Málaga, and it is therefore likely that the others were taken off and sent by another vessel since the delay in sailing from Livorno was considerable; see the essay by Eleanor Hughes in the present volume.

82. Feb. 1779, TY 7/386, Townley Archive, British Museum, London.

83. "N° 22 Dos Faunitos en pequeño q. parecen antiguos por lo gastados en parte: son de marmol de carrara, el uno tiene un sistro en cada mano, y el otro un tirso en la diestra." (No. 22 Two very small fauns that appear to be antique given their partially worn condition, [which] are made of Carrara marble; one holds a sistrum in each hand and the other a thyrsus in the right hand.) Crate "C. T.," 4-87-1-49, Archivo-Biblioteca, RABASF (translation by Clare Hornsby).

84. Luzón Nogué 2002a, 95.

85. Howard 1990, 117–29.

86. For the ship *Favorite* and the *Homer*, respectively, see Jenkins to Townley, Nov. 15, 1780, and Jan. 18, 1783, TY 7/656 and 7/656, Townley Archive, British Museum, London.

87. Browne to Townley, July 1776, TY 7/1489, Townley Archive, British Museum, London.

88. The plate was inscribed, "urna cineraria antica di marmo con suo coperchio, una volta si vedeva in Roma appresso il Signor Tommaso Jenkins" (antique marble cinerary urn with its own cover, formerly at Rome, in the collection of Mr Thomas Jenkins). Wilton-Ely 1994, vol. 2, no. 983 (translation by Clare Hornsby). *Corpus inscriptionum Latinarum*, 6:3495.

89. Thomas Jenkins to Lord Bessborough, Rome, April 23, 1763, MSS fol. 46A, Bessborough Papers, West Sussex Record Office, Chichester.

90. For the *Cupid and Psyche*, see Haskell and Penny 1981, 189–91. For the Mattei *Amazon*, which was excavated in 1770, see Spinola 1999, 2:48.

91. The dubious circumstances of its restoration are colorfully described in Smith 1828, 1:11–12.

92. Aug. 9, 1769, fol. 38, Royal Academy Library, London, Council Minutes (C), vol. I. The gift is mentioned in Baretti 1781, 29; referring to Jenkins, Baretti observed that "a great dealer in antiquities" sold the original sculpture for £3,000, and Baretti added rather pointedly, "If the fact is true, this ought to be the Venus of all Venusses."

93. Jenkins to Townley, Sept. 27, 1768, TY 7/297, Townley Archive, British Museum, London.

94. The visit is recorded in the *Diario ordinario di Roma*, nos. 8350, 8352–64.

95. Jenkins to Townley, Oct. 9, 1772, TY 7/316, Townley Archive, British Museum, London.

96. González-Palacios 2008, 17–23.

97. Hamilton to Townley, May 27, 1776, TY 7/610, Townley Archive, British Museum, London.

98. "[No.] 310. Quadraro. Di pertinenza di S.E. il Signor Principe Sciarra Barberini confinante colle Vigne di Roma, e colle Tenute di Tor S. Giovanni, S. Croce, o Casatta degli Angeli, Tor spaccata, o sia Roma vecchia, Quadrato, Carcaricola, Torrenova, Quarticciolo di S. Maria Maggiore, e Casetta, o Casacalda. Estensione totale ritrovata maggiore di quella indicata nella Pianta del Cingolani . . . R[ubbi].a 401." (Quadraro, belonging to His Excellency Prince Sciarra Barberini, bordering the vineyards or Rome and with the landholdings of Tor S Giovanni, S. Croce, or Casatta degli Angeli, Tor Spaccata otherwise known as Roma Vecchia, Quadrato, Carcaricola, Torrenova, Quarticciolo of S Maria Maggiore, and Casetta or Casacalda. Total extent found to be greater than that shown in the plan of Cingolani . . . 401 rubbia). For the

estate details, see Albani 1783, fol. 487:3 (translation by Clare Hornsby).

99. See Yarker and Hornsby 2011, 21–29.

100. Jenkins to Townley, July 23, 1777, TY 7/371, Townley Archive, British Museum, London. Jenkins compared the *Minerva* to one that had been restored for Pierre-Gaspard-Marie Grimond d'Orsay. See Brook and Curzi, 2010, 411, no. III.7.

101. See Bowron and Rishel 2000, 550.

102. Horace Walpole observed that Maratti "formed a new Roman School, and added grace, beauty, and lightness, to the majesty, dignity, and solemnity of their predecessors, namely Guido, Carracci and Raphael." Walpole 1767, vi.

103. See Torre 2002, 431–62. For the art market in Venice in the eighteenth century, see Borean and Mason 2009.

104. Buchanan 1824, 1:320–34. The collection arrived in London in 1777; Moore Slade eventually sold the Venetian paintings, including five canvases attributed to Titian, to John Bligh, fourth Earl of Darnley. See Penny 2008, 448–49.

105. The Ansidei altarpiece came from the monastery of San Fiorenzo dei Serviti in Perugia and is now in the National Gallery, London. See Cesareo 2002, 233–34. The *David* was sold at Christie's, London, July 6, 2010, lot 7, and the *Samian Sybil* is still at Althorp House.

106. For Raphael alone, failures include Jenkins's attempt to purchase the *Madonna di Foligno* from the monastery of Sant'Anna in Foligno in 1770 and Hamilton's attempt to purchase the early *Coronation of Saint Nicholas of Tolentino* from the church of Sant'Agostino in Città di Castello in 1788.

107. As Steffi Roettgen observed in relation to Mengs's painting of a *Sibyl*, he "was aiming for a synthesis of the qualities of those seventeenth-century Bolognese masters [Guercino, Domenichino, and Guido Reni] to whom he felt the greatest affinity." Roettgen 1993, no. 23.

108. James Northcote observed in 1778 that "one or two miserable wretches who are sycophants to them [British dealers] make all the copies for the English nobility at very small prices. Besides there are the Italian painters who are starving although they can live on almost nothing, and these work for the meanest trifle." James Northcote to Samuel and Polly Northcote, Feb. 4, 1778, NOR/40, Royal Academy Archive, London.

109. See, for example, García Sánchez and de la Cruz Alcañiz 2010, 665–70; and Arizzoli-Clémentel 1985, 73–84.

110. In the second *Discourse* Reynolds specifically discouraged the "drudgery of copying," which he considered "a delusive kind of industry." See Wark 1997, 29.

111. James Barry to Edmund Burke, Jan. 6, 1769, in Barry 1809, 113.

112. J. Richardson 1719, 226.

113. For copying in the Uffizi, see Borroni Salvadori 1985, 3–72.

114. For the most recent discussion of the project, see Wood 1999, 394–417. Batoni's copies are now in Palazzo Labia, Venice.

115. See Figgis 1998, 53–56. In 1774 Thorpe noted that "the English artists expect to make mountains of gold by their copies of it [the *Transfiguration*]." Thorpe to Lord Arundell, Nov. 16, 1774; see also July 30, 1774, and Oct. 15, 1774. Photocopies are in the Brinsley Ford Archive, Paul Mellon Centre, London.

116. Thorpe to Lord Arundell, Feb. 20, 1771. Photocopies are in the Brinsley Ford Archive, Paul Mellon Centre, London.

117. Figgis 1998, 53–56.

118. "Mr Nevay likewise promises to finish by the same time the copy of the Fortune by Guido, the head of the Sappho is done, as also the Jupiter and Juno from Carrach." James Byres to William Constable, June 20, 1772. See I. Hall 1970, no. 87.

119. Allan was asking 50 sequins for the copy. Patrick Home to Thomas Chase, June 3, 1775. Although Home seems not to have purchased the finished picture, he did commission a copy of the ancient fresco known as the *Aldobrandini Wedding* from Allan through Colin Morison. In a note of things to be sent, Home mentioned "two pictures by Allen. Priest confessing and a copy of the Aldobrandini marriage for both of which paid 30 Roman sequins without frames." Patrick Home, MS Notebooks, June 15, 1775. Photocopies of the letter and diary are in the Brinsley Ford Archive, Paul Mellon Centre, London.

120. See Westmorland 2002, no. 92 (entry by Ana María Suárez Huerta). Francis Basset eventually installed a large copy of the *Aurora* on the ceiling of the Saloon at Tehidy Park. For the ubiquity of the composition, see Russell 1975–76, 109–11.

121. For a description of Ribston and the painters involved in the scheme, see Hargrove 1798, 242–43.

122. At Palazzo Spada the Guercino actually hung next to Giacinto Campana's contemporary copy of the Reni, the original having been sent to France. See Pepper 1984, no. 132.

123. As the British tourist John Owen observed, the *Aurora* was a painting "so often engraved, that a transcript of its beauties—so far as frescoes can be copied into miniatures—is in the collection of every one who is at all an amateur of the fine arts." Something similar could be said for Giovanni Volpato's engraving of Raphael's *School of Athens*, copies of which were in crates owned by the Earl of Dartmouth, Penn Assheton Curzon, and Basset; in all, ten impressions were on board. J. Owen 1796, 2, 43.

124. The dissemination of Volpato's engravings north of the Alps was the subject of a recent exhibition, although there is very little on the British use of the engravings. Gilet 2007.

125. Coltman 2006, 97–123.

126. Hopkinson 2009, 365–69.

127. Hamilton described the Carracci as "boldly painted tho' not high finished . . . in a word it is more a fine picture than a pleasing one." The painting is now missing. Hamilton had contracted to send Lord Upper Ossory "one agreeable picture of each good master" to fill the gallery of the earl's Bedfordshire house, Ampthill Park. Gavin Hamilton to John FitzPatrick, second Earl of Upper Ossory, March 6, 1770, National Library of Ireland, Dublin.

128. Hamilton 1773, pl. 28. A print by Cunego on board the *Westmorland* after a version of Jusepe de Ribera's *Pietà* in the Certosa di San Martino in Naples, subsequently in the collection of Lord Arundell of Wardour, suggests another such instance of attempts by a British dealer to celebrate an exportable painting. The picture was sold at Sotheby's, London, Dec. 12, 1990. It had previously been sold at Sotheby's on April 22, 1953, lot 56, erroneously labeled "from the collection of the Earl of Arundel."

129. For a discussion of Hamilton's activities as a dealer of paintings, see Cesareo 2002, esp. 231–44.

130. Orlandi 1775.

131. Notable examples include Count Jan Potocki and Princes Stanislas Poniatowski and Nikolai Borisovich Yusupov, as well as the Grand Duke Paul and Grand Duchess Maria Feodorovna of Russia.

132. Some recent scholarship has attempted to stress a continuity into the nineteenth century, but after 1798 the "infrastructures" of Grand Tour travel discussed in this essay were so radically altered that the process and experiences of travel were completely different. See, for example, in F. Salmon 2001.

133. See "A Calendar of Excavations," in Bignamini and Hornsby 2010, 1:35–37. There were approximately sixty British-led excavations from the mid-1760s to 1798.

134. Recent studies include Coen 2010, Petrucci 2010, and Paul 2008, as well as a number of recent exhibitions examining the Italian Grand Tour: for example, d'Agliano and Melegati 2008, and Brook and Curzi 2010. Adolf Michaelis, in Michaelis 1882, called the period the "golden age of classical dilettantism."

Educating the Traveler: The Tutors

MARÍA DOLORES SÁNCHEZ-JÁUREGUI

In earlier years I sometimes had the odd notion that nothing could please me more than to be taken to Italy by some knowledgeable man, say, an Englishman well versed in art and history.

—*Johann Wolfgang von Goethe*

GOETHE'S WORDS on his arrival in Rome point to the cultural significance of the figure of the tutor who traveled with young Grand Tourists. Through the signatures and annotations in the books that constitute an important part of the materials on the *Westmorland*, it has been possible to identify the names of the tutors who accompanied three of the travelers sending possessions home on the ship.[1] The crates belonging to George Legge, Viscount Lewisham, contained two Italian grammars, a collection of prints by Jakob Frey, and maps of Rome and of the drainage of the Pontine Marshes, all inscribed "D. Stevenson, Rome 1778" (fig. 50).[2] Among the items sent by Frederick Ponsonby, Viscount Duncannon, were maps, a musical score, and various views of ancient Roman monuments, marked with the initials "S: W: T:" or the name "Mr. Thomson," corresponding to his tutor, Samuel Wells Thomson (fig. 51).[3] Francis Basset's tutor, the Reverend William Sandys, added his signature to various works of history, geography, and poetry in Basset's crates (fig. 52).[4] The presence of these names suggests that it was the tutors rather than the young aristocrats who were the owners of these "souvenirs," which in turn

reveals much about the tutors' backgrounds and particular interests. By piecing together what is known of David Stevenson, Thomson, and Sandys, we can not only recover something of the identities of these three men but also bring into greater focus the previously under-examined role of the Grand Tour tutor.

The word "tutor" is itself problematic. Grand Tour literature includes at least three different terms that describe the person who accompanied and took charge of the young travelers: "bear leader," "tutor," and "governor," of which the latter two are the most commonly encountered (fig. 49).[5] Although it would seem that a tutor played an active role in the education of the young tourist while a governor probably supervised his general behavior and moral welfare, the distinction is not clear. On occasion all three terms are employed to describe the same person.[6] A letter from Lord Lewisham to his father, William Legge, second Earl of Dartmouth, and the latter's reply are revealing of both the terms and the ambiguous class status of the position:

> Stevenson—which I am very sorry for—was mentioned in Lord Carmarthen's letter as my *gouverneur*, a charge which is here confided to such low people, that the "Gens de condition" do not shew attentions to the travelling tutors *vulgo*—bearleaders; so that by that means, Stevenson is unfortunately excluded from those societies for which I am *redevable* to the Duke de Nivernois.[7]

Figure 49. Pier Leone Ghezzi, *Dr. James Hay as a Bear Leader*, ca. 1725,
pen and brown ink, 14¼ x 9½ in. (36.3 x 24 cm). British Museum, Department of Prints and Drawings

Figure 50. Giambattista Ghigi, *Pianta delle Paludi Pontine* (Rome, 1778), engraving and watercolor, 21⅞ x 31¼ in. (55.5 x 79.5 cm). Real Academia de Bellas Artes de San Fernando, Archivo-Biblioteca (cat. 114), and detail showing Stevenson's signature on the verso

Figure 51. Joseph Haydn, *Six Simphonies, ou Quatuors dialogués pour deux violons . . .* (Paris, 1764?). Real Academia de Bellas Artes de San Fernando, Archivo-Biblioteca (cat. 90), detail showing Thomson's signature

Figure 52. Pietro Giannone, *Istoria civile del Regno di Napoli* (The Hague, 1753). Real Academia de Bellas Artes de San Fernando, Archivo-Biblioteca, detail showing Sandys's signature, location, date, and price

I am exceeding vexed at your disappointment in Mr. Stevenson's not being included in the civilities shown to you by the D. de Nivernois, and I cannot understand how it has happened, for I particularly desired Lord Carmarthen to mention him as a friend and companion of yours, and he told Lady D., who saw him the day before yesterday, that he had done so, and that he had not made use of the obnoxious word *Gouverneur*.[8]

In fact, in all the letters that the Earl of Dartmouth addressed to his son, he always referred to Stevenson as "your companion."

Frequently we know little of the educational backgrounds of the tutors. Of the 174 tutors, governors, and bear leaders recorded in John Ingamells's *Dictionary of British and Irish Travellers in Italy, 1701–1800*, information on their education and studies is provided in only fifty-seven cases; of those, fifty-three had university qualifications before becoming tutors or travel companions, including those who were ordained ministers. Only eighteen had joined the Church of England before embarking on the trip. In a few instances Ingamells's *Dictionary* records the type of university qualifications obtained, of which a bachelor of arts degree was the most common, fol-

lowed by a master of arts degree. Two of the tutors associated with the *Westmorland*, Thomson and Sandys, were ordained ministers at the time of their departure. The former had studied at Christ Church, Oxford, obtaining a doctorate in canon law, and was a fellow of the Royal Society, London.[9] Sandys had a master's degree from All Souls, Oxford, and was vicar of the parish of St. Illogan, in Cornwall, when he set out to accompany Basset. Stevenson does not seem to have had any connection with the Church of England.[10] Another sizable group of tutors had military backgrounds,[11] and we also encounter various examples of those belonging to the liberal professions who acted as Grand Tour tutors.[12]

The tutor was a director of studies rather than a teacher. He planned timetables and subjects, selected teachers and ciceroni, and supervised progress. Ultimately he was the only figure accountable to the parents of his charge. In a letter sent to the Earl of Dartmouth from Tours, Stevenson, Lord Lewisham's tutor, provided information on the program that they were following at an academy there:

At seven the fencing begins, which lasts usually till half after eight, when we breakfast. At nine the dancing master and Lord Lewisham open the ball,

which seldom closes before eleven; from that time to one French is the only employment; from one to two, hour of dinner, the Abbé reviews our compositions. At half after three we begin reading to the Abbé; this exercise usually lasts two hours, when we walk. At dusk we return, and commonly close the day with a sober rubber at whist.[13]

The tutor-pupil relationship, and the ways in which differences in social standing were resolved when abroad and within the circumstances of the trip, involved a complex set of negotiations. How, for example, did a tutor, who was a servant employed by the parents of his charge, exercise the necessary authority and control without earning himself the enmity of the young man in his care? And what status was the tutor to be accorded in the various social situations that would arise during the tour? The Earl of Dartmouth's displeasure on learning that his son's tutor had not been appropriately treated has already been mentioned. In fact, the entire correspondence between the earl, Lord Lewisham, and Stevenson makes clear that Stevenson was present at and fully participated in Lewisham's social activities.

In the balance of power between tutor and charge, control of the finances was in the hands of the tutor, who had the authority to withdraw money from the parents' account when abroad and was responsible for managing the young person's expenses. This meant that all bills, from lodgings to food and including books, paintings, antiquities, and other items that could be acquired, were settled, and thus overseen, by the tutor (fig. 53). Naturally he was obliged to justify all expenses to the parents.[14] Once again, a letter from Stevenson to the Earl of Dartmouth is illuminating:

I shall never be inattentive to so essential an article as the expenses. I think it one of the first duties imposed on me by my charge. I will never exceed the needful, if I can possibly avoid it. But your Lordship must view me in the light of a man, who has not only your and Lord Lewisham's common interests to manage, but likewise his passions to direct. For this reason I do not always oppose him in the gratification of an innocent wish, which

may cost a trifle. By interposing and contradicting too often, I might become importunate and lose that weight, so necessary to be preserved for important occasions, such have and must necessarily occur.[15]

In turn the role of tutor offered bright and well-educated men an unparalleled opportunity to gain access to higher social circles and to develop their particular interests. The tutor Joseph Spence expressed it this way: "One of the greatest advantages in travelling, for a little man like me, is to make acquaintance with several persons of higher rank than one could well get at in England."[16] In the years that he spent as a tutor in Italy, Spence posed for the portraitist Rosalba Carriera, became friends with the antiquarians Francesco Ficoroni and Baron Philipp von Stosch, and wrote his book *Polymetis*.[17] For such men the Grand Tour thus offered an outstanding opportunity for social advancement. Robert Liston, minister plenipotentiary in Madrid in 1784 and responsible for the *Westmorland* claims, had himself traveled around Italy as a tutor between 1769 and 1770.[18]

In order to become a tutor it was useful to have already been to continental Europe, and it was normal for tutors to accompany young aristocrats on more than one occasion.[19] Among the best-known cases are those of James Hay, who was tutor to eight different travelers over the course of thirty years, and Edward Holdsworth, who acted as tutor on five occasions.[20] This might point to a certain degree of specialization and explain the fact that these tutors undertook almost identical routes with very different young men. After years accompanying young travelers, the tutors would have established a personal network of lodging places, transport, and personal associations that largely determined their routes and, on occasion, their contacts in the art world.

To some extent, this was the case with William Sandys. Son of a steward on the Basset estates, Sandys was at Eton as tutor to John Prideaux Basset, whom he would undoubtedly have accompanied on his Grand Tour had Basset not died at the age of sixteen. Sandys went up to Oxford, where he obtained a bachelor's degree in 1760 and a master's degree in 1763.[21]

Figure 53. James Russel, *William Drake of Shardeloes with His Tutor Dr. Townson and Edward Holdsworth in His Apartment in Rome*, 1744, oil on canvas, 18 x 24 in. (45.7 x 61 cm). Tyrwhitt-Drake Collection

Some years later, in 1771, he went to Italy, where he remained until 1774. Among the few known contemporary references to him, one by Joseph Farington specifically refers to this first trip.[22] We know that he was in Capua, probably in late 1772, and the following year was in Rome, where he made friends with the landscape artist Jacob More, who had recently arrived there. In May 1774 Sandys was in Florence with Charles Bampfylde, John Barber, and another Grand Tourist named Derval. At this point (or possibly when previously in Rome) he learned that Bampfylde had commissioned a landscape from Solomon Delane that was associated with the villa of the classical Roman poet Horace, near Licenza. Sandys's contacts with the Italian art world went further. On his return to

England, for example, he remained in contact with the art dealer Thomas Jenkins. In the sizable correspondence between that dealer and the collector Charles Townley, the former mentioned a commission for Sandys: "Mr Sandys's his Commission . . . Cav. Piranesi Works ready, and . . . a Perfect Set of the Coloured Prints are Compleat, the whole will be Sent away as directed."[23]

We have seen that Sandys was perfectly familiar with the workings of the Italian art market from the time of his first trip. In fact, the contacts he established during that trip may largely explain the collection that Francis Basset built up during his Grand Tour. In 1777, when Sandys was once again in Rome, accompanying the young Basset, Delane was still in

Figure 54. Solomon Delane, *View of the Monastery of San Cosimato*, 1778, oil on canvas, 59 x 94⅛ in. (150 x 239 cm). Real Academia de Bellas Artes de San Fernando, Museo (cat. 22)

possession of the painting that he had executed for Bampfylde, which that Grand Tourist ultimately did not purchase.[24] It must have been through the mediation of Sandys that the painting (fig. 54) was finally acquired by Basset. Again probably through Sandys, Basset commissioned a painting from More and a set of six watercolors that More would later send to Sandys, suggesting that the two watercolors by More on board the *Westmorland* (cats. 52–53) were also for Basset.[25] Another of Sandys's earlier contacts was Giovanni Battista Piranesi. In Basset's crates on board the ship were no fewer than fourteen volumes of the artist's work, and the grateful Piranesi dedicated to Basset a print from his two-volume series *Vasi, candelabri, cippi, sarcofagi, tripodi, lucerne ed ornamenti antichi* (Vases, Candelabras, Gravestones, Sarcophagi, Tripods, Lamps, and Antique Ornaments). Piranesi also

wished to acknowledge Sandys and dedicated a different print of the same tripod to the tutor in order to complete the set.[26] Among the *Westmorland*'s objects were two loose prints of this tripod, which may well have belonged to Sandys (cats. 38–39). In addition to artists, Sandys had friends among the dealers. Jenkins wrote to Townley from Castel Gandolfo: "I hear Mr Sandys with his Pupil are in Rome, tho' I have not yet seen them."[27] Some of the items in Basset's cargo undoubtedly must have been purchased through Jenkins.[28]

Sandys's connections with artists and the art market, together with other known examples of tutors, among them John Clephane and William Patoun, suggest that the role of the tutors within the complex phenomenon of Grand Tour collecting has been underestimated in previous literature on the subject.

Figure 55. Johan Zoffany, *The Tribuna of the Uffizi* (detail),
1772–77, oil on canvas, 48⅝ x 61 in. (123.5 x 155 cm). The Royal
Collection, Her Majesty Queen Elizabeth II

Tutors must have been present whenever a work of
art was purchased or commissioned as well as on the
occasion of visits to artists' studios, and their letters
and diaries constitute an important source for docu-
menting the Grand Tour.[29]

In the spring of 1778 Basset made a second visit to
Florence and, in the company of the British diplomat
Sir Horace Mann attended the baptism of the second
son of the third Earl Cowper.[30] Sandys must also have
maintained friendships in Florence from his previous
visits. Having gained access to Florentine cultural cir-

cles, it is likely that Sandys and Basset would have met
the painter Johan Zoffany while he was completing his
painting *The Tribuna of the Uffizi* (fig. 25).[31] Zoffany's
selection of the individuals to be included in his paint-
ing was both well known in English circles and a matter
of considerable criticism. Having seen the canvas on
its arrival in England, Horace Walpole wrote to Mann
that it was "absurd . . . rendered more so by being
crowded with a flock of travelling boys and one does
not know nor care whom," to which Mann replied, "I
told him often of the impropriety of sticking so many
figures in it . . . he made the same merit with all the
young travellers at Florence, some of whom he after-
wards rubbed out."[32] In fact, Zoffany continued to add
figures to the painting until just prior to his return to
England.

In December 1777 Zoffany added the portraits of
Lord Lewisham and his tutor, Stevenson, next to the
depiction of Raphael's *Niccolini-Cowper Madonna*.[33]
A similarly arranged group stands next to the sculp-
ture of the dancing satyr. The younger man seems to
be speaking while he looks at a second, apparently
older one who is seen in profile contemplating the
sculpture (fig. 55). The former identification of the
younger man with Joseph Leeson, Viscount Russbor-
ough (who was born in 1730), is no longer thought ten-
able, and it should be noted that the features of this
young Englishman are strikingly similar to Italian por-
traits of Francis Basset. While the older man has been
identified as Valentine Knightley of Fawsley, might it
not be possible that these two are Basset and Sandys?[34]

Stevenson, Sandys, and Thomson, the three tutors
associated with the *Westmorland*'s contents, along
with others such as Joseph Spence, Robert Liston,
and William Patoun, represent an entire generation
of well-qualified men for whom the occupation of
tutor offered a means of prospering and advancing
their professional ambitions, and whose knowledge
and taste enriched the experience of the Grand Tour.

The epigraph is from a letter by Johann Wolfgang von Goethe, Nov. 7, 1786, in Goethe 1994, 109. A few days earlier, on Nov. 1, Goethe had written, "Yes, I have finally arrived in this city, the capital of the world! I wish I had been in the fortunate position of seeing it fifteen years ago with good companions and some really intelligent man as a guide." Goethe 1994, 103.

1. An essential text for the present study is John Ingamells, *A Dictionary of British and Irish Travellers in Italy, 1701–1800: Compiled from the Brinsley Ford Archive* (hereafter Ingamells 1997). The evidence provided by some of the objects on the *Westmorland* enabled us to confirm the tutors' identities and, in the case of Samuel Wells Thomson, to correct the spelling of his surname. The general information on the tutors provided here derives from a more extensive study on the subject that will be included in a chapter in the present author's doctoral thesis.

2. Benedetto Buonmmattei, *Della lingua toscana* (Naples, 1759), C-189, Archivo-Biblioteca, RABASF; Girolamo Gigli, *Regole per la toscana favella* (Rome, 1721), B-2978, Archivo-Biblioteca, RABASF; twelve loose engravings by Jakob Frey, all signed on verso, B-8, Archivo-Biblioteca, RABASF; Michael and Franciscus Tramezini, *Effigies antiquae Romae ex vestigiis . . .* (Rome, 1773), all sheets signed on verso, B-1893 and B-1893bis, Archivo-Biblioteca, RABASF; and Giambattista Ghigi, *Pianta delle Paludi Pontine* (cat. 114).

3. Two maps of Naples: Giuseppe Bracci and Antoine Cardon, *Icon sinus Baiarum . . .* (Map of the Gulf of Baia), Mp-29, Archivo-Biblioteca, RABASF, and *Antiquitatum Neapolitanarum* (Naples: printed by Filippo Morghen, 1772), Mp-26, Archivo-Biblioteca, RABASF; a score by Joseph Haydn (cat. 90); and gouache views of the Flavian Amphitheater (known as the Colosseum), the Arch of Titus, the Arch of Constantine, and the Temple of Antoninus and Faustina (cat. 74), all in Rome, and of the temples of Vesta and of the Sibyl at Tivoli (cat. 73). All these items were signed either "S: W: T:" or "Mr. Thomson."

4. These are Pietro Giannone, *Istoria civile del Regno di Napoli*; J. Trusler, *Chronology or, The Historian's Vade-Mecum . . .* (cat. 50); Agostino Gobbi, *Scelta di sonetti e canzoni de' più eccellenti rimatori . . .* (Venice, 1739), B-2171-75, Archivo-Biblioteca, RABASF; Benedetto Varchi, *Istoria delle guerre della Republica Fiorentina . . .* (Leiden, [1600s]), C-306, Archivo-Biblioteca, RABASF; Ottavio da Beltrano, *Breve descrittione del Regno di Napoli . . .* (Naples, 1644); *The Miscellaneous Works of H. St John Vct. Bolingbroke* (Edinburgh, 1733); G. M. della Torre, *Storia e fenomeni del Vesuvio . . .* (Naples, 1755); and della Torre, *Incendio del Vesuvio accaduto . . .* (Naples, 1767).

5. A total of 174 tutors are listed in Ingamells 1997. Of these, 105 are referred to as "tutor" and 45 as "governor"; only rarely is the term "bear leader" (or "bear-leader") used. For an explanation of that term, see Wilton and Bignamini 1996, no. 54 (entry by Hugh Belsey).

6. James Hay is described as "bear-leader" of Nicholas Bacon, "tutor" to William Robinson, and "governor" of Richard and William Wynne. Ingamells 1997, 39, 817, 1031, respectively.

7. Lord Lewisham to the Earl of Dartmouth, Dec. 22, 1775, Historical Manuscripts Commission 1899, 223.

8. The Earl of Dartmouth to Lord Lewisham, Jan. 3, 1776, D(W)1778/V/853, Papers of the Legge Family, Earls of Dartmouth, Staffordshire and Stoke-on-Trent Archive Service, Staffordshire Record Office, Stafford (hereafter SRO).

9. Ingamells 1997, 936, under "Thompson."

10. Ingamells 1997, 841, 897, under "Sandys" and "Stevenson," respectively.

11. They held different ranks: colonels such as Wittestein, the Swiss tutor to Philip Yorke; captains such as Bruyers, tutor to Charles Anderson Pelham; and other officers such as James Ogilvie, tutor to Lucius Henry Cary, sixth Viscount Falkland. Ingamells 1997, 1035, 150, 720, respectively.

12. For example, Aaron Hill, prior to embarking on the Grand Tour as tutor to Sir William Wentworth, fourth Baronet, had already published various works and was director of the Theatre Royal, Drury Lane, London.

13. David Stevenson to the Earl of Dartmouth, Sept. 20, 1775, D(W)1778/V/885, SRO. Academies of this type were extremely popular in France, particularly in the Loire valley (Angers, Blois, and Tours), as well as in Besançon. Other, similar ones were to be found in Switzerland (Geneva) and in Italy, of which the most popular was possibly the one in Turin.

14. In the case of Stevenson and the Earl of Dartmouth, it would seem that the tutor sent detailed reports on expenses at regular intervals throughout the year: "quarterly," according to a letter sent from Paris. Stevenson to the Earl of Dartmouth, Jan. 29, 1776, D(W)1778/V/886, SRO. In addition, the entire correspondence contains numerous references to and specific explanations of the amount of money drawn on each occasion.

15. Stevenson to the Earl of Dartmouth, Jan. 29, 1776, D(W)1778/V/886, SRO.

16. Spence traveled to mainland Europe three times as tutor of Charles Sackville, Earl of Middlesex; Henry Pelham-Clinton, ninth Earl of Lincoln; and John Morley Trevor. See Ingamells 1997, 881.

17. Spence 1747.

18. Some even became members of Parliament, such as William Garthshore, who wished to be considered "the friend and not the governor" of his pupil, Charles Montagu-Scott, Earl of Dalkeith. Garthshore turned down payment

for his services as tutor in favor of the patronage of Lord Dalkeith's father in relation to his diplomatic career. See Ingamells 1997, 393.

19. Ingamells 1997 includes fifty-six cases in which the tutor had accompanied young travelers on more than one occasion.

20. See Ingamells 1997, 476, 508–9.

21. Boase 1890, 866; and Polsue 1868, 2:220. I am most indebted to Jonathan Yarker, who generously shared all this information.

22. Farington 1978–98, 10:3758–59, entry for Sept. 20, 1810.

23. Thomas Jenkins to Charles Townley, Jan. 7, 1775, in Bignamini and Hornsby 2010, 2:56. In a letter from Jenkins to Townley, March 4, 1775, the dealer mentioned the commission again, writing that "when you see Mr Sandys will you be so kind with my compliments to acquaint him his commission is executed and the case by this time ought to be at Leghorn." Bignamini and Hornsby 2010, 2:61. Over the years Sandys maintained his relationship with Townley, engaging in discussions about collecting sculpture and other artistic questions. Several letters give evidence of this. See, for example, TY 7/18, 7/1203, 7/1204, Townley Archive, British Museum, London.

24. Delane had been made a member of the Accademia delle Arti del Disegno in Florence in July of that year. See Figgis and Rooney 2001, 1:126.

25. Between 1776 and 1779 More produced six watercolors for Sandys that were copied by Richard Cooper. Andrew 1986b, 177.

26. There is at least one other case in which Piranesi dedicated a print from this series, of a vase, to a Grand Tour tutor, "Guglielmo Patoun" (William Patoun). Wilton-Ely 1994, vol. 2, no. 901.

27. Jenkins to Townley, Oct. 29, 1777, in Bignamini and Hornsby 2010, 2:105.

28. Purchases through Jenkins very probably include at least the two busts of Basset by Christopher Hewetson, in terracotta (cat. 128) and plaster, and a copy of the book *Le nozze di Paride ed Elena rappresentate in un vaso antico del museo del signor Tommaso Jenkins, gentiluomo inglese* (cat. 91).

29. For example, see George Berkeley's letters and journals in Berkeley 1948–57; and Joseph Spence's letters and other writings in Spence 1966 and Spence 1975.

30. Both Basset and Sandys had already been there in the spring of 1777. Sandys was employed by Cowper to act as intermediary between the earl and the landscape painter More. Andrew 1986a, 93.

31. Sandys may have met Zoffany during his first trip to Italy, although there is no proof of this.

32. Horace Walpole to Sir Horace Mann, Nov. 12, 1779, and Mann to Walpole, Dec. 10, 1779, in Millar 1966, 33, 20–21, respectively.

33. Millar 1966, 27–28.

34. Millar 1966, 20 and app., "Contents of the Tribuna," nos. 9, 10.

Anton Raphael Mengs's *The Liberation of Andromeda by Perseus*: A European Odyssey from Rome to St. Petersburg

STEFFI ROETTGEN

Ella era sfortunata sul mare.

—*Gian Ludovico Bianconi*

THE MOST IMPORTANT and valuable single object from the *Westmorland* that did not end up in the Real Academia de Bellas Artes de San Fernando, Madrid, in 1783 was a painting by Anton Raphael Mengs, who from 1761 to 1777 was *primer pintor de cámara* (first painter of the court) in the service of Carlos III (cat. 7). After the "abduction" of the painting, according to the artist's biographer Gian Ludovico Bianconi,

Il Mengs [. . .] disse che Andromeda lo meritava, perché doveva aver imparata da lungo tempo che ella era sfortunata sul mare. Non è stato però possibile al suo nuovo britannico Perseo il liberarla, malgrado gran somma d'oro offerta al nimico corsaro. (Mengs . . . said that Andromeda deserved it, because she should have learned long ago that she was unfortunate at sea. It has not been possible for her new British Perseus [Sir Watkin Williams Wynn, who had commissioned the painting] to free her, despite the large sum of gold offered to the enemy pirates.)[1]

The Liberation of Andromeda by Perseus (fig. 56) was the first large-scale work that Mengs completed after his return to Rome from Madrid in 1777, and with it

he once again attracted the attention of the Roman and international art public. A year and a half later he died, probably as a result of chronic poisoning from paint pigment.[2] By this time the painter had achieved everything that seemed worth striving for, even if at the cost of his health: a highly regarded and well-paid position that afforded him and his family a comfortable lifestyle, many followers and pupils, and great international recognition. In February 1778 the painting was displayed to the public in his handsomely furnished studio in the Villa Barberini, near St. Peter's Basilica. Just a few weeks after the exhibition, however, his hopes of a harmonious old age with his family were shattered. On April 3, 1778, his wife died of a fever, and, from that day on, his own health also deteriorated inexorably. At that point, as recorded in the diary of Prince August von Sachsen-Gotha-Altenburg, the painting of the liberation of Andromeda was in the studio of Mengs's brother-in-law Anton von Maron, probably in anticipation of being sent to England shortly afterward.[3]

The odyssey of the painting, which had restored Mengs to a top-ranking position in the Roman art world after many years' absence, unfolded over the

Figure 56. Anton Raphael Mengs, *The Liberation of Andromeda by Perseus*, 1773–78, oil on canvas, 89⅜ x 60⅜ in. (227 x 153.5 cm). State Hermitage Museum, St. Petersburg (cat. 17)

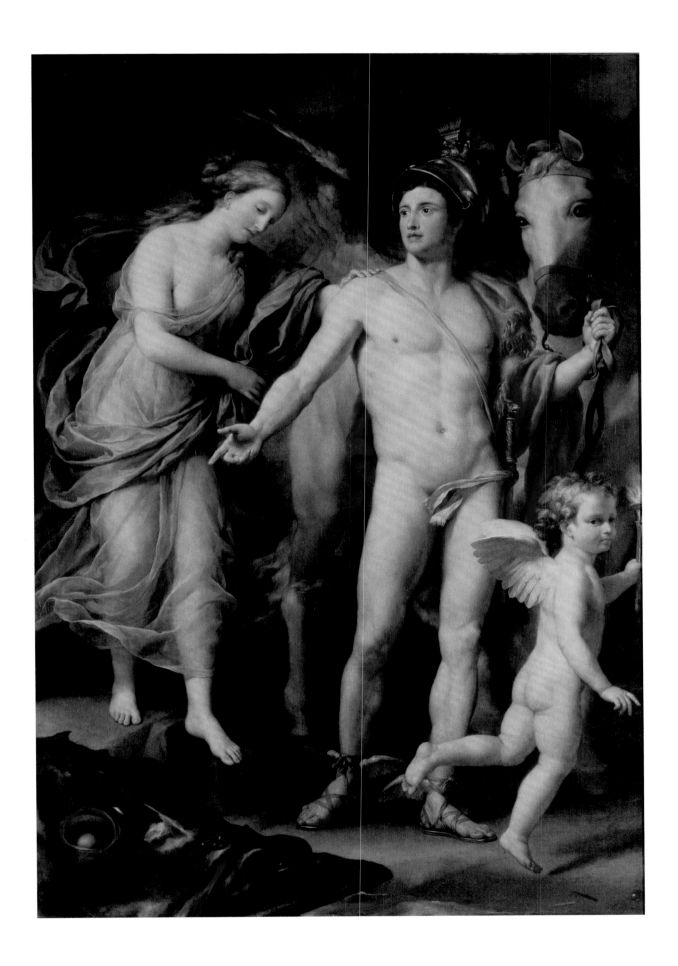

following months in parallel with the dramatic decline in his health. Some of the players who took part in the "rescuing" of the picture after the capture were people who were close to Mengs during the last phase of his life in Rome, namely, the Spanish diplomat José Nicolás de Azara y Perera, marqués de Nibbiano (see fig. 62, p. 108), and the imperial Russian councillor and art dealer Johann Friedrich Reiffenstein; they were probably already turning their attention to his artistic estate, although they had different interests. Azara regarded himself as counsel to the Spanish king, who had generously supported Mengs and who would therefore have had a moral entitlement to his artistic legacy; by contrast Reiffenstein represented the interests of Catherine II, empress of Russia, who was prepared to invest a great deal of money in acquiring works by the German painter. *The Liberation of Andromeda by Perseus*, destined for England, became the object of these differing interests by coincidence. The long sequence of events leading to the eventual acquisition of the painting by Catherine is now, thanks to research by José M. Luzón Nogué and his team, much more precisely understood and well documented.[4] Even if many pieces of the jigsaw puzzle are still missing, the following account attempts to reconstruct those events, which, it seems, were not without political explosiveness.

The commission, ill-starred from the beginning, had come in 1768 from Williams Wynn, via the British cicerone and agent James Byres in Rome, to Mengs, who was then in Madrid. Mengs repeatedly postponed or interrupted work on it. From Rome (during an interval back in Italy from 1771 to 1773) Mengs finally sent a prepared canvas to Spain in 1772, but having decided during a stay in Florence (from August 1773 to April 1774) to paint the picture there, he had to prepare a new canvas. In an attempt not to annoy Byres, from whom Mengs had already ascertained the measurements of the picture several times without having begun work on it, he now asked his brother-in-law Maron to find out about this himself from Byres.[5] The work done on this canvas is recorded in a self-portrait painted in Florence (fig. 57). The painter gestures with his hand to a primed canvas in the background, of which only the left border with the figure of Androm-

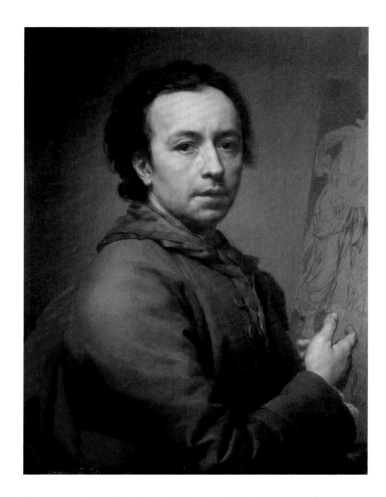

Figure 57. Anton Raphael Mengs, *Self-Portrait*, 1773–74, oil on panel, 29 x 22¼ in. (73.5 x 56.5 cm). National Museums Liverpool, Walker Art Gallery

eda can be seen, laid out in a black-and-white contour drawing.[6] The drapery and the position of Andromeda's arms, together with the protagonists' joined hands, differ from the finished painting but match the large-format monochrome painting *The Liberation of Andromeda by Perseus* (fig. 58) held in the Russian Academy of Arts, St. Petersburg.[7] When Mengs returned to Spain by an overland route in April 1774, he probably left behind this canvas, which he had started in Florence. Whether the picture completed in the winter of 1777–78 in Rome was painted on the original prepared canvas brought back with him from Spain is unclear. The only certainty is that neither of the two canvases, though similar in size, matches the dimensions of Pompeo Batoni's painting *Bacchus Comforts Ariadne on the Island of Naxos* (1768–72;

Figure 58. Anton Raphael Mengs, *The Liberation of Andromeda by Perseus*, 1773–74, oil on canvas, 84¼ x 57½ in. (214 x 146 cm). The Research Museum of the Russian Academy of Arts, St. Petersburg

Figure 59. Pompeo Batoni, *Bacchus Comforts Ariadne on the Island of Naxos*, 1768–72, oil on canvas, 87¾ x 58¼ in. (223 x 148 cm). Collection Apolloni, Rome

Collection Apolloni, Rome), for which it was intended as a companion piece (fig. 59).[8]

An account by the Welsh painter Thomas Jones gives a vivid as well as critical description of how Mengs's finished painting was presented in the artist's Roman studio at the beginning of February 1778:

> This Picture made a stir in Rome in proportion to the Celebrity of the Painter—& the Exhibition was conducted with the utmost Pomp— All the Grand Apartments of the Palace being thrown open—in most of which were groupes of Pupils making Studies after drawings pictures or Statues, according to their respective Classes— In the room where this famous piece was placed for public Admiration, decorated with a Superb frame & green silk cur-
> tain, the Senior Pupils attended in form, ready to explain the Subject, point out the different beauties of the Performance, & expatiate on the transcendent excellencies of their great Master— The Ceremony was indeed striking—and did honor to the Arts—but after all—the principal Merit of the piece consisted in its laborious high-Finishing— The result of German flegmatic Industry.[9]

While the British were critically inclined, most other commentators were full of praise. The Swiss sculptor Alexander Trippel considered it to be the most beautiful picture he had seen by a "living painter."[10] The architectural theorist Francesco Milizia, a friend of Mengs's, saw in the work confirmation of his opinion that Mengs was a painter of the first rank.[11] Azara was

convinced that Mengs had succeeded in realizing the heroic character of the Greeks.[12]

After this exhibition the painting was rolled up and taken to the Tuscan free port of Livorno, where, in December 1778, it was loaded onto the *Westmorland*.[13] Following its seizure by the French on January 7, 1779, and its entry into the Spanish harbor of Málaga the following day, the French consul there sent a dispatch from the commanders of the warships *Caton* and *Destin*, which had captured the *Westmorland*, to the French navy minister, Antoine Gabriel de Sartine, comte d'Alby, informing him of the incident. News reached Madrid eight days later, together with the information that the cargo of the *Westmorland*, estimated to be worth £100,000, contained not only the crates with marble statues, portraits, copperplate engravings, and books but also a painting, whose artist was unknown at that date, estimated to be worth 10,000 pesos.[14]

On February 15, 1779, Reiffenstein wrote to Friedrich Melchior Grimm, who sometimes acted as Catherine II's agent in Paris, with the news—emerging from letters by several Livorno-based merchants that were circulating in Rome—that the French had seized the *Westmorland* and taken it to Toulon (in fact, Málaga) in order to sell it there, complete with its cargo. And on the ship, among other objects and goods, was a "sublime" painting by Mengs, "one of the most erudite and perfect" that he had ever painted.[15] Reiffenstein suggested to Grimm that he should try to acquire it for the Russian czarina, and he relied on the fact that Grimm, with his excellent connections in Paris, would be able to find suitable means of implementing this plan. After approval came from St. Petersburg, Reiffenstein informed Grimm on March 24 that Mengs had told him of the matter through a pupil and had asked him to notify Grimm about it.[16] Whether Mengs hoped to use Grimm to help him procure the return of the picture, or had his eye on a sale to Russia, remains a matter of speculation. At any rate, in view of the desperate state of his health, Mengs had a bad conscience as regards the czarina, who had commissioned two paintings from him, for which he had already received a payment on account of 2,000 scudi.[17] Perhaps he hoped that he would not be asked

to return this deposit if the purchase were successful. Seen thus, the sale of the picture to Russia may have appeared to him a pragmatic way of solving the commission problem, especially as there was no chance of delivering the painting to its rightful owner as long as England and France were at war. How Williams Wynn reacted and what steps he undertook to obtain compensation remain unclear. Bianconi, who was very close to Mengs in his last months, merely wrote that the painter had promised a second "Andromeda" to the disappointed Welshman.[18] It might be that he planned to use the other prepared canvas for this, which was probably still in Florence at that time.

Just two months after the seizure Mengs received a message that his picture had come up for auction ("messo in vendita") in Marseilles, but that the unnamed owner did not want to sell it for 9,000 scudi. This false information, which Mengs communicated in a letter to his former pupil Nicolas Guibal, the Stuttgart court painter, inspired him to reflect seriously on his true market worth.[19] He decided to charge 500 scudi per figure in a painting for a German commission, justifying this price by referring to the supposed high bid for the seized painting.

Mengs had probably first received news of the seizure from Byres, who, as agent of Williams Wynn, may have learned of the misfortune directly from someone in Livorno or from Azara. As *procurador del rey en la corte de Roma* (king's attorney at the Roman court), Azara was in frequent correspondence with officials in Madrid and particularly with his superior, the prime minister, José Moñino y Redondo, conde de Floridablanca. At that moment, however, Azara was evidently not aware that the painting had already become the object of negotiations on behalf of the Russian czarina. While Grimm in Paris seems to have been busy concluding the sale, Reiffenstein and Mengs in Rome kept the matter secret from Azara. Only when the picture had reached Paris did Azara—endeavoring to obtain it at any price, though it is unclear on whose behalf he was acting—learn that Grimm had beaten him to it.

The painting's shipment to Paris followed the decision by the naval commander responsible for the capture of the *Westmorland* to make it a personal gift to

the French navy minister, Sartine. The French consul in Málaga sent the picture immediately by land to the French ambassador in Madrid, who forwarded it to Sartine.[20] At that point Sartine evidently was already in negotiations with Grimm about the sale of the picture to the czarina, although no documents relating to the sale are known. We learn from Carlo Fea's commentary in the Roman edition of Mengs's writings published in 1787 that before the picture arrived in Paris, it was shown—temporarily, and probably not very attractively, mounted—in the French embassy in Madrid, where it was seen by "tutto il mondo" (the whole world). Nothing is known of the reaction that the presentation must have provoked in Madrid or the length of time it was shown there. As Mengs was held in high regard in that city, it might be assumed that the Spanish crown would have expressed interest in this picture and charged Azara with obtaining it. But, as we know, the final destination of the picture had already been determined by that point.[21]

When Azara wrote his biography of Mengs in Italian at the beginning of 1780, he either could not or did not want to say anything definite about the whereabouts of the picture.[22] In the manuscript for the Spanish edition that he submitted in June of that year, he announced that the picture had been given to the navy minister, "pasando por Madrid" (passing through Madrid), from which an innocent and uninformed reader would have to infer that an officially sanctioned division of the prize had taken place; however, according to the Spanish sources, this was not the case.[23] Only in Fea's publication of 1787 can we read, with reference to Azara, that "tutto il mondo" had seen the picture in the French embassy in Madrid.

The web that had been spun between Rome, Paris, and St. Petersburg had ensnared the painting before Azara could react. The czarina appreciated Grimm's successful intervention, as hinted in a letter to him dated May 16, 1780. In it she insisted that the picture was to be sent to her immediately, and that the arm of Perseus, which she mentioned as being damaged, should, if possible, not be restored in Paris.[24] In the meantime, however, more than a year had passed since the painting had been handed over to the French embassy in Madrid. Why the subsequent business had

been so protracted can only be a matter of speculation. Then, in 1780, the finance minister, Jacques Necker, accused Sartine of having embezzled government funds, and the navy minister was consequently dismissed on August 14 of that year. Nevertheless, the czarina's letter to Grimm in May makes clear that the former French foreign minister Charles Gravier, comte de Vergennes, must have intervened to have the painting handed over to Catherine's agents.[25] On January 12, 1781, Joseph Marie Vien, the director of the Académie de France in Rome, criticized the fact that Sartine had sold the picture to the Russian empress. Vien wrote that the picture—the creation of which he had followed in Rome, and in which he had found the "plus grand beauté" (utmost beauty) even if it did not entirely please all the connoisseurs—would have been a suitable present for "Sa Majesté," that is, the French queen.[26]

The impact that the painting had in Roman circles and the turbulence surrounding its wanderings in Europe were followed by a rather inconspicuous existence in St. Petersburg. The painting—followed a year later by other works by Mengs from his estate, for which Catherine II paid the highest prices—was exhibited in the gallery of the imperial palace and later in Pavlovsk.[27] It was thus accessible to a public of high social standing, who would scarcely have differed from the public that would have been found in Williams Wynn's city mansion in London. The impact of Mengs's short and brilliant appearance in Rome found expression in the works of a younger generation of artists who, notwithstanding the nature of their responses, reacted with their creations to the new perceptiveness that Mengs had shown toward a centuries-old prominent theme in secular painting.[28] The visitors who had seen the painting in the artist's studio in 1778 included Jacques-Louis David. Mengs is said to have recommended—perhaps even on this occasion—that David should copy classical statues constantly, to free himself from the mannered painting style that he still followed at that time.[29] When the Accademia di San Luca in Rome chose the Liberation of Andromeda as the theme for the academy competition in sculpture in 1786, prizes were awarded to works that in style and motif were completely different from

Mengs's painting but were in the style of the same classical models as in his work.[30] Not long afterward, John Flaxman also referred directly to Mengs's work, of which *bozzetti* and sketches were available at the time in Rome, for his group *Cephalus and Aurora* (1789–90; Walker Art Gallery, National Museums Liverpool). With this the influence of this picture ended; for a time, however, it had been—alongside the ceiling fresco *Apollo, Mnemosyne and the Muses*, painted in 1761 in the Villa Albani, Rome—Mengs's most important contribution to the establishment of the Neoclassical style.

1. Bianconi 1780, quoted in Perini 1998, 280.

2. Roettgen 2003, 384.

3. "Ich sah mit Woronzow [Semjon Romanowitsch, 1744–1832] insgeheim beim Maler Maron die schöne Andromeda des Ritters Mengs, der vor einigen Tagen seine Frau verloren hat." (I saw with Woronzow [Semjon Romanowitsch] secretly at the painter Maron's the beautiful Andromeda by Mengs, who had lost his wife a few days previously.) Eckardt 1985, 49. From 1771 Maron lived on the second floor of a house in Vicolo Cacciabove, no. 2, in the parish of Santa Maria in Via, where he also had his studio. See Michel 1971, 287–322.

4. Westmorland 2002. Of particular importance for this essay are Suárez Huerta 2002, 49–67; and Luzón Nogué 2002b, 69–87.

5. "Or avendo promesso al Signor Byres di farle il quadro, che da tanto tempo ho acettato, in tutto il prossimo mese di Marzo mi conviene pensarvi seriamente, e farlo qui, poi che spero essere quel mese per viaggio; Avevo la tela bella che preparata e la mandai a Spagna con Alessandro Cittadino, ma ora quella non mi puo servire, onde sono a pregarla di farsi dare dal Signor Byres sudetto la misura del sudetto quadro, conputato a palmi Romani." (Now, having promised Mr. Byres to paint him the picture, which [i.e., the commission] I accepted a long time ago, I need to think about it seriously during all the next month of March, and about doing it here, since I expect to be traveling that month. I had the canvas totally ready and sent it to Spain with Alessandro Cittadino, but now it cannot be of use for me, hence I ask you to provide yourself with the dimensions of the painting, measured in Roman palms, from Mr. Byres.) Mengs to Maron, Nov. 23, 1773, quoted in Einem 1973, 67.

6. The self-portrait in Liverpool was commissioned by George Nassau Clavering Cowper, third Earl Cowper. See Roettgen 1993, 46–47; and Roettgen 1999, no. 279.

7. Roettgen 1999, 173, no. 111. This painting was acquired in 1844 in Italy, but evidently it did not come from the painter's estate.

8. Batoni's painting measures 87⅞ x 58¼ in. (223 x 148 cm). See Barroero and Mazzocca 2008, 354–55, no. 81. The Mengs painting at the Russian Academy of Arts is 84¼ x 57½ in. (214 x 146 cm); the one at the Hermitage is 89⅜ x 60½ in. (227 x 153.5 cm).

9. T. Jones 1946–48, 68–69.

10. Jonathan Northcote to his brother Samuel Northcote, Feb. 4, 1778, in Roettgen 1999, 170, doc. 8. See also Alexander Tripper to Christian von Mechel, Jan. 21, 1778, in ibid., 170, doc. 4.

11. Milizia 1781, 31.

12. "Terminò un Quadro di Andromeda, e Perseo incominciato anni prima, e vi fece spiccare il carattere eroico de' Greci; carattere che non può essere gustato dal volgo ignorante delle bellezze ideali." ([He] finished a painting of Perseus and Andromeda, begun years before, and therein he made the heroic spirit of the Greeks stand out; a spirit that cannot please the ordinary people ignorant of ideal beauty.) Azara 1780b, 25–26.

13. Who was responsible for the transport to Livorno and precisely when this took place is not certain, though it seems likely that Byres dealt with handling the transport and the formalities.

14. "Hay tambien una pintura del valor de 80 escudos romanos, ó 40 libras tornesas, que componen diez mil pesos de nuestra moneda." (There is also a painting worth 80 Roman scudi or 40 Tours pounds, equal to 10,000 pesos in our money.) Luzón Nogué 2002b, 74. The author of the list made a mistake in describing its worth in scudi; the value given in Roman scudi does not correspond with the actual exchange rate. The most common currency in Spain then, the real de vellón, had a value to the scudo of 21.4:1. The exchange rate of the peso, commonly found in Spain's American colonies and given here, may relate approximately to that of the real de vellón. Thus, 10,000 reales de vellón would convert into approximately 468 Roman scudi.

15. Frank 2001, 87–95.

16. Frank 2001, 90.

17. Roettgen 1999, 506, pl. 14; and Roettgen 2003, 417. Reiffenstein estimated the price of the painting at 600 sequins. Frank 2001, 93 n. 20. According to Thomas Jones, Mengs received 500 sequins (equal to 1,000 scudi). T. Jones 1946–48, 69.

18. "Per consolarlo gliene promise il Mengs un'altra, ma il destino tutt'altro disponeva." (To comfort him, Mengs promised him another painting, but destiny disposed with something else). Perini 1998, 280.

19. "Il quadro, che io feci alla fine del 1777, di Perseo, Andromeda, e un Imeneo, fanciullo, essendo stato messo in vendita a Marsiglia, vi è stato offerto nove mila scudi romani; ed il proprietario non lo ha voluto lasciare per questo prezzo, parendogli poco." (The picture that I have painted at the end of 1777, of Perseus, Andromeda, and one Hymen as a child, having been sold at Marseilles, was offered for 9,000 Roman scudi; and the owner did not want to sell it for this amount as he considered it too little.) Anton Raphael Mengs to Nicolas Guibal, March 6, 1779, in Azara and Fea 1787, 379–80.

20. In a letter in April the French consul informed the navy minister, "J'avrai soin de retirer le Rouleau dans le quel est renfermé un Tableau representant la Délivrance d'Andromede et Je vous le ferai [arriver] sur le champ par la voïe de M. L'Ambassadeur du Roy á Madrid quí avrá soin de vous l'expedier par la voye la plus sûre, et la plus prompte." (I will take care to remove the roll case where a painting depicting the deliverance of Andromeda is enclosed and I will have it [arrive] to you immediately via the king's ambassador at Madrid, who will take care to send it to you by the most secure and fastest way.) M. Humbourg to Antoine de Sartine, April 20, 1779, quoted in Luzón Nogué 2002b, 76. Although we have only the letter, we might assume that the dispatch contained detailed information concerning the captured material.

21. Azara's version of the story was related in this way: "L'intiera storia di questo quadro, come mi dice il sig. cav. Azara, è la seguente: Esso fu imbarcato a Livorno sopra un bastimento inglese, che fu predato da una nave da Guerra francese della squadra del conte d'Esaing [sic]. Il capitano di questa volendolo regalare al sig. de Sartine ministro della marina, glielo inviò per la via di Madrid, ove fu veduto da tutto il mondo presso l'ambasciator di Francia. Se ne parlò tanto, che ne giunse notizia al baron di Grim a Parigi, il quale propose al sig. de Sartine di venderglielo per l'impetratrice delle Russie, che lo ebbe per otto o nove mila lire; e senza che fosse ne veduto, nè aperta la cassa in Francia, fu mandato al suo destino. Il sig. cav. Azara fece ogni prova per averlo subito a qualunque costo; ma quell capitano non lo volle vendere." (The whole story of this painting, as Cavalier Azara told me, is as follows: In Livorno it was loaded onto an English vessel that was captured by a French warship belonging to the squadron of Count d'Estaing [sic]. The captain of that ship wanting to make it a gift to M. Sartine, minister of the navy, sent it via Madrid, where everybody saw it at the residence of the French ambassador. It was so praised that the news reached Grimm in Paris, who proposed to M. Sartine that he sell it to him for the Russian empress, who acquired it for eight or nine thousand lire; and without its being seen or its case opened in France, it was delivered to its addressee. Cavalier Azara suddenly tried everything to obtain it at any price; but that captain did not want to sell it.) Azara and Fea 1787, xxv n. (a).

22. José Nicolás de Azara y Perera to Giambattista Bodoni, Jan. 1, 1789, in Ciavarella 1979, 1:10. See also Azara 1780a, xxvi.

23. Azara 1780a, xxiv. For information on the handing over of the other works of art to the Spanish king by the Compañía de Lonjistas de Madrid (Company of Commercial Agents of Madrid), see Luzón Nogué 2002, 81–87; and the essay by Sánchez-Jáuregui and Wilcox in this volume.

24. "J'admire la persévérance de M. de Vergennes et la vôtre pour me faire avoir le tableau de l'Andromède de Mengs, et vous en ai beaucoup de remerciments à faire. Mais s'il est possible que le bras de Persée molesté ne soit point réparé à Paris, j'aimerais mieux l'avoir tel qu'il est." (I admire M. de Vergennes' and your persistence in obtaining Mengs's painting of Andromeda for me, and I have much to thank you for this. Though if it were possible that the damaged arm of Perseus would not be repaired in Paris I would rather like to have it as it is.) Catherine II to Friedrich Melchior Grimm, May 16, 1780, quoted in Réau 1932, 73–74.

25. Catherine II to Grimm, May 16, 1780, quoted in Réau 1932, 73 n. 52.

26. Joseph Marie Vien to Claude-Charles de La Billarderie, comte d'Angiviller, Jan. 12, 1781, quoted in Montaiglon and Guiffrey 1895, 80–81, no. 8097.

27. Roettgen 1999, 583–85. See also E. Munich, "Catalogue raisonné des tableaux qui se trouvent dals les Galeries et Cabinets du Palais Imperial à St. Petersbourg," 1773 ff., MS Fond 1, opis VI-a, no. 2348, Hermitage Archive, St. Petersburg); and Nikulin 1981, 25–26, no. 16.

28. Roettgen 1999, 172; and Roettgen 2003, 374–75.

29. Roettgen 2003, 376.

30. Cipriani 2000, 106–7.

Christopher Hewetson: Sculpture, Commerce, and Sociability in Rome

ALISON YARRINGTON

WHEN TWO FRENCH NAVY frigates intercepted the *Westmorland* at the start of 1779, among the rich variety of sequestered goods were three crates containing portrait busts by the Irish sculptor Christopher Hewetson.[1] This group of works provides both evidence of the Anglo-Italian sculpture trade and an insight into Hewetson's studio practice at this high point in his career.[2] For example, alongside these clay and plaster busts Hewetson also included "molds in loose pieces," presumably so that further replicas could be made for patrons in Britain.[3] In terms of detailed analyses of his techniques, for example, a recent program of restoration of the terra-cotta bust portraying Francis Basset (fig. 60) has revealed a treatment containing egg tempera to make its surface look like bronze.[4] But the *Westmorland*'s cargo, besides demonstrating Hewetson's role as a portraitist to Grand Tourists, also reveals the intricate social and commercial network that facilitated both production and collecting, of which sculpture was just one glittering facet.

In 1778 Hewetson had been resident in Rome for some thirteen years, and his studio workshop in the Vicolo delle Orsoline was the hub of a flourishing enterprise, the bedrock of which was the production of lively portraits of Grand Tourists who sat during their sojourns in the city.[5] During the 1770s and 1780s Hewetson attracted not only Grand Tourists but leading figures from both Roman and international society as sitters. The busts that Grand Tourists commissioned from him, exemplified by the terra-cotta busts of Basset and of "an unknown man" found within the *Westmorland*'s rich cargo (cat. 136), were mementos of their educative travels as well as signs of their discernment and good taste. Busts—some of them plaster models or copies, some of them in the process of being modeled or carved—would be viewed by the many tourists who visited sculptors' studios as part of their itineraries, often guided there by influential ciceroni such as Thomas Jenkins and James Byres, both of whom are known to have acted as intermediaries on Hewetson's behalf. In addition to viewing art being made, studio visits reinforced the idea that to sit for a portrait was a means of providing permanent evidence of being part of fashionable society. It was therefore of great importance for Hewetson's professional advancement that he could attract such sitters as William Henry, Duke of Gloucester (fig. 61). Luckily this bust had been safely received in England well before the duke's further Italian purchases, including two marble fireplaces (see cats. 95–98), were shipped on the *Westmorland*.[6]

The material evidence of Hewetson's ability to attract the international nobility as sitters is found in busts he produced in the late 1770s and early 1780s when business was booming, including one in marble of Maria Feodorovna, Grand Duchess of Russia,

Figure 60. Christopher Hewetson, *Francis Basset*, 1777–78, terra-cotta with egg tempera patina, 16½ x 11⅜ x 9 in. (42 x 29 x 23 cm). Real Academia de Bellas Artes de San Fernando, Museo (cat. 128)

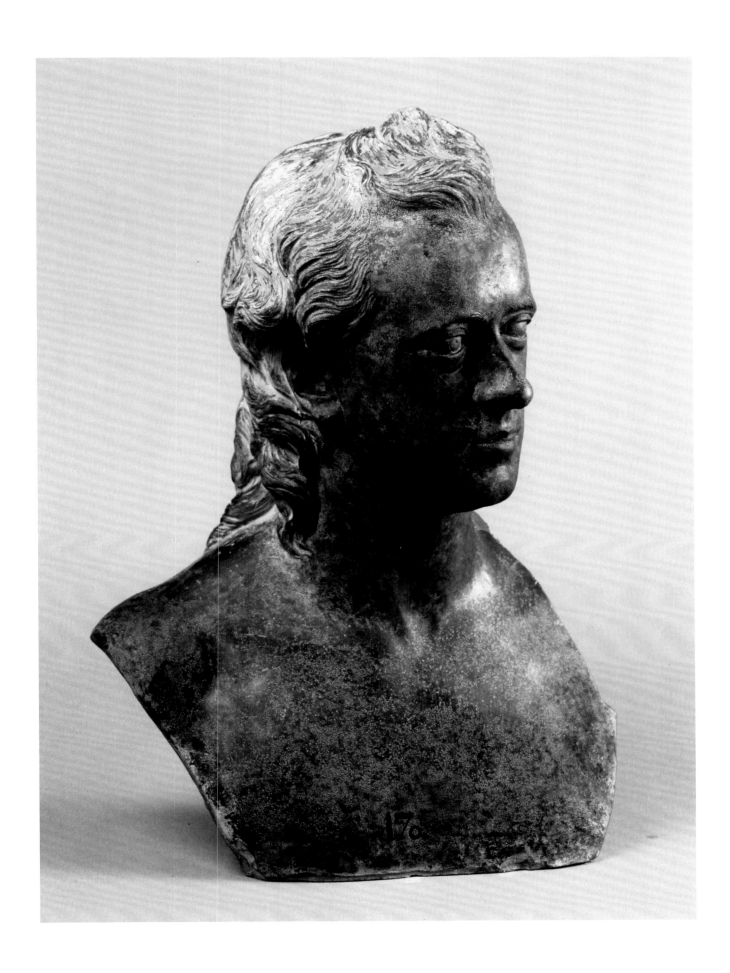

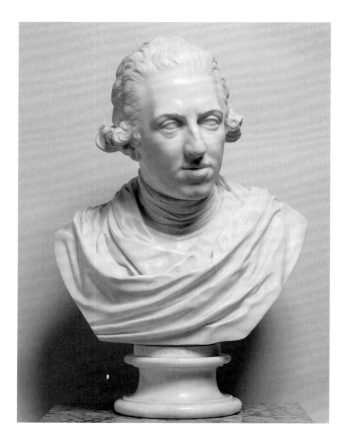

Figure 61. Christopher Hewetson, *William Henry, Duke of Gloucester*, 1772, marble, 25⅜ in. (64.5 cm). The Royal Collection, Her Majesty Queen Elizabeth II

Figure 62. Christopher Hewetson, *José Nicolás de Azara y Perera, Marqués de Nibbiano*, 1778, bronze, 19¾ in. (50 cm). Bibliothèque Mazarine, Paris

wife of the future czar Paul I (1784; untraced).[7] His bronze bust of the Spanish *procurador general* (king's attorney) in Rome, José Nicolás de Azara y Perera, marqués de Nibbiano (fig. 62, and several other versions), is significant in the context of the *Westmorland*, although it was not among Hewetson's works that were on board.[8] It was, after all, Azara who attempted unsuccessfully to obtain Anton Raphael Mengs's *The Liberation of Andromeda by Perseus* (cat. 17; for the story of this painting, see the essay by Steffi Roettgen in this volume), and it was to Azara that Father John Thorpe appealed when he tried to recover a crate containing holy relics that Pope Clement XIV sent to Henry Arundell, eighth Baron Arundell of Wardour, in the *Westmorland* shipment (for the history of these relics, see the essay by José M. Luzón Nogué in this volume).[9] It was Azara's role as a biographer of Mengs, however, that should be noted here: Azara's bust by Hewetson is recorded as

having been created with Mengs's direct input. It is also linked to the bust of Mengs by Hewetson that the Spanish ambassador commissioned, a plaster version of which was on board the *Westmorland* (fig. 63).[10] As Terence Hodgkinson has suggested, Hewetson's work was equally the result of Mengs's input; according to Azara, "Then I . . . had made and placed his [Mengs's] portrait in bronze, modelled under his own direction, in the Pantheon beside that of Raphael."[11] These busts of Azara and Mengs therefore stand as a material record of friendship and artistic collaboration between the sculptor, painter, and diplomat.

Such commissions signaled Hewetson's standing in Roman society and also helped to stimulate demand for further copies and versions, as well as to attract

Figure 63. Christopher Hewetson, *Anton Raphael Mengs*, ca. 1777–78, plaster cast, 25⅝ in. (65 cm). Real Academia de Bellas Artes de San Fernando, Museo (cat. 135)

Figure 64. Christopher Hewetson, *Pope Clement XIV*, 1772, marble, 31 in. (78.7 cm). National Trust, Beningbrough Hall, York

Figure 65. Christopher Hewetson, *Monument to Provost Richard Baldwin*, 1771–84, black and white marble and dark red porphyry. Trinity College, Dublin

patrons. Perhaps the most significant commission for this Protestant sculptor working in Rome was the one for a bust of Pope Clement XIV, of which there are four extant versions in marble and one in plaster dating from 1772–73 (fig. 64).[12] The dealer Jenkins, widely envied for his "power to make the Pope do as he pleased," undoubtedly engineered the sitting.[13] Hewetson's later failure to gain the commissions for papal tombs of Clement XIV and Clement XIII in St. Peter's Basilica must therefore have been particularly bitter for both sculptor and dealer. That Antonio Canova was chosen over him marked the beginning of a decline in Hewetson's business that had become critical by the early 1790s.

At his peak in the 1780s, however, regard for Hewetson's portraiture among his fellow artists was not confined to friends but also extended to potential rivals. As Hugh Honour has shown, the young Canova—during his exploratory tour of Roman studios in 1780, assessing the market before his move there—commented in his diary on the many "good" portraits he had seen in the studio of "Mr Cristoforo

Irlandese," a distinctive output compared to those of others he observed.[14] Each studio workshop would have had a mixed sculptural repertoire, but developing a particular genre was helpful in this highly competitive marketplace; John Deare, for example, was known for his exquisite bas-reliefs, while Bartolomeo Cavaceppi and Carlo Albacini were sought after for their fluent marble carving and their ability to provide copies after antiquities. Although Hewetson produced a complex and prestigious monument to Provost Richard Baldwin (fig. 65), with richly colored marbles offsetting the white Carrara marble figures, and another to Cardinal Giovanni Battista Rezzonico (1783–84; church of San Nicola in Carcere, Rome), such works were not the mainstay of his practice.[15] His renown as a portraitist is found in the comments of British visitors who included his studio on their itineraries and observed his role in the art market at first hand. Hodgkinson has provided instances that demonstrate Hewetson's dominance in this area of sculptural practice; for example, in September 1779 George Augustus Herbert, Lord Herbert, wrote in his

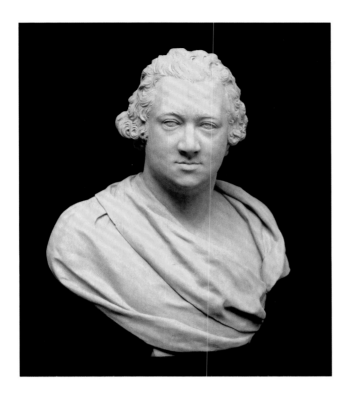

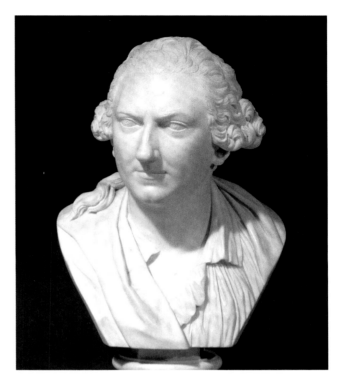

Figure 66. Christopher Hewetson, *Sir Watkin Williams Wynn*, 1769, terra-cotta, 20⅞ in. (53 cm). National Gallery of Ireland, Dublin

Figure 67. Christopher Hewetson, *Charles Townley*, 1769, marble, 22⅝ in. (57.5 cm). British Museum, Department of Prehistory and Europe

diary that he had dined with Hewetson and Jenkins and a few days later visited the studio, commenting afterward that it was "very good I believe, several British heads, I knew, very like."[16] The later author Mary Berry, guided by M. Boroni in March and April 1784, noted "several good busts, portraits," and her comment that Rome was otherwise generally "not a place in which to admire modern busts" indicates the extent to which the sculptor had developed this specialty to advantage.[17] And as late as spring 1793, the Scottish banker Sir William Forbes, sixth Baronet of Pitsligo, who was no lover of modern portraiture, taking issue with the genre in general, nevertheless recognized that Hewetson was "chiefly employed in doing Busts in sculpture of those who sit to him, as people do for a portrait to a painter. In this branch he is esteemed to be eminent."[18]

Hewetson's talent had been fostered initially in his native Ireland. Very little is known about his training in sculpture, except that in the 1750s he worked with John Nost III on statues for the Rotunda Gardens, Dublin. His arrival in Rome in 1765 in the company

of Henry Benbridge, an American artist, therefore marks the beginning of a professional career, with scant evidence of any portrait busts executed prior to this.[19] Those that he produced during his early years in Rome demonstrate that his success grew from an ability to model likenesses of his sitters imbued with an air of easy informality of manner, yet conveying intensity of thought—the hallmark of every aspiring Grand Tourist. One of his earliest commissions was for two clay busts, of Sir Watkin Williams Wynn (fig. 66), and an unpublished portrait at Chatsworth, Derbyshire, of William Cavendish, fifth Duke of Devonshire (1769). The busts constitute a record of friendly acquaintance: in November 1768 both were in Rome and shared the costs of a trip to Tivoli.[20] They were guided in Rome by Byres, who therefore may have also acted as intermediary in the commission. Williams Wynn obviously trusted Byres, who sold him "over £1,000 worth of works of art."[21] Alternatively, it is possible that Jenkins, who also managed to sell the young man pictures and statues, could have acted in this role.[22] After traveling to Naples the two tourists

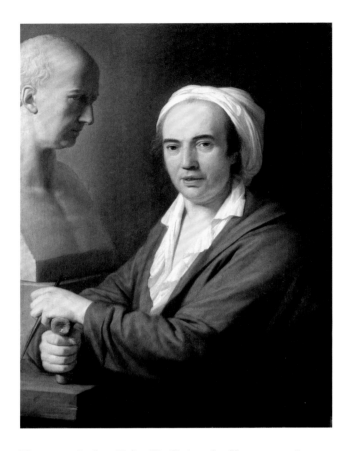

Figure 68. Stefano Tofanelli, *Christopher Hewetson*, 1784, oil on canvas, 38¾ x 29 in. (98.5 x 73.5 cm). Wallraf-Richartz-Museum und Fondation Corbourd, Cologne, WRM 1071

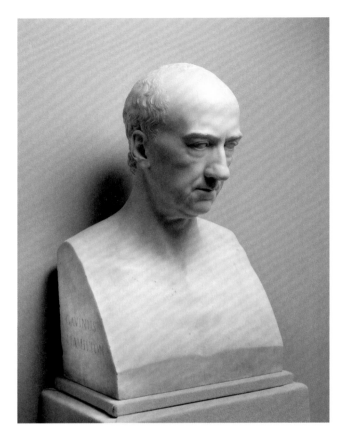

Figure 69. Christopher Hewetson, *Gavin Hamilton*, 1784, marble, 22⅞ in. (58 cm). Hunterian Museum and Art Gallery, University of Glasgow

returned in January 1769 to Rome, where, in addition to sitting to Hewetson, they also sat to Pompeo Batoni and Anton von Maron. Although no records of the duke's commission survive in the Devonshire archive, there are records of payment for "a bust in Clay of Sr Watkin & some Casts from it," which may have been another instance of the use of molds like those found in the *Westmorland*'s cargo.[23] The strong similarities between these two busts—the drapery, the turn of the heads, and the modeling—are such that they form companion pieces. Also in 1769 Hewetson made a marble bust of the antiquarian Charles Townley (fig. 67) that is similar in format and signature to those of the young Grand Tourists. To capture clients such as Williams Wynn and Townley, with their wealth, influence, and appetite for collecting, was of mutual advantage to the sculptor and to the intermediaries Jenkins and Byres. It is noteworthy that the *Westmorland*'s cargo included Mengs's fabulously expensive

Liberation of Andromeda by Perseus (cat. 17), destined for Williams Wynn after having been commissioned for him by Byres.[24]

To persuade some wary Grand Tourists to part with their money could be a complex task. Writing to the collector and artist George Cumberland from Rome in 1780, the history painter and picture dealer James Irvine suggested as much: "As for the arts I cannot say they are in the most flourishing state here at present. There are some English here . . . but they will scarce go to see an Artist for fear they should be expected to bespeak something."[25] Still, it seems that Hewetson's relationship with Jenkins from the outset was both particularly companionable and commercially productive.[26] The strongest evidence of a long-standing mutual regard is contained in Jenkins's will, with its bequest to Hewetson of "cinquecento scudi Romano, o il valore di cento lire sterline" (500 Roman scudi, or the equivalent value of 100 pounds sterling), to

purchase a ring in memory of their friendship.[27] It is well known that Jenkins's overt support for Hewetson could cause bitterness; for example, Deare felt that this vigorous promotion damaged his own chances for commissions. In a letter to Cumberland in 1794, Deare stated that he was no longer on speaking terms with Hewetson and recounted that he had managed to obtain a commission from Thomas Noel Hill, second Baron Berwick, for copies after the Apollo Belvedere and Venus de Medici, despite the machinations of Jenkins, whom he described as "that villain" and "the old thief," while also angrily referring to Jenkins's "very good friend Hewetson."[28]

Nevertheless, Hewetson was also sustained by friendships with artists, a circle that included countrymen such as Henry Tresham, James Durno, Michael Foy, Gavin Hamilton, and Hugh Douglas Hamilton, as well as Batoni and Mengs, working together to their mutual commercial advantage.[29] A visual statement of one such alliance and friendship is Stefano Tofanelli's portrait of Hewetson (fig. 68), made when the sculptor's reputation was at a high level. In the painting he wears working clothes and has carving tools in his hands; looking down on him as both muse and mentor is a depiction of his marble bust of Gavin Hamilton (fig. 69).[30] Hewetson's austere, almost harsh interpretation of the painter and antiquary conveys unswerving intellectual rigor (despite the slight irony that

Hewetson's inscribed signature is misspelled), yet with all those subtleties of surface that Hewetson was able to conjure. The contrast between this and other, more sumptuously fleshy marble busts, such as those of the version of Mengs in the Promoteca Capitolina, Rome (1781), and of John Pryse Campbell, first Baron Cawdor (ca. 1784?; Cawdor Castle, Nairn), demonstrates the depth and richness of his repertoire.

Hewetson's star was on the wane by the 1790s, when the precarious nature of a business operated in self-imposed exile was constantly present. A "melancholy Letter" by the sculptor published in the *True Briton* reporting the death of his friend and fellow Irish artist Durno from "putrid fever" (typhus) in 1795 and the details of the Protestant funeral in Rome, attended by British artists and Prince Augustus Frederick (sixth son of George III), conveys Hewetson's loss and anxiety at that time.[31] His dependence on a constant flow of commissions and materials became very clear when the French invasion of Italy in 1796, culminating in the taking of Rome two years later, discouraged tourism and disrupted trade between Britain and the Italian states; the British "colony" in Rome contracted, and Hewetson's business suffered badly.[32] In so many ways the deaths of Hewetson, Deare, and Jenkins, all in 1798, marked the end of a distinctive phase in the history of the Grand Tour and the collecting of sculpture.

1. "Caxon M G: Una cabeza de barro cocido, y dos vaciadas en yeso; una de estas es el retrato de Mengs. [. . .] Caxon ⟨H⟩: Dos cabezas de Yeso, y una de barro cocido. Una de las primeras es el retrato de Mengs. [. . .] Caxon H ⟨G⟩ E: Quatro cabezas dos de barro, y dos vaciadas en yeso con sus moldes en pedazos sueltos." (Crate M G: A terra-cotta head and two plaster casts; one of these is the portrait of Mengs. . . . Crate ⟨H⟩: Two Plaster heads, and one in terra-cotta. One of the former is the portrait of Mengs. . . . Crate H ⟨G⟩ E: Four heads, two of terra-cotta, and two plaster casts with their molds in loose pieces.) Antonio Ponz, "Catalogo de pinturas al oleo, y otras curiosidades contenidas en varios caxones de la expresada segunda remesa que se depositaron en la Academia de San Fernando," 4-87-1-26, Archivo-Biblioteca, RABASF (cat. 14); see appendix 2 in this volume, pp. 342, 343, and 345.

2. The details of Hewetson's life and career have been meticulously assembled in Hodgkinson 1952–54, 42–54; and De Breffny 1986, 52–75. The most recent account is Roscoe, Hardy, and Sullivan 2009, 608–12.

3. Westmorland 2002, no. 70 (entry by María Dolores Sánchez-Jáuregui). Neither the owner of the crate nor the contents have been identified.

4. Westmorland 2002, no. 52 (entry by María Dolores Sánchez-Jáuregui), points to the findings of restoration work carried out on the bust in the Real Academia de Bellas Artes de San Fernando, Madrid, showing that when first applied to the terra-cotta, this surface treatment would have given the appearance of bronze. Coloring terra-cotta and plaster casts was common at this time. See Penny 1998, 250, in which Nicholas Penny cited a suggestion by the poet William Shenstone that he might use "some bronze

powder '[on plaster figures] which would turn them a kind of orange colour.'" For Basset's Grand Tour, see Sánchez-Jáuregui 2002, 119–43.

5. Figgis 1986, 28–36. There Nicola Figgis stated that, according to Joseph Farington's list of artists living in Rome in 1790, Hewetson resided at this address in the "immediate area of the Palazzo Piombino," where several British artists resided, while the Stato delle Anime (census) for 1792 and 1795 places him at that time in a street off Strada Vittoria, in the parish of San Lorenzo in Lucina.

6. "Caxon H R H: Caxon donde hai un cornisamento de marmol en cinco piezas, y parece parte de la Chimenea que vino en la primera remesa [anotado a la izquierda] Dado al Rey por ser parte de la Chimenea." (Crate "H R H": Crate containing a marble entablature in five pieces that seems to form part of the mantelpiece that came in the first consignment [noted on the left-hand side] Given to the King as part of the mantelpiece.) Ponz, "Catalogo de pinturas . . ."; see appendix 2 in this volume, p. 344.

7. S. P. 1917, 40. Hewetson's bust of the grand duchess, signed "Christophorus Hewetson Hibernus fecit Romae MDC-CLXXXIIII," is listed as being at the palace at Gatchina by M. P. P. Weiner in the journal he edited, Starÿe Godÿ (1914).

8. De Breffny 1986, 54, lists two bronze versions of this bust, nos. 1a–b.

9. See the "nota pro-memoria" given by Thorpe to Azara in Rome, 4-87-1-48, Archivo-Biblioteca, RABASF (cat. 11). See also the discussion of the same in Westmorland 2002, no. 10 (entry by José M. Luzón Nogué); and cat. 11 in this volume.

10. In his biography of Mengs (Azara 1780a), Azara mentioned both the capture of the Westmorland and Mengs's bust. See Westmorland 2002, no. 87 (entry by Almudena Negrete Plano).

11. De Breffny 1986, 57, no. 18a, citing a translation in Hodgkinson 1952–54, 44.

12. De Breffny 1986, 55, nos. 4a–e. The four marble versions are Beningbrough Hall, York (n.d.); Gorhambury Park, Hertfordshire (1772); Ammerdown Park, Somerset (1772); and Victoria and Albert Museum, London (1773). There is also an undated plaster bust at the Museo Civico, Bassano.

13. Ingamells 1997, 555, 556 nn. 25, 26.

14. Honour 1959, 244. Honour noted, however, that Canova was "less impressed" with Hewetson's monument to Martha Swinburne (d. 1779; Venerable English College, Rome).

15. For the monument to Baldwin, see Esdaile 1947, 134–35. For the monument to Rezzonico, see De Breffny 1986, 58, no. 22. Only three other monuments by Hewetson are known: to Fredrick August I, duke of Oldenburg (1792–93), and to Count Anton Günther (n.d.), both in the church of Saint Lambert, Oldenburg, Germany, and the memorial to Martha Swinburne. See Roscoe, Hardy, and Sullivan 2009, 610.

16. Hodgkinson 1952–54, 45 n. 3.

17. Berry 1866, 1:103–4, entry for April 1, 1784.

18. Sir William Forbes, "Journal of Sir William Forbes in Italy 1792–3," 6:173, entry for April 30, 1793, Forbes MSS, 1539–45, National Library of Scotland, Edinburgh, cited in Hodgkinson 1952–54, 52.

19. The only bust attributed to him from this period is of Richard Rigby, late master of the rolls for Ireland (1758–65; Provost's House, Trinity College, Dublin).

20. Ingamells 1997, 1030.

21. Ingamells 1997, 1030.

22. Ingamells 1997, 1030 n. 8.

23. Documentary evidence of the transaction and of the later (plaster) casts made from Hewetson's "mold" by Joseph Nollekens in 1775, at a cost of £7 17s. 6d., is in Wynnstay MSS, Box 115/1, 7, National Library of Wales, Aberystwyth, cited in Roscoe, Hardy, and Sullivan 2009, 609. I would like to thank Charles Noble (Collections Documentation at Chatsworth) for his advice concerning the bust of the fifth Duke of Devonshire.

24. See the essay by Steffi Roettgen in this volume.

25. James Irvine to George Cumberland, Dec. 16, 1780, Add. MSS 36493, fol. 68, Cumberland Papers, vol. 3, British Museum, London.

26. Hodgkinson 1952–54, 43–44, citing the artist Thomas Jones's account of his meetings with Hewetson and Jenkins.

27. Hodgkinson 1952–54, 53 n. 1.

28. John Deare to George Cumberland, March 1, 1794, Add. MSS 36497, fol. 288, Cumberland Papers, vol. 7, British Museum, London.

29. De Breffny 1986, 53, details this network and his friendship with Jenkins, taking evidence from the Cumberland correspondence in the British Museum, London.

30. The bust bears the inscriptions "GAVINUS / HAMILTON" on the left-hand side and "OPUS / CHRISTOPH: HEWE-TOSN / MDCCLXXXIIII" on the right-hand side. Given the spelling error in his name, it must be presumed that these were carried out by Hewetson's Italian workmen.

31. "Extract of a Letter Received from Christopher Hewetson, Esq., Dated Rome, 26th Sept. 1795," True Briton, Jan. 27, 1796. Nicola Figgis did not refer to Hewetson's letter but did discuss the death and burial of British and Irish artists in Rome, where Protestants were interred outside the city walls near the Pyramid of Caius Cestius, at what was called "the Protestant Burying Ground." Figgis 1986, 33–36, esp. 36 n. 51.

32. Hodgkinson 1952–54, 53; De Breffny 1986, 53, 54 n. 24.

"Surpassing the Others in Prospect and Situation":

Six Watercolors by John Robert Cozens

KIM SLOAN

JOHN CONSTABLE famously described the water-colors of John Robert Cozens as "all poetry" and the artist himself as "the greatest genius that ever touched landscape."[1] Although Cozens's name is now less well known than those of many of his contemporaries, Martin Hardie noted in his history of watercolor painting in Britain that "it isn't easy to analyse precisely the qualities of Cozens' work which roused, and still rouse, such enthusiasm. They are of the spirit, and seldom has any artist succeeded with such subtlety and delicacy in evoking the spirit and sentiment of a scene."[2]

The son of Alexander Cozens, a successful drawing master and author of systems for understanding and inventing landscape compositions, John Robert made an impression with his first exhibit at the Royal Academy of Arts, in 1776: an oil painting of Hannibal crossing the Alps, sadly now lost. A few months later Richard Payne Knight, the "arrogant connoisseur" and writer on the picturesque, became his first patron. Payne Knight took the twenty-three-year-old Cozens with him through the Alps and on to Florence and Rome in a journey that lasted from August to November 1776 and resulted in a series of fifty-seven pen, ink, and wash drawings of the mountains and valleys of Switzerland. The drawings, which were mostly 9¼ x 14¼ inches (23.5 x 36 cm) with a few half that size, were mounted in an album but are now dispersed (see fig. 76), apart from twenty-four in the British Museum.[3] The following year Payne Knight commissioned Cozens to work up some of the drawings made by the gentleman amateur Charles Gore and the German artist Jacob Philipp Hackert, who had accompanied Payne Knight to Sicily in the spring of 1777. The resulting watercolors had more color than the Swiss views and were full of a new breadth and simplicity in composition.[4]

Cozens returned to England in 1779 with a portfolio of mountainous and lyrical Italian compositions from which he had already painted watercolor versions for Grand Tourists he had met while abroad, and he was ready to produce more variations for patrons in England. One of these was his father's most famous pupil, William Beckford, "England's wealthiest son" and the builder of Fonthill Abbey, who commissioned ten watercolors from the younger Cozens.[5] Beckford then decided to take Cozens along as his artist on Beckford's own visit to Italy, setting out in May 1782. On this journey Cozens filled at least seven sketchbooks, which show a maturity of composition and light and shade that enable evocation of atmosphere and emotions through landscape, reflected and enhanced through the color and scale of nearly one hundred finished watercolors that he eventually produced for Beckford.[6] Now scattered, they reflect his father's teaching concerning landscapes of sentiment, sensibility, and morality. These evocative and poetic landscapes translated visually what Beckford's journals of their travel described in words; Beckford's ideas about landscape had a profound effect on the color and atmosphere in the watercolors that Cozens produced for his patron, which were notably more

Figure 70. John Robert Cozens, *Lake Albano from the Galleria di Sopra*, 1777–78, watercolor over graphite on paper, 17 x 23⅝ in. (43.2 x 60.1 cm). Real Academia de Bellas Artes de San Fernando, Museo (cat. 23)

intense and form a distinctive type within his oeuvre. Thus the two men might be seen to have mutually guided each other's hand and vision.[7]

Only half of Payne Knight's collection of drawings by Cozens has remained intact, and Beckford's were scattered after their sale in 1805, making it difficult for posterity to judge the mutual influence of patron and artist; however, with Francis Basset's collection of six watercolors (figs. 70–75), we have something unique in Cozens's oeuvre in the constitution of a complete set, in its original condition, which can be dated quite specifically. The six present us with the opportunity to examine his work carefully at this pivotal point in his development as an artist—during his first trip to Rome with Payne Knight and before his mature work for Beckford.

Although we have no record of the commission or purchase, it was a significant one for Basset, five years younger than Cozens, to have made.[8] Apart from two

views by Jacob More of the area around Naples (cats. 52–53), which were probably for Basset or his tutor and More's friend, the Reverend William Sandys, there were no other watercolors on the ship. There were souvenir gouache *vedute* (views) by local artists, many books of prints, and some very important works in oil, but the existence of this set of original, colored views of the hills and lakes around Rome, especially to the south, tells us something about Basset's taste and education that is quite distinct from his other acquisitions during his Grand Tour. As David Solkin has pointed out, "A view of Italy, commissioned from a living artist, paid tribute to a gentleman's direct exposure to the fountainhead of the civilised world, and at the same time complimented his generosity as a patron of the arts. With such a picture over his mantelpiece, he could hold up his head in polite circles, look down his nose at the masses of the unenlightened, and begin to take charge of the nation's affairs."[9]

Figure 71. John Robert Cozens, *Lake Albano from the Shore*, 1777–78,
watercolor over graphite on paper, 17⅛ x 23⅞ in. (43.5 x 60.5 cm). Real Academia de Bellas Artes de San Fernando, Museo (cat. 24)

Certainly Basset was to become a member of Parliament on his return and later a baron; his house in Cornwall was one of the most significant in the county, subsequently joined by a residence opposite that of Horace Walpole in Twickenham and another in the heart of fashionable London; and after his death the German art historian Gustav Friedrich Waagen placed Basset fifteenth among the top forty-seven patrons of art in the nation.[10] His views of Italy would certainly fulfill these purposes; nevertheless, how did he come to commission or purchase watercolors from an artist who was not yet established either at home or abroad, what made him select these particular views, what did he intend to do with them at home, and what do they demonstrate about Basset that might set him apart from other gentlemen on the Grand Tour?

Cozens had exhibited regularly at the Society of Arts from the age of fifteen, had published a set of views of Bath in 1772, and had made a strong impression on many, including the young J. M. W. Turner, with his large painting of Hannibal exhibited at the Royal Academy before he headed off to the Continent in the summer of 1776 with Payne Knight. But in Italy he was well known only to his fellow artists, and there are no known remarks about him or his work by Grand Tourists or any other direct evidence of commissions from them. How, then, was Basset even aware of his work?

The answer may be quite straightforward. In March 1771, two months after Basset's arrival at Eton College, his dame (who boarded and otherwise took care of students), Mrs. (Mary) Young, wrote to the steward at Tehidy, the Basset family manor: "Dancing and Drawing (which he chose to Learn) I have enter'd him to, and likewise writing; which I should think, with his school Business would be sufficient work for him for the present; but when I have the opportunity I will ask his Master's or Tutor's opinion."[11] There were no

Figure 72. John Robert Cozens, *Lake Albano from Palazzolo*, 1777–78,
watercolor over graphite on paper, 17⅛ x 23⅞ in. (43.5 x 60.5 cm). Real Academia de Bellas Artes de San Fernando, Museo (cat. 25)

dancing, music, or drawing masters on staff at Eton at this time, but masters took rooms in town during term, offering private and group lessons there—and Alexander Cozens was well known as the Eton drawing master from at least the early 1760s until the 1780s. Hundreds of future patrons of the arts passed through his hands, and Francis Basset was undoubtedly one of them. Cozens's novel methods of teaching made a strong impression on his students, who were, without exception, fond of him, and it is entirely possible that his son, who was then living with him in Leicester Street off Leicester Fields, assisted him in his teaching during this period.[12]

Basset had four years at Eton before going on to Cambridge, and if he had forgotten either Cozens before leaving England in early 1777, undoubtedly he would have been reminded of them again on his way through the Alps when he and Sandys were poring through Marc Théodore Bourrit's *A Relation of a*

Journey to the Glaciers in the Dutchy of Savoy, translated from the French by the Reverend Charles Davy and his brother Frederick.[13] This English edition, first published in 1775, contains a preface by Charles Davy, who was tutor to Sir George Beaumont, seventh Baronet, another of the elder Cozens's Eton pupils.[14] In the preface Davy drew parallels between viewing landscape and listening to music, writing:

It is impossible, one would think, to look upon the world diversified with so much *elegance* in all its *lesser* parts, and enobled with such *grandeur* and *sublimity* in the larger . . . without the highest pleasure. . . . The *general* effect of a survey of Nature is Delight; whilst every species of Landscape, like every different species of *Melody excites its own peculiar genuine emotions, nor are they limited to the imagination only they make their passage through it to the heart, and

Figure 73. John Robert Cozens, *Ariccia*, 1777–78,
watercolor over graphite on paper, 17⅛ x 23⅞ in. (43.5 x 60.5 cm). Real Academia de Bellas Artes de San Fernando, Museo (cat. 26)

lead to acts of Gratitude and Adoration. . . . The dullest finds his mind exalted by the contemplating of *Sublimity* and Vastness, and the giddy feels his spirits calmed for temperate enjoyments by that of *elegant simplicity*. . . .

* The several species of *Melody*, have never yet been accurately determined; whereas those of *Landscape* are found to be no more than sixteen, from whose different combinations, with the addition of accessory circumstances, all the varieties of Landscape are derived. . . . The world may shortly be favoured with a Treatise upon the Principles and Effects of Landscape, by a very ingenious artist, Mr. *Alexander Cozens*.[15]

This passage and the scenery they encountered would have been a powerful reminder of landscape's capability to exalt the mind, inspire the imagination, and move the spirit.

Basset and Sandys arrived in Rome, the goal of their journey, in November or December 1777—a time when the artist Thomas Jones recorded the presence in Rome of Cozens, More, William Pars, Ozias Humphry, and the artist, agent, and excavator Gavin Hamilton. Most of them were already friends or professional acquaintances of Alexander Cozens and his son. Basset was to purchase Hamilton's set of engravings of the Italian school of painting, which was on the *Westmorland* (see cat. 41), but also, more significantly, Hamilton's history painting *The Death of Lucretia* and two mythological paintings, *Venus* and *Cupid*, which were not on the *Westmorland* and which all later hung at Tehidy.[16] Cozens's only dated drawings from around that time are a view of Tivoli from April 1778 (see fig. 77) and another of Terracina from October 1777, one of a series of drawings from this period now in Sir John Soane's Museum, London; the latter is exceptionally close to one of the

Figure 74. John Robert Cozens, *Lake Nemi*, 1777–78,
watercolor over graphite on paper, 17⅛ x 23⅞ in. (43.5 x 60.5 cm). Real Academia de Bellas Artes de San Fernando, Museo (cat. 27)

views by More that also belonged to Basset or Sandys (cat. 53) and for which More may have charged £5 each, providing a possible price for Cozens's watercolors.[17] Two oils by More, *The Cascade of Terni* and *The Cascatellis of Tivoli, with Maecenas's Villa*, dated 1778 and for which he would have charged close to 100 guineas each, must have been commissioned at this time and sent on another ship, as they are also recorded at Tehidy.[18] Solomon Delane was not mentioned by Jones, but he was an established presence in the city, and Basset purchased one oil painting by him that was on the *Westmorland* (cat. 22); a second painting by him, of the *Lake of Nemi*, must also have traveled on another ship, as it, too, hung at Tehidy.[19] All these purchases or commissions must have been made either by the end of December 1777, when Basset and Sandys headed for Naples for a stay until the spring of 1778, or on their return to Rome for a month or so before heading off for Florence in May. The con-

tents of the various ships were undoubtedly gathered together by an agent after their departure but before the *Westmorland* eventually left the harbor at Livorno in December 1778. Although Cozens's watercolors are undated, they must have been made between November 1777 and the summer of 1778.[20]

From the moment of their recent rediscovery in the Real Academia de Bellas Artes de San Fernando, Madrid, and identification as works by Cozens, these six views of the "Magick Land" to the south of Rome have impressed viewers with their fresh handling, color, and visual impact, so different from Cozens's preceding works for Payne Knight or his later work for Beckford.[21] They do not form a link between the two but instead present yet another stage in Cozens's thirty-year career as a watercolorist, each one reflecting a new development in his progress as a distinctive artist whose work was to change the medium and its message.

Figure 75. John Robert Cozens, *Lake Vico*, 1777–78,
watercolor over graphite on paper, 17⅛ x 23⅞ in. (43.5 x 60.5 cm). Real Academia de Bellas Artes de San Fernando, Museo (cat. 28)

The bright colors are the most evident change from Cozens's pen-and-ink Alpine sketches with washes of gray, blue, and brown (fig. 76) and from his watercolor of Tivoli dated 1778 (fig. 77), with its unusual addition of pale washes of orange to the more common range of blue, gray, and brown, as well as from the muted tones of his other works dated 1778.[22] The depth and brightness are not only due to their unfaded condition: an increased use of greens, yellows, and deeper blues is noticeable; they seldom appear in later works with this clearness, purity, and strength. Cozens listed red lead, king's yellow (canary to gold yellow), raw umber (brown), and grays with warmed whites as colors to use (along with the paper itself) for a sunset at Hampstead Heath in 1771.[23] In an account of his method recorded by a pupil in the 1780s, Cozens emphasized that no gum was to be used, apart from a thin solution in water to fix the colors in the sky and distance, and he noted that india rubber was useful for vapor and sun

rays, but otherwise lake (usually red), Prussian blue, and gamboge (dark mustard yellow), with india ink, were "generally sufficient"; gamboge and lake would produce orange, for example, and for clouds inclining to orange, gamboge and red lead would be combined. Saffron infused in water was a useful tint if used sparingly to enliven browns and could also be used with blue and black in azure parts of the sky and with lake for clouds. India ink and brown were mixed for shadows in the foreground, "worked with freedom."[24] There was no mention of greens, but of course they could be produced by mixing yellow and blue. No blue was mentioned in the 1771 list of pigments, but it was certainly in use by 1776 for the Alpine views. Thus, the Basset set of watercolors marks the first use of what was to become Cozens's staple selection of pigments.

The application of the watercolor is equally different from anything Cozens had produced before. In fact, this should not be surprising—indeed, it

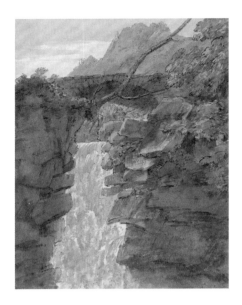

Figure 76. John Robert Cozens,
The Fall of the Reichenbach, 1776, pen and
black ink with gray wash and green wash,
9⅝ x 7⅛ in. (24.4 x 18.1 cm). Yale Center
for British Art, Paul Mellon Collection

Figure 77. John Robert Cozens, *Tivoli*,
1778, pen and black ink, watercolor and
graphite, 13 x 19¼ in. (33 x 48.9 cm). Yale
Center for British Art, Paul Mellon
Collection

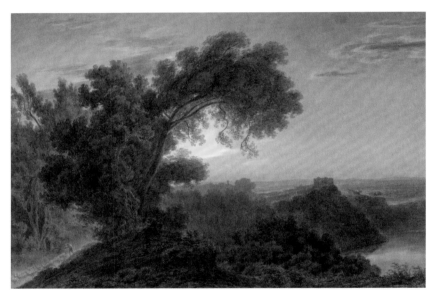

Figure 78. John Robert Cozens, *Lake
Albano and Castel Gandolfo*, ca. 1779,
watercolor and graphite, 17½ x 25⅛ in.
(44.5 x 63.8 cm). Yale Center for British
Art, Paul Mellon Collection

Figure 79. John Robert Cozens, *Lake
and Town of Nemi*, ca. 1779, watercolor,
brushed black ink, black wash and
graphite, 14⅜ x 20½ in. (36.5 x 52.1 cm).
Yale Center for British Art,
Paul Mellon Collection

Figure 80. John Robert Cozens, *Lake Vico between Florence and Rome*, ca. 1780, watercolor and graphite, 10⅛ x 14¾ in. (25.7 x 37.5 cm). Yale Center for British Art, Paul Mellon Collection

would be strange if he had not been influenced at all by those artist friends with whom he may have compared works or painted side by side. There is much of both the color and the handling evident in the works of More, in addition to something of the lightness of touch of Pars. Cozens moved from a reliance on the pen work and strong underlying pencil outlines found in the Alpine views to a light pencil sketch that is used to provide definition to the outlines of buildings and to clumps of trees and bushes, but he was a long way from the tinted drawings of contemporary watercolors of the topographical school. There is little evidence of any influence from Jones's fussy, detailed watercolors. Among the strongest elements of Cozens's watercolors are his own unique way of shading larger dark areas of the sides of hills or rocks with broad strokes of dark colors on lighter ones and his buildup of details in the foreground through the use of the brush to draw, both of which are derived completely from his father's similar use of the brush. Equally evident here is the attention he paid to the sky, its tones and light, and the effect it has on the atmosphere and mood of the landscape. This, too, is derived entirely from his father's teaching and is not found in the work of any of his contemporaries with the skill that is already apparent here.

Still, these are not the accomplished, poetic, and carefully constructed and painted works of his maturity; there is evidence here of mistakes that occurred while painting, in the wet blots that are noticeable in the water of the lake to the left of the fishermen, on the left of Lake Vico (fig. 75), and at the top of the sky in the view from Palazzolo (fig. 72). These are large sheets that required a great deal of control, and Cozens's skill did not yet quite match his ambition and vision. The view of Lake Albano from the Capuchin monastery of Albano (fig. 70) is quite stark and needs a *repoussoir*, provided in the form of a large arching tree and herd of goats in all the later, lyrical, and elegiac versions of this view, which was to become his most popular composition (fig. 78). The view of Lake Nemi (fig. 74) is also a first attempt at a composition that was repeated many times later with greater skill, evenness of tone, and atmospheric blending of land and sky (fig. 79).

As a whole these watercolors form an interesting comparison with the small, now scattered group that Beckford commissioned after Cozens's return to England in 1779, most of which are dated 1780 and mounted in a similar way—as a set, with framing wash and line mounts. They are smaller than Basset's, but Cozens's ability to capture the essence of the Italian landscape, its light and atmosphere, and to combine it with the English idea of that "classic ground" of antiquity—in the writer Joseph Addison's enraptured words—had improved considerably in the two intervening years (fig. 80).[25]

These six watercolors intended for Basset's home in England are significant for one more reason: they

depict every Grand Tourist's idea of Arcadia, the Alban Hills surrounding the site of Cicero's villa at Tusculum and steeped in the most revered of all the tales of classical antiquity. These beautiful wooded, volcanic hills and crater lakes provided the rewarding destination at the end of a fourteen-mile pilgrimage down the Via Appia Antica that was a day's excursion from Rome taken by every visitor to the city. Even before it was visited, this "classic ground" was familiar not only from the writings of Horace, Virgil, and Ovid, as well as modern imitators such as Addison, but also through dozens of paintings by Claude Lorraine, Gaspar Dughet, and Richard Wilson, whom all artists in Rome emulated, consciously or not. Earlier Grand Tour souvenirs of these sites took the form of large oils or engravings after them, or drawn or small

colored views that could be kept in portfolios. But Basset's watercolors by Cozens were surely too large for a portfolio or album, to be taken out and held in the hand, and must have been intended to be hung on walls, as indeed Richard Colt Hoare was to do in the late 1780s in a hang that included a pair of large works by Cozens along with watercolors by John "Warwick" Smith, Turner, and the Swiss artist Louis Ducros.[26] Cozens's six striking watercolors, suffused with the sentiment of an Arcadian past and memories of Basset's own Grand Tour, were surely intended both to brighten the walls of the library at Tehidy and at the same time to lend it the gravitas of classical antiquity, indicating that the owner was a man of taste and education—and as such, they are certainly among the earliest examples of their type.

The quotation in the title is from Hoare 1819, describing the view from the gardens of the church of San Paolo in the hill above the lake and town of Albano, cited in Keaveney 1988, 277. I would like to thank Scott Wilcox and Elisabeth Fairman for inviting me to write about this fascinating group of watercolors. I would also like to acknowledge the work of José M. Luzón Nogué on the rediscovery of the contents of the *Westmorland* and especially María Dolores Sánchez-Jáuregui's essay on Francis Basset and her extensive and excellent entries on these watercolors in Westmorland 2002, and to thank them both for their kindness and generosity with their research.

1. Leslie (1843) 1951, 242.
2. Hardie 1966, 1:132.
3. The album was inscribed: "Views in Swisserland, a present from R. P. Knight, and taken by the late Mr. Cozens under his inspection during a Tour in Swisserland in 1776," according to Wilton 1980, 39; Wilton stated that the album was given to John Towneley and then dispersed at his sale on May 1–15, 1816. For this journey by Knight, see Clarke and Penny 1982; and Sloan 1986, 127–37.
4. For an early discussion of these drawings and potential influences, now much disputed, see C. F. Bell and Girtin 1934–35), 10, 24; for the trip to Sicily, see Stumpf 1982, 19–31; and Stumpf 1986. See also Oppé 1952, 142 n. 1.
5. Bryon's description of Beckford is cited in Fothergill 1979, 233. For the group of ten watercolors commissioned in 1779, see Sloan 1986, 138–39; C. F. Bell and Girtin

1934–35, 96; and a list produced by Henry Wemyss for the sale of one of the ten, *Rome from the Villa Madama* (signed and dated 1780), Sotheby's, London, April 10, 1997, lot 32.
6. The seven sketchbooks that survive are now in the Whitworth Art Gallery, University of Manchester; they do not include views of Rome, indicating that there were possibly one or two other sketchbooks from this journey that are not yet located. Beckford sold the nearly one hundred finished watercolors that Cozens produced for him from this trip in a sale at Christie's, London, April 10, 1805. See Sloan 1986, 139, 176 n. 2.
7. For their relationship and a discussion of their influences on each other, see Sloan 1986, 138–57; Hauptman 2001, 308–11; and Sloan 2006, 19–52.
8. For Basset's Grand Tour and what he and his tutor collected, see Sánchez-Jáuregui 2002; and Westmorland 2002, nos. 21, 22, 55–58 (entries by Sánchez-Jáuregui).
9. Solkin 1982, 39.
10. For Basset's family history and a contemporary description of his house and contents, with an engraved view from the lawn, see Gilbert 1820, 2:690–91; see also Thorne 2006; and for Waagen's description, see Sánchez-Jáuregui 2002, 122, 141 n. 21.
11. March 4, 1771, Tehidy Minerals MSS, Cornwall Record Office, Truro. I am grateful to Jonathan Yarker for this information.
12. For Alexander Cozens and his teaching at Eton, see Sloan 1986, 36–55.

13. See Sánchez-Jáuregui 2002, 129–30; and Negrete Plano 2002, 106–17.

14. Dated Dec. 26, 1774, Henstead. The Reverend Charles Davy (1722/23–1797) was rector of Benacre and Henstead and later of Onehouse, all in Suffolk, and his coauthor, Frederick Davy, was his brother. See F. Owen and Brown 1988, 9–14.

15. Cited in Sloan 1986, 57–58.

16. These three paintings were described in Basset's collection at Tehidy by C. S. Gilbert in his survey of Cornwall; see Gilbert 1820, 690. Only the painting of Lucretia was included in the Basset sale at Christie's, London, Jan. 9, 1920, lot 104 (58 x 78 in. [147.3 x 198.1 cm], 15 guineas); there is a version of Hamilton's *Death of Lucretia*, commissioned in Rome in 1763 by Charles, Lord Hope of Hopetoun, in the Yale Center for British Art.

17. For Cozens's views of Tivoli and Terracina, see Wilton 1980, nos. 91, 125, 129. For More's views, see cats. 52–53, and for More's price for his watercolors in 1776, see Holloway 1987, 10.

18. Described in Gilbert 1820, 690, and included in the Basset sale at Christie's, London, Jan. 9, 1920, lots 131, 132 (66 x 87 in. [167.6 x 221 cm] and 67 x 81 in. [170.2 x 205.7 cm], respectively, sold for 18 guineas each). In 1782 More's price for oils of this size was 100 guineas; see Holloway 1987, 10.

19. Gilbert 1820, 690; and Suárez Huerta 2009b, 177–86.

20. In his "Memoirs" Thomas Jones recorded that from May and through the summer of 1778, he paid regular visits to Cozens, who lodged with Signor Martinelli in his villa near the church of Sant'Agnese on the Via Nomentana outside the Porta Pia, on a gentle hill that commanded views of Rome on one side and the Campagna and Apennines on the other. Cozens always lodged there when in Rome: "as he was not well in health, when the Weather was favourable, resided at this Villa for the benefit of the Air, and riding about on a jackAss which he had purchased for that purpose." T. Jones 1946–48, 73.

21. Although I have referred to this group of six collectively as views of the Alban Hills, in fact one of them probably is a view of Lake Vico to the north of Rome (cat. 28); nevertheless, the sentiment of the view would have connotations for the owner similar to the views of Lake Albano. The phrase "Magick Land" was used by Thomas Jones to describe this area on Dec. 14, 1776; see T. Jones 1946–48, 55. For a description of his visit there and work by contemporaries, including Cozens and Pars, see Hawcroft 1988, 60–69.

22. There are also twenty-eight large drawings in Sir John Soane's Museum (acc. no. XLIV), including views of the Alps from Aug. 1776, Tivoli from April 1777, and Rome from March and Oct. 1778. Some record the basic compositions of the Basset group; they are mostly uncolored, apart from a few with blue or gray wash. Other works signed and dated 1778 include *Villa d'Este, Tivoli* (Aberdeen Art Gallery & Museums), a view of a river gorge in *Valley of the Ober-Hasli* (College Collections, Eton College), *View of the Valley of the Ober-Hasli* and *Lake Nemi* (Victoria and Albert Museum, London), *Galleria di Sopra*, above Lake Albano, two views (private collection; National Gallery of Victoria, Melbourne), and *Interior of the Colosseum* (Leeds Art Gallery).

23. These colors are inscribed on a pencil sketch of the setting sun from Hampstead Heath, Sept. 3, 1771. See Joyner and Sloan 1995), no. 30(a), pl. 86.

24. C. F. Bell and Girtin 1947, 3–4.

25. For this group, see note 5 above. Addison, *Letter from Italy*, 1701: "Poetick Fields encompass me around, / And still I seem to tread on Classic Ground," cited in Bull 1981, title page. Five of the watercolors are 8⅛ x 11⅞ in. (20.5 x 30 cm). The view of Lake Vico, which is 10⅛ x 14¾ in. (25.7 x 37.5 cm), is one of a handful of other watercolors of different sizes that also once belonged to Beckford and are based on views that must have been drawn during Cozens's first trip.

26. Hoare's hang is still preserved at Stourhead today and was described in Hoare 1822, 1:82–83; see also C. F. Bell and Girtin 1934–35, 13–14 n. 1, nos. 12, 141.

The *Westmorland* and Architecture

FRANK SALMON

After a sleepless night I trod with a lofty step the ruins of the Forum; each memorable spot where Romulus stood, or Tully spoke, or Caesar fell was at once present to my eye.

—*Edward Gibbon*

EDWARD GIBBON's famous account of his first morning in Rome, in October 1764, gives a valuable insight into what must have been the sentiments of some, and probably many, of those British travelers of the following decade whose possessions were to be shipped home on the *Westmorland*.[1] Schooled as they were in the literature and history of the ancient world, eighteenth-century Grand Tourists and their tutors found the topography of the city of Rome far more redolent of its original inhabitants than it is for most modern-day visitors. The same might be said of the ancient city's surviving architecture. One *Westmorland* Grand Tourist, perhaps Frederick Ponsonby, Viscount Duncannon, had acquired a trio of drawings of the Pantheon (figs. 81 and 82), the plan of which articulates the decoration of the building's floor.[2] While the purchaser's primary interest here was presumably in the exquisite marble patterning, it might not be too far-fetched to conceive of this image as representative of a floor actually trodden by ancient Roman and modern Briton alike, somewhat in the sense that Gibbon "trod" the Forum. Indeed, John Chetwode Eustace was to write of his visit to the building in 1802 that the "pavement laid by Agrippa, and trodden by Augustus, still forms its floor."[3] Most

Figure 81. Unknown architect (possibly Giovanni Stern or Vincenzo Brenna), *Plan of the Pantheon, Rome, Showing the Marble Decoration of the Floor*, pen, ink, black, pink, gray, mauve and brown-orange washes, 28⅞ x 20⅛ in. (73.3 x 51.2 cm). Real Academia de Bellas Artes de San Fernando, Museo

126

Figure 82. Attributed to Vincenzo Brenna, *Longitudinal Section of the Pantheon from the East*, pen and ink and watercolor on paper, 20 x 28¾ in. (50.7 x 73 cm). Real Academia de Bellas Artes de San Francisco, Museo (cat. 65)

ancient Roman edifices, however, were not in anything like the relatively good state of repair of the Pantheon; the generally ruined architecture of the city was seen either as symbolic of the decline and fall of high political and cultural ideals that Gibbon was to chronicle or, as the eighteenth century progressed, as simply picturesque. Both of these cultural understandings of architecture are well represented by the many etchings of Giovanni Battista Piranesi and the numerous watercolor/gouache views of ruined Roman buildings that were sent home on the *Westmorland*.[4]

In addition to its ability to form a tangible representation of history or to stimulate the visual sensibility, architecture was a matter of considerable theoretical and practical interest to many traveling aristocrats in the second half of the eighteenth century. The architectural profession itself was still in its infancy in Britain, and the great aristocrat-architects of the first half

of the century, such as Richard Boyle, third Earl of Burlington, and Henry Herbert, ninth Earl of Pembroke, were within living memory, having died only in the 1750s.[5] The foremost amateur architect of the 1770s was surely Thomas Pitt, a member of Parliament and of the Society of Dilettanti, and later first Baron Camelford. Pitt had been designing buildings from the early 1760s, first for friends and then for himself, when he encountered and became friendly with the young architectural student John Soane in Rome late in 1778. While Soane doubtless sought to ingratiate himself with a potential patron who had good ties to other patrons, he had real respect for what he was later to call Pitt's "classical taste and profound architectural knowledge" and, from 1810, even told students of the profession attending his third Royal Academy of Arts lecture that "until architecture has a Burlington, a Pembroke or a Camelford to direct the public taste, we can have but little hope."[6]

There is no evidence that any of those aristocrats and gentry whose possessions were aboard the *Westmorland* had the amateur architectural skills of Pitt, but the fact that the great majority of architectural drawings that have been associated with the ship belonged to Lord Duncannon shows that at least one such traveler possessed considerable architectural interests. These had very likely been developed under the influence of his father, William Ponsonby, second Earl of Bessborough, who had made the Grand Tour in 1736–38 and was an early and active member of the Society of Dilettanti. Duncannon's childhood must have been spent between his father's London residence in Cavendish Square and Parkstead, the villa at Roehampton built for the earl by William Chambers between 1760 and 1768. There Bessborough amassed an impressive collection of more than one hundred antiquities as well as books, using Thomas Jenkins in Rome as his agent.[7] Indeed, in 1770 Jenkins wrote from Rome to the collector Charles Townley: "My Lord Bessborough is So deserving that I am glad to have it in my Power to Send him any thing worthy of his Elegant place at Roehampton."[8] Surviving examples of Duncannon's perspective drawings show him to have had a reasonable degree of graphic skill.[9] How and where this talent was developed is unknown, but it is worth observing that some on the Grand Tour made it their business to develop architectural competence under the guidance of compatriot architectural students: for example, in 1758–59 Robert Mylne taught the principles of architecture to John Stewart, Viscount Garlies, and to William Fermor of Tusmore, Edward Knight from Kent, and a Mr. Miller; in 1761 George Dance the younger gave instruction on the classical orders to John Hinchliffe, later bishop of Peterborough.[10] In the 1770s, when the *Westmorland* Grand Tourists were in Rome, we may perhaps assume that James Byres's exhaustive tours of the city included some architectural instruction for those who cared to have it.

While architectural students can be presumed to have possessed greater knowledge of technical matters such as architectural draftsmanship and construction, the educational background of some Grand Tourists must have placed them just as well,

Figure 83. Copy after James Byres, *Plan of the Palatine Hill Palaces, Rome*, black ink with gray and blue watercolor over graphite, 14⅛ x 10⅛ in. (35.8 x 25.6 cm). Real Academia de Bellas Artes de San Fernando, Museo

if not better, to appreciate antiquarian debate in Rome and elsewhere. By the 1770s, with Giovanni Battista Visconti in place as *commissario delle antichità di Roma e suo distretto* in succession to Ridolfino Venuti and Johann Joachim Winckelmann, and on the back of Piranesi's quasi-archaeological publications, antiquarian knowledge was advancing significantly. One crate on the *Westmorland*, possibly containing the possessions of John Henderson of Fordell (later a founding member of the Society of Antiquaries of Scotland), included small plans of the Palatine Hill palaces (fig. 83), the Circus of "Caracalla" (actually of Maxentius, on the Via Appia Antica), the Theater of Marcellus, and the Colosseum.[11] The first two of these were relatively unusual subjects in themselves, and the plan of the Palatine has a somewhat scholarly

Figure 84. James Byres (?) after George Dance, *A Geometrical Elevation of the Remains of a Tenple* [sic] *at Tivoli*, 1770s, pen and ink and black, gray, and green washes over graphite on paper, 20⅜ x 28⅝ in. (51.6 x 72.6 cm). Real Academia de Bellas Artes de San Fernando, Museo (cat. 70)

Figure 85. George Dance the younger, *Measured Elevation of the Round Temple of "Vesta" at Tivoli*, 1763, pen and wash on card, 23 x 33⅛ in. (58.5 x 84 cm). Sir John Soane's Museum, London

character. Black-wash lines have been used to denote surviving fabric while gray wash denotes hypothetical restorations, including a spectacular approach to the Palatine Hill beside the Arch of Titus, entered by a great flight of steps leading to an exedral space. The origin of this drawing is made clear by the survival of an almost identical version in the collection of the British architectural student Thomas Hardwick (in Italy 1774–78) that is annotated "da Sigr. Byers Copia," and Hardwick had also acquired small-scale copies from Byres of the plans of the Baths of "Titus" (actually of Trajan), of Diocletian, and of Caracalla.[12] Henderson might also have been the owner of a copy of Carlo Nolli's *Dell'Arco Trajano in Benevento* (see cat. 93 for another copy belonging to Duncannon), which, published in 1770 to record measurements made four years earlier by Luigi Vanvitelli, was a substantial new survey of this important and well-preserved monument.[13] The fact that there were five copies of this book on board the *Westmorland* suggests that several of the Grand Tourists whose possessions happened to be on the ship had serious interests in the latest discoveries and publications about antique buildings.

Such interests are also borne out by a collection of four much larger drawings of ancient Roman buildings, found on the *Westmorland*, that belonged to Lord Duncannon: a plan and a perspective of the Temple of "Fortuna Virilis" in Rome (actually the Temple of Portunus); a plan of the "Temple of Serapis" (the Macellum) at Pozzuoli; and a plan of the Pantheon.[14] The view of the Temple of "Fortuna Virilis," which removes its eighteenth-century dilapidations and the Christian church that had been built into it in the ninth century, has some infelicities that might suggest an amateur hand—conceivably even Duncannon's own, though this seems unlikely. Alternatively this could be the work of a young British architectural student directly employed by the viscount (some later eighteenth-century British travelers employed architects to journey with them for the purpose of making drawings, as was the case with Soane, who accompanied a group of five Grand Tourists to Sicily in this capacity in 1779).[15] A third possibility, however, is that the drawings were not commissioned but came from stock—and were, moreover, copies by Roman-based

architects of popular subjects. The section in Duncannon's smaller trio of drawings of the Pantheon (cat. 65) is attributed in this volume to the Ticinese architect Vincenzo Brenna on the basis of closely similar sections in the Victoria and Albert Museum, London, and in the Biblioteca di Archeologia e Storia dell'Arte, Rome, the former of which is documented as having been supplied by Brenna to Townley.[16] Two sets of drawings of the Temple of "Vesta" at Tivoli, moreover, each with an elevation and a plan but at different scales, certainly belong in the category of stock and, moreover, have an explicitly British pedigree (fig. 84). They are copies of the celebrated study of this temple made by George Dance the younger in consort with an unnamed Roman architect (perhaps Giovanni Stern) in 1761–63, and, as Dance's original is now in such poor condition, they have considerable value as an indication of the original coloration (fig. 85).[17] The recent sale at Christie's in London of an identical elevation signed by Byres confirms his very likely authorship of, or origination of, the versions on the *Westmorland*.[18] Dance later told Joseph Farington that Byres had borrowed his elevation, "copied it and sold a great number of copies of that as from his own measurement."[19] Whether or not Byres was passing such works off as his own studies, he was certainly operating an industry in making and selling copies of studies of antique buildings during the 1770s, as we have already seen in the case of the small plans of the Palatine Hill and Roman bath complexes that Hardwick had acquired.

In addition to drawings of actual Roman antiquities, the cargo on the *Westmorland* included works that show the Neoclassical inventiveness of architects whose experiences representing the ruins themselves had prepared them well for the task. It was Robert Adam who, in the late 1750s, had learned from his mentor Charles-Louis Clérisseau the fashion for imagining ruins or fictive "Roman" buildings, and who, by the 1770s, had done so much to establish the British taste for Neoclassical walls and ceilings. Perhaps this underlies Lord Duncannon's purchase from Brenna of two elaborate and beautiful ceiling designs (figs. 86 and 87). Executed in 1776 and 1777, respectively, before Duncannon had arrived at Rome,

they show that Brenna was capitalizing on what he had learned from work as an architect-illustrator of Giuseppe Carletti's and Ludovico Mirri's great book on the "Baths of Titus" (actually the Domus Aurea of Nero), *Le antiche camere delle Terme di Tito e le loro pitture* (1776), two copies of which, belonging to Lord Lewisham and to the unknown owner of crate "J. G.," were also on the *Westmorland*. The Brenna designs, which at first glance could readily be mistaken for restored representations of Roman decorative paintings, have an air of authenticity about them to which Duncannon seems to have responded, for the pair of plans and elevations of "temples" that he commissioned or purchased also have intriguing half-real, half-fictive characters. Both plans (figs. 88 and 89) show Roman tombs, drawn in the sixteenth century and known in the eighteenth from printed versions (figs. 90 and 91), one currently unidentified but the other ("In the Garden where Today stands the Church of St. Sebastian Outside the Walls") representing the Tomb of the Attilii Calatinii.[20] These Renaissance hypothetical reconstructions of the superstructures of the tombs, however, are quite different in character from Duncannon's elevations (fig. 92 and cat. 69), which are decidedly close to the way architecture was being represented in the annual exhibition of the Royal Academy in London in the third quarter of the eighteenth century. The distinctive eye-catching technique of offsetting a carefully modulated elevation against sketched-in perspective backgrounds to either side was a graphic innovation by William Chambers in the late 1750s (fig. 93), deployed by his pupil John Yenn in drawings displayed at the Royal Academy in the mid-1770s and picked up by another Chambers pupil, Hardwick, and by Soane.[21]

Figure 86. Vincenzo Brenna, *A Ceiling Design in the Antique Style*, 1776, watercolor and gouache over graphite on paper, 20⅞ x 23½ in. (53 x 59.8 cm). Real Academia de Bellas Artes de San Fernando, Museo (cat. 63)

Figure 87. Vincenzo Brenna, *A Ceiling Design in the Antique Style*, ca. 1777, watercolor and gouache over graphite on paper, 28⅜ in. x 20 in. (72 x 50.8 cm). Real Academia de Bellas Artes de San Fernando, Museo (cat. 64)

88

89

Tempio Antico

90

Questo Sepolcro fu fatto dalli antichi doue hoggi e' la Chiera di s. sebastiano dentro al Giardino doue sono le
Vasche, li ornamenti suoi sono Corintij nella parte di fuori et il di dentro e' senza ornamento alcuno.

91

Figure 88. Unknown artist, *Floor Plan of a Temple near Albano*, 1770s, pen and ink and watercolor over graphite on paper, 22½ x 17¾ in. (57.3 x 45.2 cm). Real Academia de Bellas Artes de San Fernando, Museo (cat. 66)

Figure 89. Unknown artist, *Floor Plan of a Temple That Once Stood on the Site of Today's Church of San Sebastiano Fuori le Mura*, 1770s, pen and ink and black and gray wash over graphite on paper, 22⅝ x 17¾ in. (57.6 x 45.2 cm). Real Academia de Bellas Artes de San Fernando, Museo (cat. 68)

Figure 90. Giovanni Battista Montano, *Plan and Part Elevation / Part Section of a "Tempio Antico,"* from *Raccolta de templi, e sepolcri designati dall'antico* (Rome, 1638, pl. XX), as reprinted by G. B. de Rossi (Rome, 1684). Faculty of Architecture and History of Art, University of Cambridge

Figure 91. Giovanni Battista Montano, *Plan and Part Elevation / Part Section of a Tomb*, from *Raccolta de templi, e sepolcri designati dall'antico* (Rome, 1638, pl. XXVI), as reprinted by G. B. de Rossi (Rome, 1684). Faculty of Architecture and History of Art, University of Cambridge

Figure 92. Unknown artist, *Elevation of a Temple near Albano*, 1770s, pen and ink and watercolor over graphite on paper, 18⅛ x 21¼ in. (45.9 x 53.9 cm). Real Academia de Bellas Artes de San Fernando, Museo (cat. 67)

Figure 93. William Chambers, *Design for the Wilton Casina*, 1759, pen and ink, pencil and watercolor on paper, 14½ in. x 16¾ in. (36.8 x 42.5 cm). Victoria and Albert Museum, London

92

93

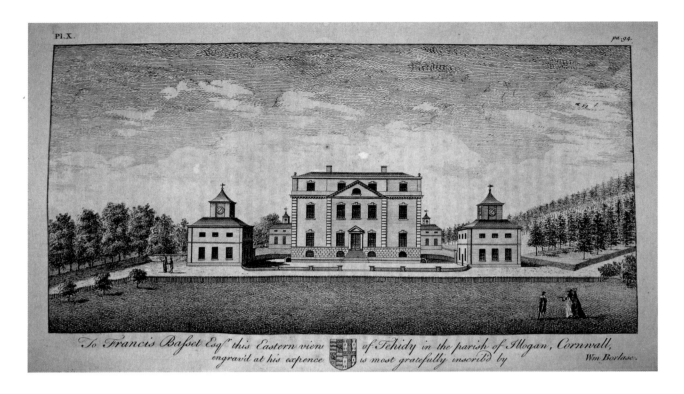

To Francis Basset Esq.ʳ this Eastern view of Tehidy in the parish of Illogan, Cornwall, engrav'd at his expence is most gratefully inscrib'd by Wm Borlase.

Figure 94. Unknown artist, *Tehidy, Cornwall, View of the East Front in 1754*, from William Borlase, *The Natural History of Cornwall* (Oxford, 1758). By permission of the Master and Fellows of St. John's College, Cambridge

The cargo of the *Westmorland* did contain some drawings that are very probably from the hand of a traveling British architect, but they belong to an entirely different context from those discussed hitherto. These are the original designs perhaps made by Christopher Ebdon for a chapel (cats. 29–32), quite possibly intended for Tehidy Park in Cornwall, the house of Francis Basset (fig. 94). It was by no means uncommon for British Grand Tourists to commission designs from compatriot architectural students, although the number of these commissions that were eventually erected was far smaller. These designs varied in scale from fixtures such as chimneypieces (like those that Dance produced for Sir Henry Mainwaring's Over Peover) to whole rooms or even entire country houses (such as Robert Mylne's Cally Palace in Dumfries and Galloway, commissioned in Rome by a pupil of Mylne's, the twenty-two-year-old Lord Garlies, for his brother-in-law, James Murray of Broughton).[22] In 1778 the most notorious of all potential Grand Tour patrons, as far as British artists were concerned, was active in Rome; this was Frederick Her-vey, bishop of Derry, playing the newly arrived Soane off against John Henderson (no relation to Henderson of Fordell), a Scottish architectural student, in a competition to design a new summer dining room at his Irish country house, Downhill.[23] Indeed, Soane cut short his precious time in Italy when he was lured to Ireland by the promise of a commission from the bishop, who had unexpectedly inherited the earldom of Bristol at the turn of 1780. In 1794 the Earl of Bristol was back in Rome on the last of his six visits, this time asking the British architects Charles Heathcote Tatham and Francis Sandys to design a new house for him at Ickworth in Suffolk (a commission that went finally to Tatham's Roman friend Mario Asprucci).

Tatham and Ebdon in fact had something in common, in that both of them had reached Italy thanks to the employment of Henry Holland, an architect established in practice by the 1770s who therefore could not travel himself but who nonetheless appreciated the importance of the firsthand gathering of architectural information. The professional successes of Chambers and Adam, following their sojourns in

Italy in the 1750s, had made a period of study in the Mediterranean more or less de rigueur for any young architect who aspired to practice at the highest levels of patronage. The establishment of proper pupilage and in 1768 of the Royal Academy, with its schools, library, and competitions, further consolidated the new pattern of training. Gold medalists became eligible for the three-year King's Travelling Studentship, which Soane was the first architect to receive in 1777, thanks to the support of Chambers. As a Royal Academy student, Soane would have heard very little about the benefits of foreign travel in the lectures of the professor of architecture, Thomas Sandby, who recommended that access to antiquity be sought by reading and by attentively copying casts of sculptures.[24] Chambers, however, took an entirely different view. In 1770 he had drafted a set of lectures in the event that Sandby, who had become ill, might be unable to deliver his. In the first of these Chambers laid out a manifesto on the necessity of travel to Italy by British architectural students, which he would repeat in a letter sent to his student Edward Stevens in Rome in 1774, a copy of which was handed to Soane.[25] That this pedagogic instruction was being heeded is clear from the fact that, in addition to the six architects mentioned so far in this essay as present in Rome in the mid- to late 1770s (Soane, Hardwick, Ebdon, Stevens, Henderson, and Brettingham), a further four (Thomas Harrison, Thomas O'Brien, Theodosius Keene, and James Paine Jr.) can be identified as studying in Italy at that time and could have had contact with their social superiors whose treasures were on board the *Westmorland*.

Architectural students traveling in Italy were, of course, living (and indeed working) under far less advantageous circumstances than Grand Tourists. One major point of difference was that they generally lacked the means to ship their possessions back to Britain. Exceptions can be found, as in the cases of Ebdon and later Tatham, whose collections of fragments and casts were transported by sea at the expense of their employer, Henry Holland, architect for George, Prince of Wales (the future George IV).[26] In most cases, however, architectural students were constrained to collecting what they could carry with them. As Soane traveled through Switzerland on his way home from Italy in 1780, the bottom of his trunk came loose on the back of the carriage, spilling onto the road behind it many possessions, including his Royal Academy gold and silver medals; boxes of silver and leather architect's instruments; many letters received; notebooks and printed architectural books in Italian, French, and English; many clothes; and some jewelry for presentation to ladies.[27] The incident may serve to remind us that those eighteenth-century travelers who kept their belongings with them as they journeyed were as liable to lose them as those who consigned them to ships. Unlike the Grand Tourists whose goods were on the *Westmorland* and have now been happily rediscovered in Spain, however, Soane's possessions—no less valuable to him or to us as historians—have never been seen since.

I am especially grateful to Jonathan Yarker for his assistance in the preparation of this essay, and to María Dolores Sánchez-Jáuregui and José M. Luzón Nogué for sharing with me the fruits of their research on the *Westmorland*. I also thank Robert Coates-Stephens, Richard Hewlings, and Martin Clayton for advice on the Via Appia Antica mausoleums, Christopher Ebdon, and Vincenzo Brenna, respectively.

1. Gibbon 1984, 141.
2. Duncannon certainly had a large-scale perfunctory plan of the Pantheon. A-4956, Museo, RABASF. Figure 1, however, together with its accompanying elevation and section, may equally have belonged to George Legge, Viscount Lew-

isham. Another version of this plan, from the collection of the late Sir Howard Colvin and attributed to Giovanni Stern (but see note 16 below for the possible involvement of Vincenzo Brenna), was with the dealers Abbott and Holder in London in spring 2010. Both versions idealize the paving of the Pantheon's portico, but the *Westmorland* version is a closer representation of the paving pattern inside the rotunda itself.

3. Eustace 1821, 3:400. I am grateful to William Hank Johnson for drawing this quotation to my attention. Eustace was, of course, mistaken about the actual date of the Pantheon (which, in its current Hadrianic form, was known to neither Agrippa nor Augustus), but Gibbon's notion of

physical treading common to ancient and modern worlds is nonetheless substantiated as a trope of the time by his comment—and perhaps gains credence in relation to this drawing from the *Westmorland* when one considers the inclusion of contemporary staffage in the matching cross section (a technical drawing, not a perspective view).

4. Penn Assheton Curzon and Francis Basset were each shipping fourteen volumes of Piranesi prints, while Lord Duncannon and the unidentified owner of crate ◇E◇ on the *Westmorland* had especially extensive collections of watercolor/gouache topographical views (see cats. 71–74 and 125–27).

5. See Worsley 1994, a useful collection of essays on the subject listing amateur architects in appendices; and Harris and Hradsky 2007.

6. Soane 1835, 14 n.; and Watkin 1996, 531.

7. See Scott 2003, 139–40.

8. Bignamini and Hornsby 2010, 2:17.

9. An album of topographical drawings, for example, that Duncannon made during tours of Hampshire and Derbyshire in 1786, is in the British Museum, Department of Prints and Drawings, 1956.0714.3.

10. Ingamells 1997, 274, 694–95 (entries by Frank Salmon).

11. A-3739, A-3417, A-3370, and A-3416, Museo, RABASF, respectively. The crate may, alternatively, have belonged to Duncannon or to Lord Lewisham.

12. Lever 1973, 95–96, no. 50, from Hardwick Album 7, fol. 36r. This sheet measures 13 x 13⅝ in. (33 x 34.5 cm), close to the 14⅛ x 10⅛ in. (35.8 x 25.6 cm) of the *Westmorland* version, but the distinction between existing fabric (black wash) and hypothetical (gray) is clearer in the latter. There are also a few minor differences. The Baths of "Titus," Diocletian, and Caracalla can be found on fols. 52r, 52v, and 53r, respectively.

13. Nolli 1770. This book, dedicated to Sir William Hamilton, comprised eight plates with short descriptive texts, presumably by Nolli. Vanvitelli had been sent to Benevento to repair the town's bridge when he made the detailed survey of the arch. The drawings as published are by his acolyte Giuseppe Piermarini.

14. A-4725, A-4726, A-4727, and A-4956, Museo, RABASF (see note 2 above).

15. Darley 1999, 43.

16. Victoria and Albert Museum, Department of Prints, Drawings and Paintings, 8479.15. For Brenna and Townley, see Vaughan 1996, 37–41. For the Rome version, see Misiti and Prosperi Valenti Rodinò 2010, 90–91. The Rome version is almost the same size—19⅜ x 28⅜ in. (49.3 x 72 cm)—as the *Westmorland* version, with many of the same details—but with the addition of fictive ruins behind the portico. The V&A version is larger—25¼ x 36⅝ in. (64 x 93 cm)—

but less worked up, though it does have ruins in the same position as the V&A version. The attribution of the section to Brenna casts doubt, of course, on the attribution of the corresponding plan (fig. 81 here) to Stern (see note 2 above), though it is worth noting that the third drawing of the set, the elevation (A-4958, Museo, RABASF), while on the same paper, is in a different and less skilled hand.

17. See Lever 2003, 67–68.

18. Christie's South Kensington, sale 5697 (April 27, 2010), lot 245. I am grateful to Jonathan Yarker for drawing my attention to this. The *Westmorland* versions seem to have been purchased by Duncannon or Lewisham, or by both.

19. Farington 1978–98, 3:767, entry for Feb. 10, 1797.

20. For an account of Giovanni Battista Montano and his work, as well as for catalogue entries on the specific drawings, see Fairbairn 1998, 2:541–54, 658–59, 672–73, 747, 749.

21. See Worsley 1995, 190; and Savage 2001, 201–16. For a recent but not convincing attribution of cat. 69 [Tomb of the Attilii Calatanii] to Giacomo Quarenghi, see Pasquali 2007, 28–29.

22. Ingamells 1997, 273, 694 (entries by Frank Salmon). Of course, there were many more instances in which Grand Tourists, after their return to Britain, commissioned architects they had met in Italy. Byres, though resident in Rome from 1758 to 1790 and hardly destined to practice as an architect in Britain, nonetheless produced at least three designs for country houses for Grand Tourists, most spectacularly that of 1770 for Wynnstay in Denbighshire. See Mowl 1995, 33–41.

23. According to Robert William Furze Brettingham, with whom Soane had traveled to Italy, other architects were involved in the same competition. See Bolton 1924, 19–20.

24. SaT 1/1 (see, for example, fols. 13, 44), Royal Institute of British Architects, British Architectural Library, London.

25. For the letter, see Bolton 1924, 10–13. Chambers's ideas gained even more widespread currency when he incorporated them into the "introductory discourse; designed to point out, and briefly to explain, the requisite qualifications and duty of an architect, at this time," which he added to the third edition of his *Treatise on the [Decorative Part of] Civil Architecture*. See Chambers 1791, v. The introduction itself falls on 7–15.

26. See Pearce and Salmon 2005, 1–91 (including 12–14 for Ebdon).

27. Bolton 1924, 31–32. In the letter detailing his losses that Bolton reproduced, Soane appealed above all for the return of the medals, the instruments, and the loose papers, because these were the things "of the greatest possible consequence" to him "for his entire life." Dance also reported this story to Farington on March 4, 1810. See Farington 1978–98, 10:3610.

Piranesi and the Tourists

JOHN WILTON-ELY

THE IMPACT of Giovanni Battista Piranesi's unique vision of Rome cannot be overestimated, through not only his magisterial etched images of the Eternal City but also his theoretical works on the Roman achievement as well as his personal contact with hundreds of visiting artists, architects, and writers. His influence was at its greatest during the second half of the eighteenth century, when the Grand Tour reached its climax and British visitors and collectors formed the majority of his clients. The capture of the *Westmorland*, very shortly after his death in late 1778, therefore, occurred at a moment when his reputation was particularly significant (fig. 95). For nearly four decades before his death, through his etchings and publications, the Venetian architect and designer radically transformed the conventional view of Roman antiquity. Moreover, he introduced an original concept of contemporary design, grounded in a highly imaginative and eclectic view of the past. As an ingenious designer of marble chimneypieces and restorer of decorative classical antiquities for the Grand Tour market, he also had a considerable influence on the furnishing and collections of outstanding town and country houses in Britain. Quite apart from the visual revolution in the fine and applied arts that Piranesi carried out, he also made a deep impression on the dramatic imagination of contemporary British writers and artists from Horace Walpole to J. M. W. Turner.

Born near Venice in 1720, the son of a master builder, Piranesi trained as an architect and engineer

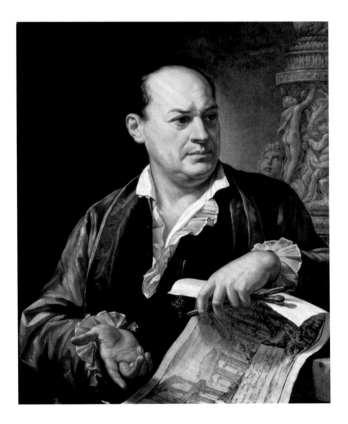

Figure 95. Pietro Labruzzi, *Posthumous Portrait of Giovanni Battista Piranesi*, 1778, oil on canvas, 29⅛ x 28⅜ in. (74 x 72 cm). Museo di Roma, Palazzo Braschi

before first arriving in Rome in 1740 as a draftsman in the retinue of the republic's ambassador. Frustrated by a lack of professional opportunities there, he developed a livelihood by engraving *vedute*, or views, for visiting tourists while sublimating his radical architectural ideas in elaborate fantasy designs,

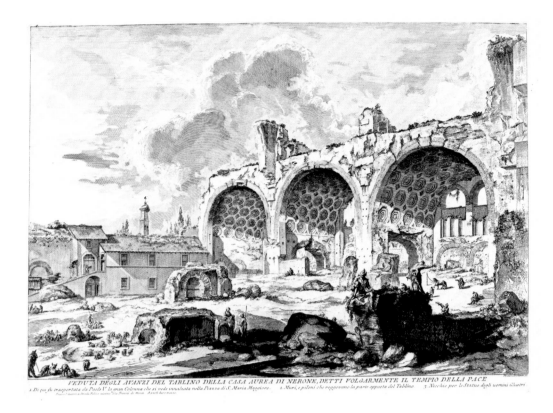

VEDUTA DEGLI AVANZI DEL TABLINO DELLA CASA AUREA DI NERONE, DETTI VOLGARMENTE IL TEMPIO DELLA PACE

Figure 96. Giovanni Battista Piranesi, *Veduta degli avanzi del Tablino della Casa aurea di Nerone detti volgarmente il Tempio della Pace*, 1749–50, etching, 19⅛ x 27¾ in. (48.5 x 70.5 cm). Real Academia de Bellas Artes de San Fernando, Archivo-Biblioteca

stimulated by the grandeur and ornamental originality of the ruins around him.[1]

Already through small illustrations to guidebooks, Piranesi had begun to transform the conventional engraved *veduta* into a strongly emotional and didactic vehicle of expression. He developed a fresh approach toward defining architectural character by registering the way a particular site or monument involved the spectator. Exploiting the expressive range offered by the flexibility of the etching needle, he used light to emphasize the structure and materials while his skilled use of perspective, derived from his early training in stage design, brought a new drama to the experience of Rome. By the late 1740s he was able to address a far wider audience through the larger format of 135 plates in the celebrated *Vedute di Roma*, which challenged the impressive painted views by masters such as Giovanni Paolo Panini.[2] These etchings, issued singly and in batches throughout the rest

of his career, disseminated powerful images of the Eternal City throughout the Western world (fig. 96). Most tourists acquired these prints in groups from Piranesi and had them specially bound as a record of their visit. The *Westmorland*'s cargo included forty such volumes of his works as well as loose prints among various crates. The biggest purchasers were Francis Basset (cats. 38–39, 47), Penn Assheton Curzon (cat. 61), and Frederick Ponsonby, Viscount Duncannon. Other clients associated with the cargo included John Barber, John Henderson of Fordell, and George Legge, Viscount Lewisham.

There are few great country houses that do not have Piranesi volumes in their libraries, while individual unframed plates were often kept in folios or incorporated into wall decorations in the form of "print rooms," such as that found at Blickling Hall, Norfolk. The impact of these images is also to be seen in the landscaped parks of great country houses such

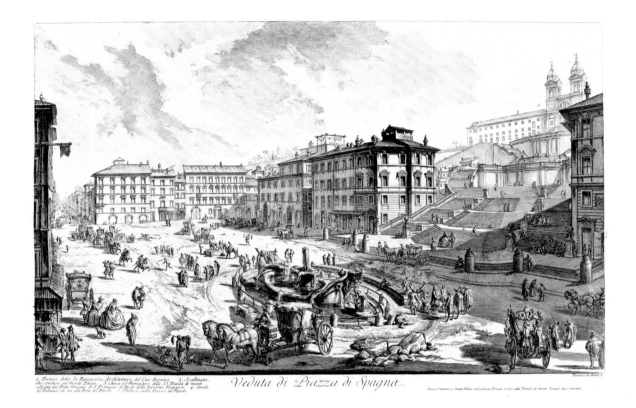

Figure 97. Giovanni Battista Piranesi, *Veduta di Piazza di Spagna*, 1750–51, etching, 15 x 23¼ in. (38 x 59.2 cm). Real Academia de Bellas Artes de San Fernando, Archivo-Biblioteca (cat. 61)

as Stowe House, Buckinghamshire, where the construction and setting of classical temples and artificial ruins were inspired by these iconic images of Rome.

Each phase in the production of the *Vedute* reflected Piranesi's intellectual concerns and artistic development. While the early plates of the 1740s record the principal monuments against the background of frenetic daily life in the city, by the 1750s archaeology had begun to dominate his career. The focus and emphasis on major monuments became more selective as he endeavored to provide inspiration for contemporary architects. A major landmark in archaeological publications was reached with his production of a four-volume comprehensive survey, the *Antichità Romane* (The Antiquities of Rome), in 1756. This was particularly addressed to architects, especially those studying in Rome such as the British designers William Chambers, George Dance the younger, and, above all, Robert Adam, with whom Piranesi was to form a lifelong creative relationship.

His polemical activities during the heat of the Graeco-Roman controversy (over the superiority of ancient Greek versus Roman art and architecture), which came to a head in the 1760s, served to heighten the drama and intensity of the subsequent *Vedute* even more, tending to exaggerate the Roman achievement in response to the attacks by Johann Joachim Winckelmann and his philhellene followers.

This decade marked a climacteric point in Piranesi's career when, in 1761, he set up his independent printmaking establishment at the top of the Spanish Steps in Palazzo Tomati, Via Sistina, in the heart of the British quarter (fig. 97). Diversifying his activities, he developed a wide-ranging business as a dealer and acted as an agent for collectors in Britain in search of old master paintings and objects of *virtu* (classical souvenirs). Recognition of his scholarly achievements in the *Antichità Romane* had already been marked by an honorary fellowship of the Society of Antiquaries of London in 1757. His creative status

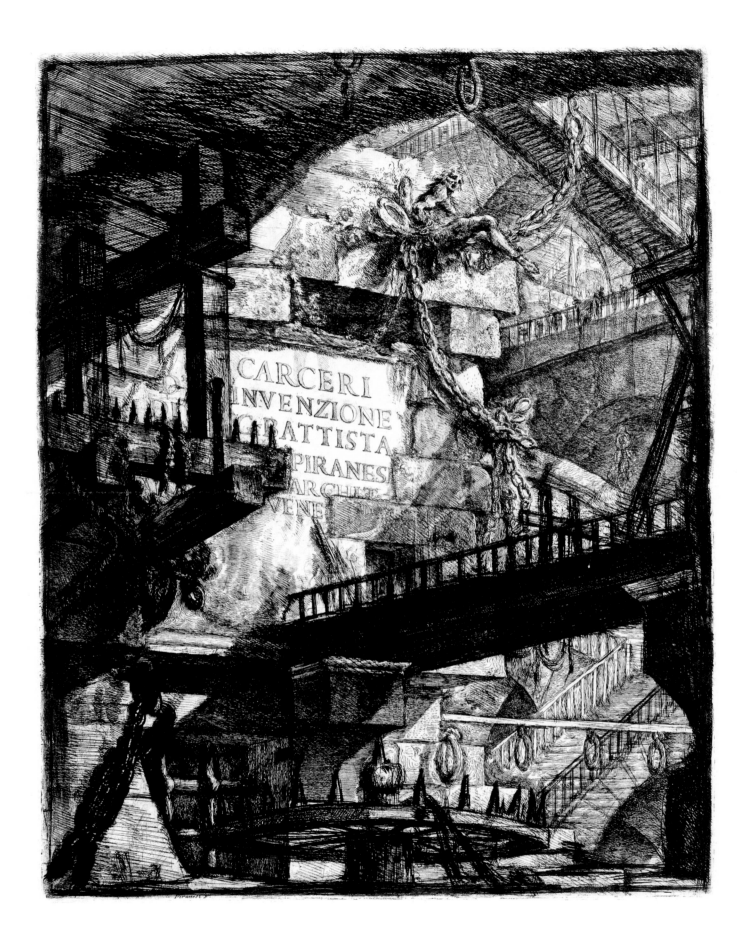

CARCERI
INVENZIONE
GRATTISTA
PIRANESI
ARCHIT
VENE

was further recognized by his election to the premier association of artists in Rome, the Accademia di San Luca, in 1761. He also collaborated with a fellow academician, the prominent dealer Thomas Jenkins, in publishing a collection of etchings, mainly of paintings by Guercino, two copies of which were found on the *Westmorland*. Most important of all, the election of the Venetian pope Clement XIII in 1758 led to a decade of substantial patronage from the pontiff and other members of the Rezzonico family, which enabled Piranesi to embark on a long-awaited opportunity to practice as an architect and designer. He reconstructed Santa Maria del Priorato, the priory church of the Knights of Malta on the Aventine Hill, in 1764–65 (for which he received a papal knighthood) while drawing up ambitious proposals for San Giovanni in Laterano (subsequently unrealized).[3] While he was also involved in designing a number of furnished interiors for the papal family, he was to produce a pioneering Egyptian Revival interior for the Caffè degli Inglesi (English Coffee House) in Piazza di Spagna, which was frequented by a range of British patrons, artists, and architects on the Grand Tour.

Meanwhile Piranesi's polemical activities continued to be pursued with energetic intensity as he became increasingly involved with British architects and artists who sympathized with his championship of ancient Rome. A series of lavish folios, many of them funded by Clement XIII, addressed archaeological issues, such as the growth of the ancient metropolis in his *Campo Marzio dell'Antica Roma* of 1762. This impressive folio was dedicated to Adam, who had recently returned to Britain to develop a highly innovative style of design through Piranesi's inspiration and active encouragement, while Robert Mylne, Dance, and Chambers were to show considerable debts to the Venetian in their monumental works in London: Blackfriars Bridge (1760–69), Newgate Prison (1770–80), and Somerset House (1776–86), respectively. Within this creative ferment Piranesi's dra-

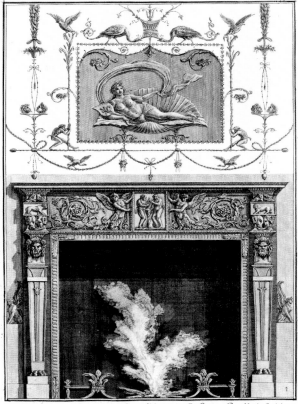

Figure 99. Giovanni Battista Piranesi, *Cammino che si vede nel Palazzo di Sua Ecc'za Milord Conte D'Exeter a Burghley in Inghilterra . . .* , ca. 1769, etching, 13⅜ x 9½ in. (34 x 24 cm). Real Academia de Bellas Artes de San Fernando, Archivo-Biblioteca

matically reworked plates of his *Carceri d'invenzione* (Prisons of the Imagination), reissued in 1761 and found in one of Basset's volumes on the *Westmorland* (fig. 98), were to affect profoundly the visionary ideas of British writers such as William Beckford, Samuel Taylor Coleridge, and Thomas de Quincey.[4]

By the mid-1760s Piranesi's inclination for fantasy as a stimulus to creation was even more evident in the ephemeral media of furniture and interior design.[5] Gradually moving away from his confrontational position toward the Greek Revival style, in 1765 he published the *Parere su l'architettura* (Opinions on Architecture)—a fictitious debate between two architects—in favor of creative eclecticism.[6] Prompted by this aesthetic and with a keen eye to the needs

Figure 98. Giovanni Battista Piranesi, Title page of *Carceri d'invenzione di G. Battista Piranesi, archit[etto] vene[ziano]*, 1761, etching, 21½ x 16⅛ in. (54.5 x 41 cm). Real Academia de Bellas Artes de San Fernando, Archivo-Biblioteca (cat. 47)

of British tourists, he developed a profitable business, collaborating with specialist restorers in creating monumental chimneypieces that incorporated antique fragments. In 1769 he issued his manifesto of design in the folio *Diverse maniere d'adornare i cammini ed ogni altra parte degli edifizi . . .* (Various Ways of Decorating Chimney-pieces and Other Parts of Buildings . . .). Its sixty-seven plates represent a highly productive decade that involved the design of a wide variety of furniture types and fittings, not to mention decorative utensils, coachwork, and sedan chairs.[7] The prefatory essay (with parallel texts in Italian, French, and English), addressed to an international audience of designers and patrons, offers a final act of polemical defiance to a world increasingly dominated by the austere tastes of the emerging Greek Revival. In it Piranesi furthered his argument for a highly eclectic approach based on a wide assimilation of different styles: Greek, Roman, Etruscan, even Egyptian. Dominating his etched designs are sixty-one compositions for chimneypieces, including one already carried out for Brownlow Cecil, ninth Earl of Exeter, at Burghley House, Lincolnshire, after the latter's second Grand Tour, in 1768–69 (fig. 99).

During the final decades of his life, Piranesi's genius for the transposition of the past for contemporary patrons found even greater scope in the imaginative restoration of decorative classical antiquities. Employing some of the leading restorers of the time, such as Bartolomeo Cavaceppi, Vincenzo Pacetti, and the British sculptor Joseph Nollekens, he set up a highly effective group of sale rooms, or *museo*, in Palazzo Tomati, where he was to display an impressive range of ornamental features that were avidly collected by the British.[8] A series of engraved plates of these works—which Piranesi enterprisingly used as advertisements, frequently indicating the location of those already sold to foreign collectors—was issued separately during the 1770s. (It is particularly striking that more than thirty of these objects were already in twenty-two British collections, while only a single item was then in another foreign collection. The current location of a significant number of works, however, has yet to be traced in the author's current research.) In addition, most plates include an

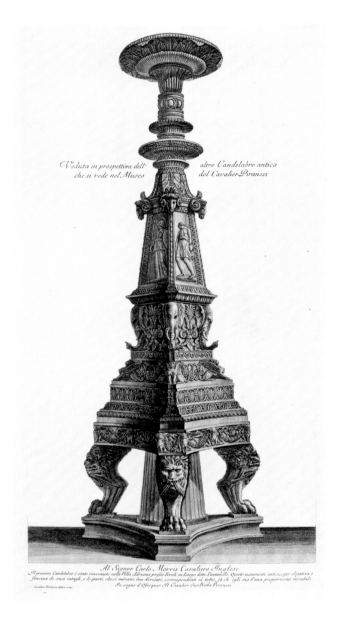

Figure 100. Giovanni Battista Piranesi, *Altra veduta in prospettiva del altro Candelabro antico che si vede nel Museo del Cavaliere Piranesi. Dedicato al Signor Carlo Morris, Cavaliere Inglese*, 1778, etching, 27½ x 13⅞ in. (70 x 35.3 cm). Real Academia de Bellas Artes de San Fernando, Archivo-Biblioteca

engraved dedication to visiting tourists and clients as well as to influential dignitaries and personalities in the art world. Among the forty-six British names cited (as opposed to only six from other countries outside Italy) are John Barber; Basset and his tutor, William Sandys (cats. 38–39); William Constable; Penn Assheton Curzon; and Maria Udny, among those associated

with the *Westmorland*. These widely diffused images were eventually gathered together in the publication *Vasi, candelabri, cippi, sarcofagi, tripodi, lucerne ed ornamenti antichi* (Vases, Candelabras, Gravestones, Sarcophagi, Tripods, Lamps, and Antique Ornaments), published in two volumes in 1778.

Preeminent among these restored works were monumental vases and candelabras, a number of which were to be included in leading sculpture collections in Britain as ornamental features, valued for their intrinsic value as much as more complete and authentic antiquities. Chief among these was the giant Warwick Vase (now in the Burrell Collection, Glasgow), which was commissioned by Sir William Hamilton and re-created from a modest quantity of marble fragments excavated from the Pantanello area of Hadrian's Villa, Tivoli, by the artist and dealer Gavin Hamilton in 1769–70. The extent of its reputation is reflected by the many copies made, ranging from full-scale replicas in bronze to reductions in the form of silver wine coolers. It was in the production of elaborate ornamental marble candelabras, however, that Piranesi's genius for creating three-dimensional *capricci*, or fantasies, found its greatest expression. Particularly outstanding were the pair acquired by Sir Roger Newdigate, fifth Baronet, in 1775 and now in the Ashmolean Museum, Oxford (fig. 100). The importance that Piranesi attached to such works is indicated by the ambitious example he devised for his own funerary monument, now in the Musée du Louvre.[9] The market was swift to respond to this demand, represented by a set of four candelabras found on the *Westmorland* (cats. 130–131). Through the skillful combination of authentic fragments with modern elements, they reflect the creative dialogue with antiquity that Piranesi considered the basis of progressive design.

In the final years of his life, the artist's activities continued unabated. He embarked on a particularly arduous group of etchings of the three Greek Doric temples at Paestum, while suffering a serious bladder complaint that led to his death on November 9, 1778. These seminal plates, which made a powerful impression on a new generation of designers such as the young John Soane (who met Piranesi in Rome in 1778), were finished and published posthumously by Piranesi's elder son, Francesco.[10] He also completed several of his father's other enterprises, including a highly significant map of Hadrian's Villa, Tivoli, and a pictorial survey of the new excavations at Pompeii. The sheer breadth and fertility of Piranesi's vision, which so deeply engaged several generations of Grand Tourists, can best be summed up in his own words: "J'ai besoin de produire de grande idées, et je crois que si l'on m'ordonnait le plan d'un nouvel univers j'aurais la folie de l'entreprendre." (I need to produce great ideas, and I believe that were I to be given the planning of a new world, I would be mad enough to undertake it.)[11]

1. Wilton-Ely 1978; and Robison 1986.

2. For reproductions and a discussion of Piranesi's *vedute* and other etched works, see Wilton-Ely 1994.

3. The Aventine church and Lateran project are discussed in Wilton-Ely 1993, 63–119.

4. The genesis and impact of the *Carceri d'invenzione* are examined in Wilton-Ely 1978, 81–91.

5. For Piranesi's activities in architecture, furniture, and interiors, as well as their impact on British designers, see Lawrence and Wilton-Ely 2007.

6. Piranesi's complex polemical and theoretical development is examined in the introduction by John Wilton-Ely to Piranesi 2002, 1–82.

7. For a modern approach to Piranesi's creative activities in the applied arts and restoration, see illustrations in De Lucchi, Lowe, and Pavanello 2010.

8. Piranesi's *museo* is explored in Gasparri 1982, 91–107.

9. Wilton-Ely 2007, 40–46.

10. For the Paestum publication and its impact on Soane, see Wilton-Ely 2002.

11. Quoted in the early manuscript biography of Piranesi by Jacques-Guillaume Legrand, "Notice historique sur la vie et les ouvrages de J. B. Piranesi," transcribed by Gilbert Erouart and Monique Mosser in Brunel 1978, 248.

Books on the *Westmorland*

MARÍA DOLORES SÁNCHEZ-JÁUREGUI

IVIDED AMONG the fifty crates from the *Westmorland* that arrived at the Real Academia de Bellas Artes de San Fernando in Madrid in 1783 were 378 titles of literature, history, geography, dictionaries, botanical texts, travel guides, essays, and books of prints.[1] Deposited in the library of the Real Academia, these books were absorbed into the collection and quickly lost their separate identity. The task of identifying and tracing the *Westmorland*'s volumes within the library was central to the project of recovering the *Westmorland*'s contents; at the same time it was one of the most difficult and lengthy aspects of that project. The vague, ambiguous nature of the descriptions in the inventories meant that identifying volumes in the library was by no means straightforward; the inventory makers frequently did not understand the language in which the books were written, and titles were transcribed with numerous errors or translated in a very approximate manner.[2] Distinguishing the *Westmorland*'s books from the rest of the library's eighteenth-century collection would have been almost impossible if not for the efforts of the librarian in the 1780s, Pascual Colomer, who marked many of the volumes with the initials "P. Y." for "Presa Ynglesa" (English Prize) to indicate their provenance (fig. 101). The collation of the information in the various inventories with these marked volumes allowed the identification of the books from the *Westmorland*. As the process of identification progressed it was discovered that a number of the books had been annotated with travel observations, prices, signatures, corrections,

and other information, which made it possible to identify for the first time the names of some of the travelers and in some cases even to reconstruct their itineraries (fig. 102).

Taken together the books on the *Westmorland* constitute an extraordinarily rich Grand Tour library, which can not only provide an instructive context for the other acquisitions shipped on the *Westmorland*, but also tell us much about the cultural phenomenon of the Grand Tour in the 1770s and the experiences of other Grand Tourists in the period. Of course, the volumes on the *Westmorland* were not assembled by a single collecting will; they were the acquisitions of a variety of travelers and collectors, each with particular tastes and interests and predilections. Considering these books in the aggregate, as one large travel library, and examining them as multiple discrete collections can each provide a valuable perspective.

If we begin by examining the books on the *Westmorland* as a single entity, we can usefully divide the contents into two broad groups, distinguishing the practical volumes acquired for use on the trip, which were largely or entirely textual, from what were primarily compilations of prints, acquired to grace a library back in Britain. Of course, the distinction may not always be as clear-cut; nevertheless, it has proved to be the most useful criterion for classification in order to organize and give sense to the collection so that conclusive analyses could be undertaken.

Text-based books mentioned in the inventories as being on the *Westmorland* amount to 294 different

Figure 101. Annibale Antonini, *Dizionario Italiano, Latino e Francese* (Lyon, 1770). Real Academia de Bellas Artes de San Fernando, Archivo-Biblioteca (cat. 58)

Figure 102. Endpapers with bookplate of Robert Henderson, in Claude-Prospèrer Jolyot de Crébillon, *Les égaremens du coeur et de l'esprit, ou Memoires de Mr. de Meilcour* (Paris, 1765). Real Academia de Bellas Artes de San Fernando, Archivo-Biblioteca (cat. 104)

103

104

105

Figure 103. Original Dutch paper binding, William Hamilton, *Campi Phlegraei. Observations on the Volcanos of the Two Sicilies* . . . (Naples, 1776). Real Academia de Bellas Artes de San Fernando, Archivo-Biblioteca (cat. 60)

Figure 104. Original Dutch paper binding, *Serie degli uomini piu illustri nella pittura, Scultura, ed Architecttura* (Florence, 1769–75). Real Academia de Bellas Artes de San Fernando, Archivo-Biblioteca (cat. 116)

Figure 105. Original Dutch paper binding, Dante Alighieri, *La divina commedia* (Venice, 1757–58). Real Academia de Bellas Artes de San Fernando, Archivo-Biblioteca (cat. 86)

Figure 106. Original Dutch paper binding, John Andrews, *Essai sur le caractere et les moeurs des françois comparés a ceux des anglois* (London, 1776). Real Academia de Bellas Artes de San Fernando, Archivo-Biblioteca (cat. 103)

Figure 107. Original Dutch paper binding, Orazio Orlandi, *Le nozze di Paride ed Elena rappresentate in un vaso antico del Museo del signor Tommaso Jenkins, Gentiluomo Inglese* (Rome, 1775). Real Academia de Bellas Artes de San Fernando, Archivo-Biblioteca (cat. 91)

106

107

titles. Of them the present study located 114 in the library of the Real Academia. In addition, 84 volumes of prints were on the *Westmorland*, of which 51 are still in the Real Academia's library. Remarkably, many have their original, Dutch printed-paper covers. These papers were printed in color with geometric and floral patterns, inspired by contemporary textile designs (figs. 103–107). These would have been replaced with permanent leather bindings when the books entered the owners' libraries.

BOOKS FOR THE TRIP

Text-based books include the actual copies used by travelers on the Grand Tour, with annotations recorded during the tour. The various volumes of practical value being sent home on the *Westmorland* are particularly informative about Grand Tour practices. They fall into several categories.

GRAMMARS AND DICTIONARIES. Among the titles are fourteen grammars written in various languages, as well as seven Italian, French, Latin, German, and English dictionaries. The handwritten notes in many of them speak to their use during the trip, as well as to the importance of learning French and Italian as one of the educational aims of the Grand Tour.

TRAVEL GUIDES. These range from the most general types of guides, such as *Travels through Germany, Bohemia, Hungary, Switzerland, Italy, and Lorrain*, to more specific ones on particular cities, such as *Description des villes de Berlin et de Potsdam*.[3] Within this category the most numerous are guides on art, most of which refer to Italian collections or monuments. Various subdivisions can be identified: first, the most specific guides, such as *Descrizione ... della Real Cappella di S. Lorenzo*, which was written by a local author and printed as a leaflet; second, the most methodical and extensive texts, such as *L'antiquario fiorentino ...*; and third, those written by well-known authors, including *Pitture, scolture ... della città di Bologna*, by Carlo Cesare Malvasia.[4] With a more theoretical focus are treatises on ancient art, such as *Eclaricissements sur les antiquités de la ville de Nismes* (cat. 88) and Johann Joachim Winckelmann's *Histoire de l'art*.[5]

GEOGRAPHY, HISTORY, AND POLITICS. In principle the educational component of the Grand Tour

was of fundamental importance to the young travelers, their parents, and especially their tutors. Travel provided rich subjects for study, and in turn the study of geography and natural history could enrich the experience of travel. For example, various volumes on the geography of Switzerland and Italy and on the eruptions of Mount Vesuvius were on board the *Westmorland*, including two copies of the notable *Campi Phlegraei* (cat. 60), a book that was useful on the spot in Naples as well as one of the most sumptuous books to grace a library back home. In addition, eleven titles on the history of Rome, Britain, France, and Italy have been identified in the crates of Francis Basset; John Henderson of Fordell; George Legge, Viscount Lewisham; and Frederick Ponsonby, Viscount Duncannon. They were written by native authors in their own language, and all show signs of having been used. Another key reason for undertaking the Grand Tour was to learn about the politics and laws of foreign countries, on which there was an extensive literature in the eighteenth century, well represented on the *Westmorland*. Part of the traveler's political education included an exposure to foreign views of Britain, as, for example, in the satirical *Le nouveau Parlement d'Angleterre*, which Henderson acquired for his library.[6]

MANNERS AND CUSTOMS. Besides artistic and more academic forms of education, the Grand Tour aimed to equip the young traveler socially. In contrast to the purchase of art objects, the acquisition of social skills did not always manifest itself in a tangible form. The *Westmorland*'s libraries, however, offer an exceptional record of this subject. In order to enable travelers to move with ease in society, numerous books were published on social rules and manners in different countries. Lord Duncannon's crates, for example, contained *Le nouveau secrétaire du cabinet*, which, according to the subtitle, provides "les maximes & conseils pour plaire & se conduire dans le monde" (maxims and advice on how to be pleasing and behave oneself in the world).[7] Closely linked to this category were the books on national customs. Learning about and comparing British habits and customs with those of other European countries lay at the very heart of the trip abroad, and a specific body of literature

existed to satisfy the demands of the young tourists. Examples include *Essai sur le caractère et les moeurs des François comparés a ceux des Anglois* (cat. 103) and *New Observations on Italy and Its Inhabitants*, found in a number of the crates on board.[8]

LITERATURE, THEATER, AND MUSIC. Literature was present in the crates in the form of general compilations such as *Les trois siècles de la littérature françoise*, as well as classic titles such as Dante's *La divina commedia* (cat. 86).[9] Knowledge of music, theater, and dance was among the attributes of gentility that the young traveler aimed to acquire abroad. The presence of about twenty-seven titles on these subjects indicates their importance. Most of the books on theater and opera are in Italian, written by the two leading authors of the day, Carlo Goldoni and Pietro Metastasio. The French theater was also represented through works by Molière, books on the Parisian theaters, and the stories of ballets such as the famous *Les Horaces*, performed in Paris in 1777 around the time that the book's owner, Henderson, was there.[10] Musical scores, which could also have been intended to be performed by the travelers, such as the scores of string quartets by Joseph Haydn signed by Duncannon's tutor, "S. Wells Thomson Ch: Ch: Oxon" (cat. 90), were in the cargo.

ALMANACS. Being abreast of the latest cultural events was among the travelers' concerns. Thematic almanacs such as the *Almanach des Muses: 1777*, present on board the *Westmorland*, provided information on new publications, theater, performances, and music of the day.[11]

BOOKS FOR AMUSEMENT. Books were also important for pursuing personal interests and pleasures, as several volumes on board the *Westmorland* attest. Amorous issues were covered by titles such as *Les égaremens du coeur et de l'esprit* (cat. 104), as were less serious but no less important matters such as fashion, evident in *Parfait ouvrage sur la coiffure* (cat. 106).

VOLUMES OF PRINTS

With regard to the high-end volumes of prints intended for libraries in Britain, problems of identification have resulted from changes to the outside covers, rebinding, unbinding, and the dispersal

of the prints that made up these books. This is the case with *Theatrum Basilicae Pisanae*, a volume of twelve plates that were separated on arrival and are now preserved as loose sheets in the Real Academia's collection.[12] Nevertheless, the fifty-one volumes still existing in the library of the Real Academia and identified as coming from the *Westmorland* tell us much about various issues related to the printing, engraving, and publishing of some of the period's most celebrated enterprises of their kind. From the way in which they were conceived and produced, they can be grouped as follows:

PERSONALIZED EDITIONS. The crates that arrived at the Real Academia contained a total of forty volumes of prints by Giovanni Battista Piranesi.[13] Fourteen of them had been acquired by Basset and are still kept at the Real Academia in their original binding, including *Vasi, candelabri, cippi, sarcofagi, tripodi, lucerne, et ornamenti antichi* (Vases, Candelabras, Gravestones, Sarcophagi, Tripods, Lamps, and Antique Ornaments).[14] This publication comprises a set of prints depicting the objects in the title, dedicated to a variety of individuals, some of whom are connected with the *Westmorland* episode, namely, William Constable, Sir Watkin Williams Wynn, Penn Assheton Curzon, Robert Udny, John Barber, the Reverend William Sandys, and Francis Basset. While it is known that Piranesi changed the combinations of prints in his compilations, with the result that every copy was different to varying degrees, this copy has one particularly interesting feature: the first image, a depiction of a tripod, is dedicated to Basset (cat. 38), while the second, a different view of the same object, is dedicated to his tutor, Sandys (cat. 39). From this copy, then, it would appear that the choice and order of the prints in Piranesi's volumes could be adapted to the client who acquired the volume.

INDIVIDUAL INITIATIVES. This group includes books conceived as major commercial enterprises and undertaken by a particular individual who assumed all the risk and was also responsible for the artistic execution. This is the case with Giuseppe Vasi, whose most ambitious project was the publication of a series of ten volumes entitled *Delle magnificenze di Roma*, of which various loose sheets were on the *Westmorland*.[15] This work was followed in 1763 by the *Itinerario istruttivo di Roma diviso in otto giornate*, of which there were two copies of a later French translation on board, and which made reference to the engravings published in the *Magnificenze*.[16] In 1765 Vasi published a panorama of the city of Rome entitled *Prospetto dell'alma città di Roma*, also present on the *Westmorland*.[17] This had a numbered index that in turn referred to the *Itinerario*, thus completing the connection between his three principal works.

GROUP PROJECTS. This category consists of publishing projects that involved various professionals with regard to the different aspects of their production and publication. Examples include *Le Logge di Rafaele* (cat. 123) and *Vestigia delle Terme di Tito*. The latter was a project directed by Ludovico Mirri, who in 1774 took charge of the excavations and clearing of the site erroneously identified at the time as the Baths of Titus, uncovering sixteen different rooms. Mirri obtained sole license from the pope to publish the frescoes found there. He contracted Giuseppe Carletti to write a descriptive catalogue, Franciszek Smuglewicz and Vincenzo Brenna to produce the designs for the illustrations, and Marco Carloni to reproduce them as prints. Envisaged as a profit-making enterprise, the prints could be acquired on subscription in three groups priced at 60 sequins each, while nonsubscribers could acquire the complete set at a slightly later date and a higher price.[18]

Draftsmen, engravers, and illuminators were essential for the realization of this type of project. One of the most important figures for the success of the undertaking, however, was the *stampatore* (printer), and some of these professionals acquired a high reputation. Of the volumes on the *Westmorland*, the *Indice delle stampe . . .*, *Le antiche camere . . .*, and five of the Piranesi volumes were printed in Rome by the same individual, Generoso Salomoni.[19]

THE OWNERS AND THE CRATES OF BOOKS

We should bear in mind that discussion of the *Westmorland*'s books as a single group is based on an artificial construct. The ship's cargo comprised various collections belonging to different owners and consequently reflecting different tastes and personal

Figure 108. Giovanni Veneroni, *The Complete Italian Master: Containing the Best and Easiest Rules . . .* , 1763. Real Academia de Bellas Artes de San Fernando, Archivo-Biblioteca

Figure 109. Anonymous, *Interior of the Bouchard and Gravier Bookshop in Rome*, ca. 1774, oil on canvas, 49 ¼ x 70 ⅞ in. (125 x 180 cm). Private collection

interests. From an analysis of the books contained in the crates, it is possible to identify some dealers' dispatches. The crates marked "G. M.," for the Reverend George Moir, brother-in-law of the dealer James Byres, or "R. Uy.," for Robert Udny, brother of John Udny, the British consul in Livorno, contained prints probably intended for sale in England. Other books were being sent under particular commission. The crates marked with initials indicating the Duke of Gloucester ("H. R. H. D. G."), brother of the king of England, which contained only two books on very specific subjects, or with those of the banker Lyde Browne ("L. B."), which contained a botanical text (cat. 55), seem to respond to specific commissions to acquire these particular titles, since both men had recently left Italy and were already back in England by the time the *Westmorland* departed from Livorno.[20] There is a further group of crates, the owners of which have not so far been identified from their initials (such as "J. G.," "W. D.," "L. D.," and "L. J. C."), that primarily contained prints, loose or bound in volumes. They may have belonged to dealers or have been a particular commission, but they were probably not libraries of Grand Tourists. Nonetheless, the books in the

crates marked "J. B." (perhaps John Barber) may be a small travel library. They include various volumes of prints, dictionaries, and Italian grammars with numerous marks and annotations (fig. 108).[21]

The most significant groups of books on board the *Westmorland*, however, belonged to travelers. The crates that contained grammars, travel guides, maps, and other travel-related books and items coincide with the initials of Francis Basset, Lord Lewisham, John Henderson, and Lord Duncannon. In other words they were typical travel libraries of young aristocrats undertaking the Grand Tour.

On occasion the selections of books offer insight into the personality and interests of the owner. Henderson's library is particularly notable for the number of plays and other literary works and for the number of titles in French, while that of Duncannon reveals a greater interest in art and antiquities.

The books on the *Westmorland*, mainly acquired in Italy (fig. 109), correspond to the last stages of the Grand Tour for these travelers; books acquired before they reached Italy presumably would have been sent back to Britain in earlier shipments. Some of the works on board, however, would have been

Figure 110. Edward Gibbon's traveling case for books. By courtesy of the Governing Body of Christ Church, Oxford

Figure 111. Interior view of the Library at Francis Basset's house at Tehidy Park

acquired at home in preparation for the trip. These include maps, such as the one of Paris published by John Rocque in the Strand (cat. 82); historical texts, such as *Chronology or, The Historian's Vade-Mecum* (cat. 50), signed "William Sandys 1776" (Basset's tutor); and contemporary literature, such as *Tristram Shandy* (cat. 49), with which they must have pleasantly whiled away the time on the long journeys between cities.[22] This leads to a consideration of practical issues related to traveling with books (fig. 110). In 1776 David Stevenson, Lewisham's tutor, wrote from Paris to the young man's father, William Legge, second Earl of Dartmouth, regarding the need to acquire a traveling chaise, explaining, "It must be strong crane-necked, deep, wide, lined with green leather . . . with a deep and roomy well . . . on each side of the stool under the cushion a place to contain papers, two small moveable bookcases under the front glasses."[23]

While the travelers may well have brought books with them from England, it was without doubt the volumes acquired on their Grand Tour that were considered especially valuable. Thomas Coke, a traveler who did not have any possessions on the *Westmorland*, explained this as follows:

During my voyage around Italy I have bought several of the most valuable authors that have written in Italian about the country . . . if I missed the occasion of buying books, I should not be able to find several of the best of them . . . and certainly one of the greatest ornaments to a Gentleman or his family is a fine Library.[24]

Having lost his travel library on the *Westmorland*, Henderson repurchased the books that he had acquired and used on the Grand Tour. An inventory of his personal library, drawn up for the purposes of his will, reveals that some of the lost books had been replaced, including *Amusement du loisir des dames* . . . ; *La quinzaine angloise à Paris* (cat. 107); *Aminta: Favola Boscareccia*; *Oeuvres de Molière* (cat. 105); and the *Lettres du M. de Voltaire à l'Académie Française*, among others.[25]

On a gentleman's return to Britain his library constituted a demonstration of the intellectual and moral superiority of the elite classes, in which books were repositories of knowledge and the classical tradition—and in which Grand Tour purchases must have played a key role, alongside the works of art in these same individuals' collections.[26] In addition, the

library formed part of a gentleman's daily routine. In 1811 during a visit to the residence in Cornwall of Francis Basset, now first Baron de Dunstanville, Joseph Farington noted the importance of the library at Tehidy (fig. 111) during the course of a normal day:

> Lord Dunstanville's application to business and study when he is at Tehidy Park and without company. The morning he passes in his study, all but the time he gives to exercise. After dinner he drinks about four glasses of wine, and soon after the Ladies retire, goes to his library, where he remains till tea time; after tea, he plays a game of cards and then again goes to his library or takes up a book.[27]

Unfortunately for Basset, he would not have been able to turn to any of those volumes that he had acquired on his Grand Tour in the 1770s and had sent home on the *Westmorland*. The loss of these bibliographic collections must have been highly regretted by Basset, Henderson, and the other book owners involved in the *Westmorland* case. While we have evidence of several attempts to recover their acquisitions, there is no record that any books were returned.[28] Fortunately for scholars these collections have been preserved almost in their entirety in the library of the Real Academia de Bellas Artes de San Fernando in Madrid, and mostly saved from being split up or dispersed.

I would like to thank the staff of the Library of the Real Academia de Bellas Artes de San Fernando for all the help and assistance they offered me during my research in their collection.

1. This final inventory and the results presented here were obtained from an electronic database designed and elaborated by the present author.
2. This is the case with *Opere di Polidoro da Caravaggio, disegnate, et intagliate, da Gio. Battista Galestruzzi, pittore fiorentino* (Rome, 1653), which is described among the crates belonging to George Legge, Viscount Lewisham, as "Another notebook, in the grotesque style, with 28 plates, the work of Polidoro, engraved by Caravaggio." Egerton Papers, 545, British Library, London.
3. In the crate of "J.B." (John Barber?): John George Keyssler, *Travels through Germany, Bohemia, Hungary, Switzerland, Italy, and Lorrain: Giving a true and just description of the present state of those countries . . .*, 3rd ed., 4 vols. (London: G. Keith, 1760). C-1837, Archivo-Biblioteca, RABASF. In the crates of Penn Assheton Curzon: *Description des villes de Berlin et de Potsdam, et de tout ce qu'elles contiennent de plus remarquable, traduite de l'allemand* (Berlin: Chez Fréderic Nicolai, 1769). B-3151, Archivo-Biblioteca, RABASF.
4. One copy each in Lord Lewisham's crates and in those of Frederick Ponsonby, Viscount Duncannon: *Descrizione di tutte le pietre ed ornamenti che si ammirano nella magnifica fabbrica della Real Cappella di S. Lorenzo* (Florence, 1775). The library of the Real Academia has only one copy, which cannot be identified as belonging to one or the other of the two travelers. C-1444, Archivo-Biblioteca, RABASF. In Lord Duncannon's crates: *L'antiquario fiorentino o sia guida per osservar con metodo le cose notabili della città di Firenze* (Florence, 1778). C-1421, Archivo-Biblioteca, RABASF. Two copies on board the *Westmorland*, in the crates of Lord Duncannon and Lord Lewisham: *Pitture, scolture ed architetture delle chiese luoghi pubblici, palazzi, e case della città di Bologna, e suoi sobborghi* (Bologna, 1776). C-286, A-940, Archivo-Biblioteca, RABASF.
5. In Lord Lewisham's crates: *Histoire de l'art chez les anciens . . .*, 2 vols. (Paris: E. van Harrevelt, 1766). C-1098–99, Archivo-Biblioteca, RABASF.
6. *Le nouveau Parlement d'Angleterre érigé en communes à la taverne de la liberté par une société de citoyens . . .* (Amsterdam, 1775). C-289, Archivo-Biblioteca, RABASF.
7. In Lord Duncannon's crates: *Le nouveau secrétaire du cabinet: . . . les maximes & conseils pour plaire & se conduire dans le monde* (Amsterdam, 1739). B-3149, Archivo-Biblioteca, RABASF.
8. In the crate belonging to "J. B." (John Barber?): Pierre-Jean Grosley, *New Observations on Italy and Its Inhabitants, Written in French by Two Swedish Gentlemen*, trans. Thomas Nugent (London: L. Davis and C. Reymers, 1769), 2 vols. B-1553–54, Archivo-Biblioteca, RABASF.
9. Among Henderson's books: Antoine Sabatier de Castres, *Les trois siècles de la littérature françoise ou tableau de l'esprit de nos écrivains: Depuis François I, jusqu'en 1774 . . .* (Amsterdam, 1775), 4 vols. A-946–49, Archivo-Biblioteca, RABASF.
10. This ballet was performed first in Vienna in 1773 and subsequently in Paris at the Académie Royale de Musique

from Jan. 1777. Henderson was traveling in France from Dec. 1775 and could have acquired this volume after seeing the performance. (For more on Henderson's Grand Tour, see "The *Westmorland*: Crates, Contents, and Owners" by María Dolores Sánchez-Jáuregui and Scott Wilcox in this volume, 24–25.) The book is not in the library of the Real Academia but is listed in the inventories as *Les Horaces, Ballet Tragique*, which coincides with the title of the French edition by Jean-Georges Noverre.

11. Among John Henderson's crates: *Almanach des Muses 1777* (Paris: Delalain, 1777). B-2384, Archivo-Biblioteca, RABASF.

12. In Lord Duncannon's crate: Petrus de Petris and others, *Theatrum Basilicae Pisanae Erectae in Honorem Deiparae Virginis in Coelum Assumptae* (Rome, 1705). The loose sheets were incorporated into the Real Academia's print collection. Gr-952–63, Archivo-Biblioteca, RABASF. The total number of loose prints from the *Westmorland* is seventy-three.

13. Following their arrival many of these volumes were sent to other academies founded after that of San Fernando, including the Real Academia de San Carlos in Valencia and its namesake in Mexico. Another important group was sent to the library of the Escuela de Arquitectura when the teaching of that subject moved there.

14. Giovanni Battista Piranesi, *Vasi, candelabri, cippi, sarcofagi, tripodi, lucerne, et ornamenti antichi diseg. ed inc. dal cav. Gio. Batta. Piranesi* (Rome, 1778). A-1070, Archivo-Biblioteca, RABASF.

15. Forty loose prints arrived at the Real Academia, some from this set, in the crates of Lord Lewisham and Curzon. Only four are now to be found in the print collection: Gr-996, 997, 998, 999, Archivo-Biblioteca, RABASF.

16. The *Westmorland* carried two copies of the French edition of 1773, in the crates of Henderson and Lord Duncannon, although only the former has survived, identifiable from his signature: Giuseppe Agostino Vasi, *Itinéraire instructif divisé en huit journées: Pour trouver avec facilité toutes les anciennes, & modernes magnificences de Rome . . .* (Rome, 1773) (cat. 109).

17. Of the original group that reached the Real Academia in Lord Lewisham's and Curzon's crates, only five plates have survived, bound in a volume with the Real Academia's own covers. B-1916, Archivo-Biblioteca, RABASF.

18. This publishing project consisted of two volumes. A copy of the first arrived in Lord Lewisham's crates: Giuseppe Carletti, *Le antiche camere delle Terme di Tito e le loro pitture . . .* (Rome, 1776). Its prospectus states the publisher's intention to distribute the prints in three groups: on March 30, 1776; in Dec. 1776; and in Dec. 1777. The price of the entire collection was 180 sequins for subscribers and 200 for nonsubscribers. Two copies of the volume of plates entitled *Vestigia delle Terme di Tito e loro interne pitture* (Rome, 1776) arrived at the Real Academia, one of them in Lewisham's crate and the other in that of the as-yet-unidentified crate "J. G." B-1915bis/ter and B-1915, Archivo-Biblioteca, RABASF, respectively. Another small group of prints, hand-colored by Brenna, belonged to Lord Duncannon (see cat. 63). Shortly after publication Mirri accused Brenna of selling duplicates of the prints without permission, which gave rise to a complex court case.

19. One copy each in the crates of Henderson and Lord Duncannon: *Indice delle stampe intagliate in Rame a Bulino, ed in acqua forte esistenti nella calcografia della Reverendissima Camera Apostolica* (Rome, 1776). The library of the Real Academia now has only one copy and it cannot be determined to which of the two travelers it belonged: F-3676, Archivo-Biblioteca, RABASF.

20. In the Duke of Gloucester's crates: J. B. Louis Crevier, *Storia degli imperatori romani . . .* (Siena, 1777). C-1641–53, Archivo-Biblioteca, RABASF. The lists also record "A book of music with duets," which has not been identified among the Real Academia's holdings. In Lyde Browne's crates: Filippo Arena, *La natura, e coltura de' fiori . . .* , 2 vols. (Palermo, 1767–68) (cat. 55).

21. Barber had been in Florence at the same time as Sandys in 1774. Piranesi dedicated one of the plates in *Vasi, candelabri . . .* to Barber, and he also seems to have been a client of the landscape artist Jacob More. See Ingamells 1997, 49.

22. In Lord Duncannon's crates: John Rocque, *A plan of Paris, reduced to the same scale as that of London . . .* (London, 1754). C-510, Archivo-Biblioteca, RABASF. Among those of Basset: John Trusler, *Chronology or, The Historian's Vade-Mecum* (London, 1776). B-2372, Archivo-Biblioteca, RABASF.

23. D. Stevenson to the second Earl of Dartmouth, Jan. 29, 1776, D(W)1778/V/886 (1776–1779), Papers of the Legge Family, Earls of Dartmouth, Staffordshire and Stoke-on-Trent Archive Service, Staffordshire Record Office, Stafford.

24. Skeat 1952, 23. Coke was in Italy from 1771 to 1774.

25. MS/6308, esp. 122, National Library of Scotland, Edinburgh.

26. For a discussion of the library as a physical and intellectual space in the eighteenth century, see Coltman 2006, esp. chap. 1, "(Neo)classicism in the British Library," 17–37.

27. Farington 1978–98, 6:3902.

28. For correspondence concerning claims for the return of the seized cargo, see "The *Westmorland*: Crates, Contents, and Owners" by María Dolores Sánchez-Jáuregui and Scott Wilcox in this volume, 25–26.

A Crate of Saints' Relics

JOSÉ M. LUZÓN NOGUÉ

I N ADDITION TO THE numerous souvenirs belonging to Grand Tourists that made up such a notable feature of the *Westmorland*'s cargo, there was, unbeknownst to the ship's captain, a small box on board containing sacred relics that Pope Clement XIV (fig. 112) had sent as a gift to Henry Arundell, eighth Baron Arundell of Wardour (fig. 113).[1] They were to be placed within the altar of the Chapel of All Saints that Lord Arundell had built at Wardour Castle, near Tisbury in Wiltshire, and would spend the rest of his

life furnishing. The manner in which the relics were disguised in order to pass unnoticed by the customs authorities in London reveals the lengths to which the former Jesuit Father John Thorpe would go to ensure that the pope's gift reached its destination.[2]

The earliest reference to finding a means of sending these relics to Lord Arundell appears in a letter from Rome in November 1776, in which Thorpe informed Arundell that he had finally decided to send the relics from the port of Livorno (which the British called Leghorn) with the help of an agent named William MacCarty.[3] MacCarty, who was probably an Irish Catholic, planned to send a crate containing the relics via Captain James Meads of the ship *Hannanel* to another person in London, Thomas Mansel Talbot.[4] More than a year later, however, the crate was still in Livorno; in a letter to Arundell in December 1777, Thorpe lamented the difficulties he was having with the shipment:

> I am sorry to inform Your Lordship that the Corpo Santo yet remains at Leghorn. By the last Tuscan post Macarty writes that Capt. Meads of the Hannanel came to see the small case containing the Corp[o] S[an]to, which he assured me that he

Figure 112. Christopher Hewetson, *Pope Clement XIV*, 1773, marble, 29½ in. (75 cm). Victoria and Albert Museum, London

Figure 113. Sir Joshua Reynolds, *Portrait of Henry, Eighth Lord Arundell of Wardour*, ca. 1764–67, oil on canvas, 94 x 58 in. (238.8 x 147.3 cm). The Dayton Art Institute, Gift of Mr. and Mrs. Harry S. Price, Jr., 1969.52

Figure 114. Compañía de Lonjistas de Madrid, Inventory of the Contents of the *Westmorland*, Málaga, July 13, 1783. British Library, London, Egerton Papers, 545 (cat. 12)

would not venture to take on board upon any consideration whatever, to be delivered to Mr Tho. Talbot at London. Now as the assurance, which I had for this Capt's taking charge of it, has thus failed, I am at a loss how to proceed. To have it inclosed within a block of marble at Leghorn is what I do not chuse to risk, unless I could see in what manner it was done: but tho' I could be present, it is scarce safe to have it so covered at Leghorn, where the artifice might be noticed & information of it given to those who would create trouble. Bringing it back hither is multiplying risk, trouble, & expense. I shall not without some impatience wait Your Lordship's instructions.[5]

Thorpe was, as we can see, already devising an alternative plan, which would take a further year to be implemented. A new addressee had to be found; this was Thomas Hornyold, another Catholic and a London banker whose family was friends with the Arundells.[6] As a result the crate was finally shipped bearing the initials "T. Hd. No. 7" (fig. 114), which is the way in which it is recorded in the inventories compiled both in Málaga and on its arrival at the Real Academia de Bellas Artes de San Fernando in Madrid.[7]

The other precaution consisted of placing the relics in a small box concealed within a block of marble carved to look like a pedestal.[8] Thorpe commissioned the block from one of the marble-carving workshops, probably back in Rome rather than in Livorno, that made souvenirs for tourists and where he was very probably a regular client. It may have been the same workshop that, one year earlier, had carved an altar and tabernacle in sumptuous marbles as well as a superb marble vase for the Wardour chapel, as published in the *Diario ordinario di Roma*, to which Thorpe also refers in his letters.[9] The altar, designed by Giacomo Quarenghi, was carved in the workshop of Antonio Blasi (fig. 115). A few years later Thorpe wrote to Arundell, describing the method of concealment: "Please to remember that on the marble block no mark appears of any opening, nor can it be discovered without particular directions, being made rough bottom of the pedestal that seal up the Cpo. Sto. being hewn or chipped after it was fixed & the whole bottom made so rugged as to perplex the eye of anyone, who should suspect or ever know the opening to be on that side."[10]

The crate containing the marble block with the relics inside was finally shipped in December 1778 on the *Westmorland*, which had been anchored in Livorno since March. This time Thorpe managed to keep the contents of the crate a secret from Willis Machell, captain of the vessel.

When news of the *Westmorland*'s capture in January 1779 began to filter out, Thorpe's principal concern was to ensure that the crate was not sold.

Figure 115. Giacomo Quarenghi, Altar of the Chapel at New Wardour Castle, ca. 1777

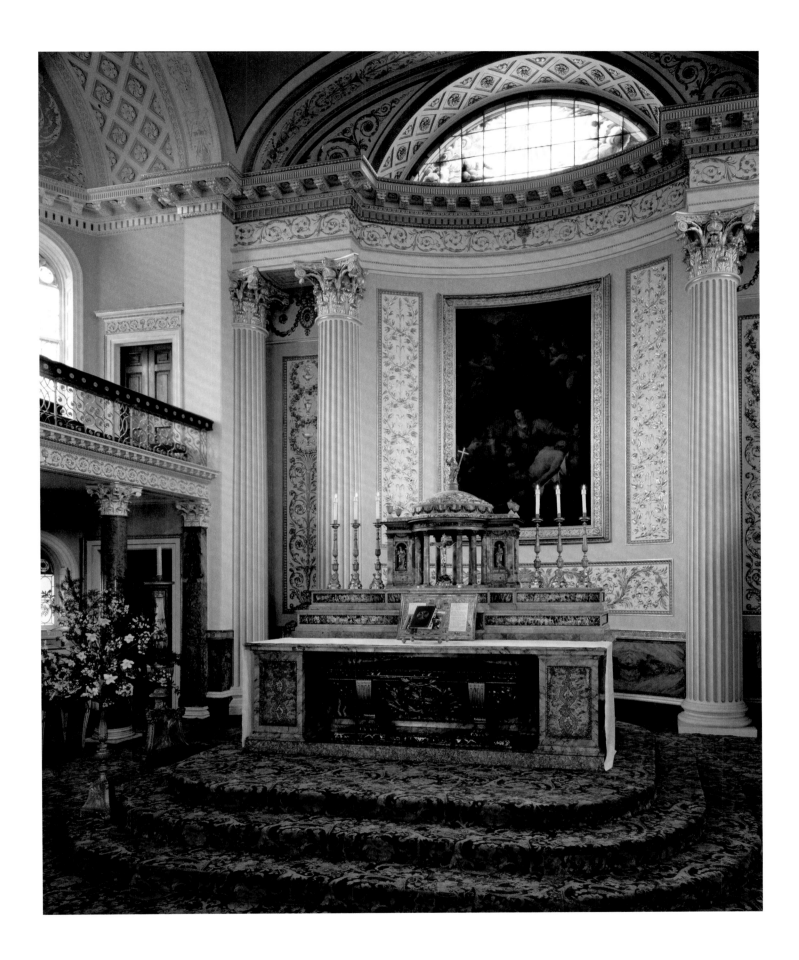

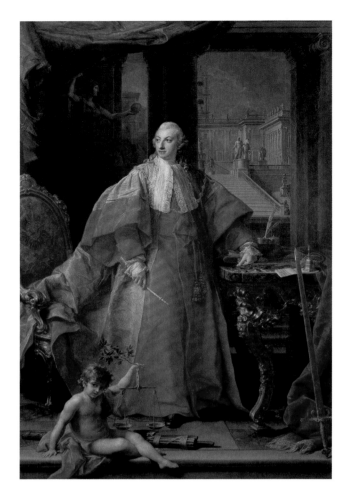

Figure 116. Pompeo Batoni, *Prince Abbondio Rezzonico*, 1766, oil on canvas, 117⅛ x 77⅜ in. (297.5 x 196.5 cm). Private collection

of gaining access to the most influential people who could help them to recover the relics. Thorpe believed that negotiations could be undertaken from London and he thus wrote to Arundell, in the same letter, in the hope that the latter could find a means of recovering the crate:

> If your Lordship has not in some manner application from London for the recovery of it, I cannot imagine from where any order can proceed for not selling it. . . . The block of marble was never presented as otherwise than as a pedestal of a particular kind which could not be equivalently supplied by any other stone in the market with the same shape. It was supposed to be adapted to a particular service in your Altar or Chapel & upon this consideration was directed to spare no expenses.[11]

These lines indicate that Thorpe was trying to use all means at his disposal to prevent the sale of the marble block and would pay any amount to recover it. On January 30, 1782, Thorpe reported that he had news: the *corpo santo* was safe in the port of Málaga.[12] He met with Prince Abbondio Rezzonico, a Roman senator and nephew of the former pope Clement XIII (fig. 116), who seems to have promised to exercise his influence and do everything possible to ensure that the relics arrived at their intended destination.[13]

The crate with the block of Siena marble concealing the relics remained in a warehouse in Málaga, together with all the other objects from the captured ship that had been acquired by the Compañía de Lonjistas de Madrid (Company of Commercial Agents).[14] After these items were transported to Madrid in 1783, an inventory was compiled at the Real Academia, at the end of which appears a note that "últimamente un cajón donde dicen que hay un cuerpo de un santo, y no se ha abierto" (finally a crate in which it is said that there is a body of a saint, and which has not been opened).[15] At some point, probably near the beginning of 1784, Thorpe met with the *procurador general* (king's attorney) in Rome, José Nicolás de Azara y Perera, marqués de Nibbiano (fig. 117), in order to apprise him of the secret contents of the crate and to inform him that in accordance with canonical precepts, these

The argument that both he and Thomas Hornyold employed was that it contained a block of marble specifically intended for a project that was being created in England and was therefore of no use elsewhere. Neither man was initially sure as to the port in which the ship was to be found, and so they made their first attempts at negotiations in Livorno through the agent MacCarty. In a letter from Thorpe to Arundell in June 1780, it is evident that there was some confusion regarding the capture of the *Westmorland*. In the letter Thorpe mentioned the crate marked "T. Hd." and the name of the ship transporting it, but he believed that it was a vessel captured by the Spanish fleet, seemingly unaware that Spain had not yet entered the war. This was one of a series of letters that passed among Thorpe, MacCarty, and Arundell with the aim

relics could not be sold. Thorpe wrote a *pro memoria* note to Azara in his own hand, in Italian, summarizing their meeting and setting out the actions he had taken (fig. 118).[16] Azara forwarded this note to the Spanish prime minister, José Moñino y Redondo, conde de Floridablanca, who in turn sent it to the Real Academia's vice protector, Pedro Pimentel de Prado, marqués de la Florida Pimentel. Instructions had already arrived in Madrid that the crate in question should be set aside as it contained "el cuerpo de un santo" (the body of a saint), and this had in fact been done.

A letter in March 1784 from the Real Academia's secretary, Antonio Ponz, to Francisco Pérez de Lema, a secretary of state of the king's council, responds to the latter's inquiries, prompted by Thorpe's discussions with Azara in Rome:

> Mi estimado dueño, y Sr. Dn. Francisco: hay un cajón entre los que vinieron de Málaga que no se ha desclavado, ni abierto, y es el único que se mantiene del mismo modo que llegó. Desde luego dijeron que contenía un Cuerpo de un Santo, y tuvieron la consideración de no llegar a él, y así se le dijo a S.E. cuando estuvo en la Academia. Tiene dicho cajón las mismas letras de la memoria que Vm. me ha incluido, y le devuelvo. Parece que en los catálogos que enviaron de Málaga a S. E. está anotado de modo, que confronta con la memoria adjunta, y es natural que VM. los tenga . . . el cajón THD se mantiene cerrado enteramente, y es de la manera que expresa la memoria. Dicen que pesa 40 o más arrobas. Lo que hay dentro no se sabe. Sin duda serán las reliquias, o el cuerpo del Santo según todas las señales. Si se diese orden de abrirlo o cualquiera otra me parece que convendría dirigirla al señor marqués de la Florida

Figure 117. Anton Raphael Mengs, *Portrait of José Nicolás de Azara y Perera, Marqués de Nibbiano*, 1774, oil on canvas, 33⅛ x 25¼ in. (84 x 64 cm). Private collection

Figure 118. Letter from Father John Thorpe to José Nicolás de Azara y Perera, marqués de Nibbiano (Rome, 1784?). Real Academia de Bellas Artes de San Fernando, Archivo-Biblioteca (cat. 11)

quien corrió con este negocio desde el principio, y es aquí la cabeza. [Firmado] Ponz. (My esteemed lord, Sr. Dn. Francisco: there is a crate among those that came from Málaga that has not had the nails taken out nor has it been opened, and it is the only one that remains in the same state in which it arrived. From the very outset we were told that it contained a Body of a Saint and thus it was not opened out of respect, as His Excellency was informed when he was at the Academia. This crate bears the same initials that appear in the *pro memoria* note that you sent to me [originally from Thorpe], and I return it to you. It seems that in the lists that were sent from Málaga to His Excellency, it is listed in a way that conforms to the attached note, and it is appropriate that you should have them. . . . The crate THD remains completely unopened, and is as described in the said text. It is stated to weigh forty or more *arrobas* [about 500 kg.]. It is not known what is inside. It will undoubtedly contain relics or the body of a saint, according to all indications. If the instruction is given to open it or any other [instruction given], I think it should be sent to the marqués de la Florida, who has been in charge of this affair from the outset and who is responsible here. [Signed] Ponz.)[17]

A week later instructions were issued at the Real Academia to release the crate with the relics. On the document quoted above, written in another hand, is the following annotation:

en 27 marzo tuvo el señor marqués de la Florida orden por escrito del señor conde de Floridablanca de que se entregase dicho cajón THd donde se suponía estar el cuerpo del Santo a quien acudiese por el, y esta orden se la comunicó al conserje en mi presencia. [Firmado] Ponz. (on March 27 the marqués de la Florida received a written instruction from the conde de Floridablanca to hand over the said "THd" crate, which is presumed to contain the body of the saint, to whoever comes to collect it, and this instruction has been passed on to the steward in my presence. [Signed] Ponz.)[18]

Figure 119. Box containing relics of St. Clement in the Chapel at New Wardour Castle

Another four years would pass before the crate was finally handed over. In April 1788 Thorpe wrote to Arundell that Prince Rezzonico had promised to reopen the matter of the *corpo santo*. Once it had been determined that the marble plinth was, indeed, at Madrid and had not been opened, it was to be sent to the Spanish ambassador in London, without any mention of its ultimate destination.[19] On May 19, 1788, Floridablanca sent instructions from Aranjuez to the Real Academia's secretary to give the crate to whoever came to collect it on behalf of the papal nuncio:

Entre las cosas que se pasaron a la Academia de la presa que se hizo a los Ingleses, hay un cajón, y dentro otro de mármol que contiene varias reliquias de Santos Mártires, y el primero tiene la señal THd N.1 Se lo prevengo a V. S. Para que lo tenga pronto cuando vayan a buscarlo y recogerlo de parte de un Nuncio. [Firmado] Floridablanca. (Among the items that passed to the Academia from the ship captured from the English, there is a crate, and inside another of marble that contains various relics of Martyr Saints, and the first is marked "THd N. 1." Please ensure that it is ready when the nuncio's representative comes to find it and collect it. [Signed] Floridablanca.)

A note in the left margin briefly states: "Se entregó el cajón en la forma que expresa esta orden." (The crate was handed over in accordance with this order.)[20]

On April 22, 1789, Thorpe wrote to Arundell marking "the safe arrival of the Cpo. Sto. at Wardour after so many years of bondage in Spain." He then gave Arundell instructions for removing the relics from the marble plinth, describing the *corpo santo* within a tin box "covered with crimson silk & bound with ribands & seals." Thorpe ended by advising that, when the relics were placed in an urn beneath the altar, the urn should bear the inscription "CORPUS S. CLEMENTIS / M. CLEMENTIS XIII P. M. DONUM"—revealing to us at last the identity of the saint.[21] Appropriately enough, considering that their gift originated with Pope Clement XIII, the relics were those of Saint Clement. Although it was not placed beneath the altar as Thorpe had expected, the box containing the relics, with its silk covering, ribbons, and seal (fig. 119), much as Thorpe described it, continues to reside in the chapel in a display cabinet to the side of the altar.

1. Clement XIV appears to have been carrying out the wishes of his predecessor, Clement XIII, who befriended Arundell during his Grand Tour in 1758–60. Clement XIV himself had died in 1774, leaving the arrangements for the gift to others. For this suggestion, as well as much information based on his research on Arundell, I am grateful to Barry Williamson.
2. Luzón Nogué 2002c, 165ff.; and Coltman 2009, 155ff.
3. Father John Thorpe to Henry Arundell, eighth Baron Arundell of Wardour, Nov. 30, 1776. Archives of the British Province of the Society of Jesus, London.
4. The fact that Giovanni Battista Piranesi dedicated a print in his two-volume publication entitled *Vasi, candelabri, cippi, sarcofagi, tripodi, lucerne ed ornamenti antichi* (Vases, Candelabras, Gravestones, Sarcophagi, Tripods, Lamps, and Antique Ornaments) to Thomas Manzel [*sic*] Talbot suggests that the latter was a good client of the artist.
5. Thorpe to Lord Arundell, Dec. 10, 1777. Photocopies are in the Brinsley Ford Archive, Paul Mellon Centre, London.
6. Catholic Encyclopedia 1910, s.v. "Hornyold"; and Kirk 1909, 125–27, 225.
7. In the inventories this number was sometimes read as "7" and sometimes as "1." The bill of lading sent by Thorpe to Arundell clearly reads "7," although this was the only crate consigned to Thomas Hornyold.
8. The block was described as measuring three cubic *palmos* (about 62.5 cm³).
9. "Dal sig. Antonio Blasi scalpellino nella Piazza della Consolazione con il disegno e direzione del sig. Giacomo Guarengi si è terminato un ricco e bellissimo Altare formato di tutte pietre rare. . . . Ordinato da un abate inglese." (By Mr. Antonio Blasi, stonecutter at Piazza della Consolazione, after the design and direction of Mr. Giacomo Quarengi, a rich and beautiful altar formed with all kind of rare stones has been finished . . . commissioned by an English abbot.) Diario 1777, 23.
10. Thorpe to Lord Arundell, June 28, 1780, Archives of the British Province of the Society of Jesus, London. Photocopies with manuscript annotations are in the Brinsley Ford Archive, Paul Mellon Centre, London.
11. Thorpe to Lord Arundell, June 28, 1780, Archives of the British Province of the Society of Jesus, London. Photocopies with manuscript annotations are in the Brinsley Ford Archive, Paul Mellon Centre, London.
12. Thorpe to Lord Arundell, Jan. 30, 1782, 2667/20/22/5, Wiltshire and Swindon Archives, Chippenham, Wiltshire.
13. Thorpe's relationship with Prince Rezzonico was a close one, and one of the paintings Thorpe sent to Arundell in 1775 was a copy by Robillard of the prince's portrait by Pompeo Batoni. Ingamells 1997, 940.
14. Luzón Nogué and Sánchez-Jáuregui 2003, 67–100.
15. Second unpacking list, 4-87-1-26, Archivo-Biblioteca, RABASF.
16. The *pro memoria* note that Thorpe sent to Azara in Rome explains the contents of the crate in question. 4-87-1-48, Archivo-Biblioteca, RABASF.
17. Antonio Ponz to Francisco Pérez de Lema, March 21, 1784, 4-87-1-21, Archivo-Biblioteca, RABASF.
18. Ponz to Pérez de Lema, March 21, 1784, 4-87-1-21, Archivo-Biblioteca, RABASF.
19. Thorpe to Lord Arundell, April 16, 1788, 2667/20/22/6, Wiltshire and Swindon Archives, Chippenham, Wiltshire.
20. Conde de Floridablanca to Ponz, May 19, 1788, 4-87-1-47, Archivo-Biblioteca, RABASF.
21. Thorpe to Lord Arundell, April 22, 1789, 2667/20/22/6, Wiltshire and Swindon Archives, Chippenham, Wiltshire. It was Barry Williamson who alerted me to the presence of Saint Clement's relics at Wardour and drew my attention to the letters from Thorpe to Arundell in the Wiltshire and Swindon Archives that document the successful conclusion of the episode.

Catalogue

Introduction

The catalogue is divided into two sections. The first briefly provides a visual context and documentary record of the capture of the *Westmorland*, the sale of its contents, the arrival of the contents in Madrid, and subsequent attempts by some of the owners to recover their property.

The second section is devoted to the contents of the *Westmorland*, organized by the owners of the crates on the ship when they are known, each introduced by a brief biographical statement emphasizing that person's Grand Tour experiences and collecting activity. These groupings by owner are followed by those objects for which the owners have not yet been identified, organized by the markings on the crates in which the objects were packed.

In addition to the references, provided in short form at the end of the entries and in full in the bibliography, all the contributors relied on information provided by María Dolores Sánchez-Jáuregui from her extensive research on the *Westmorland*. John Ingamells, *A Dictionary of British and Irish Travellers in Italy, 1701–1800, Compiled from the Brinsley Ford Archive* (1997), and the online edition of the *Oxford Dictionary of National Biography* were consulted throughout. Contributors to the catalogue are identified by the following initials:

MCAR María del Carmen Alonso Rodríguez
SA Sarah Armitage
KC Kelly Cannon
EF Elisabeth Fairman
CH Clare Hornsby
EH Eleanor Hughes
JMLN José M. Luzón Nogué
ANC Aurelio Nieto Codina
SR Steffi Roettgen
FS Frank Salmon
MDSJ María Dolores Sánchez-Jáuregui
KS Kim Sloan
CS Christina Smylitopoulos
CW Catherine Whistler
SW Scott Wilcox
JW-E John Wilton-Ely
JY Jonathan Yarker
AY Alison Yarrington

1

Declaration for a Letter of Marque for the Westmorland

October 9, 1777

From *Letters of Marque against the Americans from 1st August 1777 to 3rd February 1778*
National Archives, Kew, HCA 26/61, fol. 79

2

Declaration for a Letter of Marque for the Westmorland

August 20, 1778

From *Letters of Marque against the French from 17th August to the 26th 1778*
National Archives, Kew, HCA 26/33, fol. 131

Letters of marque granted the owners and crew of private vessels the rights to any proceeds from enemy vessels and goods taken as prizes during periods of declared conflict. In order to obtain a commission, the commander of a vessel (or his representative) was obliged to make a sworn statement before the High Court of Admiralty, giving certain details of the ship, its armaments, and its crew. During the American War of Independence, a commission had to be obtained for each adversary and for each voyage.

The declarations made for letters of marque for the *Westmorland* not only contain the most detailed information about the ship but also shed light on the long delay in sailing from Livorno (which the British called Leghorn) that so exercised the insurers of its perishable homebound cargo. On October 9, 1777, Willis Machell appeared before the Admiralty with a warrant for a letter against the American colonies, then Britain's only opponent in the war. Here the *Westmorland* is described as a three-hundred-ton, square-sterned, three-masted ship with a figurehead, employed in trade and with a cargo of "Woollens, Linnens, Iron, Lead, Hardware, Leather, Indigo & other Merchandize." The

1

2

declaration states that the ship's armaments include twenty six-pounders (cannons capable of firing six-pound shot) and no swivel guns, and it is crewed by fifty men and equipped with enough small arms and cutlasses for each to participate in any action the ship might encounter, along with sufficient victuals to sustain the crew for ten months. The crew included a mate, gunner, boatswain, carpenter, cook, and surgeon.

By March 1778 the *Westmorland* was anchored in Livorno, after having called at Nice and Genoa, according to the route advertised in the newspapers. At this date it was becoming clear that the French would enter the war; it seems likely that Machell sent instructions to his agent in London to apply for a letter of marque against the French, then waited to receive word that the commission had been granted.

On August 20, 1778, three days after letters of marque against the French began to be issued following the declaration of hostilities, Samuel Enderby appeared before the court "on behalf of Capt.ⁿ Willis Machell now at Leghorn" to apply for a commission "for the apprehending, seizing and

taking the ships Vessels and Goods belonging to the French King his Vassals and subjects or others inhabiting . . . any of his countries Territories or Dominions." There are a number of discrepancies between the information declared in the two letters; while some may have been due to miscommunication between Machell and Enderby, others may be attributable to the opening of hostilities against the French. For example, the *Westmorland* was now declared to carry twelve swivel guns and twenty-two carriage guns, reinforcing a report made in Livorno in June that Machell had been increasing the ship's armaments. Likewise, the complete change of personnel in the positions named above was probably due to the *Westmorland*'s consequent delay in sailing. EH

REFERENCES: Starkey 1990; Suárez Huerta 2002.

3

Atalanta
ca. 1775

Wood, bone, cotton, brass, mica, paint, and varnish
21⅞ x 31⅞ x 12¼ in. (55.7 x 81 x 31.2 cm)
National Maritime Museum, Greenwich, SLR 0340

Although the *Atalanta* was built at the Royal
Dockyard in Sheerness as a sloop of war for the Royal
Navy, it was comparable in size and form to the
Westmorland, a merchant ship built in a commercial
Thames dockyard. Both ships were built in 1775
and were capable of carrying approximately three
hundred tons' burden. Each had a square stern, three
masts, and a figurehead, and they were similarly
armed: the *Westmorland* carried twenty-two carriage
guns, and the *Atalanta* sixteen, and both ships were
armed with a number of swivel guns. The *Atalanta*
was captured by the American ship *Alliance*, of
thirty-six guns, in 1781, but it was retaken by the
British shortly thereafter. This model may have been
made as a presentation gift at the time of the ship's
launch. EH

REFERENCE: National Maritime Museum, Green-
wich, "Collections," accessed December 5, 2011,
http://collections.nmm.ac.uk/collections/
objects/66301.html.

4

NICHOLAS POCOCK (1740–1821)

**The Ranger, Private Ship of War,
with Her Prizes**
1780

Pen and ink and gray wash on paper
15 x 21 in. (38.1 x 53.3 cm)
Inscribed below image: "The Ranger, Private Ship of
War, with Her Prizes / La Cigale from St. Domingo /
Le Compte D'Artois From the East Indies / St. Innis,
Spanish Frigate from Manilla / Le Cantabre, from
Martinique / N. Pocock Ft 1780"
Yale Center for British Art, Paul Mellon Collection,
B1977.14.4371

Nicholas Pocock began his working life as a mariner
and merchant captain, based in Bristol, and left the
sea to become a marine painter in the late 1770s. He
appears to have found patronage initially among the
owners of privateers operating from Bristol, making

3

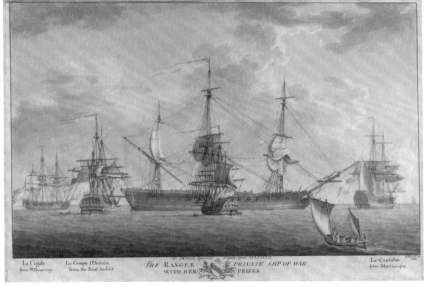

4

portrait drawings of their ships. This particularly fine and elaborate example depicts the *Ranger*, an American-built Bristol privateer of two hundred tons and eighteen guns, along with four vessels it captured in 1778 and 1779. Unlike the *Westmorland*, an armed merchant ship whose primary interest was trade, the *Ranger* appears to have been a private ship of war, a vessel engaged in cruising for prey— and a rapacious one at that. Pocock's picture shows the *Ranger*'s prizes in chronological order of their capture, from left to right: the *Cigale*, of three hundred tons, taken off Bristol en route from Santo Domingo to Nantes in October 1778; the *Comte d'Artois*, a five-hundred-ton French East Indiaman, taken by the *Ranger* while cruising with another letter of marque, the *Minerva*, homeward bound from Mauritius in April 1779; the *Santa Inés* (called here the *St. Innis*), an enormous Manila galleon (a Spanish ship sailing a trade route between the Philippines and Mexico) of seven or eight hundred tons, captured by the *Ranger* with the *Amazon*, a Liverpool privateer of fourteen guns, in August 1779; and the *Cantabre*, taken en route from Martinique to France in late 1779. The image undoubtedly comprises an imaginary grouping of the ships, each of which Pocock could have drawn from life when the prizes were brought into port and sold at auction. The drawing appears to have been made for James Rogers, whose coat of arms it bears, and who, with Henry Garnett, owned the *Ranger* and a number of other Bristol privateers. The captures were made under the command of two different captains: the first two by Joseph Robbins, the latter two by Daniel Dale.

The most spectacular of the *Ranger*'s prizes was the *Santa Inés*, a Spanish galleon initially reported to contain gold, silver, coffee, china, cochineal, and indigo, but which in fact carried sugar, black pepper, dyewood, and beeswax; it dwarfs the *Ranger* in Pocock's depiction. The *Ranger*'s role in the capture was disputed in the account of the engagement by the *Amazon*'s captain, Charles Lowe Whytell:

[*The* Santa Inés] *looked exceeding large, and shewed 15 guns on a side. . . . We gave her two broadsides for one, and continued the engagement for three glasses, very briskly, and then lost sight of her for ten minutes in a cloud of smoak, and feared she had sunk; when it cleared up we perceived her endeavouring to make her escape, and gave chace to her again; came up with, received her broadside, and returned only a few guns before she struck her colours. A Bristol privateer [*the* Ranger] came up during the engagement, but*

kept aloof, and never fired one gun. We having received much damage in our rigging and sails, and our yard tackles shot away, the Bristol privateer took the advantage and boarded her first, and received the Captain's sword and papers, which they did not deserve.

The *Ranger* continued to cruise for prizes, taking several more ships in 1780. The following year the *Ranger* was lost in the Gulf of Finland, en route from St. Petersburg. EH

REFERENCES: *Daily Advertiser*, October 20, 1778; *Lloyd's Evening Post*, April 9–12, 1779; April 12–14, 1779; September 20–22, 1779; February 22–24, 1780; *Morning Chronicle and London Advertiser*, September 13, 1779; February 3, 1780; *Public Advertiser*, September 18, 1779; *London Chronicle*, September 18–21, 1779; Damer Powell 1930; Cordingly 1986; Williams 2004.

5

MARIANO RAMÓN SÁNCHEZ (1740–1822)

Vista del Puerto de Málaga (View of the Port of Málaga)
1785

Oil on canvas
30¾ x 47⅝ in. (78 x 121 cm)
Patrimonio Nacional, Madrid, 10069336

Mariano Ramón Sánchez was born in Valencia and moved with his family at an early age to Madrid, where he studied at the Real Academia de Bellas Artes de San Fernando. A painting by Andrés de la Calleja in the collections of the Real Academia depicts the young artist being awarded a medal for painting in 1753. He became an accomplished miniaturist, taught miniature painting as a supernumerary at the Real Academia, and in 1791 was named *pintor de cámara* (court painter) to Carlos IV.

In 1781 Sánchez received a commission from Carlos III to paint a series of views of Spanish ports, bays, and naval dockyards, including this view of the Mediterranean port of Málaga. The commission was undoubtedly inspired by the model of Claude-Joseph Vernet's *Ports of France*, painted between 1753 and 1765; the view of Málaga certainly bears a compositional and stylistic resemblance to Vernet's *L'entrée du port de Marseille* (Musée de la Marine, Paris).

The *Westmorland* was brought into the port of

Málaga following its capture by the *Caton* and *Destin* in January 1779. Although war between Britain and Spain would not be declared until later that year, a state of hostile neutrality existed between the two powers, while Spain enjoyed friendly relations with France. The *Westmorland*'s cargo was unloaded and inventoried, and the ship and its contents were purchased by the Compañía de Lonjistas de Madrid. The crates of Grand Tourist material remained in Málaga until 1783, when their contents were sold to the Spanish crown and transported to Madrid. EH

REFERENCES: Ruiz Alcón 1968, 56–66; Luzón Nogué 2002b; Espinós Díaz 2011.

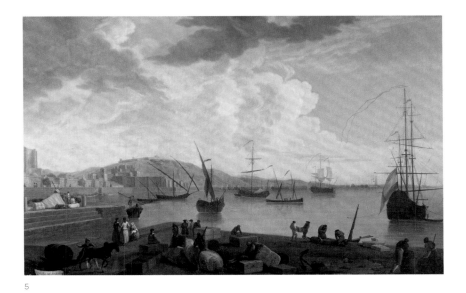

5

6

POMPEO BATONI (1708–1787)

José Moñino y Redondo, Conde de Floridablanca

1775–76

Oil on canvas
39 ¼ x 29 ⅝ in. (99.7 x 75 cm)
Inscribed on verso of canvas: "Ritratto del Conte di Floridabianca. Ambasciatore di Spagna presso la Sta. Sede. 1769"
Art Institute of Chicago, Charles H. and Mary F. S. Worcester Collection, 1974.386

José Moñino y Redondo was appointed Spanish ambassador to the Vatican with the principal mission of persuading Pope Clement XIV to suppress the Jesuit order in Europe. In recognition of his successful effort, in 1773, Carlos III awarded him the title of conde de Floridablanca. In 1776 Floridablanca left Rome to assume the position of prime minister in Madrid, and Pompeo Batoni must have painted this portrait to commemorate the appointment, shortly before his departure. Although the inscription on the back of the canvas reads "1769," this must be a mistake as Floridablanca only reached Rome on July 4, 1772. The canvas originally belonged to Giuliana Falconieri, Princess Santacroce, with whom Floridablanca had an illegitimate son at about this time.

Floridablanca played a crucial role in the *Westmorland* episode. He was responsible for informing the king of the existence of the cargo and for ordering its transport to Madrid; he personally checked the state of the crates on their arrival at the Real Academia de Bellas Artes de San Fernando in Madrid; he undertook negotiations with the

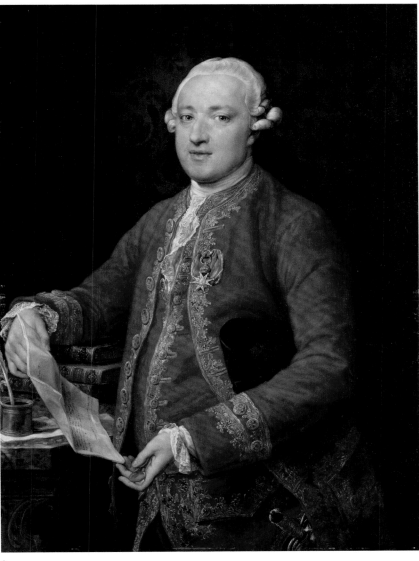

6

Compañía de Lonjistas de Madrid; and he maintained correspondence with the secretary of the Real Academia, Antonio Ponz, on the distribution of the items. Certainly the count was well suited to assess the value of the cargo and its particular characteristics. In his Ambassador's Residence in Rome on Piazza di Spagna, near the Caffè degli Inglesi (English Coffee House), Floridablanca would have had frequent contact with young Englishmen and their tutors, as well as the artists and dealers who catered to them. Having sat for Batoni himself, Floridablanca ordered the artist's portraits of Grand Tourists Francis Basset (cat. 21) and George Legge, Viscount Lewisham (cat. 110), to be brought to his palace, where he may have hung them alongside Batoni's portrait of Manuel de Roda y Arrieta, marqués de Roda (now in the Real Academia).

Batoni's portrait of Floridablanca reuses the composition he devised for his portrait of the marqués de Roda, painted in 1765. Like Floridablanca, Roda was a distinguished diplomat in Rome, occupying the positions of Spanish procurator and minister plenipotentiary until 1765. These two portraits are the only known depictions of Spanish sitters within Batoni's oeuvre. MDSJ

REFERENCES: Clark and Bowron 1985; Olaechea 1988–90, 149–66; Belda Navarro 2008.

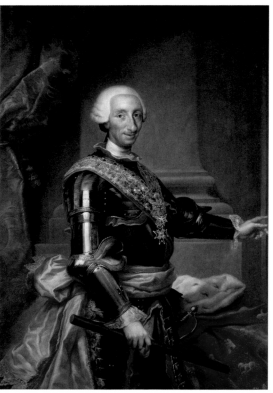

7

STUDIO OF ANTON RAPHAEL MENGS (1728–1779)

Carlos III
after 1771

Oil on canvas
60¼ x 41¾ in. (153 x 106 cm)
Museo Nacional del Prado, Madrid (deposited at the Real Sociedad Económica Matritense de Amigos del País), P05011

Carlos III was the son of Felipe V, the first king of Spain from the French House of Bourbon, and his second wife, Queen Isabel (née Elisabetta) Farnese. As the duke of Parma, Carlos had conquered the kingdoms of Naples and Sicily, which he ruled as Carlos de Borbón until his accession to the Spanish throne upon the death of his half-brother, Fernando VI, in 1759. The king had made the acquaintance of Anton Raphael Mengs in Naples during the year of his accession, before departing for Spain; in 1761 Carlos offered Mengs, then in Rome, the position of court painter at a salary of 120,000 reales a year. Mengs, a native of Bohemia, had served as painter to the Saxon court in Dresden. Although he worried "lest he be asked only to paint portraits," he traveled to Madrid, where he remained for ten years. He became associated with the Real Academia de Bellas Artes de San Fernando, first as its honorary director of painting and then as an honorary member; however, his relations with the institution were stormy. Upon his departure for Rome in 1776, Mengs left the king his collection of sculpture casts.

This work is a version of the original portrait painted shortly after Mengs arrived at the Spanish court in September 1761, which became in effect the official portrait of the monarch. Reflecting his status as soldier-king, it depicts Carlos III wearing a suit of armor bearing the insignia of the Order of the Golden Fleece, the Order of the Holy Spirit, and the Royal Order of San Gennaro, which he had created in Naples. He also wears the blue-and-white sash of the Order of Carlos III, established in 1771.

Carlos III's royal order, administered by José Moñino y Redondo, conde de Floridablanca, that the *Westmorland*'s cargo be acquired for royal collections and for the Real Academia was in keeping with the enlightened despotism of his rule, under which the fostering of the arts was a priority. EH

REFERENCES: Roettgen 1999, 207–9, no. 138: WK6; Westmorland 2002, no. 6 (entry by María del Carmen Alonso Rodríguez).

8

DIEGO DE VILLANUEVA (1715–1774)

Project for the Main Facade of the Real Academia de Bellas Artes de San Fernando

1773

Watercolor and pen and ink over graphite on paper
15⅝ x 23¼ in. (39.6 x 59 cm)
Signed and dated: "Diego de Villanueva, March 30, 1773"
Real Academia de Bellas Artes de San Fernando, Museo, D-2376

From the time that the first steps were taken toward the foundation of the Real Academia de Bellas Artes de San Fernando with the establishment of the Preparatory Committee in 1744, the institution was housed in various venues in Madrid. It was first located in the studio of the sculptor Domenico Olivieri in the Palacio Real (Royal Palace). In 1752 it moved to the Casa de la Panadería in the Plaza Mayor, where it remained until 1773. In that year a royal order authorized the purchase of its permanent home at the Palacio de Goyeneche on Calle de Alcalá, which would be shared with the Real Gabinete de Historia Natural.

The Palacio de Goyeneche was built between 1724 and 1725 by José Churriguera, the great architect of the Madrid Baroque style. It had a monumental facade with inset pilasters, moldings, cantilevers, and a characteristic rusticated base. As such it completely contradicted the Neoclassical precepts upheld by the Real Academia, the members of which commissioned Diego de Villanueva to redesign the exterior.

The present drawing is part of Villanueva's project, specifically the definitive design for the facade as it is seen today. The Baroque ornamental motifs were chipped off, the moldings simplified, and a new Doric portico constructed, among other modifications, resulting in a facade that constituted a symbol of the new ideas that would be taught within the building.

Work began on the palace in January 1774 and continued on the facade for some years. In 1783, when the *Westmorland* crates arrived at the Real Academia, work was being carried out to inset a stone slab with an inscription commemorating its royal foundation, over the entrance on Calle de Alcalá. As a consequence the top of the door as it appears in the present drawing does not conform to its appearance today; the granite slab has replaced the previous coat of arms on the lintel. MDSJ

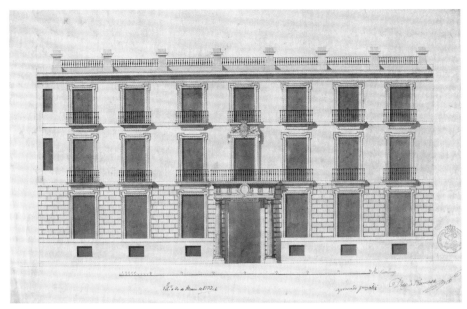

8

REFERENCES: 3-225, 1783, Libro de Cuentas de la Real Academia, Archivo de la Real Academia de Bellas Artes de San Fernando; Sambricio 1986, 71–77; Bedat 1989, 109–24; Martín González 1992, 163–211.

9

Letter from Thomas Jenkins (1722–1798) to William Legge, Second Earl of Dartmouth (1731–1801), with Consignment Note for the Crate on Board the *Westmorland*

Rome, September 2, 1778

Staffordshire Record Office, Stafford, Staffordshire and Stoke-on-Trent Archive Service, Papers of the Legge Family, Earls of Dartmouth, D(W)1778/III/378

Sent by the dealer Thomas Jenkins to William Legge, second Earl of Dartmouth, in September 1778, this letter explains that the earl's eldest son, George Legge, Viscount Lewisham, had already departed from Rome by that date, leaving Jenkins in charge of various matters including paying for acquisitions and sending them in crates from Rome to Livorno, where they would be loaded onto the *Westmorland*.

Jenkins's relationship with the Earl of Dartmouth dated to the earl's Grand Tour, undertaken in 1752–54, when Jenkins was just beginning to make his way as a picture dealer in Rome. Since that time he had become Dartmouth's principal agent, so it was logical that he should assist the earl's son. As this letter makes clear, Jenkins took charge of

9

sending the items, including checking the bill of lading and their loading onto the ship.

It is also clear that Lord Lewisham's crates were loaded at different times. "One case containing prints etc. and another with some plants" had already been sent to Livorno by May, while the letter also mentions a "re-shipping" of Pompeo Batoni's portrait of Lewisham on August 2 and a bill of lading signed August 19 for "a case containing pictures," confirming continual delays experienced by the *Westmorland* before it set sail.

Jenkins had little to say about the works of art and other acquisitions, but enough to permit some of them to be identified among the Spanish inventories. They include the Batoni portrait, plants and bulbs acquired from the gardener at Palazzo Borghese (described in the cargo manifest, cat. 10), books of prints, and two portraits of a man and woman in oval format, which have yet to be identified. MDSJ

REFERENCE: Historical Manuscripts Commission 1899, 243.

The author would like to thank Barton Thurber, who provided the complete transcription of this document.

10

Note on the Ship Manifest of the English Ship Westmorland

Málaga, January 1779

Archivo Histórico Nacional, Madrid, Estado, 540

On January 8, 1779, the captured *Westmorland* reached the port of Málaga; however, due to heavy seas, it was not until January 9 that the captain of the *Westmorland* disembarked and made this declaration regarding the ship's cargo, recorded by the port authorities.

The document reached the Spanish prime minister, José Moñino y Redondo, conde de Floridablanca, a week later in a dispatch from Nicolás Manuel Bucareli y Ursúa, conde de Xerena Bucareli, governor of Cádiz, who had been given it in confidence by Jean Baptiste Poirel, the French consul of the city, against the eventuality of having to request permission for his ships to enter Cádiz to undertake the exchange of prisoners there.

Although brief, the manifest includes the most important information on the cargo and its value. The ship's contents are listed as including 3,837 barrels of anchovies, as well as sunflower seeds, earthenware drinking vessels, crates containing bottles of oil, thirty-two Parmesan cheeses, and

Madeira wine, together with a significant quantity of other varied merchandise: black gauze from Bologna, paper from Genoa, casks of paste for paint, and boxes of seeds and bulbs. In addition, there was a cello in its case, a box of violin strings, and a double-barreled shotgun. Although important, the artistic items were only a small part of the total cargo, comprising twenty-three crates of marble statues, thirty-five pieces of marble, and twenty-two crates of prints, portraits, and books. At the end of the list the port authorities added a note, as follows:

La carga importara como 100mil. lbs. esterlinas. El Capitan asegura hay muchos retratos, y estatuas de bastante precio, y entre ellos algunos, que estaban destinados para S.A.R. el Sor. Duque de Gosesther [sic], Hermano del Rey de Inglaterra. Hay tambien una pintura del valor de 80 escudos romanos, ó 40 libras tornesas, que componen diez mil pesos de nuestra moneda. La carga de los otros dos Buques Ingleses apresados consiste en 8500. quintales de Bacalao Superior. (The cargo is worth around 100,000 English pounds. The captain affirms that there are numerous portraits and statues of considerable value, and among them some that were destined for His Royal Highness the Duke of Gloucester, brother of the King of England. There is also a painting worth 80 Roman scudi, or 40 Tours pounds, equivalent to 10,000 pesos of our currency. The cargo of the other two captured English ships consists of 8,500 quintales of Superior Cod.)

The *Westmorland*'s captain, Willis Machell, seems to have been fully acquainted with the fact that the cases marked "H. R. H. D. G." belonged to William Henry, Duke of Gloucester, as well as with the nature of their contents. He was also aware of the extremely high value of one of the paintings on board, namely, *The Liberation of Andromeda by Perseus* (cat. 17) by Anton Raphael Mengs, sent to Sir Watkin Williams Wynn. MDSJ

REFERENCE: Westmorland 2002, no. 5 (entry by José M. Luzón Nogué).

10

II

Letter from Father John Thorpe (1726–1792) to José Nicolás de Azara y Perera, Marqués de Nibbiano (1730–1804)
Rome, 1784 (?)

Real Academia de Bellas Artes de San Fernando, Archivo-Biblioteca, 4-87-1-48

This document comprises a detailed report sent by Father John Thorpe in Rome to the Spanish ambassador to the Vatican, José Nicolás de Azara y Perera, marqués de Nibbiano, following a meeting between the two men. Thorpe was acting on behalf of Henry Arundell, eighth Baron Arundell of Wardour, in attempting the recovery of a box containing relics of a martyred saint that were intended to adorn the

11

altar in the Wardour Castle chapel designed by Giacomo Quarenghi in 1776.

Thorpe described how, in a crate marked "T. HD. No. 7." (addressed to Thomas Hornyold, a London banker and a Catholic), he had sent "una cassettina coperta di raso cremisino" (a small box covered with crimson silk) containing various relics, which were a personal gift from Pope Clement XIV to Lord Arundell. The crate was loaded on board the *Westmorland* by Florenzio MacCarty and Son in Livorno (probably associated with the agent William MacCarty), and the relics were concealed in a plinth of giallo di Siena marble to avoid the notice of English customs officials. The text goes on to explain that the ship had been captured and brought into Málaga. It details how the Spanish ambassador at the time, Jerónimo Grimaldi, marqués y duque de Grimaldi, acting on the request of Prince Abbondio Rezzonico, nephew of the former pope Clement XIII, had personally agreed with the then governor of the port of Málaga that preference would be given to Arundell's agents to acquire the crate when the cargo was sold.

Although Thorpe's report is undated, it must have been written in 1784, as Thorpe was aware that the whole cargo had been acquired by the company of Patricio O'Brien, a member of the Compañía de Lonjistas de Madrid, and that it had been brought to

Madrid on the orders of the king, "sul fin dell'anno scorso" (at the end of the last year). Thorpe expressed the wish that the block of marble, in which he had no interest, should be opened and that the *cassettina* alone, with its relics, should be returned to him. It was, however, the only crate that was never opened at the Real Academia de Bellas Artes de San Fernando.

This *pro memoria* note, filed among the Real Academia's documents, offered scholars the first clues for embarking on the principal lines of research in the present *Westmorland* project, providing precise information on Livorno, the port of departure; the name of the ship, "*Westmarland*"; the captain, "Willis Machel [*sic*] Inglese"; and details of the ship's capture: "nell'anno 1778, la qual nave appena uscita dal porto restó predate nel Mediterraneo, e condotta a Malaga" (in the year 1778, shortly after the said ship left port, it was captured in the Mediterranean, and brought into Málaga). MDSJ

REFERENCES: Luzón Nogué 2002c, 165–71; Westmorland 2002, no. 11 (entry by José M. Luzón Nogué); Bignamini and Hornsby 2010, 1:325; for more on the episode of the Arundell relics, see "A Crate of Saints' Relics" by José M. Luzón Nogué in this volume.

12

Compañia de Lonjistas de Madrid, Inventory of the Contents of the *Westmorland*
Málaga, July 13, 1783

British Library, London, Egerton Papers, 545

When the Spanish prime minister, José Moñino y Redondo, conde de Floridablanca, ordered the *Westmorland* crates stored in Málaga to be sent to Madrid to be examined at the Real Academia de Bellas Artes de San Fernando, he asked the Compañía de Lonjistas de Madrid in Málaga to send him a detailed list of the items from the *Westmorland* in order to certify that the delivery had been correctly carried out. That inventory of the objects, which had been in storage in a maritime trading house for more than four years, had been drawn up a few days earlier by a customs official at the request of the Compañía de Lonjistas.

The list, which is transcribed and translated in appendix 1, itemizes the contents of fifty-nine

crates, with a careful annotation of the initials on the outside of the crates. This is the most complete inventory to have survived, as it also refers to nine crates as "no vá" (not taken). These were not sent to Madrid because their contents were not considered of interest: a dismantled bed frame, a violin, shoes, medicines, forks, and "Twenty-one Blocks of uncut marble."

The discovery of this inventory constituted a major step forward regarding our knowledge of the contents of the crates and their owners. First, it includes initials that do not appear in the Real Academia's inventories, including "J. M." and "A.," and even complete names such as "Thomas Farrar Esquire Corn. Factor," possibly the same British merchant who, according to *The Universal Pocket companion containing . . . a list of Merchants . . . ,* was based at "nº. 27 prescot Street, goodman's fields." Another name is "Mr. Vest London," to whom two boxes were to be sent and who may well have been the American-born artist Benjamin West. Second, this inventory allows us to correct errors in the Real Academia's lists that would not otherwise have come to light. For example, it enables us to know that a copy of *Saint Cecilia* by Guido Reni and two copies of *The Cardsharps* by Caravaggio were in the crate of "J. M." and not in that of "W. A. F." as indicated in one of the later lists prepared by the secretary of the Real Academia, Antonio Ponz (cat. 14). MDSJ

REFERENCES: Universal 1767, 129; Luzón Nogué and Sánchez-Jáuregui 2003, 67–100.

13

JOSÉ MOÑINO Y REDONDO, CONDE DE FLORIDABLANCA (1728–1808)

Royal Order (Copy)

July 9, 1783

Real Academia de Bellas Artes de San Fernando, Archivo-Biblioteca, 4-87-1-2

Following the acquisition of the *Westmorland*'s cargo by the Compañía de Lonjistas de Madrid in Málaga in 1780, the crates with works of art and other Grand Tour acquisitions remained in warehouses, as the agents seem to have been unable to sell them.

With the conclusion of hostilities between Spain and Britain in 1783, Carlos III was informed of the existence of these crates, probably by his prime

12

13

minister, José Moñino y Redondo, conde de Florida-blanca. The king then issued a royal order to the Real Academia de Bellas Artes de San Fernando setting out that "el Viceprotector Marqués de la Florida Pimentel nombre sujeto inteligente que reconozca unas pinturas y otras obras delas artes detenidas en Malaga que se apresaron por los franceses a los ingleses en la Guerra" (the vice protector, the marqués de la Florida Pimentel, should appoint a man of taste to identify various paintings and other works of art retained in Málaga that were captured by the French from the English in the war). It went on to state that these objects should be taken into storage and the Real Academia should appoint someone from the area who could provide a detailed description of their value and the nature of the "Diseños, Pinturas, y otras efectos de los mas celebres Profesores, pertenecientes á las Nobles Artes, que se sacaron de Italia para Inglaterra" (drawings, paintings, and other objects by the most celebrated experts, belonging to the noble arts, that had been taken from Italy for sending to England).

A few days later, on July 13, 1783, Pedro Pimentel de Prado, marqués de la Florida Pimentel, wrote to Floridablanca to explain that, from past experience, he did not believe there was anyone in Málaga or nearby who could undertake the task in hand with rigor and judgment. Instead, in a letter that enclosed the list made by the Compañía de Lonjistas (cat. 12), he suggested the most appropriate course of action:

supuesto que los Ingleses las traherian con toda curiosidad, vengan en los mismos Cajones, cubiertos con encerado: Que quedandose con razon delo que remiten dirixan á V.E. un duplicado de ella; Y que luego que lleguen, se reconozcan y aprecien por los Directores de Pintura, y sus tenientes, y se dé á V.E. puntual aviso de las resultas. (assuming that the English sent everything well packed, they could come in the same crates, covered with waxed cloth. They should keep a receipt of what they send and provide Your Excellency with a copy. And when they arrive, they should be identified and valued by the Directors of Painting and their assistants, and Your Excellency be promptly informed of the results.)

Following this, on October 7, 1783, Floridablanca informed the vice protector that the first dispatch of crates from Málaga was on its way to the Real Academia. MDSJ

REFERENCE: Westmorland 2002, no. 7 (entry by José M. Luzón Nogué).

14

14

ANTONIO PONZ (1725–1792)

Catalogue of Books, Prints, and Other Papers That Arrived in the Second Dispatch of Crates, Ordered to be Deposited in the Academia de San Fernando
April 1784

Real Academia de Bellas Artes de San Fernando, Archivo-Biblioteca, 4-87-1-26

The present list, which is transcribed and translated in appendix 2, must have been compiled in early April 1784, as it is accompanied by a letter from José Moñino y Redondo, conde de Floridablanca, to

Antonio Ponz dated April 19 of that year. Florida-blanca noted that he was returning the inventory on which Ponz had marked those items that he wished to be retained for the Real Academia de Bellas Artes de San Fernando. The note goes on to indicate that the prime minister himself has marked with a slash (/) everything that the king wants for his palace. The secretary of the Real Academia can dispose of the rest, after which what remains can be offered to the Compañía de Lonjistas de Madrid, given that the British ambassador is interested in trying to get the contents back.

In light of these remarks the list can be inter-preted as follows: The marks "*" and "//" located to the right and left of various objects correspond to the first selection made by Ponz. The mark "/," as Floridablanca explained, corresponds to the items that Carlos III wanted. There are also comments or annotations in Ponz's hand in the margins. In the case of two identical items, he wrote "se toma el uno" (one has been taken), while next to the description of the views in crate ⟨E⟩, he noted in relation to the views of Rome that "estos 24 papeles podrían ser útiles, pero son curiosísimos y muy propios para un gabinete" (these twenty-four sheets could be useful, but they are very curious and very fitting for a cabinet). In the case of various marks he clarified the situation with the comment "ya esta tomado" (it has already been taken).

These marginal notes have provided a wealth of information about numerous objects, such as the fireplaces and *pietre dure* tables, traced largely through the annotations that offer clues as to their whereabouts.

Other interesting pieces of information to be gleaned from this document include the facts that in the end, the king decided to keep very little for himself and gave most of the items to the Real Academia; that the portraits by Pompeo Batoni were taken directly to Floridablanca's house; and, amusingly, that the liqueurs and sweetmeats were consumed at the Real Academia "para que no se acabran de perder" (so that they would not go off). MDSJ

REFERENCES: Luzón Nogué 2002a, 89–105; Luzón Nogué and Sánchez-Jáuregui 2003, 67–100.

15

Letter from "Andrew" to Robert Liston (1742–1836)
[Edinburgh], December 16, 1783

National Library of Scotland, Edinburgh, MS 5539, no. 3

16

Letter from Bernardo del Campo (d. 1800) to José de Anduaga
London, June 15, 1785

Archivo General de Simancas, Valladolid, Estado, 8157

On the cessation of hostilities between Spain and Britain in 1783, diplomatic relations were renewed, and Robert Liston was appointed minister plenipo-tentiary to Spain. Claims arising from the war began to be filed immediately, among them petitions from individuals affected by the capture of the *Westmorland*.

The first evidence of attempts by John Hender-son, by then the fifth Baronet of Fordell, to recover his possessions comes in a letter of October 1783 to Liston from a friend known to us simply as "Andrew." Henderson approached Liston through Andrew in an attempt to discover the whereabouts of his possessions, and the British diplomat was able to report that Henderson's crates, along with the rest of the cargo, were in the possession of the Compañía de Lonjistas de Madrid and that the Spanish king was going to buy and take possession of everything that appealed to him. Liston was confident that Hender-son's items, which were merely copies and objects of low value, would not be selected by the monarch and that he could recover them by offering a sum of money to the agents. Liston seemed to know nothing regarding the role of the Real Academia de Bellas Artes de San Fernando in the matter. In the letter to Liston of December 16, 1783, Andrew passed along Henderson's thanks for his efforts and expressed hope that the portrait (cat. 101) could be recovered: "There is a Portrait he joys [*sic*] which he wishes much to have, for it cannot be of great value to any body in Spain." In the end, however, Liston's efforts were fruitless, as the sale was concluded without his having the opportunity to bid or to offer any sum of money for Henderson's items.

Two years later Henderson made another effort to recover his lost possessions, making use of a different diplomatic channel, as a folder of documents

15

16

in the Archivo General de Simancas, Valladolid, reveals. It includes a note written by Henderson in May 1785 thanking the Spanish ambassador, Bernardo del Campo, for his kindness in receiving him for an interview in St. James's Park, London, on which occasion he was able to explain his case "relative to the pictures which he is too desirous to recover on payment of value." Attached to this note is another by del Campo to José de Anduaga, a diplomat and official of the First State Secretariat, written one month later, in which he presents Henderson's case, which "supone por relación de Liston que están todavía por vender y ofrece pagarlas como las pagaría otro extraño" (suggests, according to Liston, that they are still for sale, and he offers to pay for them as any other foreigner would). This indicates Henderson still did not know that the items had passed into the collection of the Real Academia. Nor did del Campo, who suggested, "Si hay originales ó alguna cosa de provecho no se debe permitir la salida ni andarnos en ridículas condescendencias. Si son copias indiferentes mas vale que las pague bien y las saque" (If there are originals or anything valuable, they should not be allowed to leave nor should we be absurdly accommodating. If they are mediocre copies, better that he pay well for them and take them away.) Once again Henderson's efforts proved fruitless.

The last attempt on Liston's part to recover items from the *Westmorland* for Henderson and

other individuals dates from November 17, 1788, in the form of a letter to the Spanish prime minister, José Moñino y Redondo, conde de Floridablanca, who eventually replied in the following manner:

dispondré en yendo a Madrid se entregasen a Vuestra Señoría algunos de los efectos pertenecientes a los caballeros ingleses de que Vuestra Señoría trata; respecto de no poder ser todos, especialmente las chimeneas, los retratos y parte de los dibujos, que no quiere el Rey quitarlos a quien los dio habiendo pagado S.M. por ellos cerca de 300 mil reales. (I will arrange that when you come to Madrid, Your Excellency is handed over some of the possessions belonging to the English gentleman to which Your Excellency refers; in this regard, it will not be all of them, particularly the fireplaces, the portraits, and some of the drawings, as the king does not wish to take them away from those to whom he gave them, having paid for them the sum of almost 300 thousand reales.)

MDSJ

REFERENCE: Luzón Nogué 2002a, 105 n. 30.

Mercedes Cerón drew the author's attention to the existence of the documents in the Archivo General de Simancas.

Vista del Puerto de Málaga (cat. 5, detail)

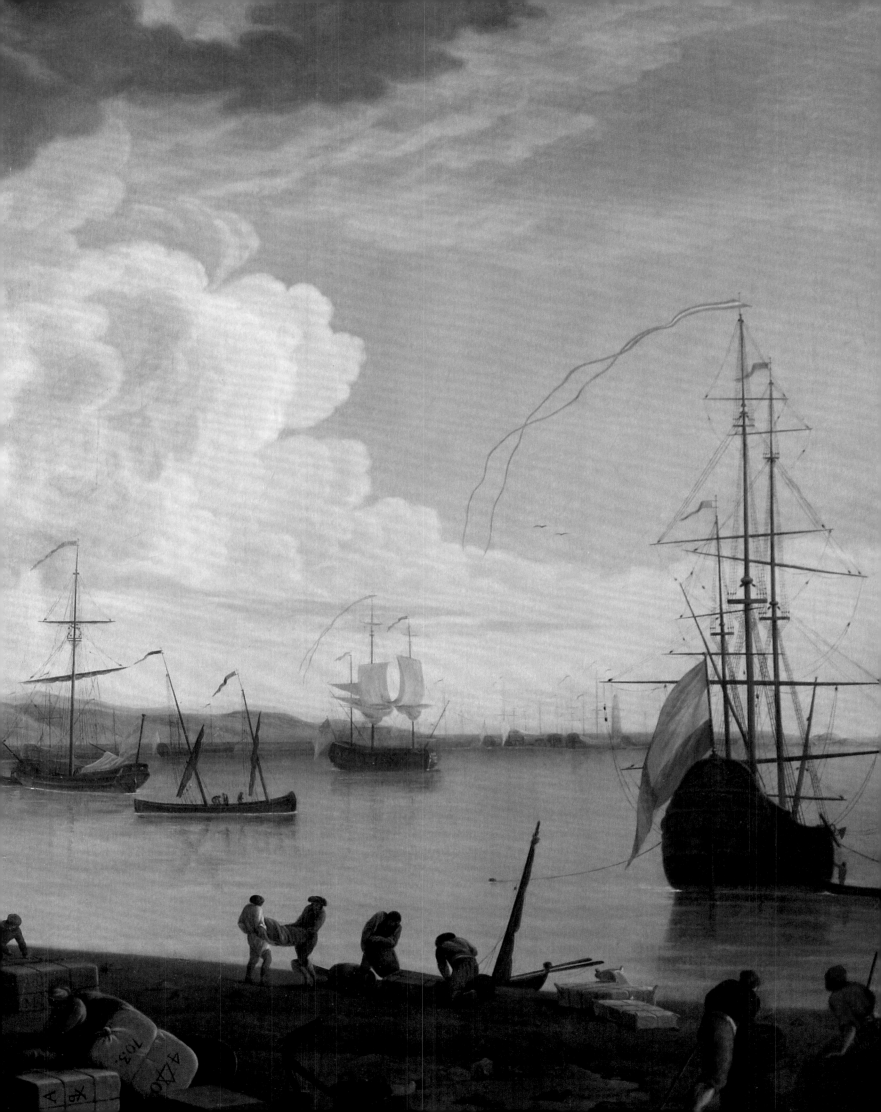

Contents of the *Westmorland*

17

ANTON RAPHAEL MENGS (1728–1779)

The Liberation of Andromeda by Perseus
1773–78

Oil on canvas
89⅜ x 60⅜ in. (227 x 153.5 cm)
State Hermitage Museum, St. Petersburg, 1328

During his short stay in Rome in November and
December 1768, the young, wealthy Sir Watkin
Williams Wynn had his portrait painted by Pompeo
Batoni as a conversation piece showing him with
his traveling companions Thomas Apperley and
Edward Hamilton (National Museum of Wales,
Cardiff). He also commissioned Batoni to paint a
mythological picture with life-size figures, *Bacchus
Comforts Ariadne on the Island of Naxos* (fig. 59,
p. 101), at the same time that he commissioned *The
Liberation of Andromeda by Perseus* from Anton
Raphael Mengs. Williams Wynn's intention was to
possess comparable works by the two most important
historical painters of the day in Rome. As Mengs's
picture never reached its intended destination,
the two paintings, each characteristic of the very
different stylistic features of its creator, would
never hang side by side.

 It is not known who was responsible for the
choice of subjects. Both are taken from Ovid's
Metamorphoses, and both deal with the archetypal
theme of the rescue of women abandoned on an
island in the sea. Andromeda was chained to a rock
as a sacrifice to a sea monster sent by Poseidon as
punishment for the boasting of her mother, Cassio-
peia. From the later sixteenth century, there was a
prevailing tendency in depictions of Perseus's rescue
of Andromeda to treat the defenseless and naked
virgin as the real focus of attention; however, Mengs
allowed himself to be guided by the verses from
Ovid that relate to the freeing of Andromeda and the
ensuing marriage: "Released from her chains, the
virgin walks along, both the reward and the cause of

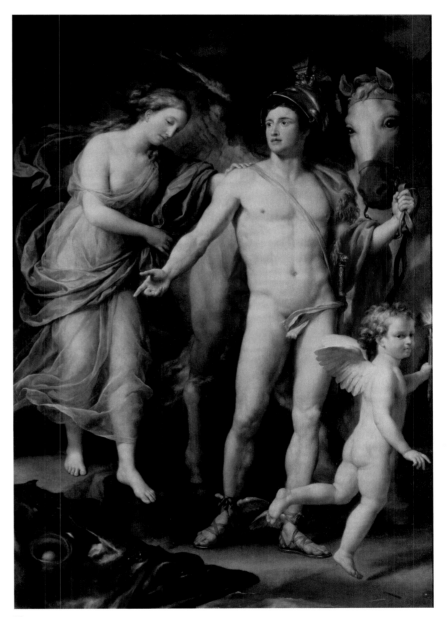

17

Centaur Goaded by a Maenad with Thyrsus (cat. 33, detail)

his labours" (4.738–39). He derived the motif of Hymen with a raised torch leading the couple from these verses: "Forthwith he takes Andromeda, and the reward of an achievement so great, without any dowry. Hymen and Amor wave their torches before them" (4.757–59). Clothed in a transparent chiton, Andromeda descends from the rock with head bowed and places her hand on the shoulder of the naked Perseus. For the pose of Perseus, confident of victory, Mengs took his models from the Apollo Belvedere (Vatican Museums, Rome) and the classical mosaic of Hercules in the collection of Cardinal Alessandro Albani in Rome, which portrays the freeing of Hesione by Hercules (Villa Albani, Rome).

Although reaction to the picture was mixed when it was presented in public in February 1778, it ushered in a phase of intensive debate about the classicizing treatment of the subject. The subsequent history of the painting until its acquisition by Catherine II, empress of Russia, is discussed in the essay "Mengs's *The Liberation of Andromeda by Perseus*: A European Odyssey from Rome to St. Petersburg" by the present author in this volume. SR

REFERENCES: Musée de l'Ermitage 1958, 2:323, no. 1301; Clark and Bowron 1985, 325–26, no. 353; Wilton and Bignamini 1996, 255, nos. 210, 211; Ingamells 1997, 1029–30; Roettgen 1999, 169–74, nos. 110–112 (with detailed bibliography); Roettgen 2001, 244–47, nos. 78–79; Roettgen 2003, 373–76; Grandesso 2008, 354, no. 81; Roettgen 2008, 134.

Crate J. B.

OWNED BY JOHN BARBER?

This may have been the "Jan Barher" or "J. Barber" or "Lord Gohn Barberz" who was recorded in Florence and Rome between 1771 and 1774. Giovanni Battista Piranesi engraved a vase from the collection of "Signr. Cavaliere Giovanni Barber" for his *Vasi, candelabri, cippi, sarcofagi, tripodi, lucerne ed ornamenti antichi* of 1778. The contents of the crate make clear Barber's interest in the antiquities of Rome, including, in addition to the volumes by Giovanni Pietro Bellori and Francesco Bartoli described below, three albums of prints by Piranesi and eight prints of the Arch of Trajan in Benevento by Carlo Nolli. Also listed among the contents are an engraving by Giovanni Volpato of the *School of Athens* after Raphael; an Italian dictionary; an octavo volume of an English and Italian grammar; a cork model of a temple or ruin; four glass jars of preserves, "now in poor state"; and "samples of stones, fossils, pieces of lava from Vesuvius, oil lamps," and "a lacrimatory," or tear bottle, an example of the glass vessels found in ancient Roman tombs that were believed to have collected the tears of mourners. CS

18

PIETRO SANTI BARTOLI (1615–1700)

Le antiche lucerne sepolcrali figurate
Rome: Antonio de Rossi, 1729

Real Academia de Bellas Artes de San Fernando, Archivo-Biblioteca, B-1179

First published in 1691, this was the second collaborative project between Giovanni Pietro Bellori and Pietro Santi Bartoli, who had previously worked together on *Le pitture delle grotte di Roma*, published in 1680. In his preliminary address to the reader in the present volume, Bartoli noted that he was responsible for the drawings and prints while the texts were written by Bellori. The book is dedicated to Ranuccio II Farnese, duke of Parma and Piacenza.

There are two earlier publications on ancient lamps, *De lucernis antiquorum reconditis* by Fortunio Liceti and *De veterum lucernis sepulchralibus* by Ottavio Ferrari, in both of which the authors also focused on the subject of perpetual lamps. In contrast to those texts *Le antiche lucerne: Raccolte dalle Cave sotteranee, e Grotte di Roma* goes beyond a mere catalogue of types of lamps aimed at the collector. Instead Bellori analyzed the iconography of each example in order to explain the reasons that specific motifs or themes were chosen for use in the context of funerary goods. Aside from this aspect, the text's focus on oil lamps also reflects a growing interest in everyday objects that transcended their financial value. Most of the examples selected were originally from funerary sites in Rome, and in each case the text provides the name of the owner or collection in which it was to be found at the time of the book's publication. A significant number of the examples described belonged to Bellori and Bartoli themselves, and mention is frequently made of the fact that they had had to reassemble the lamps from numerous fragments. Following Bellori's death his collection of antiquities was rapidly dispersed; part of it, including various lamps, was acquired by Frederick III, prince-elector of Brandenburg.

Le antiche lucerne sepolcrali figurate is divided into three parts. The first groups together examples that depict mythological subjects or circus or gladiatorial games, which the author interpreted as funerary games. As an iconographic comparison the text illustrates a mosaic found in the Villa Corsini, San Pancrazio, that includes a motif also found on one of the lamps. The second part of the text focuses on deities and their role as protector of the deceased person. The plate shown here illustrates a lamp representing Jupiter with a hound at his feet. In the British Museum there is a drawing from Cassiano dal Pozzo's Paper Museum, which was published by Fortunio Liceti in *De Lucernis Antiquorum Reconditis* (1652). According to Liceti the lamp belonged to Cardinal Francesco Barberini. The engraving in Liceti's volume provided the source for Bartoli's plate. A similar lamp in the British Museum (claimed by some scholars to be the same lamp) was formerly in Charles Townley's collection. MCAR

REFERENCES: Jenkins 1999, 134, 162, no. 59; Heres 2000, 2:499–501; Marzi 2000, 2:540, no. 21.

The author thanks Kim Sloan for the information about the drawing and lamp in the British Museum.

18

19

PIETRO SANTI BARTOLI (1615–1700)

Colonna Traiana eretta dal Senato, e Popolo Romano all'Imperatore Traiano Augusto nel suo Foro in Roma
Rome: Gio. Giacomo de Rossi, [1673]

Inscribed on front free endpaper: "PY"
Real Academia de Bellas Artes de San Fernando, Archivo-Biblioteca, A-37

Colonna Traiana, by the printmaker, painter, and draftsman Pietro Santi Bartoli, is just one volume in his prolific output of antiquarian engravings of ancient Roman and early Christian monuments. According to Maximilien Misson in his popular

A new voyage to Italy . . . , Bartoli was "universally
known to be an excellent Engraver and Designer."
His images and portfolios were in high demand by
Grand Tourists of various nationalities, particularly
the British and French. Four copies of books by
Bartoli were among the contents of the crate marked
"J. B." In addition to this copy of *Colonna Traiana*,
they were *Le pitture antiche delle grotte di Roma, e
del sepolcro de' Nasoni* (cat. 20), *Veteres arcus
augustorum triumphis insignes* (RABASF, Archivo-
Biblioteca, B-1154), and *Le antiche lucerne sepolcrali
figurate: Raccolte dalle Cave sotteranee, e Grotte
di Roma* (cat. 18). Although this was the only copy of
Colonna Traiana on board the *Westmorland*, the
book was a popular purchase among Grand Tourists
of the early 1770s.

Bartoli's handsome books were not, however,
simply souvenirs to adorn a personal library.
Rather, the diaries of travelers such as James Russel
indicate that they used the images and descriptions
to inform their visits to the ancient ruins: studied
ahead of time, the clear engravings helped elucidate
worn bas-reliefs and provided plans for understand-
ing ruined structures. As Edward Wright com-
mented in 1730, in most cases Bartoli's images were
all that preserved the memory of the complete
original. A collaboration with the Latin scholar
Alfonso Ciaccone and the historian Giovanni Pietro
Bellori, *Colonna Traiana* reproduces sections of
Trajan's column, built in 113 to commemorate
the Roman emperor's victory in the Dacian Wars,
but also features a foldout engraving of the column
in its entirety with measurements, descriptions,
and cutaway views of the interior. An inscription,
"5. 50," written in ink inside the front cover, most
likely indicates the price paid for it. KC

REFERENCES: Wright 1730, 360; Misson 1739, 546;
Russel 1750.

GIOVANNI PIETRO BELLORI (1613–1696)

**Le pitture antiche delle grotte di Roma,
e del sepolcro de' Nasoni**

Rome: Nuova Stamperia di Gaetano degli Zenobi,
1706

Inscribed on front free endpaper: "PY"; on title
page: "E. Severi"
Real Academia de Bellas Artes de San Fernando,
Archivo-Biblioteca, B-593

The discovery of a tomb from the Antonine era on
the Via Flaminia, Rome, in 1674 considerably
increased the number of classical paintings known
at the time. The popularity of the tomb, identified as
the burial place of the Nasoni, was enhanced by the
belief that this was the family of Ovid. In 1680
Giovanni Pietro Bellori and the artist Pietro Santi
Bartoli published the discovery in a monograph
entitled *Sepolcro de' Nasoni dissegnate, e intagliate
alla similitudine degli antichi originali.*

Bel\li was *commissario delle antichità di Roma
e suo distretto* from 1670 onward, a position in
which he was succeeded in 1694 by his close collabo-
rator, Bartoli. The knowledge gained from this
position allowed Bellori to produce a series of
volumes that aimed to document the vast heritage
of Roman archaeology. Meanwhile, Bartoli had
become an artist of note with regard to classical
painting, both for his drawn reproductions and his
copies in color, many of them commissioned by
Cardinal Camillo Massimo. This desire to record
Roman painting faithfully was inspired by Cassiano
dal Pozzo's Paper Museum. Many of Bartoli's
watercolors (Royal Collection, Windsor, and
University Library, Glasgow), are direct copies of
the Roman originals, made when they still retained
their original polychromy. The death of Cardinal
Massimo in 1677 left Bellori and Bartoli without an
important patron, and as a result many of their
projects and drawings remained unpublished.

This edition of *Le pitture antiche delle grotte di
Roma, e del sepolcro de' Nasoni* from 1706, acquired
by "J. B." (John Barber?) along with other books
by Bellori, is the result of a collaboration between
Francesco Bartoli, who took over his father's
activities, and the Rome-based, Parisian antiquarian
Michelangelo Causei de La Chausse. This new
version of the text is enhanced by the presence of
more illustrations depicting other monuments and
includes additional prints based on unpublished

20

drawings by Pietro Santi Bartoli. The volume
includes three different texts: *Le pitture antiche delle
grotte di Roma* by Causei de La Chausse, the above-
mentioned *Sepolcro de' Nasoni* by Bellori and Bartoli,
and an *Appendice di alcune memorie sepolcrali*, which
includes tombs and objects from outside the area of
Rome, such as an Etruscan tomb in Perugia. MCAR

REFERENCES: de Vos 1993; Faedo 2000, 1:116–17;
Lachenal 2000, 2:630ff.; Messineo 2000, 14–15;
Montanari 2000, 1:43–45.

Crates F. Bt., F. B., and F. S. B.

OWNED BY FRANCIS BASSET

21

Born in Walcot, Oxfordshire, Francis Basset (1757–1835) became heir at the age of twelve to the estate of Tehidy Park in Cornwall, which had been in the Basset family since the mid-twelfth century, and to profitable tin and copper mines in nearby Carn Brea. He attended Harrow School, Eton College, and King's College, Cambridge, before setting out in the spring of 1777 on a yearlong Grand Tour, accompanied by his tutor, the Reverend William Sandys. The son of a steward of the Basset estates, Sandys himself had been educated at Queens and All Souls colleges, Oxford, and had toured Italy in 1771–74, essentially training for his role as tutor, when he made the acquaintance of the painter Jacob More. Together Basset and Sandys toured France and, following a stay in Paris, passed through Geneva before crossing the Alps into Italy in late July. In December Basset and Sandys were in Rome; then they traveled on to Naples early in 1778. They visited Pompeii, Herculaneum, and probably Paestum, before returning north to Florence by mid-May. By the end of the month they had arrived in Venice. After spending some time with the Prussian army commanded by Prince Henry of Prussia, they returned to England.

Figure 120. Pompeo Batoni, *copy of portrait of Francis Basset*, 1778, oil on canvas, 33⅛ x 15¾ in. (84 x 40 cm). Real Academia de Belles Artes de San Fernando, Museo

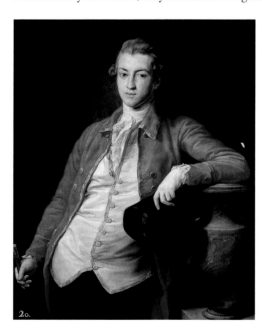

2o.

The inventories of Basset's crates reveal that he lost the largest number of art objects with the greatest combined value when the *Westmorland* was captured. They included the full-length and half-length portraits of Basset commissioned from Pompeo Batoni; watercolors by John Robert Cozens and possibly More; a view of San Cosimato by Solomon Delane; portrait busts by the sculptor Christopher Hewetson; plans for a chapel, possibly by the architect Christopher Ebdon; two marble tabletops; numerous books on languages, history, geography, and antiquities; and a great many engravings, including the colored series of the *Loggie di Rafaele nel Vaticano* and the *Galleria Farnese* by Giovanni Volpato as well as fourteen volumes of engravings by Giovanni Battista Piranesi, who dedicated plates to both Basset and Sandys in his *Vasi, candelabri, cippi, sarcofagi, tripodi, lucerne et ornamenti antichi* of 1778. Sandys remained in contact with the dealer Thomas Jenkins following his return to England. Basset returned to Italy in 1788 with his family and pursued what became a lifelong interest in collecting and commissioning art. He became first Baron de Dunstanville in 1796 and first Baron Basset in 1797. CS

REFERENCES: Burke 1832, 331; Sánchez-Jáuregui 2002.

21

POMPEO BATONI (1708–1787)

Francis Basset

1778

Oil on canvas
87 x 61⅞ in. (221 x 157 cm)
Signed and dated: "Pompeius de Batoni. Pinx.
Romae 1778"
Museo Nacional del Prado, Madrid, P00049

Two portraits of Basset by Pompeo Batoni arrived unframed in Madrid. On arrival at the Real Academia de Bellas Artes de San Fernando, they were split up: the full-length portrait was sent to the palace of José Moñino y Redondo, conde de Floridablanca. From there it passed to the Palacio Real and subsequently, in the nineteenth century, to the Museo del Prado. The smaller version (fig. 120) remained at the Real Academia, where it is still to be found today.

The full-length image conforms to the Grand Tour portrait model. The composition, with St. Peter's Basilica and the Castel Sant'Angelo in the background, as well as the antique architectural fragment on the ground, are found in earlier portraits by Batoni, although this is the only known example to include the low-relief *Orestes and Electra* (Palazzo Altemps, Rome), depicted in reverse. The sitter holds a reduced copy of Giambattista Nolli's *Topografia di Roma* (cat. 113). The painting is considered to be the last portrait of this size to have been wholly painted by the artist.

Basset must have posed for Batoni in Rome between December 1777 and May 1778. Batoni would have been well paid, given that the commission involved a full-length image and a replica. As Father John Thorpe noted, "Pompeo works only for those who pay him most and at the same time he is meanly raising his price," a comment that once again indicates the considerable financial means at Basset's disposal during his Grand Tour and his commitment to collecting.

Batoni frequently supplied copies of his works, and about thirty examples of two versions of the same portrait are known within his oeuvre. The issue of how much of the copy was actually painted by Batoni and how much by his studio, however, depended on the particular client. In general the second version was executed by the studio, and particularly after 1760 these replicas were largely painted by assistants, including his biographer Johann Gottlieb Puhlmann and his own sons. This

would seem to be the case with the painting in the Real Academia, which is a smaller, simplified version of the full-length image. The young sitter poses in exactly the same position, but the more highly worked elements, such as the marble pedestal and the map by Nolli, drawn in graphite over the oil paint, have been replaced by other, simpler motifs. Other elements have simply been eliminated, including the view in the distance, which is replaced by a flat, dark background. The high quality of the brushstroke in the hands and in particular the face, however, may suggest the involvement of Batoni himself. MDSJ

REFERENCES: Clark and Bowron 1985; Sánchez-Jáuregui 2001b, 420–25; Westmorland 2002, no. 51 (entry by María Dolores Sánchez-Jáuregui); Bowron and Kerber 2007.

22

SOLOMON DELANE (CA. 1727–1812)

View of the Monastery of San Cosimato

1778

Oil on canvas
59 x 94⅛ in. (150 x 239 cm)
Signed and dated: "S. Delane. Rome 1778"
Real Academia de Bellas Artes de San Fernando,
Museo, 294

This canvas is briefly described in the first inventory of the collections of the Real Academia de Bellas Artes de San Fernando (1804) as a damaged landscape attributed to "Scot. Cron" (Robert Crone, a Dublin-born artist and student of Richard Wilson).

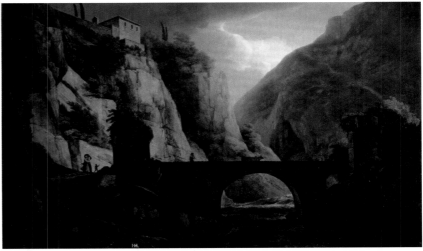

22

Over the years successive inventories and catalogue entries attributed it to Jacob Philipp Hackert and the Spanish painter Eugenio Orozco. Fortunately, despite conservation problems, the signature "S. Delane. Rome 1778" has survived, though concealed in a dark area of the composition.

The Dublin-trained Solomon Delane traveled to Italy for the first time in 1755. In 1764 he settled in Rome, where he remained until 1782, developing a type of landscape painting influenced by Wilson. In Italy Delane was favored by British Grand Tourists and promoted by the dealer James Byres, who possessed various works by him. One of his clients was Charles Bampfylde, who commissioned the present painting in 1774 but in the end did not purchase the canvas. As a result Basset was able to purchase it in late 1777 while in Rome with his tutor, the Reverend William Sandys, who was aware of the unsold canvas.

The painting depicts the monastery of San Cosimato in the valley of Licenza, where the famous villa of the classical Roman poet Horace was believed to have been located. Although Delane must have started work on the painting in 1774, it is dated 1778.

In his depiction of this view Delane deployed numerous artistic devices to convey a heightened sense of drama, using a low viewpoint and exaggerating the scale of the landscape elements in contrast to the small figures. The artist used thin glazes to create an effect of cool, diffused light that bathes the composition, executed in a style that James Irvine described as "in the manner of Poussin's but that his colouring was a little too cold." MDSJ

REFERENCES: Figgis 1987, 60–65; Figgis and Rooney 2001, 125–26; Crookshank and Glin 2002, 138–42; Suárez Huerta 2009b, 177–86.

23–28

JOHN ROBERT COZENS (1752–1797)

Six Watercolors of the Alban Hills
1777–78

In Antonio Ponz's inventory of the *Westmorland* contents (cat. 14), crate "F. Bt. no. 4" was listed as containing "a tin tube with six landscapes in washes and four drawings, of the ground plan, and elevations of a chapel." The four drawings of the chapel have been identified as the ones attributed here to Christopher Ebdon (cats. 29–32), and the six watercolor landscapes are these works by John Robert Cozens. Although there is no record of the commission or purchase of these watercolors, it seems clear from their common mode of presentation that they formed a suite. See the essay by Kim Sloan in this volume for a discussion of the significance of their acquisition for Basset and the importance of their rediscovery in documenting the early development of Cozens, one of the most significant British artists of the eighteenth century working in watercolors.

All the drawings are on C&I Honig (Dutch) watermarked paper and, just after they were drawn, were mounted on slightly larger Honig paper and given a complementary gray wash border. The measurements given are the size of the mount. They are numbered in pen and ink on the upper left corner of the mount, and all bear the stamp of the Real Academia de Bellas Artes de San Fernando. They are all inscribed in pen and ink on the verso with the title of the work both in English and in Spanish; neither hand appears to be Cozens's, and indeed one of the inscriptions gives the wrong title for the drawing (cat. 28) and another is incorrectly inscribed as a view of Lake Albano from the town of Genzano, which is actually on Lake Nemi (cat. 24).

REFERENCES: Ashby 1924, 193–94; C. F. Bell and Girtin 1934–35, relating to nos. (in order they occur here) 163, 149, [none for the view from the shore], 149A, 156, 144, 163; T. Jones 1946–48; C. F. Bell and Girtin 1947; Oppé 1952; Hawcroft 1971; Wilton 1980; Sloan 1986; Keaveney 1988, 277; Sánchez-Jáuregui 2002; Westmorland 2002, nos. 21, 22, 55–58 (entries by María Dolores Sánchez-Jáuregui).

23

JOHN ROBERT COZENS (1752–1797)

Lake Albano from the Galleria di Sopra

Watercolor over graphite on paper
17 x 23⅝ in. (43.2 x 60.1 cm)
Inscribed on mount, upper left: "No. 2"; on verso:
"Lake of Albano"; "Lago de Albano"
Real Academia de Bellas Artes de San Fernando,
Museo, D-2587

In his guide, *The Roman Campagna in Classical Times* of 1927, Thomas Ashby described travelers' routes through the Alban Hills: "From Castel Gandolfo two lovely roads fringed with old ilexes, the Galleria di Sopra and the Galleria di Sotto . . . lead to Albano. If we keep to the upper one, along the crater rim, we soon come to the Capuchin monastery of Albano. The old wood behind it occupies a lofty hill, and one would imagine that some temple had once stood there." Writing more than a century earlier in his own *Classical Tour through Italy and Sicily* (1819), Sir Richard Colt Hoare explained that this hill, "surpassing the others in prospect and situation, appears to have been the seat of pleasure, amusement, and devotion." Its slopes bear the remains of an amphitheater, theater, and temple and are still the home of convents and churches. The view from the top of the old amphitheater looking west reveals the entire sweep of the Campagna region, encompassing the hills of the spine of Italy to the northeast, the city of Rome and the far coastline to the northwest. This was the view from the Galleria di Sotto, captured several times by John Robert Cozens in his series of almost a dozen variations on the theme of a road with travelers at the base of the ancient ilexes waving above them, over a view of the Campagna and the Lazio plain stretching to the sea. They were also visible from the beginning of the Galleria di Sopra, just as it left the town, as they are in an unfinished watercolor by Cozens of about 1778 in the Yale Center for British Art (fig. 121).

If travelers followed the Galleria di Sopra, which leads around the upper rim on the inside of the crater of Lake Albano, looking to the east, they would catch wonderful glimpses through the trees of the lake and its steep wooded banks; eventually, from the highest point of the Colle dei Cappuccini, the wooded hill beyond the monastery on the southwest corner of the lake, they would encounter the view Cozens has captured here, encompassing the lake, Castel Gandolfo, and the Campagna beyond.

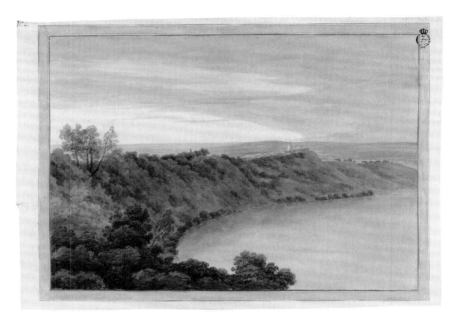

23

Figure 121. John Robert Cozens, *Galleria di Sopra, Albano*, ca. 1778, watercolor and graphite, 14⅜ x 20⅞ in. (36.5 x 53 cm). Yale Center for British Art, Paul Mellon Collection

This is Cozens's first use of this composition in a finished watercolor, and he is extremely successful in capturing the stillness of the lake and, by concentrating on the tones of the sky, both the clear light falling on the vista beyond and the hint of darkness of the woods. There is one other version of this view, in which he depicts a very dark and stormy sky that casts a haunting mood over the entire landscape; once belonging to Thomas Lawrence and then to the

descendants of Thomas Girtin, it recently sold for the highest price ever paid for a Cozens watercolor (B&G 149; sale, Sotheby's, London, July 14, 2010, lot 60). His most successful composition, however, was taken from the Galleria di Sopra slightly closer to Castel Gandolfo, with a large ilex hanging over the lake, dominating the sky, and a goatherd at its base (see fig. 78, p. 122). ks

24

JOHN ROBERT COZENS (1752–1797)

Lake Albano from the Shore

Watercolor over graphite on paper
17⅛ x 23⅞ in. (43.5 x 60.5 cm)
Inscribed on mount, upper left: "No. 3"; on verso: "Lake of Albano"; "Lago de Albano por Genzano" Real Academia de Bellas Artes de San Fernando, Museo, D-2590

The way to the Alban Hills from Rome was out through the Porta San Sebastiano and along the Via Appia Antica, lined with the ruins of Roman monuments, finally arriving at Marino, at the northern end of Lake Albano. As Thomas Jones noted in his memoirs, the traveler then "passed through Castello Gandolfo, L'arici and arrived at Gensano [on Lake Nemi] in the Evening—This walk considered with respect to its classick locality, the Awful marks of the most tremendous Convulsions of nature in the remotest Ages, the antient and modern Specimens of

Art, and the various extensive & delightful prospects it commands is, to the Scholar, naturalist, Antiquarian and Artist, without doubt, the most pleasing and interesting in the whole world."

The view that John Robert Cozens has depicted here was most travelers' first sight of Lake Albano and Castel Gandolfo as, after passing through Marino, they approached the lake at the lowest point of its crater on a road that skirted the shore seen here and then climbed, curving up to the right and eventually back around to the city's gate, to the right of the papal palace clearly visible here. Beyond it is Gian Lorenzo Bernini's distinctive dome on the church of San Tommaso; the Capuchin monastery is just visible crowning the hill beyond. The previous view (cat. 23) was probably taken from the top of one of the hills to the left.

Cozens was adept at selecting staffage that not only was useful for indicating—even exaggerating—scale in his landscapes, but also was perfectly appropriate for the mood and information about the landscape he wished to convey. Although this view of Lake Albano was not repeated during his career, this is the first occurrence of a type of composition that he frequently used later with great success in coastal views, especially of the coast around Salerno. ks

25

JOHN ROBERT COZENS (1752–1797)

Lake Albano from Palazzolo

Watercolor over graphite on paper
17⅛ x 23⅞ in. (43.5 x 60.5 cm)
There is a vertical fold down the center. Inscribed on mount, upper left: "No. 4"; on verso at top in both pen and in pencil, the latter possibly in Cozens's hand: "Lake of Albano"; at bottom in ink: "Lago de Albano desde lo alto de Marino" [Lake of Albano from the height of Marino] Real Academia de Bellas Artes de San Fernando, Museo, D-2591

The wooded hill next to the Capuchin monastery from which John Robert Cozens took his other view of Castel Gandolfo is clearly visible on the left of this watercolor. He has walked farther around the Galleria di Sopra, which had recently been improved by Pope Clement XIV, skirting the rim of the southern part of the lake and ending at the Convento di Palazzolo tucked into the southeastern slopes of the crater just below Monte Cavo. From

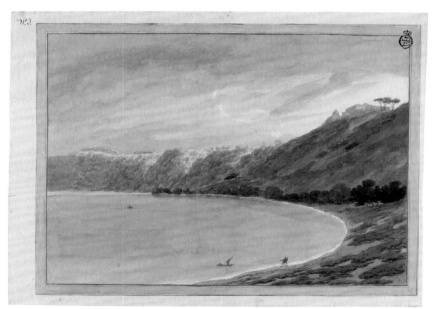

24

this convent, at one time thought to be on the site of
an ancient city that was the home of the first founders
of Rome, Cozens has taken a view of Lake Albano
with Castel Gandolfo on the opposite shore and the
Tiber River beyond it, winding through the Cam-
pagna and the Lazio plain to the sea in the far
distance. Palazzolo has been home to Benedictines,
Cistercians, Franciscans, and more recently, in the
summers, to the English College of Rome. To reach
it, the traveler still passes tufa cliffs dotted with
grottoes that housed hermits in the tenth century,
before emerging from the trees that line this
ancient public path and arriving at the convent
terrace, with its spectacular view and fountains to
refresh the pilgrim.

This is an accomplished watercolor, in spite of
the too-wet wash in the top of the sky, which is
compensated for by its deeper blue reflection in the
lake. The bright clear day turns the normally darkly
wooded slopes a brilliantly lit green, and a pair of
umbrella pines provides an elegant foreground
feature to frame the lake and lead the eye to the
sheep grazing on the meadow below. This composi-
tion was also to become a stock favorite of Cozens; a
later example in the Leeds City Art Gallery (B&G
149A) has an additional pine running vertically
through the view on the right, and he also exagger-
ated the height of the Colle dei Cappuccini and
moved Monte Circeo to the north of its real location
in order to echo the shape of the hills. KS

26

JOHN ROBERT COZENS (1752–1797)

Ariccia

Watercolor over graphite on paper
17⅛ x 23⅞ in. (43.5 x 60.5 cm)
Inscribed on mount, upper left: "No. 5"; on verso:
"View of Laricia" and "Laricha"
Real Academia de Bellas Artes de San Fernando,
Museo, D-2588

Ariccia could be reached from Lake Albano by
following the Galleria di Sopra to the town of Albano
and then dipping down into a deep valley where one
would join the road that led to it from the Via Appia
Antica, the more straightforward approach from
Rome. John Robert Cozens shows the view as one
approached Ariccia from this road, with Palazzo
Chigi visible on the left and Gian Lorenzo Bernini's
dome of the church of Santa Maria Assunta facing it

25

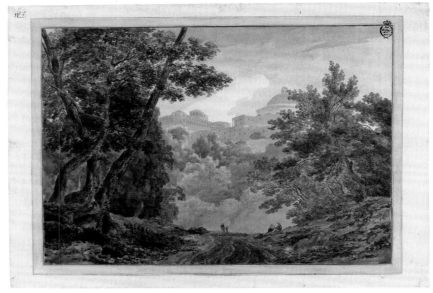

26

on the opposite side as the road came into the town
at the top of the hill.

This is certainly the most accomplished composi-
tion of this group of watercolors by Cozens, but it is
not entirely due to his art; this view was a favorite
of most British landscapists who traveled to Rome,
and it can be found in the work of Richard Wilson,
William Pars, Thomas Jones, John "Warwick"
Smith, and Francis Towne. Nature provided the
framing trees, and thus they are not Cozens's own
addition here, but it is interesting that he chose a
viewpoint that covered up one of the most striking

features of the church, the two "onion dome" bell towers that decorate the back of it, obscured entirely by trees on the right in this and in all his later versions of this view. In this, Cozens was demonstrating his consummate skill at creating a particular mood in a landscape, as the fussy domes would create a focal point that would distract from the gently flowing lines that sweep the eye around this composition.

One of the later versions of this view by Cozens was turned into a vertical composition; it was one of a group of six Grand Tour views that have also stayed together since their acquisition by their original owner—George Ashburnham, Viscount St. Asaph, who was in Italy at the same time as his friend Sir George Beaumont, seventh Baronet, a former pupil of Cozens's father, Alexander, and a fellow amateur, and with whom he may have drawn in the company of the younger Cozens in 1782 or 1783. Lord St. Asaph's set is now part of the Leslie Wright Bequest in the Birmingham Museum and Art Gallery; the other five were a pendant vertical view of a ravine, a pair showing Lake Albano and Lake Nemi (a variation of cat. 27), and another pair, of Lake Maggiore and a view of mountains over a lake. KS

27

JOHN ROBERT COZENS (1752–1797)

Lake Nemi

Watercolor over graphite on paper
17⅛ x 23⅞ in. (43.5 x 60.5 cm)
Inscribed on mount, upper left: "No. 6"; on verso: "Lake of Nemi"; "Lago de Nemi".
Real Academia de Bellas Artes de San Fernando, Museo, D-2592

Travelers who reached Lake Nemi via Albano, Ariccia, and the Via Appia Antica would arrive first in Genzano, with the town of Nemi and its distinctive circular tower of Palazzo Ruspoli visible on the opposite rim of the volcanic crater. Following the road around the eastern rim, they would come to John Robert Cozens's viewpoint here. The arches next to the tower traverse a ravine in the town, from which is a spectacular view of the entire nearly circular lake, known from ancient times as the Speculum Diana (mirror of Diana), with Genzano perched on the other side. The esplanade known as Il Giardino leads down the cliff to the sacred wood that housed an ancient temple dedicated to Diana, where,

according to legend, one of her vestal virgins gave birth to Romulus and Remus, the founders of ancient Rome. In this watercolor Monte Cavo, which also looms over Lake Albano, rises behind the town, a little more largely than in reality, and is capped with snow, indicating that the view was probably taken in the late spring, when the snow lingers on its eastern slopes. The crater is deep and the slopes are steep but not quite as vertical as Cozens has made them here, allowing light to fall on the cliff faces below the town and a soft yellow beam of light to spill down the slope, highlighting the spring growth and providing relief from the dark, heavily wooded foreground.

Although the composition is nature's own, and is based on a simple washed drawing now in Sir John Soane's Museum, London, once again Cozens has altered nature in his watercolor to increase the impact of the view; however, his handling is still a little rough in the foreground and has not yet reached the accomplished work of his several later watercolors of the same popular site (fig. 79, p. 122). In these later versions, although he does not add a *repoussoir* of trees as in the Albano views, he does increase the detail on the cliffs to the left, adding groves of trees there and in the foreground, using colors to unify the different component parts; he also turns the cliff that Nemi stands on into a concave spur of rock and brings clouds to hover, like the mists of time, over Monte Cavo, where Romulus and Remus were legendarily suckled by a she-wolf, and the site of the ancient temple of Jupiter Laterius. KS

28

JOHN ROBERT COZENS (1752–1797)

Lake Vico, formerly called Lake Albano from the Galleria di Sopra

Watercolor over graphite on paper
17⅛ x 23⅞ in. (43.5 x 60.5 cm)
Inscribed on mount upper left: "No.1"; on verso: "Lake of Albano"; "Lago di Albano"
Real Academia de Bellas Artes de San Fernando, Museo, D-2589

Understandably, given its inscription on the verso and the similarity in composition to the other views of Lake Albano, this watercolor has formerly been given that title. The group of buildings just visible on the horizon to the right of center was presumed to be Castel Gandolfo. Closer inspection, however,

reveals the outline of the buildings to be quite wrong for that town, and although John Robert Cozens often took liberties with the landscape, when he was depicting a building on a hill he was usually fairly accurate. The distinctive dome of the church, visible in all other views of the town, is missing here. In fact, this composition is identical to that of a watercolor now in the Yale Center for British Art that is inscribed on the verso in pen and ink, not in Cozens's hand, "Lake of Vico. between Rome and Florence," and faintly in pencil below, in another hand, "Lago di Vico" (see fig. 80, p. 123). Yale's view once belonged to William Beckford and is probably one of a group he commissioned from Cozens after his return from Italy in 1779.

In looking at the present watercolor again with Lake Vico in mind, it is easy to see this as an earlier, slightly less accomplished watercolor, typical of the Basset group in its brush-drawn foreground and use of yellows and greens. Its strong, dramatic sky, which dictates the atmosphere of the entire landscape, is quite different from the accomplished sfumato effect and soft tones of the later version at Yale, which conform to the elegiac, deeply romantic mood of a set for a very different patron.

Lake Vico is also a volcanic crater lake but to the north of Rome, just below Lake Bolsena and Viterbo. It is on the route that Cozens is presumed to have taken on his return to Florence and then England at the end of his stay in Rome in the late spring of 1779. But as this work was on the *Westmorland* in 1778, the theory about Cozens's routes to Rome via the more eastern road and his return via the more westerly one must be revised, or he made a sketching trip to the north of Rome at some stage during his stay, which would not be impossible. There are three sketches of Lake Vico from quite different viewpoints in the Beaumont Album, now also at Yale.

This view is taken from the slight rise to the southwest of the lake, looking past Monte Fogliano, which is clearly visible on the left, skirted at the bottom with trees (which now cover the entire hillside, as the area is a nature reserve), and, along a ridge in the farther distance, the Monti Cimini range, which is slightly exaggerated in height but has the twin-towered abbey of San Martino and Palazzo Doria Pamphili next to it, visible in the pencil outline. To the right, out of the view here, would be Monte Venere. KS

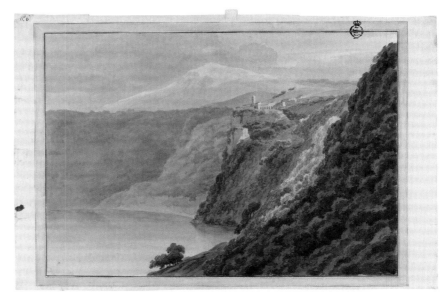

27

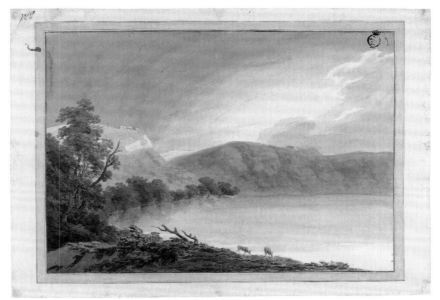

28

29–32

ATTRIBUTED TO CHRISTOPHER EBDON
(1744–1824)

**Floor Plan and Elevations of a Chapel,
Possibly Intended for Tehidy Park, Cornwall,
the House of Francis Basset**
1777–78

29

ATTRIBUTED TO CHRISTOPHER EBDON
(1744–1824)

Floor Plan of a Chapel

Pen and ink and watercolor on paper
23¼ x 17¼ in. (59 x 43.8 cm)
Inscribed in upper right corner: "21."
Real Academia de Bellas Artes de San Fernando,
Museo, A-5117

30

ATTRIBUTED TO CHRISTOPHER EBDON
(1744–1824)

**Elevation of the Same Chapel
(Section CD toward the Altar)**

Pencil, pen and ink, black, gray, pink, and yellow
washes
17 x 23⅛ in. (43.3 x 58.6 cm)
Inscribed in upper right corner: "22."
Real Academia de Bellas Artes de San Fernando,
Museo, A-5118

31

ATTRIBUTED TO CHRISTOPHER EBDON
(1744–1824)

**Elevation of the Same Chapel
(Section AB toward the Door)**

Pencil, pen and ink, black, gray, pink, and yellow
washes
17⅛ x 23⅛ in. (43.4 x 58.7 cm)
Inscribed in upper right corner: "23."
Real Academia de Bellas Artes de San Fernando,
Museo, A-5119

29

32

ATTRIBUTED TO CHRISTOPHER EBDON
(1744–1824)

**Elevation of the Same Chapel
(Section AB toward the Pulpit)**

Pencil, pen and ink, black, gray, pink, and yellow
washes
17⅛ x 23 in. (43.4 x 58.4 cm)
Inscribed in upper right corner: "24."
Real Academia de Bellas Artes de San Fernando,
Museo, A-5120

This exquisitely rendered set of designs for a
small chapel, executed on paper watermarked "J
WHATMAN & CO," was among the *Westmorland*
possessions of Basset and may thus be associated
with Tehidy Park in Cornwall, the seat of the Basset
family. Their attribution to the Durham-born
architect Christopher Ebdon, first made by Brian
Allen, is circumstantial. Ebdon was based in
Florence from 1774, was elected to the Accademia
delle Arti del Disegno in 1776, and received a medal
from the academy in February 1777 in recognition of
designs he had presented to Pietro Leopoldo di
Lorena, grand duke of Tuscany. Basset could have
met Ebdon in Florence in the autumn of 1777

(although it is not certain that he visited the city on his way south to Rome) or in the spring of 1778, if indeed Ebdon was still there (he was evidently back in London later that year, when he exhibited at the Society of Arts, giving a London address). The likelihood of this Italian connection is greatly strengthened by the fact that in 1783 Ebdon appeared in Cornwall, where he designed gate lodges for Tehidy Park and, at the nearby county town of Truro, built the Assembly Rooms, which opened in 1787 (the same year that he designed a chapel for the then newly established town of Torpoint in southern Cornwall). The graphic style of the chapel designs catalogued here bear comparison with the gray-wash austerity found in drawings by James Paine Sr., to whom Ebdon had been apprenticed in 1761.

The details of the chapel's design suggest that it was intended for a specific location. The entrance opposite the altar is through a narrow corner door from an adjoining room with a fireplace, and it leads onto a family platform. The pulpit is set back into a blind side wall, which, with a depth at that point of a mere nine inches or so, is unlikely to have been external (although the projecting cornice might suggest otherwise). Opposite, a door between two windows evidently opens directly to the outside, and the wall behind the altar is also external since it features a window. The sections imply a flat, unornamented ceiling and give no idea of any roof structure above. It is thus possible that what was under consideration here was a ground-floor remodeling of one corner of the house at Tehidy Park (built 1736–39 by Thomas Edwards), or of part of one of its four detached pavilions. These were initially intended for offices, for other functional purposes associated with the running of a great house, and as sleeping quarters for the servants. In 1820, however, the pavilion that sported a clock in its turret was described as housing "a handsome chapel." Unfortunately there is no compass point on the plan to indicate the orientation and thus to give some idea of precise location. From the scale bars we can deduce that the chapel was to have been a modestly sized room, just over thirty feet long by exactly twenty feet wide, the height approximately twenty feet.

It was far from uncommon for young British architects in Italy to receive commissions from Grand Tourists for alterations or additions to their houses back home. In 1779, for example, John Soane worked on the design of two rooms for John Patteson's family house in Norwich, and Patteson proposed to post the drawings to his mother.

30

31

32

The family platform at the back of Basset's proposed chapel is fronted by a balustrade, divided to allow descent to the floor of the chapel by means of two steps. On the facing side the sanctuary is closed off by another balustrade but can be entered via a brass gate to the left—that is, on the side of the entrance door to the building from the outside. The other side of the sanctuary gives direct access to four steps leading up to the pulpit, protected by a continuation of the beautiful foliated brass railing. The pulpit is set in a frame that parallels the doorway into the chapel opposite. It is fronted by, and set on, marble revetments. To the left and right are large beaded frames on the walls (more than nine feet in height), possibly intended to house a pair of paintings. This arrangement mirrors the windows of the external wall opposite. In the sectional drawings of both lateral walls, Ebdon took some small liberties with what should be shown on his line AB.

Perhaps the most striking drawing of all in the set, however, is the section that shows the altar wall of the chapel (cat. 30). The stone balustrade and brass railings are elegant and simple in their design. The Ionic order, seen to best advantage here where there is a pair of columns as opposed to the pilasters of the lateral walls, is Grecian in its severity and has a simple entablature above—with bead moldings on the architrave, plain frieze, and dentiled cornice. The surprise comes with the window above the altar (eight feet high and five feet wide), which contains an image of the Holy Spirit in the form of the dove amid a starburst surrounded by clouds. As seen in windows above altars in churches in Rome (and most famously in St. Peter's Basilica), this seems an extraordinarily Catholic feature for Ebdon to have designed for Basset, a man not otherwise known to have entertained Catholic sympathies and traveling with the Anglican clergyman (and Tehidy Park estate steward) the Reverend William Sandys as his tutor. Admittedly the altar here is bare and there are no other signs of Catholic ritual, but it is worth noting that Basset was somewhat unusual in having St. Peter's included in the background of his full-length portrait by Pompeo Batoni—as opposed to the more common antique architecture or sculpture.

Whether Basset attempted to get Ebdon to make new designs for the chapel at Tehidy Park to replace those lost on the *Westmorland* cannot be established. However, a domestic chaplain was retained by Basset (who lived until 1835) at least from 1800, and the chapel at Tehidy Park was certainly present in one of the pavilions by 1810, albeit with an over-altar picture painted by his only child, Frances Basset, not the Holy Spirit window of the *Westmorland* design. Ebdon, for his part, was back in London by 1789, where he undertook some draftsmanship for Soane. In 1793 he returned to his birthplace, Durham, and spent the rest of his life working there. FS

REFERENCES: du Prey 1982, 114; F. Salmon 1990, 206; Tangye 2002; Pearce and Salmon 2005, 2–3, 12–14; Colvin 2008, 340.

33

AFTER THE ROMAN ORIGINAL

Centaur Goaded by a Maenad with Thyrsus
1770s

Oil on silk
10⅝ x 14⅛ in. (27 x 36 cm)
Real Academia de Bellas Artes de San Fernando, Museo, 322

From the seventeenth century on, both antiquarians and artists set out to reproduce Roman paintings in color. Good examples of this interest were Cassiano dal Pozzo's Paper Museum and the copies made by Pietro Santi Bartoli for Cardinal Camillo Massimo. Such individuals had firsthand experience of the way that Roman paintings rapidly deteriorated after they were excavated, losing the intensity of their colors on exposure to light and air.

This concern was also shared by Carlos III of Spain and his secretary of state Bernardo Tanucci, although both considered that Monsignor Giovanni Gaetano Bottari's proposal of publishing a large number of colored prints was not economically feasible. As an example of how Pompeian wall paintings could be reproduced in the form of colored illustrations, Bottari had sent Tanucci a copy of the book *Recueil de peintures antiques trouvées à Rome* (1757), by Anne-Claude-Philippe de Thubières, comte de Caylus, and Pierre-Jean Mariette, which was then sent on to the king of Spain for his decision. Shortly thereafter the king rejected the proposal. In a letter of May 3, 1763, Carlos III mentioned to Tanucci that during the period of his Neapolitan reign (1735–59) before becoming the Spanish monarch, he had commissioned from Camillo Paderni colored copies of various original paintings as a means of documenting the original polychromy in case it should be lost.

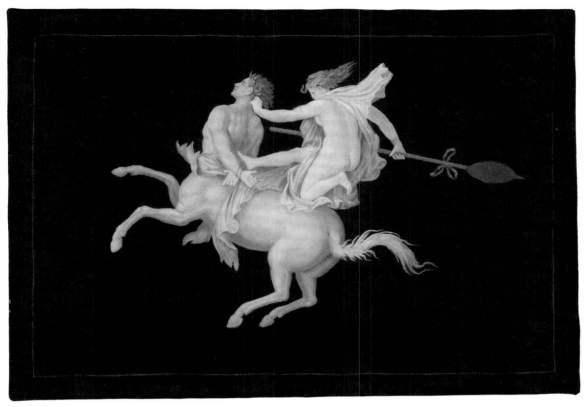

33

Among the paintings copied as drawings by
Paderni and engraved by Filippo Morghen for *Le
pitture antiche di Ercolano e contorni incise* (1757),
the first volume of *Le antichità di Ercolano esposte*
(1757–79), are a series of scenes of male and female
centaurs. These images were discovered on January
18, 1749, in the peristyle of the so-called Villa of
Cicero in Pompeii, and they comprised four separate
scenes that were joined together after they were
excavated (Museo Archeologico Nazionale, Naples).

The copy on silk that Basset acquired reproduces
a male centaur with bound hands ridden by a maenad
who grasps his hair at the nape of his neck in order
to lead him. It formed a pair with a painting on silk,
now lost, that reproduced another of the four
images, that one of a female centaur holding a lyre
and bearing a hermaphrodite through the air while
they play the cymbals. The eroticism of the series
had a major impact in Europe, and it was used as the
model for numerous items inspired by Pompeii. It
was selected, for example, by the Fabbrica Ferdinan-
dea, Naples, to decorate the plates in the Servizio
Ercolanese, the first service produced at that factory.
Reproductions on silk were among the souvenirs
acquired in Naples by Grand Tour visitors. MCAR

REFERENCES: Fiorelli 1865, 7; Museo Nacional de
Reproducciones Artísticas 1915, 22, no. 29–30;
Carlos III 1988, 430; Tanucci 1997, 88, 101, 120, 177;
Alonso Rodríguez 2006, 225–59; Bragantini and
Sampaolo 2009, 30–31.

34

POSSIBLY FRIEDRICH ANDERS (B. CA. 1734)
AFTER THE ROMAN ORIGINAL

The Aldobrandini Wedding
1776

Gouache on paper
13⅜ x 33⅛ in. (34 x 84 cm)
Signed in monogram and dated, lower right:
"FA fecit 1776"
Real Academia de Bellas Artes de San Fernando,
Museo, 1476

The Aldobrandini Wedding, being one of the best-
preserved, and certainly most accessible, fragments
of ancient fresco in Rome, had been greatly cel-
ebrated since its discovery in 1601. Initially pub-
lished by the artist Federico Zuccaro, it remained of
interest equally to painters and antiquarians as a rare

34

example of ancient painting. As a result it was the subject of a series of high-quality engravings and detailed scholarly interpretations. Pietro da Cortona's watercolor copy made for Cassiano dal Pozzo was engraved in 1627 by Bernardino Capitelli, and prints featured prominently in Pietro Santi Bartoli's *Admiranda Romanarum Antiquitatum* (1693) and Bernard de Montfaucon's *L'antiquitée expliquée . . .* (1722), while the fresco's iconography was dissected by Johann Joachim Winckelmann in his *Monumenti antichi inediti* (1767).

All these publications were familiar to Grand Tourists, and the expected educational legacy of Italian travel meant that guidebooks often referred to prints in their accounts of works of art. The two Jonathan Richardsons, father and son, for example, cited Montfaucon's engraving when describing *The Aldobrandini Wedding* in 1722. By 1741 George Turnbull, in his *Curious Collection of Ancient Paintings*, was able to observe that "Colour'd Prints of it are now common," discussing a "Copy of it in Colours" made by Camillo Paderni. It seems likely that the gouache found on the *Westmorland* was just such a colored copy, probably made from an engraving and purchased by Basset as a visual supplement for his library. The presence of the monogram "FA" and the date suggests that this is an original painted copy, possibly by the German artist Friedrich Anders, who worked as a draftsman producing souvenirs of this type for Grand Tourists. On November 20, 1771, John Frederick Sackville, third Duke of Dorset, according to his account book, purchased from James Byres "An ancient marriage painted in Watercolours

by one Andrews a German; at Rome" for £7. Andrews was almost certainly Anders and the "ancient marriage" *The Aldobrandini Wedding*. The Duke of Dorset gave the picture to his mistress Anne Parsons, who was traveling with him.

The ornamental border of Basset's gouache suggests its decorative potential; indeed it seems to have been purchased as a pair with Guido Reni's *Aurora* (cat. 35). *The Aldobrandini Wedding* had become a favorite in Neoclassical interiors; James "Athenian" Stuart used it to decorate the chimneypiece of the painted room at Spencer House, London. Given their similar oblong format, it was frequently paired with the *Aurora*—for example, in the overdoors at Ribston Hall, Yorkshire. JY

REFERENCES: J. Richardson 1722, 305; Turnbull 1741, 4–5, 11–12; Joyce 1992, 219–46; Müller 1994.

35

UNKNOWN ARTIST AFTER GUIDO RENI (1575–1642)

Aurora
1770s

Gouache on paper
15¾ x 33⅛ in. (40 x 84 cm)
Real Academia de Bellas Artes de San Fernando, Museo, 531

In his *Travels into different parts of Europe in the years 1791 and 1792* (1796), John Owen observed that Guido Reni's *Aurora* was a painting "so often

35

engraved, that a transcript of its beauties—so far
as frescoes can be copied into miniatures—is in the
collection of every one who is at all an amateur of
the fine arts." By that date the *Aurora*, which had
been painted in 1614 on the ceiling of a loggia in the
garden of Cardinal Scipione Borghese's palace on
the Quirinal Hill, had become a staple of Neoclassi-
cal design, being used on almost every scale and in a
variety of settings, from full-scale easel paintings to
fans (see cat. 77).

This gouache copy was acquired by Basset with
another of *The Aldobrandini Wedding* (cat. 34),
which is signed with the monogram FA, probably
for the draftsman Friedrich Anders, and dated 1776.
While the *Aurora* is not signed, it seems probable
from the similarity of the decorative borders that
they were conceived as a pair and executed by the
same hand. Indeed, in the earliest lists of property
from the *Westmorland*, they appear, along with the
Bacchus and Ariadne (cat. 36), to have been sent
from Rome glazed and framed in the same case.

Shortly after their arrival in the Real Academia
de Bellas Artes de San Fernando, these gouache
copies were listed as "estampas iluminadas," or
colored engravings. While there is no evidence that
the *Aurora* was painted over an engraving, it was
certainly closely related to the famous print of the
composition made by Jakob Frey, which had been
published in Rome in 1722. The difficulty in access-
ing the actual fresco meant that many painters
turned to Frey's print as an intermediary. It is telling
that this gouache is the same size as the print, three
impressions of which were on the *Westmorland*,

destined for different owners. Colored engravings
were even more desirable and much more expensive
than the prints themselves, as they were often
colored by established painters. Henry Hoare
commissioned a series of colored prints in 1759,
through the painter John Plimmer, from Hendrik
Frans van Lint, known as lo Studio, who worked in
Rome principally as a landscape painter. Van Lint
supplied Hoare with a list of prints that he proposed
to color, with an itemized account of their costs.
While Frey's engraving of the *Aurora* cost 1 scudo,
Van Lint charged 12 scudi to color it; the fragile
pictures were sent framed, costing a further 3 scudi
and 80 baiocchi. Hoare was required to pay Van Lint
up front for the engraving and the balance on their
completion. Paired, in this case, with *The Aldobran-
dini Wedding*, the pictures would have served not
only as a "transcript" of Guido Reni's composition—
as Owen noted, a requisite for "an amateur of the
fine arts"—but also as a pair of highly decorative
souvenirs. JY

REFERENCES: John Plimmer to Henry Hoare, Rome,
June 9, 1759, 387/907, Wiltshire and Swindon
Archives, Chippenham, Wiltshire; J. Owen 1796,
2:43; Pepper 1984, no. 40; Ubl 1999, 209–41.

36

36

UNKNOWN ARTIST AFTER GUIDO RENI (1575–1642)

Bacchus and Ariadne

1770s

Gouache (over engraving) on paper
16⅛ x 35⅜ in. (41 x 90 cm)
Real Academia de Bellas Artes de San Fernando,
Museo, 508

This decorative gouache copy of Guido Reni's
Bacchus and Ariadne is first recorded in Málaga in
the same crate as the reduced copies of *The Aldo-
brandini Wedding* (cat. 34) and Reni's *Aurora*
(cat. 35); each arrived framed and glazed. Given the
difference in quality, however, it seems unlikely that
the three were conceived as a set. The *Bacchus and
Ariadne* was much copied during the eighteenth
century, even though the original had been destroyed
in 1650. Travelers could see a contemporary version by
Giovanni Andrea Sirani then in the Museo Capito-
lino (now in the Accademia di San Luca, Rome).
But Reni's original composition—as described by
Carlo Cesare Malvasia—was best known from a
series of prints, the most famous being that of the
Swiss engraver Jakob Frey, which had been pub-
lished in Rome in 1727, and which appears to provide
the basis for this gouache copy.

After Frey's death in 1752, his son Filippo
continued to sell his father's prints from a shop
next to the church of Santa Maria di Costantinopoli,
near Piazza Barberini (on what is now the Via del
Tritone), which, along with those of Giovanni
Battista Piranesi and Giovanni Volpato, became

popular destinations for travelers. A printed
catalogue of Frey's engravings entitled *Catalogi
delle Stampe, doppo le piu' celebri pitture, che
esistono nelle chiese, e palazzi di Roma*, lists the
Bacchus and Ariadne as among the most expensive
prints, at 1 scudo. The popularity of the engraving is
attested to by the presence of several impressions on
board the *Westmorland*, but more highly prized
were the professionally colored prints, such as this.
The use of gouache—watercolor mixed with white
pigment to render it opaque—suggests that the
artist intended to mask the print, although engraved
lines can clearly be seen in the sky and foreground.
Prints such as these were probably purchased to act
as a visual supplement to the traveler's library;
Basset owned a copy of the 1775 guide to the Museo
Capitolino collections in which Sirani's canvas is
described. Such prints were also highly decorative
objects, frequently colored by established painters.
In 1775 Gavin Hamilton wrote to his patrons Charles
Townley and William Petty, second Earl of Shel-
burne, offering sets of Volpato's Loggia engravings
(see cat. 123) colored "with great exactness" by
Francesco Panini, son of Giovanni Paolo Panini. JY

REFERENCES: Pepper 1984, no. 169; Bignamini and
Hornsby 2010, 2:44, 58.

37

37

ROBERT GARDELLE (1682–1766)

Veue de la ville de Geneve du coté du Septentrion (View of Geneva from the North)
ca. 1726

Engraving
(sheet) 10⅞ x 30¾ in. (27.7 x 78 cm)
Inscribed on verso: "P.Y."
Real Academia de Bellas Artes de San Fernando,
Archivo-Biblioteca, Gr-877

Robert Gardelle was a Swiss painter and engraver
who trained at Kassel, Germany, and in Paris at the
studio of Nicolas de Largillière. In 1713 he returned
to Switzerland and became a portrait painter, also
producing views of Geneva and Bern and making
etchings and mezzotints after his own work. The
view of Geneva from the north was included in a new
edition in 1730 of Jacob Spon's *Histoire de Genève*,
first published in 1680, and also appears to have
been sold as a single plate. EH

REFERENCE: Zumbach 2011.

38

GIOVANNI BATTISTA PIRANESI (1720–1778)
AND STUDIO

Tripode, ovvero ara antica di Marmo (Ancient Marble Tripod or Altar)
ca. 1778

Etching
26½ x 16⅝ in. (67.3 x 42.1 cm), (sheet) 31½ x
22½ in. (80 x 57 cm)
Real Academia de Bellas Artes de San Fernando,
Archivo-Biblioteca, Gr-1207

39

GIOVANNI BATTISTA PIRANESI (1720–1778)
AND STUDIO

Altra veduta dello stesso tripode antico di Marmo (Another View of the Same Ancient Marble Tripod)
ca. 1778

Etching
26½ x 16⅝ in. (67.3 x 42.1 cm)
Real Academia de Bellas Artes de San Fernando,
Archivo-Biblioteca, Gr-1208

These plates come from Giovanni Battista Piranesi's
series of 120 separate illustrations of decorative
antiquities, eventually gathered together in 1778 in
two volumes and published as *Vasi, candelabri, cippi,
sarcofagi, tripodi, lucerne ed ornamenti antichi*. A
substantial number of works illustrated were heavily
restored, many in an extremely imaginative way, by
skilled sculptors under the direction of the artist and

38

39

were sold from his *museo* (showrooms) in Palazzo Tomati, Rome. These plates not only celebrated his reconstructive skills but also served to advertise pieces still for sale. In many cases captions detail the original locations of the finds (often with elaborate iconographic interpretations) and, in the case of those already sold, their current locations, some of them already in British sculpture collections.

In addition to this commercial enterprise, Piranesi frequently added a dedication to an eminent personality from the social and artistic world of Rome as well as to favored clients, as in this particular case. The first is inscribed "Al Sig. Francesco Basset Cavaliere Inglese, Amatore delle belle Arti, in atto d'ossequio il Cavalier Gio. Batta. Piranesi, D.D.D." (To Mr. Francis Basset, English nobleman, lover of the fine arts, in homage by Cavaliere Gio. Batta. Piranesi, Dono Dedit Dedicavit—He gave

as a gift), which was justified for someone who had purchased a total of fourteen volumes of etched plates. The other is dedicated "Al Sig. Guglielmo Sandys Cavaliere Inglese, Amatore delle belle Arti. In atto d'ossequio il Cavalier Gio. Batta. Piranesi, D.D.D." (To Mr. William Sandys, English gentleman, lover of the fine arts, in homage by Cavaliere Gio. Batta. Piranesi, D.D.D.), which probably indicated a long-standing acquaintance, dating back to Sandys's earlier visit to Rome in 1771, as well as his role as tutor in bringing such a generous client to Palazzo Tomati. These loose copies came from a crate marked "F. Bt.," belonging to Basset, but, as was usual, the prints also appear at the beginning of his bound copy of the *Vasi*. From approximately 1775, when Piranesi's elder son, Francesco, was seventeen, he appears to have taken an increasingly significant role in the graphic process. However,

while some of the *Vasi* plates indicate a heavier, darker manner characteristic of his style, his father signed all but nine of the plates and was certainly responsible for the compositional power of the entire series.

Among the various tripods in the *Vasi*, according to the captions, this work was excavated in 1775 at the coastal city of Ostia, near Rome, by Gavin Hamilton, who worked closely with Piranesi in his restoration business. We are also told that, because of its outstanding workmanship, the work had already been acquired by Pius VI for the rapidly expanding Museo Nuovo at the Vatican. Its importance is further emphasized by the tripod's prominent appearance in a tempera lunette of 1783 in the Vatican, by Stefano Piale, showing Pius VI visiting the Museo Pio-Clementino, for which he was largely responsible. JW-E

REFERENCES: Wilton-Ely 1994, 2:961–62, 1025–26; Wilton and Bignamini 1996, 246, no. 198.

40

GIOVANNI VOLPATO (1740–1803), ENGRAVER;
LUDOVICO TESEO (1731–1782), DRAFTSMAN;
FRANCESCO PANINI (1745–1812), DRAFTSMAN
AND COLORIST

Veduta della Galleria dipinta da Annibale Carracci e suoi scolari essistente nel Palazzo Farnese a Roma (View of the Gallery Painted by Annibale Carracci and His Pupils in the Palazzo Farnese in Rome)

1777

Etching and gouache
18¾ x 12⅜ in. (47.7 x 31.3 cm)
Real Academia de Bellas Artes de San Fernando, Museo, OG-130

This plate is one of a set of seven after Annibale Carracci's frescoes in the *Galleria* in Palazzo Farnese. Carracci's decorative scheme had been reproduced in print form in 1657 by Carlo Cesi, accompanied by a text by Giovanni Pietro Bellori, and again in 1674 by Pietro Aquila, with a frontispiece by Carlo Maratti. Volpato must have started work in 1775, while he was completing his prints of the pilasters of the Raphael Loggia. The project was finished in 1777.

The original set was engraved by Volpato on the basis of drawings by Francesco Panini and Ludovico

40

Teseo. A complete, hand-colored set arrived in Madrid in Basset's crates. Three of the plates were framed shortly after their arrival at the Real Academia de Bellas Artes de San Fernando and are in that institution's museum: an overall view of the gallery (reproduced here), a view of the west wall, and one of the south wall. In addition, the Real Academia's library has an unframed impression of the view of the north wall.

Volpato's artistic involvement in this project consisted of etching the outlines that would

subsequently be colored, with the decorative elements richly gilded, as can be seen in the impressions now in the Musée des Beaux-Arts, Tours. At a later date chiaroscuro shading was added to the plates by Pietro Bettelini, who inserted his name in the inscription alongside those of Teseo and Panini.

The impressions now in the Real Academia show the figures indicated only by their etched outlines, without the subsequent interior shading by Bettelini, whose name does not appear. They are thus impressions of a state prior to these subsequent additions and are probably among the earliest hand-colored impressions to emerge from Volpato's studio. In addition, the coloring on the Real Academia's prints has survived in extremely good condition, allowing for an appreciation of the delicacy of Panini's gouache, which in some areas is totally independent of the printed lines.

This set was Volpato's first solo publishing project, and its technique ensured it enormous success among foreign clients. Volpato specifically adapted his productions to this market, with particular emphasis on places that foreign travelers would be likely to visit. Through Gavin Hamilton, with whom he had worked on the collection of prints entitled *Schola Italica Picturae* (1773; cat. 59), Volpato entered the social circles of Piazza di Spagna and the Caffè degli Inglesi, where he encountered numerous potential clients. When sending a set of Volpato's prints to William Petty, second Earl of Shelburne, Hamilton himself described them as "the most beautiful work of this type that I have ever seen."

In addition to this set, Basset sent on the *Westmorland* another series of Volpato's prints after the Raphael Loggia and an impression of his print after Raphael's *School of Athens*. It is likely that some years after the capture of the ship, Basset attempted to replace some of these prints through his former tutor, the Reverend William Sandys. Once back in England Sandys embarked on an extensive correspondence with the landscape artist Jacob More regarding the shipment of works from Rome. On several occasions he mentioned prints by Volpato sent to Sandys from Livorno "in a tin case and inclosed in a small box." MDSJ

REFERENCES: Jacob More, "Letters to William Sandys," MS 13, fols. 1–44, Laing.IV.20, Edinburgh University Library; Borea and Mariani 1986; Bernini Passini 1988, 22–29; Marini 2003, 157–77; Gilet 2007, 21–27, 107–11, 190–99.

41

GIOVANNI VOLPATO (1740–1803)
AFTER MICHELANGELO MERISI DA CARAVAGGIO
(1571–1610)

Lusores (The Cardsharps)

1773

Engraving
18⅝ x 25¼ in. (47.3 x 64 cm)
Loose plate from Gavin Hamilton, *Schola Italica Picturae*
Real Academia de Bellas Artes de San Fernando, Archivo-Biblioteca, B-11

The paintings illustrated in Gavin Hamilton's *Schola Italica Picturae* were, for the most part, of famous paintings in Italy not then available as good-quality prints. The popularity of such reproductive engravings is exemplified by the presence on board the *Westmorland* of several impressions of Jakob Frey's *Aurora* and *Bacchus and Ariadne* after Guido Reni, initially made in the 1720s but still being published by his son in the 1770s. Several earlier British printmakers had tried to capitalize on this market. Robert Strange spent five years in Italy preparing a series of highly finished drawings of celebrated paintings, which he exhibited in London in 1769 and published during the following decade. But Hamilton's volume was unusual for its scale: he employed seven engravers to complete forty plates.

Lusores, also known as *I Bari*, or in English as *The Cardsharps*, is the last plate and only composition by Michelangelo Merisi da Caravaggio included in the collection. As an early work, painted in about 1594 and acquired by Cardinal Maria del Monte, *The Cardsharps* had an appeal during the eighteenth century that lay less in the celebrity of Caravaggio's name and technique than in the subject matter. In their book *Account of some of the Statues, Bas-reliefs, Drawings and Pictures in Italy . . .* (1722), Jonathan Richardson and his son Jonathan described the picture as "excellent for the Expression. A young Fellow is cheated of his Money by sharping Gamesters; in Them there is so much Roguery, and Craft, and in Him so much stupidity, and Fright, that 'tis deservedly very famous." This fame inevitably meant it was much copied. In June 1775 the American painter James Smith made a copy for Patrick Home of Wedderburn, and there were two same-size copies on the *Westmorland*, both in the crate marked "J. M.," one of which survives in the Real Academia de Bellas Artes de San Fernando.

Lusores

Ludus enim genuit trepidum certamen, et iram : Jra truces inimicitias, et funebre bellum. Hor. I. Epist.19.

E Tabula in Ædibus Barberinis Romæ asservata

Michelangelo da Caravaggio pinxit.

Johannis Volpato sculpsit Romæ 1772.

41

The plate was engraved by Giovanni Volpato in Rome in 1772. Volpato had moved to the city only a year earlier, having been trained in the print works of Giovanni Battista Remondini in his native Bassano and subsequently in Venice and Parma. Volpato produced eight plates for Hamilton, including another from the Barberini collection, Bernardino Luini's *Modesty and Vanity*. Hamilton in turn promoted Volpato's deluxe publication of Raphael's decoration of the Vatican Loggia and Stanze to his British patrons, writing in 1779 that Volpato was his "particular friend." Volpato's print of *The Card-sharps* shows Caravaggio's composition as contemporaries would have seen it in Palazzo Barberini alle Quattro Fontane in Rome, slightly enlarged along the top, an addition that was not removed until the painting was purchased by the Kimbell Art Museum, Forth Worth, in 1987. Hamilton added to the print a Latin inscription taken from Horace's *Epistles*. This sort of thing was common; Frey, for example, frequently ornamented his plates with biblical or classical quotations, and it was a habit that Hamilton adopted for prints of his own compositions made by Domenico Cunego. The presence of four copies of the *Schola Italica Picturae* on the *Westmorland* hints at its impact and popularity among Grand Tourists. JY

REFERENCES: J. Richardson 1722, 165; Moir 1976, 105–7; Mahon 1988, 10–26; Marini 1988; Bignamini and Hornsby 2010, 339–40.

42

42

ANTOINE-ALEXANDRE-JOSEPH CARDON (1739–1822)
AFTER GIUSEPPE BRACCI (ACTIVE 1765–68)

Map of the Bay of Naples
Naples: Filippo Morghen, 1772

Engraving
(sheet) 35⅞ x 45⅝ in. (91 x 116 cm)
Inscribed on verso, top center: "P.Y."
Real Academia de Bellas Artes de San Fernando,
Archivo-Biblioteca, Mp-22

Filippo Morghen was a leading engraver and
publisher of views and maps of Naples. His map of
the Bay of Naples is a superb example, combining
images of the city in ancient times with an idealized
view of the erupting Vesuvius and ruined temples
with information on early Roman settlements.
Between 1766 and 1769 Morghen executed a series of
forty *vedute*, or views, published as *Le antichità di*

Pozzuoli, Baja, e Cuma (see cat. 46), which he
individually dedicated to native noblemen or
distinguished foreigners. His map of the gulf of
Naples is no exception, as he dedicated it to Sir
William Hamilton, with an inscription on the tablet
at the lower right.

Three copies of this engraving were on the
Westmorland, found in crates belonging to Basset;
George Legge, Viscount Lewisham; and Frederick
Ponsonby, Viscount Duncannon. EF

REFERENCE: Westmorland 2002, no. 18 (entry by
Pablo Vázquez Gestal).

43a

43

PHILIPP CLÜVER (1580–1622)

Sicilia Antiqua
Leiden: Pieter van der Aa, 1619

Inscribed on title page: "P. Y."
Real Academia de Bellas Artes de San Fernando,
Archivo-Biblioteca, B-1191

This volume includes several works on Sicily by
different authors bound together, the first of which
is *Sicilia Antiqua* by Philipp Clüver, published in
1619. In contrast to other geographers, Clüver
combined his knowledge of classical sources and
epigraphy with a direct study of the terrain, thus
emphasizing that identifications needed to be
confirmed by on-site investigation. In order to
accomplish this aim he traveled around Sicily on foot
in the company of his follower Lucas Holstenius
(born Lukas Holste) during a trip to Italy that began
in 1617. Their observations are set out in *Sicilia
Antiqua*, which includes two historical maps that
identify and locate archaeological sites on the island,
one using Greek names and the other with the names
in Latin. The work also includes another map of the
Lipari Islands and Malta, plans of the most impor-
tant cities, and a view of Etna.

43b

Prior to this trip Clüver had traveled around England, Scotland, Germany, and France, and, through funding awarded to him by the Universiteit Leiden in 1616, he was able to focus all his scholarly attention on the field of historical geography. The academic merit of *Sicilia Antiqua* and other works by Clüver meant that they became essential reference texts and sources for consultation for future generations, particularly antiquarians and the first travelers who reached as far as Sicily in the eighteenth century.

The present bound volume also contains four texts taken from the numerous monographic publications that existed on Sicily, the first of which began to appear in the sixteenth century, while numerous others circulated in the form of manuscripts. This copy of *Sicilia Antiqua*, which was found in the *Westmorland crates addressed to Basset*, is the first volume in Johann Georg Graevius's compilation of such texts published in 1723 with the title *Thesaurus Antiquitatum et Historiarum Siciliae*. Among the works in this compilation is *Siciliae chorographia accuratissima* by Claudio Mario Arezzo, a historian in the service of Holy Roman Emperor Charles V. This in turn includes *Sicilia descriptio* by Domenico Mario Nigro, published in 1557, which initiated a lengthy series of geographic studies on Sicily. It is followed by *Sicaniae descriptio et delineatio* of 1653, written by Placido Carraffa, a Neapolitan historian. The series ends with *Regni Siciliae delineatio* by Antonio Mongitore, a member of the Accademia degli Arcadi, a literary academy founded in Rome, and the author of various works on civil and ecclesiastical history. MCAR

REFERENCES: Partsch 1891; Maja 1985.

44a

44b

44

GIOVANNI MARIA DELLA TORRE (1713–1782)

Incendio del Vesuvio accaduto li 19 d'Ottobre del 1767
Naples: Nella Stamperia, e a Spese di Donato Campo, 1767

Inscribed on title page: "Wm. Sandys.1778"
Real Academia de Bellas Artes de San Fernando, Archivo-Biblioteca, B-792

This book belonged to the Reverend William Sandys, whose name appears on the title page with the date 1778. It was in one of Basset's crates, together with another book by the same author

that Sandys also owned, entitled *Storia e fenomeni del Vesuvio* (1755). The same crate also contained a French edition of the book published in 1771 and entitled *Histoire et phenomenes du Vesuve*. Clearly Sandys and his young charge were interested in the subject of volcanoes, as were many of the travelers who reached the kingdoms of Naples and Sicily.

The book was written by the physicist and naturalist Giovanni Maria della Torre, a professor at the two seminaries in Naples, the inventor of various microscopes, and a member of the Accademia Ercolanese, founded in Naples in 1755 by Carlos de Borbón, king of Naples and Sicily (before he became Carlos III of Spain four years later). Among Della Torre's numerous positions was that of director of the Stamperia Reale, Naples, which published *Le antichità di Ercolano esposte*. His first work on the subject of volcanoes was published in 1751, with the title *Narrazione del torrente di fuoco uscito dal Monte Vesubio*, and was followed by others on descriptions of the eruptions that took place in 1754–55 and 1760–61.

Della Torre witnessed the eruption of October 19, 1767, from the country residence of Marchese Giovan Domenico Berio in San Giorgio a Cremano, where he had been invited by Margaret Shirley, Countess of Orford, Baroness Clinton, to whom this book is dedicated. At the end of the volume is a print by Francesco Cepparuli, shown here, which depicts Vesuvius, the lava flow, and the places and houses that it engulfed. In the left margin the letter "Y" indicates Berio's country residence. Johann Joachim Winckelmann, who was visiting the palace at Caserta when the eruption took place, noted that Baroness Clinton and her guests were so close to the lava flow that they were obliged to flee with all haste. Another person who was nearby and left a description of the event was Sir William Hamilton, the British envoy extraordinary and minister plenipotentiary to the court of Naples. In a letter to James Douglas, fourteenth Earl of Morton, president of the Royal Society of Arts, London, Hamilton wrote, "I must confess that I was not at my ease. I followed close, and we ran near three miles without stopping." Travelers to Naples frequently acquired Hamilton's works and also took home pieces of lava from Vesuvius, among them John Barber, whose items to be sent back to England were probably in one of the *Westmorland* cases. MCAR

REFERENCES: Winckelmann 1961; C. Knight 1990; Westmorland 2002, no. 36 (entry by María del Carmen Alonso Rodríguez).

45

45

GIOVANNI LAMI (1697–1770)

Lezioni di antichità toscane e spezialmente della città di Firenze, vol. 1
Florence: Andrea Bonducci, 1766

Real Academia de Bellas Artes de San Fernando, Archivo-Biblioteca, C-1292

Giovanni Lami was a jurist, church historian, and antiquarian based in Florence. A professor of ecclesiastical history at the Università degli Studi di Firenze and a member of the Accademia della Crusca, he also acted as theologian and counselor to the court of Pietro Leopoldo di Lorena, grand duke of Tuscany, to whom this work is dedicated.

The two volumes are divided into eighteen *lezioni* (lessons), or chapters, which discuss the history of Florence from its Etruscan origins through the Romans and the Lombards by describing its monuments together with its language. The volumes include several foldout engravings of the monuments, ruins, coins, and inscriptions considered.

The highly erudite author followed itineraries around Tuscany and the city of Florence, stopping at relevant monuments to describe not only the actual monument but also the former monuments over which ruins the existing structures were build. In this way he offered visitors a guide both to the actual city and to ancient Florence as well as its surroundings, also depicted in an engraved foldout map shown here. The origins and distinguishing features of the Tuscan dialect share equal importance in Lami's text.

Several pages in volume 1 contain marks and notes similar to those in other books in Basset's

crates signed with the name of his tutor, the Reverend William Sandys. Most often they mark a line, or a whole paragraph; in other instances the reader (presumably Sandys) added a short note. This is the case where Lami discusses the possible origins of the guttural pronunciation found in the Phoenician, Canaanite, Punic, and other languages, "framischiate ancora nell'idioma Maltese" (yet mixed with the Maltese language], beside which the reader wrote with pencil, "Quid Hoc?" (Why this?) This may point to a knowledge and interest in linguistic questions more likely ascribed to the tutor than to his charge. MDSJ

REFERENCES: Cole 1973, 452–57; Treccani.it, s.v. "Lami, Giovanni."

46

FILIPPO MORGHEN (1730–AFTER 1777)

Sei vedute delle rovine di Pesto (Six Views of the Ruins of Paestum)
[Naples]: Filippo Morghen, 1765

Inscribed on verso of each plate: "P. Y."
Shown: Filippo Morghen after Antonio Jolli (1700–1777), *Veduta interior del tempio esastilo i petro dalla parte di Levante*, 1765, engraving
Bound with *Le antichità di Pozzuoli, Baja, e Cuma* (Antiquities of Pozzuoli, Baiae, and Cuma)
[Naples]: Filippo Morghen, 1769
Real Academia de Bellas Artes de San Fernando, Archivo-Biblioteca, B-30

The Greek temples at Paestum, located in a valley sixty miles south of Naples, had been "discovered" in 1746. Contemporary responses to the site registered the disparity between the stunning situation of the temples and the almost shocking heaviness and simplicity of their unadorned Doric order—a very different form of classicism than seen in Rome. Nonetheless, the site rapidly became popular with tourists and artists, as is indicated in the plate shown here. Eight illustrated accounts of the temples were published between 1764 and 1784. Morghen's series of engravings, which were published without an accompanying text, are dedicated to Frederick Calvert, sixth Baron Baltimore, the author and libertine who had traveled to the Levant in 1763–64. They are based on paintings made in 1759 by Antonio Jolli, painter to Carlos de Borbón, king of Naples and Sicily (and subsequently Carlos III of Spain). It

has been suggested that the inaccuracies in Jolli's renditions of the temples indicate he may not have visited Paestum himself, but instead based his drawings on engravings by Francesco Bartolozzi, who had worked on the first publication of the ruins and established a school of engraving in Rome that was attended by Filippo Morghen's son Raphael.

Morghen and his brother Giovanni, natives of Florence, were brought from Rome to Naples in the 1750s by the king. The arrival of Sir William Hamilton as envoy extraordinary to the court in 1764 provided the Morghens with a new patron and with a connection to antiquarian circles in England, including the Royal Society for the Encouragement of Arts, Manufactures and Commerce (known as the Royal Society of Arts), to which *Antiquities of Pozzuoli, Baiae, and Cuma* is dedicated; individual plates in both series are dedicated to members of the Royal Society of Arts, to other British patrons who traveled in the region during the 1760s, and to friends of Hamilton, all probably through Hamilton's influence. EH

REFERENCES: Lang 1950, 48–64; Raspi Serra 1986; Jenkins and Sloan 1996, 164; de Jong 2010, 334–51.

47

GIOVANNI BATTISTA PIRANESI (1720–1778)

Carceri d'invenzione di G. Battista Piranesi archit[etto] vene[ziano]
[Rome], 1761

Shown: Title page (47a); also illustrated: pl. VII (47b)
Etching
Real Academia de Bellas Artes de San Fernando, Archivo-Biblioteca, A-1077

The *Carceri* (Prisons), for all their considerable impact on the arts and literature over the last 250 years, are among the most intimate and personal works of Giovanni Battista Piranesi's architectural thinking and fertile imagination. When first published anonymously in Rome through the printseller Giovanni Bouchard in 1749–50 as *Invenzioni Capric. di Carceri all acqua forte*, the group of fourteen etched plates of imaginary prison interiors represented a marriage between the architect's Venetian origins in architecture and theater design and his fresh experiences of monumental Rome. Hastily sketched onto the waxed plates in a highly idiosyncratic style, these *capricci*,

VEDUTA INTERIORE DEL TEMPIO ESASTILO IPETRO DALLA PARTE DI LEVANTE.
Segnato nella veduta generale. lettera f.

46

or fantasies, arose from a creative crisis when
confronted with the stimulus of heroic antiquity and
lack of architectural commissions for his fertile
imagination. He transformed the subject of prison
interiors (a common theme in contemporary stage
design) into an abstract language of naked masonry
and endless space, often introducing conflicting
perspectives with no means of escape.

These arcane plates were included in a combi-
nation volume of the artist's fantasies, the *Opere
varie* (Miscellaneous Works), first published in 1750
and the title of this folio volume bound in white
vellum, probably acquired by Basset. Two fourteen-
volume sets of Piranesi's prints were on the *West-
morland*, however, one belonging to Bassett, the
other to Penn Assheton Curzon. It is impossible to
say definitely to whose set this volume belonged. In
1761, from his new printmaking establishment at
Palazzo Tomati, Piranesi reissued the plates in their
definitive version as *Carceri d'invenzione* (Imaginary
Prisons), with the addition of two new compositions
and his name on the title page, exhibited here.
Now fiercely involved in the Graeco-Roman debate,
Piranesi was also forging a radical contemporary

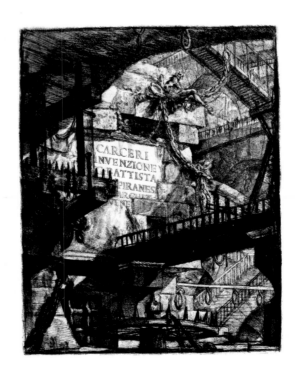

47a

47b

language of design involving ornamental complexity and highly eclectic sources from antiquity. The new version included in this copy of the *Opere varie* contains a major degree of intensive reworking, with heightened tonal contrasts and more explicit definition of structure. Structural immensity and spatial ambiguity are amplified by the addition of further staircases, galleries, and roof structures receding into infinity. The macabre and the sinister are emphasized by chains, gallows, and instruments of torture, while in the two added plates compositional balance is sacrificed to an almost hysterical plethora of motifs and inscriptions celebrating early Roman history.

The appearance of this iconic work, on which the artist continued to work into the late 1770s, is a valuable documented early instance of the second edition being in circulation. The *Carceri* had begun their momentous journey of influence through the collectors on the Grand Tour and the stage designers, writers, and poets of Romanticism to the film directors, set designers, and architects of our own era. JW-E

REFERENCES: Wilton-Ely 1978, 81–91; Robison 1986, 37–58, 138–210, 212–13; Gavuzzo-Stewart 1999.

48

ROBERT PRANKER (ACTIVE 1750–74)
AND THOMAS WHITE (CA. 1730–CA. 1775)
AFTER FRANCIS SMITH (ACTIVE 1763–80)

Turkish Dress
published February 20, 1769

Shown: *The Dances or Rather Devotions of the Dervises and Inside View of the Temple at Pera in Constantinople*
Engraving
Real Academia de Bellas Artes de San Fernando, Archivo-Biblioteca, B-58

This volume comprises a bound set of prints by various engravers after paintings by Francis Smith, who in 1763 accompanied the scholar and libertine Frederick Calvert, sixth Baron Baltimore, on a tour of the Levant (including Greece) and Poland. The volume is described in the Antonio Ponz inventory of 1784 at the Real Academia (cat. 14) as "Otro quaderno con 28 estampas, y plan de Constantinopla, que representan funciones de aquella Corte, trages turcos, griegos, y Polacos" (another album with twenty-eight prints, and a map of Constantinople, which depict ceremonies of that Court, Turkish, Greek, and Polish costumes). The majority of the prints portray ceremonies and officers of the court of Constantinople, as well as common people, in keeping with a long European tradition of identifying hierarchies and types through costume, from the grand signor giving audience to the *boustangi* (gardener) and *arshi* (cook of the seraglio), and a Turkish lady going with her slave to the bath. Several of Smith's pictures of Turkish subjects are similar in composition to the series made by the French painter Jean-Baptiste Vanmour, who spent most of his career in Constantinople and whose images of Ottoman court and customs were engraved and published in the *Recueil Ferriol* in 1712. The prints included here, each engraved "from the collection of Lord Baltimore," were published in London in 1768 and 1769. The map of Constantinople, including the Pera district, and the first plate are missing from this copy, although it is clear that they were present at the time of Ponz's inventory. The whirling dance of the Sufi Muslim ascetics known as dervishes, shown in the illustration, was a ceremony intended for the attainment of religious ecstasy; it had become an attraction for tourists.

During the eighteenth century the tour of

48

Asia Minor and the eastern Mediterranean became increasingly popular as a second circle of the classical Grand Tour. It is possible that Basset brought this portfolio with him from London, intending to travel farther. EH

REFERENCE: O'Donoghue and Dias 2004.

49

LAURENCE STERNE (1713–1768)

The Life and Opinions of Tristram Shandy, Gentleman in three vols.

London, 1775

Inscribed on front free endpaper of vol. 1: "P.Y." Real Academia de Bellas Artes de San Fernando, Archivo-Biblioteca, A-925

The three volumes of Laurence Sterne's *Tristram Shandy* were in the crate marked "F. Bt.," belonging to Basset. This crate also contained dictionaries,

49

grammar books, travel books, descriptions of Swiss glaciers, a copy in French of the *Life of Guzmán de Alfarache* by Mateo Alemán, and twenty-one prints of Sicily, Paestum, and other subjects. In Antonio Ponz's inventory of the books arriving at the Real Academia in the second consignment (cat. 14), Sterne's work is described in the list of books as "Otro ingles dela Vida, y opinions de Tristram Shandi" (another in English on the Life and Opinions of Tristram Shandy).

Sterne's great comic novel was originally published between 1759 and 1767 in nine separate volumes. The book was an immediate success. After the publication of the first volume, James Boswell noted famously, "Who has not 'Tristram Shandy' read? / Is any mortal so ill-bred?" Within weeks of his arrival in London in 1760 as a literary sensation, Sterne had his portrait painted by Joshua Reynolds. The image was immediately engraved by Simon François Ravenet as the frontispiece for Sterne's *Sermons*; it appeared later in dozens of editions of *Tristram Shandy*, including Basset's copy shown here. This edition of 1775, with no publisher noted, appears to be an unauthorized publication. (Sterne's publisher Robert Dodsley did issue an edition in 1775, the tenth, but it is not this one.) EF

REFERENCES: Ross 2001; Westmorland 2002, no. 44 (entry by María del Carmen Alonso Rodríguez); Gerard 2006.

50

50

JOHN TRUSLER (1735–1820)

Chronology, or, The Historian's Vade Mecum, 8th ed.

London, 1776

Inscribed opposite title page: "Wm. Sandys. 1776"; "PY"

Real Academia de Bellas Artes de San Fernando, Archivo-Biblioteca, B-2372

Although the Reverend William Sandys's copy of *Chronology, or, The Historian's Vade Mecum* was the only one on board the *Westmorland* and, most likely, one of the few brought on the Grand Tour by travelers, this concise history of England enjoyed a wide circulation at home. A Church of England clergyman who engaged in the book business, John Trusler became a prolific author first by creating compilations and abridgments of previous authors' works and then by publishing his own memoirs and essays. An obituary stated uncharitably that while not all of his books "attain[ed] great praise . . . a few of them, at least, claim[ed] the merit of utility." Trusler's *Chronology* was popular enough to go though many editions. Sandys owned the eighth, which he heavily annotated, making corrections and adding information throughout the volume. In one instance he updated the book to reflect recent news: in a listing of "Cofferers" on page 240, he added, "dead 1776" beside the text "Jeremiah Dyson, esq., 1774" (Dyson had been appointed "cofferer of the household," a political appointment, in 1774). As tutor to Basset, Sandys may have been motivated to bring along books about England by his pedagogical role or by their use as reference for comparative purposes when studying Continental history. The equally high number of Italian history texts points to a special interest in the role of history in his pupil's education. KC

REFERENCE: Annual 1822, 6:453.

JOHANN JOACHIM WINCKELMANN (1717–1768)

Lettre de M. L'Abbé Winckelmann: Antiquaire de Sa Sainteté, a Monsieur le Comte de Brühl, Chambellan du Roi de Pologne, Electeur de Saxe, sur les découvertes d'Herculanum. Traduit de l'Allemand

Dresden and Paris: N. M. Tilliard, 1764

Real Academia de Bellas Artes de San Fernando, Archivo-Biblioteca, A-762

The second trip that Johann Joachim Winckelmann took to Naples with the aim of learning about the new discoveries at the excavations in Herculaneum, Pompeii, and Stabia occurred during the carnival period in 1762. His impressions of this trip are recorded in a letter to Count Heinrich von Brühl, which was published in German in Dresden that same year. The criticisms set out in Winckelmann's letter caused a serious commotion in Naples, given that in addition to the works of classical art, he commented on a complete range of issues relating to the excavations, including the individuals involved in them. His letter reached its maximum audience, however, on its translation into French in 1764, and a copy of this publication belonged to either Basset or his tutor, the Reverend William Sandys. By 1771 it had been translated into English, suggesting that this Paris edition could have been acquired while Basset and Sandys were traveling.

It was again during the carnival period, this time in 1778, that these English travelers visited the places described by Winckelmann, taking with them a copy of his text, to which they added their comments. These annotations were made at different times, with those inserted during the trip marked in pencil; other, more reflective remarks in pen were probably written after the visits.

During the visit to Pompeii, on page 19, where Winckelmann notes, "Je ne trouvai dans mon dernier voyage que huit hommes au travail" (On my last trip I found only eight men at work), the owner of this text has written, "1778: le même" (1778: the same). However, in the scrupulous accounts compiled at Palazzo Reale in Portici, from which the archaeological excavations were managed, it is noted that twenty workmen were employed at Pompeii that year, one of whom was ill, while there were eleven at Stabia and two at Herculaneum.

In the section of the text on the Museo Ercolanese in Portici, next to the description of the amphorae and dolia, the name "Townley" is written (51b).

51a

51b

Charles Townley owned various large vases of these types, in addition to a relief in which a faun carries an amphora. The book's owner evidently reread the entire text later in a more careful manner, listing the rooms and marking in ink the objects seen. These marginal comments reveal a profound interest in antiquities and their discovery. In addition to the handwriting, there is other evidence that all points to Sandys as the author of these comments. MCAR

REFERENCES: Winckelmann 1771; Ellis 1846, 1:104,155–56; Sánchez-Jáuregui 2002, 125ff.; Westmorland 2002, no. 46 (entry by María del Carmen Alonso Rodríguez); Archivio di Stato, Naples, Casa Real Antica files 1232, 1236.

Crate Unknown

PROBABLY OWNED BY FRANCIS BASSET

52

JACOB MORE (1740–1793)

Bay of Naples and Vesuvius

ca. 1778

Watercolor with pen and ink over graphite on paper
17 x 26¼ in. (43.3 x 66.7 cm)
Inscribed on mount, upper left: "No. 7"; on verso:
"Napoles"
Real Academia de Bellas Artes de San Fernando,
Museo, D-2614

53

JACOB MORE (1740–1793)

Terracina

ca. 1778

Watercolor with pen and ink over graphite on paper
14 x 19½ in. (35.5 x 49.6 cm)
Inscribed on mount, upper left: "No. 8"; on verso:
"Vista de Posilipo"
Real Academia de Bellas Artes de San Fernando,
Museo, D-2615

Although it has not been possible to associate these two watercolors with any of the descriptions in Antonio Ponz's inventory (cat. 14), it seems almost certain that they entered the collections of the Real Academia as part of the contents of the *Westmorland* and further that they had most likely been acquired by Francis Basset, through the offices of his tutor, the Reverend William Sandys.

The Scottish painter Jacob More was in Rome by 1773 and remained based there until his death in 1793. During Sandys's first stay in Italy, he got to know More, and the two men remained friends. Between 1776 and 1779, More painted six watercolors for Sandys, which were copied by Richard Cooper in a sketchbook inscribed, "Six views in Italy by Jacob More — Sent to England for the Revd. Mr. Sandys, Cornwall. copied by Richard Cooper / To be Kept. R. C." (Birmingham Museum and Art Gallery;

the location of More's original drawings is not known). Drafts of several letters to Sandys appear in More's letter book for the years 1786–87 (Laing.IV.25, Department of Manuscripts, Edinburgh University Library), referring both to prints and drawings being sent to More and to paintings More had undertaken for Basset and Sir William Molesworth. Basset owned a pair of paintings by More: *View of Tivoli* and *The Waterfall at Terni* (present locations unknown).

Toward the end of September 1778 More traveled to Naples with the young British architects Thomas Hardwick, John Henderson (not Henderson of Fordell, who had possessions on the *Westmorland*), and Robert William Furze Brettingham to view the eruption of Vesuvius. In Naples they met Thomas Jones, with whom they toured the environs. In his memoirs Jones noted: "We were amused with *More's* flying Sketches as he call'd them—for tho' none of the Company waited a moment for him, he contrived to keep up with the party & brought back a dozen *Views* & these were to pass as *portraits* of the respective Scenes." Presumably More's watercolors of Terracina and the Bay of Naples were based on the "flying sketches" from this trip. Both compositions are known in other versions. SW

REFERENCES: T. Jones 1946–48, 79–80; Andrew 1986b, 26–41; Andrew 1989–90, 105–96; Westmorland 2002, nos. 59, 60 (entries by María Dolores Sánchez-Jáuregui).

52

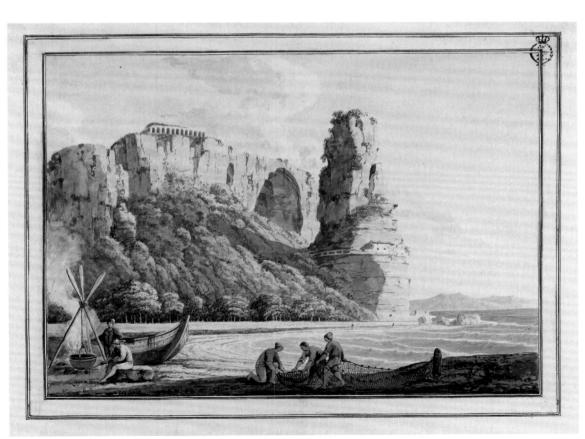

53

Crate L. B.

OWNED BY LYDE BROWNE

Lyde Browne (d. 1787) was an important antiquarian and collector of ancient sculpture, gems, and old master paintings. From 1752 he was a fellow of the Society of Antiquaries of London and from 1780 a member of the Society of Dilettanti; at the time of the *Westmorland*'s capture, he was a director of the Bank of England. Browne's collection of marble sculptures, which he amassed at his villa in Wimbledon, was an influence on the collector Charles Townley, with whom Browne corresponded and socialized, and to whom he sold a number of marbles. Browne traveled to Rome in 1753 and made contact with Thomas Jenkins, the dealer who not only would serve as Browne's agent but also sent letters and drawings to the Society of Antiquaries, which Browne read at its meetings. In 1776–77, in search of further acquisitions, Browne traveled with his family to Rome, where his daughter's portrait was painted by Pompeo Batoni. The two crates on the *Westmorland* belonging to Browne presumably constituted a portion of the acquisitions he made on this second trip. One contained four "Alabaster" statues of goddesses; the other, two boxes of artificial flowers, "very small and finely made," and a packet of prints, addressed to the Royal Society of Arts in London, now identified as *La natura, e coltura de' fiori . . .* by Filippo Arena. Browne published two catalogues of his sculpture collection in 1768 and 1779, and eventually he sold the bulk of the collection to Catherine the Great in 1785 for £22,000. EH

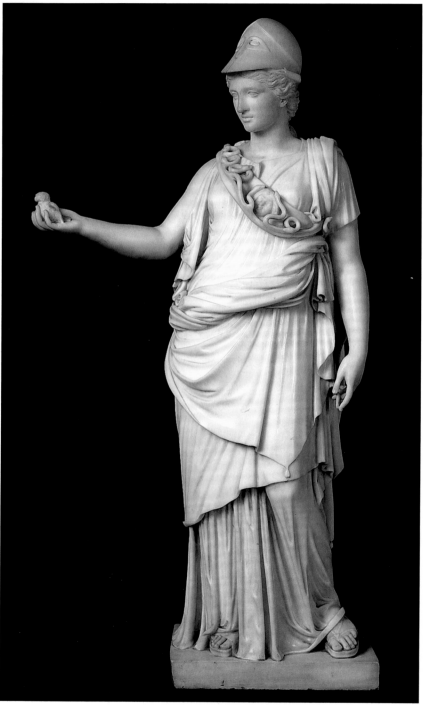

54

54

Minerva
1770s

Marble
30⅜ x 16½ x 12¼ in. (77 x 42 x 31 cm)
Real Academia de Bellas Artes de San Fernando,
Museo, E-87

This small, reduced-scale sculpture, which was in the crate marked "L. B.," depicts a standing Minerva with her right arm extended holding an owl and her left arm parallel to her body, once supporting a lance. The goddess wears a Corinthian helmet set back off her face and an aegis with snakes that crosses her breast, falling from her right shoulder. Neither the latter detail nor other small ones are found in the standard iconography of Minerva.

The present work is a copy of a life-size classical sculpture acquired in Rome in 1765 by William Weddell, member of Parliament for Hull. Weddell had unexpectedly inherited a large fortune at the age of twenty-six and consequently decided to undertake the Grand Tour and assemble an important sculpture collection. In order to install it in the manner fashionable at the time, he commissioned Robert Adam to design Newby Hall near Ripon, Yorkshire, for him. This rectangular building has three large rooms designed and decorated in the Neoclassical taste and specially conceived for the display of sculptures. Among the highlights of Weddell's collection were a *Venus* and an *Athena* (or *Minerva*) acquired from Thomas Jenkins, which were installed in the same room in opposite niches.

This *Minerva* is notably similar to the one in the Henry Blundell collection, which was said to come from the Villa Lante in Rome. It has the same expression and attribute in the right hand but with iconographic differences in the aegis and garment.

Adolf Michaelis's catalogue and study of surviving sculpture galleries in private British collections included a detailed description of the Newby Hall *Athena*, which he judged to be undoubtedly authentic. Nonetheless, he drew attention to the goddess's untypical garment, which he considered closer to the type worn by Roman matrons. He also noted that the head did not belong to the torso and was carved from different marble.

The small sculptures on the *Westmorland*, which

also included two sets of *Bacchus and Ariadne* and *Cupid and Psyche*, one also belonging to Lyde Browne and the other to William Henry, Duke of Gloucester (cats. 95 and 96), and an *Amazon*, belonging to Browne as well, have been attributed to Carlo Albacini or to Bartolomeo Cavaceppi, who were the most active sculptors in Rome at the time of their acquisition. No documentation on their purchase survives. It should be borne in mind that Joseph Nollekens, who worked in Cavaceppi's studio, was also involved in the restoration and sale of the Newby Hall sculpture and that workshops such as Cavaceppi's frequently reproduced the same work in different materials and sizes for the art market. The attribution to Albacini of the sculptural groups intended for the Duke of Gloucester's chimneypiece (see cats. 95 and 96) makes the further attribution of Browne's group of small sculptures to Albacini seem likely. JMLN

REFERENCES: Michaelis 1882, 529; Ashmole 1929; Neverov 1984, 33; Coltman 2003, 371–96; Worsley, Bristol, and Connor 2004, 51; Coltman 2009, 145.

55

La natura, e coltura de'fiori: Físicamente esposta, 3 vols. bound in 2
Palermo: Angelo Felicella, 1767–68

Real Academia de Bellas Artes de San Fernando, Archivo-Biblioteca, B-2956 (vol. 2)

Filippo Arena, a Jesuit professor of mathematics and philosophy at the university in Palermo, Sicily, produced many works on natural history. He read widely and knew the work of colleagues elsewhere in Europe, including that of the great Swedish botanist Carl Linnaeus. Indeed, *La natura* is addressed not only to "florists" but to scientists as well, in particular "botanists, physicists, and agriculturists." Arena's text describes experiments from direct observation of the fertilization of flowers through pollination by means of their insect visitors, a "remarkably advanced dissertation on the sexual generation of plants, including the function of pollen and the importance of its transmission by insects." This was well before men such as Joseph Gottlieb Kölreuter and Christian Konrad Sprengel reported their discoveries.

Arena described in some detail how to set up a flower garden. He suggested first seeking a flat, sunny piece of ground, well sheltered from harsh winds, with

55a

55b

good soil and an abundant source of water. He was not fond of elaborate French parterre, declaring the design too impractical; he suggested that a flower bed be laid out as a regular polygon and surrounded by a narrow path, permitting the flower lover "full enjoyment of all the flowers" while at the same time allowing the gardener access to every plant.

Arena's significant contributions to the history of botany and horticulture appear to have been largely forgotten, and his work is known only to a handful of contemporaries—likely because of the distance from Palermo to major intellectual centers in Europe. It is certainly interesting that the work was acquired by the banker Lyde Browne; it is not known if he had a particular interest in natural history or was acquiring it for someone else. EF

REFERENCE: Tomasi 1997.

Crate W. Ce.

OWNED BY WILLIAM CONSTABLE

William Constable (1721–1791) came from an old Yorkshire Catholic family; many of his acquisitions in Italy were made for Burton Constable, the Elizabethan manor house that he remodeled in the 1760s. Constable is known to have been in Naples and Rome in 1750 and 1765, but his tour in 1770–71 with his sister Winefred is well recorded. They traveled from Turin to Milan, Florence, Naples, Rome, and Bologna before returning to Yorkshire via Milan. In Rome Constable, a man learned in the fine arts in addition to natural and experimental philosophy, took up a daily study of antiquities with James Byres: "the morning till 12 to myself. Then Mr Byres & Antiquity & Pictures & Sculpture till four or Later." In addition to cameos, copies after old master paintings by Guido Reni and Annibale Carracci, and works by Giovanni Battista Piranesi— who dedicated plates in *Vasi, candelabri, cippi, sarcofagi, tripodi, lucerne ed ornamenti antichi* to Constable and his sister—Constable's purchases in Rome included a portrait by Anton von Maron of him and Winefred as the Roman orator Cato the younger and his wife Marcia. The copy of a portrait of his cousin Lady Anne Clifford by Pierre Subleyras was the only object on the *Westmorland* belonging to Constable. He continued to correspond with Byres and to purchase works through him in the 1780s. EH

56

GIOVANNI DOMENICO CHERUBINI (1754–1815)
AFTER PIERRE SUBLEYRAS (1699–1749)

Lady Anne Clifford
1778

Oil on canvas
39 x 28¾ in. (99 x 73 cm)
Real Academia de Bellas Artes de San Fernando, Museo, 548)

This picture is a copy by Giovanni Domenico Cherubini of the portrait of Lady Anne Clifford by Pierret Subleyras of 1740 (Musée des Beaux-Arts, Caen). The copy was painted in 1778 for Anne Clifford's cousin William Constable and dispatched by James Byres on the *Westmorland* the same year.

Lady Anne had married the Franco-Irish Count James Mahony in Paris in 1739, before settling in Italy, where she was painted by Subleyras, the following year. She probably met Constable while he was visiting Italy in 1770, a trip he undertook with his sister ostensibly for his health but also in part to acquire works for his Yorkshire house, Burton Constable Hall. In Rome Constable engaged James Byres in February 1771 as his cicerone and collected widely through him; on his departure in April, Constable left a series of commissions, which are detailed in the surviving correspondence and accounts from Byres. Byres also kept Constable up-to-date on news of his cousin and her family in Italy. In a letter dated April 1774, Byres informed Constable that Anne's second husband, "Don Carlo Severino," who was "at least some twenty years younger than she is, and was reckon'ed a little flighty," had gone "quite mad. the physicians have little hope of his recovery."

The idea of commissioning a copy of Subleyras's portrait probably came while Constable was remodeling Burton Constable Hall. On November 24, 1778, Byres wrote to inform Constable that "the copy of Lady Ann Severinos portrait, in the Giustiniani

56

Palace was finish'd some months ago. It is on a ship at Leghorn which is waiting to sale [*sic*] this month." Shortly afterward Constable recorded payment of 24.60 sequins to "Cherubini / a scholar of Maron's / for a copy of the Countess Mahoni's portrait by Subleyras," and a further 9.75 sequins for packing and transporting the painting to Livorno. While in Rome Constable had been painted by Anton von Maron; it was therefore natural for Constable to entrust the commission to him or one of his followers. Cherubini, who trained with Maron, is perhaps better known as the brother of Caterina Cherubini, the miniaturist and wife of the director of the Academia de España in Rome, Francisco Preciado de la Vega. The picture, placed on board the *Westmorland*, never reached Constable, instead entering the collection of the Real Academia, where it was erroneously identified as being a portrait of Bárbara de Braganza, wife of Fernando VI of Spain.

In 1785 Constable ordered a replacement copy through Byres, this time from Pompeo Batoni (fig. 122). At the same time he commissioned Batoni to paint portraits of Lady Anne's daughter Cecilia (National Galleries of Scotland, Edinburgh) and son-in-law, Principe Benedetto Giustiniani (private collection). In a long letter dated June 11, 1785, Byres informed Constable that Batoni's portraits would cost "one hundred Zuchins for the two originals and thirty Zuchins for a copy of the Countess," a similar price to that paid to Cherubini. JY

REFERENCES: I. Hall 1970; Clark and Bowron 1985, nos. 454, 456, 457; Retford 2006, 164–65; De la Cruz Alcañiz 2009; Suárez Huerta 2009a, 81–92; James Byres, Rome, to William Constable, DDCC/145/6, East Riding of Yorkshire Archives and Local Studies Service, Beverley.

Figure 122. Pompeo Batoni, *Lady Anne Clifford, Countess Mahoni*, 1785, oil on canvas, 28 x 24 in. (71 x 61 cm). Burton Constable Hall, East Yorkshire

Crate P. C. or P. Cn.

OWNED BY PENN ASSHETON CURZON

Penn Assheton Curzon (1757–1797), the son of Assheton Curzon, first Viscount Curzon, and his wife, Esther Hanmer, was born in Rugeley, Staffordshire, and studied at Brasenose College, Oxford. Although the details of his Grand Tour are unknown, a "Mr. Curzon" was in Rome for the Christmas of 1777 and March and December of 1778. The books and maps in his crates suggest that the tour included stops in France, Switzerland, Italy, and Germany. Curzon's crates included Gavin Hamilton's *Schola Italica Picturae*; a fourteen-volume set of the works of Giovanni Battista Piranesi; Latin, French, and Italian dictionaries; a map of Rome by Giuseppe Vasi; prints after Raphael's *School of Athens* and *Transfiguration* and of the *Descent from the Cross* after Daniele da Volterra; and a wax portrait of Pope Pius VI, set in an oval box. After returning to England, Curzon became a member of Parliament for Leominster, Herefordshire, in 1784 and, three years later, married Sophia Charlotte Howe, Baroness Howe of Langar, with whom he had four children. He became MP for Clitheroe, Lancashire, in 1790 and for Leicester in 1792. CS

57

GIOVANNI VOLPATO (1740–1803), ENGRAVER;
STEFANO TOFANELLI (1752–1812),
BERNARDINO NOCCHI (1741–1812),
AND GIUSEPPE CADES (1750–1799), DRAFTSMEN,
AFTER RAPHAEL (1483–1520)

The School of Athens
1778

Etching with engraving
(sheet) 13 x 17¾ in. (33 x 45 cm)
Real Academia de Bellas Artes de San Fernando,
Archivo-Biblioteca, GR-2990

This etching with engraving is one of a series of eight plates by Giovanni Volpato based on the Vatican Stanze, painted in fresco by Raphael between 1510

and 1517 as a commission from Pope Julius II. The present plate was one of three copies transported in Penn Assheton Curzon's crates. There were a total of fifteen impressions of this print on board the *Westmorland*, belonging to six different owners: besides the three copies for Curzon, there were three copies belonging to George Legge, Viscount Lewisham; four copies acquired by Frederick Ponsonby, Viscount Duncannon; one in Francis Basset's crates; another one in crates marked "J. B." (tentatively identified as John Barber); and three more for the as-yet-unidentified individual whose initials are L. J. C. In addition, John Udny, British consul in Livorno, sent his brother Robert three prints of the Stanze.

In 1775, while still involved in the reproduction of the Vatican Loggia in print form, Volpato undertook the considerable endeavor of making a print after *The School of Athens*, directly based on the original. Some years later this project would give rise to the commission from Pope Pius VI to reproduce the complete series of the Vatican Stanze, based directly on the frescoes. Working with Volpato on this ambitious project were Stefano Tofanelli, Bernardino Nocchi, and Giuseppe Cades, who produced the drawings on which the prints were based. The eight plates that constitute the series were produced over a lengthy period and completed in 1784.

Graphically this series marks the high point of Volpato's artistic achievements, and he made full use of his technical skills, acquired in Venice from Francesco Bartolozzi. His use of a mixed technique of etching and engraving allowed him to reproduce the tonal contrasts and pictorial qualities of the original. Volpato first created the chiaroscuro effects in the background through the use of the aquatint ground, biting the plate several times so as to achieve graduated effects. The engraving, applied in simple or hatched strokes, forms a network of lines that conveys the impression of the glazes on the original painting through the variation in the distances between the engraved lines.

RAPHAEL SANTIVS PINX

IN AEDIBVS VATICANIS.

PIO SEXTO PONT. MAX.
BONARVM ARTIVM RESTITVTORI AC VINDICI D.D.D.

JOANNES VOLPATO

57

In his various studies on Volpato, Giorgio Marini has suggested that the prints after *The School of Athens* and the *Disputa* were completed in 1779, when Volpato presented hand-colored impressions of them to Pius VI. However, the presence of *The School of Athens* among the *Westmorland*'s cargo, which was seized in early January 1779 following many months of waiting before the ship's departure, provides a *terminus ante quem* for the print's completion, bringing it forward to 1778. This may also be the case with the *Disputà* if it was one of the three plates shipped to Robert Udny, which were vaguely described only as "three of the rooms by Raphael."

The School of Athens was one of Raphael's most admired works in the eighteenth century and was copied by artists such as Anton Raphael Mengs, Pompeo Batoni, and Joshua Reynolds, the latter

offering his own version in his *Parody of the School of Athens*. Volpato's image is one of the most commonly encountered prints in the *Westmorland*'s cargo, giving an idea of the popularity of publishing projects of this type, and Volpato's in particular, among the English art-loving public. In 1773 Barber wrote from Rome to the collector Charles Rogers on the availability of prints by Volpato, while James Northcote noted in his diary that Basset owned some of Nocchi's original drawings for Volpato's prints. MDSJ

REFERENCES: M. Hall 1997; Marini 1988; Marini 2003, 157–77.

58

ANNIBALE ANTONINI (1702–1753)

Dizionario italiano, latino e francese in 2 vols.

Lyons: Pietro Duplain, 1770

Inscribed opposite title page of each volume: "PY";
on title page: "P. A. Curzon"
Real Academia de Bellas Artes de San Fernando,
Archivo-Biblioteca, B-2323

Annibale Antonini based his multilingual dictionary
on a work issued by the Accademia della Crusca
(the society of linguists and philologists dedicated
to maintaining the purity of the Italian language) in
1729, adding more than two thousand words in the
Roman, Florentine, and Sienese dialects. Antonini
was one of the most important lexicographers of the
era, publishing some thirteen dictionaries between
1735 and 1804. Multilingual dictionaries such as this
one obviously would have been useful to travelers,
and indeed, some twenty-five different grammars
and dictionaries are found among the crates shipped
on the *Westmorland*. This copy is signed on the
title page by Penn Assheton Curzon. Its presence in
the crate marked with the initials "P. C." led to the
identification of Curzon as the owner of the contents
of this case. EF

REFERENCES: Lillo 2010, 189–205; Westmorland
2002, no. 39 (entry by María Dolores Sánchez-
Jáuregui).

59

GAVIN HAMILTON (1723–1798)

Schola Italica Picturae

Rome, 1773

Real Academia de Bellas Artes de San Fernando,
Archivo-Biblioteca, B-12

The painter, excavator, and dealer Gavin Hamilton
produced this lavish set of engravings after the
works of Italian sixteenth- and seventeenth-century
painters and had them bound as a single volume in
1773. The ambitious scheme involved seven engrav-
ers resident in Rome, and the thirty-eight plates,
plus an elaborate frontispiece incorporating a bust
of Minerva and two *ignudi* from the Sistine Chapel
ceiling, were executed over a five-year period.
Although the title page states that the prints were
chosen and engraved by Hamilton to give a summa-

58

tion of the Italian schools of painting, the genesis of
the project seems to have been less ambitious.

The earliest works, engraved in 1769, were all
paintings that Hamilton handled in his capacity
as an art dealer. These included two small canvases
attributed to Guido Reni and Jacopo Bassano, both
purchased from Hamilton by William Beckford of
Somerley Hall, a Reni of *Saint Jerome* in his own
collection, and Lodovico Carracci's *Birth of John
the Baptist*, which Hamilton dispatched to John
FitzPatrick, second Earl of Upper Ossory, in March
1770; all were executed by Domenico Cunego, who
had engraved several of Hamilton's own composi-
tions in the 1760s for sale in London. Cunego
specialized in producing reproductive prints for the
tourist market—several examples of his work were
on board the *Westmorland*, including a version of
Jusepe de Ribera's *Lamentation*, specifically
engraved with the arms of Henry Arundell, eighth
Baron Arundell of Wardour.

The decision to publish a volume of engravings
with a more didactic purpose came in about 1770.
No more of Hamilton's stock were included; instead,
leading engravers, such as Giovanni Volpato (as well
as less well known ones like François-Louis Lonsing),
created plates of famous examples of paintings
and frescoes by a limited number of celebrated
masters. The volume is arranged geographically by
painter, broadly following the traditional four
schools of Italian painting identified by French
classical theorists: Roman, Parmese, Venetian, and
Bolognese. This format and the choice of subjects
were designed to appeal to a British audience.

59

Hamilton chose paintings, such as the panels from the Sistine Chapel, that had not previously been engraved; conscious of the tourist market, he ensured that almost half the plates were of secular subjects, a fact noted by an Italian critic in the *Antologia Romana*. The four copies on board the *Westmorland* testify to the volume's popularity in Rome, and shortly after its publication Joshua Reynolds wrote to Benjamin West inquiring where it could be purchased in London. JY

REFERENCES: Irwin 1962, 98–99; Reynolds 2000, 48; Cesareo 2002, 211–322; Hopkinson 2009, 364–69.

60

WILLIAM HAMILTON (1730–1803)

Campi Phlegraei. Observations on the Volcanos of the Two Sicilies As They have been communicated to the Royal Society of London by Sir William Hamilton, K.B. F.R.S., His Britannic Majesty's Envoy Extraordinary and Plenipotentiary at the Court of Naples.
Naples, 1776

Shown at Oxford: Pietro Fabris, pl. VI, *View of the Great Eruption of Vesuvius from the Mole of Naples in the Night of the 20th of Octr 1767* (60a)
Shown at Yale: Pietro Fabris, pl. XXXVIII, *A Night View of a Current of Lava, that ran from Mount Vesuvius towards Resina, the 11th of May 1771* (60b)
Hand-colored etchings
Real Academia de Bellas Artes de San Fernando, Archivo-Biblioteca, B-3209, B-3210

Sir William Hamilton was responsible for three of the most beautiful books published in the eighteenth century: two with plates illustrating his famous collections of vases, and this publication on the volcanic fields around Naples, the Campi Phlegraei. Vesuvius erupted three times during the thirty-six years Hamilton spent in Naples. When the first activity began in 1765, he had telescopes set up at each of his villas around the city, making continuous careful observations and notes over the two years of eruptions. He made regular expeditions to its slopes and craters, with several very narrow escapes from its explosions, ash, and lava flows. He sent regular reports accompanied by his own illustrations to the Royal Society in London and developed theories about what caused the eruptions in their various manifestations. He was soon made a fellow of the society, and his reports were published in its *Philosophical Transactions* in 1772. In addition, in 1769 Hamilton had visited Etna, Stromboli, and the Lipari Islands to observe the volcanic activity there. He gathered specimens of lava and minerals from every site and sent the collection to the British Museum.

By 1776 he had also studied the older craters all around the Bay of Naples and had gathered all the material together for publication in the present lavish volume. It was illustrated with hand-colored engravings he had commissioned from the artist Pietro Fabris, about whom very little is known. Believed to have been born in London to an Italian father, he had settled in Naples and was making a

60a

60b

living from genre pictures and souvenir views of the city when Hamilton commissioned him to take views of the eruptions and the Campi Phlegraei under his careful direction. Hamilton reported to his nephew Charles Greville, an avid collector of minerals to whom he sent many specimens, that the book had cost him at least £1,300.

This was not only a beautiful but also a ground-breaking publication in its careful empirical observation and illustration. When another eruption began in August 1779, Hamilton quickly published a supplementary volume with five more colored plates. But unlike his books on vases—attractive to collectors, connoisseurs, and modern manufacturers

such as Josiah Wedgwood—the *Campi Phlegraei* was addressed to a very specialized audience, mineral collectors and volcanologists, and was an expensive rarity.

Among Grand Tourists the volumes would be most attractive to any with an interest in natural history and philosophy who visited Naples and accompanied Hamilton on his dangerous expeditions to the slopes of the volcano. We must assume that Penn Assheton Curzon was one such visitor, as he purchased his copy very soon after it was published and was sending it home on the *Westmorland* with a small collection of minerals (cat. 62). Another copy on the ship had been ordered by George Legge, Viscount Lewisham, after his visit to Naples early in 1778. KS

REFERENCES: Brown 1996, 39–43; Thackray 1996, 65–74, 128–29, 165–68; Westmorland 2002, no. 50 (entry by Ana María Suárez Huerta).

61

GIOVANNI BATTISTA PIRANESI (1720–1778)

Vedute di Roma disegnate ed incise da Giambattista Piranesi architetto veneziano
1778

Etching
Shown: *Veduta di Piazza di Spagna* (fig. 97, p. 139); also illustrated: title page
Real Academia de Bellas Artes de San Fernando, Archivo-Biblioteca, A-1071

The etched views of Giovanni Battista Piranesi acquired by Grand Tour travelers to Rome and its environs were among the most popular acquisitions for many decades and served to diffuse an image of the Eternal City that has lasted until the present day. After Piranesi's arrival in Rome from Venice in 1740, he radically transformed the souvenir view, or *veduta*, in a series of small etched plates. Between 1746 and 1748, however, his grandiose visions began to be transferred to a series of large plates of the 135 *Vedute di Roma*, issued singly or in batches throughout the rest of his life (with the sole exception of the collection *Magnificenze di Roma*, published in 1751). When Piranesi set up his printmaking business at Palazzo Tomati in 1761, helped later by his son Francesco, he was able to control the printing as well as to enhance further these magisterial images, which the collectors of the *Westmorland* acquired

61

there around the year of his death in 1778. The *Westmorland* episode, therefore, provides a valuable *terminus ad quem* in dating these particular impressions. The *Westmorland*'s cargo contained forty bound volumes and loose prints by Piranesi in various crates; the largest purchasers were Francis Basset, Penn Assheton Curzon, and Frederick Ponsonby, Viscount Duncannon, the first two acquiring a total of fourteen volumes each. Other clients of Piranesi represented in the cargo included John Henderson of Fordell; George Legge, Viscount Lewisham; "J. B." (tentatively identified as John Barber); and another unidentified person, indicated by the initials "L. J. C."

The two folio volumes represented here by one of them, bound in white vellum with gilded decoration on the spine and title in red leather, belonged either to Curzon or to Basset. They contain a carefully grouped series of *vedute* that provide a visual journey around the Eternal City. They also combine early and later views of the same monument (often exterior and interior), which indicate the artist's developing technique and changing intellectual preoccupations. Opening with a frontispiece and a plan of the city (ca. 1774), the sequence visits the great basilicas, the major piazzas, fountains, principal palaces and villas, bridges and other features on the Tiber River, the Capitoline Hill, the Roman Forum, the Trajan and Antonine Columns, the Colosseum, triumphal arches, aqueducts and baths, and the Pantheon. It then proceeds south of Rome to Cori, then toward Frascati and finally to Tivoli, where the so-called

Villa of Maecenas and Temple of Vesta, as well as the dramatic ruins of Hadrian's Villa, provide an impressive epilogue. Only missing from the complete set are its title page and two views, namely the exterior of the Portico of Octavia and the Arch of Trajan at Benevento. JW-E

REFERENCES: Robison 1983, 11–33; Wilton-Ely 1994, 1:176–312.

62

Four Mineral Samples

Basalt lava
with label: "35 Lava del anno 1776"
Sulfur
Calcite impregnated with sulfur
Sulfur with calcite
Museo Nacional de Ciencias Naturales, Madrid,
15931, 789, 787, 808

62a

Among the objects being sent home on the *Westmorland* by travelers, there were a few that spoke not to artistic taste but to an increasing interest in natural phenomena as part of the Grand Tour. The crate marked "J. B." (tentatively identified as John Barber) included a box "con piezas de varias muestras de piedras, petrificaciones, lavas del Vesuvio" (with samples of stones, fossils, pieces of lava from Vesuvius). One of the crates sent by George Legge, Viscount Lewisham, is also mentioned as containing "un Paquetico con varias petrificaciones y con algunos azufres" (a small package with some petrified rocks and sulfurs).

When the *Westmorland*'s crates arrived in Madrid, the Real Academia was sharing the same building (cat. 8) with the Real Gabinete de Historia Natural, which Carlos III had created by a royal decree of October 17, 1771. The Real Gabinete was created after the state had acquired the naturalist collections gathered by Pedro Franco Dávila in Paris. It is likely that the geological samples from the *Westmorland* were allocated to the Real Gabinete when the contents of the crates were distributed.

On August 3, 1895, it was decided that all scientific materials in the Real Gabinete should be moved from the building in the Calle de Alcalá to a new location, the Biblioteca y Museos Nacionales in the Paseo de Recoletos. The rocks and minerals were presumably moved at this time. The Real Gabinete collections were moved again in 1907, to the Palacio de la Industria y las Artes in the Paseo de la Castellana, the present location of the Museo Nacional de Ciencias Naturales, where some samples of lava from Vesuvius and sulfurs from southern Italy are still part of the collection. Although there is no definitive documentation proving their provenance from the *Westmorland*, it is highly probable that at least some of them belonged to this cargo.

The lava sample shown here, bearing a historical label in Italian, "Lava dell'anno 1776" (lava from the year 1776), refers to an eruption on February 1, 1776, that is, shortly before travelers connected with the *Westmorland* might have visited Naples. Frederick Ponsonby, Viscount Duncannon, and his tutor, Samuel Wells Thomson; Francis Basset and his tutor, the Reverend William Sandys; Lord Lewisham and his tutor, David Stevenson; and John Henderson of Fordell were all in that kingdom between 1777 and 1778. The three sulfurs on display, from the same date, come from the Solfatara in Pozzuoli, an obligatory Grand Tour stop because of the benefits of its medicinal waters. ANC

REFERENCES: Barreiro 1992, 509; Villena et al. 2009, 1170; Gomis 2011, 149.

62b

Crate E. B.

Frederick Ponsonby (1758–1844), Viscount Duncannon, was the fifth and only surviving son of William Ponsonby, second Earl of Bessborough, and his wife, Lady Caroline Cavendish, daughter of William Cavendish, third Duke of Devonshire. Connected to the leading Whig families, Lord Duncannon followed the example set by his father, who had amassed an important art collection on his own Grand Tour between 1736 and 1738. After attending Christ Church, Oxford, from 1774 to 1777, Duncannon set off on a Grand Tour with his tutor, Samuel Wells Thomson, who, like Francis Basset's tutor, the Reverend William Sandys, was an ordained minister of the Church of England. French grammars and dictionaries, plans of Paris and guidebooks, as well as maps and prints, suggest travel through both France and Switzerland before their arrival in Milan in November 1777. Duncannon and Thomson then traveled to Naples, Benevento, Rome, and on to Venice. During their journey Duncannon acquired numerous prints and maps; he also seems to have been a keen amateur artist, as exemplified by the many watercolors, probably by his own hand, contained within the crates. After their stay in Venice he and Thomson turned north, but the death of his tutor at Gratz (now Graz), Austria, on July 27, 1778, probably from consumption, signaled the end of Duncannon's Grand Tour. He returned to England and, in 1780, married Lady Henrietta Frances Spencer, daughter of John Spencer, first Earl Spencer, and the sister of Georgiana Cavendish, Duchess of Devonshire. His subsequent political career included serving as member of Parliament for Knaresborough, North Yorkshire, and a brief spell as lord of the Admiralty. In 1793 he succeeded his father as third Earl of Bessborough. CS

63

VINCENZO BRENNA (B. 1741)

A Ceiling Design in the Antique Style
1776

Watercolor and gouache over graphite on paper
20⅞ x 23½ in. (53 x 59.8 cm)
Inscribed lower right: "Vincenzo Brenna inv: et delineavit 1776"
Real Academia de Bellas Artes de San Fernando, Museo, A-5787

Both this and another drawing (cat. 64) by Vincenzo Brenna were evidently purchased by Frederick Ponsonby, Viscount Duncannon, and must have come from stock as they predate his arrival in Rome. Interest in Roman wall and ceiling decoration was high in the city at the time that Duncannon and the other *Westmorland* Grand Tourists were there, the Villa Negroni frescoes with their brilliant colors having been unearthed in July 1777. From the point of view of this drawing, however, it is the renewed interest in the subterranean rooms of the "Baths of Titus" (actually the Domus Aurea, or Golden House, of Nero) that is the immediate source of influence. A pioneering excavation had been made by the British architect Charles Cameron in about 1769, and Cameron's resulting folio volume, *The Baths of the Romans*, had been published in 1772. Two years later much more substantial explorations were begun at the initiative of the Roman picture dealer and publisher Ludovico Mirri, the results of which were published as *Le antiche camere delle Terme di Tito e le loro pitture* in 1776, with text by Giuseppe Carletti. He described the "straordinaria fatica" (extraordinary effort) shown by Brenna in spending several months underground scrupulously drawing the architectural and decorative parts of the ceilings and walls. Meanwhile the figurative parts of the Roman paintings were copied by the Polish artist Franciszek Smuglewicz.

In addition to the standard black-and-white

63

volume of *Le antiche camere*, Mirri produced a small number of copies of a deluxe edition, specially etched and hand-colored by Brenna, Smuglewicz, and the printmaker Marco Carloni. One of these volumes survives at Windsor Castle in the Royal Library of George III, for whom it was likely purchased by William Henry, Duke of Gloucester. The duke, brother of George III, was in Rome for six months in 1776–77, "dabbled in archaeology" at that time, and indeed had some possessions on board the *Westmorland*. Brenna's experience in making vividly colored versions of his original drawings of

walls and ceilings from the Domus Aurea doubtless underpinned his production of such fictive images as the two that were on the *Westmorland*.

The maroon ground of the border and four mandorlas here are similar to those of Brenna's rendition of the lunette in Room 23 in some versions of the hand-colored prints of the Domus Aurea, and the brilliant red, defining the outlines of the principal scenes, can also be found in his vision of Nero's palace. The olive-green ground, however, is for the eighteenth-century aesthetic sensibility, and the fact that some of the imagery relates to

antiquities that Grand Tourists could see in Roman collections further confirms that this drawing is from Brenna's imagination (it is, after all, inscribed "Brenna inv[enit]" as well as "delineavit"). In 2002 it was published as a record of an actual Roman mural decoration, whereas the shape and disposition of the design surely suggest a ceiling location.

The central tableau of this design shows the Judgment of Paris (with Mercury and Cupid in attendance), surrounded by grotesque sea beasts and crabs. Then comes a border of jesters' faces and griffins. Next are pairs of square and rectangular panels, featuring figures in mandorlas: the males are a dancing satyr with a lion skin (perhaps derived from the Dancing Satyr or Faun in the Musei Capitolini, with his tilted-back head) and Bacchus, surrounded by pairs of peacocks and griffins; the females are bacchantes—one with a garland, the other with a water vessel. Eagle-headed shields with figures on a turquoise ground show sacrifices to the gods at tripods or with a goat, all supported by sea beasts (derived in their form and color from those on plate 6 in colored versions of Mirri). Finally, in the corner spandrels are two male and two female figures. The males are Mars (the pose with hands clasping the raised left leg derived from the "Ludovisi," or "Resting," Ares in Palazzo Altemps, Rome) and a Genius with a Lyre; the females Cassandra and, possibly, a bacchante, both worshipping Minerva. The whole is set in a border of grotesques with centaurs at each corner.

Another ceiling design by Brenna of similar size (on Honig and Zoonen paper) was sent from Rome by the dealer Thomas Jenkins in 1791 to the wife of one of his most significant patrons, William Weddell, at Newby Hall, Yorkshire, "as an act of respect for this Ladys' taste" (offered for sale at Christie's in 2004). FS

REFERENCES: Joyce 1983, 423–40; F. Salmon 1993, 69–93; Vaughan 1996, 37–41; Westmorland 2002, no. 25 (entry by José M. Luzón Nogué); Christie's, King Street, sale 6926 (July 6, 2004), lot 91; Tedeschi 2011, 257–69.

64

VINCENZO BRENNA (B. 1741)

A Ceiling Design in the Antique Style

ca. 1777

Watercolor and gouache over graphite on paper
28⅜ in. x 20 in. (72 x 50.8 cm)
Inscribed lower right: "Vincenzo Brenna Arch. disegno 177[7]"
Real Academia de Bellas Artes de San Fernando, Museo, A-5788

This drawing, on paper watermarked "J. HONIG & ZOONEN," was first published in 2010 as a copy of a Roman wall decoration, but, like another drawing by Vincenzo Brenna (cat. 63), it is more likely an invented "design" in the antique manner and for a ceiling. The elongated shape and similarities with Brenna's drawings of corridor ceiling decorations in the Domus Aurea (Golden House) of Nero suggest that this design was promulgated for a corridor setting. The lateral Greek-key pattern does not appear in any of the ceiling drawings of the Domus Aurea executed by Brenna.

The central tableau shows a sacrifice with Bacchus on an ass accompanied by Pan and a satyr, two women, and Cupid. The scene is surrounded by herms, with pairs of peacocks and tripods with eagles (these relate to plate 44 in *Le antiche camere delle Terme di Tito e le loro pitture,* published by Ludovico Mirri in 1776). Then come panels with bacchantes in crimson mandorlas, closely modeled on those in the mandorlas in catalogue 63. They are supported by griffins and set between panels showing gods in chariots pulled respectively by four lions, two griffins, and two winged sea beasts. The fourth panel has a charioted herm being pulled by two stags. Finally. the two end panels have trophies supported by winged Victories and set between rampant panther grotesques, the whole being set in a double border of rinceau on red ground and a Greek key on green. FS

REFERENCES: Brook and Curzi 2010, no. II.3 (entry by Letizia Tedeschi); Tedeschi 2011, 257–69.

64

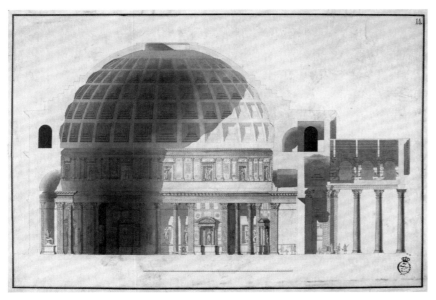

65

65

ATTRIBUTED TO VINCENZO BRENNA (B. 1741)

Longitudinal Section of the Pantheon from the East

ca. 1775

Pen and ink and watercolor on paper
20 x 28¾ in. (50.7 x 73 cm)
Inscribed upper left: "14"
Real Academia de Bellas Artes de San Fernando, Museo, A-4959

Evidently destined for the collection of either Frederick Ponsonby, Viscount Duncannon, or George Legge, Viscount Lewisham, this beautifully drawn and intriguing section of the Pantheon in Rome was part of a set on the *Westmorland* that also included a ground plan (see fig. 81, p. 126, almost certainly by the same hand) and an elevation of the north front; the latter, while on the same Honig & Zoonen paper and given the same scale, was surely by a different and less skilled hand, lacking the color and vitality of the section and the plan. Another version of the section (bearing Roman and English scales; Victoria and Albert Museum, London) was one of a number of drawings supplied to the collector Charles Townley in about 1775 by Vincenzo Brenna and this, coupled with the recent appearance in an exhibition at Palazzo Venezia, Rome, of a third version signed by Brenna, surely confirms that the *Westmorland* copy either was by Brenna or at least emanated from his studio.

The Pantheon is shown here as a classical temple,

the Christian elements that accreted since the building's seventh-century conversion to the church of Santa Maria ad Martyres having all been removed by the artist. Most obvious is the visual restoration of the central story of the Pantheon's internal elevation to the original Roman form, rather than the supposedly "improved" Neoclassical version that had been executed in 1747. Brenna must have depended on Renaissance textbooks for the ancient Roman detail but, as the prints in those were in black and white, also on painted records from before that eighteenth-century alteration, such as Giovanni Paolo Panini's *Interior of the Pantheon, Rome* (eight autograph versions of which were painted between 1730 and 1735), for the pinkish color of the pilasters and panels. The three columns of the portico shown should be the replacements added to the building by order of Pope Urban VIII in the seventeenth century, with Barberini family bees in the abacus flower of the capitals—but apparently they have also been restored here to their antique form. Of the classical gods present as statues, Neptune is clearly identifiable at the central recess of the west side (where the lighting effects are most dramatic, as seen by the shadow cast by the column). In the segmental niche south of that stands a figure possibly identifiable as Apollo. In the southern apse the figure must be Jupiter, as he holds a thunderbolt. He is illuminated by light that appears to emanate, Bernini-like, from some hidden aperture but that must, in fact, be reflected back from the interior of the dome opposite. Indeed, the lighting effect from the oculus has not been followed naturalistically, so that instead of modulated light we see half of the interior in bright sun and half in dramatic, deep gray shadow.

The staffage inside this ancient building consists of eighteenth-century persons, a common feature of interior views such as those painted by Panini but unusual in the context of a technical architectural drawing such as this section. The figures include two Grand Tourists with a dog (apparently a greyhound) at the center inside, a party of four (including a child) just entering, and four other adults in the portico—evidently including a liveried footman and a cleric, approaching two veiled children, who are perhaps begging. FS

REFERENCES: Vaughan 1996, 37–41; Bowron and Rishel 2000, 418–19; Misiti and Prosperi Valenti Rodinò 2010, 233–36; Tedeschi 2011, 257–69.

66

67

66

UNKNOWN ARTIST

Floor Plan of a Temple near Albano

1770s

Pen and ink and watercolor over graphite on paper
22½ x 17¾ in. (57.3 x 45.2 cm)
Inscribed in upper left corner: "1"; below drawing:
"TEMPIO ANTICO . . . Nella Via Appia vicino
Albano N.1"
Real Academia de Bellas Artes de San Fernando,
Museo, A-4718

67

UNKNOWN ARTIST

Elevation of a Temple near Albano

1770s

Pen and ink and watercolor over graphite on paper
18⅛ x 21¼ in. (45.9 x 53.9 cm)
Inscribed in upper left corner: "2"; below drawing:
"Nella Via Appia. Vicino Albano. N.1"
Real Academia de Bellas Artes de San Fernando,
Museo, A-4719

This plan and elevation were in a crate marked "E. B."
on the *Westmorland*. The plan reproduces that of a
"ruined temple outside Rome" included by Sebas-
tiano Serlio in Book 3 ("On Antiquities") of *Tutte*

l'opere d'architettura et prospetiva, originally
published in 1540. In the accompanying text, Serlio
explained that he had measured the ground plan in
Roman *palmi*, gave dimensions, described the shape
of the spaces (which he read as two interconnected
"temples" and four "chapels"), and, as no super-
structure had survived, hypothesized about internal
disposition and lighting. In addition to showing the
plan, Serlio offered sample internal elevations of
the opening between the larger and smaller "tem-
ples" and of the apse in the smaller, both with
square-coffered domes above. Lord Duncannon's
plan emulates Serlio's in all its particulars, except
that it introduces a pair of circular stairs within the
thickness of walls between the two rotundas and
provides the columns shown with bases. The plan
of the same building—in fact, almost certainly a
mausoleum rather than a temple—was drawn by
Renaissance architects on six other occasions,
according to Lynda Fairbairn. It is likely, however,
that the eighteenth-century architect took his ideas
not from these manuscript sources, or even directly
from Serlio (the scale and measurements do not
quite correspond with those specified by that
author), but instead from the studies of the architect
Giovanni Battista Montano, which were printed
posthumously by Montano's pupil Giovanni Battista
Soria and others in the 1620s and 1630s (and again,
in complete book form, by G. B. de Rossi in 1684).

Montano twice made use of this mausoleum plan in drawings now in the Bibliothèque Nationale, Paris, and in Sir John Soane's Museum, London, and two versions appear, respectively, as plate 16 in *Scielta di varii tempietti antiche con le piante et alzatte, designati in prospettiva* (1624) and plate XX in *Raccolta de templi, e sepolcri designati dall'antico* (1638; see fig. 90, p. 133). The former is captioned "from Serlio, who says he had drawn it in the Campagna of Rome," suggesting both that Serlio was Montano's source and that the building could no longer be located (so that the "near Albano" inscription on Duncannon's drawing may be erroneous). In this version Montano changed the plan, however, by increasing the depth of the portico and introducing one of the circular stairs. He also added a part-elevation, part-section hypothetical restoration of the building, replacing the coffers suggested by Serlio with ribs and strapwork of seventeenth-century Roman Baroque character. The version reproduced in the *Raccolta*, though captioned simply "Tempio Antico," is actually closer to Serlio, both in plan and in retaining the square-coffered dome, at least for the larger of the two round spaces, while the smaller space's dome, with ribs and oval panels, is modeled on the Temple of Portumnus at Porto, according to Fairbairn.

None of these drawings or prints provided the eighteenth-century architect responsible for Duncannon's "Temple" with evidence for the frontal elevation, beyond the mere presence of Corinthian columns and, in the case of Montano's *Scielta* plate 16, a large female goddess on top of the portico. The elevation was thus conceived as a miniature version of the Pantheon. A tetrastyle Corinthian portico (the entablature is not enriched) fronts the narthex and main rotunda, which has relieving arches in the brickwork in the manner of the Pantheon. The circular central space behind rises above to a cornice and two-stepped hemispheric dome. Possible small fissures in the columns and the vegetation sprouting from the oculus and various cornices hint at ruination (and the background architecture appears to show a ruined aqueduct). One should recall, however, that vegetation sprouts from the entablatures of churches in Rome even today, and in other respects this building is shown entire.

The way in which the building has been rendered, in terms of both the palette and the placement of the textured elevation against small glimpses of landscape perspective to left and right behind, calls for some comment. The method is close to that pioneered in the English context by William Chambers in elevations he began to prepare for clients in the late 1750s and early 1760s, with naturalistically weathered stonework, stormy skies, and wispy foliage. The style was picked up by Chambers's pupils, including John Yenn—who showed elevations of this type at Royal Academy of Arts exhibitions in London throughout the 1770s. Other pupils of Chambers, to whom this style will have been familiar, were Edward Stevens and Thomas Hardwick—both of whom were in Italy in the 1770s. Stevens, however, had died at Rome in 1775, and the handwriting on the drawings catalogued here is not Hardwick's, although his dates in Rome do overlap quite precisely with those of the *Westmorland* Grand Tourists. However, since Chambers had developed his style of showing antique buildings working alongside French architects such as Charles-Louis Clérisseau in Rome during the 1750s, this means of rendition was hardly unique to the British, and attribution of Duncannon's drawings to an Italian architect, especially given the scale bar and grammatically correct inscriptions, is equally possible. FS

REFERENCES: Worsley 1995, 190; Serlio 1996, 1:121–22; Fairbairn 1998, 2:541–44, 672–73, 749; Savage 2001, 201–16; Westmorland 2002, nos. 26, 27 (entries by José M. Luzón Nogué).

68

UNKNOWN ARTIST

Floor Plan of a "Temple" That Once Stood on the Site of Today's Church of San Sebastiano Fuori le Mura
1770s

Pen and ink and black and gray wash over graphite on paper
22⅝ x 17¾ in. (57.6 x 45.2 cm)
Inscribed in upper left corner: "4"; below drawing: "Nel Giardino dove e' oggi la chiesa di S. Sebastiano fuori le Mura. No. 2"
Real Academia de Bellas Artes de San Fernando, Museo, A-4406

68

69

69

UNKNOWN ARTIST

Plan/Elevation of a "Temple" That Once Stood in the Garden Surrounding the Present-Day Church of San Sebastiano Fuori le Mura

1770S

Pen and ink and watercolor over graphite on paper
22 x 17½ in. (56 x 44.4 cm)
Inscribed in upper left corner: "3"; below drawing: "Nel Giardino dove e' oggi la chiesa di S. Sebastiano fuori le Mura. No. 2"
Real Academia de Bellas Artes de San Fernando, Museo, A-4270

Clearly by the same hand as the drawings of the "Tempio Antico" on the Via Appia Antica near Albano (cats. 66–67), this plan and elevation were in the same crate marked "E. B." The building shown can be identified as the Tomb of the Attilii Calatinii, which stood on the Via Appia Antica at the crossing of the Via delle Sette Chiese to the left of the church of San Sebastiano fuori le Mura. (The identification of this family comes from epigraphs known at the time when Pirro Ligorio and a draftsman in the circle of Fulvio Orsini studied the tomb in the sixteenth century.) The inscription given on Lord Duncannon's drawings—"in the Garden where today stands the Church of Saint Sebastian Outside the Walls"—

is thus accurate and also confirms that the specific source for the architect here was plate XXXVI in Giovanni Battista Montano's *Raccolta de templi, e sepolcri designati dall'antico* of 1638, reprinted in 1684 (fig. 91, p. 132), because that plate's inscription also states that the tomb was situated "where today stands the church of San Sebastiano, within the garden where there are fountain basins." It goes on to state that the external order was Corinthian and that the interior had no order at all.

The architect of Duncannon's drawings followed Montano closely for the plan. However, where Montano's plan shows just a single circular stair in the drum where the rotunda meets the narthex, here symmetry is maintained by the addition of a second on the other side. Here, too, the details are enriched by the addition of column bases and answering pilasters that do not appear on Montano's version. At either end of the narthex the architect's plan shows the modern feature of window openings with pale gray wash, and these are absent from Montano's plan, as are the frontal steps. The steps, however, are based on those shown in the elevation given by Montano. Whereas his view shows the building in part section, elevation of half the portico and perspective of half the drum, the architect of Duncannon's drawing has rendered it in strict orthogonal terms—but with greatly enriched detail. Round-headed windows shown by Montano around the drum are also

omitted here. On this drawing, as with the "Tempio Antico" (cat. 67), ruination is hinted at by rough jointing between the stones (for both the portico and cella here appear to be fronted with ashlar, as opposed to the brick-faced concrete of the "Tempio Antico" example), and fragments of ruined Roman buildings are apparent behind to left and right. The growth of foliage is more conspicuous here, not just emerging from fissures and the oculus but also obstructing the inner doorway into the building.

This elevation and its matching plan were recently attributed by Susanna Pasquali to the Italian architect Giacomo Quarenghi on the basis of nine similar drawings now in the Cooper-Hewitt, National Design Museum, New York. Since the attribution of the Cooper-Hewitt drawings to Quarenghi is not itself certain, however, there is need for caution. In one of the New York drawings, published in 1978 and appearing to show the Tomb of Romulus (also near San Sebastiano on the Via Appia Antica) with a possible source in Montano, the handling of the masonry is indeed similar to that of the Duncannon elevation and some scenic effects are achieved by a cloudy sky. However, there are none of the contextual background ruins that characterize Duncannon's tomb and "Tempio Antico" elevations. They were, perhaps, specifically aimed at an English taste familiar with such scenic effects from Royal Academy of Arts exhibitions. FS

REFERENCES: Bernard 1978, 131–33; Fairbairn 1998, 2:658–59, 747; Pasquali 2007, 28–29.

70

JAMES BYRES (?) (1734–1817)
AFTER GEORGE DANCE (1741–1825)

A Geometrical Elevation of the Remains of a Tenple [*sic*] at Tivoli
1770s

Pen and ink and black, gray, and green washes over graphite on paper
20⅜ x 28⅝ in. (51.6 x 72.6 cm)
Inscribed in upper left corner: "6"
Real Academia de Bellas Artes de San Fernando, Museo, A-4722

This elevation of the so-called Temple of Vesta was accompanied on the *Westmorland* by a corresponding plan. There was also a reduced-size copy of both the plan and the elevation on the ship. It is unclear whether these two pairs of drawings were possessions of Lord Duncannon or of George Legge, Viscount Lewisham (who seem to have been traveling together for part of their time in Italy), but a logical conclusion would be that they had each purchased a set, since to have owned both pairs would seem superfluous.

The drawings are reduced-scale copies of those produced in Rome in 1763 by the British architectural student George Dance the Younger, who had surveyed this famous little circular temple at Tivoli in 1761 and again, working with an unnamed Italian architect (possibly Giovanni Stern), in 1762. When coupled with the recent appearance in the salesroom of yet another version of the elevation, slightly larger than the present drawing but this time signed "Ia. Byres. Fecit./1765," it is evident that all of these copies must have emerged from the factory that James Byres had been running during the previous decade, turning out copies of technical drawings of antiquities. Indeed, in 1797, the diarist Joseph Farington reported that Byres had borrowed Dance's survey, "copied it and sold a great number of copies of that as from his own measurement." The inscription "Byres. Fecit" and the absence of Dance's name on the foreground tablet in any of the copies confirms the story, and Dance must have come to regret not publishing the survey as he had intended, thereby establishing his authorship.

The *opus incertum* masonry of the temple's cella wall is shown clearly here, as are the capitals and frieze details. The elevation corresponds in most respects with Dance's drawing, the most significant difference being the omission here of the architrave inscription. In general, however, the draftsmanship here is not as fine as Dance's. He handled the crumpling contours of masonry, the crisp shading of fluting and capitals, and the landscape features—including the sprigs of foliage—much better. Indeed, the draftsman who produced this drawing is unlikely to have been Byres himself but rather an Italian assistant, as may be inferred from the misspelling of the word "Tenple" on the inscription. The smaller copy of the elevation that was on the *Westmorland* was by another hand again.

Byres was not the only person to have transgressed in his relationship with Dance's Tivoli drawings. Sometime between 1780 and 1784 John Soane also borrowed and copied them, supplanting Dance's name with his own and hanging his versions up in his house. Farington recorded three conversations between 1797 and 1810 in which Dance told this story—also giving Soane's explanation, which was that he had merely used Dance's work to confirm

70

his own studies. Indeed, it has been speculated that Soane's own survey work on the Temple of Vesta might have been among his possessions spilled on the road in Switzerland when his trunk burst open during his return journey in 1780. In 1794–95, however, Dance did not object to lending Soane the drawing of the capital a second time so that his pupils could reproduce it precisely for the Lothbury corner of the Bank of England in London. Finally, after Dance's death in 1825 Soane gained possession of the originals, which survive today in his museum. Having been much exposed to the light, however, the elevation is now in very poor condition, so the present drawing has an importance as an indication of the original coloration.

It might be wondered why Dance's survey drawings of the Temple of Vesta at Tivoli aroused quite such a level of excitement in the later eighteenth century. The answer lies in part in the long-standing celebrity of the building and its spectacular position, high on the cliff above the gorge of the Aniene River. It also lies in part in the particular character of British visitors, who were increasingly well attuned by the later eighteenth century to the picturesque and sublime possibilities of buildings in such scenic situations. Moreover, traveling architectural students such as Dance and Soane were bent on gaining a better understanding

of the form and dimensions of Roman antiquities than existed in the books they could consult at home. Dance indicated that part of his purpose was to correct the representation of the Temple of Vesta given by Andrea Palladio, and his measurements have been found to be extraordinarily accurate by the standard of the most recent surveys. This building from the Roman Republic (L. Gellius Poplicola, whose name appears in beautiful calligraphy on part of the surviving frieze, was consul in 72 BC) also presented an exemplar of the Corinthian order at small scale with a frieze and other details that sanctioned variety as a characteristic of Roman architectural design. Architects such as Dance and Soane were seeking just such variety, beyond the canonical understanding of classical practice, and Soane later told Royal Academy of Arts students that the Tivoli capital was "of very singular fancy and invention." He also commented that the order was "wonderfully adapted to its situation." In his own practice he adapted it for use many times, most famously in the paraphrase of the temple's surviving ellipse that appears as the curved "Tivoli Corner" at the Bank of England in 1803–5. FS

REFERENCES: Farington 1978–98, 3:767; 6:2122; 10:3610; Lever 2003, 66–71; M. Richardson 2003, 127–46; Suárez Huerta 2007, 4–19.

71

UNKNOWN ARTIST

Arch of Titus

1770S

Gouache on paper
17⅝ x 24⅜ in. (44.9 x 61.9 cm)
Inscribed on verso: "No. 16"; "Arco de Tito";
"No. 10. Duncannon"
Real Academia de Bellas Artes de San Fernando,
Museo, D-2603

72

UNKNOWN ARTIST

Temple of Vesta at Rome

1770S

Gouache on paper
11⅞ x 17⅛ in. (30.2 x 43.5 cm)
Inscribed on verso: "No. 26"; "Templo de Vesta?";
"Duncannon"
Real Academia de Bellas Artes de San Fernando,
Museo, D-2611

73

UNKNOWN ARTIST

Temples of Vesta and the Sybil at Tivoli

1770S

Gouache on paper
17¾ x 24⅜ in. (45 x 61.7 cm)
Inscribed on verso: "No. 12"; "Templos de Vesta y de
la Sibila en Tivoli"; "Mr. Thomson"
Real Academia de Bellas Artes de San Fernando,
Museo, D-2594

74

UNKNOWN ARTIST

**Temple of Antoninus and Faustina (Campo
Vaccino)**

1770S

Gouache on paper
18 x 24⅝ in. (45.7 x 62.6 cm)
Inscribed on verso: "No. 13"; "Templo de Antonino
y Faustina en la via sacra"; "Mr. Thomson"
Real Academia de Bellas Artes de San Fernando,
Museo, D-2595

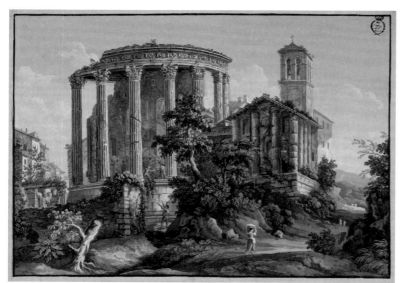

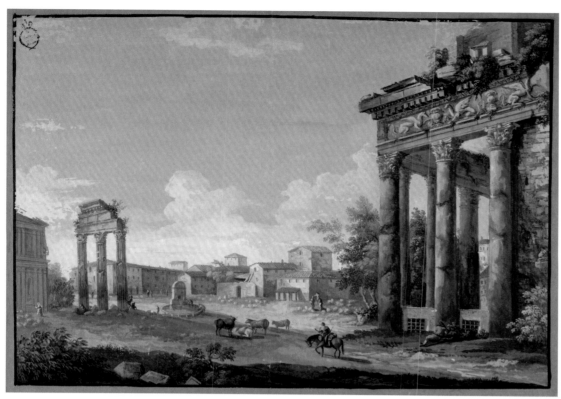

74

According to Antonio Ponz's list of the *Westmorland* artworks to be set aside and kept in the Real Academia de Bellas Artes de San Fernando (cat. 14), the contents of one of the crates marked "E. B." included, among much else, the following: "Nueve papeles grandes, coloridos de aguadas, de Varias antiguedades de Roma / Otros quatro mas pequeños del mismo asunto / otros quatro pequeños, idem con un dibuxo" (Nine large sheets, colored in wash, of Various antiquities of Rome / Another four smaller ones on the same subject / Another four smaller, ditto, with a drawing). Of these seventeen watercolor views, eight of the nine large views and all eight of the smaller views have been identified in the museum of the Real Academia; the identity of the "drawing" remains uncertain.

The presence of Lord Duncannon's name on the back of some of the views and Samuel Wells Thomson's name on the back of others suggests that the views were the acquisitions of both the young gentleman and his tutor. This is confirmed by the duplication of a number of the subjects, such as the temples of Vesta and of the Sybil at Tivoli and the Arch of Titus, the Flavian Amphitheater (known as the Colosseum), and the Temple of Antoninus and Faustina, all in Rome, with, in each case, one version inscribed "Duncannon" and the other "Mr. Thom-

son." What is interesting, and perhaps unexpected, is that in several instances Thomson's version is the larger and grander of the two.

Like the other set of souvenir views of Rome on the *Westmorland*, those in crate ⟨E⟩ (cats. 125–27), all the views in this group belonging to Duncannon and Thomson are of ancient Rome. Unlike the views in crate ⟨E⟩, which were finished in watercolor over etched outlines to facilitate multiple reproductions, these appear to be original paintings in opaque watercolor, or gouache. Not that these, any more than the watercolors in crate ⟨E⟩, would have been considered high-end aesthetic objects; they are workshop products, with stylistic variations through-out the group suggesting the involvement of a number of hands, valued for their combination of the documentary and the decorative. The sequence of numbering on the back, which dates from after arrival at the Real Academia, suggests that this group from crate "E. B." was combined and inter-mingled with the views from crate ⟨E⟩. sw

REFERENCES: Westmorland 2002, nos. 63 (entry by José Jacobo Storch de Gracia y Asensio), 64 (entry by Elena Castillo Rodríguez), 65 (entry by María Dolores Sánchez-Jáuregui).

75

75

Fan Depicting Venus and Nymph with Putti

1770s

Watercolor and gouache on vellum
6¾ x 12¼ in. (17 x 31 cm)
Patrimonio Nacional, Madrid, 10053187

76

Fan Depicting the Aldobrandini Wedding

1770s

Watercolor and gouache on vellum
6½ x 11⅞ in. (16.5 x 30 cm)
Patrimonio Nacional, Madrid, 10052943

77

Fan Depicting the Aurora

1770s

Watercolor and gouache on vellum
10⅝ x 19¾ in. (27 x 50 cm)
Patrimonio Nacional, Madrid, 10074271

78

Fan Depicting a View of St. Peter's Basilica

1770s

Watercolor and gouache on vellum
5¼ x 13 in. (13.2 x 33 cm)
Museo Nacional de Artes Decorativas, Madrid,
CE04864

The parchment leaves of these four fans are thought to have been among the eight recorded in one of Lord Duncannon's crates on the *Westmorland*, perhaps intended as a gift for his bride-to-be, Lady Henrietta Frances Spencer. Inventories indicate that these fans were given to the princess of Asturias (María Luisa de Borbón-Parma) on their arrival in Madrid, when they were mounted on elaborate ivory and bronze sticks and guards, with precious stones used for the central rivets of the *Aldobrandini Wedding* and *Aurora* fans. The redistribution of the fans to the Patrimonio Nacional and the Museo Nacional de Artes Decorativas after the Spanish Civil War (1936–39) has clouded their provenance; nonetheless, these four fans are among those most likely to have traveled on the *Westmorland*.

Grand Tourists such as Duncannon often acquired decorative fans as souvenir items. Though not regarded as strictly fine art, Grand Tour fans displayed a range of artistic skill. Some artists who were well known to Grand Tourists, such as Pompeo Batoni, did produce fans at the outset of their careers. Fan makers developed a common repertoire of images and motifs, and much of this work was unsigned. Ciceroni, or local tour guides, frequently introduced visitors to the workshops and studios that together produced hundreds of painted fans to meet the tourist demand.

As these examples indicate, many Grand Tour fans portrayed subjects from ancient mythology, often copied from famous paintings, whether antique or more recent. These images could be painted across the entire fan leaf or reduced to smaller medallions and geometric boxes surrounded by decorative elements, as with the three fans depicting mythological subjects here. Both the fan reproducing *Venus and Nymph with Putti* and the one copying the *Aldobrandini Wedding* take their central images from wall paintings found in the interior of Roman buildings excavated during the seventeenth or eighteenth century: *Venus and Nymph with Putti* came from the Villa Negroni, a site excavated a year before the departure of the *Westmorland*, and the famous *Aldobrandini Wedding* mural was discovered in a Roman house in 1601. The *Aldobrandini Wedding* was also reproduced in a gouache found in one of Francis Basset's crates (cat. 34); a slightly later Italian fan with the image is in the British Royal Collection. Guido Reni's celebrated ceiling fresco *Aurora*, painted at Palazzo Pallavicini-Rospigliosi, provides the central oval medallion of the third fan. The image was one of

the most common subjects for Grand Tour fans
(other examples are in the British Royal Collection
Patrimonio Nacional, and the Metropolitan
Museum of Art, New York) and was often repro-
duced in other media; a number of versions were on
the *Westmorland* (see cat. 35). Indeed, decorative
fans were an integral part of the late eighteenth-
century demand for art copies and reproductions
among Grand Tourists.

Grand Tour fans also frequently depicted views
of popular tourist destinations. A panoramic view of
St. Peter's Basilica at the Vatican covers almost the
entire leaf of the fourth fan, with groups of figures,
many of whom are likely Grand Tourists themselves,
filling the piazza. On the *Aurora* and *Venus and
Nymph with Putti* fans, the side medallions are each
filled with an image of a Roman monument: the
Temple of Vesta and the Mausoleum of Caecilia
Metella on the *Aurora* and the Temple of Minerva
Medica and the Pyramid of Caius Cestius on *Venus
and Nymph with Putti*.

Numerous Grand Tour fans from the second half
of the eighteenth century included decorative motifs
reminiscent of wall paintings excavated at Pompeii
or Herculaneum, such as the leaves, laurel branches,
and flowers found on the *Aurora* fan. This light,
Roman-inspired ornamentation is representative of
the Neoclassical style, which the Grand Tour helped
to spread to Britain, recalling the interior decorative
work of the Neoclassical architect Robert Adam.
The decorative elements on the fan of *Venus and
Nymph with Putti* stand apart, however, as more
reminiscent of patterns found on pottery in Etruscan
tombs, then recently discovered and increasingly
popular at the end of the eighteenth century. In both
cases the fans' stronger coloring remains true to
their Roman or Etruscan inspirations, in contrast
to the more delicate tints of French fans from the
same period. SA

REFERENCE: Valverde Merino 2010.

Curators José Luis Valverde, head of curatorial
services at the Patrimonio Nacional, Madrid, and
Maruja Merino de Torres, curator of fans at the
Museo Nacional de Artes Decorativas, Madrid,
provided much information about the fans in their
respective collections.

76

77

78

Vue de la Ville de Genéve, et d'une partie du Lac, prise de Cologny.
Desiné et Gravé par C. G. Geisler Geneve 1777.

79

Desiné d'aprés Nature par Monsieur Talabar. Vue de la Vallée de Chamouni depuis l'Avanchet. Tiré du Cabinet de Monsieur le Professeur de Saussure. Gravé par C. G. Geisler.

80

79

CHRISTIAN GOTTLIEB GEISSLER (1729–1814)

Vue de la Ville de Genève, et d'une partie du Lac, prise de Cologny (View of Geneva with the Lake, from Cologny)

1777

Hand-colored etching
10⅝ x 16 in. (27 x 40.5 cm)
Inscribed on verso: "No. 1"; "P.Y."
Real Academia de Bellas Artes de San Fernando,
Archivo-Biblioteca, Gr-1963

80

CHRISTIAN GOTTLIEB GEISSLER (1729–1814)
AFTER JEAN JALABERT (1712–1768)

Vue de la Vallée de Chamouni depuis l'Avalanchet (View of the Valley of Chamonix after the Avalanche)

1777

Hand-colored etching
11⅛ x 17⅜ in. (28.4 x 44 cm)
Inscribed on verso: "No. 4"; "P.Y."
Real Academia de Bellas Artes de San Fernando,
Archivo-Biblioteca, Gr-1966

81

CHRISTIAN GOTTLIEB GEISSLER (1729–1814)
AFTER JEAN JALABERT (1712–1768)

Vue du Prioure et de la Vallée de Chamouni du coté du Glacier des bois (View of the Priory and of the Valley of Chamonix from the Forest Glacier)

1777

Hand-colored etching
11⅜ x 17½ in. (29 x 44.5 cm)
Inscribed on verso: "No. 7"; "P.Y."
Real Academia de Bellas Artes de San Fernando,
Archivo-Biblioteca, Gr-1969

All three of these views were produced for the tourist market in the same year that Lord Duncannon passed through Switzerland on his way to Italy. They are listed in Antonio Ponz's inventory (cat. 14) as "Siete estampas iluminadas, Vistas de Ginebra, y de otras Ciudades" (Seven colored prints, Views of Geneva, and of other Cities). The set includes five views, with duplicates of the two views of Chamonix; the others not included in the exhibition are *Vue de la Ville de Genève, d'une partie de la montagne des*

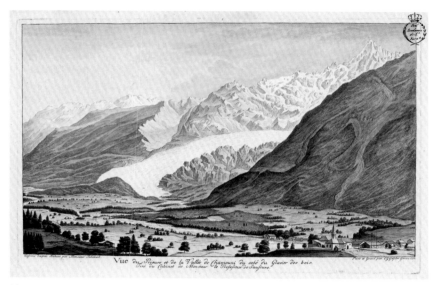

81

Voirons, du Mole, des Glacieres, et d'une partie de Salève prise de petit Saconnex (View of Geneva, with Part of the Voirons, the Mole, Glaciers, and Part of the Salève, taken from Petit-Saconnex) and *Vue d'un partie de Chatelaine et des montagnes de Gex, prise du Chateau de la Bâtie* (View of Chatelaine and the Gex Mountains, Taken from Château-de-la-Bâtie).

The German-born printmaker Christian Gottlieb Geissler moved to Geneva in about 1771. There is a drawing by Geissler for *View of Geneva from Cologny* in the British Museum, London (1958,0712.1282). The views of Chamonix are based on paintings by Jean Jalabert, a Swiss printmaker and intellectual, in the collection of the Swiss physicist, geologist, and early Alpine explorer Horace Bénédict de Saussure. As John Brewer notes in his essay in this volume, the overland route to Italy was increasingly popular in the eighteenth century, and crossing the Alps provided opportunities to revel in sublime mountain scenery, prompted by contemporary descriptions such as Marc Théodore Bourrit's *Description des glaciers, glaciers et amas de glace du Duché de Savoye* (cat. 85). EH

REFERENCES: Westmorland 2002, nos. 23, 24
(entries by Almudena Negrete Plano).

82a 82b

82

JOHN ROCQUE (CA. 1709–1762)

A Plan of Paris &c., reduc'd to the same scale of London . . . Plan de Paris &c., Reduit sur la meme Echelle que Celui de Londres
London: J. Rocque, 1754

Hand-colored engraving
20⅛ x 28⅜ in. (51 x 72 cm)
Real Academia de Bellas Artes de San Fernando, Archivo-Biblioteca, C-510

John Rocque, a French Huguenot surveyor who settled in London in about 1709, produced a number of popular large-scale maps of that city. His map of Paris in 1754 was produced at the same scale as one of London in order to offer a ready comparison of the size of the two cities. The map is a convenient size for a tourist, mounted on linen and easily folded into its marbled paper sleeve, also shown, and was presumably used by Lord Duncannon for his stay in Paris. Duncannon acquired a number of French grammars, dictionaries, and guidebooks during his time in France; these may have been used for study with his tutor, Samuel Wells Thomson. These works, along with the Rocque map, were found in the same crate marked "E. B." EF

83

JEAN-BAPTISTE NOLIN (1657–1725)

Le Canal Royal de Languedoc
1697

Engraving, on three sheets
31½ x 62⅝ in. (80 x 159 cm)
Inscribed on verso of left sheet: "bourgoigne"
Real Academia de Bellas Artes de San Fernando, Archivo-Biblioteca, Mp-44

One of the crates marked "E. B." included a "Libro grande de Varios Mapas, y el plan de Roma que son 47" (Large book of Various Maps, and the map of Rome totaling 47). It is presumed that Jean-Baptiste Nolin's map of the extraordinary Canal Royal de Languedoc (more commonly known today as the Canal du Midi) is part of that group; the holes from the stitching are still visible in the margin.

From 1681, when it opened, the canal was considered a remarkable achievement. Nolin, an engraver at the court of Louis XIV of France, noted on one of the sheets that the project was "l'une des merveilles du regne de Louis Le Grand, . . . tant pour la gloire de vôtre Auguste Souverain que pour l'utilité publique de tous ces sujets" (one of the marvels of the reign of Louis the Great, as much for

the glory of Your August Sovereign as for the public use of all these subjects). Considered one of the greatest civil engineering feats in Europe, it linked the Atlantic Ocean and the Mediterranean, thus avoiding the long and arduous sea passage around the Iberian Peninsula. Baron Pierre-Paul Riquet de Bonrepos, the engineer of the project, overcame the enormous difficulties involved in feeding the canal with a regular and abundant supply of water. A number of reservoirs were constructed, along with many locks and aqueducts, including the first-ever underground canal. The complete route, a 150-mile stretch from the Bay of Biscay on the Atlantic to the port of Cette (today Sète) in the Gulf of Lion, is shown in a small insert in the lower left-hand corner of the central sheet.

By the first quarter of the eighteenth century, the canal had become a valuable strategic and commercial asset, and it also quickly emerged as a tourist attraction for foreigners. Francis Egerton, third Duke of Bridgewater, spent a life-changing period of time studying the canal in 1754 during a stop on his Grand Tour, accompanied by his tutor, Robert Wood. Egerton was apparently so impressed with the innovative system of locks and other new techniques of engineering that he was inspired to

begin taking courses in science and engineering. In 1759 he began construction of his own underground canal—the first man-made waterway of industrial significance in England—to carry coal from his colliery to the city of Manchester, a few miles away. The Duke of Bridgewater's canal inspired the building of both short-haul and longer trunk canals, and it attracted the attention of Josiah Wedgwood and other promoters who were eager to use this safe and inexpensive mode of transporting fragile goods. EF

REFERENCES: Malet 1977; Petto 2007.

84

84

JEAN-BAPTISTE NOLIN (1657–1725)

Diocese de Nismes: Dressé nouvellement sur les lieux par le Sr. Gautier architecte et ingenieur de la province de Languedoc
Paris: I. B. Nollin, 1698

Hand-colored engraving
22⅝ x 31½ in. (57.5 x 80 cm)
Real Academia de Bellas Artes de San Fernando, Archivo-Biblioteca, Mp-48

Jean-Baptiste Nolin's map of Nîmes and its surroundings in southern France includes a number of insets depicting several of the most famous of the city's ancient Roman remains, including the amphitheater, the Maison Quarrée (now Carrée), and the Pont du Gard. Lord Duncannon, who owned other maps of engineering works, would have been particularly interested in the aqueduct, well known in the eighteenth century as one of the best preserved in the Roman world. Tobias Smollett, writing in his

Travels through France and Italy (1766), expressed surprise that the "noble monument" was in such good condition: "I expected to find the building, in some measure, ruinous; but was agreeably disappointed, to see it look as fresh as the bridge at Westminster. The climate is either so pure and dry, or the free-stone, with which it is built, so hard, that the very angles of them remain as acute as if they had been cut last year. Indeed, some large stones have dropped out of the arches; but the whole is admirably preserved, and presents the eye with a piece of architecture, so unaffectedly elegant, so simple, and majestic, that I will defy the most phlegmatic and stupid spectator to behold it without admiration." Nolin's map and a guidebook by Charles Chaumette (cat. 88) were part of the Duncannon crate marked "E. B." that included a number of other guidebooks and maps about France. EF

REFERENCE: Smollett 1766, 1:156–57.

85

MARC THÉODORE BOURRIT (1739–1819)

Description des glaciers, glaciers et amas de glace du Duché de Savoye

Geneva: Imprimerie de Bonnant au Molard, 1773

Real Academia de Bellas Artes de San Fernando, Archivo-Biblioteca, B-807

Description des glaciers, glaciers et amas de glace du Duché de Savoye was the first of six books written by the cathedral precentor and mountaineer Marc Théodore Bourrit. Having discovered his passion for the mountains while on an early ascent of the Voirons (in France), Bourrit would go on to be named historiographer of the Alps by Holy Roman Emperor Joseph II despite his mediocre climbing ability. Known for their romantic, dramatic style, the accounts of his expeditions privilege descriptions of the mountains' overwhelming natural beauty over practical advice on crossing the range. Nonetheless, the English translation (Norwich, 1775) of *Description des glaciers* found many Grand Tourist subscribers, such as the Swiss-Austrian Angelica Kauffman and the British readers Edmund Burke, Joshua Reynolds, and Samuel Johnson, some of whom may have used the volume as an aid in their own passage through the Alps to Italy. Lord Duncannon, the owner of the single copy sent on the *Westmorland*, most likely crossed the mountain range with his tutor by following a path similar to that recommended by Bourrit. Although Duncannon's version is in good condition and does not show annotations, Francis Basset's copy of *A Relation of a Journey to the Glaciers in the Dutchy of Savoy*, the English translation of Bourrit's text, has many marks that evidence its heavy usage both during the travel preparations and while on the journey. KC

REFERENCES: Gribble 1899, 148–61; Gribble 1914, 182–83.

85

86

86

DANTE ALIGHERI (1265–1321)

La divina commedia, vol. 1

Venice: Antonio Zatta, 1757–58 (5 vols.)

Inscribed on front free endpaper of vol. 1: "P.Y."
Real Academia de Bellas Artes de San Fernando, Archivo-Biblioteca, B-875

La divina commedia constitutes the first three volumes of this first collected edition ever published of all of Dante's works. Volumes four and five, published in 1758, contain the *Prose e rime Liriche, edite ed inedite* (Lyrical Prose and Rhymes, Published and Unpublished) and a biography of Dante. Lord Duncannon was sending home the complete five-volume set.

The text is beautifully illustrated with decorative cartouches and initial letters and features 106 copper engravings by Giuliano Giampicoli, Bartolomeo Crivellari, Giuseppe Magnini, and others after various artists. Each canto is preceded by a plate depicting a scene described in the canto and followed by scholarly commentary by Giovanni Antonio Volpi, a professor of classic literature at the Università degli Studi in Padua, or by the renowned Dante specialist P. Pompeo Venturi. Although several editions of Dante's *Divina commedia* were published in Italy in the eighteenth century, this is the only illustrated edition since the very early seventeenth century.

As a former student at Christ Church, Oxford, Duncannon could have become familiar with Thomas Warton's *History of English Poetry* (1774–81), which specifically spoke to Dante's influence on Geoffrey Chaucer and John Milton. Although Duncannon's copy is not annotated, it was most likely bought to complete his education in Italian language and culture. MDSJ

REFERENCES: Sweet 2007; Treccani.it, s.v. "Volpi, Giovanni Antonio."

87

Descrizione delle statue, bassirilievi, busti, altri antichi monumenti, e quadri de più celebri pennelli, che si custodiscono ne Palazzi di Campidoglio. Edizione terza emendata ed accresciuta
Rome, 1775

Real Academia de Bellas Artes de San Fernando, Archivo-Biblioteca, C-1420

Although it is not inscribed with the initials "P. Y." and contains no annotations or signature, this volume is listed by the correct title in Antonio Ponz's inventory (cat. 14) as being in crate "E. B.," along with a comment that it was softbound; it was given the standard binding used by the Real Academia de Bellas Artes de San Fernando shortly after its arrival.

The book, published in 1775 by Gaetano Quojani, is the third edition of one of the earliest and most popular guides to the Musei Capitolini in Rome.

The Capitoline Museums were opened to the public by Pope Clement XII in 1734, and they became one of the first public institutions of their kind and a cultural reference point throughout Europe. A visit to them was an obligatory stop on the Grand Tour. There travelers could admire the most celebrated sculptures of antiquity, including the Capitoline Wolf, the Dying Gaul, the Red Faun, and the equestrian statue of Marcus Aurelius. The museums were also a meeting point for artists such as Pompeo Batoni, who visited the galleries to copy classical statues and paintings. In addition, the Palazzo dei Conservatori housed the Accademia del Nudo (founded by Pope Benedict XIV), where Anton Raphael Mengs gave classes.

The guidebook is structured as an orderly progression through each of the museums' rooms, first commenting on the architecture and then describing the collection of busts, low reliefs, and inscriptions, moving from the Palazzo Nuovo to the Palazzo dei Conservatori. Finally it describes the collection of paintings displayed in two galleries above the Archivio di Stato and the Accademia del Nudo.

The books on board the *Westmorland* included a large number of practical guides for visiting cities; all the ones that refer to Rome include a description of the capitoline collections, with some actually reproducing the complete text of this guide—for example, as the first 167 pages in volume 1 of *Il Mercurio errante delle grandezze di Roma* (cat. 117). MDSJ

REFERENCE: Sommella Mura 2005.

88

CHARLES CHAUMETTE

Eclaircissemens sur les antiquités de la ville de Nismes, 4th ed.
Nîmes: Veuve Belle, 1775

Inscribed on title page: "P.Y."
Real Academia de Bellas Artes de San Fernando, Archivo-Biblioteca, C-2385

Nîmes was one of the most important cities of Roman Gaul, now southern France, and a popular stop on the Grand Tour. The vestiges of its imperial

past, including the imposing Pont du Gard aqueduct
and the splendid Maison Quarrée (now Carrée),
were greatly admired in the eighteenth century
(88b). The sites were depicted by painters such as
Hubert Robert and served as inspiration for
Neoclassical architects including Pierre-Alexandre
Vignon, whose church of La Madeleine in Paris
(1806) was closely modeled on the Augustan temple
illustrated here. Writers such as Tobias Smollett
were enormously impressed by the temple. He
described the proportions of the building his *Travels
through France and Italy* (1766) as

*so happily united, as to give it an air of majesty
and grandeur, which the most indifferent spectator
cannot behold without emotion. A man needs not be a
connoisseur in architecture, to enjoy these beauties.
They are indeed so exquisite that you may return to
them every day with a fresh appetite for seven years
together. What renders them the more curious, they
are still entire, and very little affected, either by the
ravages of time, or the havoc of war. . . . Without all
doubt it is ravishingly beautiful. The whole world
cannot parallel it; and I am astonished to see it
standing entire, like the effects of inchantment, after
such a succession of ages, every one more barbarous
than another.*

The author of the present work also notes
the attempts to reconstruct the epigraphs on the
building by filling in the missing letters of the
inscription running along the architrave. On the
strength of this research it was discovered that the
temple had originally been dedicated to Gaius Caesar
and Lucius Caesar, grandsons of the Roman emperor
Augustus. The deciphering of the inscription was
apparently of some considerable interest to Lord
Duncannon; he also owned a copy of *Dissertation sur
l'ancienne inscription de la Maison Carrée de Nismes*
(1759) by Jean-François Séguier, found in the same
crate as other works on Nîmes. EF

REFERENCES: Smollett 1766, 1:166–67; Hibbert
1987; Westmorland 2002, no. 39 (entry by Irene
Mañas Rodríguez).

87

88a

88b

89

他 libretti were widely used by numerous composers, making a decisive contribution to the development of the new genre of opera buffa.

Goldoni was a prolific author, and his works became enormously successful and widely known in Europe. In the autumn of 1759 the Haymarket Theatre in London first performed *Il mondo della luna* and *Il filosofo di campagna*. While his name did not always appear on his librettos, many of them were used or adapted for English performances, and some of his works, such as *Il filosofo inglese* (dedicated to Joseph Smith, the British consul in Venice) and *La ritornata di Londra*, centered on English characters.

The first works by Goldoni to be translated into English were *Pamela* and *Il padre de famiglia*, in 1756. The texts, by the eminent translator Thomas Nugent, were used as practical exercises for learning Italian. The method was published by G. Nourse, for decades the leading printer of Italian texts and language-learning methods at his premises on the Strand, and it was Nourse who produced the present volumes. Published in London in 1777, they constitute the first edition of Goldoni's works in Britain. MDSJ

REFERENCES: Sohm 1982, 256–73; Goldoni 1994; Cope 1995, 101–31.

89

CARLO GOLDONI (1707–1793)

Commedie scelte di Carlo Goldoni, Avvocato Veneto, vols. 1 and 3
London: P. Molini, G. Nourse, T. Cadell, and P. Elmsley, 1777

Inscribed on front free endpaper of vol. 1: "P.Y."
Real Academia de Bellas Artes de San Fernando, Archivo-Biblioteca, C-1423

This selection of works by the playwright Carlo Goldoni originally consisted of three volumes, though only the first and the third arrived at the Real Academia de Bellas Artes de San Fernando, where they still preserve their original bindings. Volume 1, annotated with the initials "P.Y.," includes *Pamela*, *Pamela maritata*, and *L'avventuriere onorato*, while volume 3 includes *Il cavaliere e la dama*, *Un curioso accidente*, and *La dama prudente*.

Goldoni was the great modernizer of Italian theater. Taking Molière as his model, Goldoni moved away from the rigid formulas of the Commedia dell'Arte through his use of more profound characterization and a more natural language. His plots focus on human relations, everyday affairs, and easily recognizable contemporary social types. He also collaborated on a large number of operas, and

90

JOSEPH HAYDN (1732–1809)

Six simphonies ou quattuors dialogués. Pour deux violons, alto viola et basse obligés
Paris, [1764?]

Inscribed on title page: "S. Wells Thomson. Ch: Ch: Oxon."
Real Academia de Bellas Artes de San Fernando, Archivo-Biblioteca, LJIM-1934

Crate "E. B." contained, according to Antonio Ponz's inventory (cat. 14), "Ciento y veinte quadernos de Musica" (one hundred and twenty musical scores). Crate "J. H.," filled with books and prints belonging to John Henderson of Fordell, included "Un legajo de papeles, y quadernos de Musica" (a bundle of papers, and Musical scores). "Diez quadernos de papetes de musica" (ten musical scores) were in one of Francis Basset's crates. These annotations suggest that, from the crates of Lord Duncannon, Henderson, and Basset alone, a substantial amount of

90

Joseph Toeschi. The Haydn quartets were composed for Baron Karl Joseph von Fürnberg in about 1757–60, to be played by the baron and his associates at soirees held at his castle in Wienzierl, lower Austria. The publication of the quartets by Louis Balthazard de la Chevardière in Paris in 1764 seems to be the first appearance of Haydn's music in print. Haydn's pupil Ignace Pleyel later grouped these four quartets with two others as the composer's opus 1 in Pleyel's catalogue of Haydn's work.

The cover is inscribed in ink "S. Wells Thomson. Ch[rist]: Ch[urch]: Oxon[iensis]." Whether all 120 musical scores in crate "E. B." belonged to Thomson or represented the musical tastes of both Duncannon and his tutor cannot at this point be determined. Their existence does suggest that amateur music making played a significant role in the recreation and social activities of the two men's Grand Tour. sw

REFERENCES: Westmorland 2002, no. 66 (entry by Isabel Rodríguez López); Webster and Feder 2011.

91

ORAZIO ORLANDI (ACTIVE 1771–75)

Le nozze di Paride ed Elena rappresentate in un vaso antico del Museo del signor Tommaso Jenkins, gentiluomo inglese
Rome: printed by Giovanni Zempel, 1775

Inscribed on front free endpaper: "S. W. Thomson"; on verso of front free endpaper: "P.Y."
Real Academia de Bellas Artes de San Fernando, Archivo-Biblioteca, B-2421

In 1769 the dealer Thomas Jenkins purchased an ancient *puteal* (wellhead), decorated with a relief of the marriage of Paris and Helen attended by Eros and the Muses, from Palazzo Columbrano in Naples. Adding a lip and base, Jenkins had it mounted as a vase, which, he explained in a letter to the collector Charles Townley, "turns out so fine, that I believe it will be sold for £500 in short it is the Very finest Vase in the World." Jenkins undoubtedly hoped this new antiquity would rival the more established Farnese and Medici vases and began a determined campaign of promotion. He engaged his "in-house" team, which included the antiquary Orazio Orlandi and the draftsman Friedrich Anders, to publish the vase. In 1772 Orlandi, who worked as a cicerone, frequently for Jenkins's clients, had published an essay interpreting a marble altar belonging to

music entered the collections of the Real Academia de Bellas Artes de San Fernando. This material, however, has proved almost impossible to trace within the Real Academia's library. Only in the case of two examples bearing the signatures of the owners—this set of Joseph Haydn's quartets belonging to Samuel Wells Thomson and the set of *Twelve Easy Duets* by Friedrich Schwindl belonging to Henderson (cat. 108)—can we be sure that the music was on the *Westmorland*.

Though designated on the title page as "six symphonies" by Haydn, this publication actually contains his four earliest string quartets, together with two quartets by the composer and violinist Carl

91

Antonio Casali, governor of Rome. Anders worked as a picture restorer and antiquarian draftsman, producing many of the "sales drawings" that Jenkins enclosed in letters to his clients. Orlandi prepared an erudite discussion of the vase's iconography—indebted to Johann Joachim Winckelmann's analysis of the antique *Aldobrandini Wedding* fresco in his *Monumenti antichi inediti* (1767)—and Anders produced drawings of the whole vase and its frieze, which were engraved in Rome by the English painter William Miller. By September 1774 proofs of the engravings were ready and dispatched to Townley (Department of Greek and Roman Antiquities, British Museum, London). Jenkins had been unable to sell the vase itself, so the publication, which was printed in Rome in 1775 by Giovanni Zempel, was undoubtedly designed in part to act as an advertisement; indeed, Jenkins sold the vase in the same year to James Hugh Smith Barry for £500.

The presence on board the *Westmorland* of three copies, apparently all belonging to different owners, suggests Jenkins's desire to promote what he called "one of the most Interesting Monuments in all

Antiquity" to British travelers after its sale. The volume itself had an antiquarian appeal conferring an aura of scholarship on Jenkins's commercial activities, while Miller's engraving of the whole relief was designed, in part, to show its suitability for decorative use. Jenkins had the frieze painted by Pietro Angeletti as an overdoor in the Saloon of Ribston Hall, Yorkshire, where it was placed opposite a copy of the *Aldobrandini Wedding*. Jenkins was probably responsible for Angelica Kauffman adopting the subject matter and composition for her *Venus Persuading Helen to Love Paris* (State Hermitage Museum, St. Petersburg), painted in 1790, the year she completed Jenkins's portrait (National Portrait Gallery, London). JY

REFERENCES: Winckelmann 1767, 60, 152; Orlandi 1772; Eddy 1976, 569–73; Wilton and Bignamini 1996, no. 226; de Divitiis 2007, 99–117; Bignamini and Hornsby 2010, 1: 234–36.

92

JOSEPH JÉRÔME LEFRANÇAIS DE LA LANDE
(1732–1807)

Voyage d'un Français en Italie, fait dans les années 1765 & 1766, contenant l'histoire & les anecdotes les plus singulières de l'Italie . . . , vol. 1

Venice and Paris: Desaint, 1769 (6 vols.)

Inscribed on front free endpaper of vol. 1: "P.Y."
Real Academia de Bellas Artes de San Fernando,
Archivo-Biblioteca, B-452

92a

92b

This is the first edition of Joseph Jérôme Lefrançais de La Lande's *Voyage d'un Français en Italie*, which is based on his trip to Italy in 1765–66. A copy of another edition, published in Yverdon, Switzerland, was on the *Westmorland* in the crates of George Legge, Viscount Lewisham. That also consisted of six volumes, of which only volumes 3, 5, and 6 survive, none of them with illustrations (Real Academia de Bellas Artes de San Fernando, Archivo-Biblioteca, C-2782–2784).

In his text the French astronomer and mathematician described a route from Paris to Naples, providing details of the distances and stops along the route. He also described the cities and included engravings with plans and views of the buildings.

La Lande included practical information and commentaries on literature, the arts, natural history, and antiquities, as his title indicates. For example, in volume 5 he referred to Pompeo Batoni: "Il peint également l'histoire & le portrait, & travaille beaucoup pour les Anglois [. . .] Il ne fait pas des portraits à moins de 50 sequins pour une tête & 100 sequins quand on demande le corps & les mains; aussi sa fortune est elle très considérable" (He paints history and portraits equally, and works a great deal for the English. . . . He does not paint portraits for less than 50 sequins for a head and 100 sequins when he is asked for the body and hands; so his fortune is very considerable); a few pages later he discussed Giovanni Battista Piranesi: "D'abord architecte & graveur, actuellement antiquaire & homme de lettres, est connu depuis long-temps par ses belles estampes des monuments de Rome & de ses antiquités, & il continue à en tirer beaucoup d'argent" (At first an architect and engraver, currently antiquary and man of letters, he has long been known for his beautiful prints of the monuments of Rome and its antiquities, and from them he continues to make much money).

For his comments on literature and natural history, La Lande made use of both classical sources and the latest scientific research. When describing landscapes he referred as frequently to classical writers such as Pliny the elder and Horace as to Jean-Antoine Nollet with reference, for example, to Tivoli, for which La Lande provided a lengthy explanation on the Solfatara volcanic geyser and the flowerlike crystallized sulfur formations that it produced.

Volume 2 contains numerous notes that Lord Duncannon or possibly Samuel Wells Thomson wrote in the margins, all relating to monuments and works of art. For example, next to the description of the cathedral baptistery in Siena is the annotation, shown (92b), "By Nico de Pisa [Nicola Pisano]." MDSJ

REFERENCE: Westmorland 2002, no. 47 (entry by Mercedes Cerón).

ELEVAZIONE DELL' ARCO TRAJANO IN BENEVENTO

IMP·CAESARI·DIVI·NERVAE·FILIO
NERVAE·TRAIANO·OPTIMO·AVG
GERMANICO·DACICO·PONT·MAX·TRIB
POTEST·XVIII·IMP·VII·CON·VI·P·P·
FORTISSIMO·PRINCIPI·SENATVS·P·Q·R·

93

93

CARLO NOLLI (1724–1770)

Dell'Arco Trajano in Benevento
Naples: Carlo Nolli, 1770

Inscribed on front free endpaper: "P.Y."
Real Academia de Bellas Artes de San Fernando,
Archivo-Biblioteca, B-34

Published by Carlo Nolli, son of Giambattista Nolli (see cat. 113), this volume comprises eight engravings of views and details of architectural elements with their measurements and an explanatory text by Monsignor Giovan Camillo Rossi. Nolli's preface explains the genesis of the book: When Luigi Vanvitelli, *architetto di corte e direttore di tutte le reali fabbriche* (court architect and director of all royal works), was obliged by Carlos III to travel to Benevento, thirty-four miles northeast of Naples, to supervise various projects, he admired the beauty of its Arch of Trajan and decided to measure it with the assistance of his son Carlo and his pupil Giuseppe Piermarini. His intention was to combine the drawings made of it with those of the Arch of Trajan in Ancona, also measured by him. According to Nolli, it was the senior Vanvitelli who gave him the drawings—made by Piermarini, as indicated by the inscription "Piermarini del." in the lower margin of each—from which to make engravings. Nolli also referred in his preface to the drawings of the arch at Ancona, which he said he would be publishing in the near future (as he did in 1775, in a series of nine engravings of the arch from drawings by Andrea Vici).

The arch at Benevento had already been reproduced in engraved form by various artists, such as Giovanni Battista Piranesi (in his *Vedute di Roma*) and Teresa del Po, whose series of prints on the subject was also found in the same crate. None, however, had measured it with the exactitude to be found in the present work. The interest in the arch among Grand Tour travelers is evident in the praise that it received in the diaries of individuals such as the pioneering Grand Tourist and diplomat Thomas Hoby and the philosopher George Berkeley, and the popularity of this set of prints is suggested by the fact that there were five copies on the *Westmorland* (the other four belonging to George Legge, Viscount Lewisham; Francis Basset; J. B. (John Barber?); and the as-yet-unidentified "L. D." Although the arch was along the route from Rome to Naples, located on the old Via Traiana, the road was in such poor state that most few tourists visited it. The owner of the present copy, Duncannon, was an exception. On March 24, 1778, after Duncannon left Naples, Sir William Hamilton wrote to Duncannon's father, William Ponsonby, second Earl of Bessborough: "He has infinite curiosity, spirit and resolution; this I saw in his having persevered in going to Benevento, to see the famous arch, when the rest of his party, except Thomson [Duncannon's tutor], gave it up in account of difficulties and bad roads." MDSJ

REFERENCES: Vanvitelli 1756; d'Hancarville 1766–67; Rotili 1972; Wilton-Ely 1994; Chaney 1998, 119, 347; W. Hamilton 1999, letter no. 63; Westmorland 2002, no. 67 (entry by Almudena Negrete Plano).

94

GEORGES-LOUIS LE ROUGE (1722–1778)

Nouveau voyage de France, géographique, historique et curieux: disposé par différentes routes, à l'usage des étrangers & des François, contenant une exacte explication de tout ce qu'il y a de singulier & de rare à voir dans ce Royaume
Paris, 1771

Inscribed on front free endpaper: "P.Y."
Real Academia de Bellas Artes de San Fernando, Archivo-Biblioteca, C-1149

Georges-Louis Le Rouge was a military engineer of German origin who moved to Paris, where he assumed a French name and set up as an engraver and publisher of maps on the rue des Grands Augustins. He published numerous translations of English books and maps and from 1747 adapted and translated maps from England in collaboration with John Rocque. In 1769 Le Rouge worked with Benjamin Franklin on the French edition of the celebrated Franklin / Folger Map of the Gulf Stream. His work in the field of cartography earned him the title "Géographe du Roi."

The present guide contains a map of France by Jean-Baptiste Nolin (see cat. 83) and engravings of views of cities and monuments. The guide is organized according to the suggested routes, which start in other countries (Italy, Germany, Spain, the Netherlands, and so on) and end in Paris or vice versa, either by sea or by land. In addition, the guide includes journeys from other regions of France (including Brittany and Normandy) to Paris.

The text assumes that in order to reach France from England, the traveler will normally disembark on the coast of Picardy, suggesting that the most direct route from Dunkirk to the French capital was following the coastline through Calais to Abbeville and from there to Amiens and Paris. His guide includes a brief description of each city, its location, and precise information on coaching posts and distances: for example, two posts between Dunkirk and Gravelines (the equivalent of four leagues).

There is also information on coaches and the postal service. For example, coaches left Paris from the Grand Cerf on the rue Saint-Denis on Mondays and Fridays. They took seven days to reach Calais and eight to reach Dunkirk. The price of the trip was 30 livres per person from Paris to Calais and 50 sous from Calais to Dunkirk. Mail for England, Scotland, and Ireland left Paris on Wednesdays and Saturdays

94

at 8 a.m. Letters cost 10 sous for a single sheet, 11 in an envelope, 18 for a double sheet, and 40 sous per ounce for packages, both one way and return. Finally, Le Rouge offered estimates on the prices of sleeping and eating in each place, the total cost of the journey from England to Paris being about 71 livres. MDSJ

REFERENCES: Cohn 2000, 124–42; Le Rouge 2011.

Crates ◇A◇, H. R. H., and H. R. H. D. G.

OWNED BY WILLIAM HENRY, FIRST DUKE OF GLOUCESTER

William Henry (1743–1805), the younger brother of George III, made three trips to Italy. His first, in 1771–72, was as both a tourist and a diplomatic representative. Thomas Jenkins served as his cicerone in Rome, arranging for the duke's portrait to be painted by Pompeo Batoni and Anton von Maron and sculpted by Christopher Hewetson. Although Jenkins supplied the duke with a number of antiquities and persuaded him to fund an excavation, he was unable to inspire a serious interest in the antique on the part of the duke—or of the king of England. Much of Gloucester's collecting focused on art and furnishings for his London town house. In 1775, in an act of self-imposed exile, the duke returned to Rome in the company of his wife, Lady Maria Waldegrave, whom he had married secretly in 1766. Before returning to England in 1777 the duke commissioned a series of paintings from Carlo Labruzzi and a chimneypiece, which was probably executed by Carlo Albacini and, on completion, was shipped on the *Westmorland* in three separate crates, along with several pieces of sculpture, four packets of books, and a box of artificial flowers. Gloucester's final journey to Italy, again in the company of his family, took place in 1786. EH

95

ATTRIBUTED TO CARLO ALBACINI
(1739?–AFTER 1807)

Bacchus and Ariadne

ca. 1776–77

Marble
27½ x 12⅝ x 11⅞ in. (70 x 32 x 30 cm)
Real Academia de Bellas Artes de San Fernando, Madrid, E-75

96

ATTRIBUTED TO CARLO ALBACINI
(1739?–AFTER 1807)

Cupid and Psyche

ca. 1776–77

Marble
28⅜ x 11⅜ x 9½ in. (72 x 29 x 24 cm)
Real Academia de Bellas Artes de San Fernando, Madrid, E-72

97

ATTRIBUTED TO CARLO ALBACINI
(1739?–AFTER 1807)

Pedestal

ca. 1776–77

Marble
12⅝ x 13¾ in. (32 x 35 cm)
Real Academia de Bellas Artes de San Fernando, Museo, E-53

98

ATTRIBUTED TO CARLO ALBACINI
(1739?–AFTER 1807)

Pedestal

ca. 1776–77

Marble
12⅝ x 13¾ in. (32 x 35 cm)
Real Academia de Bellas Artes de San Fernando, Museo, E-54

Two copies of the sculptural group *Bacchus and Ariadne* were on board the *Westmorland*, together with two copies of *Cupid and Psyche*. One of each, forming a pair, was to be sent to the banker Lyde Browne and the other pair to William Henry, Duke of Gloucester. Following their arrival at the Real Academia, one pair was sent to the royal collection and the other remained at the Real Academia. It is no longer possible to know definitely which pair belonged to Browne and which to the Duke of Gloucester. Although the four sculptures reveal slight differences with regard to the manner of carving the marble as well as minor variations in details and dimensions, all must have been based on the same models. There is a terra-cotta in Palazzo Venezia that seems to be the model from which the present version of the *Cupid and Psyche* group, which is an interpretation of the famous work at the Museo Capitolino, derives. The terra-cotta was among the collection of casts made and assembled by Bartolomeo Cavaceppi. Gerard Vaughan, however, considers the author of the group to be Carlo Albacini, a pupil of Cavaceppi's, who was a close associate of the dealer Thomas Jenkins from the 1770s on. In the 1804 inventory of the Real Academia, the sculpture is also attributed to Albacini, although that list contains numerous errors.

The original marble of the *Bacchus and Ariadne* is today at the Museum of Fine Arts, Boston (68.770). It has been fairly extensively reworked and little remains of the original antique sculpture, the provenance of which is unknown. Jenkins originally sold the group to the Duke of Gloucester during the duke's first visit to Rome, in 1772. When George III heard of his younger brother's morganatic marriage, however, the king drastically reduced the duke's income, obliging him to forgo acquisition of the work. Jenkins sold it soon afterward to James Hugh Smith Barry. Consequently, the group sent on the *Westmorland* to the Duke of Gloucester can be interpreted as an attempt on the duke's part to obtain at least a version of a work that was to have belonged to him. Palazzo Venezia also has a terra-cotta version of the group, attributed to Cavaceppi, which is probably the model for the present marble sculpture and may perhaps, as Alvar González-Palacios has noted, have been the model for the reworking of the antique group now in Boston.

The *Westmorland* inventories state that the sculptures in the Duke of Gloucester's crate each had a "basa de emparrado" (base ornamented with carved vine leaves and tendrils). This phrase

95

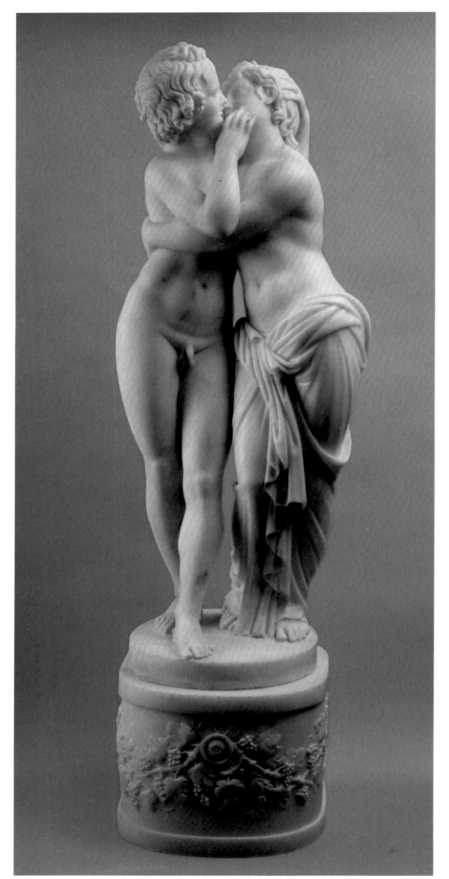

96

recently allowed the identification of two small pedestals in a storeroom of the Real Academia. The front and sides are delicately carved with vine leafs and grapes bunches, but the back is simply roughed out, suggesting that this side would not have been seen.

The same inventories also described a chimney-piece for the Duke of Gloucester that was disassembled into pieces and packed in several crates. The different elements are recorded as follows:

Crate "H. R. H. D. G. No. 4°":
Dos Columnas de Alabastro Estriadas, y tiene de largo cada una 63 dedos, y 11 dhos de ancho la basa de cada una = Dos Pilastras tambien de Alabastro, Estriadas, y tiene cada una 63 dedos de largo, y 12 dchos de ancho. Y se nota, que una de ellas tiene quebrada una Estria, y se conoce que la pieza estuvo pegada con dos arambritos, y 10 quebrado puesto, y metido en un Papelito como bá. (Two Fluted, Alabaster Columns, each 63 dedos *long, the bases each 11* dedos *wide = Two Pilasters also of Fluted Alabaster, each 63* dedos *long, and 12* dedos *wide. It should be noted that one has a cracked Flute and it is known that this piece was stuck together with two small metal rods, and the broken piece taken, and wrapped in a piece of Paper as it will be sent.)*

Crate "H. R. H. D. G. No. 2":
Dos Basas de Alabastro para Columnas, y tiene cada una 33 dedos de largo, 18 de ancho, y 8 de grueso = Dos Basas de Alabastro quadrilongas de bajo relieve, y tiene cada una 28 dedos de largo, 13 de alto, y 10 de grueso = Dos Piezas de Alabastro que representan los Diagonales de una Cornisa, y tiene cada una 34 dedos de largo, 16 de alto, y 6 de grueso = Y Quatro Paquetes, que incluyen 12 libros en 8°. de pasta, que tratan de Historia Romana en Idioma Italiano. (Two Alabaster Bases for Columns, each 33 dedos *long, 18 wide, and 8 deep = Two square Alabaster Bases of low relief, each 28* dedos *long. 13 high, and 10 deep = Two Pieces of Alabaster that represent the Diagonals of a Cornice, each 34* dedos *long, 16 high, and 6 deep = And Four Packets, that include 12 books, octavo, board binding, on Roman History in the Italian Language.)*

Crate ⟨A⟩:
Una pieza de Cornisa de Alabastro, labrada de vajo relieve, y tiene de largo 35 dedos, 19 de ancho, y 7 de grueso = Otra pieza de Cornisa tambien de Alabastro, labrada de vajo relieve, y tiene de largo 62 dedos, de alto 16, por su planta vaja 8, y por la planta alta 3

= Una Cabeza de Alabastro, labrada de relieve, que representa Venus, y tiene 26 dedos de alto = Un Paquete, que contiene 3 tomos en Pasta en 8° el 9, 10, y 11 que trata de la Literatura Italiana, en dicha Lengua. (A Piece of Alabaster Cornice carved in low relief, and measures 35 dedos long, 19 wide, and 7 deep = Another piece of Cornice also of Alabaster, worked in low relief, that measures 62 dedos long, 16 high, 8 at the bottom, and 3 at the top = An Antique Head, carved in relief, that depicts Venus, 26 dedos high = A Packet, containing 3 books in Board binding, octavo, the 9th, 10th and 11th on Italian Literature, in that Language.)

Documents in the Real Academia record that these elements constituting the chimneypiece were given to Carlos III; however, an exhaustive search has revealed that no fireplace corresponding to this description is at present in the Spanish royal collections, nor is there any documentation to indicate that such a one ever existed.

Following the discovery of the pedestals intended for the sculptures, another possibility suggested itself. An auction at Sotheby's, London, on November 26, 2003, included a chimneypiece from Ickworth House, Sussex, that had been acquired by Frederick Hervey, fourth Earl of Bristol and bishop of Derry. The chimneypiece included the sculptural groups *Bacchus and Ariadne* and *Cupid and Psyche* and was attributed to Carlo Albacini.

If the various elements from the chimneypiece described in the *Westmorland* inventories are assumed to form an ensemble with the two sculptural groups and the bases decorated with vine motifs, a fireplace similar to the one at Ickworth could be reconstructed. In fact, on September 21, 1776, Father John Thorpe wrote to Henry Arundell, eighth Baron Arundell of Wardour, that "divers rich pieces of work are making for the Duke & Duchess [of Gloucester], among them are an elegant tableclock case and a chimney piece ornamented with groups of statues." Thorpe referred again to the chimneypiece in his correspondence with Arundell, on January 10, 1778:

A grand chimneypiece is now erecting for the Duke of Gloucester, & two contrived by himself & English artists fully acquainted with what is used and exteem'd in England, it is exactly in size & design agreeable to what are commonly made here. Neither the English gentry, nor the English artists make here any objection to the manner of them, except that now for them are desired to be higher than is customary in

97

98

this country. The Bp. of Derry is making three for his new home in Ireland.

The chimneypiece for the Duke of Gloucester to which Thorpe referred must be the one sent on the *Westmorland*, dismantled into various parts that were to be reassembled again in England. After the crates were opened at the Real Academia, it seems that all the elements were considered as separate pieces and the sculptures were handed over to the Spanish king while the pedestals remained at the Real Academia. As a result, the chimneypiece was permanently broken up, with the cornices, columns, and other elements probably reused to complete other fireplaces in the royal palaces.

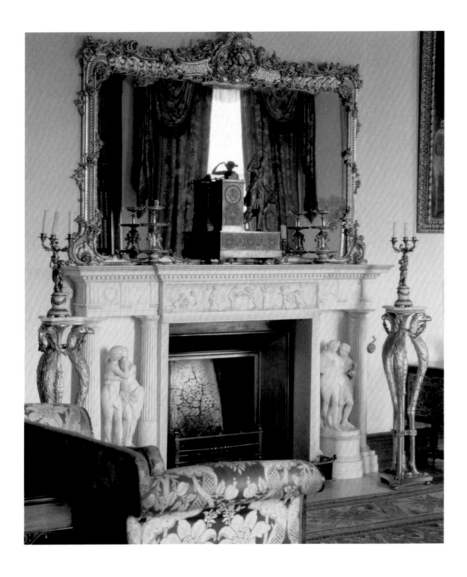

a document that records the payments made to that artist in 1813 for the design of the fireplace at Castelporziano. This proposal is supported by an entry in Elizabeth Gibbes's Roman diary on April 10, 1790, in which she refers to the artist making Lord Darnley's fireplace, noting, "This sculptor is repairing the Farnese Flora." While she does not give a name, the artist in question must be Carlo Albacini. MDSJ

REFERENCES: Brinsley Ford Archive, Paul Mellon Centre, London, box 66 (Sept. 21, 1776; Jan. 10, 1778); "Inventario de las Alhajas y Muebles existentes en la Real Academia de San Fernando (1796–1805)," no. 619-3; Honour 1989, 1:167–79, 553–54; Vaughan 1991, 183–97; Sotheby's, London, sale cat., Nov. 26, 2003, lot 87; González-Palacios 2008, 14–60; Bignamini and Hornsby 2010, 1:270–71.

Emma Lauze of the Paul Mellon Centre for Studies in British Art, London, provided the reference regarding Thorpe's letters, Jonathan Yarker shared ideas about the attribution to Albacini, and Alastair Laing provided details on the bishop of Derry's fireplaces and drew attention to the existence of various drawings by Friedrich Wilhelm von Erdmannsdorff of the fireplace at Ickworth.

99

UNKNOWN SCULPTOR

Head of the Medici Venus, Copy of the Antique Roman Original

1770s

Marble
15¾ x 9 x 9 in. (40 x 23 x 23 cm)
Real Academia de Bellas Artes de San Fernando, Museo, E-26

This slightly more than life-size head of extremely fine white marble, a typical souvenir of the type acquired by Grand Tour visitors passing through Italy, is based on one of the classical sculptures that was most celebrated in the seventeenth and eighteenth centuries. The original had been in the Tribuna of the Galleria degli Uffizi in Florence since 1688, along with other masterpieces of painting and sculpture. Johan Zoffany's painting of the Tribuna (fig. 25, p. 47), finished not long before the capture of the *Westmorland*, conveys the atmosphere of enthusiasm and admiration characteristic of the English travelers who visited the Medici

Figure 123. View of the chimneypiece in the library at Ickworth, Suffolk.

The design of this ill-fated ensemble enjoyed considerable success. Of the chimneypieces of this type made for Hervey, Alastair Laing has informed the present author that another one, identical to the one that appeared at auction in Sotheby's, was installed in the library at Ickworth House (fig. 123). The third must have been sent to Downhill House in Ireland during its construction for Hervey between 1776 and 1779 and it was probably lost in the fire that destroyed much of the house in 1851.

In addition to those at Ickworth, there is another identical fireplace at Cobham Hall, Kent, made for John Bligh, fourth Earl of Darnley, in 1790. There is also an almost identical version in the Italian president's summer residence at Castelporziano.

The design of the Ickworth chimneypieces was previously given to Antonio Canova, but Hugh Honour has recently rejected this attribution. Instead he assigned them to Albacini, on the basis of

collection in Florence, with a group of identifiable English visitors admiring the statue.

The present, exceptionally well-executed head, which is smaller in size than the original, was in a crate together with a packet containing three books on Italian literature and language, as well as two parts of the cornice of a chimneypiece. In the description drawn up of the contents of the *Westmorland*'s crates at the Real Academia, it is described as a "copia dela del original de la Venus llamada de Medicis con su basita de dho marmol" (copy of the original of the Venus known as de Medici with its small base of said marble).

The prestige of the *Medici Venus* was increased by the presence of an inscription on it in Greek stating that it was the work of the Athenian Cleomenes, son of Apollodorus. It was thus considered for some time to be a Greek work taken to Rome during the classical period. The subject of eulogies by poets, scholars of art, and intellectuals, the sculpture's fame meant that it was reproduced on a commercial scale for the art market in numerous different types and materials. JMLN

REFERENCES: Millar 1966; Haskell and Penny 1981, 325ff., no. 88; Azcue Brea 1994; Sánchez-Jáuregui 2001b, 420ff.; Westmorland 2002, no. 78 (entry by Almudena Negrete Plano).

100

UNKNOWN SCULPTOR

Head of Dionysus Tauros, after an Antique Roman Original

1770s

Marble
26 x 13¾ x 16⅛ in. (66 x 35 x 41 cm)
Real Academia de Bellas Artes de San Fernando, Museo, E-99

The elusive identity of this bust has caused much confusion from the time of its arrival at the Real Academia in a crate marked "H. R. H. D. G." It was first described as the "Busto de cabeza q. parece Griega Muger Griega Mayor q. el natural. Hai quien la cree de Agrippina: de marmol de Carrara copia del antiguo" (Bust of a head that seems Greek of a Greek woman larger than life size. Some believe it to be Agrippina: of Carrara marble copy of the antique) (list of October 18, 1783). In Antonio Ponz's inventory for the Real Academia, it is described as

a "cabeza grande de una bacante con su peana, uno y otro de marmol, de mas de tres quartas de alto" (large head of a bacchante in marble, after the Antique, over three *quartas* high with its round base) (list of March 27, 1784). Subsequent inventories add the information that the subject may be Leucothea: "Una cabeza grande de marmol, copia del antiguo, que parece una Bacante, ó Leucotea" (A large marble head, copy of the antique, which seems to be a bacchante or Leucothea) (list of April 28, 1784). The subject was subsequently identified as Ariadne, and the most complete inventory of the collections at the Real Academia, compiled between 1804 and 1814, attributed the work to one of the Real Academia's *pensionados* who spent some years studying in Rome, stating that "La Cabeza llamada de Ariadna, es de marmol de Carrara, mayor que la del antiguo, modelada en Roma por Dⁿ Pasqual Cortés, esta colocada sobre un pedestal de marmol verde en forma de columna con zocalo blanco" (The head known as Ariadne is of Carrara marble, larger than the antique one, modeled in Rome by Don Pascual Cortés, it is installed on a green marble pedestal in the form of a column with a white base). The bust's cylindrical pedestal of green marble with a white base also came from the *Westmorland* but in a different crate, whose owner has not been identified.

Although the early inventories consistently characterize the subject as a woman, the present work is in fact a good-quality copy of a bust of Dionysus in the Musei Capitolini, Rome. It was brought to Paris in 1797, where it remained until 1815 as one of the sculptures selected for the Musée Napoléon, the name given to the Louvre in 1801. The work depicts a youthful Dionysus, whose androgynous beauty explains the confusion with Ariadne and other female subjects. In the Capitoline Museum version the figure's hair, which looks back to late Hellenistic models, seems to suggest the presence of small horns, hence the name "Dionysus Tauros." The horns refer to the concept of fecundity, also found in the iconography and attributes of other gods. The copyist, possibly unaware of the significance of the feature, has eliminated this detail. Aside from this omission the present work is a notably faithful copy of the Roman original. JMLN

REFERENCES: H. S. Jones 1912, 344, no. 5, pl. 86; Steuben 1966, 236, no. 1430; Melendreras Gimeno 1993, 163–68; Azcue Brea 1994, 334.

Crate J. H.

OWNED BY SIR JOHN HENDERSON OF FORDELL

Born to a family of wealthy Scottish landowners, Sir John Henderson (1762–1817) later became a lawyer and member of Parliament for the county of Fife. Prior to the discovery of the Fordell coat of arms and Henderson's signature in the contents of the crate, it was not known that he had made a Grand Tour. Subsequent research has placed Henderson in Paris in December 1775, in Florence in September 1777, and in Rome three months later. In the spring of 1778 Henderson was apparently in Naples to refute the paternity claim of a Nicolas Henderson, which may have dated back to the Grand Tour made between 1739 and 1742 by his father, Sir Robert Henderson, fourth Baronet of Fordell. The contents of Henderson's crate illustrate a refined interest in French and Italian literature, theater, poetry, music, philosophy, and politics. They included a collection of prints by Giovanni Battista Piranesi representing antiquities and views of Rome; books by such authors as Carlo Goldoni, Pietro Metastasio, Petrarch, Torquato Tasso, and Molière; and copies of old master paintings, including Titian's *Venus and Adonis* and *Danaë* and Correggio's *La Zingarella*, along with a portrait of an unidentified male sitter. He became fifth Baronet of Fordell in 1781. CS

Figure 124. *Portrait of an Unknown Man* in its original frame.

101

UNKNOWN ARTIST

Portrait of an Unknown Man

ca. 1777

Oil on canvas
19¾ x 15¾ in. (50 x 40 cm)
Real Academia de Bellas Artes de San Fernando, Museo, 522

This painting is described from the outset in the lists of the Real Academia as a "Retrato de joven con marco dorado" (Portrait of a young man in a gilded frame). It is one of the few instances in which a painting from the *Westmorland* was being shipped framed. The portrait still has its original, wooden frame with a simple molding and gold leaf (fig. 124).

The identity of the sitter remains unknown. Its presence in Henderson's cases might suggest that it is his portrait, which, like those of Francis Basset and George Legge, Viscount Lewisham, he would have had painted in Italy in accordance with habitual Grand Tour practice. The present portrait, however, is notably different from the normal Grand Tour image. It does not contain any element that refers to Italy or to Roman antiquities. The bust-length, three-quarter-profile format is unusual, and the small size (not quite twenty inches high) and informal dress do not correspond in any way to the models developed by Anton Raphael Mengs and Pompeo Batoni. The unknown artist, clearly with the aim of emphasizing the gaze and expression, has not included any accessories that might detract attention from the face, resulting in an image that looks closer to Romantic portraiture.

Comparison with the black chalk drawing of Henderson executed by John Brown in 1782—by which time the subject had become Sir John Henderson, fifth Baronet of Fordell—for the Society of Antiquaries of Scotland (fig. 14, p. 24) does not suggest that this is the same person, even allowing for a degree of idealization in the painting. In the

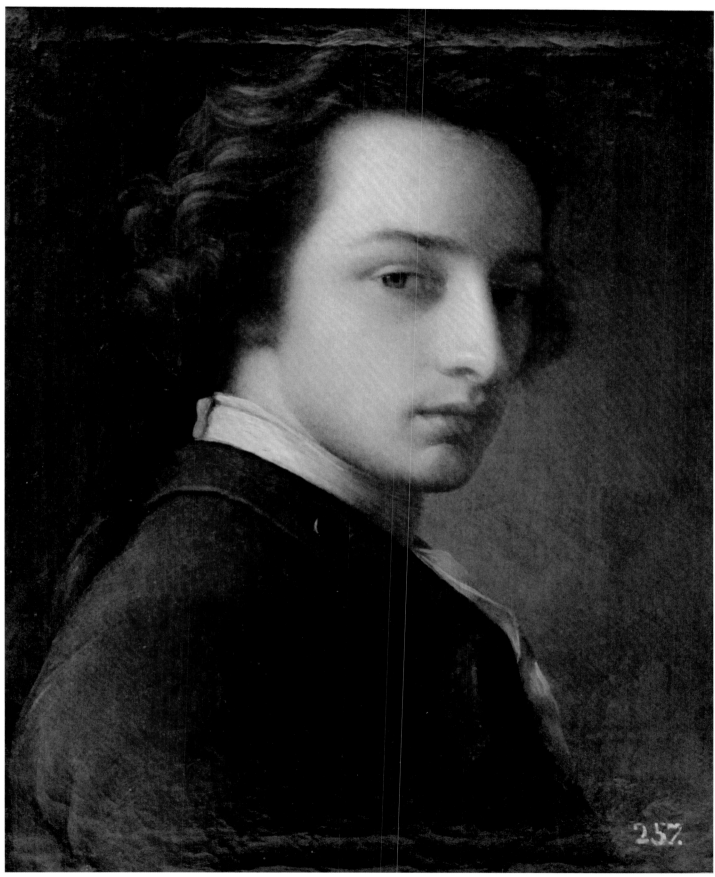

257.

correspondence between Robert Liston, minister plenipotentiary in Madrid in 1783, and an acquaintance simply referred to as "Andrew" concerning attempts to recover Henderson's possessions lost on the *Westmorland*, Andrew wrote, "There is a Portrait he joys [*sic*] which he wishes much to have, for it cannot be of great value to any body in Spain" (cat. 15).

It is possible that if the painting in question were in fact a portrait of John Henderson, a common friend would not refer to it as a "portrait he joys which he wishes much to have" but rather as "his portrait." It has also been suggested that one of Christopher Hewetson's terra-cottas on board the *Westmorland* (cat. 136) may depict the same sitter as the present portrait. Although there is certainly a resemblance, the fact that the terra-cotta traveled in a different crate raises doubts about this suggestion. MDSJ

REFERENCES: Westmorland 2002, nos. 70, 71 (entries by María Dolores Sánchez-Jáuregui); Sloan and Lloyd 2008, 31; National Library of Scotland, Edinburgh, MS 5539, no. 3, "Andrew" to Robert Liston, Dec. 16, 1783.

102

FRANCESCO LANDINI AFTER TITIAN
(CA. 1488–1576)

Venus and Adonis

ca. 1777

Oil on canvas
18⅜ x 22⅝ in. (46.8 x 57.6 cm)
Inscribed on verso: "Tiziano"; signed: "Francesco Landini pinx."
Real Academia de Bellas Artes de San Fernando, Museo, 506

Among the different versions of this composition, catalogued by the Titian scholar Harold Wethey as "Museo del Prado type," "Barberini type," or "Farnese type," the present copy corresponds to the latter. According to Wethey, there are reasons for believing that the Farnese *Venus and Adonis* was executed as a pair with the *Danaë* that Titian painted for Alessandro Farnese between 1545 and 1546. The presence of the *Venus and Adonis* in the Farnese collection can be traced to the inventory of Palazzo Farnese, Rome, in 1649, and to another drawn up in

102

Parma in 1680. In 1710 the painting was again mentioned, in an inventory of Palazzo del Giardino, Parma, after which nothing is known of it. In 1759 the Farnese collection was moved to Naples, but, unlike the *Danaë*, it is not recorded in the inventories at Palazzo di Capodimonte. However, William Buchanan referred to a letter from James Irvine, sent from Rome back in 1804, that includes a description of a *Venus and Adonis* painting by Titian that Irvine was about to buy and which he wrote was "like the one in Naples, in Capodimonte, and which was engraved by Strange." The painting that Irvine wanted was originally in the Mariscotti collection in Rome, from which it was purchased by the Camuccini brothers and subsequently by Irvine; it is now in the Metropolitan Museum of Art, New York (fig. 125).

Robert Strange's print (fig. 126) dates from 1769 and has been considered the most reliable record of the appearance of the original Farnese Titian. The print does reveal notable differences from the New York canvas, including the background vegetation, the rainbow, the bench at Venus's feet, and other elements. The copy at the Real Academia de Bellas Artes de San Fernando is identical to the version now in New York. This painting is signed "Francesco Landini" on the stretcher. Along with the painting, the same crate on board the *Westmorland* contained a copy of Titian's *Danaë*, also of the "Farnese type" and of exactly the same dimensions as the present *Venus and Adonis*. This *Danaë* has not been located in the Real Academia. In addition, the crate belonging to Henderson contained a copy of Correggio's *La Zingarella* (also known as *Madonna of the Rabbit*), also signed by Landini.

Nothing is known of Francesco Landini, but, as both *Danaë* and *La Zingarella* were in Capidomonte, he was perhaps a local artist who specialized in making copies and had access to that collection. MDSJ

REFERENCES: Wethey 1975, 55–60, nos. 5, L-19; Zapperi 1991, 159–71; Falomir Faus 2003, 77–91, no. 40.

Figure 125. Titian, *Venus and Adonis*, oil on canvas, 42 x 52½ in. (106.7 x 133.4 cm). The Metropolitan Museum of Art, The Jules Bache Collection, 1949

Figure 126. Robert Strange, after Titian, *Venus and Adonis*, 1762-69, engraving with etching, 19 x 23¼ in. (48.3 x 58.9 cm). British Museum, Department of Prints and Drawings

103

104

103

JOHN ANDREWS (1736–1809)

Essai sur le caractere et les moeurs des François comparés a ceux des Anglois

London [Paris?], 1776

Inscribed on front free endpaper: "P.Y."; annotation of the menu for a meal on back paste-down endpaper
Real Academia de Bellas Artes de San Fernando, Archivo-Biblioteca, B-1098

This volume is unusual in that it retains its original soft binding in the form of a paper cover with a floral and geometric pattern printed in color. Known as Dutch floral paper, with patterns inspired by contemporary textiles, this type of paper was used in the eighteenth century for temporary bindings prior to a permanent library binding.

The title page does not include the name of the author or editor. Although in the past the author has been suggested to be Jean-Jacques Rutledge (or Rutlidge), recent cataloguing has identified it as a translation of *An Account of the Characters and the Manners of the French* by the English author John Andrews, translated into French by Rutledge in 1776. Contrary to what appears on the title page, recent scholarship based on its printing and typography has led to the conclusion that it was probably printed in Paris.

The text is structured as a succession of paragraphs or brief statements, numbered 1 to 458, that deal with specific aspects of French and English society. Among the many topics covered are politics, systems of government, the clergy, fashion, and French women. Through his examples and comparisons and within the ideal context offered by traveling, the author aimed at an exchange of ideas to achieve both self-awareness and awareness of others.

This copy contains numerous annotations, underlined passages, and sketches of monuments presumably made by its owner, Henderson, revealing his particular interests and the use that he made of the book on his trip. The most evocative element with regard to Henderson's trip is possibly to be found on the last page, shown here, on which he wrote in English the menu, price, and dishes of a meal in France consisting of "Rice soup, Buillie, Friqandau, Roast Beef, Fricassé bowl with mu[shrooms?], Colly flower, Petit Paties and Forend." MDSJ

REFERENCES: Westmorland 2002, no. 37 (entry by José M. Luzón Nogué); Monnier 2006; Bibliothèque Nationale de France.

104

(1707–1777)

**Les égaremens du coeur et de l'esprit,
ou Memoires de Mr. de Melicour**
Paris: Prault, 1765

Ex libris and coat of arms of Robert Henderson
of Fordell on front paste-down endpaper; inscribed
on flyleaf: "P.Y."
Real Academia de Bellas Artes de San Fernando,
Archivo-Biblioteca, C-1456

Claude Prosper Jolyot de Crébillon, son of the
playwright Prosper Jolyot de Crébillon, was also a
playwright and the author of novels. Combined with
his notorious personal life, the licentious nature of
some of his novels and their critique of power brought
him into conflict with the authorities, resulting in a
prison sentence and obliging him to flee Paris.

This novel focuses on the initiation into the adult
world of a young aristocrat, Mr. de Melicour, at the
hands of a libertine mentor; his experiences with
different lovers; and his discovery of true love with a
young lady. It was originally published in three parts
between 1736 and 1738. It seems unfinished but
specialists are not in agreement as to whether this
is deliberate or not. The present copy consists of
three volumes; though printed in Paris, the first and
third parts have their own frontispiece on which is
printed: "A La Haye: Chez Gosse & Neaulme, 1738."

Les égaremens was among Crébillon's most
successful titles, running into numerous editions
and translated into other languages. An English
edition was published in London in 1751 with the
title *The wanderings of the heart and mind*, trans-
lated by Michael Clancy.

The front paste-down endpaper has the book-
plate of Robert Henderson, fourth Baronet of
Fordell and father of John Henderson. Beneath the
coat of arms is the family motto: "SOLA VIRTUS
NOBILITAT" (Virtue alone ennobles). This ex libris
allowed us to identify John Henderson as the owner
of the crates on the *Westmorland* marked with
the initials "J. H." The book contains annotations
and comments in French on the back flyleaf and
endpapers that allude to the number of plays by
"Crébillon le père" (Crébillon the father)—"a écrit
6 tragédies" (wrote six tragedies)—and to some titles
by "C. le fils" (Crébillon the son). Next to one of the
titles, which he recorded as "Ah! Quel conte" (*Ah,
quel conte! Conte politique et astronomique*, 1754),
the younger Henderson added a few words about the

plot of the play: "Le Comte Vermandois fils de la
Valiere & de Lursa[y] pour avoir donné un soufflet au
Dauphin" (Count Vermandois son of de la Valiere
and of de Lursa[y] for having given the Dauphin a
slap in the face). MDSJ

REFERENCE: Westmorland 2002, no. 73 (entry by
José M. Luzón Nogué).

105

Oeuvres de Molière. Nouvelle Edition, vol. 7
Paris: Hochereau, 1770 (8 vols.)

Inscribed on front free endpaper of vol. 1: "P.Y."
Real Academia de Bellas Artes de San Fernando,
Archivo-Biblioteca, B-2391

While traveling in Paris, Grand Tourists would often
visit the theater with their French hosts or with
groups of foreign travelers. The most popular plays
were those of Jean-Baptiste Poquelin, known by his
stage name, Molière—the father of French comedy
and arguably the most successful comedic French
playwright. His works were translated into English
for the first time in 1714 and translated again in 1739
in a more complete edition. It is telling of Hender-
son's knowledge of French language and culture that

105a 105b

he used the original French version. Grand Tourists would have been particularly attracted to Molière's works because of the interest taken in him by contemporary academics such as Voltaire, who wrote a life of the playwright and was a frequent host to Grand Tour travelers. Their diaries often mention Molière in relation to a contemporary playwright, Carlo Goldoni, who was well represented within the *Westmorland*'s cargo by, for instance, a copy of the multivolume *Commedie scelte di Carlo Goldoni* in the shipment for Frederick Ponsonby, Viscount Duncannon (cat. 89). Henderson's copy of Molière's plays is of particular interest due to his selective annotations. Although he made only occasional marks on the pages of Molière's most famous play, *Le misanthrope*, he corrected the French, underlined sections, and commented in the margins of the play *Les femmes savantes* (105b). His substantial interactions with this lesser-known play suggest a closer and more engaged reading of Molière than the casual dilettante may have had. KC

106

Le parfait ouvrage, ou essai sur la coiffure, traduit du persan, par le sieur l'Allemand, coiffeur, neveu du sieur André perruquier, breveté du grand roi de Perse, correspondant du grand Turc, de plusieurs sociétés de coiffeurs, perruquiers, baigneurs, etc.
Caesarea, 1776

Inscribed on front paste-down endpaper: "P.Y."
Real Academia de Bellas Artes de San Fernando, Archivo-Biblioteca, C-1052

Le parfait ouvrage, ou essai sur la coiffure (The Complete Work, or Essay on Hairdressing) speaks to British tourists' fascination with French fashions in the late eighteenth century. Hairstyles were one of the most striking features of French style during this period, and *Le parfait ouvrage*, ostensibly translated from an original Persian text by a coiffeur-cum-literati, both explains and ridicules the importance of coiffure in polite society. *Le parfait ouvrage* was one of a number of books in Henderson's crates dealing with French poetry, theater and opera, and customs and manners, suggesting that his interest in French culture was particularly strong.

Hairstyles realized new levels of elaborateness in the 1770s and 1780s, especially in great metropolitan centers such as Paris. It was not uncommon for women's hairstyles, the focus of this book, to reach two to three feet in height, requiring technical expertise as well as artistic creativity for their proper execution. A significant coiffure industry emerged in Paris and other cities, with hairdressers, wigmakers, and merchants of powder, feathers, and additional ornaments all competing for a portion of this lucrative business. Ornate hairstyles were ultimately part of the carefully constructed public images that wealthy men and women were expected to present.

An abundant literature developed around this industry. Numerous contemporary treatises catalogued fashionable hairstyles. In 1772, for example, the book *Éloge des coiffures adressé aux dames* (Praise of Hairdressing, Addressed to Women) recorded 3,744 different ways of styling hair. Fashion journals multiplied in Paris and elsewhere, frequently reproducing discussions of hairstyles from other printed works. Extreme hairstyles engendered mockery, however. *Le parfait ouvrage* joins in a satirical tradition that originated with *La perruque*, a mid-century French play ridiculing wigmakers. In *Le parfait ouvrage* the narrator lauds coiffure as the grandest and most useful profession, claiming that it provides "un spectacle délicieux" that can mask even the ugliest natural features and therefore has created the empire of the female sex. The author satirizes the world that has given rise to this coiffure industry as much as he mocks the coiffeurs themselves. SA

REFERENCES: Gerbod 1995; Biddle-Perry and Cheang 2008.

107

JEAN-JACQUES RUTLEDGE (1742–1794)

La quinzaine Angloise a Paris ou l'art de s'y ruiner en peu de tems ouvrage posthume du Docteur Stéarne traduit de l'Anglois par un observateur
London, 1776

Inscribed opposite title page: "P.Y."
Real Academia de Bellas Artes de San Fernando, Archivo-Biblioteca, B-1097

According to the title page, this novel is a posthumous work by Docteur Stéarne; however, the name "Rutledge" is written in pencil on the same page in handwriting notably similar to that found in other books belonging to Henderson.

Jean-Jacques, or John James, Rutledge, or Rutlidge, was a Frenchman of Irish descent who led an extremely active life in the fields of literature and politics. He published various works on English literature in French, translated books from both languages, edited the journal *Le babillard* (equivalent to the popular *Tatler*), wrote lampoons on well-known figures of the society, and engaged in polemics with Voltaire, all in a combative and revolutionary spirit. Many of his works were signed with pseudonyms such as Provence, K. S. Chevalier R***, or, in this case, Dr. Stéarne, in reference to Laurence Sterne, with whose work *A Sentimental Journey through France and Italy* this volume reveals numerous similarities.

The present novel recounts the experience of a young and inexperienced English lord on the Grand Tour. The text is divided into fifteen chapters that cover the fortnight when the young man is in Paris without a tutor. He becomes involved in a wide range of absurd situations, ending up in prison. Eventually the young aristocrat is obliged to return home, as he has spent all his funds for the Grand Tour during these two weeks in Paris.

The novel, which was banned in France, was first published in London, in 1776, with the text in French. A year later it was translated into English. Encouraged by its success Rutledge wrote a second part entitled *Premier et second voyage de mylord de *** à Paris, contenant la quinzaine anglaise et le retour de Mylord dans cette capitale après sa majorité, par le ch. R**** (1782). He also wrote other, similar titles such as *Les confessions d'un Anglois, ou Mémoire de Sir Charles Simpson* (1786), which brought him a degree of fame among enthusiasts of travel literature. MDSJ

REFERENCES: Westmorland 2002, no. 45 (entry by Alejandra Hernández); Monnier 2006; Bibliothèque Nationale de France.

106

107

108

FRIEDRICH SCHWINDL (1737–1786)

Twelve Easy Duets for Two Violins
London: R. Bremner, [ca. 1770]

Inscribed on title page: "J. Henderson. 1770"
Real Academia de Bellas Artes de San Fernando,
Archivo-Biblioteca, FJIM-67

According to the inventory prepared by the Compañía de Lonjistas de Madrid (cat. 12 and appendix 1, p. 322), crate "J. H." included "Una porcion de Quadernos de Musica" (A group of musical scores), while Antonio Ponz's inventory for the Real Academia de Bellas Artes de San Fernando (cat. 14 and appendix 2, p. 332) noted "Un legajo de papeles, y quadernos de Musica" (A bundle of papers and musical scores). These entries suggest that Henderson's copy of *Twelve Easy Duets for Two Violins* was part of a larger collection of music with which he was traveling and which has not yet been identified within the musical collections of the library of the Real Academia. That Henderson possessed Schwindl's set of duets for two violins indicates that he was an amateur violinist, the "easy" in the title suggesting that he was perhaps not a particularly proficient musician. The publication of the duets in London also suggests that he set out with the music rather than acquiring it on his travels.

Schwindl was active as a composer, violinist, and teacher in Germany, Switzerland, and the Netherlands. Though little known today, his symphonies and chamber music, which appeared frequently in publications beginning in the 1760s, enjoyed wide circulation throughout Europe. The music historian and critic Charles Burney noted that he was "well known in the musical world, by his admirable compositions for violins, which are full of taste, grace, and effects." SW

REFERENCES: Westmorland 2002, no. 72 (entry by Isabel Rodríguez López); Downs 2011.

109

GIUSEPPE VASI (1710–1782)

**Itineraire instructif divisé en huit journées:
Pour trouver avec facilité toutes les anciennes,
& modernes magnificences de Rome**
Rome: Michel-Ange Barbiellini, 1773

Inscribed on title page: "JH"
Real Academia de Bellas Artes de San Fernando,
Archivo-Biblioteca, B-3150

Giuseppe Vasi was born in rural Sicily. His early work in Palermo was under the patronage of Carlos de Borbón, king of Naples and Sicily. Still under royal patronage Vasi went to Rome in 1736, moving in 1748 into a workshop in Palazzo Farnese, owned by the Neapolitan royal family. From there he continued work on his ten volumes of masterly engravings entitled *Delle magnificenze di Roma*, which illustrate the whole city and its environs in more than two hundred plates. This project extended until 1761 and provided the basis for Vasi's future successes.

The *Itineraire instructif divisé en huit journées: Pour trouver avec facilité toutes les anciennes, & modernes magnificences de Rome* (1773) found in Henderson's crate aboard the *Westmorland* (another copy in French belonged to Frederick Ponsonby, Viscount Duncannon) is the first French translation of Vasi's illustrated guidebook to Rome, which had first appeared ten years earlier, in Italian. It provided the visitor to the city with a single volume containing information on all the sites that had been illustrated in the ten volumes of *Delle magnificenze* but in a more accessible and portable form. Some of the major monuments are illustrated in the guidebook with much-reduced versions of the large (typically 7⅞ x 11⅞ in.) engravings that appear in

109a

109b

Delle magnificenze. Above each of these appears the reference to the volume and plate number where the large image can be found; this was not only a useful tool for the connoisseur but also a clever marketing device, pointing out to the visitor what to ask for if interested in finding—and buying—the fine larger print. There is also text describing each of the sites in order, although for reasons of space not all are illustrated. Vasi explained his intentions in the preface:

Et pour que mon Ouvrage presente plus de commodité à tout le Monde, je l'ai arrangé en forme d'Itineraire, divisé en huit Journées de chemin, & j'ai mis le numero de la Table dans chaque Chapitre, conformement aux dix Livres, a fin que, lors qu'on le voudra, on puisse y observer plus distinctement la magnificence des Edifices representés par les gravures, en trouver les explications, & en prendre des conoissances plus étendues & plus claires. (And in order that my work be more convenient for everyone, I have arranged it as an itinerary divided into eight days of walks, and I have put the number of the plate in each chapter conforming to the ten books, so that one can observe more closely the magnificence of the buildings represented by the prints, find their explanations, and acquire a broader and more accurate knowledge.)

The guidebook proposes an eight-day tour of the city's monuments, following on earlier traditions of guides, such as *Le cose meravigliose dell' alma città di Roma* and the pilgrims' guide *Le sette chiese principali di Roma*, that also propose highly detailed, exhaustive (and exhausting) visits. For example, Vasi's first "day" contains the improbably large number of sixty-six sites to be seen, from the Ponte Milvio on the northern approach to the city to the basilica of Santa Croce in Gerusalemme to the south. Giambattista Nolli's *Nuova topografia di Roma* (see cat. 113), published in 1748, was of crucial importance in all of Vasi's subsequent work, especially the creation of the itinerary.

The present copy tells us the date of Henderson's arrival in Rome; it is noted as "19 December 1777." in ink underneath the engraving that shows the Porta del Popolo, the most famous and notable point of entry to the city for Grand Tourists (109b).

The book was also translated into English, an edition that sold very well, and its success helped to fund further projects. One of them, the *Prospetto dell'alma città di Roma* (1765), is a large panoramic view, taken from the Gianicolo Hill above Palazzo Corsini, that shows the whole extent of the city within the walls—a tour de force of illustrative mapping, combining Vasi's technical brilliance with a painterly flair. CH

REFERENCES: Lamaro 1996; Westmorland 2002, no. 43 (entry by José M. Luzón Nogué); Bevilacqua 2004; Imago Urbis 2008.

Crates E. D. and E. L. D.

OWNED BY GEORGE LEGGE, VISCOUNT LEWISHAM

George Legge, Viscount Lewisham (1755–1810), the eldest son of William Legge, second Earl of Dartmouth, was educated at Harrow School and Christ Church, Oxford. Lord Lewisham spent nearly three years touring Europe with his tutor, David Stevenson, who was considered by Sir William Hamilton to be "as proper a companion for a young man as any I have ever seen in that situation," and, for a time, with Lewisham's younger brother William. Their travels, during which Lewisham studied fencing, dancing, languages, and literature, included France, the Netherlands, Germany, Hungary, Switzerland, and

Italy. Lewisham's Italian tour took him from Genoa and Milan to Florence, Rome, Naples (where Hamilton described Lewisham as faultless, "except that his outside is a little too fat"), and Venice. The contents of Lewisham's crates on the *Westmorland* included books in Italian on art, literature, theater, and history, as well as maps of Rome, engravings by Giovanni Volpato and Salvator Rosa, lava samples from Vesuvius, and the standard Grand Tour accessories of guidebooks, grammars, and dictionaries, some of which are inscribed with Stevenson's name and presumably belonged to him. The crates also contained copies of Raphael's *Madonna della Seggiola* and of Domenichino's *Cumaean Sibyl*, a pair of miniature portraits, and a small view of Vesuvius on paper. Following his Grand Tour, Lewisham received a doctorate in civil law from Oxford and subsequently filled a series of government and court appointments. He was a trustee of the British Museum from 1802 and was appointed a Knight of the Garter in 1805. He succeeded his father as Earl of Dartmouth on the latter's death in 1801. CS

110

110

POMPEO BATONI (1708–1787)

George Legge, Viscount Lewisham
1777–78

Oil on canvas
50 x 39⅜ in. (127 x 100 cm)
Signed and dated: "Pompeo de Batoni Pinx. Romae 1778."
Museo Nacional del Prado, P00048

Like the full-length portrait of Francis Basset (cat. no. 21), the portrait of Lord Lewisham was sent to the residence of the prime minister, José Moñino y Redondo, conde de Floridablanca, shortly after its arrival in Madrid. From there it entered the royal collections and subsequently the Museo del Prado when that museum was founded.

Correspondence between Lewisham and his father, William Legge, second Earl of Dartmouth, directly refers both to the canvas and to Pompeo Batoni's working methods. A letter of April 25, 1778, sent to Lewisham in Rome by his father refers to the costs of his trip and states: "I do not at all lament the expense you have put me to with Signor Pompeo Battoni [*sic*]. I do not know whether I should not have proposed it to you if I had thought you could spare so much time as he used to require. I think he kept me between 40 & 50 hours in all."

The earl was referring to the portrait and a miniature that Batoni painted of him in Rome when he made the Ground Tour in 1752–54. The reference to the number of hours that he posed for Batoni is interesting. The portrait of William Legge is one of the first that Batoni painted for English Grand Tour clients. The artist's beginnings in this genre and his efforts to gain a reputation as a portraitist made Batoni's portraits of these years particularly outstanding with regard to their quality, which would explain the number of hours required for the sittings. By the time the young Lewisham arrived in Rome in 1777, however, Batoni had been painting Grand Tour portraits of the English nobility for twenty-five years and had become highly adept in the genre. By then, as Anthony M. Clark and Edgar Peters Bowron have noted, in order to avoid lengthy sittings he required only two or three sessions, during which he captured the sitter's features directly on the canvas; he subsequently added the poses, gestures, and details such as the map of Italy and the bust of Faustina Minor, which he took from his ample repertoire.

As was the case with the present sitter's father, the commission for this portrait must have come about through the dealer Thomas Jenkins, who in a note to the Earl of Dartmouth (cat. 9) recorded payment "to Pompeo Batoni for the remainder of Ld Lewishams portrait . . . 155 [sequins]," the equivalent of about £75 at the time and thus a high price for Batoni during that period.

Like other travelers who lost works on the *Westmorland*, Lord Lewisham made several attempts to recover his canvas. He may also have commissioned a copy of the painting by the Spanish artist Joaquín María Cortés in 1796 (Museo de Bellas Artes, Seville). As a result of the renewal of hostilities between Britain and Spain in that year, Lewisham never came to possess that work either. MDSJ

REFERENCES: Clark and Bowron 1985, no. 368; Westmorland 2002, no. 48 (entry by Ana María Suárez Huerta); Suárez Huerta 2006, 252–56.

III

UNKNOWN ARTIST AFTER RAPHAEL (1483–1520)

Madonna della Seggiola

1770s

Gouache on paper
Diam. 11 in. (28 cm)
Real Academia de Bellas Artes de San Fernando, Museo, 501

The *Madonna della Seggiola* (also called *Madonna della Sedia*) was one of those paintings, along with Guido Reni's *Aurora* (see cats. 35 and 77), that became a must-see for travelers in Italy; consequently, replicas, in some form or another, became a ubiquitous Grand Tour purchase. Painted by Raphael in Rome in about 1515, the picture entered the Medici collection in Florence by 1589. During the eighteenth century it was housed in Palazzo Pitti and, unusually for an oil painting, as Friedrich Leopold, Count Stolberg, observed in 1797, was "kept covered with a glass." The painting was the subject of enthusiastic passages in most of the standard guidebooks to Italy; for example, Charles-Nicolas Cochin, writing in 1758, observed that "c'est véritablement une des plus belles choses qu'on puisse voir de ce grand maître" (it is truly one of the most beautiful things that one can see by this great master). The picture naturally became a popular subject for copyists. When visiting the Palazzo Pitti Tobias Smollett observed that "there was an English painter employed in copying this picture, and what he had done was executed with great success. I am one of those who think it very possible to imitate the best pieces in such a manner, that even the connoisseurs shall not be able to distinguish the original from the copy." Although ostensibly an educational practice, copying was also a lucrative activity for artists studying in Italy, as copies of favorite compositions were highly sought after by travelers.

This reduced-scale gouache copy was unlikely to have been produced in the Palazzo Pitti itself, a privilege that required specific permission from the Florentine authorities. In fact the number of engravings made of the composition meant that this version, which Lord Lewisham shipped on the *Westmorland*, was just as likely to have been purchased in Rome

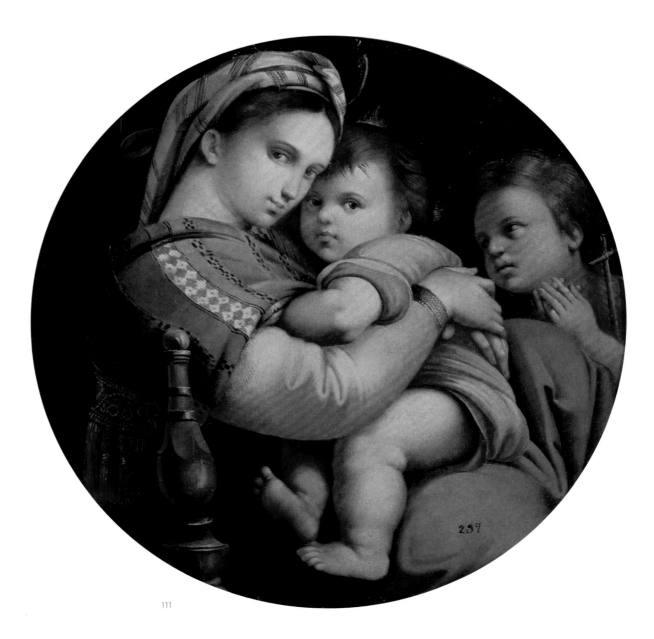

111

as in Florence. On the other hand, Lewisham and his tutor, David Stevenson, were added to Johan Zoffany's painting of *The Tribuna of the Uffizi* (Royal Collection) in December 1777, below the *Madonna della Seggiola*, which Zoffany fancifully depicted as hanging in the Tribuna, so the copy after Raphael's painting might well have been purchased to commemorate their time in Florence. Unlike other reduced copies on board the *Westmorland*, this *Madonna della Seggiola* does not rely on the outline provided by an engraving and is instead finely painted. JY

REFERENCES: Cochin 1758, 2:66–67; Smollett 1766, 2:72; Stolberg 1797, 2:68; Gregori et al. 1984; Meyer zur Capellen 2005, vol. 2, no. 57.

112

UNKNOWN ARTIST AFTER DOMENICO ZAMPIERI, CALLED DOMENICHINO (1581–1641)

The Cumaean Sibyl

1770s

Monochrome wash over graphite on paper
27⅝ x 23⅜ in. (70.2 x 59.4 cm)
Real Academia de Bellas Artes de San Fernando, Museo, 1126

Domenichino had a high reputation in eighteenth-century England (the influential Anthony Ashley-Cooper, third Earl of Shaftesbury, had judged his *Last Communion of Saint Jerome* to be the best picture in the world) and was often held up as the equal of

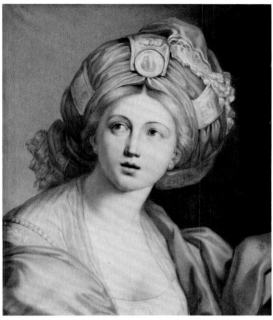

112

into a sweeter, more placid image. The copy may have been acquired more or less off the shelf as an inexpensive souvenir of a celebrated painting. Of course, monochrome or grisaille elements were familiar in eighteenth-century interior decoration, and the classical character of Domenichino's art lent itself to such treatment. In addition, as Lewisham knew, authoritative writers on art held that the nobility of concept and the design of a painting were of serious intellectual interest, superior to the pleasurable effects of rich coloring, which appealed only to the senses. A monochrome version of a well-known and magnificent painting might have sparked conversations that tested or asserted this traditional view. cw

REFERENCE: Spear 1982, vol. 2, no. 51.

Raphael. The owner of this copy, Lord Lewisham, also acquired a copy of the *Madonna della Seggiola* by Raphael (cat. 111). Indeed, the *Cumaean Sibyl* was inspired by Raphael's *Saint Cecilia* altarpiece in Domenichino's native Bologna. Painted in late 1616 or early 1617 for Cardinal Scipione Borghese, the *Sibyl* has remained in the Borghese collection in Rome.

The theme of the sibyl, an oracular figure from classical literature, allowed the artist to explore ideas of virtue, beauty, and wisdom. Domenichino depicted a gorgeously dressed figure with musical and literary attributes in a garden setting. His painting was described by a contemporary source, Giulio Mancini, as "a sibyl of great art and perfection"; she is traditionally identified with the Cumaean Sibyl, who foretold the coming of the Messiah, an appropriate subject for a cardinal's collection. Domenichino's composition proved extremely popular: bust-length paintings of beautiful women gazing distantly upward, their exotic headdresses and jewels characterizing them as sibyls, proliferated in the seventeenth century.

This monochrome copy shows only part of the turning figure against a plain background, and it may already be based on a reduced version, possibly a drawing. In effect the copyist has provided a simplified image of ideal beauty and rapt expressiveness, using a refined tonal treatment. The brilliance of color and the lavishly rendered textures of Domenichino's *Sibyl* are replaced by a gentle blending of light and shade, while its sensuous qualities are distilled

113

ignazio benedetti after giambattista nolli (1701–1756) and giovanni battista piranesi (1720–1778)

La topografia di Roma
1773

Engraving
21⅞ x 31½ in. (55.5 x 80 cm)
Inscribed on scroll: "D. Stevenson. Janry: 12 1778"
Real Academia de Bellas Artes de San Fernando, Archivo-Biblioteca, Mp-38

Giambattista Nolli, the greatest of the mapmakers to represent the city of Rome in the post-antique period, was born in Como, and he trained and worked as a cartographer in the Milan area until 1735. In that year he arrived in Rome and was soon working under the patronage of Cardinal Alessandro Albani, for whom he was to prepare plans and detailed terrain maps for the wealthy prelate's villa on Via Salaria, on the northern fringes of the city. It was to this cardinal that Nolli dedicated *La topografia di Roma*—a smaller-sized version of his major mapping project, the *Nuova topografia di Roma* (known as *La pianta grande di Roma*), made on twelve copper plates that measure in total approximately 69¼ x 81⅞ in. (176 x 208 cm). The success of this great map was guaranteed by the careful manner in which Nolli organized the works; he entered into a series of contracts with the banker Girolamo Belloni from 1742 on, to provide funding for the cost of the plates and for the engravers he

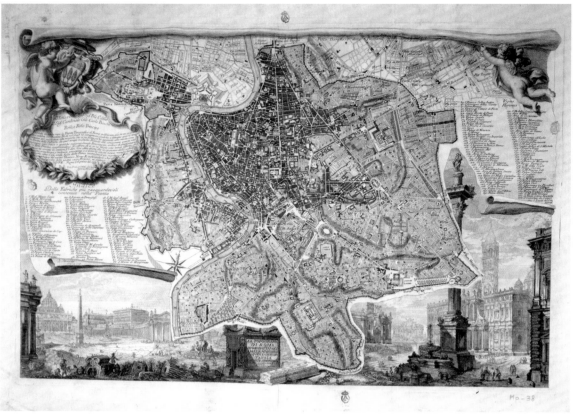

113

Detail of signature

employed. Via advertisements in the Roman newspaper *Diario ordinario di Roma,* the public was made aware of each stage of the preparation for publication of the map. In 1748, the same year in which the *Pianta grande* appeared, Nolli published the smaller version as well; on the engraved altar that serves as a central caption, he described it as "dalla maggiore in questa minor tavola dal medesimo ridotto" (reduced by the same author from the larger plate to this smaller one). It is this map that provided the model for many others in subsequent years,

one of them being this fine engraving by Ignazio Benedetti, made in 1773, nearly twenty years after Nolli's death.

Benedetti dedicated his map to Cardinal Giovanni Carlo Boschi, substituting Boschi's coat of arms, grasped by a putto, for those of Cardinal Albani above the dedicatory text at the top left of the map. He added three more churches to the numbered index that appears below the dedication and at the top right; as in the Nolli plan each number can be found in its relevant position on the map itself. Taken directly from the Nolli original, the city is shown, with north at the top of the sheet, engraved on a trompe l'oeil piece of parchment that curls up around the shape of the walls and below the two indexes to reveal capriccio views of some of the major monuments of the city, which were drawn by Nolli's collaborator, Giovanni Battista Piranesi. Piazza San Pietro, with a view of St. Peter's Basilica, appears on the left, and opposite it is Santa Maria Maggiore, in the background behind the massive Corinthian column that supports a statue of the Virgin Mary; the statue is sprouting with plants that indicate its antiquity, characteristic of Piranesi's style.

The grandeur of the design concept reflects the

ambition of the patron, Albani, to outdo all previous maps, including the famed Bufalini map (a woodcut named for the artist, Leonardo Bufalini) of the mid-sixteenth century. The cartographic skill of Nolli, his attention to detail in the tracing of the roads of modern Rome, and the inclusion of so many ancient monuments as well as churches meant that every educated visitor to the city would require a copy of his map. This later version belonged to David Stevenson, the tutor to Lord Lewisham, and is signed by him.

It remains an indispensable guide to any student of the history of eighteenth-century Rome, and its clarity, precision, and beauty are outstanding. CH

REFERENCES: Frutaz 1962, 1:236 (this specific version is examined); Bevilacqua 1998, 176, no. 7 (this specific version is examined, with other examples listed and further bibliography); Ceen 2000, 137–39; Westmorland 2002, no. 17 (entry by Pablo Vázquez Gestal); Nolli map 2005.

114

Pianta delle Paludi Pontine
Rome: Giambattista Ghigi, 1778

Hand-colored engraving
21 ⅞ x 31 ¼ in. (55.5 x 79.5 cm)
Signed and dated on verso: "D. Stevenson Rome. 1778"
Real Academia de Bellas Artes de San Fernando, Archivo-Biblioteca, Mp-40

The Paludi Pontine (Pontine Marshes) lie south of Rome along the Via Appia Antica near Terracina. Attempts by early Romans to drain the land—a constant source of diseases such as malaria—were unsuccessful. Numerous reclamation projects were begun by various popes from the end of the thirteenth century, but all of them came to a standstill until 1775 when Pope Pius VI commissioned the Bolognese hydraulic engineer Gaetano Rappini to survey the land and determine the best way to avoid future flooding. Work began in 1777, with the excavation of a canal running parallel to the Via Appia Antica, to be called the Linea Pio and designed to direct water to the sea at Terracina. Huts were built to accommodate up to thirty-five hundred workers.

The site of this ambitious project became a popular stop for travelers interested in both the

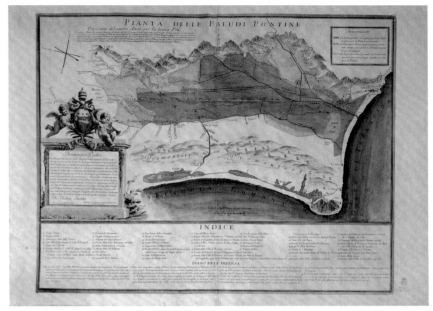

114

natural beauty of the area and the engineering project itself. Three copies of the plan of the Pontine Marshes were on the *Westmorland*. This copy is signed and dated on the verso "D. Stevenson Rome 1778," so it clearly belonged to David Stevenson, Lord Lewisham's tutor. It is one of three found in the crate marked "E. D.," belonging to Lewisham.

The print here, engraved by Giambattista Ghigi in 1778 and dedicated to Pius VI, includes details of the planned project and a map of the area from the thirty-ninth milestone of the Via Appia Antica to Terracina, with different flood stages noted. The numbered index lists sites of particular interest to travelers, including ruins tentatively identified as Palazzo e Granario d'Augusto, Villa di Mecenate, Tempio di Ercole Epophrodito, Ponte di Traiano, and Villa di Lucculo.

By the time Johann Wolfgang von Goethe visited in 1787, the landscape had been totally transformed. He was clearly impressed by the attempts to improve the land, noting in his *Italian Journey* (first published in 1816–17 as *Italienische Reise*):

We were already on our way at three o'clock in the morning. At dawn we found ourselves in the Pontine marshes, which are by no means as wretched in appearance as generally described in Rome. To be sure, one cannot, while just passing through, judge such a large and extensive undertaking as the proposed drainage of the marshes, but it does seem to me that the works ordered by the pope will attain the desired goals at least for the most part. . . . To

designate the central point of the area, the pope has had a large and beautiful building erected where the town of Meza formerly stood. The sight of it makes one more hopeful and confident about the whole undertaking.

As it turned out the pontiff's ambitious and complex project was interrupted by the Napoleonic Wars and in fact was never resumed. EF

REFERENCES: Goethe 1994, 148–49; Bowron and Rishel 2000; Westmorland 2002, no. 19 (entry by José M. Luzón Nogué); Linoli 2005, 27–57.

115

SALVATOR ROSA (1615–1673)

Album of prints

Real Academia de Bellas Artes de San Fernando, Archivo-Biblioteca, B-31

This compilation of prints originally had cardboard covers that were damaged by rain during transport from Málaga to Madrid and were replaced with the present binding. The rain also penetrated to some of the plates, which still have damp stains. The volume now has seventy-eight prints, although physical evidence indicates that it originally contained eighty-four. In the second half of the eighteenth century, Salvator Rosa's printed oeuvre was estimated to number between seventy-five and eighty-four compositions. This volume thus represented the entire known graphic output of the artist at the time.

As with the majority of old albums of prints by Rosa, the first plates in this volume are those of characters described as "Figurine" or "Banditi," printed two by two on quarto-size sheets, bound together to constitute a folio sheet so that each page shows four "figurine" (115a). This series is followed by the "Triton Group," arranged in the same way as the previous group with four prints per page. It is followed in turn by a group of more complex compositions with one per page, although some have been cut down to fit onto the album pages. Finally, there is a group of four prints of larger size on double-sized, folded sheets.

Rosa's work and artistic personality were renowned and highly esteemed in England throughout the eighteenth century. His prints became very popular from the second half of the century on,

115a

115b

particularly his scenes of "Banditi," which were even confused with the artist's own life story; the legend spread that he had been captured by bandits and lived with them for some years in the Abruzzi region of central Italy. The dissemination of these prints contributed to the creation of a romantic, picturesque image of Italy. Numerous Grand Tour travelers mentioned Rosa in their letters and diaries, and James Northcote imagined seeing the artist in the company of a group of bandits as he passed through the Alps.

William Legge, second Earl of Dartmouth—the father of Lord Lewisham—had purchased a number of paintings by Rosa from the dealer Thomas Jenkins. It thus seems likely that Jenkins could have acted as Lewisham's agent when the latter acquired this compilation of prints. MDSJ

REFERENCES: Ozzola 1909, 146–47, 149–50; Barricelli 1969; Tomory 1971; Bozzolato 1973; Sunderland 1973, 785–89; Rotili 1974; Wallace 1979; Scott 1996, 109–67; Langdon 2010.

116

116

Serie degli uomini i più illustri nella pittura, scultura, e architettura con i loro elogi, e ritratti incisi in rame cominciando dalla sua prima restaurazione fino ai tempi presenti
Florence: printed by Gaetano Cambiagi, 1769–75

Real Academia de Bellas Artes de San Fernando, Archivo-Biblioteca, A-1133

An anonymous, collective text simply signed "gli autori" (the authors), this is the first volume of twelve comprising biographies of the most celebrated artists, both Italians and others who visited Italy, as well as details of their work. Shortly after the initial completion of the set, an additional volume was published in Florence in 1776, but it is not recorded in the *Westmorland* inventories. Although all twelve volumes arrived at the Real Academia de Bellas Artes de San Fernando, volume 2 is now missing. As with other books from the *Westmorland*, the set retains its original binding as purchased, with thin card covers lined with Dutch paper and a leather spine.

The artists are ordered chronologically: the first volume starts with Arnolfo di Lapo, and the final volume concludes with the most recent names, such as Francesco Trevisani and Jean-Baptiste (here,

Giovanni Battista) Van Loo. In total the series includes three hundred artists' biographies organized into groups of twenty-five per volume. There is a print portraying each artist, many of which are taken from Giorgio Vasari's *Le Vite de' più eccellenti pittori, scultori ed architettori* or other similar works, as stated below each illustration. Others are original images. Different artists produced the portraits in the different volumes, although many of them are by Giovanni Battista Cecchi, "Maestro d'intaglio della Real Galleria di Firenze" (master engraver to the Royal Gallery in Florence), as it reads in the caption.

Each volume is dedicated to a different person, almost all of whom are Italian aristocrats associated with Florence except for the dedicatee of the eighth volume: "Sua Eccelenza Milord Nassau Clavering Conte di Cowper" (To his excellent lord Nassau Clavering, Count of Cowper)—a reference to George Nassau Clavering Cowper, third Earl Cowper—a figure whose known links with Florentine artistic circles would have earned him this distinction.

Both its structure and contents make this series the direct heir to the literary-artistic tradition that began with Vasari's *Lives* (1550), the first attempt to present the history of art in terms of periods. It also reveals an intention to be comprehensive, listing the

titles of all the most important texts on art that helped to establish this art historical model from Vasari on, among them works by Carlo Ridolfi (1648), Giovanni Pietro Bellori (1672), Roger de Piles (1699), and Filippo Baldinucci (1681–1728).

Despite following a traditional art historical approach, at the start of the text there is an essay that proposes a systematic methodology based on nations and periods and starting with the Egyptians. Such a proposal reflects the new trend in artistic thought that Johann Joachim Winckelmann had set out not long before in his *Geschichte der Kunst des Alterthums* of 1764. MDSJ

REFERENCES: Ridolfi 1648; Bellori 1672; Piles 1699; Baldinucci 1681–1728; Schlosser 1986.

117

PIETRO ROSSINI

Il Mercurio errante delle grandezze di Roma: Tanto antiche, che moderne
Rome: Gaetano Quojani Libraro, 1776

Inscribed on front free endpaper of vol. 1: "P. Y."
Shown: *San Pietro in Vaticano*
Real Academia de Bellas Artes de San Fernando, Archivo-Biblioteca, B-3164

Pietro Rossini, an antiquary from Pesaro, was also a cicerone, or professional guide, for foreign visitors to Rome. His very popular guidebook was first published in 1693 and issued in at least twelve different editions until 1789. Each one provides updated and

additional information, including particulars on new buildings and the names of current owners of palaces. Rossini's descriptions are more comprehensive than those found in other guidebooks of the time. He included information on ancient Roman ruins and villas, palaces and gardens, with special attention paid to Christian churches and their transformation from ancient buildings. Details of restorations are given, providing useful information for archaeologists today. The third edition (1715) was corrected and enlarged by the author's son Giovanni Pietro Rossini, who added material on buildings in and around Rome. By the time the present edition was published, the work had moved beyond an inventory of buildings and sites to a complete compendium of Roman attractions, "more like a cultural history of the contemporary city than a mere topographical vade mecum to be used on visits through Rome," as Martha Pollack described it. Rossini's book was in a crate that included other guidebooks and maps of Italy and Rome. EF

REFERENCE: Pollack and Baines 2000.

118

BENEDETTO BUONMATTEI (1581–1647)

Della lingua toscana
Naples: Nella Stamperia de Vincenzo Mazzola, 1759

Inscribed on front paste-down endpaper: "P. Y.";
on title page: "D. Stevenson Janry 28 Rome 1778."
Real Academia de Bellas Artes de San Fernando, Archivo-Biblioteca, C-189

Although there is little evidence that Benedetto Buonmattei's volume of instruction on the Tuscan language was a common purchase for Grand Tourists, one finds much comment on the differences between the Tuscan and Roman dialects in travelers' diaries. "Lingua Toscana in bocca Romana," was a favorite proverb, indicating that the Tuscan language was sweetest when spoken by a Roman. Most travelers do not seem to have pursued the subject of the Italian languages much further than the purchase and study of a standard Italian grammar. David Stevenson's ownership of Buonmattei's *Della lingua toscana*—based on the inscription in the copy in crate "E. D."—suggests an unusual interest in the subject.

A prominent grammarian and academic, Buonmattei met the celebrated English poet John

San Pietro in Vaticano

117

118

119

Milton when the latter was in Florence during his Grand Tour in the mid-seventeenth century. Through a shared interest in language—particularly Latin—and poetry, the two became good friends and carried on a correspondence well after Milton's return to England. The poet's advice to his friend helped to guide some of the content of *Della lingua toscana*, such as his suggestion to include "some little section on right pronunciation of the language," purportedly to help in his own use of Latin. KC

REFERENCES: Matthews 1835, 246; Luxon 1997–, note on "Italian."

119

TORQUATO TASSO (1544–1595)

Il Goffredo ovvero Gerusalemme Liberata, vol. 1
Venice: Antonio Groppo, 1760–61 (2 vols.)

Inscribed on title page of vol. 1: "PY"
Real Academia de Bellas Artes de San Fernando, Archivo-Biblioteca, A-455

Initially published in 1581, *Gerusalemme Liberata* is a romantically visionary interpretation of the siege of Jerusalem during the final phase of the eleventh-century First Crusade led by the Frankish knight Godfrey of Bouillon. This two-volume set is the first edition undertaken by Antonio Groppo of Torquato Tasso's epic poem. The first volume includes a short

biography of Tasso, and both volumes contain notes to the text by Scipione Gentili and Giulio Guastavini. Groppo's sumptuous edition features engraved illustrations by Giacomo Leonardis after designs by the painter Bernardo Castello, a friend of Tasso and considered by many to be the best interpreter of the work; the illustrations had first appeared in a Genoa edition of 1617. In the present edition the engraved borders around the arguments and the illustrative initials were designed by Pietro Antonio Novelli and engraved by Leonardis, together with a portrait of the author after Agostino Carracci in the frontispiece.

Tasso's work had long been popular in England, exerting a discernible influence on John Milton and Edmund Spenser. It was first translated partially by Richard Carew in 1594 and then, to considerable acclaim, in its entirety by Edward Fairfax in 1600. In the latter part of the seventeenth century and early in the eighteenth, however, Tasso's standing had waned under the influence of Enlightenment rationalism. Nonetheless, during the eighteenth century, several editions of his work were published in Italy, and Johann Wolfgang von Goethe's play *Torquato Tasso*, exploring the poet's life, was first published in 1790. MDSJ

REFERENCE: C. G. Bell 1954, 26–52, esp. 29.

Crate G. M.

OWNED BY GEORGE MOIR

The Reverend George Moir (1741–1818), minister at Peterhead from 1763, was the brother-in-law of James Byres, the highly successful Scottish dealer, agent, and cicerone. Byres lived in Rome from 1758 until he retired to Scotland in 1790, leaving his collection and business in Rome to Patrick Moir, his nephew and George Moir's son. In addition to two copies of *The Origin of Painting* by David Allan, Moir's crates on the *Westmorland* contained two albums and a number of loose prints. Presumably these were being sent to Moir by Byres; letters at the University of Aberdeen suggest that Patrick Moir sent drawings to his father from Rome in 1785. George Moir appears to have had antiquarian interests on the evidence of his membership in the Spalding Club, "for the printing of the Historical, Ecclesiastical, Genealogical, Topographical, and Literary remains of the North-Eastern Counties of Scotland." EH

120

DAVID ALLAN? (1744–1796)
AFTER HIS OWN ORIGINAL

The Origin of Painting
ca. 1775–78

Oil on panel
(oval) 15 x 12 in. (38.1 x 30.5 cm)
Real Academia de Bellas Artes de San Fernando, Museo, 513

The primary version of *The Origin of Painting* was executed by David Allan in Rome in 1775 and acquired by the Scottish dealer James Byres for the drawing room of his residence on Strada Paolina (National Galleries of Scotland, Edinburgh, NG612). Two copies of this oil painting were among the crates sent to the Reverend George Moir, Byres's brother-in-law and his partner in some transactions. Allan himself may well have painted the copies, given that he made another copy for his friend James Denholm.

Domenico Cunego drew and engraved Allan's composition in 1776, possibly at the suggestion of Byres. An impression of Cunego's print arrived at the Real Academia de Bellas Artes de San Fernando in one of Francis Basset's crates.

There are various reasons for copies to be made of contemporary paintings (these are the only such copies on the *Westmorland*). First, the presence of the original on the walls of one of the leading art dealers in Rome offered an ideal showcase for the work, creating a demand for further versions. In addition, Allan had won the Concorso di Ballestra, organized by the Accademia di San Luca in Rome in 1773, becoming the first British painter—and the only one in the eighteenth century—to win this prestigious competition. It was widely believed that Allan had obtained the gold medal for *The Origin of Painting*, when in fact he had won it for *Incontro di Ettore e Andromaca alle Porte Scee* (*The Parting of Hector and Andromache*; Academia di San Luca). Whether intentional or not, the confusion added further prestige to *The Origin of Painting*.

The subject of the young Corinthian girl Dibutades tracing the outline of her lover, as recounted by Pliny the Elder, enjoyed enormous success in the second half of the eighteenth century. Painters such as Alexander Runciman, Joseph Wright of Derby, Jean-Baptiste Regnault, and Joseph-Benôit Suvée offered their own interpretations. In 1790 a print was made by José Gómez de Navia (draftsman) and José López Enguídanos (engraver) after the copies in the Real Academia and published by the Calcografía of the Real Academia. It thus became one of the few examples of objects from the *Westmorland* that acted as a source of inspiration for students at the Real Academia. MDSJ

REFERENCES: Gordon 1951; Bermingham 2000; Sánchez-Jáuregui 2001a, 64ff.; Westmorland 2002, nos. 89, 90 (entries by María Dolores Sánchez-Jáuregui).

120

Crate A. Ry.

OWNED BY ALLAN RAMSAY

The painter and antiquarian Allan Ramsay (1713–1784) was born in Edinburgh and received his early education there, learning Latin and French, to which he would later add Greek, Italian, and German. He enrolled at the short-lived artists' Academy of Saint Luke in Edinburgh in 1729, but by 1732 he was in London studying with the Swedish painter Hans Hysing. Ramsay made four extended trips to Italy, the first from 1736 to 1739 and the second from 1754 to 1757. There he copied paintings by old masters, sketched Roman antiquities, and developed friendships with important Italian artists, including Pompeo Batoni and Giovanni Battista Piranesi, who honored Ramsay in one of his *capricci*, or fantasies, in the *Antichità Romane* (1756). Ramsay returned to London in 1757 and began one of the most successful periods of his professional life, becoming Painter in Ordinary to George III in 1761 and Principal Painter in Ordinary to the king in 1767. Six years later Ramsay damaged his right arm in a fall, which effectively ended his painting career. In 1775 he returned to Italy to take the waters at Pisa and Casiano. Increasingly engrossed with antiquarian pursuits, he also toured through Rome, Turin, and Ischia, after which he returned to Rome before traveling to Licenza. He returned to London via Rome in October 1777, sending on board the *Westmorland* a crate containing two unframed landscape paintings in oil. He set out on his final visit to Italy in 1782, staying there for two years. He left to meet with his daughter, Amelia, who was returning to London from the West Indies, but died after arriving at Dover. CS

121

UNKNOWN ARTIST

Landscape with Cascade and Hunters: View of Tivoli
1770s

Oil on canvas
39⅜ x 50 in. (100 x 127 cm)
Real Academia de Bellas Artes de San Fernando, Museo, 535

122

UNKNOWN ARTIST

Landscape with a Bridge: View of San Cosimato
1770s

Oil on canvas
39 x 53½ in. (99 x 136 cm)
Real Academia de Bellas Artes de San Fernando, Museo, 113

It was on a visit to Tivoli and the valley of Licenza during his second trip to Italy (1754–57) that Allan Ramsay began his investigation into the remains of the country retreat of the Roman poet Horace. By the time of his third visit to Italy (1775–77), Ramsay had retired from painting and devoted himself to antiquarian pursuits. Staying in a suite of rooms in Palazzo Orsini in Licenza in the summer of 1777, Ramsay explored the site and wrote his "Enquiry into the Situation and Circumstances of Horace's Sabine Villa," revised and expanded during his last trip to Italy in 1782–84 but never published during his lifetime. Among the travelers with possessions on the *Westmorland*, Frederick Ponsonby, Viscount Duncannon, shared Ramsay's interest in Horace's villa. The books Duncannon was sending home included the three volumes of Abbé Bertrand Capmartin de Chaupy's *Découverte de la maison de champagne d'Horace*, published in Rome in 1767–69.

These landscape paintings are two of four in

121

122

the Real Academia that from the early nineteenth century have been attributed to the German landscape painter Jacob Phillip Hackert. All four paintings arrived in the *Westmorland*'s cargo; the other two were in the crate marked "W. A. F." The size of these two paintings corresponds to the description given by Antonio Ponz in his inventory (cat. 14) of the contents of crate "A. Ry." The combination of the subjects—both views are in the vicinity of Licenza—and the initials on the crate have suggested the identification of the owner as Ramsay and these particular canvases as works he had commissioned or at least acquired in connection with his interest in Horace's villa.

The attribution of these two paintings to Hackert seems less likely. Hackert had visited Licenza as early as 1769, but in 1777, when Ramsay was there working with his fellow countryman Jacob More to record the landscape in a set of drawings, presumably intended as illustrations to his "Enquiry," Hackert was in Naples with his pupil Charles Gore. In 1780 Hackert produced a series of ten paintings in gouache of Licenza subjects (on permanent loan to the Goethe-Museum, Düsseldorf), which were subsequently (1784) published in a set of prints. In 1782, during his final Italian visit, Ramsay met Hackert, who showed him some drawings related to the print project and consulted with him on the identification of some of the views. Although *View of the Bridge and Ruined Aqueduct near San Cosimato* in the Hackert set adopts a viewpoint similar to that of the *Westmorland*'s painting of

the subject, it is too different in detail as well as in style and atmosphere to make plausible any association of the *Westmorland*'s picture with Hackert. Indeed, neither of the two canvases in crate "A. Ry." shows more than a superficial resemblance to Hackert's landscape style of the 1770s.

It seems unlikely that the two paintings are even by the same hand, although both are clearly the work of accomplished landscape painters. If not Hackert, what other artists working in Italy at the time could have painted them? Stylistic differences would seem to rule out the other most likely candidates: Jacob More (see cats. 52 and 53), who worked with Ramsay at Licenza in 1777 and produced a number of drawings of the area, and Solomon Delane, whose own painting of San Cosimato, purchased by Francis Basset, was on the *Westmorland* (cat. 22). While the painting of the falls at Tivoli shows some affinities with More's earlier paintings of the falls of the Clyde in Scotland, the hunters with their dogs and horses are certainly not by More, and neither More nor Delane worked in oils with quite the same combination of precision and fluency evident in the painting of San Cosimato. It seems probable that these two paintings are by Italian landscape painters, but for the moment the question of the identity of the artists remains open. sw

REFERENCES: Frischer and Brown 2001; Westmorland 2002, no. 91 (entry by José M. Luzón Nogué).

Crate R. Uy.

OWNED BY ROBERT UDNY

Robert Udny (1722–1802), the second son of James Udny of Udny Castle in Aberdeenshire, Scotland, was a successful West Indian merchant, an art collector, and the older brother of John Fullarton Udny, the British consul in Livorno. The bulk of Robert Udny's notable collection of old master paintings and drawings, many of which hung in the picture gallery of his villa in Teddington, Middlesex, were acquired through his brother, who acted as agent in Italy. There is evidence, however, that Robert Udny was in Turin with his wife and daughter in September 1769 and in Rome from December to April 1770, before traveling to Venice. While in Rome he exported several old master paintings and sat for a half-length portrait by Pompeo Batoni, which remained in the family until it was sold in 2006; it depicts Udny in a gold-trimmed coat with the Temple of the Sybil at Tivoli in the background. Giovanni Battista Piranesi dedicated two plates in the *Vasi, candelabri, cippi, sarcofagi, tripodi, lucerne ed ornamenti antichi* of 1778 to Udny and one to his daughter, Maria (Mary). In addition to a series of prints of the Raphael Loggia, a book on the history of Italian literature by the critic and historian Girolamo Tiraboschi, and a box of artificial flowers, Udny's crate contained a number of packets of fine prints. Robert Udny became a fellow of the Society of Antiquaries and in 1785 was elected to the Royal Society of Arts. He succeeded to the paternal estates of Udny Castle late in life, and after his death the bulk of his collection was sold at Christie's. CS

123

GIOVANNI VOLPATO (1740–1803), ENGRAVER;
LUDOVICO TESEO (1731–1782), DRAFTSMAN;
FRANCESCO PANINI (1745–1812), COLORIST

The Raphael Loggia (part 3)

1775

Etching and gouache
Real Academia de Bellas Artes de San Fernando,
Archivo-Biblioteca, B-10

This volume contains twelve hand-colored prints that reproduce the decoration of the interior pilasters of the Vatican Loggia, painted by Raphael and his workshop between 1518 and 1519. They are from a series of forty-six plates that were published in three parts between 1772 and 1776.

The project was started in about 1768 by the painter Gaetano Savorelli, the architect Pietro Camporesi, and the engraver Giovanni Ottaviani, who joined forces to offer printed reproductions of the fresco decoration of the Loggia. The first part reproduces the pilasters, without their bases, and the doors opening onto the gallery. Giovanni Volpato arrived in Rome in 1770 to take over the management of the project at the point when the plates of the biblical scenes were being made. That second part includes reproductions of three of the ceilings painted with biblical episodes, with their corresponding lunettes and pendentives, as well as the frontispiece of part 1. For the third part Volpato worked solely with the painter Ludovico Teseo.

Part 3, which is exhibited here, was produced between 1774 and 1776 and reproduces twelve interior pilasters in the gallery. Given the poor state of some of the frescoes and the problems of depicting the height of the architectural elements, Volpato allowed himself certain liberties, modifying the arrangement of the elements so that the pilasters are flanked by vertical bands that contain decorative motifs taken from different parts of the gallery. In order to complete some of the exterior pilasters, he

also added new motifs that he copied from tapestry borders. The final result, though not strictly accurate, marked a milestone in reproductive printmaking and was enormously successful with the public, determining the future of subsequent compilations of decorative prints.

Part of the edition was hand-colored by Francesco Panini, and examples were sent to the leading courts of Europe. The prints became widely known internationally; in 1778 Catherine the Great of Russia ordered the complete series to be reproduced in the Winter Palace in St. Petersburg, while in Sweden, France, and Germany pavilions, private rooms, and other spaces were decorated with motifs based on those in Volpato's plates. Alessandro Verri noted in 1776: "Dopo che si sono stampate in Roma le Loggie del Vaticano tutto ha cambiato di gusto. Le carrozze, i muri, gli intagli, le argenterie, hanno preso gli ornamenti de quel fonte perenne di ogni varietà." (After the *Loggie del Vaticano* were printed in Rome, all taste changed. Carriages, walls, carving, silverware all have assimilated the ornaments of that perpetual source of every variety.)

Nonetheless, the enormous success of these plates can be fully understood only in the context of the discovery of the paintings at Pompeii and Herculaneum. Those paintings remained unpublished for some years, with the result that Raphael's decorations became the closest modern interpretation of antique wall painting, at least up to the time of the publication of Ludovico Mirri's prints.

Three complete sets of the entire series were on board the *Westmorland*. One of them belonged to Francis Basset, while the other two were for Robert Udny. The latter had a colored set to which these plates belonged, as well as prints of six pilasters that are still in the Real Academia. The rest of the uncolored plates are now in the Real Academia's library. MDSJ

REFERENCES: Marini 1988; Marini 2003, 157–77; Dacos 2008, 307–29.

123

Crate

OWNER UNKNOWN

124

Inlaid Decorative Stone Tabletop
Italy, 18th century

31¾ x 62¼ in. (80.5 x 158 cm)
Museo Nacional de Ciencias Naturales, 15821

This tabletop is made up of inlaid samples of decorative stones. The numbers on the squares must be significant, as they no doubt correspond to a list of names of the samples. While it is not known which traveler acquired the tabletop (it was found in crate "B," with no further identification as to the consigner), it likely was acquired directly from a *scalpellino* (stonecutter) in Rome, who no doubt would have welcomed visits from Grand Tourists. Responsible for general stonecutting work, the *scalpellini* also had a long tradition of reworking stones found in ancient ruins and giving their own names for them. Eighteenth-century stonecutters would have had a stock of decorative stones, including rare, ancient slabs that would have been salvaged from archaeological digs, various engineering works, or the demolition of ancient villas.

Although any list associated with this particular tabletop is now lost, it is possible to classify many of the different kinds of marbles, granites, serpentinites, and other decorative stones used. In fact, all may be identified as ancient stones, from quarries long closed. The green stone used as the border around the edge of the tabletop, for example, is a serpentine marble from Greece, named *verde antico* by the *scalpellini* of medieval Italy. It has been traced in building remains back to the first century, and it reached its height of popularity in the fifth and sixth centuries. Other inlaid squares are of types of alabaster, identified as being from Egypt (numbers 51, 59, 68, 70), Italy (26), Algeria (67, 69), and Turkey (49, 72). Square number 10 may be identified as a type of fossiliferous limestone from Tunisia, called lumachella d'Egitto by the *scalpellini* of Rome, and highly prized by them due to its rarity.

The stone has been found in the ruins of Rome, used mainly for small slabs in pavements. In the tabletop there are also examples of colorful limestones and marbles: pink breccia coralline (number 12), originally from Turkey and found in excavations of ancient Roman settlements all around the Mediterranean; and, from Italy, red and violet breccia di Seravezza (number 22) and breccia di Settebasi (number 25).

As each stone sample would have been enormously attractive to those interested in the ancient world, it is not surprising that at least five other inlaid-marble tabletops were on the *Westmorland*. One, which has not been traced, was in a crate intended for Thomas Farrar, a corn factor. Two, from a crate marked "L. J. C.," were given to the princess of Asturias, Maria Luisa de Borbón-Parma, and probably sent to the small palace (Casita del Príncipe) in El Pardo, after the initial inventory was completed. Those tabletops were much more elaborate, described in the inventory as "two . . . beautiful marble tables inlaid with various fine stones." Two other tabletops, in crates belonging to Francis Basset, remained at the Real Academia de Bellas Artes de San Fernando and were mounted on elaborate gold-leaf tables. The inlaid stone samples in these are not numbered. It is presumed that the numbered tabletop would have been considered much more an object of antiquarian curiosity and less a decorative object to be displayed in an entrance hall or other public space. Indeed, the current home of this tabletop is Madrid's natural history museum, where it is on display in the newly renovated minerals hall. EF

REFERENCES: Price 2007; Cooke 2010, 185–95.

Special thanks are owed to Monica Price, assistant curator in the mineralogy department at the Oxford University Museum of Natural History, who provided a preliminary identification of the stones in the tabletop.

124

125

125

Flavian Amphitheater (Colosseum)

1770s

Watercolor and gouache over etched outline
19¾ x 28½ in. (50.2 x 72.5 cm)
Inscribed on verso: "No. 5"; "Anfiteatro Flavio"
Real Academia de Bellas Artes de San Fernando,
Museo, D-2855

126

Temple of Jupiter Stator

1770s

Watercolor and gouache over etched outline
20½ x 14⅞ in. (52 x 37.8 cm)
Inscribed on verso: "No. 25"; "Tre colonne del
Tempio di Giove Statore"
Real Academia de Bellas Artes de San Fernando,
Museo, D-2866

127

Agrippa's Pantheon

1770s

Watercolor over etched outline, 17⅜ x 24⅜ in.
(44 x 61.7 cm)
Inscribed on verso: "No. 6"; "Antico Tempio del
Panteon"
Real Academia de Bellas Artes de San Fernando,
Museo, D-2856

There seem to have been twenty-four views of Rome in
a portfolio in crate ⟨E⟩, of which twenty-two have
been identified in the Museum of the Real Academia.
These are listed by subject in the inventory by Antonio
Ponz (cat. 14 and appendix 2, pp. 332–33), the above
three appearing as "Amphiteatro flavio," "Tre colonne
del Tempio di Jove statore," and "La Rotunda." Ponz
noted these twenty-four works as "útiles" (useful) and
"curiosisimos, y muy propios para un gavinete" (very
curious, and very fitting for a cabinet).

126

127

While the repetition of two of the subjects in this group—two views of the Arch of Titus and two views of the Temple of Antoninus and Faustina—might suggest that these were stock views being sent by a dealer for sale in England, the repeated subjects are actually presented in different compositions. The lack of further repetitions among the group and the absence of any duplicate compositions make it seem more likely that this was either a portfolio of souvenir views being sent home by a tourist or a selection of Roman views being sent to an armchair traveler back in Britain. The twenty-two identified works from crate ⟨E⟩ all bear numbers on the verso, from 2 to 39; these numbers were assigned to the views after they had arrived at the Real Academia, as the sequence intermingles the works from crate ⟨E⟩ with similar views from crate "E. B.," belonging to Frederick Ponsonby, Viscount Duncannon, and his tutor, Samuel Wells Thomson (cats. 71–74).

The subjects of the views are all from ancient rather than modern Rome. Many correspond to subjects treated by Giovanni Battista Piranesi in his *Vedute di Roma*, and in a few instances they actually reproduce Piranesi's compositions; however, many adopt different viewpoints, often chosen—it would seem deliberately—to exclude, in a manner antithetical to Piranesi's *Vedute*, evidence of the buildings of Renaissance and Baroque Rome. All the works in crate ⟨E⟩ share the same mode of production: they are painted in watercolor over lightly etched outlines. These are to be distinguished from hand-colored prints, in that the printed outlines are not sufficient for the work to exist uncolored; they simply provide a repeatable framework for the production of multiple watercolor paintings of the same composition. This method of mass production was shortly to be employed by Louis Ducros and Giovanni Volpato in their *Vues de Rome et de ses environs* (1780), in which lightly etched outlines were worked up in watercolor by assistants or students working under the supervision of Volpato and Ducros. sw

REFERENCES: Chessex 1985; Westmorland 2002, nos. 15, 28, 31 (entries by Irene Mañas Rodríguez), 29, 32, 33, 34 (entries by Elena Castillo Rodríguez), 30, 35 (entries by Ana María Suárez Huerta).

Crate ⬧H⬧

OWNER UNKNOWN

128

CHRISTOPHER HEWETSON (1737–1798)

Francis Basset, First Baron de Dunstanville
1777–78

Terra-cotta with egg tempera patina
16½ x 11⅜ x 9 in. (42 x 29 x 23 cm)
Real Academia de Bellas Artes de San Fernando,
Museo, E-474

Francis Basset must have sat to Christopher
Hewetson during the Grand Tourist's visit to Rome
in the winter of 1777–78. Hewetson's terra-cotta,
unsigned but typical of his work, is simple in format
and without a socle, with the sculptor's characteristi-
cally subtle modeling; the chest is bare and the hair,
drawn away from the forehead, covers the nape of
the neck. It is similar in format to his earlier signed
marble bust of Thomas Mansel Talbot of Margam
Park and Penrice Castle (1773; Victoria and Albert
Museum, London, A.41-1953). The closeness of the
features to the Pompeo Batoni portrait of Basset
(cat. 21) confirms the identity. Hewetson's bust was
transported in crate ⬧H⬧ with two made of plaster:
a further cast of his portrait of Anton Raphael
Mengs that was shipped in the crate marked "M. G."
(cat. 135) and a second bust of Basset, taken from
this terra-cotta (Real Academia de Bellas Artes de
San Fernando, Museo, E-473; 22⅞ x 15⅜ x 13⅜ in.).
In another crate, marked "H. G. E.," there were
four heads: two in terra-cotta and two of a man
and woman in plaster "con sus moldes en pedazos
sueltos" (with their molds in pieces). The markings
on these crates and the inclusions of plasters and
molds could indicate that the crates were being
shipped under the sculptor's name with the inten-
tion that further replicas or versions of the busts in
plaster, bronze, or marble would be carried out in
Britain by another sculptor. Aileen Dawson has
noted that, according to a letter from the dealer
Thomas Jenkins to the collector Charles Townley in
May 1770, Hewetson sent the "Model and Mould"

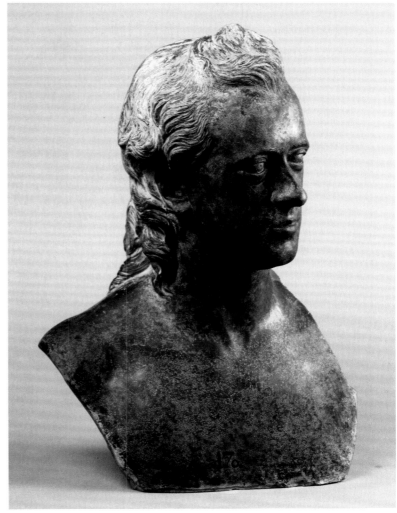

128

with his marble bust of Townley (1769; British
Museum, London, MLA 1995,4-2,1). Dawson also
suggested that in 1805 Joseph Nollekens may have
owned the "Model," as Joseph Farington recorded
that Nollekens showed him Hewetson's "Bust"
during work toward his own marble bust of Townley
(1811; British Museum, London, MLA OA 10272).

Recent conservation work carried out on this
bust of Basset at the Real Academia revealed that the
patchy dark surface is due to its treatment with an
egg tempera patina. María Dolores Sánchez-Jáuregui
has suggested that this was used to give it a bronze-
like appearance. AY

REFERENCES: Hodgkinson 1952–54, 42–54, no. 81;
Ford 1974, 416–25; De Breffny 1986, 52–75; Dawson
1999, 218–21; Bilbey and Trusted 2002, 91–92,
no. 124; Westmorland 2002, no. 52 (entry by María
Dolores Sánchez-Jáuregui); Roscoe 2009, 608–12.

Crate J. G.

OWNER UNKNOWN

129

UNKNOWN ARTIST AFTER GUERCINO (1591–1666)

The Persian Sibyl

1770s

Oil on canvas
54 x 38⅝ in. (137 x 98 cm)
Real Academia de Bellas Artes de San Fernando,
Museo, 252

The original painting on which the present work is based was executed by Guercino in 1647 for Count Carlo Rondinelli, governor of Cento. Various copies of paintings of sibyls were on the *Westmorland*. Although the descriptions are on occasion confused, the identification of the present work as the "Copia dela Sibila Persica de 7 cuartas de alto por 5 de ancho" (Copy of the Persian Sibyl measuring seven *quartas* high, and five wide) in the crate marked "J. G." seems certain. Shortly after the painting's arrival at the Real Academia, it was attributed to the *pensionado* (grant student) Vicente Velázquez. The draft of the inventory of 1804 states that Velázquez sent it from Rome on June 1, 1788. In fact, as stated in the minutes of the Junta Ordinaria (Ordinary Committees) of the Real Academia de Bellas Artes de San Fernando, Velázquez had indeed sent a copy of a sibyl by Guercino from Rome, but the dimensions of that painting do not match, whereas the dimensions of the present painting coincide exactly with those of the work on board the *Westmorland*. In addition, this extremely well-painted canvas reveals the hand of a fully trained painter rather than that of Velázquez, who, according to the academicians, "had only left for that city [Rome] just over a year ago with very few [artistic] principles" by the time he supposedly painted it.

In numerous instances the versions on board the *Westmorland* reproduce the same originals copied by Real Academia *pensionados* in Rome, and in fact the Real Academia has another copy of this painting signed by Antonio Martínez, albeit of lesser quality.

While distinguishing between *pensionado* copies and those on the ship has complicated the *Westmorland* project, the relationship between the two groups of copies is a subject that merits future study.

In the eighteenth century the original painting by Guercino was in the Musei Capitolini, which numerous artists visited in order to make copies of the paintings housed there. Some, such as Guido Reni's *Fortune*, Domenichino's *Cumaean Sibyl*, and Guercino's *Persian Sibyl*, were highly esteemed, and copies of them were in great demand for decades. In 1775 the American James Smith painted various copies for Patrick Home of Wedderburn, including Guercino's *Persian Sibyl* and Reni's *Fortune* (also represented by a copy among the *Westmorland*'s cargo). Years later the Reverend William Gunn, on his second trip to Rome, was told that the most copied works in the Capitoline Museums were the *Fortune* and the *Persian Sibyl*.

Guercino's reputation in eighteenth-century England reached its high point from the time of the purchase of his *Libyan Sibyl* by George III in 1760. This was followed by other important acquisitions, such as *Samson Taking the Honey to His Father*, purchased by Francis Russell, Marquess of Tavistock, in 1764, and the *Samian Sibyl* and *David*, both acquired by John Spencer, first Earl Spencer, in 1768. British artists as well as collectors showed considerable interest in Guercino's oeuvre at this date. Joshua Reynolds, who had studied the artist's work in Italy, made copies of some of his drawings in the collections of John Bouverie and of Reynolds's teacher Thomas Hudson. Reynolds's own collection contained various drawings by Guercino that were reproduced as engravings by William W. Ryland between 1762 and 1764, as were other Guercino drawings owned by John Michael Rysbrack and Hudson.

As the presence on the *Westmorland* of several copies of different paintings of sibyls indicates, the subject was popular in the period. Anton Raphael Mengs and Angelica Kauffman painted their own interpretations of this subject based on originals by Domenichino and Guercino, while in 1790–91 Élisabeth Vigée-Lebrun depicted Lady Emma Hamilton as a sibyl. MDSJ

REFERENCES: Junta Ordinaria de 1 de Junio de 1788, "Libro IV de Actas de la Academia 1786–1794," Archivo de la Real Academia de Bellas Artes de San Fernando, 76; Russell 1991, 4–11; Jenkins and Sloan 1996, 271–72, no. 170; Roettgen 1999, 176–77, no. 114; Rosenthal 2006, 248–51; Urrea Fernández 2006, 227.

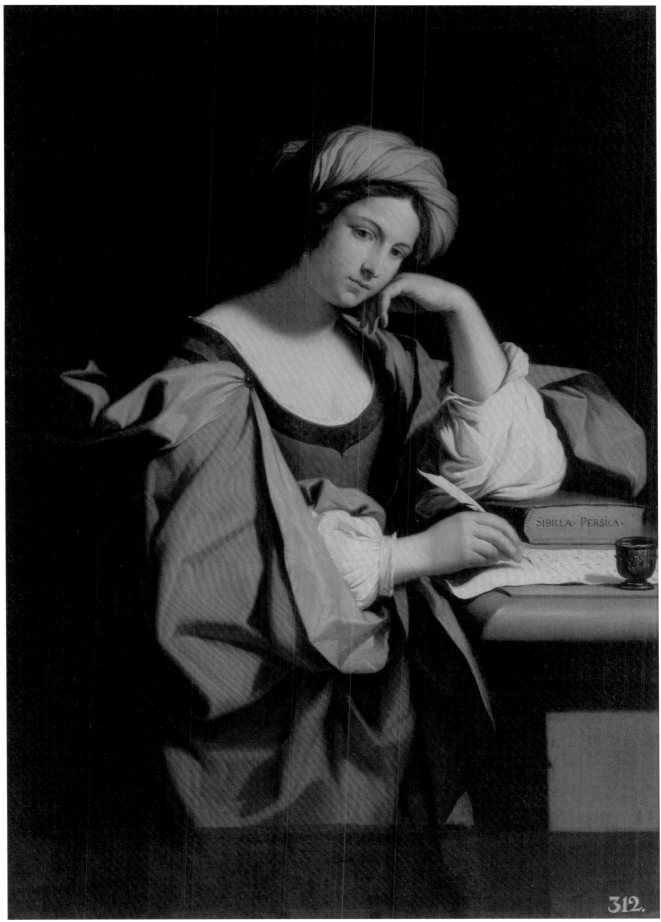

312.

Crates J. P., J. ◇C◇ P., and J. ◇D◇ P.

OWNER UNKNOWN

130–131

Two of a Group of Four Ornamental Candelabras
1770s

130

Ornamental Candelabra with Pedestal of Maenads and Satyrs

Marble
63¾ x 23⅝ x 19¾ in. (162 x 60 x 50 cm)
Real Academia de Bellas Artes de San Fernando,
Museo, E-46

131

Ornamental Candelabra with Pedestal of Maenads and Satyrs

Marble
63¾ x 23⅝ x 19¾ in. (162 x 60 x 50 cm)
Real Academia de Bellas Artes de San Fernando,
Museo, E-47

Ornamental candelabras were popular acquisitions, according to the plates of Giovanni Battista Piranesi's publication *Vasi, candelabri, cippi, sarcofagi, tripodi, lucerne ed ornamenti antichi*, which recorded the principal decorative antiquities restored and sold at his showrooms in Palazzo Tomati, Rome. Many found their way into leading British sculpture galleries, such as those of Charles Townley and Thomas Hope. Original fragments of these objects, featured in paintings and reliefs of imperial Roman domestic architecture, were often dug up at Hadrian's Villa, Tivoli, during the 1770s by Gavin Hamilton. Piranesi's skills in imaginative reconstruction are demonstrated in the *Vasi* by eight impressive examples. Inevitably a demand grew for less ambitious productions, so expert restorers such as Bartolomeo Cavaceppi and Pietro Pacilli, both of whom collaborated with the artist, produced a number of these pieces for the market.

The basic pattern consisted of a triangular pedestal, resting on animal claws and featuring lions' or rams' heads at the upper angles and three inset figurative reliefs. This supported a richly molded stem, enriched by foliage and masks, which culminated in a shallow bowl, with ovolo decoration, for some kind of illumination. Inevitably the four candelabras taken from the *Westmorland* had been dismantled for the voyage and, according to the somewhat confused information of the inventory lists, arrived in separate pieces, scattered among several crates. The triangular bases were initially identified as altars but later reassembled on a fairly pragmatic basis with the other fragments to conform to the traditional candelabra composition. It has been suggested that the initials "J. P." on the crates associated with the candelabras might correspond to John Pitt, who was in Rome with his family in February 1778.

The quality of the overall design and the high degree of ornamental finish prompted a description of these pieces in the inventory of 1804, twenty years after their arrival in Spain, as having been made in Cavaceppi's studio based on a Piranesi design. In order to give the impression of restored antique works, it appears that the Neo-Attic reliefs of dancing satyrs and maenads were incorporated into the triangular bases (the other pair of candelabras includes reliefs with putti). However, if these reliefs are compared with those on a similar pair of triangular pedestals from Cavaceppi's studio, now at Newby Hall, Yorkshire, the character of the *Westmorland*'s examples shows evident signs of being derived from early Italian Renaissance reliefs as compared to the bolder and simpler figure style of the Newby works, which are convincingly Augustan or Hadrianic pieces. JW-E

REFERENCES: Leander Touati 1998, 55–59; Jackson-Stops 1985, 306–7; Luzón Nogué and Sánchez-Jáuregui 2003, 67–100; Wilton-Ely 2007, 40–46.

130

131

132

132

UNKNOWN SCULPTOR

Head of a Woman or Goddess with Diadem
1770S

Marble
13¾ x 7⅛ x 7⅞ in. (35 x 18 x 20 cm)
Real Academia de Bellas Artes de San Fernando,
Museo, E-199

133

UNKNOWN SCULPTOR

Head of a Woman or Goddess
1770S

Marble
18 ½ x 11⅜ x 11⅜ in. (47 x 29 x 29 cm)
Real Academia de Bellas Artes de San Fernando,
Museo, E-273

These two heads are typical of the small souvenirs
in the antique taste that were acquired in Rome in
the late eighteenth century. Both have hair arranged
in the Greek manner, with locks falling on either
side of the neck in a style that returned to fashion in
the early decades of the first century AD. These heads
lack the individualized features of portraits, however,
and can thus be considered idealized depictions. The
diadem present on one head (cat. 132) would indicate
that this was either a goddess or a member of the
imperial family.

The head with the diadem was made in three
different pieces: the head itself, the bust with the
drapery, and the base. The head may have been a
reworking of an ancient original, but nothing
remains of the old surface. The nose was added in a
different marble. The drapery and base are both
clearly modern. The other head (cat. 133) was also
constructed of three pieces of marble, of different
kinds that do not match well. The head may again
elaborate an ancient original, but nothing of the
antique surface, with the possible exception of the

133

described as antique busts. This opinion was maintained in the nineteenth century. The first description of them that appears in the 1784 inventory compiled at the Real Academia describes the head with a diadem as "Otro busto de marmol de Juno de cuarta y media de alto" (Another marble bust of Juno *cuarta* and a half high), and the other as a "busto de marmol de una joven romana, con tunica cogida en los hombros con botones, alto media vara" (marble bust of a young Roman woman, with tunic held on the shoulders with buttons, half *vara* high). These heads accompanied similarly modern cinerary urns (cat. 134), suggesting that they may have been made in the same studio, but no precise information on either their manufacture or their acquisition has been discovered. JMLN

REFERENCES: Hübner 1862; Azcue Brea 1994; Westmorland 2002, no. 79 (entry by Almudena Negrete Plano).

134

UNKNOWN SCULPTOR

Cinerarium, Based on Antique Roman Originals
1770S

Marble
19 ¼ x 18 ½ x 13 ⅜ in. (49 x 47 x 34 cm)
Museo Arqueológico Nacional, Madrid, 2840

Five cineraria (funerary urns or ash chests) were present on the *Westmorland*, sent in two different crates. This urn is one of two from the crate marked with the letter "L"; it is one of a sequence of crates designated by consecutive letters of the alphabet. The other three were packed in a crate marked with a distinctive motif (see cats. 139–140).

Like the other four urns that were on board the *Westmorland*, this one, with its inscription identifying it as containing the ashes of Antonia Maxuma, has elements that suggest it is of modern manufacture. The name of its purchaser is unknown, but we should bear in mind that the Mattei collection had been dispersed in the 1770s. In 1776 Henry Blundell was in Rome with Charles Townley, and Blundell acquired a considerable number of urns from the Mattei collection that are strikingly similar to those on board the *Westmorland*. Blundell's agents were Thomas Jenkins and Father John Thorpe, both names associated with the ship. Sent as part of a larger delivery in a set of lettered crates, the urn probably

hair and knot, remains. The face is clearly modern, as are the drapery and the base. It was very common for the workshops that produced such objects to obtain the marble from excavations in order to make new pieces from old fragments. It can be assumed that in each case the sculptor aimed to create a bust in the antique style aimed at a relatively unsophisticated clientele and intended as a purely decorative object.

The two busts were in one of the crates marked solely with a letter, implying that they were part of a larger delivery to a now-unidentified recipient. In the inventories compiled in Málaga and on the arrival of the *Westmorland*'s cargo at the Real Academia de Bellas Artes de San Fernando, they are

134

would have been intended for one of the most important collectors of the day, possibly Blundell.

The present urn was published together with the other four in the nineteenth century, when they were in the Museo Arqueológico Nacional in Madrid. The museum's curator, Manuel Catalina, considered them to be classical works when he published them in 1877 and did not question either their execution or the anomalies evident in their inscriptions. The latter issue was recently reviewed by Helena Gimeno and Armin Stylow, who observed that the framed inscription on the front is a partial repetition of one in Portugal (Corpus Inscriptionum Latinarum, II, 335). The inscription on the present urn reads: "D. M. ANTONIA MAXUMA ANTONIA MODESTA LAURENTIUS GENER MARITUS EX TESTAMENTO" (Dedicated to the Manes [gods]. For Antonia Maxuma [her mother]. Antonia Modesta and her husband Laurentius Gener fulfilling her last will).

Grand Tourists frequently acquired original urns on their way through Rome. However, highly restored urns and modern copies were purchased for the decoration of Neoclassical interiors in the same way that "Etruscan vases" became standard decorative feature in aristocratic houses. John Soane's house at 13 Lincoln's Inn Fields, London, provides an example of how a wide range of small objects in the classical taste were arranged, be they originals, casts, or copies. Giovanni Battista Piranesi's ideas and designs provided the inspiration for many urns that were long considered antique. JMLN

REFERENCES: Catalina 1872; Gimeno and Stylow 1999, 92–93; Davies 2000, 187ff.; Summerson and Dorey 2001; Westmorland 2002, no. 83 (entry by Ana María Suárez Huerta); Suárez Huerta 2008, 321ff.

Crate M. G.

OWNER UNKNOWN

135

CHRISTOPHER HEWETSON (1737–1798)

Anton Raphael Mengs

ca. 1777–78

Plaster cast
25⅝ x 15¾ x 9⅞ in. (65 x 40 x 25 cm)
Real Academia de Bellas Artes de San Fernando, Museo, E-43

Christopher Hewetson's bust of Anton Raphael Mengs is one of his finest portraits, with several extant copies and versions recorded by Terence Hodgkinson and Brian De Breffny: a cast (1792) by Francesco Righetti, for example, is in the Sterling and Francine Clark Art Institute, Williamstown, Massachusetts. The plaster, shipped on the *Westmorland* to an unknown recipient, portrays this formidable arbiter of the true and correct style in a manner that corresponds to his influential theories of beauty and taste. At the same time it has all the fluidity and subtlety of surface that made Hewetson the leading portrait sculptor in Rome in the 1770s and 1780s. The Spanish ambassador in Rome, José Nicolás de Azara y Perera, marqués de Nibbiano, commissioned this portrait with another of himself (fig. 62, p. 108), a pairing that provides a record of friendship and artistic understanding between the painter, diplomat, and sculptor. Azara wrote in his biography of Mengs (1780) that his bust was made "under the direction" of the painter, and that Hewetson received similar guidance when modeling his portrait of Mengs. Following the death of his friend Mengs in 1779, Azara had the bronze version (1779; Bibliothèque Mazarine, Paris) of the plaster placed "beside that of Raphael" in Raphael's tomb in the Pantheon. Hewetson completed a larger and more sumptuous marble version of this portrait (1781; Promoteca Capitolina, Rome), which replaced the bronze in 1782. Two plasters of Azara's original commission are recorded on the *Westmorland*: one, now lost, in crate ⟨**H**⟩, the other

135

in that marked "M. G.," the recipient of which is undocumented. AY

REFERENCES: Azara 1780a; Hodgkinson 1952–54, 42–54, no. 81; Ford 1974, 416–25; De Breffny 1986, 52–75; Azcue Brea 1994, 257–59; Westmorland 2002, no. 87 (entry by Almudena Negrete Plano); Roscoe 2009, 608–12.

136

136

CHRISTOPHER HEWETSON (1737–1798)

Unknown Man

1777

Terra-cotta
19¼ x 14⅛ x 8⅝ in. (49 x 36 x 22 cm)
Signed and dated on back of right shoulder: "Chrus. Hewetson. Fect. 1777"
Real Academia de Bellas Artes de San Fernando, Museo, E-204

This finely modeled terra-cotta bust is signed "Chrus. Hewetson. Fect. 1777" in the folds of the cloak on the right shoulder. It represents a young man in modern dress and wig; his features have an intensity of expression that suggests strength of purpose and intelligence. The identity of the sitter for this bust is unknown. It was suggested in the catalogue of the *Westmorland* exhibition in Spain in 2002 that the sitter could be the same man in the portrait painting belonging to John Henderson of Fordell (cat. 101) and, in turn, that both painting and sculpture depict Henderson himself. This now seems unlikely. Comparison with the drawing of Henderson from a few years later by John Brown (fig. 14, p. 24) shows Henderson to have had rather different and less handsome features than the figure in the painting. There is nothing beyond the vague resemblance to the man in Henderson's painting to connect this bust to him. The bust appears to be the "cabeza de barro cocido" (terra-cotta head) listed in Antonio Ponz's inventory for the Real Academia de Bellas Artes de San Fernando as having been packed in the crate marked "M. G.," which also contained the plaster bust of Anton Raphael Mengs (cat. 135) and another unidentified plaster head. AY

REFERENCES: Hodgkinson 1952–54, 42–54; Ford 1974, 416–25; De Breffny 1986, 52–56; Azcue Brea 1994, 256–57; Westmorland 2002, nos. 70, 71 (entries by María Dolores Sánchez-Jáuregui); Roscoe 2009, 608–12.

Crate W. A. F.

OWNER UNKNOWN

137

UNKNOWN ARTIST AFTER GUIDO RENI (1575–1642)

The Archangel Saint Michael

1770s

Oil on canvas

54 x 39 in. (136 x 99 cm)

Real Academia de Bellas Artes de San Fernando, Museo, 280

137

Guido Reni's *Archangel Saint Michael*, painted for the Capuchin church of Santa Maria della Concezione in 1635, was one of the most admired pictures in Rome and the subject of much attention from travelers. The central figure of Saint Michael, according to a description by the two Jonathan Richardsons (father and son) in 1722, is "in the utmost perfection, and has that marvellous lightness that is in the Apollo of Bernini in the Groupe of the Villa Borghese, and the utmost beauty, and propriety of Tincts [coloring]." British critics, however, were not universal in their approbation. Tobias Smollett wryly observed that the "archangel has all the air of a French dancing-master." This was a sentiment echoed by Daniel Webb in his *Inquiry into the Beauties of Painting*, who elaborated that "the grace of Guido is rather technical than ideal," by which he meant that Reni's paintings were compositionally elegant without achieving narrative clarity. Saint Michael posed as a "dancing master," Webb suggested, was not appropriate for the archangel defeating Satan. Johann Joachim Winckelmann, the champion of Neoclassicism, naturally objected to this conclusion, seeing the "sublimity of the expression" that Reni gave Saint Michael as commensurate with an action he characterized as being "without wrath."

A picture praised by both Richardson and Winckelmann would have been of interest to both artists and collectors. For painters studying in Rome, copying was an essential activity, and inherent in the process was the judicious choice of subject. This was also commercially important, as a painter could charge a substantial price for a replica of a popular painting. The *Saint Michael* was just such a picture. Thomas James Bulkeley, seventh Viscount Bulkeley, presented a full-scale copy, probably purchased in Italy in 1774, to Jesus College, Oxford, where it was installed as the chapel altarpiece.

Given the scale of the present picture, almost exactly half the size of the original, it seems likely that the painter would have used an intermediary, such as an engraving, to help replicate the composition. The *Saint Michael* had been engraved on a number of occasions, first by Girolamo de Rossi as early as 1636, but most famously by the Swiss engraver Jakob Frey in 1734. The closeness of the colors in the copy to those in the original suggests that it might have been finished in front of the original painting itself. Although copying in most churches and palazzi required complicated permissions, Father Juan Andrés testified in 1791 to having seen a number of Spanish *pensionados* (grant students) working on copies in Santa Maria della Concezione. Indeed, the survival of several copies of the *Saint Michael* in the collection of the Real Academia by Spanish painters, including Domingo Álvarez Enciso and León Bueno, complicated the identification of the painting on board the *Westmorland*. JY

REFERENCES: J. Richardson 1722, 302; Webb 1761, 14; Winckelmann 1765, 36–37; Smollett 1766, 2:118; Gutch and Wood 1790, 316; Pepper 1984, no. 154; García Sánchez and de la Cruz Alcañiz 2010, 665–70.

138

138

UNKNOWN SCULPTOR

Head of Antoninus Pius, after an Antique Roman Original

1770S

Marble
15¾ x 10¼ x 11⅜ in. (40 x 26 x 29 cm)
Real Academia de Bellas Artes de San Fernando,
Museo, E-17

From the time of its arrival at the Real Academia de
Bellas Artes de San Fernando, this marble portrait
was incorrectly catalogued, with various suggestions
as to its subject, including Hadrian and Marcus
Aurelius. It is now known to have been on the
Westmorland, although it confusingly appears in
different crates according to the successive invento-
ries that were drawn up of the ship's contents. In the
inventory of 1804 at the Real Academia, the descrip-
tion of the work includes details of the two types
of marble from which it is made: "Bust that seems to
be of the Emperor Hadrian. The head of Carrara
marble and the rest of Badajoz, three quarters high."
In 1989 and 1994, the sculpture was published as a
portrait of Hadrian's successor as emperor, Antoni-
nus Pius, but its provenance was not established
and it was assumed to be an original antique work.
Subsequent studies have concluded, however, that
it is an eighteenth-century restoration of a type
habitually produced for the Grand Tour market.

The entire face, including the brow as well as the
front half of the skull as far as the ears, are modern
additions. These areas are sculpted in a marble that is
clearly different from the one used for the neck and
back of the head, which seem to be antique. The
added part is slightly grayer in tone, and the sculptor
has created a rough finish with the intention of
suggesting wear brought about by age. We thus have a
modern portrait in which the features of Antoninus
Pius were completely re-created in the studio. Within
the typography of official portraits of the emperor,

this one follows the model known as the "Sala a Croce Greca" (after a room in the Museo Pio-Clementino) of which the finest example is now in the Musei Capitolini, Rome (446). It was consequently a portrait easily accessible to sculptors. From the Renaissance onward numerous great houses throughout Europe had been decorated with portraits of emperors. The choice of Antoninus Pius as a representative of the Roman Empire at the height of its power may have had special resonance for collectors. He was married to Annia Galeria Faustina the Elder, who was known for her major charitable projects. On her death in 141 Antoninus Pius deified her and dedicated a temple to her on the Via Sacra in the Forum. Twenty years later, on his own death, the Senate dedicated it to the couple. The good condition in which the building survived meant that in the Middle Ages it functioned as the church of San Lorenzo in Miranda and was thus one of the monuments visible to all travelers passing through Rome. JMLN

REFERENCES: Barron Watson 1884; Fittschen and Zanker 1983, 1:63ff., no. 59, pls. 67–69; Blázquez 1989, 277ff.; Azcue Brea 1994, 68ff.

139

UNKNOWN SCULPTOR

Cinerarium, Based on Antique Roman Originals
1770s

Marble
19¼ x 14⅛ x 18⅞ in. (49 x 36 x 48 cm)
Museo Arqueológico Nacional, Madrid, 1985/74/12

140

UNKNOWN SCULPTOR

Cinerarium, Based on Antique Roman Originals
1770s

Marble
19¼ x 9⅞ x 14⅛ in. (49 x 25 x 36 cm)
Museo Arqueológico Nacional, Madrid, 2842

These cineraria (funerary urns or ash chests) are two of the three contained in the crate with this distinctive marking, and they were thus intended for a different collector from the one to whom the urns in crate ⟨L⟩ were directed. They could also have come from a different workshop. The inscription with the name Albana Catela, added at a later date on one of the urns (cat. 140), suggests that the body of that

139

urn may be ancient, while the lid is close to models by Giovanni Battista Piranesi.

Believing them to be classical works, various specialists attempted to catalogue these urns in the early 1990s, in the Museo Arqueológico Nacional, Madrid. No definitive conclusion was reached, however, due to the peculiar mixture of stylistic elements that characterize them. It was the attempt to analyze these objects and the search for surviving documentary evidence that led a group of researchers associated with the Department of Archaeology at the Universidad Complutense in Madrid to uncover the entire history of the *Westmorland*. The objects' provenance, the way in which they are carved, and, above all else, a close study of the inscriptions led to the conclusion that they are modern urns made for the eighteenth-century antiquities market in Rome. The cylindrical cinerary urn (cat. 139) has a lid made of a different marble that is also modern. It would normally have had a lid with a raised decorative motif that could be used to lift it off. In this case, however, the upper surface has been left flat for possible use as a pedestal. The urn has a large square, framed area surrounded by a curious garland of ivy leaves and

140

rosettes. On either side of it are a similarly untypical patera (metal disk) and praefericulum (metal vase for libations). The most curious elements are the errors in the inscription: "D. M. LIVIAE VENUSTAE C LIVIUS FORTUNATUS UXORIS BENE MERETI V A N XIX M IX" (Dedicated to the Manes [gods]. Caius Livius Fortunatus to his well-deserving wife who lived 19 years and 9 months); in 1999 Helena Gimeno and Armin Stylow published the puzzling anomalies to be found in the inscriptions here and elsewhere on this series of urns.

The other urn (cat. 140) also has a lid that is of a different marble and is carved by another hand with a somewhat crude design. This urn has a rectangular area on the front with the carved inscription: "D. M. A. CORNELVIUS APRILIS CORNELIAE NYMPHE PATRONAE OTTIMAE ET ALBANE CATELE B. M. F." (Dedicated to the Manes [gods]. Aulus Cornellius Aprilis made it for his well-deserving patron Cornelia Nymphe and [added later] Albane Catele). Below, a wreath with infulas (ribbons) supported on each side by a putto frames the portrait of the deceased person. The corners terminate in

tripods adorned with theatrical masks. The urn is flanked at the sides by two griffins in relief.

Glenys Davies, in a study of similar urns formerly in the Ince Blundell collection and now in the National Museums of Liverpool, has shown that, although the authenticity of this collection of more than six hundred sculptures remained unquestioned for more than two hundred years, several of their inscriptions include errors or are copies of other known inscriptions. The more than fifty urns in the Ince Blundell collection were acquired in the 1770s or early 1780s. This was the decade when a large number of classical works were sold and dispersed from the Mattei collection via the antiquarians Ferdinando Lisandroni and Antonio d'Este. The year 1778 saw the publication of volume 3 of the *Monumenta Matheiana*, which was partly devoted to the urns, although by that date much of the collection had been sold. JMLN

REFERENCES: Hübner 1862; Catalina 1872; Negueruela 1993; Gimeno and Stylow 1999; Davies 2000, 187ff.; Westmorland 2002, nos. 82–84 (entries by Ana María Suárez Huerta); Suárez Huerta 2008, 312ff.

Lake Nemi (cat. 27, detail)

Appendixes: Two Inventories

Appendix 1

Inventory of the Contents of the *Westmorland*, Compiled at Málaga for the Compañía de Lonjistas de Madrid, July 13, 1783. British Library, London, Egerton Papers, 545 (cat. 12)

The inventory begins with a cover letter from Pedro Pimentel de Prado, marqués de la Florida Pimentel, to José Moñino y Redondo, conde de Floridablanca, and concludes with a note that the inventory is a copy of one sent to the directors of the Compañía de Lonjistas de Madrid on July 1, 1783, by order of Quintin, Galwey, and Obrien of the Maritime Commercial Agents of Málaga, in whose warehouse the remaining contents of the *Westmorland* were in storage.

Appendix 2

Antonio Ponz, Catalogue of the Books, Prints, Oil Paintings, Sculptures, and Other Curiosities That Came in Two Consignments to the Real Academia de Bellas Artes de San Fernando in Madrid by Order of José Moñino y Redondo, conde de Floridablanca, April 1784. Real Academia de Bellas Artes de San Fernando, Archivo-Biblioteca, 4-87-1-26 (cat. 14)

This inventory is in three parts. The first is a catalogue of books, prints, and other papers that came in the second consignment, listed according to marked crates. The second is a catalogue of oil paintings and other curiosities in the second consignment, again listed according to marked crates. The third records works in the first consignment, listed in sixteen consecutively numbered lots, corresponding to crates but without individual crate markings. Slashes preceding the entries indicate material selected for Carlos III. Asterisks and double slashes indicate objects selected by Ponz for the Real Academia.

These are two of a total of nine known inventories of the contents of the *Westmorland*. With the exception of the one in the British Library transcribed and translated here as appendix 1, all are in the Real Academia de Bellas Artes de San Fernando. Three additional inventories are transcribed in Westmorland 2002, 175–83.

See the Acknowledgments and Notes to the Reader, p. xiii, for an explanation of the Spanish measurements used in the inventories.

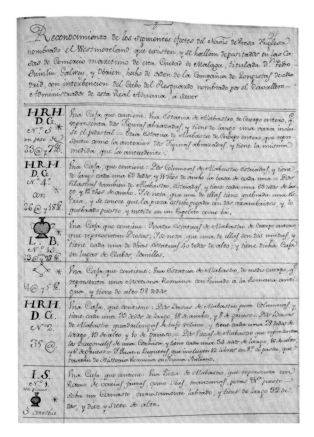

Appendix 1, fol. 191 (cat. 12)

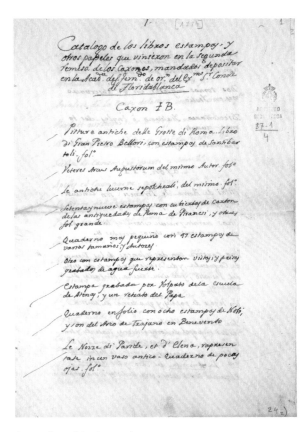

Appendix 2, fol. 1 (cat. 14)

The Cumaean Sibyl (cat. 112, detail)

Appendix 1

Inventory of the Contents of the *Westmorland*, Compiled at Málaga for the Compañía de Lonjistas de Madrid, July 13, 1783. British Library, London, Egerton Papers, 545 (cat. 12)

SPANISH TRANSCRIPTION

Lista de Antiguedades, Libros &ra., adquiridas en una Presa de embarcacion Inglesa

[Anotado al margen] No fue esta la presa en que vino la Venus de bronce y otras cosas qe. existen en la Academia

Exmo. Señor = Muy Sr. mio y mi Dueño, Con fecha de 9 del corriente, me dice V. E. qe. el Rey ha sido informado de que en una presa hecha á los Ingleses por los Franceses, se hallan Diseños, Pinturas, y otros efectos de los mas celebres Profesores, pertenecientes á las Nobles Artes, que se sacaron de Italia para Inglaterra. Que de su real orden están detenidos, y custodiados con particular cuidado, en la Ciudad de Malaga, hasta que sean reconocidos por Persona inteligente que se nombrará á este fin; Y que para que se verifique este reconocimiento con la exactitud y acierto que corresponde, quiere V. E. que le informe, quien podrá hacerlo. Deseando satisfacer al encargo de V. E. en materia que á mi parecer es muy delicada y difícil, he reflexionado el caso y no creo que en Malaga ni cerca de ella haya Sugeto de quien se pueda esperar que execute el reconocimiento con la exactitud y acierto que se desea.

Tengo presente, que en los años pasados, para satisfacer mi curiosidad, y la de algunos Profesores encargue á Malaga, procurasen adquirirme algun original de Dn. Juan Niño de Guevara que floreció en aquella Ciudad el Siglo pasado, y debió á Palomino tan desmedido elogio, que le puso superior á Murillo. Previne que se asesorasen con un Escultór que corria alli con buen credito. Y me enviaron por Originales de ~~Murillo~~ Niño dos Quadros malissimos. Con poca diferencia de tiempo vino de Granada una lista de Pinturas, suponiendo haber entre ellas algunas delos mas famosos Pintores de Italia, según aseguraban dos Profesores, los mejores de aquel Reino.

Con fiado en estos informes dió Orden un Sugeto de Gusto y caudal para que se le comprasen, y traidas á Madrid no se hallo lo que se esperaba. Pudiera referir otros chascos semejantes: Y fundado en estas experiencias me persuado á que no haya en aquellas Provincias, como queda dicho, Persona capaz de desempeñar un reconocimiento y aprecio, que aun á los Profesores mas habiles y conocedores dara mucho que hacer. Por esta razon me parece, que el medio mas seguro será, que supuesto que los Ingleses

ENGLISH TRANSLATION

List of Works of Art, Books, etc., acquired from a Captured English Ship

[Added in the margin] This was not the captured ship that had the bronze Venus and other things now in the Academia

Your Excellency = My Lord, on the 9th of this month, Your Excellency told me that the King has been informed that on board a ship captured from the English by the French there are Drawings, Paintings, and other works by the most famous Masters, belonging to the Noble Arts, that had left Italy for England. [And] that these have been detained by your royal order and are being looked after with great care, in the City of Malaga, until they are inspected by an informed Person appointed for that purpose; And so that this inspection is carried out with the appropriate precision and accuracy, Your Excellency would like me to inform you who might be able to undertake it. In my desire to carry out Your Excellency's instructions in an affair that seems to me extremely difficult and delicate, I have thought over the matter and I do not think that there is any Person in or near Malaga who can be expected to carry out the inspection with the required precision and accuracy.

I remember that some years ago, and in order to satisfy my curiosity and that of various Experts, I made the request in Malaga that an original painting be found for me by Juan Niño de Guevara, who worked in that City in the last Century and whom Palomino praised so highly as to place him above Murillo. I advised the use of the services of a Sculptor who worked there and who had a good reputation. As originals by ~~Murillo~~ Niño they sent me two terrible Paintings. Shortly afterwards a list of Paintings arrived from Granada that supposedly included some by the most celebrated Painters of Italy, according to two Experts, the best in that Region.

Trusting those reports A Person of Taste and wealth gave instructions to purchase them, and having had them brought to Madrid discovered that they were not what he was expecting. I could mention other similar disappointments: And on the basis of these experiences I am persuaded that, as I said, there is no one in that Province capable of undertaking an inspection and assessment, that would involve even the most skilled and knowledgeable experts in considerable effort. For this reason it seems to me that the surest

las traherian con toda curiosidad, vengan en los mismos Cajones, cubiertos con encerado: Que quedandose con razon de lo que remiten dirixan á V. E. un duplicado de ella; Y que luego que lleguen, se reconozcan y aprecien por los Directores de Pintura, y sus tenientes, y se dé á V. E. puntual aviso de las resultas. Esto es lo que encuentro menos expuesto para el fin deseado, si V. E. no halla inconveniente en su execucion.

Repito a V. E. mis respetos y quedo rogdo. a Dios gue su vida ms. as. Madrid 13 de Julio de 1783 = Exmo. Señor = B L M de V. E. su mas atto. Servor. = El Marqs. de la Florida Pimentel = Exmo. Señor Conde de Floridablanca =

[fol. 191]

Reconocimiento de los siguientes efectos del Navio de Presa Inglesa nombrado el Westmoreland, que existen, y se hallan depositados en las Casas de Comercio maritimo de esta Ciudad de Malaga, titulada Dn. Pedro Quintin, Galwey, y Obrien, hecho de orden dela Compañia de Longistas de Madrid, con interbencion del Cabo del Resguardo, nombrado por el Cavallero Administrador de esta Real Aduana, á saver.

H. R. H. D. G. No. 5 *

con peso de 23 @ y 7 lb.

Una Caja, que contiene: Una Estatua de Alabastro, de Cuerpo entero, qe. representa dos Figuras abrazadas, y tiene de largo una vara incluso el pedestal = Otra Estatua de Alabastro de Cuerpo entero, que representa como la anterior dos Figuras abrazadas, y tiene la misma medida, que la antecedente.

H. R. H. D. G. No. 4°. *

con 26 @ y 18 lb.

Una Caja, que contiene: Dos Columnas de Alabastro Estriadas, y tiene de largo cada una 63 dedos, y 11 dhos de ancho la basa de cada una = Dos Pilastras tambien de Alabastro, Estriadas, y tiene cada una 63 dedos de largo, y 12 dchos de ancho. Y se nota, que una de ellas tiene quebrada una Estria, y se conoce que la pieza estubo pegada con dos arambritos, y lo quebrado puesto, y metido en un Papelito como bá.

L. B. No. 15. *

con 23@ y 23 lb.

Una Caja, que contiene: Quatro Estatuas de Alabastro de Cuerpo entero, que representan Diosas. Y se nota, que una de ellas son dós unidas, y tiene cada una de dhas Estatuas 40 dedos de alto; y tiene dicha Caja en lugar de Clabos, tornillos.

method, and assuming that the English packed them well, would be to bring them in the same Crates, covered with waxed cloth: that a duplicate list of what is being sent should be addressed to Your Excellency; and that when they arrive, they are inspected and assessed by the Directors of Painting and their assistants and that Your Excellency be promptly informed of the results. I consider this to be the least risky option in order to achieve the desired end, if Your Excellency does not see any problems in its undertaking.

Once more I express my respects to Your Excellency and ask for God's protection to keep you safe. Madrid 18 July 1783 = My Lord = I remain your most attentive Servant = The Marquis de la Florida Pimentel = My Lord the Count of Floridablanca =

[fol. 191]

Inspection of the following items from the Captured English Ship named the Westmoreland, which exist, and which are in storage with the Maritime Commercial Agents of this City of Malaga, namely Messers Pedro Quintin, Galwey, and Obrien, on the order of the Compañia de Lonjistas of Madrid, with the participation of the Customs House official, appointed by the Distinguished Administrator of this Royal Customs Service, as follows.

H. R. H. D. G. No. 5 *

weighing 23 *arrobas* and 7 *libras*

A Crate, that contains: An Alabaster Statue, full-length, that depicts two embracing figures, one *vara* high including the pedestal = Another full-length Alabaster Statue that again depicts two embracing Figures and is of the same size as the previous one.

H. R. H. D. G. No. 4. *

weighing 26 *arrobas* and 18 *libras*

A Crate that contains: Two Fluted, Alabaster Columns, each 63 *dedos* long, the bases each 11 *dedos* wide = Two Pilasters also of Fluted Alabaster, each 63 *dedos* long, and 12 *dedos* wide. It should be noted that one has a cracked Flute and it is known that this piece was stuck together with two small metal rods, and the broken piece taken, and wrapped in a piece of Paper as it will be sent.

L. B. No. 15. *

weighing 23 *arrobas* and 23 *libras*.

A Crate, that contains: Four Alabaster Statues, full-length, that depict Goddesses. It is observed that one of them consists of two joined together, and each of the said Statues is 40 *dedos* high; instead of Nails this case has screws.

14 @ y 5 lb.

Una Caja, que contiene: Una Estatua de Alabastro, de medio cuerpo, qe. representa una Matrona Romana con Peinado á la Romana antigua, y tiene de alto 38 dedos.

H. R. H. D. G. No. 2.
35@

Una Caja, que contiene: Dos Basas de Alabastro para Columnas, y tiene cada una 33 dedos de largo, 18 de ancho, y 8 de grueso = Dos Basas de Alabastro quadrilongas de bajo relieve, y tiene cada una 28 dedos de largo, 13 de alto, y 10 de grueso = Dos Piezas de Alabastro que representan los Diagonales de una Cornisa, y tiene cada una 34 dedos de largo, 16 de alto, y 6 de grueso = Y Quatro Paquetes, que incluyen 12 libros en 8°. de pasta, que tratan de Historia Romana en Idioma Italiano.

IS No. 1. *
Posa Piano 5 arrobas

Una Caja, que contiene: Una Pieza de Alabastro, que representa un Ramo de varias frutas, como Ubas, manzanas, peras &ra. puesto sobre un Canasto, curiosamente labrado, y tiene de largo 32 dedos, y diez y siete de alto.

28 @

Una Caja, que contiene: Una pieza de Cornisa de Alabastro, labrada de vajo relieve, y tiene de largo 35 dedos, 19 de ancho, y 7 de grueso = Otra pieza de Cornisa tambien de Alabastro, labrada de vajo relieve, y tiene de largo 62 dedos, de alto 16, por su planta vaja 8, y por la planta alta 3 = Una Cabeza de Alabastro, labrada de relieve, que representa Venus, y tiene 26 dedos de alto = Un Paquete, que contiene 3 tomos en Pasta en 8° el 9, 10, y 11 que trata de la Literatura Italiana, en dicha Lengua.

37 @ y 10 lb.

Una Caja, que contiene = Un Cajoncito con una Cabeza de Alabastro, y tiene de largo 14 dedos = Una Pila con su tapa de Marmol blanco, y tiene de largo 27 dedos, 20 de ancho, y 22 de alto = Una Pieza de Marmol blanco labrada, con dos Columnas á los lados, y tiene 20 dedos de alto, 28 de ancho, y 9 de grueso = Un Pedestal de

14 *arrobas* and 5 *libras*.

A Crate, that contains: An Alabaster Statue of half-length that depicts a Roman Matron with her Hair in the Roman Classical Style, 38 *dedos* high.

H. R. H. D. G. No. 2.
35 *arrobas*

A Crate, that contains: Two Alabaster Bases for Columns, each 33 *dedos* long, 18 wide, and 8 deep = Two square Alabaster Bases of low relief, each 28 *dedos* long, 13 high, and 10 deep = Two Pieces of Alabaster that represent the Diagonals of a Cornice, each 34 *dedos* long, 16 high, and 6 deep = And Four Packets, that include 12 books, octavo, board binding, on Roman History in the Italian Language.

IS [J S] No. 1. *
Fragile 5 *arrobas*

A Crate, that contains: A Piece of Alabaster, that depicts a Cluster of various fruits, including Grapes, apples, pears etc, set on a finely carved Basket, it measures 32 *dedos* long, and ten and seven high.

28 *arrobas*

A Crate, that contains: A Piece of Alabaster Cornice carved in low relief, and measures 35 *dedos* long, 19 wide, and 7 deep = Another piece of Cornice also of Alabaster, worked in low relief, that measures 62 *dedos* long, 16 high, 8 at the bottom, and 3 at the top = An Antique Head, carved in relief, that depicts Venus, 26 *dedos* high = A Packet, containing 3 books in Board binding, octavo, the 9th, 10th and 11th on Italian Literature, in that Language.

37 *arrobas* and 10 *libras*.

A Crate, that contains = A Small Box with an Alabaster Head, measuring 14 *dedos* long = A Font with its white Marble top, 27 *dedos* long, 20 wide, and 22 high = A Piece of carved white Marble with two Columns on either side, 20 *dedos* high, 28 wide, and 9 deep = A Column Pedestal, its base and frieze of white Marble, the

Columna, su basa, y friso de Marmol blanco, y el Cuerpo de dho pedestal de color azul con betas blancas, y tiene de alto 22 dedos, y por la planta vaja 18 = Una Estatua de Alabastro de medio Cuerpo, y tiene de alto 17 dedos = Una Pila de Marmol blanco labrada, y tiene de alto 12 dedos, y 20 en Quadro = Otra Pila de marmol blanco labrada con una Inscripcion de letras antiguas, y tiene de alto 16 dedos, 20 de ancho, y 16 de grueso.

Body of blue color with white veins, measuring 22 *dedos* high, and 18 at the bottom = A half-length Alabaster Statue measuring 17 *dedos* high = A carved white Marble Font, 12 *dedos* high, 20 square = Another white marble Font carved with an Inscription in antique letters, measuring 16 *dedos* high, 20 wide, and 16 deep.

ł. ⟨C⟩ P. No. 1.
24 @ y 5 lb.

ł. ⟨C⟩ P. [J. C. P.] No. 1.
24 *arrobas* and 5 *libras*.

Una Caja, que contiene: Quatro remates de Marmol, que representan hastas de Candeleros con varias labores de talla, y Estrias, y tiene cada uno 49 dedos de largo, por la planta vaja 11 dedos de diametro, y por la alta 17 ½ dedos de diámetro = Quatro Piezas de Marmoles labrados con Estrias, y varios adornos, de figura Esferica, que son asientos de dhos Candeleros, todo, al parecer de fabrica antigua, labrado de vajo relieve, y tiene cada pieza 20 dedos de diametro.

A Crate, that contains: Four Marble elements that are Candelabra shafts with various types of carving and Fluting, each 49 *dedos* long at the bottom, 11 *dedos* in diameter, and at the top 17 ½ *dedos* in diameter = Four Pieces of Marble carved with Fluting, and various decorative elements, of Spherical form, that are the bases of the said Candelabra, all seemingly of antique manufacture, carved in low relief, each one 20 *dedos* in diameter.

ł. ⟨D⟩ P. No. 2. *
44 @

ł. ⟨D⟩ P. [J. D. P.] No. 2. *
44 *arrobas*

Una Caja, que contiene = Dos Remates de Marmol, labrados de vajo relieve en forma triangular, con varias figuras por todas sus Caras, y por las Esquinas Cabezas de Leones, y tiene de largo cada uno 39 dedos, por su planta vaja 35, y por la alta 28.

A Crate, that contains = Two Marble Elements, carved in low relief in triangular form, with various figures on all Sides, with Lions' Heads at the Corners, each one 39 *dedos* long, 35 at the bottom, and 28 at the top.

ł. S. No. 2. *
Posa Piano 19@ y 15 lb. nota

ł. S. [J. S.] No. 2. *
Fragile 19 *arrobas* and 15 *libras*. note

Una Caja, que contiene = Una Chimenea de Alabastro, compuesta de las Siguientes Piezas, á Saver: Una Pieza de 45 dedos de alto, y 12 de grueso: Otra de el mismo tamaño, que es basa de dicha Chimenea: y otra que tiene 81 dedos de largo, y 8 de grueso, todas labradas. En el segundo reconocimiento se hallaron dos piezecitas de Marmol de 9 dedos largo, 7 de ancho; y 7 de alto, todo labrado.

A Crate, that contains = An Alabaster Fireplace, comprising the Following Pieces, namely: A Piece of 45 *dedos* high and 12 deep; Another of the same size, which is the base of the said Fireplace; and another measuring 81 *dedos* long, and 8 deep, all carved. In the second inspection two small pieces of Marble were found, 9 *dedos* long, 7 wide; and 7 high, all carved.

⟨B⟩ *
10 @

⟨B⟩ *
10 *arrobas*

Una Caja, que contiene = Un tablero de Marmol devarios embutidos, y tiene una esquina quebrada, y averiados algunos embutidos; y tiene 70 dedos, y 33 de ancho.

A Crate, that contains = A Marble tabletop with various types of inlay, one corner broken, some of the inlay lost; it measures 70 *dedos*, and 33 wide.

Por Thomás Farrar Esqr . Corn. Factor. *

con 9 @ y 13 lb.

Una Caja, que contiene = Un tablero de Marmol de varios embutidos, del mismo largo y ancho, que el anterior, y de la misma labor el qual está tambien quebrado por medio, y por algunas esquinas.

[fol. 192]

 *

con 49 @ y 5 lb.

Una Caja que contiene = Un Jarro, ó Mazeta de Marmol labrado, que tiene 24 dedos de alto, y una tercia de vara de Diámetro = Una Pieza de Marmol labrado de vajo relieve, que representa una Urna con su tapa y contiene la sigte. Inscripción.

D. M.

G N. VOLVNTILI

SESTI. FEC.

y tiene 28 dedos de alto, 28 de largo, y 19 de grueso = Un Pedestal redondo de Marmol labrado, que tiene 19 dedos de alto, y 17 de diametro con la sigte. inscripcion:

D. M.

LIBIÆ VENVSTÆ C. LIBIVS FORTV-

NATVS VSORIS BENEMERITI. V. AN. XIX.

M. IX =

Una Estatua de Marmol de medio cuerpo, y tiene 23 dedos de alto, y 13 de ancho = Otra Estatua de Marmol de medio Cuerpo, y tiene 20 dedos de alto, y 10 de ancho = Otra Estatua de Marmol que representa hombre de medio Cuerpo, y tiene 34 dedos de alto y 17 de ancho = Otra Estatua de Marmol de medio cuerpo, que representa Muger, y tiene de alto 28 dedos, y 17 de ancho. Otra Estatua de Marmol de medio cuerpo que representa Muger, y tiene de alto 22 dedos y 13 de ancho.

L. B. No. 18

con 4@ y 5. lb.

Una Caja, que contiene = Una Caja de Flores artificiales muy primorosas menuditas, puestas sobre gasa, y tiene de largo 42 dedos y 24 de ancho = Otra Caja de flores artificiales, tambien muy primorosas, que tiene de largo 36 dedos y 24 de ancho = Un Paquete de impresos sin enquadernar, que trata sobre la naturaleza, y cultura de las flores; dirigidos á la Real Sociedad de Londres.

For Thomás Farrar Esqr . Corn. Factor. *

weighing 9 *arrobas* and 13 *libras*.

A Crate, that contains = A Marble tabletop with various types of inlay, of the same length and width as the previous one, and of the same workmanship, that is also broken in the middle, and at various corners.

[fol. 192]

 *

weighing 49 *arrobas* and 5 *libras*.

A Crate that contains = A Vessel or Vase of carved Marble, measuring 24 *dedos* high, and a third of a *vara* in Diameter = A Piece of carved Marble in low relief, that depicts an Urn with its lid and has the following inscription:

D. M.

G N. VOLVNTILI

SESTI. FEC.

and is 28 *dedos* high, 28 long, and 19 deep = A round, carved Marble Pedestal, measuring 19 *dedos* high, and 17 in diameter with the following inscription:

D. M.

LIBIAE VENVSTAE C. LIBIVS FORTV-

NATVS VSORIS BENEMERITI. V. AN. XIX.

M. IX =

A Marble Statue of half-length, measuring 23 *dedos* high, and 13 wide = Another half-length Marble Statue, measuring 20 *dedos* high, and 10 wide = Another Marble Statue that depicts a Man in Half-length, 34 *dedos* high and 17 wide = Another half-length Marble Statue that depicts a Woman, measuring 28 *dedos* high, and 17 wide. Another Marble Statue of half-length that depicts a Woman and measures 22 *dedos* high and 13 wide.

L. B. No. 18

weighing 4 *arrobas* and 5. *libras*.

A Crate, that contains = A Box of artificial flowers very small and finely made, sewed onto muslin, 42 *dedos* long and 24 wide = Another Box of Artificial flowers, also very finely made, 36 *dedos* long and 24 wide = A Packet of loose prints, on the natural world and flower cultivation; addressed to the Royal Society in London.

F. B. No. 1 *
con 6@ y 5 lb.

Una Caja, que contiene = Una <u>Pintura</u>, que representa un Niño con un Gilgero en la mano = Otra <u>Pintura</u> que representa otro Niño con unas roscas, y zerezas en las manos, y cada una de dhas Pinturas tiene 36 dedos en quadro = Dos <u>Pinturas</u> en seda con marcos dorados, que representan algunas Diosas del Gentilismo, y tiene cada una 24 dedos en quadro = Una <u>Pintura</u> en Papel con marco dorado, que representa, al parecer á Endimion, Diana, y Venus, y otras Figuras en fiestas vacanales, y tiene de largo 54 dedos, y 27 de ancho = Otra <u>Pintura</u> en papel con marco dorado, que representa al parecer, á Sileno entre las Musas, y tiene de largo 54 dedos, y 24 de ancho = Otra <u>Pintura</u> en Papel con Marco dorado, que representa al parecer á dicho Sileno en Carro triunfal entre las Ninfas, y tiene el mismo largo, y ancho que el anterior. todas estas en sus Cajas.

 *

con 7@ y 12 lb

Una Caja, que contiene un <u>Pedestal</u> de finissimo Marmol blanco, labrado, que tiene de largo 16 dedos, y 19 en quadro.

Ɨ. P. No. 3.
con 23@.

Una Caja, que contiene = Una <u>Estatua</u> de Alabastro de Cuerpo entero, que representa una Venus al natural, que tiene de largo, ó alto 78 dedos. Y se nota, que está quebrada por las piernas, y por el cuello, y parece fabrica antigua.

Ɨ. P. No. 4. *
con 37@ y 15 lb.

Una Caja, que contiene = Dos <u>Remates</u> de Marmol labrados en forma triangular labrados por sus frentes, y por las Esquinas Cabezas de Carneros, que tiene de largo 38 dedos, de ancho 33 por su planta vaja, y 23 por la planta alta; y se nota que parece fabrica antigua.

D. G. *
con 29@ y 5. lb.

Una Caja, que contiene = Una <u>Losa</u> de Marmol negro, bien bruñido, que tiene de largo 82 dedos, de ancho 38, y 5 degrueso.

F. B. No. 1 *
weighing 6 *arrobas* and 5 *libras*.

A Crate, that contains = A Painting that depicts a Boy with a Goldfinch in his hand = Another Painting that depicts another Boy with some Rusks and cherries in his hands, both of these paintings measure 36 *dedos* square = Two Paintings on silk with gilt frames, that depict various Pagan Goddesses, each 24 *dedos* square = A Painting on Paper with a gilt frame that seems to depict Endymion, Diana, and Venus, and other Figures in bacchanalian celebrations, measuring 54 *dedos* long and 27 wide = Another Painting on paper in a gilt frame that seems to depict Silenus among the Muses, measuring 54 *dedos* long, and 24 wide = Another Painting on Paper with a gilt frame that seems to depict the said Silenus on a triumphal Chariot among the Nymphs, measuring the same lengthways and in width as the previous one. All these in their Crates.

 *

weighing 7 *arrobas* and 12 *libras*.

A Crate, that contains a Pedestal of extremely fine white Marble, carved, measuring 16 *dedos* long and 19 square.

Ɨ. P. [J. P.] No. 3.
weighing 23 *arrobas*.

A Crate, that contains = A full-length Alabaster Statue, which depicts a life-size Venus, 78 *dedos* long or high. It is observed that it is broken at the legs and neck, and it seems to be of antique manufacture.

Ɨ. P. [J. P.] No. 4. *
weighing 37 *arrobas* and 15 *libras*.

A Crate, that contains = Two ornamental Tops carved in triangular form carved on the fronts, with Rams' Heads at the corners, 38 *dedos* long, 33 wide at the base, and 23 at the top; they seem to be of antique manufacture.

D. G. *
weighing 29 *arrobas* and 5. *libras*.

A Crate, that contains = A black Marble Slab, well polished, that is 82 *dedos* long, 38 wide, and 5 deep.

C. T. No. 22. *

con 10@ 15. lb.

Una Caja que contiene = Una <u>Estatua</u> de marmol labrado, que representa un Fauno en figura de hombré baylando, y tiene de alto 38 dedos = Otra <u>Estatua</u> de marmol labrado, que representa otro Fauno en figura de Muger, tambien en acto de baylar, y tiene de alto 34 dedos.

nó vá.

Una tinagita de Azeyte, que nunca se ha destapado, y se conoce, que si estubiese llena, será de cavida, como de 3@.

nó vá.

Una Armazon de Cama, que parece Caova, pero reconocida por el Mro Carpintero, dice que es madera de Avellano, y se compone de las Piezas siguientes: 4 Piezas maestras de á 120 dedos de largo, cada una, dos dhas de á 101 dedos de largo, 2 dhas de a 81 dedos de largo, dos dhas de Pino de á 108 dedos de largo, 2 dhas tambien de Pino de 84 dedos de largo, 2 baretillas de dho pino, 3 chapas de Robles, 9 tornillos , y 3 varas de fierro .

L. Ɫ. C. [L. J. C.] No 1.

15@ y 12 lb.

Una Caja, que contiene = Dos <u>tableros</u> de Marmol labrado, que tiene cada uno 163 embutidos de varias Piedras como son el Porfido, la Agata, la Onis, el Granate, <u>&ra.</u> todas raras con las quales estan adornados, con primorosa simetria los dichos dos tableros, que tiene de largo cada uno 43 dedos, y 32 de ancho, es cosa Regia, y Magnifica.

A la dicha Caja le acompaña otra dicha, que contiene = Un Cañon de Oja de lata, que incluye dos Diseños en papel, que sirbe de instruccion para el conocimiento del nombre de cada una de las piedras de los embutidos de los dhos dos tableros arriba expresados, y una Lamina fina de Sn. Pedro, y Sn. Pablo = Un Quaderno á la brutesca con Estampas finas, Obra deJuan Bautista Piranesi, de 35 dedos de largo, y 26 de ancho = Otro Quaderno á la brutesca con 20 Laminas finas, que representan en varios trozos la perspectiva de la Columna de Trajano, y tiene de largo 47 dedos, y 31 de ancho.

C. T. No. 22. *

weighing 10 *arrobas* 15. *libras*.

A Crate that contains = A carved marble Statue that depicts a Faun in the form of a dancing man, 38 *dedos* high = Another carved marble Statue that depicts another Faun the form of a Woman, also engaged in dancing, 34 *dedos* high.

Not to be sent

A large storage jar of Oil that has never been opened, which, if full, would contain around 3 *arrobas*.

Not to be sent.

A Bed Frame, which seems to be Mahogany, but according to the Carpenter it is Hazelnut wood, comprising the following pieces: 4 principal pieces of 120 *dedos* long each, two of 101 *dedos* long, 2 of 81 *dedos* long, two of Pine of 108 *dedos* long, 2 also of Pine of 84 *dedos* long, 2 small pieces of wood also of pine, three Oak planks, 9 screws and 3 iron bars.

L. Ɫ. C. [L. J. C.] No 1.

15 *arrobas* and 12 *libras*.

A Crate, that contains = Two carved Marble tabletops, each with 163 insets of various Hardstones such as Porphyry, Agate, Onyx, Granite, etc,. all these inlays rare, the two tabletops excellently symmetrical, each 43 *dedos* long, and 32 two wide, a Regal, Magnificent work.

The said Crate is accompanied by another, that contains = A Tinplate Tube containing two Drawings on paper that are the instructions for knowing the name of each of the pieces of inlay on the two above-mentioned tables, and a fine Print of Saint Peter and Saint Paul = An Album in paper covers by Juan Bautista Piranesi, 35 *dedos* long, and 26 wide = Another Album in paper covers with 20 fine Prints that depict on various sheets the view of Trajan's Column, 47 *dedos* long, and 31 wide.

F. B. No. 2.

31.@ y 12 lb.

Una Caja, que contiene = Otros dos tableros de marmol labrados, que tiene cada uno 104 embutidos de varias piedras primorosamente labradas, y son tambien raras, y tiene de largo cada tablero 73 dedos, y 38 ½ de ancho; Y le acompaña una Instruccion manuscrita para el conocimiento del nombre de las Piedras de cada uno de dichos embutidos

H. R. H. D. G. No. 6.

1@ y 20 łbras.

Una Caja, que contiene = Una Caja de <u>Flores</u> artificiales, que tiene de largo treinta y ocho dedos, y veinte y siete dedos de ancho.

E. B. No. 1.

11@.

Una Caja, que contiene = Un Quaderno á la brutesca con 40 laminas finas, pintadas al temple, y un quadernillo tambien con varias Laminas, y tiene de largo dho Quaderno 61 dedos, y 41 de ancho = Otro Quaderno con 20 Laminas finas, que tiene de largo 46 dedos, y 33 de ancho, y representan diferentes vasos antiguos, varias Historias, y Piramides = Otro Quaderno de 46 dedos de largo, y 33 de ancho, con 49 folios de Laminas finas, que representan la planta de Roma la antigua, y otras Memorias de Eliodoro = Otro Quaderno del mismo tamaño, que el anterior con 70 Laminas finas, que representan Antigüedades de Roma = Otro Quaderno delmismo tamaño que el anterior, con 69 laminas finas, que representan Roma la antigua, y moderna = Una Cartera, ó Quaderno de 35 dedos de largo, y 25 de ancho, que contiene una Lamina apaysada, y dos Dibuxos = Un Cañon de oja delata, que incluye dos Laminas finas, que representan á Sn. Pedro, y Sn.Pablo, predicando á la Gentilidad = Un Quaderno con 6 Laminas finas de 28 dedos de largo, y 21 de ancho, que representa al Arco de Trajano, y su Descripcion = 120 Quadernos de Musica de varias obras = Una Cajita, que tiene de largo 20 dedos, y 12 de ancho, y contiene <u>Flores</u> artificiales = Un Libro en folio á la brutesca, que trata de Arquitectura = Cinco Libros en 4° á la brutesca desde el 1°. al 5°. Su titulo Opere di Danti Alighieri = Tres tomos en Pasta en 8° . Su titulo Cartas de Madama la Marquesa de Pompadour en Idioma Frances = Dos tomos en vitela en 8°. Su titulo Mercurio errante de la grandeza de Roma antigua, y moderna, en Idioma Italiano = Nueve tomos en 8°. á la brutesca Su titulo Voyage d´un françois en Italie = Un tomo en Pasta en 8°, Su titulo Grammatica Inglesa, y Francesa = Un tomo en Pasta en 8°. Su titulo, Gentleman´s Guide in his tour &ra. = Un tomo en Pasta en 8°. Su titulo nuebo Secretario de Gavinete, en Idioma frances = Dos Libros pequeños de volumen con Estampas, que trata de las Bodas de Paris, y Elena representada en un Vaso

F. B. No. 2.

31. *arrobas* and 12 *libras*.

A Crate, that contains = Another two carved marble tabletops, each with 104 pieces of finely carved inlaid hardstones, these also rare, each tabletop 73 *dedos* and 38 ½ wide; And accompanied by a hand-written Explanation giving information on the name of the Stones of each inlay.

H. R. H. D. G. No. 6.

1 *arrobas* and 20 *libras*.

A Crate, that contains = A Box of artificial Flowers, thirty-eight *dedos* long, and twenty-seven wide.

E. B. No. 1.

11 *arrobas*.

A Crate, that contains = An Album in paper covers with 40 fine prints, painted in tempera, and a small album also with various Prints, this Album 61 *dedos* long, and 41 wide = Another Album with 20 fine Prints, which measures 46 *dedos*, and 33 wide and which depict different antique vases, various Histories, and Pyramids = Another Album of 46 *dedos* long, and 33 wide, with 49 plates of fine Prints, that depict the map of ancient Rome, and others of the Memoirs of Heliodorus = Another Album of the same size as the previous one with 70 fine prints, that depict Antiquities of Rome = Another Album of the same size as the previous one, with 69 fine prints that depict ancient and modern Rome = A Portfolio or Album of 35 *dedos* long, and 25 wide with a horizontal-format Print, and two Drawings = A tinplate Tube containing two fine Prints that depict Saint Peter and Saint Paul preaching to the Gentiles = An Album with 6 fine Prints of 28 *dedos* long, and 21 wide, that depicts the Arch of Trajan, with its Description = 120 Musical Scores of various works = A Small Box, measuring 20 *dedos* long, and 12 wide that contains artificial Flowers = A Book in paper covers, folio, on Architecture = Five Books, quarto, in paper covers from 1 to 5. Entitled Opere di Danti Alighieri = Three volumes with board binding, octavo. Entitled Cartas de Madama la Marquesa de Pompadour in the French Language = Two calf-bound volumes, octavo. Entitled Wandering Mercury of the Grandeur of Ancient and modern Rome, in the Italian Language = Nine volumes, octavo, paper covers, Entitled Voyage d'un françois en Italie = One volume, octavo, with Board binding, entitled English and French Grammar = A volume in board binding, octavo. Entitled Gentleman's Guide in his tour etc. = One volume in board binding, octavo. Entitled New Cabinet Secretary, in the French language = Two small Books with Prints on the Marriage of Paris and Helena represented on an antique Vase = Three volumes in paper covers, octavo. Entitled

antiguo = Tres tomos á la brutesca en 8°. Su titulo Decoverte de la Maison de Campagne d´Horace, en Idioma frances = Un tomo en Vitela en 4°. Su titulo, Flavii Eutropii Breviarium Historiae Romanae, en Idioma latino = Y finalmente 45 Librillos, y Quadernos de varias materias, y distintos Idiomas.

[fol. 193]

E. B. No 1

1@

Una Caja que contiene un pedazo de Madera petrificada.

F. Bt. No 1

14@ y 15 lb.

Una Caja, que contiene = Un Libro en Vitela de 33 dedos de largo, y 24 de ancho, su titulo, Racolta di alcuni disegni del Barberi da Cetto Il Guercino = Otro Libro en Vitela de 34 dedos de largo, y 26 de ancho, su titulo, Antichita di Albano; y di Castel Galndolfo[sic] = Otro Libro en Vitela que tiene 33 dedos de largo, y 25 de ancho, su titulo Opere varie Architettura, perspective groteschi Antichita = Otro libro del mismo tamaño, su titulo, Lapides Capitolini, sive fasti Consulares Triumphales Romanorum = Otro Libro en Vitela, su titulo Divierse[sic] maniere d´Adornare i Camini, y tiene de largo 34 dedos, y 25 de ancho = Quatro Libros en Vitela, que tiene de largo cada uno 32 dedos, y 24 de ancho; que son obras de Juan Bautista Piranesi Arquitecto Beneciano que trata de Antiguedades de Roma &ra. en Idioma Italiano = Dos Quadernos que tratan de las Bodas de Paris, y Elena representadas en un vaso antiguo del Museo del Sor. Tomas Jenkins, Gentil hombre Ingles = Otro Libro en Vitela con 65 Laminas finas tomo 1° = Otro Libro en Vitela con 69 Laminas finas tomo 2° = Otro Libro en Vitela con 93 Laminas finas, que son tres libros, cada uno de 46 dedos de largo, y 33 de ancho, Obras de dho Piranesi, qe. trata de antiguedades de Roma &ra. = Otro Libro en Vitela, que tiene de largo 33 dedos, y 25 de ancho, Obra de dicho Piranesi con Laminas finas, que representan Antigüedades de Roma = Otro libro en Vitela de 34 dedos de largo, y 25 de ancho, obra de dho. Piranesi, que trata de la Magnificencia de Roma, y de la Architectura de los Romanos = Otro Libro en Vitela de 37 dedos de largo, y 25 de ancho, Obra de dho. Piranesi, con 38 Laminas finas, que representan unas á lo Sagrado, y otras á lo profano = Otro de afolio en Vitela, que trata de Geografia de Philippi Cluveri Gedanensis, en Idioma Latino = Tres Tomos en pasta en 8°. Su titulo The Life and Opinion of Tristram, Shandi , Gentleman = Un tomo en pasta en 8°. Su titulo, Voyage en Sicilie, et dans la Grande Grèce = Un tomo en pasta en 8°. Grammatica en Ingles, y Frances = Un tomo en 8°. á la brutesca, Su titulo, Diccionario Geografico, Historico, y Politico de la Suecia = 36 Mapas, Estampas, y Diseños, Sueltos = Y varios tomitos pequeños á la brutesca que tratan de varias materias.

Decoverte de la Maison de Campagne d'Horace, in the French language = One Calf-bound volume, quarto. Entitled Flavii Eutropii Breviarium Historiae Romanae, in the Latin Language = And finally 45 small Books and Notebooks on various subjects and in different languages.

[fol. 193]

E. B. No 1

1 *arroba*

A Crate that contains a piece of fossilised Wood.

F. Bt. No 1

14 *arrobas* and 15 *libras*.

A Crate, that contains = A Calf-bound Book of 33 *dedos* long, and 24 wide, entitled Racolta de alcuni disegni del Barberi da Cetto Il Guercino = Another Calf-bound Book of 34 *dedos* long, and 26 wide, entitled Antichita di Albano; y di Castel Galndolfo = Another calf-bound Book measuring 33 *dedos* long, and 25 wide, entitled Opere varie Architettura, perspective groteschi Antichita = Another book of the same size, entitled Lapides Capitolini, sive fasti Consulares Triumphales Romanorum = Another Calf-bound Book, entitled Divierse maniere d'Adornare i Camini, measuring 34 *dedos* long, and 25 wide = Four Calf-bound Books, each 32 *dedos* long, and 24 wide; which are by works Juan Bautista Piranesi Venetian Architect on the Antiquities of Rome etc., in the Italian Language = Two Albums on the Marriage of Paris and Helen depicted on an antique vase in the Museum of Mr. Tomas Jenkins, English Gentleman = Another Calf-bound Book with 65 Prints, volume 1 = Another Calf-bound Book with 69 fine prints volume 2 = Another Calf-bound Book with 93 fine Prints, comprising three books, each of 46 *dedos* long, and 33 wide, Works of the said Piranesi, on the antiquities of Rome, etc. = Another Calf-bound Book, measuring 33 *dedos* long, and 25 wide, Work of the said Piranesi with fine Prints that depict Antiquities of Rome = Another Calf-bound Book of 34 *dedos* long, and 25 wide, work of the said Piranesi, on the Magnificence of Rome, and the Architecture of the Romans = Another Calf-bound Book of 37 *dedos* long, and 25 wide, Work of the said Piranesi, with 38 fine Prints, some on holy subjects and some on secular ones = Another Calf-bound, folio, on Geography by Philippi Cluveri Gedanensis, in the Latin Language = Three Volumes in board binding, octavo, title The Life and Opinion of Tristram Shandi , Gentleman = A volume in board binding, octavo, entitled Voyage en Sicilie, et dans la Grande Grèce = A volume in board binding, octavo. Grammar in English, and French = A volume in paper covers, octavo, Entitled Geographical, Historical and Political Dictionary of Sweden = 36 Maps, Prints, and Drawings, Loose = And various small volumes in paper covers on various subjects.

Ł. B. No. 1.

6@ y 10 lb

Una Caja, que contiene = Un Quaderno, que trata de las Bodas de Paris, y Elena, representada en un vaso antiguo del Museo del Señor Thomas Jenkins, Gentil hombre Ingles = Otro Quaderno con 12 folios de 28 dedos de largo, y 22 de ancho, Obra del Piranesi, que trata y tiene algunas Laminas finas = Otro Quaderno de 46 dedos de largo, y 34 de ancho Obra de dicho Piranesi con 80 Laminas finas = Otro Quaderno de 49 dedos de largo, y 29 de ancho Obra de dho Piranesi con 54 Laminas finas = Un Libro en Pasta de 28 dedos de largo, y 20 de ancho, su titulo, Veteres Arcus Augustorum Triumphis insignes, Su Autor, Juan Pedro Bellori con laminas finas = Otro libro en Vitela de 26 dedos de largo, y 17 de ancho, que trata de la Columna de Trajano Su Autor Pietro de Santi Bartoli = Otro Libro de afolio en pasta, Su titulo, Le Antiche, Lucerne Sepolcrali figurate, con Laminas finas. Obra del Autor anterior = Otro Libro en vitela de áfolio, Su titulo, Le Pitture Antiche delle Grotte di Roma, é del Sepolcro de Nasoni , con Laminas finas, Su Autor Pietro Santi Bartoli, é Francesco Bartoli suo Figliuoli = Dos tomos en Vitela en 4°. Su titulo, Diccionario en Ingles, y en Italiano. Dos tomos 1°. y 2°. en pasta en 8°. Su titulo, New observation on Italy And in halants, Su Autor By Thomas Nugent L. L. D. = Un tomo en pasta en 8°. Su titulo the complete Italian Master, Su Autor, By Signor Veneroni = Un Quaderno de á medio pliego con 48 Estampas de Antiguedades de Roma = Dos Laminas enrolladas en un palo, de Antigüedades de Roma = Una Cajita con otra dicha dentro que contiene quatro tarritos con conservas al parecer, yá en mal estado; y dentro de la otra Cagita, un Ladrillo con una Inscripción de letras antiguas, y varios paqueticos con antiguedades, y petrificaciones, y tiene de largo, ó en quadro 16 dedos = Otra Cagita, que tiene de largo 16 dedos, y 12 de alto, y contiene un Diseño de Corcho, que demuestra un Edificio arruinado

Ł. H. No. 1.

8@ y 19 lb.

Una Caja, que contiene = Un Quaderno de 42 dedos de largo, y 31 de ancho, con 3 laminas finas, que representan varios Diseños, y planes = Otro quaderno de 46 dedos de largo, y 34 de ancho con 29 Laminas finas que representan varios adornos de Vasos, y Candelabros antiguos = Otro Quaderno de 46 dedos de largo y 32 de ancho, con 54 Laminas finas, que representan varias perspectivas de los Edificios, y Obeliscos de Roma = Una Cagita de 31 dedos de largo y 18 de ancho, que incluye una Venus de Barro, quebrada por el Cuello, y una pierna = Otra Cagita de 35 dedos de largo, y 30 de ancho, que incluye, una Pintura en Lienzo con Marco dorado, que representa á un Joben = Otra Cagita de 32 dedos de largo, y 26 de ancho, que incluye tres Pinturas, la una de la Virgen, y el Niño Dios, y las otras son profanas de Venus, y Diana, al parecer = Ocho tomos en pasta en 8°. su titulo, Oevras[sic] de Moliere, en Idioma frances

Ł. B. [J. B.] No. 1.

6 *arrobas* and 10 *libras*

A Crate, that contains = An Album on the Marriage of Paris, and Helen, depicted on an antique vase in the Museum of Mr Thomas Jenkins, English Gentleman = Another Album with 12 pages of 28 *dedos* long, and 22 wide, Work of Piranesi, that has various fine Prints = Another Album of 46 *dedos* long, and 34 wide Work of said Piranesi with 80 fine Prints = Another Album of 49 *dedos* long, and 29 wide Work of said Piranesi with 54 fine Prints = A Book in Board binding of 28 *dedos* long, and 20 wide, entitled Veteres Arcus Augustorum Triumphis insignes, Its Author, Juan Pedro Bellori with fine prints = Another book bound in Calf of 26 *dedos* long, and 17 wide, on Trajan's Column Its Author Pietro de Santi Bartoli = Another Book in board binding, folio, entitled Le Antiche, Lucerne Sepolcrali figurate, with fine Prints. Same Author as the previous work = Another calf-bound Book, folio, entitled Le Pitture Antiche delle Grotte di Roma, é del Sepolcro de Nasoni, with fine Prints, Its Author Pietro Santi Bartoli, and Francesco Bartoli suo Figliuoli = Two Calf-bound volumes, quarto. Entitled Dictionary in English, and in Italian. Two volumes, 1st and 2nd. Board binding, octavo. Entitled New observation on Italy And in halants , Its Author By Thomas Nugent L. L. D = A volume in board binding, octavo. Entitled the complete Italian Master, Its Author, By Signor Veneroni = An Album of around a *medio pliego* with 48 Prints of Antiquities of Rome = Two rolled Prints on a stick, of Antiquities of Rome = A Small Box with another inside seemingly containing four jars of conserves, now in poor state; and inside the other Small Box, a Brick with an Inscription in ancient letters, and various small packets with antiquities and pieces of lava, 16 *dedos* long or square = Another Small Box, measuring 16 *dedos* long, and 12 high, containing a Cork Model of a ruined Building.

Ł. H. [J. H.] No. 1.

8 *arrobas* and 19 *libras*.

A Crate, that contains = An Album measuring 42 *dedos* long, and 31 wide, with 3 fine prints that depict various Designs, and maps = Another album of 46 *dedos* long, and 34 wide with 29 fine Prints depicting various ornaments of Vases, and antique Candelabra = Another Album of 46 *dedos* long and 32 wide, with 54 fine Prints, that depict various views of the Buildings, and Obelisks of Rome = A Small Box of 31 *dedos* long and 18 wide, that contains a Terra-cotta Venus, broken at the Neck, and a leg = Another Small Box of 35 *dedos* long, and 30 wide, that contains a Painting on Canvas with gilt Frame, that depicts a Young Man = Another Small Box of 32 *dedos* long, and 26 wide, that contains three Paintings, one of the Virgin, and the Christ Child, and the others are secular ones of Venus and Diana, seemingly = Eight volumes in board binding, octavo, entitled Oeuvras de Moliere, in the French Language =

= Tres tomos en pasta en 8°. que tratan Elementos de la Historia, en Idioma Frances por el Abad Millot = Quatro tomos en Pasta en 8°. su titulo, Les trois Siecles de la Literature françoise = Un tomo en pasta en 8°. Grammatica francesa é Inglesa = Otro tomo en pasta en 8° Su titulo Exercises to the Rubes[sic] of constrution, en Idioma frances = Un tomo en pasta en 8° Su titulo. Les Egarmens du Coeur, et de l´Espirit, au Memoire de Mr. de Meilcour, en Idioma frances = Un tomo en pasta en 8°. Su titulo, Utilite des Voyages sur Mer , en Idioma frances = Una porcion de Quadernos de Musica = Y finalmente 36 Quadernos pequeños á la brutesca, de varias materias, y Ydiomas.

[fol. 194]

F. S. B. No. 3.
6@ y 21 lb.

Una Caja, que contiene = Un Libro en Vitela de 46 dedos de largo, y 35 de ancho con Laminas finas que tratan de la Columna de Trajano, y varias Portadas de Edificios de Roma = Otro Libro con 19 Laminas finas, que representan varios pasages dela Sagrada Escritura, y ruinas de edificios de Roma , y tiene de largo 52 dedos, y 42 de ancho = Un Quaderno á la brutesca que tiene de largo 45 dedos, y 32 de ancho, con 25 laminas finas, que representan varios Ornatos = Otro quaderno á la brutesca que tiene de largo 31 dedos, y 24 de ancho, con 28 laminas finas que representan varias Pinturas á lo Oriental = Otro quaderno á la brutesca de 28 dedos de largo y 21 de ancho, con 13 laminas finas que representan el Arco de Trajano por diferentes vistas = Dos muestras de piedras Jaspes de varios embutidos, y tiene cada una de largo 12 dedos, y 8 de ancho = Cinco tomos en Vitela en 4°. que tratan de la Historia civil de Reyno de Napoles, en Idioma Italiano = Seis tomos en Vitela en 4° Su titulo, Opere di Mr.Giovanni de lla[sic] Casa = Un tomo en Vitela de afolio, que trata de las Guerras dela Republica de Florencia dela [sic] Casa de Medicis = Un tomo en pasta en 8°. Diccionario frances, y Aleman = Tres tomos en pasta en 8° Su titulo the Miscellaneoos[sic] Works, en Idioma Ingles = Un tomo de áfolio que trata de la Historia del fenomeno del Vesubio = Un tomo en 4°. viejo, que trata de la Descripcion del Reyno de Napoles = Un tomo en pasta en 8°. viejo, Su titulo, Lista general de las Postas de Francia = Un tomo en 8°. Diccionario frances, y Aleman = Un tomo en 8°. que parece la Biblia Sacra en Idioma Aleman = Cinco tomos a la brutesca, Su titulo, Sceta[sic] di Soneti, e Canzoni = Un tomo á la brutesca su titulo, Chronology or the Historian´s vade-mecum = Dos tomos á la brutesca en 4°. Su titulo Lecion[sic] de Antichita Toscane = Un tomo á la brutesca en 4° Su titulo Historia de los fenomenos del Vesubio, en Idioma frances = Una[sic] Mapa vieja delReyno deFrancia = Un Quaderno que trata de antigüedades = Un Poema Latino, su titulo, la trapola = Un dicho delVesubio de Napoles = Dos Mapas de Genova, = Y finalmente algunos Papeles de Musica sueltos.

Three volumes in board binding, octavo, on Elements of History, in the French Language by the Abbé Millot = Four volumes in Board binding, octavo, entitled, Les trois Siecles de la Literature françoise = A volume in board binding, octavo. Grammatica francesa é inglesa = Another volume in board binding, octavo, entitled Exercises to the Rubes of construction, in the French Language = A volume in board binding, octavo, entitled. Les Egarmens du Coeur, et de l'Esprit, au Memoire de Mr. De Meilcour, in the French Language = A volume in board binding, octavo. Entitled Utilite des Voyages sur Mer, in the French Language = A group of Musical Scores = And finally 36 small Notebooks in paper covers on various subjects, and in various Languages.

[fol. 194]

F. S. B. No. 3.
6 *arrobas* and 21 *libras*.

A Crate, that contains = A Calf-bound Book of 46 *dedos* long, and 35 wide of fine Prints on Trajan's Column, and various Doorways of Buildings in Rome = Another Book with 19 fine Prints that depict various passages from the Holy Scriptures, and ruins of buildings in Rome, measuring 52 *dedos* long, and 42 wide = An Album in paper covers measuring 45 *dedos*, and 32 wide, with 25 fine prints, that depict various Decorative Motifs = Another album in paper covers that measures 31 *dedos* long, and 24 wide, with 28 fine prints that depict various Paintings in the Oriental style = Another album in paper covers of 28 *dedos* long and 21 wide, with 13 fine prints that depict Trajan's Arch from different viewpoints = Two samples of various inlaid Jasper stones, each 12 *dedos* long, and 8 wide = Five Calf-bound volumes, quarto, on the Civil History of the Kingdom of Naples, in the Italian Language = Six Calf-bound volumes, quarto, Entitled, Opere di Mr. Giovanni de lla Casa = A Calf-bound volume, folio, on the Wars of the Republic of Florence of the House of Medici = One volume in board binding, octavo. French dictionary, and German = Three volumes in board binding, octavo, Entitled the Miscellaneoos Works, in the English Language = A volume, folio, of the History of the Phenomenon of Vesuvius = A volume, quarto, old, on the Description of the Kingdom of Naples = A volume in board binding, octavo, old, General List of Coaching Stops in France = A volume, octavo. French dictionary, and German = A volume, octavo, that seems to be the Holy Bible in the German Language = Five volumes in paper covers, Entitled Sceta di Soneti, e Canzoni = One volume in paper covers entitled Chronology or the Historian's vade-mecum = Two volumes in paper covers, quarto. Entitled Lecion de Antichita Toscane = One volume in paper covers, quarto Entitled History of the Phenomena of Vesuvius, in the French Language = One old Map of the Kingdom of France = An Album on antiquities = A Latin Poem, entitled la trapola = Another copy of the above-mentioned book on Vesuvius at Naples = Two Maps of Genoa = And finally various loose pieces of Music

F. B. No. 4.

14@.

Una Caja que contiene = Una <u>Pintura</u> en lienzo que tiene de largo 127 dedos, y 89 de ancho, y representa de Cuerpo entero el Retrato de un Cavallero Joben = Otra <u>Pintura</u> en lienzo, que tiene 55 dedos de largo, y 43 de ancho, de medio Cuerpo, y parece retratado dela anterior, Obras ambas al parecer de Pompeo Batoni = Otra <u>Pintura</u> en lienzo que tiene 134 dedos de alto, y 82 de alto[sic], que representa un Pais; y se nota que esta un poquito averiada = Otra <u>Pintura</u> en lienzo de 43 dedos de largo, y 33 de ancho, que representa á Diana, o alguna otra Diosa, que sale del vaño, sorprehendida de dos Satyros = Un Cañon de Oja de lata, de 33 dedos de largo, que incluye 10 Laminas finas, pintadas al temple.

P. C n. No. 1.

17 @

Una Caja, que contiene = Cinco libros en Vitela, cada uno de 32 dedos de largo, y 25 de ancho, Obra de Juan Bautista Piranesi, con Laminas finas, que trata de la antiguedad Romana = Otros Cinco libros en Vitela, cada uno de 34 dedos de largo, y 28 de ancho, Obra de dho Piranesi, con laminas finas que tratan de Arquitectura, del Campo Marcio, y de Antiguedades de Roma = Tres Libros en Vitela cada uno de 46 dedos de largo, y 32 de ancho ≠ , Obra de dho Piranesi, de los quales uno Con 63 laminas finas, otro con 70 Laminas finas, y el otro con 105 laminas finas, que representan perspectivas, y Antiguedades de Roma = Otro Libro en Vitela del mismo tamaño, que los tres anteriores, obra de dicho Piranesi, con 25 laminas finas, que representan la Columna de Trajano = Otro Libro en Vitela, de 39 dedos de largo, y 27 de ancho, con 42 laminas finas, Obra Amilton, que trata Escuela de la Pintura = Otro libro en Vitela de 33 dedos de largo y 25 de ancho, obra dal Barberi da Cento, detto il Guercino, con 25 laminas finas, qe. representan varios Diseños, y figuras = Otro libro en Vitela de afolio de Marca con laminas finas, Su titulo, Monumenti antichi inediti, da Giovanni Winckelman = Otro Libro en folio de marca con 54 laminas finas, que tratan del Vesubio de Napoles, Obra de Hamilton = Otro Libro ó quaderno de afolio en Italiano, que trata de Observaciones sobre las dichas 54 laminas anteriores = Un Quaderno en folio á la brutesca, Su titulo P. Virgilii Maronis Æneidos libri Sex &ra. = Dos Libros en pasta en 4° de marca Su titulo Diccionario Latino, Italiano, y Frances = Un tomo en pasta en 8°. de marca, Su titulo, Diccionario Geografico en Idioma Ingles = Quatro tomos en pasta en 8°. Su titulo, Historia de Henrrique[sic] de Moreland en Idioma Ingles = Un tomo en pasta en 8°. Su titulo, Descripcion delas Villas deVerlin y Postdam, en Idioma Frances = Un Rollo de 12 laminas, que representan varias perspectivas de Roma = Otro Rollo con tres Laminas que representan los Quadros de Rafael Carracci, y otros = Y finalmente una Cagita de doce dedos de largo, y diez de ancho, que contiene en forma de Obalo de Pio Sexto en Pasta.

F. B. No. 4.

14 *arrobas.*

A Crate containing = A Painting on canvas measuring 127 *dedos*, and 89 wide, that depicts a full-length Portrait of a Young Gentleman = Another painting, on canvas, that measures 55 *dedos* long, and 43 wide, half-length, and seems to be of the same sitter, Both works seemingly by Pompeo Batoni = Another Painting on canvas that measures 134 *dedos* high, and 82 high , and depicts a Landscape; it is observed that it is slightly damaged = Another Painting on canvas of 43 *dedos* long, and 33 wide, that depicts Diana or some other Goddess, emerging from the bath, surprised by two Satyrs = A tinplate Tube of 33 *dedos* long, containing 10 fine Prints, painted in tempera.

P. C n. No. 1.

17 *arrobas*

A Crate, that contains = Five calf-bound books, each 32 *dedos* long, and 25 wide, Work of Juan Bautista Piranesi, with fine Prints, on classical Rome = Another Five Calf-bound books, each 34 *dedos* long, and 28 wide, Work of said Piranesi, with fine prints on Architecture, on the Campo Marzio, and on Antiquities of Rome = Three calf-bound Books each one 46 *dedos* long, and 32 wide, Work of said Piranesi, of which one With 63 fine prints, another with 70 fine Prints, and the other with 105 fine prints, depicting views, and Antiquities of Rome = Another Calf-bound Book of the same size as the three previous ones, work of said Piranesi, with 25 fine prints, that depict Trajan's Column = Another calf, bound Book, of 39 *dedos* long, and 27 wide, with 42 fine prints, Work of Hamilton, on School of Painting = Another Calf-bound book of 33 *dedos* long and 25 wide, work of Barberi da Cento, known as il Guercino, with 25 fine prints that depict various Designs, and figures = Another Calf-bound book, *folio de marca*, with fine prints, Entitled Monumenti antichi inediti, da Giovanni Winckelman = Another Book, *folio de marca*, with 54 fine prints, on the Vesuvius at Naples, Work of Hamilton = Another Book or Album, folio, in Italian, of Observations on the above-mentioned 54 prints = An Album in paper covers, folio, Entitled P. Virgili Maronis Aeneidos libri Sex etc., = Two Books in board binding, *quarto de marca*, Entitled Latin, Italian and French Dictionary = A volume in board binding, *octavo de marca*, Entitled Geographical Dictionary, in the English Language = Four volumes in board binding, octavo. Entitled History of Henry of Moreland, in the English Language = A volume in board binding, octavo. Entitled Description of the Cities of Berlin and Postdam , in the French Language = A Roll of 12 prints, that depict various views of Rome = Another Roll with three Prints that depict the Paintings of Rafael Carracci, and others = And finally a Small Box of twelve *dedos* long, and ten wide, that contains an Oval portrait of Pope Pius VI in Paste.

E. D. No. 2.
9@ y 10 lb.

Una Caja que contiene = Una Cajita de 19 dedos de largo, y 12 de ancho, que incluye una Serie de Medallas antiguas grabadas en pasta encarnadas = Otra Cajita de 37 dedos de largo, y 29 de ancho, que incluye un Retrato de Muger, pintada en papel = Una Pintura en lienzo con marco dorado de 19 dedos en quadro, con Cristal, que representa á laVirgen, el Niño, y Sn. Juan = Dos Quadernos á la brutesca de 27 dedos de largo, y 19 de ancho su titulo Campi Phlegraei observations on the volcanos of the two Sicilies &ra. = Otro Quaderno á la brutesca de 47 dedos de largo, y 32 de ancho, con 12 Mapas, y laminas = Otro Quaderno á la brutesca, de 44 dedos largo, y 37 de ancho, con 77 folios, y laminas finas que representan varios Diseños, Dibujos, y Perspectivas = Otro Quaderno, á la brutesca, con 28 Laminas, Obra de Polidoro grabadas por Carabagio = Otro Quaderno á la brutesca de 37 dedos de largo, y 25 de ancho, con 24 laminas finas que representan Roma la Antigua = Otro Quaderno á la brutesca de 45 dedos de largo, y 35 de ancho, con 28 laminas finas, que representan diferentes perspectivas de Roma y Planes de Edificios = Otro Quaderno á la brutesca de 33 dedos de largo y 25 de ancho, con 33 laminas finas, Obra de Salvador Rosa = Otro Quaderno á la brutesca de 46 de largo, y 33 de ancho con 34 laminas finas, que representan varias Imagenes de Santos, y modelo de diferentes figuras = Otro Quaderno á la brutesca de 44 dedos de largo, y 37 de ancho, con 46 laminas finas que representan, diferentes adornos, y figuras de Historia = Una Cagita de 31 dedos de largo, y 19 de ancho, qe. incluye Flores artificiales = Otra Cajita que incluye dos Retratos de Miniatura, pintados en Papel en dos Obalos = Otra Cagita que incluye un papel pintado un Volcan = Un Paquetico con varias petrificaciones = Dos Libros en Vitela de áfolio, Su titulo P. Terentii Afri Comedie = Otros dos tomos de afolio en pasta de tafilete, Su titulo, La Gerusalem libertada, de Torquato Taso, en Idioma Italiano, = Un tomo en Vitela en 4º Su titulo, Il Riposo di Rafaello Borchini, en Idioma Italiano = Otro tomo en Vitela en 4º Su titulo, Della Lingua Toscan[sic], di Bedello Buonmattes, en Ydioma Italiano = Un tomo en Vitela en 8º. Su titulo Regole per la toscana favella = Otro tomo en Vitela en 8º. Su titulo, Mercurio errante de la grandeza de Roma la Antigua, y Moderna = Otro tomo en pasta en 8º. Su titulo Grammatica Italiana = Otro tomo en pasta en 8º. Su titulo, Historia de Italia en dicho Idioma = Otro tomo en pasta en 8º. Su titulo, Observations on Mount Vesubius, Mount Etna, en Idioma Ingles = Otro tomo en pasta en 8º. Su titulo, Grammatica de la Lengua Inglesa, é Italiana = Tres tomos el 3º. 5º. y 6º. en pasta en 8º. Su titulo, Voyage d´un françois en Italie, en Idioma Frances = Nuebe tomos en pasta en 8º. Su titulo, Le Comedie del Doctor Carlos Goldoni, en Idioma Italiano = Dos tomos en pasta en 8º. de marca Su titulo, Histoire de l´Art chez les Anciens = Un Quaderno á la brutesca en folio, Su titulo, Le Antiche Camere delle terme di Tito, elle loro Pitture &ra.

E. D. No. 2.
9 *arrobas* and 10 *libras*.

A Crate, that contains = A Small Box measuring 19 *dedos* long, and 12 wide, which contains a Series of classical Medallions engraved on red paste = Another Small Box measuring 37 *dedos* long, and 29 wide, that contains a Portrait of a Woman, painted on paper = A Painting on canvas in a gilt frame of 19 *dedos* square, with Glass, that represents the Virgin, the Infant Christ and Saint John = Two Albums with paper covers of 27 *dedos* long, and 19 wide entitled Campi Phlegraei observations on the volcanoes of the two Sicilies etc., = Another Album in paper covers of 47 *dedos* long, and 32 wide, with 12 Maps, and prints = Another Album in paper covers, of 44 *dedos* long, and 37 wide, with 77 pages and fine prints that depict various Designs, Drawings and Views = Another Album in paper covers, with 28 Prints, Work of Polidoro engraved by Caravaggio = Another Album in paper covers of 37 *dedos* long, and 25 wide, with 24 fine prints that depict Classical Rome = Another Album in paper covers of 45 *dedos* long, and 35 wide, with 28 fine prints that depict different views of Rome and Plans of Buildings = Another Album in paper covers of 33 *dedos* long and 25 wide, with 33 fine prints, Work of Salvator Rosa = Another Album in paper covers of 46 long, and 33 wide with 34 fine prints, that depict various Images of Saints, and model of different figures = Another Album in paper covers of 44 *dedos* long, and 37 wide, with 46 fine prints that depict different ornaments, and figures of History = A Small Box of 31 *dedos* long, and 19 wide, that contains artificial Flowers = Another Small Box that has two Miniature Portraits, painted on Paper, both Ovals = Another Small Box with a painting on paper of a Volcano = A Small Package with various pieces of lava = Two Calf-bound Books, folio, Entitled P. Terentii Afri Comedie = Another two volumes in morocco boards, Entitled La Gerusalem libertada , by Torquato Taso, in the Italian Language = A Calf-bound volume, quarto, entitled El Riposo di Rafaello Borchini, in the Italian Language = Another Calf-bound volume, quarto, Entitled Della Lingua Toscan , by Bedello Buonmattes, in the Italian Language = A Calf-bound volume, octavo. Entitled Regole per la toscana favella = Another Calf-bound volume, octavo. Entitled Wandering Mercury of the grandeur of Ancient and Modern Rome = Another volume in board binding, octavo. Entitled Grammatica Italiana = Another volume in board binding, octavo. Entitled History of Italy in that Language = Another volume in board binding, octavo. Entitled Observations on Mount Vesuvius, Mount Etna, in the English Language = Another volume in board binding, octavo. Entitled Grammar of the English and Italian Language = Three volumes, the 3rd, 5th and 6th in board binding, octavo. Entitled Voyage d'un françois en Italie, in the French Language = Nine volumes in board binding, octavo. Entitled Le Comedie del Doctor Carlos Goldoni, in the Italian Language = Two volumes in board binding, *octavo de marca* Entitled Histoire de l'Art chez les Anciens = An Album in paper

= Doce tomos á la brutesca en 4° Su titulo, Serie de los hombres mas ilustres en la Pintura, Escultura, y Arquitectura, en Idioma Italiano = Un Libro á la brutesca, Su titulo, vita de Benvenuto Cellini = Un Cañon de Oja de lata, con tres Laminas finas = Yfinalmente 16 Libretillos, y Quadernos pequeños, de varias materias, y distintos Idiomas.

E. Sr. No. 1.

3@ y 10. lb.

Una Caja, que contiene = Dos Cagitas de <u>Flores</u> artificiales, cada una de 29 dedos de largo, y 19 de ancho = Una Cagita pequeña con dos Frasquitos de Piñones confitados = Y finalmente 12 vidrios de Licor.

R. Uy. No. 1.

5.@ y 13 lb.

Una Caja, que contiene = Una Caja de <u>flores</u> Artificiales, y tiene de largo 41 dedos y 27 de ancho = Un Cañon de oja delata con 12 Laminas = Un Paquete enrollado con otras 12 Laminas finas de Colores = Otro Paquete enrollado con 16 Laminas finas, que representan varias Pinturas = Otro Paquete enrollado con 14 Laminas finas, que representan varias Pinturas = Otro Paquete enrollado con 60 Laminas finas = Otro Paquete con 36 Laminas finas = Y un Libro viejo, que trata de la Literatura Italiana.

G. M. No. 1.

1@. y 20. lb.

Una Caja que contiene = Dos <u>Pinturas</u> en dos obalos de madera de 22 dedos de largo, 18 de ancho, que representan el Origen de la Pintura = Dos Quadernos á la brutesca de 38 dedos de largo, y 28 de ancho cada uno, y con 40 Laminas finas cada uno, su titulo Escuela de la Pintura en Idioma Italiano = Un Paquete enrollado con 11 laminas de varias Imagenes = Otro dho con otras 11 laminas finas Como el anterior = Dos Paquetes enrollados, cada uno con dos laminas finas, que representan á Apolo, y las Ninfas en Carro triunfal.

1@ y 18 lbs.

Una Caja, que contiene = Un Quaderno á la brutesca de 48 dedos de largo, y 37 de ancho, con 24 laminas finas, que representan varias perspectivas de templos y Edificios de Roma arruinados, están pintadas al temple muy primorosas.

covers, folio, Entitled Le Antiche Camere delle terme di Tito, elle loro Pitture etc., = Twelve volumes in paper covers, quarto, Entitled Series of the most illustrious men in Painting, Sculpture and Architecture, in the Italian Language = A Book in paper covers, Entitled vita de Benvenuto Cellini = A Tin-plate Tube containing three fine Prints = And finally 16 small Books, and small Notebooks on various subjects and in different languages.

E. Sr. No. 1.

3 *arrobas* and 10. *libras*.

A Crate, that contains = Two Small Boxes of artificial Flowers, each of 29 *dedos* long, and 19 wide = A Small Box with two small bottles of sugared Pine Nuts = And finally 12 bottles of Liqueur.

R. Uy. No. 1.

5. *arrobas* and 13 *libras*.

A Crate, that contains = A Box of Artificial flowers, measuring 41 *dedos* long and 27 wide = A tin-plate Tube containing 12 Prints = A rolled up Packet with another 12 fine, hand-coloured Prints = Another rolled-up Packet with 16 fine prints, that depict various Paintings = Another rolled-up Packet with 14 fine Prints, that depict various Paintings = Another rolled-up Packet with 60 fine Prints = Another Packet with 36 fine Prints = And an old Book on Italian Literature.

G. M. No. 1.

1 *arroba* and 20. *libras*.

A Crate, that contains = Two Paintings in two oval wooden frames of 22 *dedos* long, 18 wide, that depict the Origin of Painting = Two Albums in paper covers of 38 *dedos* long, and 28 wide each, each with 40 fine Prints, entitled School of Painting in the Italian Language = A rolled-up Packet with 11 prints of various Images = Another the same with 11 fine prints Like the previous one = Two rolled-up Packets, each with two fine prints, that depict Apollo, and the Nymphs on a triumphal Chariot.

1 *arroba* and 18 *libras*.

A Crate, that contains = An Album in paper covers of 48 *dedos* long, and 37 wide, with 24 fine prints, that depict various views of ruined temples and Buildings in Rome, very finely painted in tempera.

1@ y 13 lb.

Una Caja, que contiene = Una Caja de <u>Flores</u> artificiales, que tiene de largo 41 dedos, y 28 de ancho.

W. D.
20. lb.

Un Paquete que contiene dos Libros sin enquadernar con varias Laminas, que trata de las Ciencias, y Artes

Ł. S. No. 10
nó vá.

Una Cagita que contiene = El tomo 11°. de afolio de marca con varias Laminas que trata como el anterior, pero se nota que está todo manchado de azeyte.

Ł. G. No. 1.
14@ y 17 lb.

Una caja que contiene = Una <u>Pintura</u> en Lienzo de 58 dedos de largo, y 42 de ancho que representa al Señor S.n Pedro Penitente, que parece Copia de Rafael Carraci = Otra <u>Pintura</u> en Lienzo de 43 dedos de largo, y 41 de ancho que representa á laVirgen, el Niño Jesús, y S.n Juan, tambien parece Copia de dho Rafael = Otra <u>Pintura</u> en Lienzo de 38 dedos de largo, y 32 de ancho, que representa á Sta. Maria Magdalena = Otra <u>Pintura</u> en Lienzo de 70 dedos de largo, y 54 de ancho, que representa á la Musica = Otra <u>Pintura</u> de 99 dedos de largo, y 80 de ancho que representa á la Victoria, ó a la Fortuna = Otra <u>Pintura</u> de 78 dedos de largo, y 57 de ancho, que representa, en lienzo, la Sibila Persica = Otra <u>Pintura</u> en lienzo de 58 dedos de largo, y 113 de ancho, que representa á Apolo en Carro triunfal con algunas Diosas ó Ninfas = Otra <u>Pintura</u> en lienzo de 68 dedos de largo, y 104 de ancho, que representa Diosas del Gentilismo = Dos <u>Pinturas</u> en lienzo con marcos dorados de 46 dedos de largo, y 40 de ancho, que representan á la Magdalena = Y finalmente un Quaderno á la brutesca con 58 laminas finas, que representan varios pavimentos, y ornatos y tiene 44 dedos de largo y 37 de ancho.

[fol. 196]

L. D. No. 1. *
parece del Cavallero Conca 4@ y 20 lb.

Una Caja, que contiene = Una Pintura en lienzo de 27 dedos de largo, y 24 de ancho que representa, á la Virgen, el Niño, y el Señor

1 *arroba* and 13 *libras*.

A Crate, that contains = A Box of artificial Flowers, measuring 41 *dedos* long, and 28 wide.

W. D.
20. *libras*.

A Packet that contains two unbound Books containing various Prints, on the Sciences, and Arts.

Ł. S. [J. S.] No. 10
not to be sent.

A Small Box that contains = Volume 11, *folio de marca*, with various Prints on the same subject as the previous one, but it is observed that it is completely stained with oil.

Ł. G. [J. G.] No. 1.
14 *arrobas* and 17 *libras*.

A Crate that contains = A Painting on Canvas of 58 *dedos* long, and 42 wide that depicts The Penitent Saint Peter, which seems to be a Copy of Rafael Carraci = Another Painting on Canvas of 43 *dedos* long, and 41 wide that depicts the Virgin, the Infant Christ, and Saint John, also seemingly a Copy of said Rafael = Another Painting on Canvas of 38 *dedos* long, and 32 wide, that depicts Saint Mary Magadalen = Another Painting on Canvas of 70 *dedos* long, and 54 wide, that depicts Music = Another Painting of 99 *dedos* long, and 80 wide that depicts Victory, or Fortune = Another Painting of 78 *dedos* long, and 57 wide, that depicts, on canvas, the Persian Sibyl = Another Painting on canvas of 58 *dedos* long, and 113 wide, that depicts Apollo in a triumphal Chariot with various Goddesses or Nymphs = Another Painting on canvas of 68 *dedos* long, and 104 wide, that depicts Pagan Goddesses = Two Paintings on canvas with gilt frames of 46 *dedos* long, and 40 wide, that depict the Magdalen = And finally an Album in soft covers with 58 fine prints, that depict various floors, and ornaments and which measures 44 *dedos* long and 37 wide.

[fol. 196]

L. D. No. 1. *
seemingly by Mr Conca 4 *arrobas* and 20 *libras*.

A Crate, that contains = A Painting on canvas of 27 *dedos* long, and 24 wide that depicts the Virgin and Child and Saint Joseph =

San Josef = Otra Pintura en lienzo del mismo tamaño que la anterior, y representa á la Virgen, al Niño, y al Señor San Franco. De Asis = Otra Pintura en lienzo del mismo tamaño que el anterior, y representa a Sta. Maria Magdalena, Penitente, y parecen de Lucas Jordan = Otra Pintura en Lienzo del mismo tamaño, que la anterior, que representa á la Virgen, el Niño y Sn. Juan * = Otra Pintura en lienzo de 45 dedos de largo, y 42 de ancho, que representa tambien á la Virgen, el Niño, y Sn. Juan, parece Copia de Rafael Carraci = Dos Quadernos á la brutesca de 46 dedos de largo, y 32 de ancho cada uno, y uno con 70 Laminas, y el otro con 90 dichas, todas finas, que representan varias perspectivas de Edificios, y ruinas de Roma = Otro Quaderno á la brutesca de 38 dedos de largo, y 27 de ancho con 39 laminas finas, Su titulo Escuela dela Pintura por el Cavallero Hamilton = Y finalmente dos laminas rotas en un rollo.

W. A. F. N. 1.
12@.

Una caja, que contiene = Una Pintura en lienzo que representa á Apolo en Carro triunfal con varias Ninfas, y tiene de largo 45 dedos y 75 deancho = Otra Pintura en lienzo de 78 dedos de largo, y 53 de ancho, que representa una Diosa al salir del Baño, sorprehendida de dos Satyros = Otra Pintura en lienzo de 78 dedos de largo, y 54 de ancho, querepresenta algunas Diosas, una de ellas con Corona en la Cabeza atando una venda á un Cupidillo, y otro Cupidillo que está por detras de la Diosa como burlandose = Otra Pintura en lienzo, de 54 dedos de largo, y 79 de ancho, que representa al Sor. Sn. Miguel = Otra Pintura en lienzo del mismo tamaño que la anterior, que representa a una Matrona con un Niño Sentado Sobre Sus rodillas, que parecen á Jesús, y Su Madre laVirgen Maria = Dos Pinturas en lienzo, del mismo tamaño que la anterior, que ambas representan varios Paises = Otras Dos Pinturas en lienzo de 22 dedos de largo y 28 de ancho que tambien representan varios Paises = Y finalmente Otra Pintura en lienzo de 110 dedos de ancho, y 66 de alto que representa otro Pais.

E L. D. No. 2.
5@ y 13. lb.

Una Caja, que contiene = Una Pintura en lienzo de 79 dedos de largo, y 57 de ancho que representa el Retrato de un Cavallero de Cuerpo entero, sentado sobre un Sillon, Obra de Pompeo Batoni = Otra Pintura en papel de 39 dedos de largo, y 33 de ancho, que representa una Sibila = Un Quaderno de Musica enquadernado en vitela, y dorado.

Another Painting of the same size as the previous one, depicting the Virgin, the Infant Christ and Saint Francis of Assisi = Another Painting on canvas of the same size as the previous one, depicting Saint Mary Magdalen, Penitent, and seems to be by Luca Giordano = Another Painting on Canvas of the same size as the previous one, that depicts the Virgin, the Christ Child and Saint John * = Another Painting on canvas of 45 *dedos* long, and 42 wide, that also depicts the Virgin, the Christ Child and Saint John, seemingly a Copy of Rafael Carraci = Two Albums in paper covers of 46 *dedos* long, and 32 wide each, one with 70 Prints, the other with 90, all fine, depicting various views of Buildings, and ruins of Rome = Another Album in paper covers of 38 *dedos* long, and 27 wide with 39 fine prints, Entitled School of Painting by Hamilton = and finally two torn prints in a roll.

W. A. F. N. 1.
12 *arrobas*.

A Crate, that contains = A Painting on canvas that depicts Apollo in a triumphal Chariot with various Nymphs, measuring 45 *dedos* long and 75 wide = Another Painting on canvas of 78 *dedos* long, and 53 wide, that depicts a Goddess emerging from the Bath, surprised by two Satyrs = Another Painting on canvas on 78 *dedos* long, and 54 wide, that depicts various Goddesses, one of them with a Crown on her Head tying a blindfold on a little Cupid, and another little Cupid behind the Goddess as if making fun of them = Another Painting on canvas, of 54 *dedos* long, and 79 wide, that depicts Saint Michael = Another Painting on canvas of the same size as the previous one, that depicts a Matron with a Child Seated On Her knees, who seem to be Jesus and his Mother the Virgin Mary = Two Paintings on canvas, of the same size as the previous one, both depicting various Landscapes = Another Two Paintings on canvas of 22 *dedos* long and 28 wide that also depict various Landscapes = And finally Another Painting on canvas of 110 *dedos* wide, and 66 high that depicts another Landscape.

E L. D. No. 2.
5 *arrobas* and 13. *libras*.

A Crate, that contains = A Painting on canvas of 79 *dedos* long, and 57 wide that depicts a Portrait of a Gentleman, Full-length, seated in an Armchair, Work of Pompeo Batoni = Another Painting on paper of 39 *dedos* long, and 33 wide, that depicts a Sibyl = A Musical Score bound in calf, and gilt.

I. M. No. 4.
5.@. y 13 lb.

Una caja que contiene = Una <u>Pintura</u> en Lienzo de 68 dedos de largo, y 51 de ancho, que representa la Musica = Dos <u>Pinturas</u>, en todo iguales, de 73 dedos de largo, y 59 de ancho, que representan cada una tres taures, ó Jugadores, jugando Naipes que los dos están engañando al otro.

A Ry. No 1
4@ y 15 libras

Una Caja que contiene = Dos <u>Pinturas</u> en lienzo de 73 dedos de largo, y 58 de ancho que cada una representa un Pais.

W. Ce. No. 1.
2@ y 2 libras

Una Caja que contiene = Una <u>Pintura</u> en lienzo de 58 dedos de largo, y 43 de ancho, qe. representa el Retrato de una Señora con un Perrito en los brazos.

T. H. D. No 7
55@.

Una Caja que contiene = Un Pedestal de Marmol, que segun dicen, incluye el Cuerpo de un Santo Martir, y no se há tocado Mr. Vest. London.

nó vá.

Una Caja que contiene tres Belones desarmados

nó vá.

Un Violón en su Estuche, quela puente la tiene dentro, y tiene dho. Estuche de largo 62 dedos, y 25 de ancho.

nó vá.

Un Baul, ó Caja, que contiene 169 Quadernos de Musica de los quales 128 sueltos, y 37 con tapa, y forros = Un fusil desarmado, sin llabe = Y dos Cuchillos, y dos tenedores de puño de plata, y otro Cuchillo con puño dehasta de Ciervo.

I. M. No. 4.
5. *arrobas* and 13 *libras*.

A Crate that contains = A Painting on Canvas of 68 *dedos* long, and 51 wide, that depicts Music = Two Paintings, exactly the same, of 73 *dedos* long, and 59 wide, that both depict three Players, playing Cards in which two are cheating the other.

A Ry. No 1
4 *arrobas* and 15 *libras*

A Crate that contains = Two Paintings on canvas of 73 *dedos* long, and 58 wide, of which each depicts a Landscape.

W. Ce. No. 1.
2 *arrobas* and 2 *libras*

A Crate that contains = A Painting on canvas of 58 *dedos* long, and 43 wide, that depicts a Portrait of a Lady with a Small Dog in her arms.

T. H. D. No 7
55 *arrobas*.

A Crate that contains = A Marble Pedestal, that according to what is said contains the Body of a Martyr Saint, and has not been opened Mr. Vest. London.

Not to be sent.

A Box that contains three dismounted Oil Lamps.

Not to be sent.

A Violin in its Crate, with the bridge inside, the said Crate measuring 62 *dedos* long, and 25 wide.

Not to be sent.

A Chest, or Box, that contains 169 Musical Scores of which 128 are loose, and 37 with cover and flypapers = A dismantled gun, without its key = And two Knifes, and two forks with silver handles, and another Knife with a handle of Deer horn.

no vá

Un fusil desarmado en Su Estuche, que tiene este de largo, 60 dedos, y 12 de ancho.

H. **E. No. 1.**

29 @ y 12 lbs.

Una caja que contiene = dos repisas de hieso, cada una como de una vara de alto, y están compuestas de varias piezas delmismo Yeso unido, y fajado con un Cordel = Y dos Bustos deBarro, cada uno como dos tercias de vara de alto, y representan demedio Cuerpo dos Personages de hombre y Muger.

M. G. No. 1.

con 12 @ y 23 lb.

Una caja que contiene = Dos Bustos de Medio Cuerpo de Yeso, cada uno cerca de una Vara de alto, que uno de ellos está averiado = Otro Busto de barro de medio Cuerpo, que tiene dos tercias de vara alto. Y se hecho al Escombro otro Busto de Yeso, que se encontro hecho muchos pedazos.

con 14 @ y 12 lb.

Una Caja, que contiene = Un Busto de Yeso de medio Cuerpo, en su funda tambien de Yeso de varias piezas, y tiene como una vara de alto = Otro Busto tambien de Yeso de medio cuerpo, que está algo quebrado, y és del mismo tamaño que el anterior = Y finalmente otro Busto, de medio Cuerpo, de barro, que también está quebrado, pero se puede pegar la pieza quebrada, Y se nota qe. assi este como de los demas Bustos de esta Caja, y de las otras dos anteriores quasi todos están algo quebrados poco, ó mucho, que parecen modelos, y otros sabran darle mas estimación, que lo que representan.

MEDICnas.

nó vá.

Una Cagita con Medicinas, ya viejas, en varios vidritos, y paquetes, cuya Cagita és como de tres quartas de vara.

nó vá.

Una Cagita, que contiene = Un freno, Dos Cinchas maestras, y dos Correas para estribos, arreo de Caballo = Un par de botas, y otro par de dichas estas estas de á media pierna, ya rotas = Un par de Zapatos

Not to be sent.

A dismantled gun in Its Crate, the latter measuring 60 *dedos* long, and 12 wide.

H. **E. No. 1.**

29 *arrobas* and 12 *libras*.

A case that contains = two gesso brackets, each around one *vara* high, made up of various pieces of the same Gesso joined together and bound around with a Cord = And two Terra-cotta Busts, each one around two thirds of a *vara* high, depicting A Man and a Woman in half-length.

M. G. No. 1.

weighing 12 *arrobas* and 23 *libras*.

A case that contains = Two Half-length Gesso Busts, each of around one *Vara* high, one of them damaged = Another Half-length terra-cotta Bust, measuring two thirds of a *vara* high. A Gesso Bust has been thrown away, having been found in numerous pieces.

weighing 14 *arrobas* and 12 *libras*.

A Crate, that contains = A half-length Gesso Bust, in its case also of Gesso of various pieces, measuring around one *vara* high = Another bust also of Gesso in half-length that is rather broken, and is of the same size as the previous one = And finally another Bust, of Half-length, of terra-cotta, that is also broken, but the broken piece can be stuck back on, And it is observed that the other Busts in the Crate, and those in the other two previous ones are almost all slightly or very broken, they seem to be models, others will have a better idea of what they depict.

MEDICINES.

not to be sent

A small Box of Medicines, old, in various glass flasks, and packets, the Box measuring around three quarters of a *vara*.

Not to be sent.

A Small Box, that contains = A bridle, Two Girths, and two Leather Straps for stirrups, Horse harness = A pair of boots, and another pair of the same, half-length, broken = A pair of good Shoes, and a

buenos, y una maletica pequeña, y se nota que la dicha Cagita es muy bieja, desclavada, y descompuesta.

small suitcase, it is observed that the said Small Box is very old, lacking nails and falling apart.

no ván.

Not being sent.

Veinte y una Piedra de Marmol en bruto, que están sobre el Muelle viejo del Puerto de esta Ciudad de Malaga, todas de mucha magnitud.

Twenty-one Pieces of uncarved Marble, which are on the Quayside of the Port of this City of Malaga, all very large.

Concuerda esta Relacion Copia con la remitida á Madrid á los Directores de la Compañia de Longistas en 1º. de Julio del presente año de1783, de cuya orden se reconocieron los arriba referidos efectos. Y se nota, que se hizo con todo cuidado, y diligencia posible, tratandolo todo con delicadez, por no causarles averios; y por esta causa nó será estraño Se encuentre alguna alteracion accidental. La que se há notado en el tiempo, que se han acondicio-nado, para remitir á Madrid de Orden Superior, Se anotara aqui, y es asaber =

This List is a Copy of the one sent to Madrid to the Directors of the Compañía de Lonjistas on 1 July of this year 1783, on whose order the above-mentioned items were inspected. It is noted that it was done with the utmost care and all possible diligence, treating everything with extreme care so as not to cause damages; and for this reason it will not be surprising to find the occasional accidental change of place. The one that was noted at the time, when the items were made ready for transport to Madrid in accordance with the Royal Order, will be noted here, namely =

[fol. 197]
Nota = En la Caja que tiene la marca W. A. F. No.1. Dice *la 3a. Pintura en lienzo, de 78 dedos de largo, y 54 de ancho, que representa algunas Diosas, una de ellas con una Corona en la Cabeza........* y acaba, *como burlándose.* Esta Pintura está puesta por equivocación en la dha. Caja, y se previene, que no está en ella, pero se encontrara entre las Pinturas de Caja marca Ⅎ. G. No. 1. Nota, que en la Caja delaMarca Ⅎ. S. No. 2 Se hallaron más dos Piezecitas de Marmol labrado, que tiene cada una 9 dedos de largo, 7 de ancho, y 7 de alto = PO. Quintín, Galwey, y Obrien. =

[fol. 197]
Note = In the Crate marked W. A. F. No. 1. It says "the 3rd Painting on canvas, of 78 *dedos* long, and 54 wide, that depicts various Goddesses, one of them with a Crown on her head [. . .] as if making fun of them." This Painting has been wrongly listed in the said Crate, but it is to be noted that it is not in it, and will be found among the Paintings of the Crate marked J. G. No. 1. Note that in the Crate marked J. S. No. 2 two more small Pieces of carved Marble were found, each one 9 *dedos* long, 7 wide, and 7 high = By order of Quintin, Galwey, and Obrien. =

Appendix 2

Antonio Ponz, Catalogue of the Books, Prints, Oil Paintings, Sculptures, and Other Curiosities That Came in Two Consignments to the Real Academia de Bellas Artes de San Fernando in Madrid by Order of José Moñino y Redondo, conde de Floridablanca, April 1784, Real Academia de Bellas Artes de San Fernando, Archivo-Biblioteca, 4-87-1-26 (cat. 14)

[fol. 1]

Catalogo de los libros estampas, y otros papeles que vinieron en la segunda remesa de los caxones, mandados depositar en la Acad.a de S. Fern.do de or.n del Ex.mo Sr. Conde de Floridablanca

Caxon ‡ B.

/ Pitture antiche delle Grotte di Roma, Libro di Gian Pietro Bellori, con estampas de Santibartoli. fol°.
/ Veteres Arcus Augustorum del mismo Autor. fol°
/ Le antiche lucerne sepolchrali, del mismo. fol°.
/ Setenta y nueve estampas con cubiertas de carton de las antiguedades de Roma de Piranesi, y otras fol. grande.
/ Quaderno mas pequeño con 47. estampas de varios tamaños, y Autores.
/ Otro con estampas que representan vistas, y paises grabados de agua fuerte.
/ Estampa grabada por Volpato dela Escuela de Atenas, y un retrato del Papa
/ Quaderno en folio con ocho estampas de Noli, y son del Arco de Trajano de Benevento
/ Le Nozze di Paride, et d'Elena, rapresentate in un vaso antico – Quaderno de pocas ojas. fol°.
/ Descrizione del Emisario del Lago Albano con diez estampas por Piranesi
/ Dos tomos ingleses en 8°. observaciones en Ytalia
/ Diccionario Ytaliano, è Ingles – dos tomos-quarto
/ Gramatica Ynglesa, è Ytaliana – 8°.

Caxon. I H.

/ Vistas de Roma de Piranesi – son cincuenta y quatro estampas grandes
/ Otras treinta y nueve estampas del mismo, que representan, vasos, ornatos & Una cartera con dos plantas de las Termas de Caracala, y de Diocleciano, y de dos Vistas del Vesuvio, y de una

[fol. 1]

Catalogue of the books, prints and other papers that came in the second consignment of crates sent to be deposited at the Academia de San Fernando on the orders of His Excellency the Count of Floridablanca

Crate ‡ B. [J B.]

/ Pitture antiche delle Grotte di Roma, Libro di Gian Pietro Bellori, with prints by Santibartoli. folio
/ Veteres Arcus Augustorum by the same author, folio
/ Le antiche lucerne sepolchrali, by the same author, folio
/ Seventy-nine prints with cardboard binding of the antiquities of Rome by Piranesi, and other prints. Large folio.
/ Smaller album with 47 prints of various sizes by various Artists.
/ Another album with prints of views, and etchings of landscapes.
/ Print engraved by Volpato of the School of Athens, and a portrait of the Pope
/ Album, folio, with eight prints by Noli, which depict the Arch of Trajan in Benevento
/ The Nozze di Paride, et d'Elena, rapresentate in un vaso antico – Album of a few pages, folio
/ Description of the Emissary of Lake Albano with ten prints by Piranesi
/ Two English volumes, observations in Italy, octavo
/ Italian dictionary, and English. – two volumes – quarto
/ English grammar, and Italian – octavo

Crate I H.

/ Views of Rome by Piranesi – numbering fifty-four large prints
/ Another thirty-nine prints by the same artist, depicting vases, ornaments and A Portfolio with two plans of the Baths of Caracalla, and of Diocletian, and two Views of Vesuvius, and a ruin, painted in washes.*

ruina, pintadas de aguadas. *
/ Un legajo de papeles, y quadernos de Musica
/ Una porcion de libritos los mas de ellos enquadernados en papel,
de composiciones Teatrales y son: la Pupilla, il Padre per amore,
comedias de Goldoni, la imposta scoperta, la Hosteria magra, La
Aminta del Taso, y los Horacios
/ El quinto tomo delas operas de Metast°. y una intitulada

[fol. 2]
/ La Olimpiade: expectaculos delas ferias de Paris; otro expectaculo
de los Teatros de Paris
/ Medonte Ré d'Epiro. Dramma – 8. y 12°.
/ Analise de la Carte dela Mer Mediterranee qt°.
/ Parfait ouvrage sur la coëffeure – 8°
/ Novelles provabilites en fait de Justice 8°.
/ Scelta de Canzoni, è Sonetti 2. tom. 8°.
/ Apelles et Campaspe – quaderno en quarto
/ Le Rime del Petrarca – 8°
/ Poesie burlesche del Berni 8°
/ Poesie scelte 8
/ Amusement de Loisir des Dames 8°.
/ Il Riccio rapito in lode di Newton qt°.
/ Il forestiero erudito, notizie di Pisa 8°.
/ Segreto. moderno 8°
/ Essai sur le carácter, et les moeurs des françois compares à ceux
des Anglois – 8°.
/ Il Duomo di Siena 8°.
/ Itinero. instructivo de Roma en frances 8°.
/ Ouvres de Moliere 8. tomos 8°.
/ Elemens de l' Histoire de france 3. toms. 8°.
/ Almanach des muses – 8°.
/ Le noveau Parlament d'Anglaterre – 8°.
/ Les trois siecles dela litterature françoise – quatro toms. 8°.
/ Indice delle stampe della Calcographia della Camara – 8°.
/ Examen des causes destructives du Theatre de l'Opera – 8°.
/ Les Egaremens du Coeur, et del esprit – 8°.
/ Utilite des Voyages sur mer – 8°.
/ La Quinzaine Angloise à Paris, ou l'Art de se ruiner en peu de
temps – 8°
/ Lettera de Mr. de Voltaire à l'Acada. françoise – 8°.
/ Libro Ingles: exercises to the Rules of construction of french
speech – 8°.
/ Otro que trata en ingles de las observ.es naturaleza, causas y
curacion de varios males. qt°.
/ Gramata. de la lengua francesa en Ingles. 8°.

[fol. 3]

Caxon ⟨E⟩

Una cartera, con diferentes vistas de Roma pintadas de Aguada en
cartones de diferentes tamaños, y son los mayores:

/ A bundle of papers, and Musical scores
/ A group of libretti, most of them bound in paper, of Theatrical
works, as follows: la Pupilla, il Padre per amore, plays by Goldoni,
L'impostura scoperta, la Hosteria magra, La Aminta by Tasso, and
los Horacios
/ The fifth volume of the operas of Metastasio and one untitled one

[fol. 2]
/ L'Olimpiade, spectacles to be seen at the public festivals in Paris;
another spectacle from the Theatres in Paris
/ Medonte Ré d'Epiro. Drama – octavo and 12mo
/ Analise de la Carte de la Mer Mediterranee quarto
/ Parfait ouvrage sur la coëffeure – octavo
/ Novelles provabilites en fait de Justice octavo
/ Scelta de Canzoni, è Sonetti 2. vols, octavo
/ Apelles et Campaspe – notebook in quarto
/ Le Rime del Petrarca – octavo
/ Poesie burlesche del Berni octavo
/ Poesie scelte 8
/ Amusement de Loisir des Dames octavo
/ Il Riccio rapito in lode di Newton quarto
/ Il forestiero erudito, notizie di Pisa octavo
/ Segretario moderno octavo
/ Essai sur le carácter, et les moeurs des françois compares à ceux
des Anglois – octavo
/ Il Duomo di Siena octavo
/ Instructive Itinerary of Rome in French octavo
/ Ouvres de Moliere 8 vols octavo
/ Elemens de l'Histoire de france 3 vols octavo
/ Almanach des muses – octavo
Le noveau Parlament d'Anglaterre – octavo
/ Les trois siecles de la litterature françoise – four vols octavo
/ Indice delle stampe della Calcographia della Camara – octavo
/ Examen des causes destructives du Theatre de l'Opera – octavo
/ Les Egaremens du Coeur, et del esprit – octavo
/ Utilite des Voyages sur mer – octavo
/ La Quinzaine Angloise à Paris, ou l'Art de se ruiner en peu de
temps – octavo
/ Lettera de Mr. de Voltaire à l'Academia françoise – octavo
/ English book: exercises to the Rules of construction of French
speech – octavo
/ Another book in English with observations on the nature, causes
and curing of sundry ills, quarto
/ Grammar of the French language in English. Octavo

[fol. 3]

Crate ⟨E⟩

A portfolio, with different views of Rome painted in Wash on pieces
of card of different sizes; the largest are:

La Rotonda *
Avanzi dil Tempio d'Apollo, vicino à Tivoli *
Sepolcro della familia Plautia, strada di Tivoli *
Amphiteatro flavio *
Vistas degli avanzi del secondo piano dele Terme di Tito *
Mas pequeños
Portico d'Ottavio, in oggi la Pescheria *
Arco di Settimio Severo con veduta di Campidoglo *
Arco di Tito, veduto della parte del Coloseo *
Tre colonne del Tempio di Jove statore *
Arco di Constantino con veduta del Coloseo, è meta sudante *
Fianco del Tempio di Antonino è faustina *
Foro de Nerva in oggi detto l'Arco de Pantani *
Prospetto del Tempio d'Antonino, è faustina *
Tempio de Minerva medicea, appreso Porta Magiore *
Parte interna delle otto colonne del Tempio dela Concordia *
Fabrica antica della Casa di Pilato *
Segunda vista del Arco de Tito *
Tempio della Pace *
Arco di Galieno *
Tempio de Vesta *
Tempio della fortuna Virile *
Tempio del Sole, et dela Luna *
* Terme de Tito
* Vista degli avanzi d'alcune camere sepolcrali su la antica via
Appia, fuori di Porta S.n Sebastiano = y esta es del numero delas
grandes. [anotado al margen] estos 24 papeles podrian ser útiles;
pero son curiosisimos, y muy propios para un gavinete.

Caxon. E B.

Libro grande que contiene, y el plan de Roma, y varios mapas que
son 47 *
/ Libro con 21 estampas, de Xarrones, Urnas, Candeleros & por
Piranesi.
/ Vistas de Roma del mismo con 26 estampas
Otro idem con 70 estampas
Cartera que contiene 7 papeles grandes de ornatos, pintados de
aguada, y no son iguales en el tamaño *

[fol. 4]
Alzado iluminado del templo de la fortuna Viril, con su planta *
Planta del templo de Serapis en Puzol *
Otra de la Rotunda en Roma
Alzado de un templo cerca de Alvano, pintado de aguadas, con su
planta *
Otro alzado del mismo modo, de un Templo que habia donde hoi
esta la Yglesia de S. Sebastian, extra muros de Roma, con su planta*
Nueve papeles grandes, coloridos de aguadas, de Varias antigue-
dades de Roma *
Otros quatro mas pequeños del mismo asunto. *

La Rotonda *
Avanzi dil Tempio d'Apollo, vicino à Tivoli *
Sepolcro della familia Plautia, strada di Tivoli *
Flavian Amphitheatre *
Vistas degli avanzi del secondo piano dele Terme di Tito *
Smaller
Portico d'Ottavio, in oggi la Pescheria *
Arco di Settimio Severo con veduta di Campidoglo *
Arco di Tito, veduto della parte del Coloseo *
Tre colonne del Tempio di Jove statore *
Arco di Constantino con veduta del Coloseo, è meta sudante *
Fianco del Tempio di Antonino è faustina *
Foro de Nerva in oggi detto l'Arco de Pantani *
Prospetto del Tempio d'Antonino, è faustina *
Tempio de Minerva medicea, appreso Porta Magiore *
Parte interna delle otto colonne del Tempio dela Concordia *
Fabrica antica della Casa di Pilato *
Second view of the Arch of Titus *
Tempio della Pace *
Arco di Galieno *
Tempio de Vesta *
Tempio della fortuna Virile *
Tempio del Sole, et dela Luna *
* Terme de Tito
* Vista degli avanzi d'alcune camere sepolcrali su la antica via
Appia, fuori di Porta S.n Sebastiano – and this is one of the large
ones [added in margin] these 24 sheets could be useful; but they are
very curious and very fitting for a Cabinet.

Crate E B.

Large book with a map of Rome and sundry other maps totalling
47 *
/ Book with 21 prints, of Vases, Urns, Candelabra etc. by Piranesi.
/ Views of Rome by the same with 26 prints
Another by the same with 70 prints
Portfolio containing 7 large sheets of ornaments, painted in wash,
of different sizes *

[fol. 4]
Colored elevation of the temple of Fortuna Virilis with its floor plan *
Floor plan of the temple of Serapis in Puzol
Another of the Pantheon in Rome
Elevation of a temple near Albano, painted in washes, with its floor
plan *
Another elevation in the same style, of a temple that formerly stood
on the site of today's Church of San Sebastiano fuori le mura in
Rome, with its floor plan *
Nine large sheets, colored in wash, of Various antiquities of Rome *
Another four smaller ones on the same subject. *

Otros quatro pequeños, idem con un dibuxo *

/ Siete estamp.s iluminadas, Vistas de Ginebra, y de otras ciudades

/ Ocho cabritillas para Abanicos, pintadas de aguada: representan edificios antiguos & *

/ Estampa, retrato dela Reina de Napoles

/ Explicacion del Arco de Trajano en Benevento con estampas – fol. esta duplicado

/ Seis estampas de baxosrelieves antiguos

/ Canuto de oja de lata con dos estampas dela Escuela de Atenas, de Volpato.

// Theatrum Basilice Pisane, con 12 estampas 4

/ Una cartera con una estampa de Piranesi de un puente, y un dibuxo de otro puente.

/ Mapa de los suizos, doblado en un Carterita

/ Plan de Paris, del mismo modo

/ Otro des Environs de Paris. idem.

⊬Observacions sur l'art de la Peinture appliquees à la Galeria Electoral de Duseldorff oct°.

/ Dissertacion sur l'ancienne inscription dela Maison Carre de Nismes 8°.

/ Almanach Bruxelois 8°.

Del l'insigne tabola di Bronzo, spetante à fanciuli, è fanciule, alimentati da Trajano, pr. Muratori 8°.

/ Description des Graciers, et amas de glace su Duché de Savoye pr. Mr. Bourrit 8°.

/ Memoires de Louis XV. Roi de france. 8°.

/ C. Julii Caesaris que extant ex emmendatione Jos. Scaligeri. 12°.

⊬Eclairissement sur les antiquites de Nismes. 8°.

Il Duomo de Siena. 8°.

/ Indice delle stampe della Calcographia di Roma. 8°.

/ Voyage d'Italie par Mr. Cochin. 3. toms. 8°.

/ Description historique de l'Italie, 6 toms. falta el segundo. 8°.

/ Voyage d'un françois en Italie. 6. toms. Venecia qt°. 6

[fol. 5]

/ Decouverte de la Maison de Champagne d'Horace, pr. l'Abbe M. Chapmartin 3 tom. qt°.

/ Opere di Dante Aligheri, 5. toms.

/ Lettres de la Marquise de Pompadour. 3. toms. 8°.

/ Mercurio errante delle grand.e di Roma. 2 toms 8°.

/ Dictionarium Doricum greco-latinum. qt°.

/ Dictionaire geografique, historique & dela Suisse. 2 ts. 8°.

/ Le Voyageur universel – 2 toms. 12°.

/ Itineraire instructive de Rome – 8°.

Descrizione delle Pitture, Sculture, el Architetture di Roma da filippo Titi.

Vitruvio del Marchese Galiani. Fol. *

Antiquario fiorentino, è Guida di firenze – 8°.

Pitture, Sculture, et Archits. di Bologna – 8°.

/ Amilton observaciones del Vesuvio – en Ingles – qt°.

/ Almanaque de Nautica – en Ingles – qt°.

/ Descripcion de Alem.a Boemia, Ungria & en Ingles 2. ts. qt°.

Another four smaller, ditto, with a drawing *

/ Seven colored prints, Views of Geneva, and of other Cities.

/ Eight pieces of cured kidskin for Fans with views painted in wash: they depict classical buildings etc

/ Print, portrait of the Queen of Naples

/ Explanation of the Arch of Trajan in Benevento with prints – folio. This is duplicated

/ Six prints of classical low reliefs

/ Tin tube with two prints of the School of Athens, by Volpato.

/ Theatrum Basilice Pisane, with 12 prints

/ A portfolio with a print by Piranesi of a bridge, and a drawing of another bridge.

/ Map of Switzerland, folded in a small Portfolio

/ Map of Paris, of the same type

/ Another of the Environs de Paris, ditto.

⊬Observations sur l'art de la Peinture appliquees à la Galeria Electoral de Duseldorff octavo

/ Dissertation sur l'ancienne inscription de la Maison Carre de Nismes octavo

/ Almanach Bruxelois octavo

Del l'insigne tabola di Bronzo, spetante à fanciuli, è fanciule, alimentati da Trajano, by Muratori octavo

/ Description des Graciers, et amas de glace su Duché de Savoye by Mr. Bourrit octavo

/ Memoires de Louis XV. Roi de france. Octavo

/ C. Julii Caesaris que extant ex emmendatione Jos. Scaligeri. 12mo

⊬Eclairissement sur les antiquites de Nismes. Octavo

Il Duomo de Siena. Octavo

/ Indice delle stampe della Calcographia di Roma. Octavo

/ Voyage d'Italie par Mr. Cochin. 3 vols., octavo

/ Description historique de l'Italie, 6 vols., the second missing. Octavo

/ Voyage d'un françois en Italie. 6 vols., Venice quarto

[fol. 5]

/ Decouverte de la Maison de Champagne d'Horace, by l'Abbe M. Chapmartin 3 vols., quarto

/ Opere di Dante Aligheri, 5. vols., quarto

/ Lettres de la Marquise de Pompadour. 3. vols., octavo

/ Mercurio errante delle grand.e di Roma. 2 vols octavo

/ Dictionarium Doricum greco-latinum. Quarto

/ Dictionaire geografique, historique & dela Suisse. 2 vols., octavo.

/ Le Voyageur universel – 2 volumes 12mo

/ Itineraire instructive de Rome – octavo

Descrizione delle Pitture, Sculture, el Architetture di Roma da filippo Titi.

Vitruvio del Marchese Galiani. Fol. *

Antiquario fiorentino, è Guida di Firenze – octavo

Pitture, Sculture, et Archit.e di Bologna – octavo

/ Hamilton observations of Vesuvius – in English – quarto

/ Nautical Almanach – in English – quarto

/ Description of Germany, Bohemia, Hungary etc. in English 2.

/ Flavii Eutropii, Breviarium historie Romane. 8°.
/ Il segret°. principiante – 8°.
/ The Genteleman's Guide – Viage de francia en Yngles 8°.
/ L'Sprit du Pape Clement XIV – 8°.
/ Noveau Secretaire du Cavinet – 8°.
Descrizzione delle statue, basirilievi, è busti di Campidoglio – 8°.
Le Nozze di Paride et Elena con 2. estamps. fol. esta repetido
Descrizzione dela R.l Cappella di S. Lorenzo in firenze. 2°.
/// Il Duomo di Siena – 8°. repetido
/ Maitre italien – Gramata. Inglesa – 8°.
/ Libro Ingles explica las particularidades cerca de Londres,
Cantorberi & qt°.
/ Ciento y veinte quadernos de Musica
/ Dialogos en Italiano, è Ingles 8°.
/ Gramata. Italiana, è Inglesa, sin tapas – qt°.
/ Otras dos idem.
/ Seconde parti de Diczionaire Italien, et françoise 8°.
/ Novelle gramaire Angloise & 8°.
/ Otra en ingles 8°.
/ Noveau Voyage de france 8°.
/ Noveau Diczionaire françoise et Italien & 8°.

[fol. 6]
/ Siguen diferentes libritos de representaciones Teatrales y son:
/ Primero, tercero y ~~quarto~~ octavo tomo delas Comedias de Goldoni
/ La Creduta Pastorella
/ Isabella,è Rodrigo
/ Enea nel Lazio
/ Il Curioso indiscreto
/ L'amore artegiano
/ Il Zotico incivilito
/ Se debe advertir que casi todos los libros de este caxon estan
enquadernados à la rustica, con papel, ò carton.

Caxon L. D.

Schola Italica Picture & publicada por Amilton con estampas de los
mas clasicos Autores. Num. 40 fol. repetido.
/ Quaderno con 71. estampas grandes por Piranesi – repetido, y son
Antiguedades.
/ Otro idem. Con 73 vistas de Roma – repetido
/ L'Arco Trionfale di Neva Traiano in Benvento, repetido
/ Veinte y ocho estampas sueltas de la Colección de frei, y otras.
/ Otras dos à parte de la misma Colección que representan à
Ariadna, y al Carro del sol, obra de Guido Rheni//

vols., quarto
/Flavii Eutropii, Breviarium historie Romane. Octavo – II segreto
principiante – octavo
/ The Genteleman's Guide – Journey around France in English
octavo
/L'Sprit du Pape Clement XIV – octavo
/Noveau Secretaire du Cavinet – octavo
Descrizione
delle statue, basirilievi, è busti di Campidoglio – octavo
Le Nozze di Paride et Elena with 2 prints folio. Duplicated
Descrizione dela R.I Cappella di S. Lorenzo in firenze. 2°
/Il Duomo di Siena – octavo duplicated
/Maitre italien – English grammar – octavo
/ English book explaining places of interest near London, Canter-
bury, etc., quarto
/ One hundred and twenty musical scores
/ Dialogues in Italian and English octavo
/ Italian grammar, and, English, unbound – quarto
/ Another two the same.
/ Seconde parti de Diczionaire Italien, et françois octavo
/ Novelle gramaire Angloise etc. octavo
/ Another in English octavo
/ Noveau Voyage de france octavo
/ Noveau Diczionaire françoise et Italien & octavo

[fol. 6]
/ Followed by various small books of Plays, namely:
/ First, third and ~~fourth~~ eighth volume of Goldoni's Plays
/ La Creduta Pastorella
/ Isabella è Rodrigo
/ Enea nel Lazio
/ Il Curioso indiscreto
/ L'amore artegiano
/ Il Zotico incivilito
/ It should be pointed out that nearly all the books in this crate are
soft-bound with paper or card covers.

Crate L. D.

Schola Italica Picturae etc., published by Hamilton with Prints by
the most celebrated Artists. 40 in number, folio, duplicated.
/ Album with 71 large prints by Piranesi – duplicated, depicting
Antiquities.
/ Another by the same, with 73 views of Rome – duplicated
/ L'Arco Trionfale di Neva Traiano in Benvento, duplicated
/ Twenty-eight loose prints from Frei's Collection, and others.
/ Another two separate, from the same collection and depicting
Ariadne and the Chariot of the Sun, by Guido Rheni//

Caxon L. Ɇ. C.

/ Columna Trayana – de Piranesi con todas sus partes en 19 estampas grandes.
/ Della Magnificenza, ed Arquit.a de'Romani en latin, è Italiano, de Piranesi, con 56 estampas.
Canuto de oja de lata donde estan pintadas de aguadas en papel las dos preciosas mesas de marmol embutidas de varias piedras finas con su explicacion à la margen: y en este mismo caxon estan dichas mesas. Hai tambien en el canuto una estampa dela Escuela de Atenas.⁎

Caxn. R. Uy.

// Canuto de oja de lata con doce estampas de ornatos iluminadas = firmadas Ludovicus Teseo Taurimensis, y Joannes Volpato. *
/ Un rollo de estampas, es a saber, tres de ellas de las estancias de Rafael, con sus explicaciones, y trece de las logias, ò Galeria con sus historias, y ornatos sin iluminar.
/ Otro rollo de las mismas logias sin iluminar como las antecedentes, y son 14 estampas.
/ Otro rollo de las mismas, donde estan repetidas, y son hasta el num°. de 60. estampas, alza.os en pedazos, sin iluminar.

[fol. 7]
/ Otro rollo idem con 26 estampas.
/ Otro idem con 12 estampas, todas sin iluminar.
/ Un libro tom.6. parte primera della historia de la literatura italiana de Gerono. Tiraboschi 8

Caxon F. Bt.

Treze tomos enquadernados delas obras de Piranesi, en que hai tambien otro del mismo modo intitulado schola italica publicado por Guillermo Hamilton, con 40 estampas delos mejores autores. *
Libro con 24 estampas delas obras de Guercino, imitando à sus dibuxos – fol. repetido *
/ Philippi Cluvexi – Sicilia antigua fol.
/ Le Nozze di Paride, ed Elena, fol. repetido
/ Voyage en Sicile, et en la Gran Grece de Winkelman – 8°. 9
/ Histoire del admirable Dn. Guzman de Alfarache 3. ts. 8°.
/ Gramata. inglesa – 8°
/ Libro ingles – Glacie in the Dutchi of Saboi – 8°. repet°.
/ Otro ingles dela Vida, y opiniones de Tristram Shandi tom. 1°. y 3°. en 8°.
/ Otro ingles, viage de francia
/ Diccionairo historico Geographico, y Politico de la Suisse tom. 1°. – 8°.
/ Veinte y una estampas sueltas de vistas de Sicilia, de las Antiguedades de Pesto, y de otros asuntos que son: el grupo del Toro de

Crate L. Ɇ. C. [L. J. C.]

/ Columna Trayana – by Piranesi with all its parts in 19 large prints.
/ Della Magnificenza, ed Arquit.a de' Romani in Latin, and Italian, by Piranesi, with 56 prints.
Tin tube with depictions in colored washes of the two beautiful marble tables inlaid with various hardstones, identified in the margin: the tables themselves are in this same crate. The tube also contains a print of The School of Athens.⁎

Crate R. Uy.

// Tin tube with twelve colored prints of ornaments = signed Ludovicus Teseo Taurimensis, and Joannes Volpato. *
/ A roll of prints, three of them of the Raphael Stanze, with their explanations and thirteen of the loggias, or Gallery, with their stories, and uncolored prints of ornamental motifs.
/ Another roll of the same loggias, uncolored like the previous ones, 14 prints in total.
/ Another roll of the same, duplicated, totalling up to 60 prints, some in pieces, uncolored.

[fol. 7]
/ Another roll, the same with 26 prints.
/ Another, the same, with 12 prints, all uncolored.
/ A book volume 6, first part of the history of Italian literature by Gerono. Tiraboschi

Crate F. Bt.

Thirteen bound volumes of the works of Piranesi, in which there is also another of the same type entitled Schola Italica Picturae published by Guillermo Hamilton, with 40 prints by the finest artists. *
Book with 24 prints of the works of Guercino, imitating his drawings-folio, duplicated *
/ Philippi Cluvexi – Sicilia antigua fol.
/ Le Nozze di Paride, ed Elena, fol. duplicated
/ Voyage en Sicile, et en la Gran Grece de Winkelman – octavo
/ Histoire del admirable Dn. Guzman de Alfarache 3. vols., octavo
/ English grammar – octavo
/ English book – Glacie in the Dutchi of Saboi – octavo duplicated
/ Another in English on the Life, and Opinions of Tristram Shandi vol. 1 and 3 in octavo
/ Another English book, journey in France
/ Historical, Geographical and Political dictionary of Switzerland vol. 1 – octavo
/ Twenty-one loose prints of views of Sicily, of the Antiquities of

farnes, la Transfiguracion, de Rafael; del Descendimiento, de Daniel de Volterra; de un Christo muerto del Españoleto, y otra del origen dela Pintura.

Caxon G. M.

// Schola italice Picture – por Hamilton, repetido en otros caxones, y duplicado en este con quarenta estampas cadauno. [anotado al margen] tomado*
// Rollo con diez estampas dela Colección de Frei *
Otro con once estampas repetidas dela misma Colección
// Otro con dos estampas, de la Ariadna, y carro del Sol, de Guido Rheni.*
/ Otro con las mismas dos estampas repetidas muchas veces en otros caxones.

Caxon H. R. H

/ Storia degli Imperatori Romani de Mr. Beau, rotulados en el canto Rolin – traducion italiana hasta 20. toms. en 8°. faltan los 7 primos.

Caxon E. L D

/ Un libro de musica con duetos &

Caxon L B.

/ Legajo sin enquadernar, y dice: due copie intiere, una delle dissertazioni fisiche, l'altra dela natura, è coltura d'fiori – tom. 1°. y 3°. qt°.

[fol. 8]

Caxon F. Bt. num. 4

Un canuto de oja de lata con seis paises de aguadas, y quatro dibuxos, de la planta, y alzados de una capilla *

Caxon. Ɨ G.

// Libro grande delas Termas de Tito con estampas, numerado 68 * esta tomado

Pesto, and of other subjects, namely: the group of the Farnese Bull, the Transfiguration, by Raphael; the Descent from the Cross by Daniele da Volterra; a Dead Christ by El Españoleto, and another on the invention of Painting

Crate G. M.

// Schola Italica Picturae – by Hamilton, duplicated in other crates and duplicated in this one with forty prints each one. [annotated in the margin] taken*
// Roll with ten prints from the Frei Collection*
Another with eleven duplicate prints from the same Collection
// Another with two prints, of Ariadne and the Chariot of the Sun by Guido Reni.*
/ Another with the same two prints, appearing numerous times in other crates.

Crate H. R. H

/ Storia degli Imperatori Romani by Mr. Beau, written on the fore edge Rolin – Italian translation up to 20 octavo vols. The first 7 are missing

Crate E. L D

/ A book of music with duets etc.

Crate L B.

/ Unbound bundle, on which is written: due copie intiere, una delle dissertazioni fisiche, l'altra dela natura, è coltura d'fiori – vol. 1 and 3. Quarto

[fol. 8]

Crate F. Bt. no. 4

A tin tube with six landscapes in washes, and four drawings, of the ground plan, and elevations of a chapel *

Crate. Ɨ G. [J G.]

// Large book of the Baths of Titus with prints, numbered 68* it has been taken

/ Oppere di Mr. Iovani de la Casa 6 toms. qt°.

/ Pietro Giannone, Historia Civile dil Regno di Napoli 5 toms. qt°.

/ Benedeto Barchi Historia delle guerre di fiorenza – fol.

/ Scelta de Sonetti, è Canzoni de piu eccelenti rimatori 5. toms. 8°.

/ Lezzioni della antichitá Toscane, ed spezialm.te della Citta di Firenze, por Lami 2. toms. qt°.

/ Noveau Diczionaire françois, ed Alemand, Aleman, et françois 2. toms. qt°. falta el primero.

/ Otro idem en 8°.

/ Breve discrizion del Regno de Napoli, diviso in duodeci Provinzie, da Ottavio Beltrano di Terra nuova – qt°.

/ The Miscelaneus Work of The Right Henry St'John 3 toms. 12°.

/ Histoire et Phenomenes du Vesuve, exposes por le P. Dn. Jean Marie de la Torre qt°.

/ Otro idem. Edicion italiana. qt°.

/ Chronology, or the Historian's Vademecum 12°. grande

/ Libro Aleman con una estampa al principio que representa una gloria, y la Vista de un Ciudad: Parece devocionario – 12°.

/ Lista de las postas de francia – 12°.

/ Letre de Mr. Linguet à Mr. le Comte de Vergeny quaderno en qt°.

/ Mapa de francia en una carterita

/ Letre de Winkelman al Comte de Brül sur les descouvertes de Herculanum – qt°.

/ Incendio del Vesuvio accaduto il 19 Novembre de 1767 da Dn. Giovani Maria della Torre – quaderno – qt°.

/ La trapola, poema latino del Sr. Holds Worth, y traduccion italiana di Archagelo Baldoriotti quaderno – qt°.

/ A letter to Charles Penradoke – 12°.

/ Dos estampas, vistas de Genova

[fol. 9]

/ Arco di Nerva Traiano in Benevento con nueve estampas – repetido varias veces quaderno

Otro quaderno con 28 estampas, y plan de Constantinopla, que representan funciones de aquella Corte, trages turcos, griegos, y Polacos *

/ Terza, et ultima parte delle Logge di Rafaele with 25 prints – duplicated

/ Seconda parte delle Logge Vaticane, quaderno que contiene otras estampas de Paises, y una de la Escuela de Atenas, en todas 18 =

/ Cartera grande con 36 estampas, y son las de la Columna Trajana, y otras sueltas con dos dibuxos.

La Galeria de Anibal pintada de aguadas, en un caxoncito – repetida en otro delos antecedentes *

/ Diez quadernos de papeles de Musica.

/ Oppere di Mr. Iovani de la Casa 6 vols quarto

/ Pietro Giannone, Historia Civile dil Regno di Napoli 5 vols., quarto

/ Benedeto Barchi Historia delle guerre di fiorenza – folio.

/ Scelta de Sonetti, è Canzoni de piu eccelenti rimatori 5. vols., octavo

/ Lezzioni della antichità Toscane, ed spezialmente della Citta di Firenze, by Lami, 2. vols., quarto

/ Noveau Diczionaire françois, ed Alemand, German, et françois 2 vols., quarto the first is missing.

/ Another the same in octavo

/ Breve discrizion del Regno de Napoli, diviso in duodeci Provinzie, da Ottavio Beltrano di Terra nuova – quarto

/ The Miscellaneous Work of The Right Henry St'John 3 vols., 12mo

/ Histoire et Phenomenes du Vesuve, exposes par le P. Dom. Jean Marie de la Torre quarto

/ Another the same. Italian edition, quarto

/ Chronology, or the Historian's Vademecum 12mo large

/ German book with a print at the beginning representing the Saints
in Glory, and the View of a City: Seems to be a prayer book – 12mo

/ List of coaching posts France – 12mo

/ Letre de Mr. Linguet à Mr. le Comte de Vergeny notebook in quarto

/ Map of France in a small folder

/ Letre de Winkelman al Comte de Brill sur les descouvertes de Herculanum – quarto

/ Incendio del Vesuvio accaduto il 19 Novembre de 1767 da Dn. Giovani Maria della Torre – quarto notebook –

/ La trapola, Latin poem by Sr. Holds Worth and its Italian translation by Archagelo Baldoriotti notebook – quarto

/ A letter to Charles Penradoke – 12mo

/ Two prints, views of Genoa

[fol. 9]

/ Arco di Nerva Traiano in Benevento with nine prints – duplicated several times album

Another album with 28 prints, and a map of Constantinople, which depicts ceremonies of that Court, Turkish, greek and Polish costumes *

/ Terza, et ultima parte delle Logge di Rafaele with 25 prints – duplicated

/ Seconda parte delle Logge Vaticane, album containing other prints of landscapes and one of the School of Athens, in all 18 =

/ Large Portfolio with 36 prints, depicting Trajan's Column, and other loose ones with two drawings.

The Gallery by Annibale painted in washes, in a small box – duplicated in another of the above-listed ones *

/ Ten musical scores.

Caxon P. C.

// Schola Italice picture – con 40. Estampas – por Hamilton, repetido varias veces. [anotado al margen] ya esta tomado
// Catorce toms. enquadernados de las obras de Piranesi, repetidos en otros Caxones [anotado al margen] esta tomado ya
Observations sur les Volcans des deux Siciles par le Chevalier Amilton, con dos ojas pintadas de aguadas al principio-fol.*
Otro con la misma portada, pero contiene cincuenta y dos papeles pintados, que representan Volcanes, Vistas del territ°. de Napoles, y otras cosas*
/ P. Virgilii Maronis Aeneidos libri 6. posteriores To muy textius fol. faltan los dos primeros
Monumenti Antichi inediti da Gio – Winckelman, Volume primo – solo – fol. *
// Raccolta d'alcuni disegni del Barbiere da Cento, detto il Guercino – con 24 estampas – repetido en otro caxon [anotado al margen] tomado
/ Dictionaire latin, françoise, ed Italien 2 toms. qt°.
/ The General Gazetter, or Compendious Geographical – con mapas – qt°.
/ History of Henry Carlt of Moreland. 4. toms. – 8°.
/ Description des Villes de Berlin, et de Posdam – 8.
/ Rollo de 12 papeles del Plan de Roma – del Vasi.
/// Otro rollo con tres estampas dela Escuela de Atenas, dela Transfigur.on de Rafael, y del descendimiento, de Daniel de Volterra – repetidas en otras partes.
En este caxon hai un retrato de cera del Papa Pio VI. En una caxita ovalada.

Caxon E D.

Este caxon se maltrató mucho con las aguas, y se maltrataron los libros.
/ Observations des Volcans, ut supra, con las dos ojas pintadas al principio & fol.
/ P. Terenti Afri Comedie italiano, y latin – con estampas delas scenas – fol. 2. toms.

[fol. 11]
Serie degli huomini illustri nella Pittura, Scultura, ed Architettura – 12 toms. qt°.
// Vita di Benvenuto Cellini, Orefice, et scultore Fiorentino, scritta dalui medessimo.
qt°. *
/ Gierusalemme liberata – con estamp.s 2 toms. qt°.
// Il Riposo di Raphaelo Borghini = trata dela Pinta. qt°. *
/ Benedetto Matei – della lingua Toscana qt°.
/ Guiciardino – Historia d'Italia. qt°.
/ Gramaire françoise, et Italien – 8°.
/ Histoire de l'Art, de Winckelman – 2 toms. 8°.

Crate P. C.

// Schola Italica picturae – with 40 prints – by Hamilton, repeated several times, [added in the margin] it has already been taken
// Fourteen bound volumes of the works of Piranesi, duplicated in other crates [added in the margin] it has already been taken
Observations sur les Volcans des deux Siciles par le Chevalier Amilton, with two sheets painted in washes at the beginning – folio.*
Another with the same cover, but containing fifty-two colored drawings on paper of volcanoes, views of the Region of Naples, and other subjects *
/ P. Virgilii Maronis Aeneidos libri 6. posteriores To muy textius folio. The first two are missing
Monumenti Antichi inediti da Gio – Winckelman, first Volume – only – folio. *
-Raccolta d'alcuni disegni del Barbiere da Cento, detto il Guercino – with 24 prints – duplicated in another crate [added in the margin] taken
/ Dictionaire latin, françoise, ed Italien 2 vols., quarto
/ The General Gazetter, or Compendious Geographical – with maps – quarto
/ History of Henry Carlt of Moreland. 4 vols. – octavo
/ Description des Villes de Berlin, et de Posdam – 8.
/ Roll of 12 sheets of the Map of Rome – by Vasi.
/ Another, roll with three prints of the School of Athens, of the Transfiguration by Raphael and the Descent from the Cross by Daniele da Volterra – duplicated in other places. In this crate there is a wax portrait of Pope Pius VI. In a small oval box.

Crate E D.

This crate and the books in it suffered serious water damage.
/ Observations des Volcans, ut supra, with the first two pages painted at the beginning etc. folio.
/P. Terenti Afri Comedie, Italian and Latin – with prints of the scenes – folio. 2. vols.

[fol. 11]
Serie degli huomini illustri nella Pittura, Scultura, ed Architettura – 12 volumes quarto
//Vita di Benvenuto Cellini, Orefice, et scultore Fiorentino, scritta da lui medessimo. Quarto*
/ Gierusalemme liberata – with prints, 2 vols., quarto
Il Riposo di Raphaelo Borghini = Treatise on Painting quarto*
/ Benedetto Matei – della lingua Toscana quarto
/ Guiciardino – Historia d'Italia. Quarto
/ Gramaire françoise, et Italien – octavo
/ Histoire de l'Art, de Winckelman – 2 volumes octavo

/ Libro Yngles por Hamilton, del Vesuvio, Etna, y otros volcanes – 8°.

/ Regole della Toscana fabella – 8°.

/ Regole, et osservazioni della lingua toscana – 8°.

/ Pitture, Sculture, ed Architetture della Cita di Bologna, duplicado – 8°.

/ Coleccion de las Comed.s del Goldoni, desde el tomo 2. Hasta el decimo 8°.

/ Mercurio errante = delle Grandezze di Roma = repet°. 8°.

/ Il Segretario moderno – 8°.

/ Gramatica della lingua Ynglese – en Ytaliana – 8°.

/ Letre de Miladi Juliette Catesbi – 8°.

/ Voyage d'un françoise en Italie 3,5, y 6. toms. sin los demas = 8°.
10

/ Explicacion de la Termas de Tito = quaderno sin estamps.

/ Composiciones poeticas de Teatro-ocho libritos – 8°.

/ Descrizione della Cappella di S.n Lorenzo in fiorenza. Repetido varias veces = 12°.

Tres estampas manchadas, dela Escuela de Atenas

Quaderno con 23 estampas del plan antiguo de Roma

// Quaderno de 35 estampas de varios asuntos – *

Libro grande maltratado de las termas de Tito con 44 estampas

Quarenta y quatro dibuxos sueltos de poca consideraon.

// Cinquenta estampas de Salvator Rosa, cosidas

// Quaderno de Polidoro de Caravagio con 28 estampas de ornatos

// Arco de Trajano en Benevento, repetido varias veces.

/// Hamilton – observations sur les Volcans des deux Siciles con 52 vistas pintadas de aguadas – repetido

Quaderno con 28 estampas del plan, y Vistas de Roma por Vasi

/ La planta de Roma, y varios Mapas, en todos 15.

/ Quaderno con 14 estampas delas Termas de Tito.

/ Una caxita, y en ella una erupcion del Vesuvio pintada de aguada

Otra caxita con dos cabecitas dibuxadas de lapiz

/ Otra con algunos azufres, copias del antiguo

// Un dibuxo de media figura de muger, colocada en una bastidor, y parece de Mengs*

Caxon W D.

/ Un legajo de impresos, y parecen dos toms. dela Enciclopedia

/ Ultimam.te un Caxon donde dicen que hai un cuerpo de un santo, y no se ha abierto.

Fin.

/ English book by Hamilton, on Vesuvius, Etna, and other volcanoes – octavo

/ Regole della Toscana fabella – octavo

/ Regole, et osservazioni della lingua toscana – octavo

/ Pitture, Sculture, ed Architetture della Cita di Bologna, duplicated – octavo

/ Collection of Goldoni's Plays, from volume 2 to 10 octavo

/ Mercurio errante – delle Grandezze di.Roma = duplicated octavo

/ Il Segretario moderno-octavo

/ English Grammar – and Italian – octavo

/ Letre de Miladi Juliette Catesbi – octavo

/ Voyage d'un françoise en Italie vols 3, 5 and 6 without the rest – octavo

/ Explanation of the Baths of Titus = album without prints

/ Poetic works for the Theatre – eight small books – octavo

/ Descrizione della Cappella di San Lorenzo in fiorenza. Duplicated several times = 12mo

Three stained prints of the School of Athens

Album with 23 prints of the map of Ancient Rome

Album of 35 prints of various subjects – *

Large book in poor condition of the Baths of Titus with 44 prints

Forty-four loose drawings of little merit

Fifty prints by Salvator Rosa, stitched

// Album of Polidoro de Caravagio with 28 prints of ornaments

// The Arch of Trajan in Benevento, duplicated several times.

/ Hamilton – observations sur les Volcans des deux Siciles with 52 views painted in washes – duplicated

Album with 28 prints of the map, and Views of Rome by Vasi

/ Map of Rome, and various maps, 15 in all.

/ Album with 14 prints of the Baths of Titus.

/ A small box containing a depiction of the eruption of Vesuvius painted in wash

Another small box with two small heads drawn in black chalk

/ Another with some sulphur tints, copies after the Antique

// A half-length drawing of a woman, on a stretcher, seemingly by Mengs

Crate W D.

/ A bundle of printed papers, and what seem to be two volumes of the Encyclopaedia

/ Lastly a Crate said to contain the body of a saint, which has not been opened

Catalogo de Pinturas al oleo, y otras curiosidades contenidas en Varios caxones de la expresada segunda remesa que se depositaron en la Academia de Sanfernando

Caxon I B.

Dentro de este Caxon hai una caxita de un modelo egecutado en corcho, de un templecito, ò ruina, en diferentes pedazos.
Otra con quatro botecillos de vidrio, de conserva
Otra con un ladrillo antiguo, escrito
Otra con muestras de piedras, pretrificaciones, lavas del Vesuvio, lucernas, un lacrimatorio &.

Caxn. I H.

Una caxita con tres quadros pequeños al oleo, sin marcos, y son una copia de N.a S.a del Corregio; otra, copia de Ticiano que repres.ta à Diana, y Endimion, otra copia del mismo, y es una Venus.
Una caxita que contiene un modelo pequeño en barro cocido, copia de Hermafrodita. [anotado al margen] x un retrato de un joven con marco dorado *

Caxn. L D

Pinturas sin marcos, es à saber, una copia dela N.a Sr.a de la Segiola, de Rafael, de una* vara en quadro, con poca diferencia. Otras mas pequeñas, y son:
S. Fran.co de Asis arrodillado delante N.a S.a, Copia de Caraci
La Madgalena en el desierto, copia de Coregio –
N.a S.a con el Niño, copia de Marati
Otra de la misma escuela y es la Virgen sentada con el Niño *

Caxon ⟨C⟩

// Quatro candeleros antiguos de marmol, esculpidos excelentem. te en bajo relieve *

Caxn. L I C

Dos preciosas mesas de marmol, como de una vara de largo y tres quartas de ancho, embutidas de piedras finas de diversas suertes y colores

Catalogue of oil Paintings and other curiosities contained in Various crates of the above-mentioned second consignment deposited at the Academia de *San Fernando*

Crate I B. [J. B.]

Inside this Crate is a small box with a model made in cork of a small temple, or ruin, in various pieces.
Another with four glass jars, of preserve
Another with an ancient brick, with an inscription
Another with samples of stones, fossils, pieces of lava from Vesuvius, oil lamps, a lacrymatory etc.

Crate I H. [J H.]

A small box with three small oil paintings, unframed; they are a copy of a Painting of Our Lady by Correggio, a copy of Titian's Diana and Endymion, and another copy of a work by the same artist, this one a Venus.
A small box containing a small terra-cotta model, copy of the Hermaphrodite, [added in margin] a portrait of a young man in a gilded frame *

Crate L D

Unframed paintings, namely, a copy of Raphael's Madonna della Seggiola, one* *vara* square, more or less. The others are smaller, namely:
St. Francis of Assisi kneeling before the Our Lady, copy of Caraci
Mary Magdalen in the desert, copy of Coregio
The Madonna and Child, copy of Marati
Another by the same school of the seated Virgin with the Christ Child *

Crate ⟨C⟩

// Four ancient candelabra in marble, excellently sculpted in low relief *

Crate L I C

Two beautiful marble tables one *vara* long and three *quartas* wide, inlaid with hardstones of different types and colors

Un dibuxo en un canuto de oja de lata donde se ven pintadas de aguada las mismas mesas. [anotado al margen] estas mesas, y el dibuxo se regalaron à la Reina entonces Princesa

A drawing in a tin tube which also contains wash drawings of the said tables. [added in the margin] these tables, and the drawing were given to the Queen, at that date the Princess.

Caxon – M G

/ Una cabeza de barro cocido, y dos vaciadas en yeso; una de estas es el retrato de Mengs *

Crate M G

/ A terra-cotta head, and two plaster casts; one of these is the portrait of Mengs *

Caxon H R H. D G

Un caxa de flores de pluma, que tiene de largo cerca de quatro quartas, y menos de tres de ancho. *

Crate H R H. D G

A box of feather flowers, about four *quartas* long, and less than three wide.*

Caxn. E B

Caxa mas pequeña que la antecedente, tambien con flores de plumas

Crate E B

A smaller crate than the previous one, also with feather flowers

Caxon R Uy.

/ Caxa casi del mismo tamaño que la penultima referida, tambien con flores

Crate R Uy.

/ Crate of almost the same size as the one before the last, also containing flowers

Caxon A Ry.

// Dos paises al oleo, como de seis quartas de largo, y cinco de ancho, sin marcos. *

Crate A Ry.

// Two oil landscapes, about six *quartas* long, and five wide, unframed. *

Caxon F B.

Dos mesas embutidas de varios marmoles de mezcla de cinco palmos de largo, y tres de ancho

Crate F B.

Two tables inlaid with a combination of different marbles, five *palmas* long, and three wide

Caxon ◇F◇

/ Caxa de flores, todas ellas maltratadas dela agua.

Crate ◇F◇

/ Box of flowers, all with water damage.

Caxon G M.

Dos ovalitos pintados al oleo entabla que

Crate G M.

Two small oval oil paintings on panel

[fol.13]
representan una misma cosa, y es la invencion de la pintura; ambos copias [anotado al margen]* se toma el uno

[fol. 13]
both depicting the same subject, namely the invention of painting; both copies [added in the margin]* one has been taken

Caxn. H R H.

Caxon donde hai un cornisamento de marmol en cinco piezas, y parece parte dela
Chimenea que vino en la primer remesa [anotado al margen] Dado al Rey por ser parte de la Chimenea

Caxon

// Dos cabezas de Yeso, y una de barro cocido. Una de las primeras es el retrato de Mengs

Caxon I P

// Estatua de una Venus de marmol con algunas restauraciones, copia de la de Medicis, y tiene unas siete quartas de altura.

Caxon E L D.

/ Retrato al oleo de un caballero sentado con casaca encarnada: es origil. de Pompeyo Batoni; y tiene mas de seis palmos de alto, y cinco de ancho [anotado al margen] este retrato se llevó à Casa del Sr. Protector
Carton en una caxita, copia de la Santa Cecilia de ~~Guido~~ Domeni-quino, de tres palmos de alto y menos de ancho. *

Caxon L B.

/ Contiene una caxa con una guarnicion de flores para bata, tiene como seis palmos de largo [anotado al margen] esta guarnicion y otras flores se llevaron a la Reyna
/ Otra Caxa de tres quartas de largo, y dos de ancho con flores de plumas.

Caxon F. Bt.

/ Retrato de un Joven de medio cuerpo obra de Batoni al oleo, y es de cinco palmos de alto, y quatro de ancho.
// Tabla de mas de tres quartas de largo, y de dos de ancho, pintada al oleo. Representa una figa. desnuda de muger, y dos Tritones *
Un pais de once palmos delargo, y ocho de ancho.
Retrato del Caballero Joven que se ha dicho de medio cuerpo, pero este es de cuerpo entero, original de Batoni, de mas de once quartas de alto, y de siete de ancho* [anotado al margen] se llevo este retrato a casa el Sr. Protector

Crate H R H.

Crate containing a marble entablature in five pieces that seems to form part of the mantelpiece that came in the first consignment [added in the margin] Given to the King as part of the mantelpiece.

Crate

/// Two Plaster heads, and one in terra-cotta. One of the former is the portrait of Mengs.

Crate I P [J P]

/ Marble statue of Venus with some restorations, copy of the Medici Venus, about seven *quartas* high.

Crate E L D.

/ Portrait in oil of a seated gentleman in a scarlet frock coat: it is an original by Pompeo Batoni; it is over six *palmos* high, and five wide [added in the margin] this portrait was taken to the Protector's House. Cartoon in a small box, copy of Saint Cecilia by ~~Guido~~ Domeniquino, three *palmos* high and less wide. *

Crate L B.

/ This crate contains a box with a trimming of flowers for a dressing gown; it is six *palmos* long [added in the margin]; this trimming and other flowers were taken to the Queen – Another box three *quartas* long, and two wide, with feather flowers.

Crate F. Bt.

/ Portrait of a Young Man in half-length by Batoni, it measures five *palmos* high and four wide.
/ Panel of more than three *quartas* long, and two wide, painted in oil. It depicts a nude female figure, and two Tritons *
A landscape of eleven *palmos* long and eight wide.
Portrait of a Young Gentleman said to be of
half-length, but it is full-length, original by Batoni, over eleven *quartas* high, and seven wide.* [added in the margin] It was taken to the Protector's house

Caxon E Sr.

/ Dos caxitas iguales con flores de plumas de a tres quartas de largo, y dos de ancho.

/ Otra caxita con dos botecillos de confites, al parecer

/ Diez flasquitos con licores, y ademas uno quebrado, y otro vacio, en todos doce [anotado al margen] estos y los confites se distribuy-eron para que no se acabaran de perder

Caxn. W A F.

Pinturas al oleo =

Dos paisitos de dos quartas de largo, y medio de ancho.

Otros dos de seis qtas. de largo, y cinco de ancho.

Copia de la Aurora de Guido, ò carro del Sol. De seis quartas de largo, y quatro de ancho.

Figura desnuda de muger en pie, con dos Tritones, de seis quartas de alto y quatro de ancho; repeticion de otra mas pequeña que queda expresada

/ Tres quadros de à unas seis quartas de alto, y quatro de ancho, que representan, uno à S. Miguel copia del de Guido, otro à Na. Sra. con el Niño, copia de Murillo, y otro que tambien es copia à Una Venus sobre nubes con un cupidillo.

Un pais de nueve quartas de largo, y cinco de ancho.

Caxon I G.

/ Tres copias iguales de a tres quartas de alto, y mas de dos de ancho, y son de una Magdalena de Guido Rheni de medio cuerpo: dos de ellas con marco dorado

/ Copia de la N.a S.a de la Segiola de Rafaël, demas de tres quartas en quadro = repetido

// Quadro original de un Sto. Apostol, de mas de cinco quartas de alto, y quatro de ancho * [anotado al margen] se llevó à casa el S. Protector.

[fol.14]
Quadro de S.ta Cecilia de medio cuerpo, de 6 quartas de alto y cinco de ancho, copia de Guido.

Otra copia de la Sybila Persica de siete quartas de alto, y cinco de ancho.

Otra de la Aurora, ò Carro del Sol, de diez quartas de largo, y cinco de ancho. Esta repetido

Venus vendando à Cupido, copia de Ticiano, de cerca de diez quartas de largo, y seis de ancho.

Quadro que representa la fortuna figa de muger, sobre un glovo, y un niño que la coge delos cabellos, copia de Guido; de ocho quartas de alto , y seis de ancho.

Crate E Sr.

/ Two identical small boxes with feather flowers of three *quartas* long, and two wide.

/ Another small box with two small bottles of what appear to be preserves

/ Ten small flasks with liquors, and another broken one, and one empty one, twelve in all [added in the margin] these and the preserves were distributed before they went off

Crate W A F.

Oil paintings =

Two small landscapes of two *quartas* long, and a half wide.

Another two of six *quartas* long, and five wide.

Copy of Guido's Aurora, or The Chariot of the Sun, six *quartas* long, and four wide.

Nude figure of a standing woman, with two Tritons, of six *quartas* high and four wide; repetition of another smaller one listed above

/ Three paintings six *quartas* high, and four wide, one depicting Saint Michael, copy of the one by Guido, another of the Virgin and Child, copy of Murillo, and another that is also a copy of A Venus on clouds with a small cupid.

A landscape nine *quartas* long, and five wide.

Crate I G. [J G.]

/ Three identical copies measuring three *quartas* high, and over two wide, depicting Mary Magdalen by Guido Rheni, half-length: two of them with gilded frames

/ Copy of the Madonna della Seggiola by Raphael, of more than three *quartas* square = duplicated

// Original painting of an Apostle, of more than five *quartas* high, and four wide * [added in the margin] it was taken to the Protector's House.

[fol.14]
Painting of Saint Cecilia in half-length, measuring 6 *quartas* high and five wide, copy of Guido. /

Another copy of the Persian Sibyl measuring seven *quartas* high, and five wide. /Another of Aurora, or The Chariot of the Sun, ten *quartas* long, and five wide. A duplicate /

Venus blindfolding Cupid, copy of Titian, of about ten *quartas* long and six wide. /

Painting depicting Fortune as a woman, standing on a globe, with a small boy who is holding her by the hair, copy of Guido; eight *quartas* high, and six wide.

Caxon W Ce.

/ Retrato de una Señora con un perrito de cinco quartas de alto, y seis de ancho

Caxon W A F.

Santa Cecilia, copia de Guido como la expresada mas arriba, de seis quartas de alto, y cinco de ancho.
Dos copias, lo mismo una que otra, y representan tres jugadores de naipes.

Caxon H ⬦G⬦ **E**

/ Quatro cabezas dos de barro, y dos vaciadas en yeso con sus moldes en pedazos sueltos

Caxn. E B. n. 1º.

/ Una caxa con un pedazo de tronco de arbol, petrificado en parte.

Caxon E D.

/ Caxita de flores muy maltratada por el agua.
Copia en chico, como de una quarta y media en quadro, y es de Na. Sra. dela Segiola de Rafael.

[fol.15]

Primera Remesa

Numero 1º.
Dos Niños al oleo de medio cuerpo, el uno del estilo de Rubens. *
[anotado al margen] se llevaron a casa del Sr. Protector.
Tres pinturas al temple con marcos dorados; dos de ellas la Aurora, y la Ariadna; copias de Guido Rhení, y la otra una cama nupcial.
Dos centauros, tambien al temple mas pequeños *

Numo 2º
// Seis cabezas de marmol del natural: las cinco parecen antiguas, y la una es copia de la Venus de Medicis. *
Una Xarra de marmol de mezcla con sus asas.
// Dos Urnas sepulcrales de marmol, con sus tapas, è inscripciones antiguas; adornadas de festones, animalillos &; la una es quadrada y la otra redonda.

Crate W Ce.

/ Portrait of a Lady with a lapdog measuring five *quartas* high, and six wide

Crate W A F.

/ Saint Cecilia, copy of Guido like the one listed above, of six *quartas* high, and five wide. /
/ Two copies, both the same, depicting three card players.

Crate H ⬦G⬦ **E**

/ Four heads two of terra-cotta, and two plaster casts with their molds in pieces

Crate E B. no.1

/ A crate with a piece of tree trunk, partly fossilized.

Crate E D.

/ Small box of flowers with serious water damage.
Reduced size copy, about a *quarta* and a half square, of Raphael's Madonna della Seggiola.

[fol.15]

First Consignment

Number 1.
Two Boys painted in oil half-length, one in the style of Rubens. *
[added in the margin] taken to the Protector's house. *
Three tempera paintings with gilded frames; two of them of Aurora, and Ariadne; copies of Guido Rheni, and the other of a nuptial bed.
Two centaurs, also in tempera smaller *

Number 2
// Six life-size marble heads: five seem to be ancient, and the other is a copy of the Medici Venus. *
A Vase of different marbles with its handles
/ Two marble funerary Urns with their lids, and ancient inscriptions, adorned with festoons, small animals etc; one is square and the other round.

Num°. 3°.

// Tres tomos de la literatura italiana de Tiraboshi, y son el 9°. y el 10. y el 11°.

Pedazo de cornisamiento de marmol con niños esculpidos en el friso, y parece parte de una chimenea de que se hablara. [anotado al margen] todo lo que corresponde à esta chimenea se dio de orden del Sr. Protector al Principe p.a la Casita del Pardo.

Num°. 4°.

Grupo de dos Jovenes en marmol, y parecen un Bacante, y una Bacante, con su peana, copia del antiguo, como de un vara de alto.

// Otro grupo de igual tamaño y materia, tambien copia del antiguo, y son dos figuritas besándose. *

Num°. 5

// Tres urnas cinerarias, ò sepulcrales de marmol, con diversos ornatos; dos de ellos con sus cubiertas, è inscripciones, y una sin inscripción, ni cubierta. *

Pedestal redondo de verde antiguo, con basa, y coronación de mármol blanco, como media vara de alto.

// Una cabecita de muger, antigua de marmol. *

/ Retrato en chico de un caball°., de marmol.

Num°. 6

Dos columnas istriadas de orden dorico, y de marmol, y son de cinco quartos de alto: parecen destinadas para chimenea.[anotado al margen] dado pa. la chimenea

Numero 7.

Dos figuritas de marmol que representan Bacantes; una de tres quartas de alto, y otra más pequeña. [anotado al margen] dadas con la chimenea

Num°. 8

Cinco pedazos de marmol al parecer parte de la citada chimenea; tres de ellos con ornato de flores, y la pieza mayor es de mas de seis quartas. [anotado al margen] tambien

Num°. 9

// Figurita de Palas de marmol, como de una vara de alto, copa. del antiguo

// Una de la misma materia mas pequeña que representa à Diana, copia del antiguo

Grupo dela Bacante, y el Bacante arriba expresados, y de igual tamaño, y materia, cop.a del antiguo * [anotado al margen] con la chimenea

Number 3.

/ Three volumes of Tiraboshi's Italian literature, namely the 9th, 10th and 11th.

Large piece of marble entablature with children sculpted on the frieze, seemingly part of a mantelpiece that will be dealt with later [added in the margin] everything relating to this mantelpiece was sent on the Protector's orders to the Casita del Príncipe at El Pardo.

Number 4.

Group of two Young People in marble, seemingly a Bacchant, and a Bacchante, with its pedestal, copy from the Antique, about one *vara* high.

/ Another group of the same size and material, also a copy from the Antique, of two small figures kissing. *

Number 5

// Three cinerary urns, or marble sepulchres, with diverse ornaments; two with their lids, and inscriptions, and the third with neither. *

Round pedestal of verde antico, with base, and top part of white marble, about half a *vara* high.

/ A small head of a woman, antique in marble. *

/ A small portrait of a gentleman, in marble.

Number 6

Two fluted columns of the Doric order, made of marble, five fluted *quartas* high: they seem to be intended for a mantelpiece. [added in the margin] given for the mantelpiece

Number 7.

Two small figures in marble representing Bacchantes; one of three *quartas* high, and the other one smaller. [added in the margin] Given with the mantelpiece

Number 8

Five pieces of marble apparently part of the said mantelpiece; three of them with flower ornamentation; the largest piece is over six *quartas*. [added in the margin] also [sent]

Number 9

/// Small figure of Pallas in marble, about one *vara* high, copy after the Antique

/// A smaller one of the same material representing Diana, copy after the Antique

Group of the Bacchant and Bacchante referred to above, of the same size, and material, after the Antique * [added in the margin] with the mantelpiece

Num°. 10.
Pedestal quadrado de marmol de algo mas de un pie en quadro

Numero 11
Canastillo de flores, y frutas de marmol, de un pie de alto, y parece parte de la expresada chimenea [anotado al margen] con la chimenea

Num°. 12
Una cabeza grande de Bacante, de marmol, copia del antiguo, de mas de tres quartas de alto con su peana redonda *

Numero 13.
Dos mesas con embutidos de diversos marmoles, y colores, en parte faltas, y rotas.

Num°. 14.
Dos losas de 7. quartas de largo, y tres de ancho, de marmol pardo venado.

Numero 15.
// Dos pedestales, ò Aras triangulares antiguas de marmol, demas de tres quartas, cada una con diversos ornatos, y labores *

Num°. 16
// Otras dos del mismo tamaño, y materia, tambien con ornatos *

Number 10.
Square marble pedestal of slightly over one *pie* square

Number 11
Marble basket of fruit and flowers, one *pie* high, seemingly part of the above mentioned mantelpiece [added in the margin] with the mantelpiece

Number 12
A large head of a Bacchant, in marble, after the Antique, over three *quartas* high with its round base*

Number 13.
Two tables with inlay in various marbles, and colors, some parts with pieces missing, or broken.

Number 14.
Two slabs measuring 7 *quartas* long, and three wide, of veined grey-brown marble.

Number 15.
// Two pedestals, or classical triangular Altars in marble, of more than three *quartas* high, each one with different ornamentation, and carving *

Number 16
// Another two of the same size, and material, and also with ornamentation*

Bibliography

Albani 1783. Giuseppe Andrea Albani. *Catastro delle tenute dell'agro Romano format per ordine di nostro signoroe Papa Pio Sesto.* Rome: Stamperia della Reverenda Camera Apostolico, 1783.

Alonso Rodríguez 2006. María del Carmen Alonso Rodríguez. "Documenti per lo studio degli scavi di Ercolano, Pompei e Stabia nel secolo XVIII sotto il patrocinio di Carlo III." *Rivista Storica del Sannio*, 3rd ser., 24 (2006).

Andrew 1986a. Patricia R. Andrew. "Jacob More and the Earl-Bishop of Derry." *Apollo* 124 (Aug. 1986).

Andrew 1986b. Patricia R. Andrew. "The Watercolours of Jacob More, 1740–93." In *Old Water-colour Society's Club Sixty-first Annual Volume*, ed. James Knox. London: Bankside Gallery, 1986.

Andrew 1989–90. Patricia R. Andrew. "Jacob More: Biography and Checklist of Works." *Walpole Society* 55 (1989–90).

Annual 1822. *Annual Biography and Obituary.* London: Longman, 1822.

Arizzoli-Clémentel 1985. Pierre Arizzoli-Clémentel. "Les envois de la couronne à l'Académie de France à Rome au XVIIIe siècle." *Revue de l'art* 68 (1985).

Ashby 1924. Thomas Ashby. "Topographical Notes on Cozens." *Burlington Magazine* 45 (Oct. 1924).

Ashmole 1929. Bernard Ashmole. *Catalogue of the Ancient Marbles at the Ince Blundell Hall.* Oxford: Clarendon Press, 1929.

Ayres 1997. Philip Ayres. *Classical Culture and the Idea of Rome in Eighteenth-Century England.* Cambridge: Cambridge Univ. Press, 1997.

Azara 1780a. José Nicolás de Azara. *Obras de D. Antonio Rafael Mengs, primer pintor de cámara del rey.* Madrid: En la Imprenta Real de la Gazeta, 1780.

Azara 1780b. José Nicolás de Azara, ed. *Opere di Antonio Raffaello Mengs, primo pittore della maestà di Carlo III. re di Spagna.* Parma: Stamperia Reale, 1780.

Azara and Fea 1787. José Nicolás de Azara and Carlo Fea. *Opere di Antonio Raffaello Mengs, primo pittore del Re cattolico Carlo III.* Rome: Pagliarini, 1787.

Azcue Brea 1994. Leticia Azcue Brea. *La escultura en la Real Academia de Bellas Artes de San Fernando: Catalogo y estudio.* Madrid: Real Academia de Bellas Artes de San Fernando, 1994.

Baldinucci 1681–1728. Filippo Baldinucci. *Notizie de' professori del disegno da Cimabue in qua.* 6 vols. Florence: Per Santi Franchi, 1681–1728.

Banks 1938. Thomas Banks. *Annals of Thomas Banks*, ed. C. F. Bell. Cambridge: Cambridge Univ. Press, 1938.

Baretti 1789. Giuseppe Marco. Baretti. *Guide through the Royal Academy.* London, 1781.

Barker 2009. Elizabeth E. Barker. "Documents Relating to Joseph Wright of Derby." *Walpole Society* 71 (2009).

Barreiro 1992. Agustín J. Barreiro. *El Museo Nacional de Ciencias Nacionales, 1771–1935.* Aranjuez: Doce Calles, 1992.

Barricelli 1969. Anna Barricelli, ed. *Mostra di incisioni di Salvator Rosa.* Exh. cat. Soprintendenza alle gallerie e alle opere d'arte del Piemonte 2. Turin: Galleria Sabauda, 1969.

Barroero and Mazzocca 2008. Liliana Barroero and Fernando Mazzocca, eds. *Pompeo Batoni, 1708–1787: L'Europa delle Corti e il Grand Tour.* Exh. cat. Milan: Silvana, 2008.

Barron Watson 1884. Paul Barron Watson. *Marcus Aurelius Antoninus.* London: Harper & Brothers, 1884.

Barry 1809. James Barry. *The Works of James Barry*, ed. Edward Fryer. 2 vols. London: T. Cadell and W. Davies, 1809.

Bedat 1989. Claude Bedat. *La Real Academia de Bellas Artes de San Fernando (1744–1808): Contribución al estudio de las influencias estilísticas y de la mentalidad artística en la España del siglo XVIII.* Madrid: Fundación Universitaria Española; Real Academia de Bellas Artes de San Fernando, 1989.

Belda Navarro 2008. Cristóbal Belda Navarro. *Floridablanca, 1728–1808: La utopía reformadora.* Exh. cat. Murcia: Comunidad Autónoma de la Región de Murcia; Sociedad Estatal de Conmemoraciones Culturales; Ayuntamiento de Murcia; Fundación Cajamurcia, 2008.

C. F. Bell 1938. C. F. Bell, ed. *Annals of Thomas Banks, Sculptor, Royal Academician.* Cambridge: Cambridge Univ. Press, 1938.

C. F. Bell and Girtin 1934–35. C. F. Bell and Thomas Girtin. "The Drawings and Sketches of John Robert Cozens: A Catalogue with an Historical Introduction." *Walpole Society* 23 (1934–35).

C. F. Bell and Girtin 1947. C. F. Bell and Thomas Girtin. *The Sketches and Drawings of John Robert Cozens: Some Additions and Notes to the Twenty-third Volume of the Walpole Society.* London: Oxford Univ. Press, 1947.

C. G. Bell 1954. Charles G. Bell. "Fairfax's Tasso." *Comparative Literature* 6, no. 1 (Winter 1954).

Bellori 1672. Giovanni Pietro Bellori. *Le vite dei pittori, scultori ed architetti moderni*. Rome, 1672.

Berkeley 1948–57. George Berkeley. *The Works of George Berkeley, Bishop of Cloyne*, ed. Arthur A. Luce and Thomas E. Jessop. 9 vols. London: Nelson, 1948–57.

Bermingham 1995. Ann Bermingham. "Elegant Females and Male Connoisseurs: The Commerce in Culture and Self-image in Eighteenth-Century England." In *The Consumption of Culture, 1600–1800: Image, Object, Text*, ed. Ann Bermingham and John Brewer. London: Routledge, 1995.

Bermingham 2000. Ann Bermingham. *Learning to Draw: Studies in the Cultural History of a Polite and Useful Art*. New Haven and London: Yale Univ. Press, 2000.

Bernard 1978. Catherine Bernard. *Crosscurrents: French and Italian Neoclassical Drawings and Prints from the Cooper-Hewitt Museum*. Washington, DC: Published for Cooper-Hewitt Museum by Smithsonian Institution Press, 1978.

Bernini Passini 1988. Grazia Bernini Passini. "Giovanni Volpato: Un Bassanese a Roma." In *Giovanni Volpato, 1735–1803*, ed. Giorgio Marini. Bassano, Italy: Ghedina & Tassotti, 1988.

Berry 1866. Mary Berry. *Extracts from the Journals and Correspondence of Miss Berry from the Year 1783 to 1852*, ed. Lady Theresa Lewis. 3 vols. 2nd ed. London: Longmans, Green, 1866.

Bevilacqua 1998. Mario Bevilacqua. *Roma nel Secolo dei Lumi: Architettura erudizione scienza nella Pianta di G. B. Nolli "celebre geometra."* Naples: Electa, 1998.

Bevilacqua 2004. Mario Bevilacqua. *Nolli, Vasi, Piranesi: Immagine di Roma Antica e Moderna; Rappresentare e conoscere la metropoli dei Lumi*. Rome: Artemide, 2004.

Bianconi 1780. Gian Ludovico Bianconi. *Elogio storico del Cavaliere Anton Raffaele Mengs scritto dal Consiglier Bianconi con un Catalogo in fine delle Opere da esso fatte*. Milan: Imperial Monistero di S. Ambrogio Maggiore, Giuseppe Galeazzi, 1780.

Bibliothèque Nationale de France. Bibliothèque Nationale de France. Online catalogue, accessed May 31, 2011, http://catalogue.bnf.fr/servlet/biblio?idNoeud=1&ID=31272137&SN1=0&SN2=0&host=catalogue.

Biddle-Perry and Cheang 2008. Geraldine Biddle-Perry and Sarah Cheang. *Hair: Styling, Culture, and Fashion*. Oxford, New York: Berg, 2008.

Bignamini 2010. Ilaria Bignamini. Introduction to Bignamini and Hornsby 2010.

Bignamini and Hornsby 2010. Ilaria Bignamini and Clare Hornsby. *Digging and Dealing in Eighteenth-Century Rome*, with additional research by Irma Della Giovampaoloa and Jonathan Yarker. 2 vols. New Haven and London: Yale Univ. Press, 2010.

Bilbey and Trusted 2002. Diane Bilbey and Marjorie Trusted. *British Sculpture, 1470–2000: A Concise Catalogue of the Collection at the Victoria and Albert Museum*. London: V&A Publications, 2002.

Black 1992. Jeremy Black. *The British Abroad: The Grand Tour in the Eighteenth Century*. Stroud, UK: Sutton; New York: St. Martin's Press, 1992.

Black 2003. Jeremy Black. *The British Abroad: The Grand Tour in the Eighteenth Century*. London: Sutton, 2003.

Blake 1934. George Blake. *Lloyd's Register of Shipping, 1760 to 1960*. London: Lloyd's Register of Shipping, 1934.

Blázquez 1989. José M. Blázquez. "Retratos de los emperadores Vitelio y Antonino Pío." *Academia: Boletín de la Real Academia de Bellas Artes de San Fernando*, no. 68 (1989).

Boase 1890. George Clement Boase. *Collectanea Cornubiensia, a Collection of Biographical and Topographical Notes Relating to the County of Cornwall*. Truro, 1890.

Bolton 1922. Arthur T. Bolton. *The Architecture of Robert and James Adam*. 2 vols. London: Country Life and George Newnes, 1922.

Bolton 1924. Arthur T. Bolton. *The Portrait of Sir John Soane, RA (1753–1837) Set Forth in Letters from His Friends (1775–1837)*. London: Sir John Soane's Museum, 1924.

Borea and Mariani 1986. Evelina Borea and Ginevra Mariani, eds. *Annibale Carracci e i suoi incisori*. Exh. cat. Rome: Istituto Nazionale per la Grafica and École française de Rome, 1986.

Borean and Mason 2009. Linda Borean and Stefania Mason, eds. *Il collezionismo d'arte a Venezia*. Venice: Fondazione di Venezia, 2009.

Borroni Salvadori 1985. Fabia Borroni Salvadori. "In Galleria gli artisti e i viaggiatori algi Uffizi nel Settecento." *Labyrinthos* 4, nos. 7–8 (1985).

Bourrit 1776. Marc Théodore Bourrit. *A Relation of a Journey to the Glaciers in the Dutchy of Savoy*, trans. Charles and Frederick Davy. 2nd ed. Norwich: Richard Beatniffe, 1776.

Bowron and Kerber 2007. Edgar Peters Bowron and Peter Björn Kerber. *Pompeo Batoni: Prince of Painters in Eighteenth-Century Rome*. Exh. cat. New Haven and London: Yale Univ. Press in association with the Museum of Fine Arts, Houston, 2007.

Bowron and Rishel 2000. Edgar Peters Bowron and Joseph J. Rishel, eds. *Art in Rome in the Eighteenth Century*. London: Merrell in association with Philadelphia Museum of Art, 2000.

Bozzolato 1973. Giampiero Bozzolato. *Le incisioni di Salvatore Rosa: Catalogo generale*. Padua: Marsilio Editori, 1973.

Brady and Pottle 1955. Frank Brady and Frederick A. Pottle, eds. *Boswell on the Grand Tour: Italy, Corsica and France, 1765–66*. New Haven: Yale Univ. Press, 1955.

Bragantini and Sampaolo 2009. Irene Bragantini and Valeria Sampaolo. *La pittura pompeiana*. Naples: Electa; Soprintendenza archeologica Napoli e Pompei, 2009.

Brook and Curzi 2010. Carolina Brook and Valter Curzi. *Roma e l'Antico: Realtà e visione nel '700*. Milan: Skira, 2010.

Brown 1996. Iain Gordon Brown. "The 'Real' Pietro Fabris? A Caricature of Sir William Hamilton's 'Favourite Painter.'" *Apollo* 413 (1996).

Brunel 1978. Georges Brunel, ed. *Piranèse et les Français*. Rome: Edizioni dell'Elefante for L'Académie de France à Rome, 1978.

Buchanan 1824. William Buchanan. *Memoirs of Painting: With a chronological history of the importation of pictures by the great masters into England since the French Revolution.* 2 vols. London: Rudolf Ackermann, 1824.

Bull 1981. Duncan Bull. *Classic Ground: British Artists and the Landscape of Italy, 1740–1830.* Exh. cat. New Haven: Yale Center for British Art, 1981.

Burke 1832. John Burke. *A General and Heraldic Dictionary of the Peerage and Baronetage of the British Empire.* 4th ed. Vol. 1. London: Henry Colburn and Richard Bentley, 1832.

Carlos III 1988. Carlos III. *Carlos III: Cartas a Tanucci (1759–1763),* introduction, transcription, notes by Maximiliano Barrio. Madrid: BBV / Ediciones Turner, 1988.

Catalina 1872. Manuel Catalina. "Urnas cinerarias con relieves del Museo Arqueológico Nacional." *Museo Español de Antigüedades* 1(1872).

Catholic Encyclopedia 1910. *The Catholic Encyclopedia.* 15 vols. Vol. 7, s.v. "John Joseph Hornyold." New York: Robert Appleton, 1910.

Ceen 2000. Allan Ceen. "Giambattista Nolli." In Bowron and Rishel 2000.

Cesareo 2002. Antonello Cesareo. "Gavin Hamilton (1723–1798): 'A Gentleman of Probity, Knowledge and Real Taste,'" *Saggi e memorie di storia dell'arte* 26 (2002).

Cesareo 2009. Antonello Cesareo. "'He Had for Years the Guidance of the Taste in Rome': Per un profio di Thomas Jenkins." In *Collezionisti, disegnatori e teorici dal Barocco al Neoclassico,* ed. Elisa Debenedetti. Rome: Bonsignori, 2009.

Chambers 1791. *Treatise on the [Decorative Part of] Civil Architecture.* London: Joseph Smeeton, 1791.

Chaney 1998. Edward Chaney. *The Evolution of the Grand Tour: Anglo-Italian Cultural Relations since the Renaissance.* London: Frank Cass, 1998.

Chard 1999. Chloe Chard. *Pleasure and Guilt on the Grand Tour: Travel Writing and Imaginative Geography, 1600–1830.* Manchester: Manchester Univ. Press, 1999.

Chessex 1985. Pierre Chessex. "Historical and Biographical Notes." In *Images of the Grand Tour: Louis Ducros, 1748–1810.* Exh. cat. Geneva: Editions du Tricorne, 1985.

Chesterfield 1932. *The Letters of Philip Dormer Stanhope, 4th Earl of Chesterfield,* ed. Bonamy Dobree. 6 vols. New York: AMS Press, 1932.

Ciavarella 1979. Angelo Ciavarella. *De Azara–Bodoni.* 2 vols. Parma: Museo Bodoniano, 1979.

Cipriani 2000. Angela Cipriani. *Aequa potestas: Le arti in gara a Roma nel Settecento.* Rome: De Luca, 2000.

Clark and Bowron 1985. Anthony M. Clark. *Pompeo Batoni: A Complete Catalogue of His Works with an Introductory Text,* ed Edgar Peters Bowron. New York: New York Univ. Press; Oxford: Phaidon, 1985.

Clarke and Penny 1982. Michael Clarke and Nicholas Penny, eds. *The Arrogant Connoisseur: Richard Payne Knight, 1751–1824.* Manchester: Manchester Univ. Press and Whitworth Art Gallery, 1982.

Cochin 1758. Charles-Nicolas Cochin. *Voyage d'Italie, ou Recueil de notes sur les ouvrages de peinture & de sculpture, qu'on voit dans les principales villes d'Italie.* 3 vols. Paris: Chez Ch. Ant. Jombert, Imprimeur-Libraire du Roi, pour l'Artillerie & le Génie, rue Dauphine, 1758.

Coen 2002. Paolo Coen. "L'attività di mercante d'arte e il profilo culturale di James Byres of Tonley." *Roma moderna e contemporanea* 10 (2002).

Coen 2010. Paolo Coen. *Il mercato dei quadri a Roma nel Diciottesimo Secolo: La domanda, l'offerata e la circolazione delle opere in un grande centro artistico europeo.* 2 vols. Florence: L. S. Olschki, 2010.

Cohn 2000. Ellen R. Cohn. "Benjamin Franklin, Georges-Louis Le Rouge and the Franklin / Folger Chart of the Gulf Stream." *Imago Mundi* 52 (2000).

Cole 1973. Bruce Cole. "Art Historians and Art Critics—X: Giovanni Lami's Dissertazione." *Burlington Magazine* 115 (July 1973).

Colley 2003. Linda Colley. *Captives: Britain, Empire and the World, 1600–1850.* London: Pimlico, 2003.

Collins 2004. Jeffrey Collins. *Papacy and Politics in Eighteenth-Century Rome: Pius VI and the Arts.* Cambridge: Cambridge Univ. Press, 2004.

Coltman 2003. Viccy Coltman. "'Providence Send Us a Lord': Joseph Nollekens and Bartolomeo Cavaceppi at Shugborough." *Acta Hyperborea* 10 (2003).

Coltman 2006. Viccy Coltman. *Fabricating the Antique: Neoclassicism in Britain, 1760–1800.* Chicago: Univ. of Chicago Press, 2006.

Coltman 2009. Viccy Coltman. *Classical Sculpture and the Culture of Collecting in Britain since 1760.* New York: Oxford Univ. Press, 2009.

Colvin 2008. Howard Colvin. *A Biographical Dictionary of British Architects, 1600–1840.* 4th ed. New Haven and London: Yale Univ. Press, 2008.

Cooke 2010. Lisa Cooke. "The 19th Century Corsi Collection of Decorative Stones: A Resource for the 21st Century?." In *Natural Stone Resources for Historical Monuments,* ed. Richard Přikryl and Ákos Török. Special Publications 333. London: Geological Society, 2010.

Cope 1995. Jackson I. Cope. "Goldoni's England and England's Goldoni." Italian issue, *Modern Language Notes* 110, no. 1 (Jan. 1995).

Cordingly 1986. David Cordingly. *Nicholas Pocock, 1740–1821.* London: Conway Maritime Press in association with the National Maritime Museum, 1986.

Corp 2003. Edward Corp, ed. *The Stuart Court in Rome: The Legacy of Exile.* Aldershot, UK: Ashgate, 2003.

Cox and Dannehl 2007. Nancy Cox and Karin Dannehl. *Dictionary of Traded Goods and Commodities, 1550–1820.* Wolverhampton, UK: Univ. of Wolverhampton, 2007, accessed Aug. 20, 2010, http://www.british-history.ac.uk/source.aspx?pubid=739.

Crookshank and Glin 2002. Anne Crookshank and the Knight of Glin. *Ireland's Painters, 1600–1940.* New Haven and London: Yale Univ. Press, 2002.

Dacos 2008. Nicole Dacos. *The Loggia of Raphael: A Vatican Art Treasure.* New York: Abbeville Press, 2008.

d'Agliano and Melegati 2008. Andreina d'Agliano and Luca Melegati, eds. *Ricordi dell'antico: Sculture, porcellane e arredi all'epoca del Grand Tour.* Exh. cat. Rome: Musei Capitolini, 2008.

Damer Powell 1930. J. W. Damer Powell. *Bristol Privateers and Ships of War.* Bristol: J. W. Arrowsmith, 1930.

Darley 1999. Gillian Darley. *John Soane: An Accidental Romantic.* New Haven and London: Yale Univ. Press, 1999.

Davies 2000. Glenys Davies. "The Inscriptions on the Ash Chests of the Ince Blundell Hall Collection: Ancient and Modern." In *The Epigraphy of Death: Studies on the History and Society of Greece and Rome,* ed. Graham John Oliver. Liverpool: Liverpool Univ. Press, 2000.

Davis 1967. Ralph Davis. *Aleppo and Devonshire Square.* London: Macmillan, 1967.

Dawson 1999. Aileen Dawson. *Portrait Sculpture: A Catalogue of the British Museum Collection, ca. 1675–1975.* London: British Museum, 1999.

De Breffny 1986. Brian De Breffny. "Christopher Hewetson: Biographical Notice and Preliminary Catalogue Raisonné." *Irish Arts Review* 3, no. 3 (1986).

de Divitiis 2007. Bianca de Divitiis. "New Evidence for Sculptures from Diomede Carafa's Collection of Antiquities." *Journal of the Warburg and Courtauld Institutes* 70 (2007).

de Jong 2010. Sigrid de Jong. "Staging Ruins: Paestum and Theatricality." *Art History* 33 (April 2010).

De la Cruz Alcañiz 2009. Cándido de la Cruz Alcañiz, ed. *Francisco Preciado de la Vega: Un pintor Español del siclo XVIII en Roma.* Madrid: Real Academia de Bellas Artes de San Fernando, 2009.

De Lucchi, Lowe, and Pavanello 2010. Michele De Lucchi, Adam Lowe, and Giuseppe Pavanello, eds. *Le arti di Piranesi: Architetto, incisore, antiquario, vedutista, designer.* Exh. cat. Venice: Marsilio Editori for Fondazione Giorgio Cini, 2010.

Dennistoun 1855. James Dennistoun. *Memoirs of Sir Robert Strange, Knt., Engraver . . . and of his brother-in-law Andrew Lumisden, private secretary to the Stuart Princes. . . .* 2 vols. London: Longman, Brown, Green, and Longmans, 1855.

de Vos 1993. Mariette de Vos. "Camillo Paderni, la tradizione antiquaria romana e i collezionisti inglesi." In *Ercolano, 1738–1988: 250 anni di ricerca archeologica,* ed. Luisa Franchi dell'Orto. Rome: "L'Erma" di Bretschneider, 1993.

d'Hancarville 1766–67. Pierre d'Hancarville. *Collection of Etruscan, Greek and Roman antiquities from the cabinet of the Honble. Wm. Hamilton, his Britannick Majesty's envoy extraordinary at the court of Naples.* Naples: printed by Francesco Morelli, 1766–67.

Diario 1777. *Diario ordinario di Roma,* no. 310 (1777).

Disney 1808. John Disney. *Memoirs of Thomas Brand-Hollis.* London: T. Gillet, 1808.

Downs 2011. Anneliese Downs. "Schwindl, Friedrich." In *Grove Music Online. Oxford Music Online,* accessed Dec. 2, 2011, http://www.oxfordmusiconline.com/subscriber/article/grove/music/25222.

du Prey 1982. Pierre de la Ruffinière du Prey. *John Soane: The Making of an Architect.* Chicago: Univ. of Chicago Press, 1982.

Eckardt 1985. Götz Eckardt, ed. *Das italienische Reisetagebuch des Prinzen August von Sachsen-Gotha-Altenburg, des Freundes von Herder, Wieland und Goethe.* Stendal, Ger.: Winckelmann-Gesellschaft, 1985.

Eddy 1976. Linda R. Eddy. "An Antique Model for Kauffmann's Venus Persuading Helen to Love Paris." *Art Bulletin* 58 (Dec. 1976).

Einem 1973. Herbert von Einem. "Anton Raphael Mengs: Briefe an Raimondo Ghelli und Anton Maron." In *Abhandlungen der Akademie der Wissenschaften in Göttingen.* Göttingen: Vandenhoeck & Ruprecht, 1973.

Ellis 1846. Henry Ellis. *The Townley Gallery of Classic Sculpture in the British Museum.* 2 vols. London: M. A. Nattali, 1846.

Emiliani 1996. Andrea Emiliani. *Leggi bandi e provvedimenti per la tutela dei beni artistici e culturali negli antichi stati italiani, 1571–1860.* Bologna: Nuova Alfa, 1996.

Esdaile 1947. Katharine A. Esdaile. "Christopher Hewetson and His Monument to Dr. Baldwin in Trinity College, Dublin." *Journal of the Royal Society of Antiquaries of Ireland* 77 (1947).

Espinós Díaz 2011. Adela Espinós Díaz. "Sanchis [Sánchez], Mariano (Ramón)." In *Grove Art Online. Oxford Art Online,* accessed Aug. 22, 2011, www.oxfordartonline.com:80/subscriber/article/grove/art/T075613.

Eustace 1821. John Chetwode Eustace. *A Classical Tour through Italy, an. MDCCCII.* 6th ed. 4 vols. London: J. Mawman, 1821.

Faedo 2000. Lucia Faedo. "Percorsi settecenteschi verso una storia della pittura antica: Bellori e il suo contesto." In *L'Idea del Bello: Viaggio per Roma nel Seicento con Giovan Pietro Bellori.* Rome: De Luca, 2000.

Fairbairn 1998. Lynda Fairbairn. *Italian Renaissance Drawings from the Collection of Sir John Soane's Museum.* London: Azimuth, 1998.

Falomir Faus 2003. Miguel Falomir Faus. "Tiziano: Réplicas." In *Tiziano,* ed. Miguel Falomir Faus. Exh. cat. Madrid: Museo del Prado, 2003.

Farington 1978–98. Joseph Farington. *Diary of Joseph Farington, 1784–1821,* ed. Kenneth Garlick, Angus Macintyre, and Kathryn

Cave. 17 vols. New Haven and London: Yale Univ. Press, 1978–98.

Ficacci 2000. Luigi Ficacci. *Piranesi: The Complete Etchings.* Cologne: Taschen, 2000.

Figgis 1986. Nicola Figgis. "Irish Artists and Society in Eighteenth-Century Rome." *Irish Arts Review* 3 (Autumn 1986).

Figgis 1987. Nicola Figgis. "Irish Landscapists in Rome, 1750–1780." *Irish Arts Review* 4 (Winter 1987).

Figgis 1998. Nicola Figgis. "Raphael's Transfiguration: Some Irish Grand Tour Associations." *Irish Arts Review Yearbook* 14 (1998).

Figgis and Rooney 2001. Nicola Figgis and Brendan Rooney. *Irish Paintings in the National Gallery of Ireland,* ed. Elizabeth Mayes. 3 vols. Dublin: National Gallery of Ireland, 2001.

Fiorelli 1865. Giuseppe Fiorelli. *Pompeianarum Antiquitatum Historia.* Naples, 1865.

Fittschen and Zanker 1983. Klaus Fittschen and Paul Zanker. *Katalog der Römische Porträts in den Capitolinischen Museen und den Anderen Komunalen Sammlungen der Stadt Rom.* Vol. 3, *Kaiserinnen- und Prinzessinnenbildinisse: Frauenporträts.* Beiträge Zur Erschliessung Hellensticher und Kaiserzeitlicher Skulptur und Architektur 5. 3 vols. Mainz: Philipp von Zabern, 1983.

Focillon 1963. Henri Focillon. *Piranesi.* Paris: Librairie Renovard H. Laurens, 1963.

Ford 1974. Brinsley Ford. "Thomas Jenkins: Banker, Dealer and Unofficial Agent." *Apollo* 99 (June 1974).

Fothergill 1979. Brian Fothergill. *Beckford of Fonthill.* London and Boston: Faber and Faber, 1979.

Frank 2001. Christoph Frank. "'Plus il y en aura, mieux ce sera': Katharina II von Russland und Anton Raphael Mengs. Zur Rolle ihrer Agenten Grimm und Reiffenstein." In *Mengs, die Erfindung des Klassizismus,* ed. Steffi Roettgen. Munich: Hirmer Verlag, 2001.

Frischer and Brown 2001. Bernard D. Frischer and Iain Gordon Brown, eds. *Allan Ramsay and the Search for Horace's Villa.* Aldershot, UK: Ashgate, 2001.

Frutaz 1962. Amato Pietro Frutaz, *Le piante di Roma.* 3 vols. Rome: Istituto di studi romani, 1962.

García Sánchez and de la Cruz Alcañiz 2010. Jorge García Sánchez and Cádido de la Cruz Alcañiz. "Piazza Barberini: A Spanish Artists' District in Eighteenth-Century Rome." *Burlington Magazine* 152 (Oct. 2010).

Gasparri 1982. Carlo Gasparri. "La Galleria Piranesi da Giovan Battista Piranesi a Francesco." *Xenia* 3 (1982).

Gavuzzo-Stewart 1999. Silvia Gavuzzo-Stewart. *Nelle Carceri di G. B. Piranesi.* Leeds: Northern Universities Press, 1999.

Gerard 2006. William Blake Gerard. *Laurence Sterne and the Visual Imagination.* Aldershot, UK, and Burlington, Vt.: Ashgate, 2006.

Gerbod 1995. Paul Gerbod. *Histoire de la coiffure et des coiffeurs.* Paris: Larousse, 1995.

Gibbon 1984. Edward Gibbon. *Memoirs of My Life,* ed. Betty Radice. London: Penguin, 1984.

Gilbert 1820. Charles Sandoe Gilbert. *An Historical Survey of the County of Cornwall.* 2 vols. Plymouth and London: J. Congdon, 1820.

Gilet 2007. Annie Gilet, ed. *Giovanni Volpato: Les Loges de Raphael et la Galerie du Palais Farnèse.* Exh. cat. Milan: Silvana Editoriale, 2007.

Gimeno and Stylow 1999. Helena Gimeno and Armin Stylow. "Analecta epigraphica hispánica: Manuscritos, calcos, dibujos, duplicaciones." *Sylloge Epigraphica Barcinonensis* 3 (1999).

Goethe 1994. Johann Wolfgang von Goethe. *Italian Journey,* ed. Thomas S. Paine and Jeffrey L. Sammons, trans. Robert. R. Heitner. Princeton, NJ: Princeton Univ. Press, 1994.

Goldoni 1994. Carlo Goldoni. *Memorie,* ed. Guido Davico Bonino. Milan: Einaudi Tascabili-Classici, 1994.

Gomis 2011. Alberto Gomis Blanco. *Hace cien años: El museo estrenó sede, 1910–2010.* Madrid: Museo Nacional de Ciencias Naturales del Consejo Superior de Investigaciones Científicas, 2011.

González-Palacios 2008. Alvar González-Palacios. "Souvenirs de Rome." In d'Agliano and Melegati 2008.

Gordon 1951. Thomas Crouther Gordon. *David Allan of Alloa, 1744–1796: The Scottish Hogarth.* Alva, Scotland: R. Cunningham & Sons, 1951.

Grandesso 2008. Stefano Grandesso. "Bacco e Arianna." In Barroero and Mazzocca 2008.

Gray 1794. Robert Gray. *Letters during the course of a tour through Germany, Switzerland, and Italy, in the years M.DCC.XCI, and M.DCC.XCII: With reflections on the manners, literature, and religion of those countries.* London: F. and C. Rivington, 1794.

Gregori et al. 1984. Mina Gregori et al. *Raffaello a Firenze: Dipinti e disegni delle collezioni fiorentine.* Florence: Electa, 1984.

Gribble 1899. Francis H. Gribble. *The Early Mountaineers.* London: T. Fisher Unwin, 1899.

Gribble 1914. Francis H. Gribble. "The Celebrities of Geneva." In *Seeing Europe with Famous Authors.* Vol. 6, *Germany, Austria-Hungary, and Switzerland, Part 2,* ed. Francis W. Halsey. New York and London: Funk and Wagnalls, 1914.

Gutch and Wood 1790. John Gutch and Anthony Wood, eds. *Appendix to the History and Antiquities of the Colleges and Halls in the University of Oxford.* Oxford: Clarendon Press, 1790.

I. Hall 1970. Ivan Hall. *William Constable as Patron, 1721–1791.* Exh. cat. Kingston upon Hull: Ferens Art Gallery, 1970.

M. Hall 1997. Marcia Hall, ed. *Raphael's School of Athens.* Cambridge: Cambridge Univ. Press, 1997.

Hamilton 1773. Gavin Hamilton. *Schola Italica Picturae.* Rome, 1773.

W. Hamilton 1999. Sir William Hamilton. *The Hamilton Papers.* Naples: Associazone Amici dei Musei di Napoli, 1999.

Hardie 1996. Martin Hardie. *Watercolour Painting in Britain*. 3 vols. London: Batsford, 1966.

Hargrove 1798. Ely Hargrove. *The History of the Castle, Town, and Forest of Knaresborough, with Harrogate, and Its Medicinal Waters*. 4th ed. York, 1798.

Harris and Hradsky 2007. John Harris and Robert Hradsky. *A Passion for Building: The Amateur Architect in Britain, 1650–1850*. London: Sir John Soane's Museum, 2007.

Haskell and Penny 1981. Francis Haskell and Nicholas Penny. *Taste and the Antique*. New Haven and London: Yale Univ. Press, 1981.

Hauptman 2001. William Hauptman. "Beckford and Cozens." In *William Beckford, 1760–1844: An Eye for the Magnificent*, ed. Derek E Ostergard. New Haven and London: Yale Univ. Press, 2001.

Hawcroft 1971. Francis Hawcroft. *Watercolours by John Robert Cozens*. Manchester: Whitworth Art Gallery, 1971.

Hawcroft 1988. Francis Hawcroft. *Travels in Italy, 1776–1783: Based on the "Memoirs" of Thomas Jones*. Manchester: Whitworth Art Gallery, 1988.

Heres 2000. Gerald Heres. "Bellori collezionista: Il Museum Bellorianum." In *L'Idea del Bello: Viaggio per Roma nel Seicento con Giovan Pietro Bellori*. Rome: De Luca, 2000.

Hibbert 1987. Christopher Hibbert. *The Grand Tour*. London: Thames Methuen, 1987.

Historical Manuscripts Commission 1899. *Fifteenth Report of the Royal Commission on Historical Manuscripts*. London, 1899.

Hoare 1819. Sir Richard Colt Hoare, *A Classical Tour through Italy and Sicily. . . .* London: printed for J. Mawman, 1819.

Hoare 1822. Richard Colt Hoare. *The Modern History of South Wiltshire*. 4 vols. London: John Bowyer Nichols and John Gough Nichols, 1822.

Hodgkinson 1952–54. Terence Hodgkinson. "Christopher Hewetson: An Irish Sculptor in Rome." *Walpole Society* 34 (1952–54).

Holloway 1987. James Holloway. *Jacob More, 1740–1793*. Scottish Masters 4. Edinburgh: National Galleries of Scotland, 1987.

Honour 1959. Hugh Honour. "Antonio Canova and the Anglo Romans, I." *Connoisseur* 144 (May 1959).

Honour 1989. Hugh Honour. "La decorazione scultorea nel Quirinale Napoleonico." In *Il Palazzo del Quirinale: Il mondo artistico a Roma nel periodo Napoleonico*, ed. Marina Natoli and Maria Antonietta Scarpati. 2 vols. Rome: Istituto Poligrafico e Zecca dello Stato; Libreria dello Stato, 1989.

Hopkinson 2009. Martin Hopkinson. "Cunego's Engravings after Gavin Hamilton." *Print Quarterly* 26, no. 4 (Dec. 2009).

Hornsby 2009. Clare Hornsby. "Serving Lovers of the Virtù: Barazzi, Batoni and the British Dealers." In *Intorno a Batoni: Convegno Internazionale*, ed. Liliana Barroero. Lucca: Edizioni Fondazione Ragghianti studi sull'arte, 2009.

Howard 1973. Seymour Howard. "An Antiquarian Handlist and Beginnings of the Pio-Clementino." *Eighteenth-Century Studies* 7, no. 1 (1973).

Howard 1990. Seymour Howard. *Antiquity Restored: Essays on the Afterlife of the Antique*. Vienna: IRSA, 1990.

Hübner 1862. Emil Hübner. *Die Antiken Bildwerke in Madrid*. Berlin: Georg Reimer, 1862.

Hutton 1885. James Hutton. *Selections from the Letters and Correspondence of Sir James Bland Burges, Bart., Sometime Under-secretary of State for Foreign Affairs: With Notice of His Life*. London: John Murray, 1885.

Imago Urbis 2008. *Giuseppe Vasi's Grand Tour of Rome*. Univ. of Oregon, 2008, accessed Feb. 6, 2012, http://vasi.uoregon.edu.

Ingamells 1997. John Ingamells. *A Dictionary of British and Irish Travellers in Italy, 1701–1800*. New Haven and London: Yale Univ. Press, 1997.

Irwin 1962. David Irwin. "Gavin Hamilton: Archaeologist, Painter, and Dealer." *Art Bulletin* 44 (June 1962).

Jackson-Stops 1985. Gervase Jackson-Stops, ed. *The Treasure Houses of Britain: Five Hundred Years of Private Patronage and Art Collecting*. Exh. cat. Washington, D.C.: National Gallery of Art; New Haven: Yale Univ. Press, 1985.

Jenkins 1999. Ian Jenkins. "Newly Discovered Drawings from the Museo Cartaceo in the British Museum, Cassiano dal Pozzo." In *Atti del Seminario Internazionale di Studio*, ed. Francesco Solinas. Rome: De Luca, 1999.

Jenkins and Sloan 1996. Ian Jenkins and Kim Sloan, eds. *Vases and Volcanoes: Sir William Hamilton and His Collection*. Exh. cat. London: British Museum, 1996.

H. S. Jones 1912. H. Stuart Jones, ed. *A Catalogue of the Ancient Sculptures Preserved in the Municipal Collections of Rome: The Sculptures of the Museo Capitolino, by Members of the British School at Rome*. Oxford: Clarendon Press, 1912.

T. Jones 1946–48. Thomas Jones. "Memoirs of Thomas Jones." ed. A. P. Oppé, *Walpole Society* 32 (1946–48; repr., 1951).

Joyce 1983. Hetty Joyce. "The Ancient Frescoes from the Villa Negroni and Their Influence in the Eighteenth and Nineteenth Centuries." *Art Bulletin* 65 (Sept. 1983).

Joyce 1992. Hetty Joyce. "Grasping at Shadows: Ancient Paintings and Baroque Rome." *Art Bulletin* 74 (June 1992).

Joyner and Sloan 1995. Paul Joyner and Kim Sloan. "A Cozens Album in the National Library of Wales, Aberystwyth." *Walpole Society* 57 (1995).

Keaveney 1988. Raymond Keaveney. *Views of Rome from the Thomas Ashby Collection in the Vatican Library*. London: Scala Books in association with the Biblioteca Apostolica Vaticana and the Smithsonian Institution Traveling Exhibition Service, 1988.

Kenworthy-Browne 1983. John Kenworthy-Browne. "Matthew Brettingham's Rome Account Book, 1747-1754." *Walpole Society* 49 (1983).

Kirk 1909. John Kirk. *Biographies of English Catholics in the Eighteenth Century*. London: Burns & Oates, 1909.

C. Knight 1990. Carlo Knight. *Hamilton a Napoli.* Naples: Electa, 1990.

E. C. Knight 1805. Ellis Cornelia Knight. *Description of Latium or La Campagna di Roma.* London, 1805.

E. C. Knight 1861. Ellis Cornelia Knight, *Autobiography of Miss Cornelia Knight: Lady Companion to the Princess Charlotte of Wales. . . .* 3rd ed. London: W. H. Allen, 1861.

Lachenal 2000. Lucía Lachenal. "La riscoperta della pittura antica nel XVII secolo: Scavi, disegni, collezioni." In *L'Idea del Bello: Viaggio per Roma nel Seicento con Giovan Pietro Bellori.* Rome: De Luca, 2000.

Laing 2009. Alistair Laing. "John Brown as a Painter?." *National Trust: Historic Houses and Collections Annual* 169 (2009).

Lamaro 1996. Emilia Lamaro. *Libri e incisioni della Collezione Kissner.* Rome: Camera dei Deputati, 1996.

Lanciani 2000. Ridolfo Lanciani. *Storia degli scavi di Roma e notizie le collezioni romane di antichità.* 6 vols. Rome: Quasar, 2000.

Lang 1950. Suzanne Lang. "The Early Publications of the Temples at Paestum." *Journal of the Warburg and Courtauld Institutes* 13, nos. 1–2 (1950).

Langdon 2010. Helen Langdon. *Salvator Rosa.* Exh. cat. London: Dulwich Picture Gallery and Kimbell Art Museum in association with Paul Holberton, 2010.

Lawrence and Wilton-Ely 2007. Sarah Lawrence and John Wilton-Ely, eds. *Piranesi as Designer.* New York: Assouline for the Smithsonian, Cooper-Hewitt, National Design Museum, 2007.

Leander Touati 1998. Anne-Marie Leander Touati. "Dealers and Restorers: The Roman Antiquities Market." In *Ancient Sculptures in the Royal Museum: The Eighteenth-Century Collection in Stockholm*, with contributions by Magnus Olausson. Stockholm: Nationalmuseum, 1998.

Le Rouge 2011. "Georges-Louis Le Rouge." Geographicus Fine Antique Maps, accessed July 15, 2011, http://www .geographicus.com/mm5/merchant.mvc?Screen=CAD& Product_Code=lerouge.

Leslie (1843) 1951. Charles Robert Leslie. *Memoirs of the Life of John Constable, Composed Chiefly of His Letters*, ed. Jonathan Mayne. 1843; repr., London: Phaidon Press, 1951.

Lever 1973. Jill Lever, ed. *Catalogue of the Drawings Collection of the Royal Institute of British Architects: G–K.* Farnborough, UK: Gregg International, 1973.

Lever 2003. Jill Lever. *Catalogue of the Drawings of George Dance the Younger (1741–1825) and of George Dance the Elder (1695–1768) from the Collection of Sir John Soane's Museum*, with a contribution from Sally Jeffery. London: Azimuth, 2003.

Lillo 2010. Jacqueline Lillo. "Francesco D'Alberti di Villanuova's Renewal of Bilingual Lexicography." *International Journal of Lexicography* 23 (June 2010).

Linoli 2005. Antonio Linoli. "Twenty-six Centuries of Reclamation & Agricultural Improvement on the Pontine Marshes." In *Integrated Land and Water Resources Management in History: Proceedings of the Special Session on History, International Commission on Irrigation and Drainage, European Regional Conference.* Norderstedt, Ger.: Deutschen Wasserhistorischen Gesellschaft, 2005.

Luxon 1997–. Thomas H. Luxon, ed. *Of Education*, by John Milton (1644). In *The Milton Reading Room* (1997–), http://www. dartmouth.edu/~milton/reading_room/of_education/notes. shtml.

Luzón Nogué 2000. José M. Luzón Nogué. *El Westmorland, obras de arte de una presa inglesa: Discurso leído por el académico electo Excmo. Sr. D. José María Luzón Nogué.* Madrid: printed by author, 2000.

Luzón Nogué 2002a. José M. Luzón Nogué. "Inventarios y marcas de los cajones transportados de Málaga a la Corte." In Westmorland 2002.

Luzón Nogué 2002b. José M. Luzón Nogué. "La captura y venta del *Westmorland.*" In Westmorland 2002.

Luzón Nogué 2002c. José M. Luzón Nogué. "Un cajón con reliquias de santos." In Westmorland 2002.

Luzón Nogué and Sánchez-Jáuregui 2003. José M. Luzón Nogué and María Dolores Sánchez-Jáuregui. "El Westmorland y la Sociedad de Lonjistas de Madrid." *Academia: Boletín de la Real Academia de Bellas Artes de San Fernando*, nos. 96–97 (2003).

Mahon 1988. Dennis Mahon. "Fresh Light on Caravaggio's Earliest Period: His 'Cardsharps' Recovered." *Burlington Magazine* 130 (Jan. 1988).

Maja 1985. Francesco Ambrogio Maja. *Isola di Sicilia Passegiatta: La descriziones dell'isola in inedito del seicento.* Palermo: Salvo di Matteo, 1985.

Malet 1977. Hugh Malet. *Bridgewater, the Canal Duke, 1736–1803.* Manchester: Manchester Univ. Press, 1977.

Marini 1988. Giorgio Marini, ed. *Giovanni Volpato, 1735–1803.* Bassano, Italy: Ghedina & Tassotti, 1988.

Marini 2003. Giorgio Marini. "L'antichità come presente: Giovanni Volpato e la traduzione figurativa tra documentazione e *décor.*" In *I trionfi di Volpato*, ed. Hugh Honour. Milan: Silvana, 2003.

Mariotti 1892. Filippo Mariotti. *La legislazione delle belle arti.* Rome: Unione cooperativa editrice, 1892.

Martín González 1992. J. J. Martín González. "La distribución del espacio en el edificio de la antigua academia." *Academia: Boletín de la Real Academia de Bellas Artes de San Fernando*, no. 75 (1992).

Marzi 2000. Maria Grazia Marzi. "Le antiche lucerne sepolcrali figurate raccolte dalle cave sotterranee e grotte di Roma." In *L'idea del bello: Viaggio per Roma nel Seicento con Giovan Pietro Bellori*, ed. Evelina Borea and Carlo Gasparri. 2 vols. Rome: De Luca, 2000.

Matthews 1835. Henry Matthews. *The Diary of an Invalid, being the Journal of a Tour in Pursuit of Health in Portugal, Italy,*

Switzerland and France, in the Years 1817, 1818 and 1819. Paris: Galignani, 1835.

McCarthy 1981. Michael McCarthy. "Art Education and the Grand Tour." In *Art, the Ape of Nature: Studies in Honor of H. W. Janson*, ed. Moshe Barasch, Lucy Freeman Sandler, and Patricia Egann. New York: Prentice-Hall, 1981.

Melendreras Gimeno 1993. José Luis Melendreras Gimeno. "El escultor neoclásico aragonés Pascual Cortés." *Boletin del Museo e Instituto "Camón Aznar"* 53 (1993).

Messineo 2000. Gaetano Messineo. *La tomba dei Nasonii.* Rome: L'Erma di Bretschneider, 2000.

Meyer zur Capellen 2005. Jürg Meyer zur Capellen. *Raphael: A Critical Catalogue of His Paintings.* 2 vols. Münster: Arcos, 2005.

Michaelis 1882. Adolf Michaelis. *Ancient Marbles in Great Britain.* Cambridge, 1882.

Michel 1971. Olivier Michel. "Peintres autrichiens à Rome dans la seconde moitie du XVIIIème siècle. Documents, I: Martin Knoller, Anton von Maron." *Römische historische Mitteilungen* 13 (1971).

Milizia 1781. Francesco Milizia. *Dell'arte di vedere nelle belle arti del disegno secondo i principi di Sulzer e di Mengs.* Venice, 1781.

Millar 1966. Oliver Millar. *Zoffany and His Tribuna.* London: Paul Mellon Foundation for British Art, 1966.

Misson 1739. Maximilien Misson. *A new voyage to Italy with curious observations on several other countries.* Vol. 1, pt. 2. London: C. Jephson for J and J. Bonwick, C. Rivington, S. Birt, T. Osborne, E. Comyns, et al., 1739.

Misiti and Prosperi Valenti Rodinò 2010. Maria Cristina Misiti and Simonetta Prosperi Valenti Rodinò. *Le meraviglie di Roma antica e moderna.* Turin: Daniela Piazza Editore, 2010.

Moir 1976. Alfred Moir. *Caravaggio and His Copyists.* New York: New York Univ. Press for the College Art Association of America, 1976.

Monnier 2006. Raymonde Monnier. "Tableaux croisés chez Mercier et Rutlidge: Le peuple de Paris et le plébéien anglais." *Annales historiques de la Révolution française*, no. 339 (April 2006), accessed June 2, 2011, http://ahrf.revues.org/document2234.html.

Montaiglon and Guiffrey 1895. Anatole de Montaiglon and Jules Guiffrey, eds. *Correspondance des Directeurs de l'Académie de France à Rome avec les Surintendents des Bâtiments (1666–1793) publiées d'après les Ms. des archives nationales.* Vol. 14. Paris: Societé de l'Histoire de l'Art Français, 1895.

Montanari 2000. Tommaso Montanari. "La politica culturale de Giovan Pietro Bellori." In *L'Idea del Bello: Viaggio per Roma nel Seicento con Giovan Pietro Bellori.* 2 vols. Rome: De Luca, 2000.

Moore 1985. Andrew W. Moore. *Norfolk and the Grand Tour: Eighteenth-Century Travelers Abroad and Their Souvenirs.* Norwich: Norfolk Museums Services, 1985.

Mowl 1995. Timothy Mowl. "A Roman Palace for a Welsh Prince: Byres' Designs for Sir Watkin Williams-Wynn." *Apollo* 142 (Nov. 1995).

Müller 1994. Frank G. J. M. Müller. *The Aldobrandini Wedding,* ed. J. C. Gieben. Iconological Studies in Roman Art 3. Amsterdam: J. C. Gieben, 1994.

Musée de l'Ermitage 1958. Musée de l'Ermitage, Department de l'Art Occidental. *Catalogue des Peintures.* Leningrad and Moscow: Musée de l'Ermitage, 1958.

Museo Nacional de Reproducciones Artísticas 1915. Museo Nacional de Reproducciones Artísticas. *Catálogo del Museo de Reproducciones Artísticas: Artes decorativas de la Antigüedad Clásica.* Vol. 2. Madrid: Hijos de Tello, 1915.

Navarrete Martínez 1989. Esperanza Navarrete Martínez. "Los comienzos de la Biblioteca y el Archivo de la Real Academia de Bellas Artes de San Fernando (1743–1843): Apuntes para la historia." *Academia: Boletín de la Real Academia de Bellas Artes de San Fernando,* no. 68 (1989).

Navarrete Martínez 1999. Esperanza Navarrete Martínez. "Adquisición de libros para la Biblioteca de la Academia de San Fernando (1794–1844)." *Academia: Boletín de la Real Academia de Bellas Artes de San Fernando,* no. 88 (1999).

Negrete Plano 2002. Almudena Negrete Plano. "Suiza y el paso de los Alpes en los Recuerdos del *Westmorland.*" In Westmorland 2002.

Negueruela 1993. Iván Negueruela. "Las excavaciones arqueológicas en el siglo XVIII y el M.A.N." In *De gabinete a museo: Tres siglos de historia. Museo Arqueológico Nacional,* ed. Alejandro Marcos Pous. Madrid: Ministerio de Cultura, 1993.

Neverov 1984. Oleg Neverov. "The Lyde Browne Collection and the History of Ancient Sculpture in the Hermitage Museum." *American Journal of Archaeology* 88, no. 1 (Jan. 1984).

Nikulin 1981. Nikolai Kikolaevich Nikulin, ed. *Anton Rafael Mengs.* Leningrad: State Hermitage, 1981.

Nolli 1770. Carlo Nolli. *Dell'Arco Trajano in Benevento.* Naples, 1770.

Nolli Map 2005. Interactive Nolli Map Website. Univ. of Oregon, 2005, accessed Feb. 6, 2012, http://nolli.uoregon.edu.

Northall 1766. John Northall. *Travels through Italy, Containing New and Curious Observations on That Country.* London, 1766.

O'Donoghue and Dias 2004. F. M. O'Donoghue and Rosie Dias. "Smith, Francis (*fl.* 1763–1779)," rev. Rosie Dias. *Oxford Dictionary of National Biography,* online edition, Oct. 2006, accessed Jan. 3, 2012, http://www.oxforddnb.com/view/article/25797.

Olaechea 1988–90. Rafael Olaechea. "La diplomacia de Carlos III en Italia." *Revista de historia moderna: Anales de la Universidad de Alicante,* nos. 8–9 (1988–90).

Oppé 1952. A. P. Oppé. *Alexander and John Robert Cozens.* London: Adam and Charles Black, 1952.

Orlandi 1772. Orazio Orlandi. *Ragionamento di Orazio Orlandi Romano sopra una Ara Antica Posseduta da Monsignore Antonio Casali Governatore di Roma.* Rome, 1772.

Orlandi 1775. Orazio Orlandi. *Le nozze di Paride ed Elena rappresentate in un vaso antico del museo del signor Tommaso*

Jenkins, gentiluomo inglese. Rome: printed by Giovanni Zempel, 1775.

F. Owen and Brown 1988. Felicity Owen and David Blayney Brown. *Collector of Genius: A Life of Sir George Beaumont.* New Haven and London: Yale Univ. Press, 1988.

J. Owen 1796. John Owen. *Travels into different parts of Europe in the years 1791 and 1792.* London, 1796.

Ozzola 1909. Leandro Ozzola. "Works of Salvator Rosa in England." *Burlington Magazine* 16 (Dec. 1909).

Pagano de Divitiis 1997. Gigliola Pagano de Divitiis. *English Merchants in Seventeenth-Century Italy.* Cambridge: Cambridge Univ. Press, 1997.

Partsch 1891. Josef Franz Maria Partsch. *Philipp Clüver, der Begründer der historischen Länderkunde: Ein Beitrag zur Geschichte der geographischen Wissenschaft.* Vienna and Olomouc: Eduard Hölzel, 1891.

Pascuali 2007. Susanna Pasquali. "Apprendistati italiani d'architettura nella Roma internazionale, 1750–1810." In *Contro il Barocco: Apprendistato a Roma e practica dell'architettura civile in Italia, 1780–1820,* ed. Angela Cipriani, Gian Paolo Consoli, and Susanna Pasquali. Rome: Campisano Editore, 2007.

Paul 2008. Carole Paul. *The Borghese Collections and the Display of Art in the Age of the Grand Tour.* Aldershot, UK: Ashgate, 2008.

Pearce and Salmon 2005. Susan Pearce and Frank Salmon. "Charles Heathcote Tatham in Italy, 1794–96: Letters, Drawings and Fragments, and Part of an Autobiography." *Walpole Society* 67 (2005).

Penny 1998. Nicholas Penny. "Imposing Décor." *Country Life,* June 14, 1998.

Penny 2008. Nicholas Penny. *The Sixteenth Century Italian Paintings.* Vol. 2, *Venice, 1540–1600.* London: National Gallery, 2008.

Pepper 1984. D. Stephen Pepper. *Guido Reni: A Complete Catalogue of His Works with an Introductory Text.* Oxford: Phaidon, 1984.

Perini 1998. Giovanna Perini, ed. *Giovanni Ludovico Bianconi: Scritti tedeschi.* Bologna: Minerva, 1998.

Petrucci 2010. Francesco Petrucci. *Pittura di ritratto a Roma: Il Settecento.* Rome: Andreina & Valneo Budai, 2010.

Petto 2007. Christine Marie Petto. *When France Was King of Cartography: The Patronage and Production of Maps in Early Modern France.* Lanham, MD: Lexington Books, 2007.

Piles 1699. Roger de Piles. *L'abrégé de la vie des peintres.* Paris, 1699.

Piozzi 1789. Hester Lynch Piozzi. *Observations and Reflections Made in the Course of a Journey through France, Italy, and Germany.* 2 vols. London, 1789.

Piranesi 2002. Giovanni Battista Piranesi. *Observations on the Letter of Monsieur Mariette; with Opinions on Architecture, and a Preface to a New Treatise on the Introduction and Progress of the Fine Arts in Europe in Ancient Times,* ed. Harry F. Mulgrave,

trans. Caroline Beamish and David Britt. Los Angeles: Getty Research Institute, 2002.

Pollack and Baines 2000. Martha Pollack and Claire Baines. *The Mark J. Millard Architectural Collection.* Vol. 4, *Italian and Spanish Books, Fifteenth through Nineteenth Centuries.* Washington, DC: National Gallery of Art, 2000.

Polsue 1868. Joseph Polsue. *A Complete Parochial History of the County of Cornwall, Compiled from the Best Authorities & Corrected and Improved from Actual Survey.* 2 vols. Truro: William Lake, 1868.

Price 2007. Monica Price. *Decorative Stone: The Complete Sourcebook.* London: Thames & Hudson, 2007.

Raspi Serra 1986. Joselita Raspi Serra, ed. *Paestum and the Doric Revival, 1750–1830: Essential Outlines of an Approach.* Florence: Centro Di, 1986.

Réau 1932. Louis Réau. "Correspondance artistique de Grimm avec Catherine II." *Archives de l'art français* 17, no. 52 (1932).

Retford 2006. Kate Retford. *The Art of Domestic Life: Family Portraiture in Eighteenth-Century England.* New Haven and London: Yale Univ. Press, 2006.

Reynolds 2000. Joshua Reynolds. *The Letters of Sir Joshua Reynolds,* ed. John Ingamells and John Edgcumbe. New Haven and London: Yale Univ. Press, 2000.

J. Richardson 1719. Jonathan Richardson the elder. *Two Discourses.* London, 1719.

J. Richardson 1722. Jonathan Richardson the elder. *An Account of Some of the Statues, Bas-Reliefs, Drawings and Pictures in Italy, &c. with Remarks by Mr Richardson, Sen and Jun,* ed. J. Knapton. London, 1722.

M. Richardson 2003. Margaret Richardson. "John Soane and the Temple of Vesta at Tivoli." *Architectural History* 46 (2003).

Ridley 1992. Ronald Ridley. "To Protect the Monuments: The Papal Antiquarians, 1534–1870." *Xenia Antiqua* 1 (1992).

Ridolfi 1648. Carlo Ridolfi. *Le Meraviglie dell'arte o vero le vite degli illustri pittori Veneti e dello stato.* Venice, 1648.

Robison 1983. Andrew Robison. "Dating Piranesi's Early *Vedute di Roma.*" In *Piranesi tra Venezia e l'Europa,* ed. Alessandro Bettagno. Florence: L. S. Olschki, 1983.

Robison 1986. Andrew Robison. *Piranesi: Early Architectural Fantasies; A Catalogue Raisonné of the Etchings.* Chicago and London: Univ. of Chicago Press, 1986.

Roettgen 1993. Steffi Roettgen. *Anton Raphael Mengs and His British Patrons.* London: Zwemmer / English Heritage, 1993.

Roettgen 1999. Steffi Roettgen. *Anton Raphael Mengs, 1728–1778.* Vol. 1, *Das malerische und zeichnerische Werk.* Munich: Hirmer Verlag, 1999.

Roettgen 2001. Steffi Roettgen, ed. *Mengs, die Erfindung des Klassizismus.* Munich:, Hirmer Verlag, 2001.

Roettgen 2003. Steffi Roettgen. *Anton Raphael Mengs, 1728–1779.* Vol. 2, *Leben und Wirken.* Munich: Hirmer Verlag, 2003.

Roettgen 2008. Steffi Roettgen. "Batoni e Mengs a paragone." In Barroero and Mazzocca 2008.

Roscoe 2009. Ingrid Roscoe. "Christopher Hewetson." In Roscoe, Hardy, and Sullivan 2009.

Roscoe, Hardy, and Sullivan 2009. Ingrid Roscoe, Emma Hardy, and M. G. Sullivan. *A Biographical Dictionary of Sculptors in Britain, 1660–1851*. New Haven and London: Yale Univ. Press, 2009.

Rosenberg 1994. Pierre Rosenberg, ed. *Nicolas Poussin, 1594–1665*. Exh. cat. Paris: Réunion des musées nationaux, 1994.

Rosenthal 2006. Angela Rosenthal, *Angelica Kauffman: Art and Sensibility*. New Haven and London: Yale Univ. Press, 2006.

Ross 2001. Ian Campbell Ross. *Laurence Sterne: A Life*. Oxford: Oxford Univ. Press, 2001.

Rotili 1972. Mario Rotili. *L'arco di Traiano a Benevento*. Rome: Istituto poligrafico dello Stato; Libreria dello Stato, 1972.

Rotili 1974. Mario Rotili. *Salvator Rosa incisore*. Naples: Società Editrice Napoletana, 1974.

Ruiz Alcón 1968. María Teresa Ruiz Alcón. "Temas marinos en la pintura del Patrimonio Nacional." *Reales Sitios* 17 (1968).

Russel 1750. James Russel. *Letters from a young painter abroad to his friends in England: Adorned with copper plates.* Vol. 2. London: W. Russel, 1750.

Russell 1975–76. Francis Russell. "The Stourhead Batoni and Other Copies after Reni." *National Trust Year Book* (1975–76).

Russell 1991. Francis Russell. "Guercino and England." In *Guercino in Britain: Paintings from British Collections*, ed. Michael Helston. Exh. cat. London: National Gallery, 1991.

F. Salmon 1990. Frank Salmon. "British Architects and the Florentine Academy, 1753–1794." *Mitteilungen des Kunsthistorischen Institutes in Florenz* 34, nos. 1–2 (1990).

F. Salmon 1993. Frank Salmon. "Charles Cameron and Nero's Domus Aurea: 'Una piccola esplorazione,'" *Architectural History* 36 (1993).

F. Salmon 2001. Frank Salmon. *Building on Ruins*. Aldershot, UK: Ashgate, 2001.

J. Salmon 1798–1800. J. Salmon. *An Historical Description of Ancient and Modern Rome. . . .* 2 vols. London, 1798–1800.

Sambricio 1986. Carlos Sambricio. *La arquitectura española de la Ilustración*. Madrid: Consejo Superior de los Colegios de Arquitectos de España; Instituto de estudios de administración local, 1986.

Sánchez-Jáuregui 2001a. María Dolores Sánchez-Jáuregui. "El origen de la pintura del escocés David Allan, dos copias en la Real Academia de Bellas Artes de San Fernando." *Academia de España en Roma* (2001).

Sánchez-Jáuregui 2001b. María Dolores Sánchez-Jáuregui. "Two Portraits of Francis Basset by Pompeo Batoni in Madrid." *Burlington Magazine* 143 (July 2001).

Sánchez-Jáuregui 2002. María Dolores Sánchez-Jáuregui. "El Grand Tour de Francis Basset." In Westmorland 2002.

Savage 2001. Nicholas Savage. "Exhibiting Architecture: Strategies of Representation in English Architectural Exhibition Drawings, 1760–1836." In *Art on the Line: The Royal Academy Exhibitions at Somerset House, 1780–1836*, ed. David Solkin. New Haven and London: Yale Univ. Press, 2001.

Schlosser 1986. Julius Schlosser. *La literatura artística: Manual de fuentes de la historia moderna del arte*. 3rd ed. Madrid: Cátedra, 1986.

Scott 1996. Jonathan Scott. *Salvator Rosa: His Life and Times*. New Haven and London: Yale Univ. Press, 1996.

Scott 2003. Jonathan Scott. *The Pleasures of Antiquity: British Collectors of Greece and Rome*. New Haven and London: Yale Univ. Press, 2003.

Serlio 1996. Sebastiano Serlio. *Sebastiano Serlio on Architecture*, trans. Vaughan Hart and Peter Hicks. New Haven and London: Yale Univ. Press, 1996.

Skeat 1952. T. C. Skeat. "Manuscripts and Printed Books from the Holkham Hall Library: The Library." *British Museum Quarterly* 17, no. 2 (Aug. 1952).

Sloan 1986. Kim Sloan. *Alexander and John Robert Cozens: The Poetry of Landscape*. New Haven and London: Yale Univ. Press in association with the Art Gallery of Ontario, 1986.

Sloan 2006. Kim Sloan. "'Amusements of Solitude' and 'Talismans of Transport': William Beckford and Landscape Painting in Britain and Abroad." In *The Beckford Society Annual Lectures, 2004–2006*, ed. Richard Allen. Privately printed for the Beckford Society, 2006.

Sloan and Lloyd 2008. Kim Sloan and Stephen Lloyd. *The Intimate Portrait: Drawings, Miniatures and Pastels from Ramsay to Lawrence*. Exh. cat. Edinburgh: National Galleries of Scotland; London: British Museum, 2008.

Smith 1828. John Thomas Smith. *Nollekens and His Times*. 2 vols. London, 1828.

Smollett 1766. Tobias Smollett. *Travels through France and Italy containing observations on character, customs, religion, government, police, commerce, arts, and antiquities*. 2 vols. London: printed for R. Baldwin, 1766.

Soane 1835. Sir John Soane. *Memoirs of the Professional Life of an Architect between the Years 1768 and 1835*. London: Moyes, 1835.

Sohm 1982. Philip L Sohm. "Pietro Longhi and Carlo Goldoni: Relations between Painting and Theater." *Zeitschrift für Kunstgeschichte* 45, no. 3 (1982).

Solkin 1982. David Solkin. *Richard Wilson: The Landscape of Reaction*. London: Tate Gallery, 1982.

Sommella Mura 2005. Anna Sommella Mura. *Musei Capitolini: Guida*, ed. Nunzio Giustozzi. Milan: Electa, 2005.

S. P. 1917. S. P. "Periodicals: Russian." *Burlington Magazine* 30 (Jan. 1917).

Spear 1982. Richard E. Spear. *Domenichino*. 2 vols. New Haven and London: Yale Univ. Press, 1982.

Spence 1747. Joseph Spence. *Polymetis or an Enquiry concerning the Agreement between the Works of the Roman Poets, and the*

Remain on the Antient Artists, Being an Attempt to Illustrate them mutually from One Another. London: printed for R. Dodsley, 1747.

Spence 1966. Joseph Spence. *Observations, Anecdotes, and Characters of Books and Men, Collected from Conversation*, ed. James M. Osborn. 2 vols. Oxford: Clarendon Press, 1966.

Spence 1975. Joseph Spence. *Letters from the Grand Tour*, ed. Slava Klima. Montreal: McGill-Queen's Univ. Press, 1975.

Spinola 1999. Giandomenico Spinola. *Il Museo Pio-Clementino*. Vatican City, 1999.

Stanring 1988. Timothy J. Stanring. "Some Pictures by Poussin in the Dal Pozzo Collection: Three New Inventories." *Burlington Magazine* 130 (Aug. 1988).

Starkey 1990. David J. Starkey. *British Privateering Enterprise in the Eighteenth Century*. Exeter Maritime Studies 4. Exeter: Univ. of Exeter Press, 1990.

Steuben 1966. Hans von Steuben, in *Führer durch die öffentlichen Sammlungen klassischer Altertümer in Rom*. Vol. 2, *Die stadtischen Sammlungen: kapitolinische Museen und Museo Barracco: Die Staatlichen Sammlungen*, by Wolfgang Helbig. 4th ed. Tübingen: Verlag Ernst Wasmuth, 1966.

Stillman 1970. Damie Stillman. "The Gallery for Lansdowne House: International Neoclassical Architecture and Decoration in Microcosm." *Art Bulletin* 52 (March 1970).

Stolberg 1797. Count Frederic Leopold Stolberg. *Travels through Germany, Switzerland, Italy and Sicily: Translated from the German of Frederic Leopold Count Stolberg by Thomas Holcroft*. 4 vols. London: printed for G. G. and J. Robinson, 1797.

Stumpf 1982. Claudia Stumpf. "The 'Expedition into Sicily.'" In Clarke and Penny 1982.

Stumpf 1986. Claudia Stumpf, ed. *Richard Payne Knight: Expedition into Sicily*. London: British Museum Publications, 1986.

Suárez Huerta 2002. Ana María Suárez Huerta. "Un barco Inglés en el puerto de Livorno." In Westmorland 2002.

Suárez Huerta 2006. Ana María Suárez Huerta. "A Portrait of George Legge by Batoni." *Burlington Magazine* 148 (April 2006).

Suárez Huerta 2007. Ana María Suárez Huerta. "El templo de Vesta en Tívoli, fuente de inspiración para los arquitectos del siglo XVIII." *Reales Sitios: Revista del Patrimonio Nacional*, no. 173 (2007).

Suárez Huerta 2008. Ana María Suárez Huerta. "Cinco urnas cinerarias del Museo Arqueológico Nacional." *Espacio, Tiempo y Forma*, ser. 2, no. 21 (2008).

Suárez Huerta 2009a. Ana María Suárez Huerta. "Tres retratos iguales de un mismo personaje: Lady Anne Clifford, condesa de Mahony." In *Intorno a Batoni, convegno internazionale*, ed. Liliana Barroero. Rome: Edizioni Fondazione Ragghianti studi sull'arte, 2009.

Suárez Huerta 2009b. Ana María Suárez Huerta. "Un paisaje del convento de San Cosimato en el Valle de Licenza: Un cuadro inédito de Solomon Delane." *Storia dell'arte*, n.s., 22–23 (Jan.–Aug. 2009).

Summerson and Dorey 2001. John Summerson and Helen Dorey. *A New Description of Sir John Soane's Museum*. London: Trustees of Sir John Soane's Museum, 2001.

Sumner and Smith 2003. Anne Sumner and Greg Smith, eds. *Thomas Jones (1742–1803): An Artist Rediscovered*. New Haven and London: Yale Univ. Press, 2003.

Sunderland 1973. John Sunderland. "The Legend and Influence of Salvator Rosa in England in the Eighteenth Century." *Burlington Magazine* 115 (Dec. 1973).

Sweet 2007. Rosemary Sweet. "British Perceptions of Florence in the Long Eighteenth Century." *Historical Journal* 50 (2007).

Tangye 2002. Michael Tangye. *Tehidy and the Bassets: The Rise and Fall of a Great Cornish Family*. New ed. Redruth, UK: Truran, 2002.

Tanucci 1997. Bernardo Tanucci. *Epistolario*. Vol. 12, *1763–1764*. Naples: Società Napoletana di Storia Patria, 1997.

Tedeschi 2011. Letizia Tedeschi. "Vincenzo Brenna and His Drawings from the Antique for Charles Townley." In *Roma Britannica: Art Patronage and Cultural Exchange in Eighteenth-Century Rome*, ed. David Marshall, Susan Russell, and Karin Wolfe. London: British School at Rome, 2011.

Thackray 1996. John Thackray. "'The Modern Pliny': Hamilton and Vesuvius." In Jenkins and Sloan 1996.

Thorne 2006. Roland Thorne. "Basset, Francis, Baron de Dunstanville and first Baron Basset (1757–1835)." In *Oxford Dictionary of National Biography*, online ed., Oct. 2006, accessed Aug. 17, 2010, http://www.oxforddnb.com/view/article/1637.

Tiroli 1775. Francesco Tiroli. *La vera guida per chi viaggia in Italia con la descrizione di tutti I viage e sue poste dimostrate con estate carte geografiche, con una breve annotazione di tutto cio, che si trova di piu rimarche vole in ogni citta, luogo di passo, risugardante pitture, scultura, architettura, ed antichità ricavato dai piu classici autori: Dedicata all'illustris signore Tommaso Jenkins*. Rome, 1775.

Tomasi 1997. Lucia Tongiorgi Tomasi. *An Oak Spring Flora: Flower Illustration from the Fifteenth Century to the Present Time, a Selection of the Rare Books, Manuscripts, and Works of Art in the Collection of Rachel Lambert Mellon*. Upperville, Va.: Oak Spring Garden Library, 1997.

Tomory 1971. Peter Tomory, ed. *Salvator Rosa: His Etchings and Engravings after His Works*. Exh. cat. Sarasota, FL: John and Mable Ringling Art Museum, 1971.

Torre 2002. Francesca del Torre. "Gavin Hamilton a Giovanni Maria Sasso." In *Lettere artistiche del Settecento Veneziano*, ed. Alessandro Bettagno and Marina Magrini. Venice: N. Pozza, 2002.

Treccani. it, s.v. "Lami, Giovanni." *Treccani.it, l'enciclopedia Italiana*, s.v. "Lami, Giovanni," accessed Nov. 26, 2011, http://www.treccani.it/enciclopedia/giovanni-lami/.

Treccani. it, s.v. "Volpi, Giovanni Antonio." *Treccani.it,* l'*enciclopedia Italiana*, s.v. "Volpi, Giovanni Antonio," http://www.treccani.it/enciclopedia/giovanni-antonio-volpi/.

Turnbull 1741. George Turnbull. *A Curious Collection of Ancient Paintings Accurately Engraved from Excellent Drawings*, ed. A. Millar. London, 1741.

Úbeda de los Cobos 2001. Andrés Úbeda de los Cobos. *Pensamiento artístico español del siglo XVIII: De Antonio Palomino a Francisco de Goya*. Madrid: Museo Nacional del Prado, Colección Universitaria, 2001.

Ubl 1999. Ralph Ubl. "Guido Renis Aurora: Politische Funktion, Gattungspoetik und Selbstdarstellung der Malerei im Gartenkasino der Borghese am Quirinal." *Jahrbuch des Kunsthistorischen Museums Wien* 1 (1999).

Universal 1767. *The Universal Pocket companion, containing, among many other necessary and entertaining particulars, a geographical description of the world. . . .* London: 1767.

Urrea Fernández 2006. Jesús Urrea Fernández. *Relaciones artísticas Hispano-Romanas en el s. XVIII*. Madrid: Fundación de Apoyo a la Historia del Arte Hispánico, 2006.

Valverde Merino 2010. José Luis Valverde Merino. *Abanicos del siglo XVIII en las Colecciones de Patrimonio Nacional*. Madrid: Patrimonio Nacional, 2010.

Vanvitelli 1756. Luigi Vanvitelli. *Dichiarazione dei disegni del reale Palazzo di Caserta alle sacre reali maesta di Carlo re delle Due Sicilie e di Gerus. infante di Spagna duca di Parma e di Piacenza gran prencipe ereditario di Toscana e di Maria Amalia di Sassonia regina &c &c*. Naples: Regia Stamperia, 1756.

Vaughan 1987. Gerard Vaughan. "James Hugh Smith Barry as a Collector of Antiquities." *Apollo* 126 (July 1987).

Vaughan 1991. Gerard Vaughan. "Albacini and His English Patrons." *Journal of the History of Collections* 3, no. 2 (1991).

Vaughan 1996. Gerard Vaughan. "'Vincenzo Brenna Romanus: Architectus et Pictor': Drawing the Antique in Late Eighteenth-Century Rome." *Apollo* 144 (Oct. 1996).

Vaughan 2000. Gerard Vaughan. "Thomas Jenkins and His International Clientele." In *Antikensammlungen des europäischen Adels im 18. Jahrhundert*, ed. Dietrich Boschung and Henner von Hesberg. Mainz am Rhein: Verlag Philipp von Zabern, 2000.

Verdi 1999. Richard Verdi. *Matthias Stom, Isaac Blessing Jacob*. Birmingham: Barber Institute of Fine Arts, 1999.

Villena et al. 2009. Miguel Villena Sánchez-Valero et al. *El gabinete perdido: Pedro Franco Dávila y la Historia Natural del Siglo de las Luces*. Madrid: Consejo Superior de Investigaciones Científicas, 2009.

Visconti and Visconti 1818. Giovanni Battista Visconti and Ennio Quirino Visconti. *Il Museo Pio-Clementino: Illustrato e descritto*. 7 vols. Milan: Bettoni, 1818.

Waagen 1857. Gustav Waagen. *Galleries and Cabinets of Art in Great Britain: Being an Account of More than Forty Collections of Paintings, Drawings, Sculptures, MSS., &c.* London: Murray, 1857.

Wallace 1979. Richard W. Wallace. *The Etchings of Salvator Rosa*. Princeton, NJ: Princeton Univ. Press, 1979.

Walpole 1767. Horace Walpole. *Ædes Walpolianæ: Or a description of the collections of pictures at Houghton-Hall*. London, 1767.

Walpole 1954. Horace Walpole. *Horace Walpole's Correspondence*. New Haven: Yale Univ. Press, 1954.

Wark 1997. Robert R. Wark, ed. *Discourses on Art*. London and New Haven: Yale Univ. Press, 1997.

Watkin 1996. David Watkin. *Sir John Soane: Enlightenment Thought and the Royal Academy Lectures*. Cambridge: Cambridge Univ. Press, 1996.

Webb 1761. Daniel Webb. *Inquiry into the Beauties of Painting; and into the Merits of the Most Celebrated Painters, Ancient and Modern*. 2nd ed. London: printed for R. and J. Dodsley, 1761.

Webster and Feder 2011. James Webster and Georg Feder. "Haydn, Joseph." In *Grove Music Online. Oxford Music Online*, accessed Nov. 21, 2011, http://www.oxfordmusiconline.com/subscriber/article/grove/music/44593.

Westmorland 2002. José M. Luzón Nogué, ed. *El Westmorland: Recuerdos del Grand Tour*. Seville: Fundación El Monte, 2002.

Wethey 1975. Harold E. Wethey. *The Paintings of Titian*. Vol. 3, *The Mythological and Historical Paintings*. London: Phaidon, 1975.

Whitley 1928. William T. Whitley. *Artists and Their Friends in England, 1700–1799*. 2 vols. London and Boston: Medici Society, 1928.

Williams 2004. Gomer Williams. *History of the Liverpool Privateers and Letters of Marque with an Account of the Liverpool Slave Trade, 1744–1812*. Montreal, McGill-Queen's Univ. Press, 2004.

Wilton 1980. Andrew Wilton. *The Art of Alexander and John Robert Cozens*. New Haven: Yale Center for British Art, 1980.

Wilton and Bignamini 1996. Andrew Wilton and Ilaria Bignamini, eds. *Grand Tour: The Lure of Italy in the Eighteenth Century*. Exh. cat. London: Tate Gallery, 1996.

Wilton-Ely 1978. John Wilton-Ely. *The Mind and Art of Piranesi*. New York and London: Thames & Hudson, 1978.

Wilton-Ely 1993. John Wilton-Ely. *Piranesi as Architect and Designer*. New Haven and London: Yale Univ. Press, 1993.

Wilton-Ely 1994. John Wilton-Ely. *Giovanni Battista Piranesi: The Complete Etchings*. 2 vols. San Francisco: Alan Wofsy Fine Arts, 1994.

Wilton-Ely 2002. John Wilton-Ely. *Piranesi, Paestum and Soane*. London: Asimuth Editions for Sir John Soane's Museum, 2002.

Wilton-Ely 2007. John Wilton-Ely. "The Ultimate Act of Fantasy: Piranesi's Funerary Candelabrum." *Apollo* 166 (Sept. 2007).

Winckelmann 1765. Johann Joachim Winckelmann. *Reflections on the Painting and Sculpture of the Greeks: With Instructions for the Connoisseur, and an Essay on Grace in Works of Art*,

translated from the German original of the Abbé Winkel-mann . . . by Henry Fuseli. London, 1765.

Winckelmann 1766. Johann Joachim Winckelmann. *Histoire de l'art chez les anciens, par J. Winckelmann; ouvrage traduit de l'allemand.* Paris, 1766.

Winckelmann 1767. Johann Joachim Winckelmann. *Monumenti antichi inediti.* Rome, 1767.

Winckelmann 1771. Johann Joachim Winckelmann. *Critical account of the situation and destruction by the first eruptions of Mount Vesuvius of Herculaneum, Pompeii, and Stabia; the late discovery of their remains; the subterraneous works carried on in them; . . . in a letter, (originally in German) to Count Bruhl, of Saxony, from the celebrated Abbé Winckelman, . . . Illustrated with notes, taken from the French translation.* London: printed for T. Carnan and F. Newbery, jun., 1771.

Winckelmann 1961. Johann Joachim Winckelmann. *Lettere italiane,* ed. Giorgio Zampa. Milan: Feltrinelli, 1961.

Wood 1999. Jeremy Wood. "Raphael Copies and Exemplary Picture Galleries in Mid Eighteenth-Century London." *Zeitschrift für Kunstgeschichte* 62, no. 3 (1999).

Worsley 1994. Giles Worsley, ed. *The Role of the Amateur Architect: Papers Given at the Georgian Group Symposium, 1993.* London: Georgian Group, 1994.

Worsley 1995. Giles Worsley. "Chambers and Architectural Draughtsmanship." In *Sir William Chambers: Architect to George III,* ed. John Harris and Michael Snodin. New Haven and London: Yale Univ. Press, 1995.

Worsley, Bristol, and Connor 2004. Giles Worsley, Kerry Bristol, and William Connor. *Drawing from the Past: William Weddell and the Transformation of Newby Hall.* Leeds: Leeds Museums and Galleries (City Art Gallery) in association with West Yorkshire Archive Service, 2004.

Wright 1730. Edward Wright. *Some observations made in travelling through France, Italy, &c. in the years 1720, 1721, and 1722.* London: Thomas Ward and E. Wicksteed, 1730.

Yarker and Hornsby 2011. Jonathan Yarker and Clare Hornsby. "A Speculative Grand Tour Excavation." *British Art Journal* 11, no. 3 (Spring 2011).

Zapperi 1991. Roberto Zapperi. "Alessandro Farnese, Giovanni della Casa and Titian's Danae in Naples." *Journal of the Warburg and Courtauld Institutes* 54 (1991).

Zumbach 2011. Anne Pastori Zumbach. "Gardelle, Robert." In *Grove Art Online. Oxford Art Online,* accessed Dec. 5, 2011, http://www.oxfordartonline.com/subscriber/article/grove/art/T030697.

Index

Photography Credits

Photo / akg-images / Andrea Jemolo: fig. 59

The Collection at Althorp, Northampton, UK: fig. 13

© Araldo de Luca / CORBIS: fig. 109

© Arcaid / Mark Fiennes: fig. 115

Archivo Histórico Nacional, Madrid: cat. 10

Photography © The Art Institute of Chicago: fig. 7; cat. 6

Biblioteca di Camera di Commercio di Livorno: fig. 4

Bibliothèque Mazarine, Paris: fig. 62

© The British Library Board: figs. 3, 16, 20, 114; cat. 12

© Trustees of the British Museum: figs. 5, 39, 40, 41, 49, 67, 126

Burton Constable Foundation: figs. 44, 122

By courtesy of the Governing Body of Christ Church, Oxford: fig. 110

Courtesy of P. & D. Colnaghi & Co., Ltd., London and Bernheimer Fine Old Masters, Munich: fig. 34

Comune di Bassano del Grappa: fig. 116

© Comune di Roma-Sovraintendenza Beni Culturali-Museo di Roma: fig. 95

Cornwall Record Office ref AD862/181: fig. 111

© Country Life: fig. 31, 46

The Dayton Art Institute, Gift of Mr. and Mrs. Harry S. Price, Jr., 1969.52: fig. 113

Fotógrafos Oronoz: fig. 117

Hermitage, St. Petersburg, Russia / The Bridgeman Library: fig. 56; cat. 17

© The Hunterian, University of Glasgow 2012: fig. 69

Le Claire Kunst, Hamburg: fig. 37

© The Metropolitan Museum of Art / Art Resource, NY: fig. 125

Ministerio de Cultura, Archivo General de Simancas: cat. 16

© Servicio de Fotografía MNCN, Madrid: cats. 62, 124

© 2012 Museo Nacional del Prado: front cover, figs. 10, 12; cats. 7, 21, 110

The National Archives, Kew: figs. 21, 22; cats. 1, 2

© National Gallery of Ireland: fig. 66

National Library of Scotland: cat. 15

© National Maritime Museum, Greenwich, London: fig. 18; cat. 3

Courtesy National Museums Liverpool: fig. 57

© National Portrait Gallery, London: fig. 35

© NTPL: fig. 64

©NTPL / Andreas von Einsiedel: fig. 123

© Patrimonio Nacional: figs. 1, 6, 8; cats. 5, 75, 76, 77, 95, 96

Private collection: fig. 42

Real Academia de Bellas Artes de San Fernando, Archivo-Biblioteca: figs. 11, 24, 30, 33, 48, 50, 51, 52, 96, 97, 98, 99, 100, 101, 102, 103, 104, 105, 106, 107, 108, 118; cats. 11, 13, 14, 18, 19, 20, 37, 38, 39, 41, 42, 43, 44, 45, 46, 47, 48, 49, 50, 51, 55, 57, 58, 59, 60, 61, 79, 80, 81, 82, 83, 84, 85, 86, 87, 88, 89, 90, 91, 92, 93, 94, 103, 104, 105, 106, 107, 108, 109, 113, 114, 115, 116, 117, 118, 119, 123

Real Academia de Bellas Artes de San Fernando, Museo: back cover, figs. 2, 9, 15, 28, 43, 45, 47, 54, 60, 63, 70, 71, 72, 73, 74, 75, 81, 82, 83, 84, 86, 87, 88, 89, 92, 120, 124; cats. 8, 22, 23, 24, 25, 26, 27, 28, 29, 30, 31, 32, 33, 34, 35, 36, 40, 52, 53, 54, 56, 63, 64, 65, 66, 67, 68, 69, 70, 71, 72, 73, 74, 78, 97, 98, 99, 100, 101, 102, 111, 112, 120, 121, 122, 125, 126, 127, 128, 129, 130, 131, 132, 133, 134, 135, 136, 137, 138, 139, 140

Réunion des Musées Nationaux / Art Resource, NY: fig. 32

© Rheinisches Bildarchiv, rba_c002179: fig. 68

The Royal Collection © 2012 Her Majesty Queen Elizabeth II: figs. 25, 26, 55, 61

Scottish National Portrait Gallery: figs. 14, 38

Sir John Soane's Museum, London: fig. 85

Staffordshire Record Office: fig. 19; cat. 9

By permission of the Master and Fellows of St John's College, Cambridge: fig. 94

Photo by Barry Williamson, by kind permission of Lord Talbot: fig. 119

© Towneley Hall Art Gallery and Museum, Burnley, Lancashire / The Bridgeman Art Library: fig. 27

Trinity College, Dublin: fig. 65

Tyrwhitt-Drake Collection: fig. 53

Courtesy of the Earth Sciences and Map Library, University of California, Berkeley: fig. 36

Faculty of Architecture and History of Art, University of Cambridge: figs. 90, 91

Photo © Victoria and Albert Museum, London: figs. 93, 112

Richard Caspole, Yale Center for British Art: figs. 23, 29, 76, 77, 78, 79, 80, 121; cat. 4

Yale University Library: fig. 17